ART for ALL?

THE COLLISION OF MODERN ART AND ✦ THE PUBLIC IN ✦ LATE-NINETEENTH-CENTURY GERMANY

BETH IRWIN LEWIS

PRINCETON UNIVERSITY PRESS ✦ PRINCETON AND OXFORD

Front cover: Edmund Harbürger, "The Public Prosecutor
at the Art Exhibition," 1898 (fig. 72B)
Back cover: Adolf Oberländer, "The Modern Enjoyment
of Art," 1889 (fig. 55A)
Frontispiece: Adolf Oberländer, "Understood," 1888
(fig. 4A)
Details: title page (fig. 65A); part I (fig. 5); part II (fig. 72A);
part III (fig. 106)

Published by
Princeton University Press
41 William Street
Princeton, New Jersey 08540

In the United Kingdom:
Princeton University Press
3 Market Place
Woodstock, Oxfordshire OX20 1SY

www.pupress.princeton.edu

Publication of this book was supported by a grant from The
Henry Luce III Fund for Distinguished Scholarship adminis-
tered by The College of Wooster.

Designed by Wilcox Design
Composed by Sam Potts
Printed and bound by South China Printing
Manufactured in China
(Cloth) 10 9 8 7 6 5 4 3 2 1
(Paper) 10 9 8 7 6 5 4 3 2 1

Library of Congress Cataloging-in-Publication Data
Lewis, Beth Irwin, 1934–
 Art for all? : the collision of modern art and the
 public in late-nineteenth-century Germany /
 Beth Irwin Lewis
 p. cm.
 Includes bibliographical references and index.
 ISBN 0-691-10264-3 (alk. paper) —
 ISBN 0-691-10265-1 (pbk. : alk. paper)
 1. Arts, German—19th century. 2. Modernism
 (Art)—Germany. 3. Art criticism—Germany—
 History—19th century. 4. Arts audiences—
 Germany—Psychology. I.

NX550.A1 L48 2003
709'.43'09034—dc21 2002029284

to ISABEL and PETER PARET

Contents

PROLOGUE: APE, APOTHEOSIS, and SCANDAL 8

PLATES 17

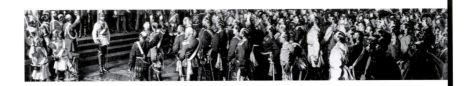

part I THE TRIUMPH of MODERN ART, 1885–1892 26

chapter 1 CONTEMPORARY ART FOR THE MODERN NATION 28

chapter 2 CARRYING ART TO THE PUBLIC 93

part II THE PUBLIC and THE CRITIC 140

part III THE FRAGMENTING of ART and ITS PUBLIC, 1893–1899 184

chapter 4 MODERN ARTISTS: PAUPER, DILETTANTE, AND PRINCE 186

chapter 5 MODERN ART FOR AN ELITE PUBLIC 238

chapter 6 MODERNISM: ACCEPTANCE AND RESISTANCE 267

EPILOGUE: JEW, EMPEROR, and PARANOIA 312

NOTES 316

SELECTED BIBLIOGRAPHY 413

ACKNOWLEDGMENTS 433

INDEX 435

PHOTOGRAPHY CREDITS 447

APE, APOTHEOSIS, AND SCANDAL

June 1888, the Third International Art Exhibition in Munich: two sensational works commanded attention. A marble life-sized gorilla, wounded and enraged, clutching a nude woman under the right arm, fending off an enemy with a huge rock in the left hand, elicited fascination and repulsion from crowds as they entered the main exhibition hall (fig. 1). Enthusiastic nationalistic fervor, however, dominated the crowds' response to a mammoth painting of the glorification of Emperor William I, triumphant founder of the German Empire, riding in stately glory past the Brandenburg Gate accompanied by Crown Prince Frederick, Chancellor Otto von Bismarck, Field Marshal Helmuth von Moltke, a German knight, angels, gods, and goddesses (fig. 2). As incongruous as these images were, the curious viewers easily recognized in both works a meticulous attention to realistic detail and superior mastery of artistic skills.

These characteristics were not, however, what drew the attention of crowds and critics. More likely the possessive sexual rage and violence of the sculptured pair aroused amorphous dreams and fears in a public vaguely aware of Darwinian struggle, of African explorations and colonies, or of their own tenuous hold on respectability. Turning from this uneasy thrill to the elevated ideal of the nation, led into higher realms of heroic fantasy and honor by the comfortable portrait of the beloved emperor, provided reassurance to the public viewers that the dark continents, whether inner sexual identity or outer threats to national identity, could be contained. This re-creation of the public's responses to the gorilla's abduction and the imperial apotheosis is speculative and partial, but not random, since it points to issues of sexual and national identity that

are embedded in the works. These are themes that thread through this study of the public presentation and popular reception of new art forms in Germany at the end of the nineteenth century.

Examining the crisp photographs of these images in a century-old journal, we also find a short story with a jolting exposition of the meaning of the sculptural pair. The tale ostensibly describes the public reaction to the gorilla and his captive when the statue was exhibited in Paris the previous year. The narrator recounts the spellbound horror and excitement that the sculpture evoked in the Parisian public, citing also the response of a critic who announced that this was "an extremely modern work of art that fulfilled all the demands for reality." But then, the story continues, a "Jewish baron of the financial aristocracy" who looked exactly like the gorilla—and this likeness is described in great detail—arrived at the exhibition with his young bride and immediately flew into a towering rage, which only emphasized his gorilla-likeness, when he recognized the birthmark of his bride on the sculptured body of the abducted nude. The narrator of the tale claims that all Paris rapidly discovered that the Jewish Baron F. had used his fortune to force the daughter of a low-level civil servant who loved the sculptor to marry him. She, however, continued her affair with the sculptor, whose artistic skill in this statue achieved his revenge over the Jew's gold.[1]

In an afternote, the German editor pointed out that because of the great attention the sculptural group had attracted in Munich, he thought readers would be interested in this short story. Of course, he commented, the significance of this tale lay not in its establishing actual facts but in its raising the major motives and clarifying the "ideal content" of this

IV. Jahrgang. Heft 1 1. Oktober 1888

→ Herausgegeben von Friedrich Pecht ←

„Die Kunst für Alle" erscheint in halbmonatlichen Heften von 2 Bogen reich illustrierten Textes und 4 Bilderbeilagen in Umschlag geh. Abonnementspreis im Buchhandel oder durch die Post (Reichspostverzeichnis Nr. 3259, bayr. Verzeichnis 415) 3 Mark 60 Pf. für das Vierteljahr (6 Hefte); das einzelne Heft 75 Pf. — Inserate (nur durch R. Mosse) die viergespaltene Nonpareillezeile 50 Pf. 12,000 Beilagen 72 Mark, bei größerem Format oder Umfang Preisaufschlag.

Die Münchener Ausstellungen von 1888
Von Friedrich Pecht

Die Bildhauerei

Nachdruck verboten

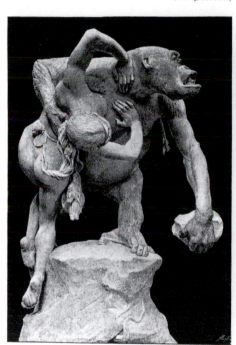

Der Gorilla. Von E. Fremiet
Münchener Jubiläums-Ausstellung
(Prämiiert mit der ersten goldenen Medaille)

Die Kunst für Alle IV

Unstreitig fehlt viel, daß die Bildhauerei dieselbe glänzende Rolle spielte auf unsrer Ausstellung, als sie der glücklicheren malenden Schwester zu teil geworden. Unsre Zeit hat offenbar weniger Verständnis für die Sprache der Formen als für die der Farben. Naturwüchsig ist darum die Plastik im Grunde jetzt nur noch in Italien. So stehen denn auch die dritthalb hundert Figuren und Büsten in dem Vestibül und den unzähligen Gemächern wie Ergänzungen der Architektur herum, zieren und beleben dieselbe, scheinen aber außer diesem dekorativen sonst weiter keinen Zweck zu haben. Natürlich mit Ausnahme der ebenso zahlreichen als gelegentlich auch guten Büsten. Und doch thäte etwas mehr Formenadel unsrer, allem Großen und Erhabenen so geflissentlich den Rücken kehrenden Kunst, die selbst in Christus nur den Proletarier, aber nicht den erhabenen Charakter sieht, so wohl! Wem ginge darum nicht das Herz auf, wenn er einmal auf eine wahrhaft gelungene Idealfigur stößt, die ihm den ganzen Adel verkörpert, dessen die Menschheit fähig ist, während uns die neueste Malerei Packträger als Götter und Helden aufschwatzen möchte. Aber wenn sie nun schon einmal beständig probiert, ob man, wie es seinerzeit Offenbach in der Musik that, diese Menschheit nicht immer noch ein wenig gemeiner darstellen könne, warum versucht sie es denn nicht einmal mit dem Hohen und Edlen? Wenn auch nur zur wohlthätigen Abwechselung mit den Apotheosen der Hausknechte und Köchinnen? — Ist es nicht trostlos, daß

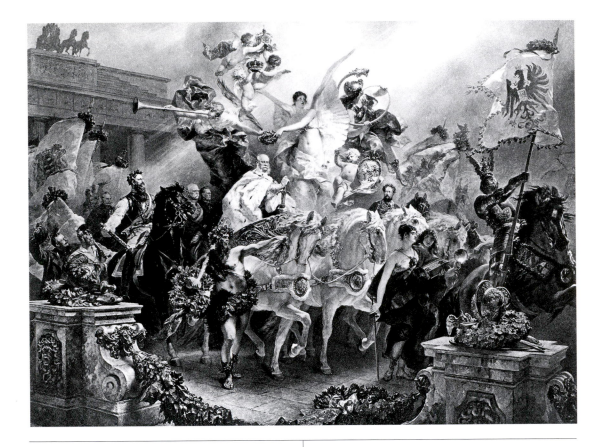

Fig. 2 **Ferdinand Keller (1842–1922),** *Emperor William,*
the Victorious Founder of the German Empire, **1888. Oil**
on canvas, 16 ft. 4 in. x 23 ft. (5 x 7 m). Photogravure by
Hanfstaengl reproduced in *Die Kunst für Alle* **4, no. 1**
(Oct. 1888): n.p.
As an apotheosis, this painting was a memorial to William
I, who died in March 1888 at the venerable age of ninety.
Riding behind the old emperor, and bathed by rays of sun-
light, is the crown prince, who as Emperor Frederick III
reigned for only ninety days before dying of cancer. His son,
William II, then became the third emperor in the new
German nation, making 1888 the year of three emperors.

work of art. From our perspective, looking back
through the congested lens refracting the devasta-
tion of twentieth-century German history, the story
loses its ideal content and takes on deeply disturb-
ing overtones. In 1888, however, we must remind
ourselves, those overtones did not bespeak geno-
cide; rather they reflected the anxieties of an art

world confronting a commercial art market, a na-
scent dealer system, popular critic-driven evalua-
tions of art, and a sensation-seeking public. And all
of this riding on top of a rapidly growing capitalistic
system in which industrial and financial entrepre-
neurs were gaining inordinate power that was, ac-
cording to popular mythology, controlled by Jewish
plutocrats. Yet, the story assures us, art in the hands
of the disciplined healthy young artist would tri-
umph over crass Jewish gold.

Nevertheless, the editor could not find any sense
of triumph or satisfaction in the sculptural group. In
his lengthy review of the Third Munich International
in one of the most widely read German art journals of
the day, *Die Kunst für Alle* (The art for all), Friedrich
Pecht gloomily viewed the gorilla as an ominous sign
of a fundamental transformation in taste that had
been presaged by the fascination with the proletariat

and now was featuring bestiality. He was much happier with Ferdinand Keller's commemoration of William I, which, created in the Renaissance tradition of a finely modeled, richly colored painting filled with both real and mythical figures celebrating a contemporary historical achievement, translated into aesthetic form the aspirations of the German nation. Another critic was less enthralled and found the painting to be a vapid, pretentious monument to Prussian Hohenzollern ambition but was similarly dismayed by the honors accorded Emmanuel Frémiet's "half revolting, half ludicrous gorilla lady-killer."[2]

A further dimension to these works must be mentioned: the national promotion of art and the international circulation of works of art. Not only was Frémiet's *Gorilla* given the place of honor in the exhibition in Munich but the jury awarded it the coveted gold medal. Furthermore, the aggressive wounded ape had already won a medal of honor at the Paris Salon of the Society of French Artists the previous year. The sculpture was later shown in the Universal Exposition in Paris in 1889 and again at the Centennial Exposition of French Art in Paris in 1900.[3] The *Gorilla*, in other words, not only represented multiple anxieties and social transformations; it was also a sensational product of the huge exhibitions that attracted works of artists and crowds of traveling tourists from all over Europe. In turn, these great exhibitions across Europe represented a confluence of national identities with the international market system.

These ingredients of scandal and national political identity were potent factors in the promotion and marketing of works of art to the public in independent galleries as well as in the great exhibitions. A year before the *Gorilla* caused a sensation at the Third Munich International, Hermine von Preuschen, an energetic young artist, brilliantly turned the rejection of her painting by the jury of the Berlin Academy Exhibition in 1887 into a major triumph by personally creating her own exhibition. Her large

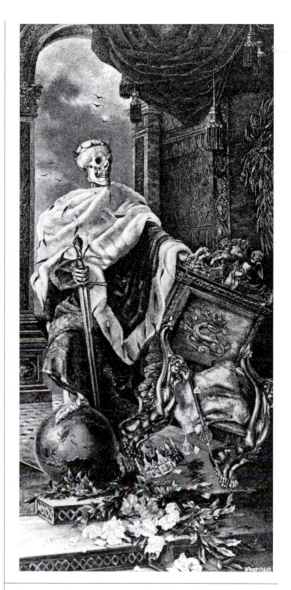

Fig. 3 **Hermine von Preuschen (1864–1918), *Mors Imperator*, 1887. Location unknown. Reproduced in *Die Kunst für Alle* 3, no. 1 (Oct. 1887): 15.**
Preuschen resorted to renting a hall to show her painting after the Berlin academy jury twice rejected her work and the well-established Berlin art dealer Eduard Schulte also refused to exhibit her painting. The exceptional success that Preuschen achieved by having her painting rejected inspired a caricature that appeared in *Ulk* (a weekly supplement to the liberal newspaper *Berliner Tageblatt*), in which the president of the Royal Academy is shown telling the artist that he will not do her the favor of rejecting any more of her paintings.

allegorical painting, *Mors Imperator*, presented a richly colored, highly decorative image of death swathed in regal ermine and purple and wearing a crown, holding a sword in one hand and toppling a throne with the other (fig. 3). In news notes, generally reserved for major artists, *Die Kunst für Alle* announced that this scene, with its "masterfully handled color," had been submitted to the exhibition and then noted the subsequent rejection of the "sensational colossal painting." The jury evidently had qualms about accepting a work that, despite its technical proficiency and symbolism, made disturbing allusions to the deteriorating condition of William I, who died six months later, as well as to the crown prince, who was suffering from cancer.[4]

Preuschen appealed to the emperor himself, who replied that he had no objection to the work but that he left the decision to the jury. The jury reconsidered and again rejected the work for its "unaesthetic expression of a distorted idea." The artist, shrewdly recognizing the value of scandal in establishing an artistic reputation, rented a hall in central Berlin and sent notices to newspapers inviting the public to view the offending painting. Responding to her published appeal to "the healthy taste of the public" to judge her work, more than six thousand people crowded into the hall in less than two weeks. National newspapers covered the scandal, and caricatures of the incident appeared in popular satirical journals. The controversy established her with a notorious reputation as the "Advertising Artist."[5] This tactic demonstrated clearly the market conditions within which artists were operating: critical acclaim, whether positive or negative, public notoriety, and distinctive exhibition spaces separate from the official exhibitions would become necessary ingredients to artistic success by the 1890s. These events also reveal that determined women artists were entering the German art world at this time when viewing art was becoming a popular leisure activity. Peering at the modest black-and-white reproduc-

tion of this long-lost work, we encounter the frequent tension between possible provocative social and political interpretations and the steady rise in the public consumption of works of art during the last decades of the nineteenth century.

———

A warning is necessary about a word that is central to this study of the simultaneous emergence of a new art and of a new art-viewing public in a period of almost unprecedented social, economic, technological, and political change after the unification of Germany in 1871. This process of transforming a rural provincial land into a modernized industrial nation brought with it the hope for a revitalized culture befitting that new nation—a modern art for a modern nation. Yet the word *modern* can be both obviously simple and profoundly misleading. Adapted from the French *moderne* in the eighteenth century, the word became fully established in German, according to Grimm's *German Dictionary* in 1885, as meaning simply "new," the opposite of "old": new fashion, new taste, new knowledge, new art (the examples in Grimm were all drawn from the cultural realm), that which was contemporary as opposed to that which was traditional or had been handed down. The focus on contemporaneity as the essential characteristic of the modern was further emphasized in the 1902 Brockhaus definition of *modern* as the "name for the quintessence of the most recent social, literary, and artistic movements." This understanding of *modern* and its derivations—*modernism* and *modernity*—was based on a strong sense of that era as being distinct from a past epoch. Another understanding of *modern* that overlaid and transposed this present-past dichotomy was the sense that the word represented more than just that which was contemporary; *modern* also came to mean a process of becoming, a series of temporary states pointing to a future reality. This consciousness of the modern as a transitory state of accelerating change—of new endlessly displaced by newer—be-

came commonplace among German writers at the end of the century.[6]

This book spans two decades, the 1880s and 1890s, in which modern art emerged fully in Germany. Concentrating upon what writers in new art journals perceived and wrote about *their own time*, I follow in part I the rise of contemporary new art in the 1880s, which they simply called "new" or "young" to distinguish it from the "old" art that continued to be created following inherited forms, styles, and ideals. In that decade the word *modern* appeared only occasionally, as in "modern life" or "modern art should resemble modern life." After a series of influential exhibitions in 1888 the word *modern* appeared more often, alongside the more common phrase *the new art*. By the critical years 1893–94, analyzed in part II, *modern*, along with *modernism* and *modernity*, had become the dominant word used to refer to the new art. A review of an art exhibition in June 1893, for instance, begins with the words, "In this year, modernism executed a powerful attack against the good city of Berlin." Several months later another critic wrote decisively that modern art was not just a question of light or dark or of certain colors nor an accidental changing of taste. This change in art could only be understood as part of a major change in modern times. "Modern artists," he insisted, "are modern people, and vice versa."[7]

Part III examines the complex shifts of modernism in relation to the public in the latter half of the 1890s. During these last years before 1900 in Germany the words *modern* and *modernism* were regularly applied to the work of contemporary German artists whose painting style and approach to subject matter had broken away from the style and categories that dominated the German art academies. These were artists who were aware of contemporary developments in the art of other countries, though often not the art we now associate with the term *modern*. Reading this account, it is important to remember that the words *modern* and *modernism* refer to the new art forms that German

artists and critics perceived *at that time* to be modern. In those decades the understanding of modernism had not yet been restricted to the canon of French classical modernism, which has dominated art historical writing in the twentieth century.[8]

In this book I utilize the new art journals published for the general public to promote art in the 1880s and 1890s in order to determine how critics and the public in Germany responded to the new art. New art by definition meant a challenge to that which was old, stable, and known. In an era of exceptional transformations and upheavals that challenge was not always welcome. The three artworks with which this prologue began represented the stability of the old art, even if they contained disturbing elements. Each of them was embedded in the tradition of narrative representation; their meaning could be read by recognizing the signs that told their story. The frozen dramatic gestures of the gorilla, presented with scientifically realistic detail, demonstrated emotions and actions of a story that any viewer could read—quite apart from the provocative tale that accompanied it in the journal. Although the procession of William I was executed in minutely realistic detail to produce a totally unrealistic scene, it was nevertheless a transparent narrative of victory that could enthrall viewers, from those who could only recognize the beloved old emperor receiving his crown of glory to those who could decipher the representations of classical symbols, victorious knights, and ancient goddesses. Similarly, death toppling a throne offered a wide spectrum of interpretation, both of contemporary events and of traditional symbols. With their overt stories and openness to interpretation and speculation, these works of art were accessible to ordinary people visiting the exhibitions. Moreover, they were skillfully composed and faultlessly painted. The new art changed all that, and many resented and resisted that change.

This book is not the book I planned to write. That book was to be primarily about works of art, about

the artists who produced them, the dealers who sold them, and the exhibitions where they were shown. The material was rich; the voices of creator, promoter, and critic were overwhelming in volume and multiplicity. My task was to weave all this together into a coherent examination of the creation, promotion, and reception of modern art in Germany.

As I examined these voices and images on the pages of journals, I gradually became aware of another actor in the drama, one who left only shadowy traces, whose voice was absent, whose presence was recorded only through derogatory and demeaning accusations. And through numbers, large numbers. By the hundreds of thousands the public flocked, poured, tromped through exhibition after exhibition; paid for the installations with their purchase of entry tickets, lottery tickets, membership tickets; enabled dealers, galleries, and patrons to buy works; and supported the whole enterprise in which the artist created the objects we can now study. Vilified by critics for having petit bourgeois philistine tastes; accused by artists for laughing, even spitting on their

work; bemoaned by reformers who wanted to refine and educate them, the public marched through the exhibitions, leaving only tantalizing traces in the pages. Their presence glimmered behind the statistics: 1.2 million at the Berlin Jubilee Exhibition of 1886; 3,000 viewed Fritz von Uhde's *Last Supper* in

Fig. 4 *A.* **Adolf Oberländer (1845–1923), "Understood,"** *Fliegende Blätter* **89, no. 2246 (1888): 58.** *B.* **Franz Stuck (1863–1928), "The Cattle-Farmer Sepp in the Art Exhibition,"** *Fliegende Blätter* **89, no. 2247 (1888): 71.** These two cartoons were both inspired by the public at the Third International Art Exhibition in Munich, then in progress. Oberländer's cartoon (*A*) accompanied a short story that was sharply critical of those members of the middle-class public who had to demonstrate their superiority by finding fault with paintings. In contrast, Stuck (*B*) depicted the astonishment of a small Bavarian farmer on his first visit to an exhibition. After resting against a woman's well-padded bustle, he becomes confident enough to touch a statue, views a painting of cattle with the critical eye of one who knows the subject well, laughs over a funny painting, and is saddened by a tragic one. By the time he leaves, his head is filled with a kaleidoscope of images.

A

B

Munich during five days in 1887; 11,212 were members of the Hanover Art Society, whose seventy-third exhibition in 1905 drew more than 100,000 visitors; large audiences gathered in Dresden to hear Woldemar von Seidlitz lecture on modern art in 1897. Ever silent in these traces, the crowds in reality were old and young, silent and outspoken, elegant, respectable, absorbed, but equally noisy, unruly, disrespectful, bored, boisterous, overwhelmed, delighted, supercilious, laughing, chattering, proclaiming, and eager to stop for coffee or beer (fig. 4).[9] Elusive, impossible to describe, with no remaining voice of its own, the public in their relation to modern art are the shadowy presence around which this book is written.

The book is also about a dream involving that public that eventually turned into a nightmare, bitterly tainting the dream in retrospect. The dream was twofold. On the one hand, it rested upon the public, hoping that in this new nation called Germany the public would become patrons for a new art befitting the new nation. On the other hand, the dream called upon artists to create a new art that would grow out of the life of that new public in the new nation. This was a liberal, egalitarian, and very nationalist dream that was lost under the pluralism and strains of a fractured nation only to be revived decades later in an insidious form.

And finally, this book is about modern art in Germany—much of which has been ignored for years—about how and where the public encountered, read about, or saw that new modern art in the last decades of the nineteenth century.

PLATES

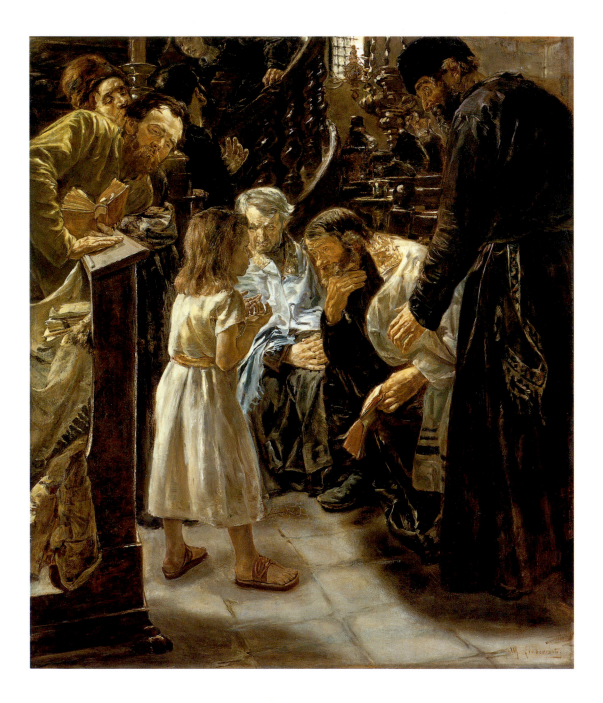

Plate 1 **Max Liebermann (1847–1935), *The Twelve-Year-Old Jesus in the Temple among the Elders*, 1879. Oil on canvas, 59 3/8 x 51 5/8 in. (151 x 131 cm). Hamburger Kunsthalle.**

The Hamburger Kunsthalle purchased this painting from Fritz von Uhde's estate after his death in 1911. It hung in the Kunsthalle's main galleries until 1936, when a new director put all of the Liebermann and Expressionist paintings into storage. In 1941 the work was sold to a Hamburg doctor who particularly prized Liebermann's work. After his death in 1979, the family loaned it to the Kunsthalle, which was finally able to purchase it back in 1989.

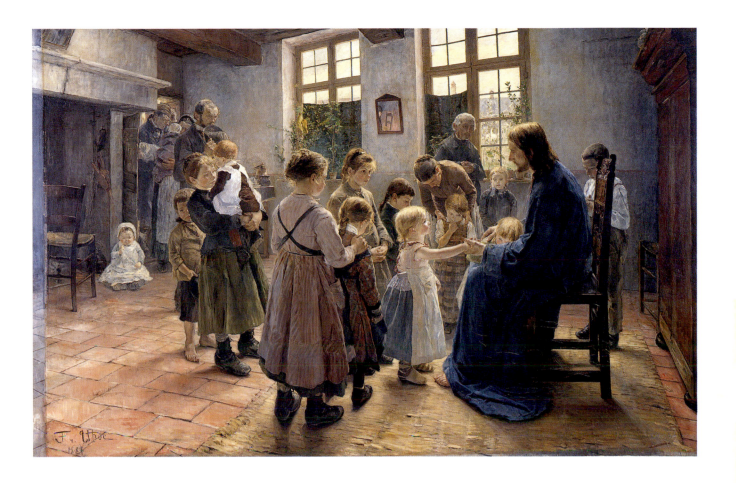

Plate 2 **Fritz von Uhde (1848–1911),** *Suffer Little Children to Come unto Me*, **1884. Oil on canvas, 6 ft. 2 in. x 9 ft. 6 in. (1.9 x 2.9 m). Museum der Bildenden Künste Leipzig. Reproduced in** *Zeitschrift für bildende Kunst* **22 (1886–87): n.p.; and in a double-page spread in** *Die Kunst für Alle* **1, no. 15 (May 1886).**

Uhde frequently reproduced the same theme, with changes made around the central figures. A smaller version of this painting, completed in 1885, in which the background figures have been shifted or changed, is at the Stiftung Pommern, Kiel.

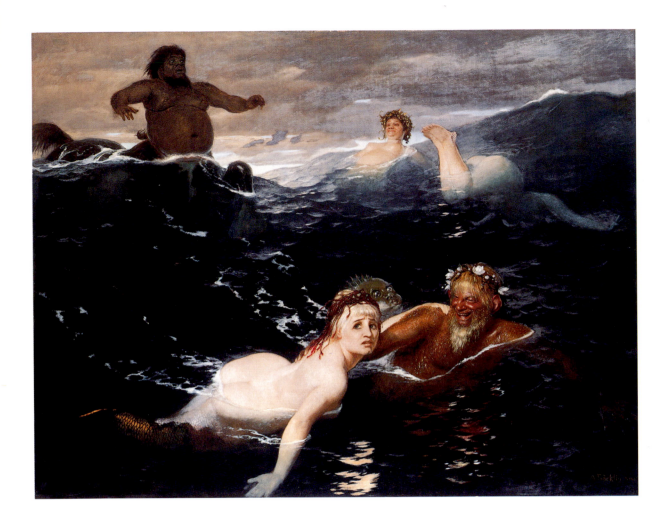

Plate 3 **Arnold Böcklin (1827–1901),** *In the Play of the* *Waves*, **1883. Oil on canvas, 71 x 93 1/2 in. (180.3 x 237.5 cm). Bayerische Staatsgemäldesammlungen, Neue Pinakothek Munich, acquired 1888. Reproduced in** *Die Kunst für Alle* **3, no. 21 (Aug. 1888): n.p.**
In 1899 Cornelius Gurlitt wrote that this painting was widely acknowledged to be "one of the greatest achievements of our century." He recalled that his brother, Fritz Gurlitt, had given the painting its title since Böcklin had simply called it "a picture." Earlier critics had judged the water creatures to be absurd or bizarre, but Gurlitt insisted that "Böcklin in his art is not a humorist; he is rather filled with wonderful humor; he is high-spirited as only a real child of nature can be." Above all, critics praised the deep, rich colors in which he painted his imaginary, frolicsome world.

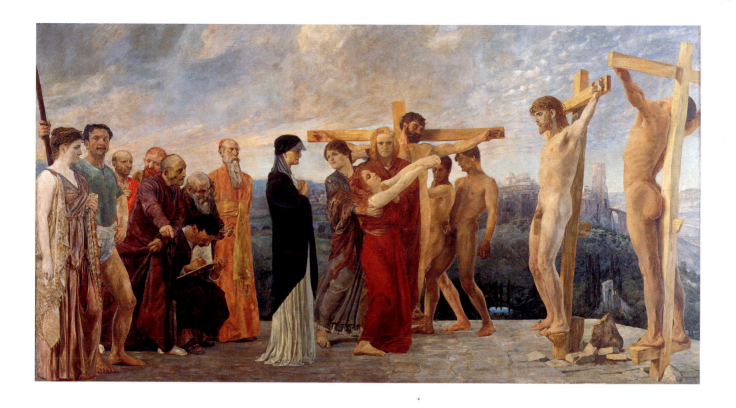

Plate 4 **Max Klinger (1857–1920),** ***The Crucifixion of Christ*, 1890. Oil on canvas, 8 ft. 2 in. x 15 ft. 3 in. (2.5 x 4.7 m). Museum der Bildenden Künste Leipzig. Reproduced in** ***Die Kunst für Alle* 10, no. 5 (Dec. 1894): n.p.**
Klinger's paintings were among the most frequently reproduced works in the art journals, particularly reproductions of *The Crucifixion* itself and of the preparatory figure studies. Wherever it was shown, this painting became a focus of heated controversy between supporters and opponents of the work. It was clear to observers that the painting deserved to find a place in a museum but that it would be extremely difficult to find a museum able to face the criticism. Opposition to the painting forced Leipzig in 1894

and again in 1897 and Hanover in 1899 to drop plans for acquiring it. Alexander Hummel finally purchased *The Crucifixion* in 1901 with the intention of having it join other works in Vienna. He died in 1914, and *The Crucifixion* remained in his villa in Trieste until April 1915, when, under the threat of war between Italy and Germany, his heirs had the painting transferred to Leipzig for safekeeping. In September 1918 Julius Vogel announced with great satisfaction that the purchase of *The Crucifixion* by the Leipzig Museum of Art had been accomplished through the aid of money raised by a committee of friends of art that was headed by the city's mayor.

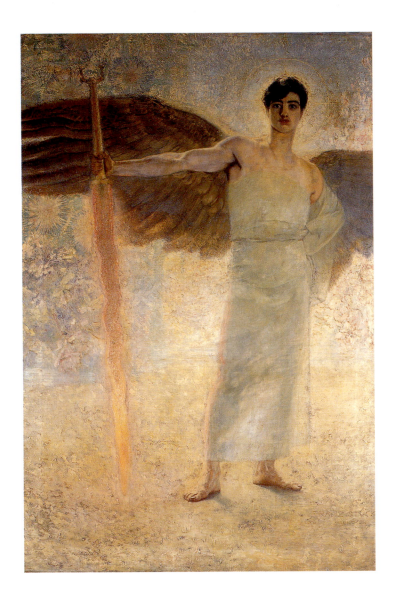

Plate 5 **Franz Stuck (1863–1928),** *The Guardian of Paradise,* **1889. Oil on canvas, 98 3/8 x 66 in. (250 x 167.5 cm). Museum Villa Stuck, Munich.**

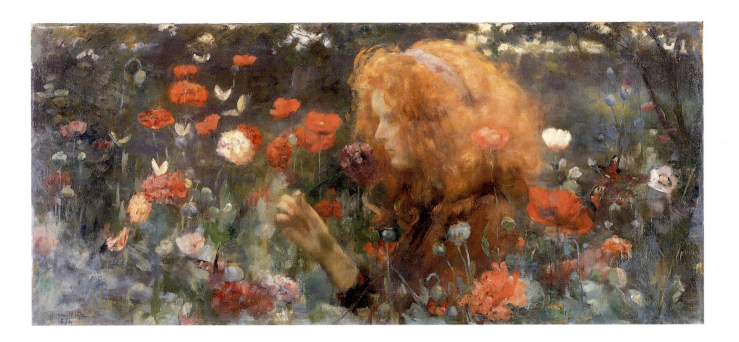

Plate 6 **Dora Hitz (1856–1924),** *Young Woman in a Poppy Field*, **1891. Oil on canvas, 18 7/8 x 42 3/8 in. (48 x 107.5 cm). Museum der Bildenden Künste Leipzig.** Hitz studied in Munich in private art schools for ladies before opening her own studio. After working for four years at a princely court in Rumania, from 1880 to 1890 she studied in Paris, where she exhibited regularly in the Paris Salon and became a member of the Société Nationale des Beaux-Arts, with which she exhibited annually in the 1890s. After spending the years 1890–92 in Dresden, she moved to Berlin, where she became a member of the Berlin Society of Women Artists and established an art school for women in 1894. Known initially for her portraits, Hitz moved toward an impressionistic style during her years in Paris. In Berlin she helped form a small progressive group, the Society of Four (later known as the November Society), which exhibited together beginning in 1894 at the Eduard Schulte Art Salon. When the group joined the Berlin Secession in 1898, Hitz was an acknowledged progressive among those artists who supported modern art against the conservative forces around the academy in Berlin.

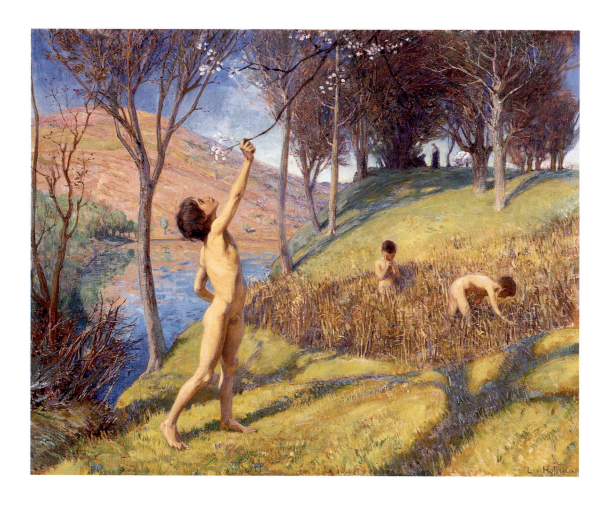

Plate 7 **Ludwig von Hofmann (1861–1945),** *Spring,* **c.**
1895. Oil on canvas, 36 1/4 x 46 1/2 in. (92 x 118 cm).
Galerie Neue Meister, Staatliche Kunstsammlungen
Dresden.

Plate 8 **Max Klinger, *The New Salome*, 1893.
Multicolored marbles, height of figure 34 5/8 in. (88 cm).
Museum der Bildenden Künste Leipzig. Reproduced as full
plates in *Die Kunst für Alle* 10, no. 5 (Dec. 1894): n.p.,
and in *Pan* 5, no. 1 (Aug. 1899): n.p.**
Klinger had handled the theme of Salome's temptation of
John the Baptist in *Temptation*, plate 9 in the graphic
series *On Death. II, Opus XIII* (1890–93), a scene laden
with traditional symbolic content, including reference to
the temptation of Christ by Satan. In the sculpture, Klinger
has stripped the ensemble to the essential figure of the
calm, self-contained New Woman. The photograph in *Die
Kunst für Alle* was taken at an angle, close up, with over-
head lighting that transformed Salome into a sultry, coarse
female and emphasized the shocked expressions of the two
male heads.

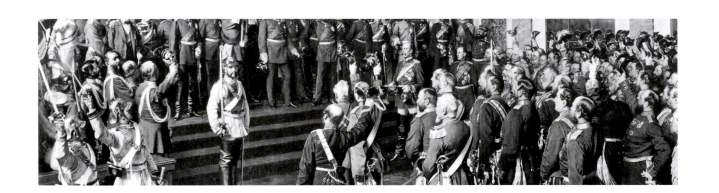

part I

THE TRIUMPH OF MODERN ART

1885–1892

Ferdinand Keller's huge painting in 1888 was a tribute to Emperor William I for the triumph of German unification (fig. 2). But what was this German Empire, this unified nation? Examining the painting, we could easily conclude that William was the victorious founder of a sixteenth-century state. Surrounded by Classical symbols of victory and empire, his chariot is led by a Roman god and heralded by Saint Michael in shining medieval armor bearing an imperial banner. The overwhelming excess of the work, with its heavy rope of laurel leaves framing the scene, its billowing flags depicting the historical principalities of Bavaria, Saxony, Baden, and Württemberg falling into place behind the new emperor—all of this anachronistic symbolism and lush painterly style masked the political reality: the German Empire was not an old nation rooted in the medieval past but a brash, upstart state.[1]

Formed after the rout of the French armies in 1870–71, the new German Empire was proclaimed to be a united nation over the defeated body of France. The Germans chose as their site for the ceremony of unification the hall of mirrors at Versailles, built to exalt the great Sun King of France, Louis XIV, two centuries before Germany's victory. Among the powerful nations that were to dominate Europe in the twentieth century, a united Germany was the newest, with all the insolence, promise, and confusion that characterize a newcomer. The diverse armies that rapidly defeated France in the autumn of 1870 owed and continued to owe their loyalty to the rulers of a patchwork of independent kingdoms and states whose roots and traditions were centuries old. By contrast with the nations of western Europe whose long histories of national consolidation were celebrated in image and verse by

citizens with a shared heritage and national identity, the newly created empire was a hybrid affair in which these kingdoms, dukedoms, and free cities retained their structures of government and their territorial integrity, including maintaining diplomatic relations with each other. At the same time, universal suffrage allowed men across all of the boundaries and regions of the new empire to elect a national parliament, the Reichstag, while financial, trade, and industrial networks integrated the various states into a national economy. In other words, the empire was a fragile federal structure balanced on top of a dynamic new industrial economy.[2]

The legal unity of the German nation having been attained through a series of military victories, the more difficult task was to achieve that elusive but stable sense of national identity already established in the other great nation-states, particularly France. Or to put it another way, the leaders of the various kingdoms and free cities that proclaimed their unity in the new empire headed by the king of Prussia, now Emperor William I, on 18 January 1871 had to confront the reality that the citizens of their respective principalities identified themselves primarily as Bavarians, Prussians, or Saxons, not necessarily as members of the new empire. While many welcomed the unification, many viewed it without enthusiasm, if not with reluctance or even downright anger, particularly in Catholic Bavaria, where those loyal to the Wittelbach dynasty looked with suspicion upon the Prussian—Hohenzollern and Protestant—claim to precedence in the empire. Loyalty that for generations had been directed toward traditional dynasties, city-states, and local communities continued its hold upon popular imagination long after the unification. Added to these obstacles were the religious divisions

and social tensions that cut across the regional loyalties: among Catholics and Protestants, whose identities had been framed by three centuries of conflict and coexistence, and among the working classes, whose struggle for existence had intensified in the industrialization of the nineteenth century. Although many people had long dreamed of and worked for a politically unified German nation, liberal Protestant bourgeois intellectuals and writers were in the vanguard of those who sought to define the German nation through its cultural heritage and accomplishments.[3]

It was not surprising, then, that one of the first steps taken to construct an image of the newly united German nation was the commissioning of a painting to record the official proclamation of the new empire. In January 1871, three days before the proclamation ceremony in Versailles, Crown Prince Frederick William of Prussia summoned a young Prussian artist, Anton von Werner, to Versailles,

where, as an eyewitness, he created a visual document of the historic event (fig. 5).[4] Commissioned as a gift from the German princes to the new emperor, William I, on his eightieth birthday, this painting stood in clear antithesis to the later Keller painting. Whereas Keller's painting was an allegorical scene with flamboyant romantic flourishes and Classical symbolism, Werner's was virtually a photographic record of the scene he had witnessed. Completed in 1877, his painting embodied the sober realism and meticulous attention to accurate historical detail that characterized the modern scientific approach cherished by progressives and liberals at the time. Compared with Keller's heavily ornate painting, with its cherubs and goddesses floating in the sky—completed almost a decade later—Werner's visual document was radically rational, contemporary, and modern.

Since it was conceived as a historical document to celebrate the proclamation of the new German

Fig. 5 **Anton von Werner (1843–1915), *The Proclamation of the German Empire (18 Jan. 1871)*, 1877. Oil on canvas, 14 ft. 2 in. x 24 ft. (4.3 x 7.3 m). Destroyed in war.**

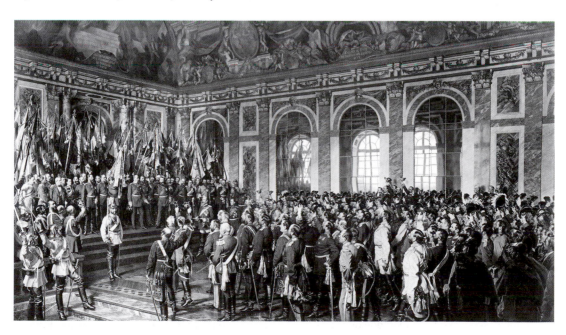

Empire, reproductions of the painting were widely distributed, frequently finding their way into history books and homes. Its message, conveyed with such detailed accuracy, was clear and coherent: the new nation had been formed through the mutual agreement of the princes, grand dukes, and the representatives of the free cities after their armies' victory over France. Standing under the massed flags of their respective states, almost all in military uniforms, they formed a sober group to either side of William, who stood on a raised dias at the distant end of the hall of mirrors, with its scenes of ancient French victories on the ceiling above. The painting, however, was dominated by the crowd of officers who were packed into the room, from the disciplined older army and corps commanders in front of the dias to the younger officers, whether Prussian, Bavarian, Saxon, or Württembergian, who formed the bulk of the crowd. Almost hidden between the officers of the staff and the new imperial leaders were the two men who had engineered the military victory that set the stage for the unification: Chancellor Otto von Bismarck and Field Marshal Helmuth von Moltke. This was a businesslike event with a minimum of ceremony and little excitement. According to Werner's memoirs, the brief ceremony was preceded by a Protestant church service in which the solemn singing of psalms and a sermon delivered by the divisional chaplain gave him time to sketch the figures of the leaders grouped in front of a temporary altar. After King William of Prussia and the German princes mounted the platform at the front, Bismarck read the proclamation almost in a monotone, followed by the grand duke of Baden's call for a triple huzzah of acclamation for the new emperor. Werner's painting captured the moment when the younger officers raised their helmets to cheer.[5]

No viewer could miss the significant perspective: the new nation was a military affair, a masculine affair, and a rational, secular modern affair. What was missing spoke loudly. This was no grand ceremonial in a vaulted cathedral. There were no bishops or cardinals bestowing an imperial crown upon an ermine-robed ruler, no elegant accompanying consorts or ladies in waiting, nor was there any hint of the strong middle and working classes that populated the German cities and towns; there was only a scattering of high-ranking civilians, many dressed in ceremonial military uniforms.[6] This was an exclusively masculine event in which the power of the sword was visibly brandished, at least by the Prussians. The massing of the military throng visually displaced the central actors and action in the scene. By his insistence upon presenting a historically accurate view as he saw it from the back of the room, Werner defined the unified nation as the men who were victorious in battle, not as the leaders, who from his perspective were not the central focus.

In subsequent versions of the painting Werner rectified this viewpoint by minimizing the cheering young officers and emphasizing the imperial group and Bismarck. In this first version, however, Werner painted one hundred twenty-eight individualized portraits—all identified in a published version—within the mass of men. This, combined with his obsessive attention to accuracy in uniform and architectural details and his clear, highly finished painting style, produced a near-photographic image that was consonant with a nation emerging as a potent military and industrial power in the heart of Europe. Sober and rational realism in both content and style marked this modern vision of the birth of the nation that was to be lodged into the minds of its new citizens.

In the 1870s and 1880s Werner continued to chronicle the military triumph of the Franco-Prussian War and the prowess of the Hohenzollern emperors and their generals. His paintings extolling the new nation's victories appeared in official places from the Royal Palace and the Victory Column in Berlin to provincial city halls. An undistinguished mixture of Prussian chauvinism and romantic mythmaking, these paintings were, ironically, frequently modeled on the work of French painters, such as the battle scenes of Ernest Meissonier and Édouard Détaille,

even as Werner repeatedly depicted the weakness of the French army.[7] More important than these works of art, however, was the prominent position Werner achieved within the Berlin art world through his close ties with the imperial family. Appointed director of the Royal Academic Institute for the Fine Arts in Berlin in 1875, at the young age of thirty-two, Werner wielded power as the elected chair, beginning in 1887, of major artists' associations. In these capacities Werner represented the bourgeois professionals whose competent service within the bureaucracies—municipal, state, and imperial—provided the cohesion that helped to stabilize the delicate balance of the federal system and to mitigate, where possible, the eccentricities of the continuing monarchic structures.

Werner was a fervent supporter of the empire, dedicated to three successive emperors, and his clearly defined bourgeois ethic manifested itself in all his work: in his meticulously executed paintings, in reforms established at the art institute in the 1870s based on his belief that all artists must master basic technical skills of the craft, and in his anti-elitist policies supporting the large number of average artists within the societies and associations. On all levels, including in his writing, Werner communicated a contemporary and triumphant image of the new nation to its inhabitants, an image that was rational, easily understandable, historicist, and painted with technical competence, in short, an image of imperial power conveyed with thoroughly liberal bourgeois values.[8] As powerful as Werner's position was in Berlin, it nonetheless simultaneously demonstrated the limitation of imperial power through the historical regionalism upon which the new nation was built. Authority over cultural issues was strictly limited on the imperial level. In matters pertaining to art, culture, and education the constitution of 1871 delegated authority to the individual states, each of which maintained its own cultural ministry and bureaucracy and established its own financial support.[9]

VISUALIZING THE NATION: MONUMENTS AND PANORAMAS

Efforts to construct a visual representation of the German nation for the public took a variety of forms in the first decades of the empire. Two of these, monuments and panoramas, were specific developments of late-nineteenth-century Europe, where technology, economics, and historicist ideology intersected to produce art forms accessible to the new national public. Seemingly very different, these two popular art forms served the same ideological function. Growing out of the strong historicism of nineteenth-century bourgeois culture, both panoramas and monuments visualized the aspirations of the nation in landscape settings made possible by industrial technology and capitalist finance.

Since the time of the pharaohs, monuments have been products of the latest technology and ideology. The peculiarity of the great German national monuments, built during the empire, lay in their deliberate settings, not in urban centers but in rural landscapes designed to evoke the mythic roots of the new nation. Tourist-pilgrims hiked or rode trams through forests and along rivers to contemplate the Hermann monument in the legendary Teutoberger Forest (1875), the Niederwald monument with the statue of Germania (1883), or the 128-foot statue of William I at Deutsche Eck (1897) or up the mountain trails to the Kyffhäuser monument, which also memorialized William I (1896). Steeped in legendary Germanic forests, rivers, and mountains, the pilgrims discovered colossal sculptural and architectonic structures glorifying mythic and real leaders, designed by artists with flamboyant historicism and manufactured using the latest industrial techniques.[10] On a mountaintop under God's open skies, as one proposal for a memorial for William I put it in 1888, diverse individuals would come to understand themselves as belonging to a national community: "The monument for the province of Westphalia should not be built in the

midst of the hurrying crowds of a heavily populated city; it should soar on towering mountain summits under God's open sky. There boys and girls, warriors and workers, gymnasts and singers, the father and his loyal family, will travel, so that at the foot of the figure of the beloved emperor, the personal and domestic festivity can become a national celebration."[11]

The experience was not, however, limited to those who could make the pilgrimage to the monuments. In a lesser key, readers of the illustrated newspapers and art journals could visualize the monuments in their settings through elaborate

Fig. 6 **Photograph of the Niederwald monument. Reproduced in _Die Kunst für Alle_ 11, no. 14 (Apr. 1896): full plate.**
In an article on the twenty-fifth anniversary of the victory over the French in 1870–71, Friedrich Pecht examined the national monuments created to commemorate that victory and found most of them less triumphant than the victory. He singled out the Niederwald monument, with the statue of Germania by Johannes Schilling, as the best of all of them.

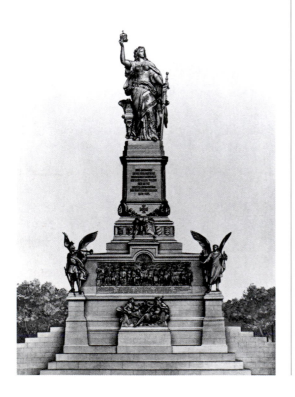

engravings of plans and landscape sites that were frequently published along with accounts of the process from initial competitions through details of construction to patriotic dedication ceremonies (fig. 6). Cultural journals carried extensive reports on the progress of monument competitions and construction through the 1880s and 1890s. Photographs of models submitted for major competitions were frequently published in the art journals. Keen interest was also demonstrated in the competition designs and models that were put on display for public perusal. One reviewer, for example, reported on the profound interest shown by the "thick crowds" that thronged the academy in Berlin in 1897 to examine the designs for a national monument honoring Bismarck.[12] Satirical weeklies paid attention to monuments by turning them into humorous cartoons (fig. 7). Romantic memoirs of visits to the sites, as well as maps and train schedules published in the journals, encouraged readers to visit the actual monuments.

Not all writers approved of these civic efforts to promote the nation. A series of articles in the cultural journal _Der Kunstwart_ (The guardian of art) arguing over the merits of the national monuments ended with a slashing attack upon the banality of the colossal figures and the bad taste of the broad classes who flocked to see them. Nonetheless, implicit in this coverage by the journals was the effort to provide the reader or viewer with a visual means of identifying with the nation through the symbolism of the monuments. At the same time, the journals did not hesitate to publish articles that seriously questioned the value of these monuments.[13]

Panoramas also sought to provide a vicarious experience of celebrated historic events that had defined the nation. Set in the heart of cities, panoramas utilized the latest technology to place the viewer in the center of a large circular landscape painting that was blended with sculptured objects and figures to re-create a historical scene. Circular panorama painting had flourished in England,

Fig. 7 A. **Adolf Oberländer, "Naturalism in Sculpture,"** *Fliegende Blätter* **98, no. 2488 (1893): 136.** *B.* **"Practical Utilization of Monuments with a Simultaneous Edifying Influence upon the People,"** *Fliegende Blätter* **109, no. 2775 (1898): 141–42.**

The great national monuments were set in landscapes, but statues celebrating individuals, from poets to civic or historic leaders, were frequently erected in municipal squares. Oberländer, an eminent graphic artist and contemporary critic, satirizes both the immense sculptural monuments of heroes, here set in the city (*A*), and the naturalist depiction of ordinary daily life in the light colors of open-air painting, parodied in the whitewash pouring over all the figures.

Several years later, *Fliegende Blätter* published an illustrated suggestion that the pedestals of the many monuments to great men in Munich should be converted into coin-operated automats that would provide edifying services to the public. A series of illustrations followed, including this one (*B*) of a statue of Friedrich Schiller with volumes of his writings installed in its base, each available for a few cents. Not only could the student thirsty for knowledge create his own classical library, the reporter noted, but the ordinary man, the worker, and even the market-woman would be able to read the classics instead of the usual trash.

France, and Germany in the early years of the century, especially in re-creating battle scenes from the Napoleonic Wars. In Germany in the early nineteenth century Carl Friedrich Schinkel (1781–1841), the preeminent architect whose legacy shaped Berlin and Potsdam, created sophisticated panoramas and dioramas of landscapes and cityscapes. After the Franco-Prussian War new technology produced a revival, especially in France, of these illusionistic paintings that encircled the viewer. At the Paris Universal Exposition of 1878 a panorama of the defense of Paris against the Germans, created by Félix Philippoteux, was enthusiastically received as a work of art by both French and German visitors. In the next two years the resounding financial success of the French panoramas of military encounters resulted in a rash of speculation in the building of panoramas—a panorama mania.[14]

Financed by investors from Brussels, the first major panorama in Germany, of the Battle of Sedan, opened in Frankfurt am Main on 1 September 1880, Sedan Day, the national holiday commemorating the victory. Celebrating the day on which Napoleon III

Idee zu einem Springbrunnen.

A

B

capitulated to the German armies, this panorama clearly demonstrated the ideological, aesthetic, and commercial importance of visual representations of the nation in these first decades of the new empire. A Munich battle painter, Louis Braun, worked with two landscape painters and an interior decorator, all from Munich, to create and install the canvas, measuring fifteen meters high by one hundred twenty meters long, in its own freestanding rotunda in the heart of Frankfurt. Ten years later, a critic looking back on this event pointed out that the work was a deliberate answer to the success of the French panoramas in producing paintings that turned their defeat on the battlefield into a moral victory over the barbarian Germans. The reception from thousands upon thousands of visitors, he wrote, was enthusiastic, not only among the general populace but also in artistic circles. As an example of this approval he cited a *History of Munich Art*, written in 1888, extolling the panorama as a new art form for the common people: "The nation was enchanted finally to see its victory in a form whose grandeur was more appropriate than ever before. . . . [People] were simply carried away by it. Battle painting that had been scorned suddenly became the most patriotic of all the arts and the poorest peasants did not hesitate to take day-long trips just to see the place and the battle where their sons fought."[15]

We may be skeptical about "the poorest peasants" making these pilgrimages to view a painting in the hope of understanding where, if not why, their sons had fought a distant enemy in order to create a new nation, but there is no question that the urban classes did flock to see this panorama—and many more. Panoramas "popped up like mushrooms," an oft-repeated phrase describing the proliferation of the three-story circular structures with domed roofs topped by cupolas designed to cast diffused daylight on the painted scene. Built to standard specifications that enabled the elaborate panoramic scenes to be exchanged every few years, panorama rotundas dotted the German map: six in Berlin, three in Ham-

burg, two each in Munich and Frankfurt am Main, one each in Hanover, Düsseldorf, Cologne, Leipzig, Breslau, Stettin, Kiel, Bremen, Stuttgart, Aachen, Karlsruhe, Mannheim, Wiesbaden, Magdeburg, and Dresden. Comparisons of entrance fees and profits establish that more than 10 million people visited these panoramas across Germany from 1880 to 1900. This public was drawn from the middle classes of civil servants, officers, shopkeepers, and property owners; the usual entrance fee of one mark would have been steep for a worker. The most popular subjects for these panoramas were battle scenes, especially from the 1870–71 war and celebrated battles from German history. Almost as popular were scenes demonstrating German colonial and industrial power.[16]

These patriotic images of the nation defined by heroic military action, however, still encountered regional competitiveness and loyalty. Reviewers, while praising the Sedan panorama in Frankfurt, reported complaints that the moment of battle portrayed by the Munich artists glorified the Bavarian armies and completely neglected the Prussian armies in the battle. The imperial—and Prussian—view of the battle and the following events that culminated in the proclamation of the empire were soon represented in a Sedan panorama in Berlin. This panorama, with three accompanying dioramas, was designed by no less a figure than Werner, who by 1880 had become a power to be reckoned with in the Berlin art world. Considered by contemporary critics to be among the best, as well as the most elaborate and expensive, Berlin's panorama was planned and painted with meticulous historical accuracy of both military and topographic details by Werner with five of his colleagues and nine of his students. Commissioned by the Sedan Panorama Joint-Stock Company in 1882 and costing more than 1 million gold marks, the canvas and its setting captured the critical moment of attack on the afternoon of 1 September 1870 from a vantage point that encompassed the hills and valleys of the surrounding battlefields.

Fifteen meters high and one hundred twenty meters long, the circular canvas was hung on the upper level of an elaborately decorated rotunda on Alexanderplatz in Berlin in which a rotating platform enabled the viewer to examine the myriad details of the expansive scene (fig. 8). Three dioramas by Werner of events of the night following the battle—the French surrender, the capitulation negotiation, and Bismarck's meeting with Napoleon—were installed in the building to enhance the public's understanding of the political significance of the panorama. The photographic quality of the paintings, combined with the painstaking integration of sculptural reproductions of trees, earth, stone, and figures against the painted backdrops, which were artfully illuminated by seventeen electric arc lights from Siemens and Halske, produced an artificial realism that amazed the public and made these art forms comprehensible for the general populace. A ground-floor restaurant decorated with lighthearted paintings depicting soldiers' lives offered refreshments. The ceremonial dedication, graced by the presence of Emperor William I, accompanied by innumerable high officers and officials, was on Sedan Day in 1883. Not surprisingly, imperial patronage and approval enhanced the publicity for the panorama. Visited not only by tourists but also by schoolchildren and veterans groups, the panorama became virtually a national monument. Steady crowds—more than a million by 1890—kept this vision of national triumph in business until 1904, when it was finally demolished because of waning attendance.[17]

Like monuments, panoramas were given serious coverage in art journals, cultural magazines such as the *Gartenlaube* (Garden bower), and the illustrated and the daily newspapers. A critic for the *Deutsche Kunstgeschichte* (German art history) judged that the artists who had created the magnificent battle scenes in the panoramas had created a new monumental art form. *Kunstchronik* (Chronicle of art), the review of contemporary art and events that accompanied the art historical *Zeitschrift für bildende Kunst* (Journal for the visual arts), provided regular positive reviews of the panoramas, characterizing the best of them as a new art form for the future. Conservative and nationalist, Adolf Rosenberg (1850–1906) frequently reported favorably in *Kunstchronik* on the high level of skill and aesthetic realism that painters demonstrated in the panoramas. In 1881 he observed that in the years since the war panorama painting in both France and Germany had been artistically refined by artists of the first rank until one could no longer speak about panoramas as mere landscape or decorative painting. Instead, Rosenberg indicated, the panorama now constituted a separate branch of painting. The leading conservative critic in Berlin, Ludwig Pietsch (1824–1911) printed in the *Vossische Zeitung* (Voss's newspaper) extraordinarily long and exact descriptions of panoramas. Writing about the Berlin Sedan panorama, he praised the details that provided a "true observation of reality" in the gigantic painting, but he found the foreground relief between the canvas and the viewing platform in particular to be splendidly successful in portraying "the physiognomy of the battlefield with all of the natural authenticity that we have become accustomed to with the modern works of this type."[18]

Favorable reviews of the panoramas also came from critics who were considered to be progressive and modern in their judgment. In a review written several years later in the *Zeitschrift für bildende Kunst*, Richard Muther (1860–1909) praised the panorama as a manifestation of modern technology and scientific research and "a triumph of modern realistic art." Only a century of exact science, photography, and the railroad, he claimed, had enabled the extensive studies that provided the scientific foundation for these great works. Only an artist who had made the most thorough research into the landscape, people, and archaeology of the site and time was capable, Muther claimed, of handling the uncounted number of objects in such a new

manner. Frequent reports, some quite lengthy, in *Die Kunst für Alle* provided lively descriptions of the new panoramas opening in various cities. The editor, Pecht, praised Werner's Sedan panorama and dioramas for capturing on canvas the heroic contemporary history of the new nation. The director of the Royal Bavarian Alte Pinakothek in Munich, Franz von Reber (1834–1919), positively reviewed in the first issue of *Die Kunst unserer Zeit* (Art of our time)

a panorama of the city of Rome painted by two professors at the Munich Academy of Art.[19]

There were dissenting voices. Opposition to the panoramas tended to focus on the artificial landscapes and props that accompanied the panoramas. Others found the panoramas to be too common and commercial to be called genuine art. An article in 1885 attacked the panoramas as a barbarism that might have been appropriate for a

Fig. 8 **The Sedan Panorama on Alexanderplatz, Berlin, 1883–1904. A. Cross-section plan for the building, from the *Centralblatt der Bauverwaltung* 4, no. 12 (1884): 114–15. B. Adolf Oberländer, "The Newest Panorama Painting," *Fliegende Blätter* 88, no. 2216 (1888): 24. C. An interior view published in the *Leipziger Illustrierte Zeitung*, 1883/214, from a woodcut based on a drawing by Wilhelm Geißler.**

In his memoirs, Werner gives considerable attention to the process of creating the Sedan panorama, including his travels with colleagues to France to examine the topography of the battleground. He chose the uniforms and the exact moment of the battle through extensive discussions with the field commanders and officers who had witnessed or participated in the battle; planned the layout for the huge, two-thousand-square-meter canvas; created meticulous sketches to exact scale; transferred those sketches to the fifteen-meter-high canvas that was already hung in the

building; and created the topography of the battlefield that stretched from the viewing platform to the canvas, where three-dimensional objects and landscape merged imperceptibly into two-dimensional space. Work began on the project in the spring of 1882; the actual painting of the canvas lasted from March to August 1883. Thereafter, he spent months completing three dioramas of the French surrender and capitulation, which particularly interested Bismarck, whose visits to the finished works Werner recounts at length.

Panoramas provided an excellent target for cartoonists. Responding to the large number of painters required to produce these immense canvases, Oberländer drew this crowd of painters on the mobile scaffold that was mounted on a track running around the inside of the circular canvas (B). His caption used witty wordplay to give appropriate names to each of the artists who were assigned to feet or noses or clouds.

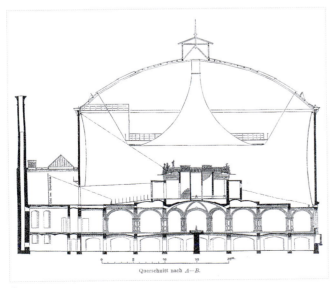

Querschnitt nach *A—B.*

A

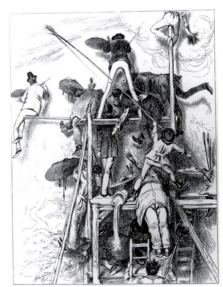

B

more primitive time but was not appropriate for contemporary modern culture. "When such a thing is not only produced today," it charged, "but is also admired as a work of art and when one considers that artists of undoubted talent have devoted themselves to such productions, then it makes one question the necessary progress of modern cultural development." The writer who quoted this critique commented briefly that these out-of-hand dismissals of the panorama had more to do with reactions against the overblown advertisements for the panoramas than with their quality. In another sophisticated critique, in *Der Kunstwart* in 1888, the writer argued that the use of the elaborate staged landscape with its props was aesthetically barbaric because it served only to deceive, not to enhance one's sense of beauty. However, he was convinced that panoramas divested of the artificial props could

become an optical advance on easel painting. Since one was always in the center of an optical world, a global painting using the scientific reasoning developed for the panoramas would be an immense step forward in the artistic representation of the contemporary world.[20]

A satirical response to the mania for panoramas and monuments came in 1886 from Dresden, where a summer festival organized by the local artists' society was held to "dedicate" a monument to Gockelbein and a panorama of the Battle of Dohna. Both were celebrated in a witty play in which the only casualties from the battle appeared to be empty beer bottles, according to the tongue-in-cheek report in *Die Kunst für Alle*. A more pragmatic criticism voiced by some critics was directed against the financial speculation that funded the panoramas and often resulted in hasty and carelessly

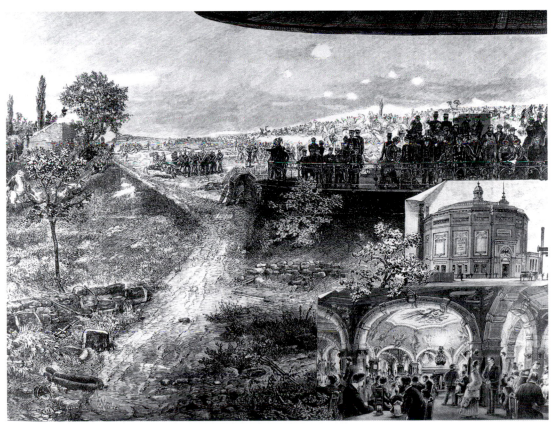

c

painted panoramas because artists were pressured by capitalist entrepreneurs to produce too rapidly. Indeed, the whole panorama bubble burst when profits slackened, in part a result of overproduction. By the end of the century the panorama mania had played itself out. Yet in the two decades of the mania, panoramas had provided work for a substantial number of artists, decorators, and architects. Both Berlin and Munich had studio workshops devoted to the creation of panoramas. The tourist traffic generated by the panoramas brought money and jobs into the cities that contributed to the eagerness with which panoramas were raised.[21]

Ideologically and artistically nationalistic, these monuments and panoramas represented a major effort to develop an art that was edifying for the people and that would enhance national consciousness within this uneasy new nation. Significantly, monuments and panoramas were products of community and private capitalist efforts. Although state funding was sometimes sought for the monuments, the initiatives generally came from civic groups and organizations, whether local, regional, or national. The panoramas were capitalist productions formed through international networks that consciously appealed to local patriotic and nationalist sentiments. That their creation produced jobs for artists, craftsmen, and artisans, brought tourist trade to the cities, and produced profits for investors meant that these art forms were favorably integrated into the economic as well as the popular cultural life of their communities.

DEFINING AN ART FOR ALL: FRIEDRICH PECHT AND *DIE KUNST FÜR ALLE*

In 1885 Friedrich Pecht (1814–1903) became the editor of a new journal whose goal was clearly stated in its title, *Die Kunst für Alle* (The art for all). The journal was part of a group of cultural reviews that appeared in the first decades of the empire and shared the common ideal of forging a new cultural politics that would transform the diverse German people into a new unified nation.[22] *Die Kunst für Alle* was not, however, a general cultural review. It had the specific purpose of acting as a mediator between artists and the ordinary people of the new nation. Pecht, who visited his first art exhibition at the age of eleven in 1835, had witnessed the major transformation in the patronage and support of art that occurred during the nineteenth century. Looking back in 1889, he reminded his readers that a fundamental shift had taken place in the first part of the century in which the ownership of art had passed from princes to the people. Art, which had once depended entirely upon the taste of a benevolent prince, he pointed out, had now become the common property of the whole nation. However, he warned, art would not become a genuine possession of the nation until art had become intimately tied to the life of the people.[23]

Pecht therefore designed the journal not only to inform the literate classes simply and clearly about contemporary art and to encourage them to support it but also to inspire artists to produce art for these new patrons of art. Pecht's dream was to create a new national art and a new collective—and collecting—public, cutting across classes, education, and regions. Years earlier, in 1862, Pecht had asserted his basic position about the necessity of creating an art that would reach beyond the upper classes or the highly cultured bourgeoisie: "For all of these people, works of art are also there, at least should be really there for them! It is, after all, the whole task of our time to make art into the common property of all of the people and not something that is merely a spoiled pet of the court, a luxury object, or a plaything for the cultivated."[24] Although he realized that the public for the journal had to be literate, Pecht steadfastly rejected the idea that art should be the privileged preserve of the court, the bourgeoisie, or the educated classes.

To capture the interest of the new public, the journal was lavishly illustrated with full-page black-and-white wood engravings, as well as smaller text illustrations. Later, photographic reproductions were integrated into the text. Although other cultural journals reviewed contemporary art, few carried reproductions before 1895. The quality of reproduction was consistently high, enhancing both the aesthetic appeal and the accessibility of the journal for the general audience. In the 1890s, color plates were introduced and at least one original engraving or etching was included in each issue—the first step in turning the reader into a collector. Despite the cost of reproduction, the price remained reasonable, at sixty pfennigs an issue. The text was easy to read and understandable; it was not written for scholars and art historians. Articles consistently gave an overview that contained accurate information on the work of artists. In these first years short stories, serialized novels, artists' memoirs, as well as articles on festivals held by artists' organizations or caricatures of art, were designed to capture the interest of the lay audience. A how-to feature on photography and articles on choosing, purchasing, framing, hanging, and cleaning paintings were regularly included. The advice ranged from "what is the appropriate color for wall paper behind a painting" or "don't use an oil dust cloth" to careful analyses of oil and graphic techniques or how to tell a forgery.

All of this was designed to form an educated public whose patronage would lead to an art that was integral to the life of the nation. The first important step was, of course, actually reaching people, and in this *Die Kunst für Alle* was effective. The public response was enthusiastic, and circulation reached sixty-one hundred copies within six months; by the end of the second year, with twelve thousand subscribers, the press run was fifteen thousand copies. The circulation of the cultural reviews tended to reach about one thousand, with a few reaching as high as five thousand.[25] These figures indicate that a large number of people were paying attention to the message that *Die Kunst für Alle* conveyed about the art world. The journal was, therefore, a significant factor in the creation of a public for contemporary art—for new art, for what was perceived at that time to be modern—in Germany. The messages and images conveyed in the journal deserve our close attention.

As editor of *Die Kunst für Alle*, Pecht had firm ideas about what form of contemporary art was appropriate for the new modern nation, though he and his colleagues, Friedrich Bruckmann, the publisher, and Friedrich Schwartz, his co-editor, were at the same time committed to presenting other viewpoints within the journal. He was already an influential critic when he became the editor. Seventy-one years old, an established artist, critic, and writer who in his lifetime wrote more than sixteen hundred books and articles published in nine daily newspapers and twenty-eight journals, Pecht had been a member of most of the official art commissions and museum boards in Munich and maintained extensive contacts among artists and writers across Germany. A liberal nationalist from the mid-nineteenth century, he was committed to the newly unified German nation. He cited favorably, for example, the Sedan Panorama Joint-Stock Company for its support of the contemporary national art in the form of the panorama and dioramas depicting historical events, and he provided extensive coverage of plans and competitions for monuments, especially the controversial monument for William I in Berlin.[26]

In his first editorials, in 1885 and 1886, Pecht defined his understanding of the modern nation as based on the Darwinian principle of the survival of the fittest. The formation of separate nations was for him "a necessary natural process" that served to evolve different national characteristics. The role of the artist in each nation was to translate those characteristics into a new art that fully resonated with the people of that nation in their own time. A genuine national art would address contemporary issues and portray the ideals and life of the people with

simplicity and honesty.[27] Pecht was critical of current academic art, which he chastised for its sterility and failure to deal with contemporary realities. A diatribe characteristic of Pecht's views on academicians appeared in an essay he wrote commending the contemporary political paintings of Werner. The mediocre pedants who ruled Germany, he fumed, had ruined the character of Germany's educated men, turning them into petty, legalistic, selfish persons who were unable to distinguish the important from the trivial. "Just look at our art!" he exclaimed, pointing out that instead of entering into the new modern period, academic artists continued to turn out Olympic gods and Trojan heroes.[28]

Pecht found one artist, Adolph Menzel, worthy of the highest praise for his refusal to paint these worn-out figures and for steadfastly choosing contemporary life as his subject matter. Menzel, he asserted, was the pathfinder for German art, who as a young artist had drawn a cautionary tale about an artist who did not live in Rome or in "cloud-cuckooland," but in Berlin, where he painted fat Jewish women, not Catherine de Medici or Cleopatra (fig. 81). Menzel continued to be his touchstone for genuine German national art, for the specificity of his depiction of every class, from farmer to emperor, such as in his great painting *The Iron Rolling Mill (Modern Cyclops)* (1872–75) or in the glittering *Supper at the Ball* (1878). Dedicating an article in the fifth issue of the new journal to the celebration of Menzel's seventieth birthday, Pecht applauded Menzel for turning people's attention in art to their own history and bringing an end to the unhealthy fascination with antiquity. Menzel, he said, had finally made art into an expression of contemporary human nature and had opened new ways for art.[29] By the late 1880s, when an increasing number of artists were turning away from nostalgic and romantic genre scenes to grittier everyday settings, Pecht singled out a contemporary painting by a young artist from Düsseldorf, Emil Schwabe, for its exemplary grasp of a scene from the "most modern

life." Not only did the work, titled *Unsolved Questions* (fig. 9), authentically portray men engaged in current political arguments in a typical restaurant, Pecht wrote, but the artist represented in these men the three major political parties of the German Empire, while wittily indicating that the real political power lay with Bismarck.[30]

A strong corollary to Pecht's Darwinian understanding of nations was his conviction that the future of art lay in independent, self-conscious national art, not in international or cosmopolitan art, which he believed could only be superficial and lacking in character. As early as 1888 he was disturbed by the increasing similarity of paintings in the international exhibitions, where he found artists from Moscow to Lisbon to New York and Naples all using similar techniques. He deplored that everywhere works of art were always "gray and more and more terribly painted" and lamented that this fashion of painting, influenced by French artists such as Jean-François Millet or Gustave Courbet, "spreads like cholera or the bustle over the whole world." Despite his derogatory use of disease and fashion metaphors, Pecht recognized that the exchange of art forms between nations was essential for the continued progress of art. Nevertheless, he was convinced that excessive imitation of foreign art would result in the serious decline of national art. Pecht had a clear definition of what a national art should be and reiterated this stubbornly over the next decade. Yet, when it came to actual judgments about works of art, he had difficulty balancing his national aspirations with his call for an art that represented contemporary social reality in the life of the people and with his awareness of new directions in art. In his editorial marking the tenth year of publication in 1894 Pecht acknowledged how hard it was to find guidelines to judge new and exasperating art; yet, he insisted again that *Die Kunst für Alle* had consistently maintained "that art must be for the whole nation and not just for the rich lovers of art."[31]

What, then, would this new German art be?

Here we encounter the same complexity that marked the debate about what constituted the new German nation. Breathtaking changes had taken place in the seventeen years since the proclamation of the empire: financial markets that soared, collapsed, and recovered; exploding industrial urban classes; rapidly expanding markets; new commercialization and consumerism; new industrial technologies. Mixed in all of this were arbitrary state and national policies that sought national coherence and control by successively attacking traditional regional loyalties to the Catholic Church and loyalties of the working classes to the international socialist movement. A series of Prussian and imperial legislative actions directed against Catholic schools and clergy in force from 1871 to 1887—the Kulturkampf (cultural struggle)—were part of the European-wide effort led by liberals and nationalists to consolidate national authority against outside influences and minorities perceived to be inimical to the unity of the new nation-state. In Germany, the cultural battle against the Roman Catholic Church, which began in the southern German states and was then strongly implemented in Prussia, served to arouse strong political opposition to state and national policies, as did the legislation directed against socialist organizations from 1878 to 1890. In both cases new mass political parties developed out of these conflicts.[32]

All of these factors created problems for artists and critics who took seriously the task of representing contemporary life and creating a new national culture. Would, for example, a painting of a Catholic religious procession be considered a positive depiction of contemporary life, or would it be considered a subversive gesture at a time when traditional ceremonies and processions in Catholic communities had become a means of political protest against the anti-Catholic policies within the new nation?[33] Similarly, given the great fear of socialism and the antisocialist law suppressing political activity in Germany by socialist organizations from 1878 to 1890, could

an artist portray incidents from the contemporary life of the working classes without being labeled disloyal? These questions point to ways in which political and confessional rifts could permeate the art world and affect both the choice of subject and its representation.

With Pecht's call for artists to represent contemporary issues facing the nation, in its first years *Die Kunst für Alle* actually did feature paintings that portrayed both Catholic processions and workers' meetings. Menzel's painting *Procession in Gastein* (fig. 10), shown frequently in both Munich and Berlin during the 1880s and 1890s, was reproduced in a double-page spread in the 15 May 1892

Fig. 9 **Emil Schwabe (1856–1904),** *Unsolved Questions,* **1887. Oil on canvas, 31 1/2 x 47 3/8 in. (80 x 120.5 cm). Kunstmuseum Düsseldorf im Ehrenhof. Reproduced in *Die Kunst für Alle* 4, no. 12 (Mar. 1889): n.p.**
Friedrich Pecht's reading of this painting was explicitly political. He identified the central figure as a lawyer or journalist, probably Jewish, who as a Progressive Party member is highly agitated by arrogant views of the National Liberal or Free Conservative landowner. The man on the right, either a priest or a professor, representing the Center Party, demonstrates in his withdrawn and reflective stance the extent to which he believes that he and his party stand above the political fray. Nevertheless, Pecht points out, all three will have to leave the decisions to the chancellor, whose portrait hangs above them all.

Fig. 10 **Adolph Menzel (1815–1905), *Procession in Gastein* (also titled *Corpus Christi Procession at Hofgastein*), 1880. Oil on canvas, 20 1/4 x 27 5/8 in. (51.3 x 70.2 cm). Bayerische Staatsgemäldesammlungen, Neue Pinakothek Munich. Reproduced as a double-page spread in *Die Kunst für Alle* 7, no. 16 (May 1892): n.p., and in *Die Kunst unserer Zeit* 2 (1891): n.p.**

issue. Although the last of the anti-Catholic laws had been repealed before this work was displayed in the journal, confessional hostility accelerated in the 1890s as both the Catholic and the Protestant communities experienced religious revivals that intensified their mutual opposition. In particular, Catholic Corpus Christi Day processions became a target of protest within Protestant communities.[34]

Pecht pointed explicitly to the cultural struggle against Catholicism when he praised Menzel's painting as "a remarkably characteristic cultural portrait of our time" that superbly expressed the contemporary anti-Catholic attitudes in Germany. Menzel's painting, a luminous depiction of the ritual progress of Catholic clergy and laity in traditional dress through the picturesque mountain village, also includes a group of laughing bourgeois German tourists in fashionable urban dress idly watching the scene. For Pecht, the painting represented the fundamentally different worlds that coexisted in Germany at the time: that of "the thoroughly modern" visitors to the village spa and that of the local Catholics, whose procession recalled a much older, traditional world. Menzel's ability to incisively depict these divergent social worlds through meticulous attention to details of dress, stance, and physiognomy was particularly expressed in these figures, whom Pecht described with delight.[35]

Watching the procession in the center of the painting, he wrote, is an Austrian cavalier with a large mustache, whom Pecht identified as a former

officer, outwardly decently attentive and inwardly totally indifferent. Behind him is a young man whom Pecht characterized as insolently turning his back on the procession to demonstrate his enormous superiority. Pecht first identified this figure as a Jewish journalist and then later described him as a Berlin student training for a position in the civil service. In the right foreground, according to Pecht, is a bragging northern German businessman surrounded by certain "more experienced than beautiful" Viennese women. These figures form a marked contrast to the kneeling worshippers behind them, the cripples and the woman with her children drawn to the procession, and the reverent villagers following the colorful banners and vessels carried by the priests. This clash within the modern world that Menzel visualized with such clarity and artistry, Pecht concluded, characterized not only the contemporary encounter of cultures in the Austrian resort but also the patronizing attitude of the educated classes toward Catholicism in Germany.

A month earlier, a report by "P.S." on the art scene in Karlsruhe in the spring of 1892 had favorably reviewed the painting *The Strike of the Blacksmiths* by Theodor Esser (fig. 11) because it drew attention to the urgent contemporary struggle over the demands of the social democratic movement and because, as he reminded the reader, "the health of art is determined by the degree of clarity with which it mirrors the national life." Describing the scene of workers gathered outside of a factory confronting a column of armed soldiers, the reviewer pointed out that the large painting was a strong warning to employers, for the strikers were questionable characters who appeared to be driven more by their love of brawling than by a struggle for their rights. At this point the reviewer quickly acknowledged that others might disagree with his interpretation; nevertheless, he insisted, this image represented a desperate real-life situation that deserved to be taken seriously.[36]

Although he opposed the exploitation of workers and supported the parliamentary rights of the Social Democratic Party, Pecht's own views on socialism as it appeared in art were more complicated. Writing in October 1890 about a painting of a people's assembly by the French artist Jean Béraud (fig. 12), Pecht commended the work as "a first rate modern painting" and a masterful presentation of contemporary life that German artists should consider emulating. Nevertheless, he scathingly described what he characterized as a typical social democratic or anarchistic meeting: "The speaker standing on the platform obviously has just played a particularly strong trump card against the damned narrow-minded possessors of capital and their blood-thirsty exploitation of the noble people, as one can see from the frenetic cheers of the throng of 'citizens,' especially the 'female citizens,' one of whom clapping in the foreground is a provocative specimen of the type of Louise Michel." (Michel was a reviled French feminist whose name became synonymous with leftist radicalism through her participation in the Paris Commune in 1871.) Commenting that everyone was smoking in the room because otherwise the smell of unwashed bodies would be unbearable, Pecht speculated uneasily on the future reality if this "urban rabble gathered from the whole world" gained control. However, he immediately turned this around to chastise German artists for their failure to pay attention to what surrounded them; not one of them, he said, had thought of painting such a socialist gathering, which offered an artist an unusually rewarding study of contemporary types of people.[37]

These themes—the call for artists to depict contemporary life and the anxiety over the filthy masses—jostled uncomfortably against each other in *Die Kunst für Alle* during the late 1880s and early 1890s. These years witnessed a rapid growth in trade unions and strike actions in industrial centers: in 1884, strikes in various Saxon cities by weavers, glassworkers, factory workers, masons, and carpenters; in 1885, twelve thousand Berlin masons on

Fig. 11 **Theodor Esser (1868–1937), *The Strike of the Blacksmiths*, 1892. Oil on canvas, 68 1/2 x 90 in. (174 x 227.5 cm). Elvehjem Museum of Art, University of Wisconsin—Madison. Gift of William C. Brumder, 13.2.1.** As the soldiers take position to fire upon the strikers, only a handful of the workers in the middle background of the picture seem to be seriously engaged in the threatening situation. Most of the workers are depicted as drunks, unruly and ungainly boys, or rowdy men spoiling for a fight. In the center, partially hidden by the large worker, is a man in a hat and a suit, perhaps a union organizer.

strike; in May 1889, a massive strike of ninety thousand coal miners in the Ruhr; in mid-1889, a carpenter strike in Munich. The antisocialist law, with its police surveillance and repression, which had clearly failed to stop the growth of workers' organizations, was voted down in the Reichstag in January 1890. Despite the measures taken by the state to hinder political activity, socialists, reorganized in 1875 as the Socialist Labor Party of Germany, had dramatically increased their votes in the national Reichstag elections during these years. In February 1890 the socialists received almost 20 percent of the popular vote, making their party one of the strongest in Germany. In the spring of 1890 labor leaders across Europe were calling for a massive international demonstration on the first of May in support of the eight-hour workday.[38]

Against this backdrop, on 1 July Pecht published an editorial in *Die Kunst für Alle* that pointed to the current scene confronting artists, one that he insisted true art should reflect. "We all know that Germany, like all of Europe, has entered into a great social-political movement, which has feverishly aroused our lower classes, above all the proletariat of the cities, and threatens us with dreadful con-

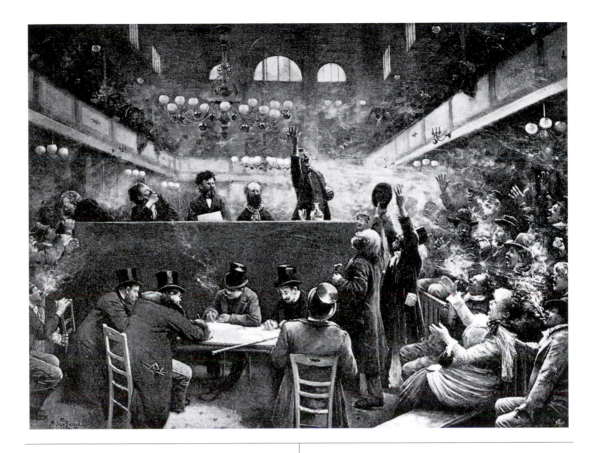

Fig. 12 **Jean Béraud (1849–1935), *A Popular Assembly*, 1889. Reproduced in *Die Kunst für Alle* 6, no. 2 (Oct. 1890): n.p.**
Béraud was a founding member and vice president of the Salon of the National Society of Fine Arts in Paris. The work was shown in the Paris Universal Exposition of 1889 under the title *At the Salle Graffard* and again in the Centennial Exposition of French art from 1800 to 1889 at the Paris world's fair in 1900.

flicts, because it declares war not only against the whole existing state order, including the recognized religions, but also places its one-sided class interest in place of national interests and, in so doing, develops the full fanaticism of superstition."[39] Thus, Pecht viewed Béraud's painting in a positive light precisely because he found in its subject matter a negative portrayal of the disorderly proletarian rabble. In other words, Pecht viewed this work as important because it presented a cautionary image that would educate the people about current political reality. His early support for social democrats had rested upon an expectation that socialism would provide the necessary discipline to control and integrate the working classes within the nation.[40] Now that hope seemed to fade in the face of the increasingly aggressive labor union activity.

The issue was not only the political threat posed by the unruly urban masses. Pecht's own commentary on the Béraud painting revealed a further source of his unease, an unease that was shared by most members of the middle and upper classes, namely, the uncouth manners and unwashed appearance of the urban working classes. Respectability, reflected in a concern for proper manners and dress, an insistence upon orderly behavior, and a belief in cleanliness and godliness, was a defining characteristic of late-nineteenth-century bourgeois

society, particularly in Germany. Upright behavior and manners were prized as marks of a civilized individual and were believed to be basic to the functioning of a strong and orderly nation. Violations of these external marks of respectability were perceived by many to be indicative of the dangerous disorder of socialism, as in the horrific images conjured in upper- and middle-class minds over the uprising of the people in the Paris Commune after the defeat of Napoleon III in 1870. That Courbet, the French artist best known in Germany for his paintings of contemporary scenes, not only cultivated a slovenly appearance but also was implicated in the actions of the Commune only reinforced the web of uncomfortable connections that linked political radicalism, external physical appearance, and certain approaches to art.[41]

Pecht himself became increasingly concerned about the negative influences of socialism on art. By 1891 he was contradicting his earlier views by lamenting the loss of character and dignity in current naturalist art, which he associated with fundamental social and economic changes. Historical paintings of kings and princes, he wrote, had given way to paintings of physiognomically uninteresting and dirty proletarian types. Furthermore, these paintings not only revealed the exhaustion and suffering of the proletariat, they also represented for Pecht a regressive development within German society by which the solid bourgeois elites of midcentury were being replaced by capitalist speculators and factory owners who required police force to protect them from the lower classes. Viewing the exhibition in Munich in 1891, he was saddened to see that portraits of upright burghers by Rembrandt and Frans Hals had given way to the portraits of undistinguished-looking Jewish stockbrokers. Among them were the "stockmarket princes" and Bismarck's Jewish banker, Gerson von Bleichröder, whom he characterized as a smart, energetic figure whose features, lacking any idealism, were wholly suited to a contemporary ruler of the world. This complete rejection of everything noble and uplifting was for Pecht "a characteristic of our newest art which is obviously more deeply influenced by social democratic ideas than anyone realizes."[42]

These issues and images generally were not sharply defined, and the message carried by *Die Kunst für Alle* was much more nuanced and contradictory than Pecht's criticism would suggest. We can catch a further glimpse of these ambiguities inherent in creating a national art, including issues of style as well as the more obvious choice of subject matter, by examining the journal's presentation of the work of two of the major painters whose art was both controversial and acclaimed in these years: Max Liebermann and Fritz von Uhde. Within its first two years of publication *Die Kunst für Alle* published lengthy lead articles spread across two issues on each artist. This was an honor granted to few; the only other artist to receive similar attention in those years was Ludwig Richter (1803–1884), the popular painter of fairy tales and medieval Germanic images. Over the next two decades only two artists, Arnold Böcklin and Max Klinger, received more attention in lead articles and reviews.[43] What makes these articles surprising is the notoriety already surrounding the work of Liebermann. Uhde became equally infamous by the end of the eighties. In both cases, the offensive works aroused accusations of religious blasphemy and socialist sympathy, entwined accusations that grew out of attitudes generated by anti-Catholic, antisocialist, and anti-Semitic campaigns.

MAX LIEBERMANN: PAINTER OF UGLINESS AND RELIGIOUS WRATH

Liebermann's first naturalist paintings, exhibited in Hamburg, Berlin, and Paris in the 1870s, were heavily criticized for their dark portrayal of depressing scenes of rural labor: women plucking down from geese, canning vegetables, or harvesting

turnips (fig. 13). A conservative critic claimed that Liebermann's works in the Berlin Academy Exhibition of 1877 had been influenced by the social democratic style of Courbet, in which, he claimed, "an uncanny gray-brown tone weighs heavily on everything, a—excuse this word—filthy melancholy. Moreover, all of the creatures of the imagination of this painter are communards and *pétroleuses*; degenerate ugly people burdened with the pressure of life."[44] His insistence that Liebermann shared these marks of a socialist style—the same dirty colors, melancholic style, and degenerate people—would haunt Liebermann's painting for years and also defined the terms by which many critics perceived the work of other artists who broke with the accepted genres and styles of the 1870s.

The real storm broke over Liebermann's painting, hung in Munich in the First International Art Exhibition, in 1879, of the twelve-year-old Jesus conversing with his elders in the temple in Jerusalem (plate 1).[45] The troubles began at the opening of the exhibition, when Prince Regent Luitpold had the painting moved from a favorable location to a side room. That relocation was not enough to deflect attention and criticism. Derogatory diatribes denounced the work and its creator. Hostile critics found the painting to be "disturbingly proletarian," a "desecration of the Lord God"; in it "the most repulsive ugliness reigns in naked loathsomeness." Caustic criticism came from the *Augsburger Allgemeinen Zeitung* (Augsburg general newspaper), written by none other than Pecht, who branded the boy Jesus "the ugliest, know-it-all Jewish boy imaginable" and the Jewish elders "a rabble of the filthiest haggling Jews." Pecht summed up his impressions in the most insulting way possible: "The painting is an offense not only to our feelings, but even to our nose, because it provokes all kinds of unfavorable memories."[46]

Pecht's slanderous critique, with its evocation of abusive stereotypes of both Jew and proletarian—ugliness, rabble, dirt, stench, vulgarity, uncivilized

behavior (fig. 14)—was quoted with approval in the January 1880 debate in the Bavarian parliament. The Catholic Center Party speaker, Dr. Balthasar Daller, flatly denied the artistic value of the painting, describing it as a blasphemous and hideous picture that portrayed the holy subject in "a nasty and despicable way" that deeply offended every faithful Christian. Carefully avoiding naming Liebermann, Daller acknowledged the right of a non-Christian to view the scene differently. By so doing, therefore, he raised the touchy issue of a Jew painting the "hideous" and "blasphemous image" of the young Christ. Another deputy picked up on this, saying that "a man of his confession" should have known better than to paint this scene.[47]

The deputies' outrage, however, was equally directed at the artistic community, especially the jury and organizers of the exhibition for accepting and supporting such a sacrilegious painting and the state officials for allowing such a form of action against Christian beliefs, which they asserted had deeply offended the Christians, who were the majority residents. In fact, leading Munich artists, especially Wilhelm Leibl, Franz von Lenbach, and Lorenz Gedon (1844–83), praised the work and eagerly welcomed Liebermann into the circle of illustrious master painters. Artists on the jury selection committee, including both Lenbach and Gedon, were excited about the work, pointing out that such a fine painting had not been created in Munich in the last fifty years, and refused to withdraw it from the exhibition. Prince Luitpold, who admitted to being displeased with the painting at first, visited Liebermann in his studio later to indicate his support after artist friends convinced him that the work was "an exceptional achievement." Whether Luitpold's position was known to him or not, Daller vented his anger against the Bavarian officials: "If such a blasphemous painting as this of one of the ruling princes, sovereign princes, or members of one of the ruling families had been exhibited, that picture would have been thrown out with the applause of the whole

nation. That in this situation nothing occurred, has wounded me."[48] This denunciation was particularly pertinent to the situation because the Bavarian minister for ecclesiastical affairs and education, Dr. Johann Freiherr von Lutz, during the years 1869–90 was known to be a vigorous advocate of the cultural actions taken against the Catholic Church. Lutz, a liberal, had proposed the measure, passed in the Reichstag in 1872, that led to the series of laws that together constituted the anti-Catholic struggle and instigated the vigorous response within the Catholic communities resulting in the rapid growth of the Catholic Center Party as a political power within Germany.

During these years of the liberals' struggle against the backwardness of the Catholic Church, a struggle that Bismarck claimed was being waged against the enemies of the empire, resentment against the entry of recently emancipated Jews into German society became overtly public and politically viable. The secularized Protestant culture that dominated the empire considered Jews and Catholics alike to be outsiders, while Catholics believed that liberal Jews had instigated the negative policies of the 1870s against the Catholic Church.

In 1879, Wilhelm Marr, who coined the term *anti-Semitism*, published a pamphlet titled *Victory of Jewry over the Germanic World* and in October founded the Antisemite League. A month later the first of a series of anti-Semitic articles was published by the eminent Berlin historian Heinrich von Treitschke in the conservative journal *Preussische Jahrbücher* (Prussian yearbooks). Writing with brilliant simplicity, Treitschke accused Jews of aggressive materialism, which, since it was alien to the German character, enabled them to take over the German economy and culture, particularly its newspapers. "The Jews," he wrote, "are our misfortune." During these same months the Prussian court chaplain in Berlin, Adolf Stoecker, turned in his preaching, notably at highly publicized mass meetings held in Berlin in September 1879, to anti-Semitic rhetoric in order to broaden the political appeal of his newly formed Christian Social Workers' Party to those sectors of the middle classes who were particularly threatened by the emerging capitalist society. Stoecker's sermons and Treitschke's articles transformed anti-Semitism from popular rabble-rousing into a respectable bourgeois position.[49]

The reception of Liebermann's *Twelve-Year-Old*

Fig. 13 **Max Liebermann (1847–1935), *Women Making Preserves*, 1879–80. Oil on wood, 19 3/8 x 25 5/8 in. (49 x 65.3 cm). Museum der Bildenden Künste Leipzig. Reproduced in *Die Kunst für Alle* 2, no. 14 (Apr. 1887): n.p.** The dark tones of this work, which allow only a suggestion of the crude space where these women are peeling and cutting vegetables, were characteristic of popular and academic paintings of the 1870s. That darkness also sets off the faces and figures of the women, giving them a solemn dignity that was as unusual as Liebermann's decision to portray women at such menial labor. At the time, lower-class women were more commonly portrayed in sentimental, jolly, or tragic situations. Critics were incensed at this painting of ugly, tired women whom they deemed unworthy of attention. Friedrich Pecht wrote that a long row of working women in another Liebermann painting of about the same time looked like "sparrows sitting on a telegraph wire."

Jesus in the Temple among the Elders in the First Munich International in that summer of 1879 needs to be seen against this tangled cluster of prejudice, fear, and resentment. Liebermann recalled in his memoirs being greeted in beer halls at that time with the cry, "Here comes the desecrator of God" and claimed that his painting helped precipitate Stoecker's campaign against the Jews. Stoecker dwelt at length on the painting in his sermon of 27 September, calling for "self-defense again modern Jewishness." The hail of verbal and printed invectives against the painting, its artist, and the jury soon reached far beyond Munich. The members of the Jewish community in Berlin were disturbed enough to withhold support from Liebermann for some years, and his mother was ashamed to go out into public. Finally, Lenbach and other established artists in Munich urged Liebermann to escape from the "wrath of the rabble" by fleeing to Dachau.[50]

Many thoughtful explanations have been given for the intemperate response to Liebermann's seriously conceived and effectively executed painting. Most concentrate upon the anti-Semitism of the 1870s; less attention has been paid to the tension between Catholics and liberals. One puzzling aspect of this affair has been the disparity between the angry attacks upon the painting and the image itself. The serious child with long blond hair and a modest white smock—a French critic in 1884 called him "a little girl"—in the painting, which now hangs in the Kunsthalle in Hamburg, simply does not look like "a very ugly boy who talks with his hands" or a "squinting Jewish boy in a dirty smock with red hair and freckles." A recent study has, however, demonstrated convincingly that Liebermann reacted to the furious anti-Semitic response from reviewers by overpainting the figure of the boy Jesus before it was exhibited in Paris in 1884. The painting was not exhibited in Germany again until the Berlin Secession exhibition of 1907, where it was well received. Evidently unaware of the alteration of the painting, Liebermann's friend and biographer commented that the painting was shown on the most visible wall of one of the large rooms, "where the painting looked relatively small, very light-colored, silver, and so noble that no one could comprehend the possibility of that dreadful scandal." A fairly complete preparatory sketch of the original conception and a photograph of the original painting in a book published in 1894 depict a barefooted young boy with short, tousled dark hair and a strong, stereotypical Jewish profile (fig. 15). Dressed like a street urchin, he is assertive in both his gestures and his stance as he engages strongly with the Jewish elders.[51]

The subject matter of the painting, drawn from

Fig. 14 **Edmund Harbürger (1846–1906), "Hardening," *Fliegende Blätter* 100, no. 2539 (1894): 125. The caption reads: "Jainkef, why are you holding your finger in the glass?" "The doctor said that I must take a bath! So I am getting used to water a little bit at a time!"** Harbürger was one of the best-known artists of *Fliegende Blätter*, over many years contributing more than fifteen hundred drawings of Bavarian urban and rural characters to the magazine. This stereotype of Polish Jews was based on the derogatory and pervasive perception that Jews did not maintain habits essential to respectable bourgeois order.

Luke's account of the childhood of Jesus, was part of a long visual tradition. Rembrandt's vision depicting the elders as Jews from Amsterdam, which Liebermann particularly admired, was a treasured part of the German artistic heritage. Menzel's 1852 lithograph was a racist depiction of a crowd of stereotypical Orthodox or Polish Jews, draped in amorphous classical robes, who were theatrically arguing around the central figure of a clean, bright haloed Jesus (fig. 16). This work caused little resistance and considerable amusement when it was first shown. Menzel's unreal Christ child was clearly distinguished from the Jews, whose dubious character and negative response conformed to current prejudices (fig. 17).[52]

Liebermann, however, presented the viewers with a closely observed scene in which a Jewish boy engaged in intense discussion with his elders, who were shown not as stereotypical Jews but as thoughtful, respectable individual men whose dress and prayer shawls marked them as contemporary Jews. The colors are somber grays, the canvas crowded, the space largely dark. This unmistakable reminder that the Christ of faith was a Jew from Nazareth was profoundly disturbing. Adding to the unease and anger that the work created was Liebermann's presentation of the Jewish elders as intently listening, not, as traditional Christological representation required, rejecting the Christ.[53] Furthermore, it was the ordinariness and contemporaneity of this scene of the all-too-human shabbily dressed Jewish child that alarmed Protestants and Catholics alike. At a time when scholars and writers, from David Friedrich Strauss to Friedrich Nietzsche (1844–1900), were casting doubts on the divinity of Christ and even on the historical Jesus, the humanizing of the biblical

Fig. 15 **Max Liebermann.** *A. **Jesus in the Temple**,* in Richard Muther, ***History of Painting in the Nineteenth Century** (1894), 3:633. B. **Sketch for "Twelve-Year-Old Jesus in the Temple,"** 1879.* **Crayon over pencil, 17 x 12 in. (43.4 x 30.4 cm). Kupferstichkabinett, Staatliche Museen zu Berlin— Preußischer Kulturbesitz.**

A

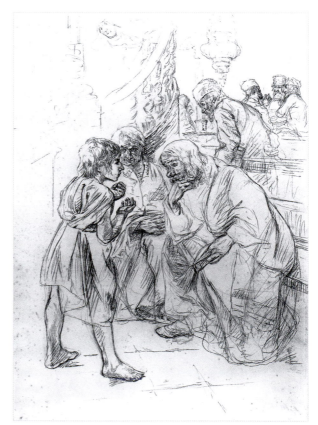

B

figures—both Jesus and the elders—as common, ordinary people by a Jewish Prussian artist could only crystallize anxieties and fears about the current rationalizing and secularizing efforts, which weighed most heavily on the Catholics.

Another factor, also an assault on a Catholic community, may have been at work for many in viewing this image of an ordinary child being closely interrogated by adults. From March until April 1879—a month before the exhibition opened—a highly publicized trial in Saarbrücken culminated a three-year investigation into the events surrounding apparitions of the Virgin Mary to three young girls in the small village of Marpingen. Although the children themselves were not on trial, their extended interrogations and arbitrary treatment by the Prussian authorities were a significant aspect of the trial. During a five-hour debate in the Reichstag in Berlin a year earlier that was given wide coverage in the press the Catholic Center Party deputies had audaciously charged the Prussian state, from the local level to Berlin, with using excessive and illegal force in its repressive actions against the Catholic villagers. As a notorious example of the mutual hostility between Catholic communities and their Protestant officials, the treatment of Marpingen, especially the children, demonstrated the bitterness that the years of anti-Catholic policies had produced.[54] Which brings us back to the debate over the Liebermann painting in the lower house of the Bavarian parliament. As Dr. Daller's statements made clear, one of the central issues for the Catholic deputies was their insistence that it was the state's responsibility to prevent offensive actions against the faith of the majority of the people in Bavaria. This painting in an official exhibition was thus perceived in the context of almost a decade of official actions against the Catholic community in much of Germany, not just in Prussia. That it had been created by a Prussian who was also a liberal Jew intensified the offense.

Not only had Liebermann scandalized the art world with his "ugly" and "blasphemous" paintings

but he had established his reputation by exhibiting in foreign countries, especially in the great salons of Paris, where in 1881 he was the first German artist since the war of 1870–71 to be granted an award. He was thus an unlikely candidate for promotion by an editor and journal searching for a new national art. Nonetheless, *Die Kunst für Alle* in 1887 published the first major articles on Liebermann, over the next two decades devoted four further lead articles to him, and reproduced most of his major paintings, as well as giving him continuous coverage in exhibition reports and articles on current works of art.[55]

Uhde, who also exhibited and first gained acclaim in Paris, received similar treatment from the journal: a double article in 1886, followed by three more lead articles, extensive reproduction of his paintings, and frequent references in reviews, articles, and editorials. Like Liebermann, Uhde had

Fig. 16 **Adolph Menzel, *Christ as a Youth in the Temple*, 1852. Lithograph, 17 x 22 5/8 in. (43.3 x 57.5 cm). Kunstbibliothek, Staatliche Museen zu Berlin—Preußischer Kulturbesitz. Reproduced in *Die Kunst für Alle* 11, no. 6 (Dec. 1895): n.p.**
The image was initially created as a large transparent painting for a Christmas showing of biblical scenes in Berlin in 1851. According to Anton von Werner, the artist Paul Meyerheim reported that whenever the curtain was lifted on Menzel's transparency, the unidealized appearance of the figures provoked great merriment in the audience. Menzel then turned it into a lithograph, which was one of his most widely distributed single works.

A

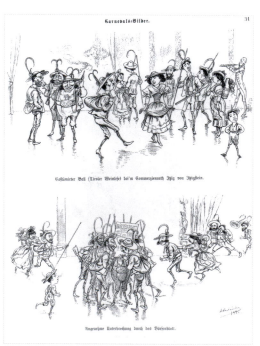

B

Fig. 17 **Cartoons from *Fliegende Blätter*.** *A.* **Jos. Greenebäum, "A Secret," 105, no. 2659 (1896): 24.** *B.* **Adolf Oberländer, "Carnival Picture," 78, no. 1956 (1883): 31.** *C.* **"Self-Confidence," 88, no. 2227 (1888): 126.** In the late 1870s and early 1880s *Fliegende Blätter*, the most widely read humor magazine, published in almost every issue at least one cartoon, drawing, or story featuring a stereotypical depiction of a ghetto or assimilated Jew. The cartoons seen here present a catalogue of typical gestures and physiognomic types that were attributed to Jews and associated with love of money and shady business deals. The middle one (*B*), showing a party of Jews dressed in German peasant costumes who abandon their dancing to get the latest stock market news, makes the claim that even assimilated Jews were only interested in making money.

C

Fig. 18 **Fritz von Uhde (1848–1911), *Drum Practice* (also titled *Bavarian Drummers*), 1883. Oil on wood, 28 3/8 x 37 3/8 in. (72 x 95 cm). Galerie Neue Meister, Staatliche Kunstsammlungen Dresden.**
Critics were offended by the soldiers' being presented in such casual positions and by the absence of any central focus to the composition. They also criticized the rumpled blue uniforms, the washed-out sky, and the messy ground. They complained that the painting simply presented a scene as it occurred, with a total absence of humor and no sense of purpose. Above all, they found the painting "too bright," "almost chalky in its lightness."

received a biting critique from Pecht, who concluded in the *Allgemeine Zeitung* (General newspaper) in 1883 that one of Uhde's first naturalist paintings, a bright spring scene of young Bavarian soldier-drummers practicing in a flowery meadow (fig. 18), was of an "unbelievably tasteless subject, certainly not more palatable through impressionistic treatment." Nonetheless, within three years Pecht published the first major article on Uhde, written by Reber, director of the Alte Pinakothek, who characterized Uhde as one of the most talented contemporary realistic painters.[56] As artists, Liebermann and Uhde were repeatedly linked in the critical literature—not only in *Die Kunst für Alle*. As men, they could scarcely have been more different. Liebermann, the son of a wealthy Jewish entrepreneurial family from Berlin whose house was immediately

adjacent to the Brandenburg Gate, was a reserved, dignified Prussian. Uhde, whose father was the president of the Protestant Consistory in the Kingdom of Saxony, was a rash, headstrong Saxon who had become an artist only after ten years as an officer in the Saxon Horse Guards.

FRITZ VON UHDE: PROLETARIAN PAINTINGS AND PUBLIC DISMAY

What Uhde and Liebermann had in common during these years was their painterly style and their focus on the lives of common people going about their daily tasks in villages and in the countryside. Liebermann, who had been greatly influenced by the French painters Courbet and Millet, and even more so by the Dutch painter Jozef Israëls and the Hague School of light atmospheric painting, spent summers in Holland experimenting with his vision of this open-air painting (fig. 19).[57] Uhde, who had moved to Munich, where Liebermann was based, followed Liebermann's example and spent a summer in Holland in the early 1880s. By the mid-1880s both men were concentrating on the play of light and shadow in everyday scenes of children playing, women laying out washing, and old men and women resting in the gardens of asylums for the aged. While Liebermann avoided religious subjects for years after the critical uproar over *Jesus in the Temple*, Uhde—who for a time owned that reviled work, which he had acquired in exchange for one of his own works—painted a series of biblical scenes from the life of Christ that simultaneously drew favorable responses and aroused considerable opposition. The objections to Uhde's work within both Catholic and Protestant circles led to the same accusations of blasphemy and socialism that Liebermann's painting had engendered, but the tone and terms of the debate demonstrate the shifts occurring within the art world over the decade of the 1880s and the greater differentiation of responses to that art.

The pivotal issue attracting critical attention was Uhde's insistence on presenting the biblical figures—Jesus and his apostles—as German peasants and villagers in the common, rough clothes that could be seen almost anywhere in the German countryside. One of his first major successes, *Suffer Little Children to Come unto Me* (1884), is a modest scene showing Jesus sitting in a sun-drenched schoolroom surrounded by village children in homespun clothes (plate 2). A Berlin critic, Hans Rosenhagen (1858–1935), later recalled the early reception of Uhde's work. *Drum Practice* (1883)—which, he wrote in 1908, was indisputably one of the exemplary works of the new art—was initially received as "an unattractive, austere copy of the most dreary reality." *Suffer Little Children*, however, which was completely unconventional, was amazingly successful, winning a gold medal in both the Paris Salon and the Berlin Academy Exhibition of 1884. No one looking at this work, Rosenhagen recollected, thought of the French origins of this light-filled style, because the light that flowed through the window illuminated German people and a German savior.[58]

This was a concise formulation of an often repeated assessment of Uhde's religious painting: that his work had such genuine inner depth that it made the new art of the 1880s, with its concentration upon natural light, acceptable to Germans. Reber emphasized this point in his lengthy articles on Uhde in *Die Kunst für Alle* in 1886. Claiming that no one could ignore this significant work, he analyzed the painting closely, finding some problems, but concluded that Uhde's effective integration of sunlight into the scene reconciled many in the Munich art world to the new use of lighter, chalkier colors. The crucial figure in the painting, for Reber and others, was the small blond child in the center, extending her hands to the seated figure of Jesus. Charmingly naive, she expressed in all her sweet radiance the inner depth that German critics so highly prized. "In the innocence and charm of the blond-haired head with light flowing around it," Reber in-

Fig. 19 **Max Liebermann, *The Net-Menders*, 1887–89. Oil on canvas, 70 x 89 in. (180.5 x 226 cm). Hamburger Kunsthalle.**

In this windswept landscape the details, depicted in muted shades of green and brown, are erased by the wind and the light emanating from the bright, billowing clouds. Women mending fishing nets dot the landscape behind the central image of the young Dutch woman. Liebermann's biographer wrote in 1914 that the artist wanted to give the viewer the impression of the wind sweeping the light-filled landscape, hence his use of broad, rough spatula strokes and his deliberate refusal to dwell on specific details that would catch the eye and reduce the overall effect.

Shown in February 1889 at an exhibition of Light-Color Painters at the Fritz Gurlitt Art Salon in Berlin, the painting was hung in the Paris Universal Exposition that summer, where Wilhelm Bode saw it and recommended it to Alfred Lichtwark, director of the Hamburger Kunsthalle. *Die Kunst für Alle* reported in July 1889 that the Kunsthalle had purchased it for a mere one thousand marks. The following year, it was shown in the Second Annual Munich Exhibition. When the painting, shown along with *Woman with Goats* (fig. 24B), failed to receive the great gold medal at the Berlin Academy Exhibition of 1892, Liebermann refused to submit any more works to the Berlin exhibitions until he was granted a special exhibit in 1897.

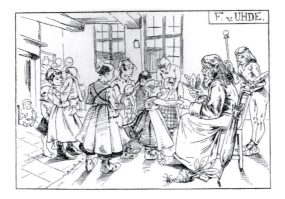

Fig. 20 **"Diefenbach Opens His Children's Home in Höllriegelskreuth," caricature of Fritz von Uhde's *Suffer Little Children to Come unto Me*, in K. Cassius, *Mockingbird in the Glass Palace* (1889), 26.**
In 1888 and 1889 Cassius published small booklets of caricatures that parodied the catalogues for the Munich annual exhibitions. The caricatures imitated the catalogue format and featured the most notorious works in each exhibition. This cartoon substitutes Karl Diefenbach, a well-known guru of the vegetarian counterculture reform movement, for Christ in Uhde's painting.

sisted, "as well as in the magic of the bare little arms and in the clothing of the child stands a masterpiece of realistic art."[59]

The strong parallels between this child and Liebermann's twelve-year-old Jesus and their receptions are difficult to ignore. That the critical conclusions, based on the same features of the children—the hair, the gesture of the arms, the serious attention of an adult to a child—were so radically different demonstrates again the ideological assumptions that determined how people viewed these works. Two decades later, in a lengthy review of a recent major Uhde retrospective in Munich, Fritz von Ostini (1861–1927), an influential critic and art editor, encapsulated the anti-Semitism in a brief sentence: "A skeptical smile, like the one hiding behind Liebermann's masterly painted *Christ in the Temple* [sic], can not be found anywhere in Uhde's humanization of the Christ legends."[60]

Even Rosenberg, who generally was not receptive to new developments in art, praised Uhde's

painting for the way in which every figure in the light-filled painting, from the engaging Jesus to the "tousled and messy" children and their ill-dressed parents, was portrayed with "depth and inwardness," qualities that conservative critics believed characterized genuine German painting. Rosenberg pointed out that Uhde's ability to instill spiritual qualities into his Christ figure even as he depicted him in a completely modern setting was a significant factor in Uhde's success. Astoundingly enough, he reported shortly after the Berlin exhibition closed in 1884, more than ten thousand photographs of *Suffer Little Children* had already been sold. Two years later Rosenberg defended Uhde's transporting Jesus and his disciples into the contemporary world as solidly based on fundamental beliefs of liberal Protestant theology. By the end of the decade the assimilation of this painting into German popular culture was effectively captured in a cartoon that appeared in an imaginative catalogue created by K. Cassius that parodied the First Annual Munich Exhibition of 1889 (fig. 20).[61]

The positive assessments of Uhde's contemporary German setting for the biblical scenes were not shared by everyone. The major negative attacks focused on Uhde's portrayal of Jesus and the disciples as ordinary workers, in almost life-size format, gathered around a plain table in *The Last Supper* (1886), shown in the Berlin Academy Exhibition of 1887 (fig. 21), or as farmhands working in the fields who stand and kneel around a modest itinerant preacher in *The Sermon on the Mount* (1887), exhibited in the Third Munich International in 1888. Catholics and Protestants alike protested that these scenes not only transformed the savior into a man among men but surrounded him with crude proletarian types. These were figures who could have stepped out of Ernst Renan's *Life of Christ* (1863), in which the historical Jesus, supporter of the poor, struggled against the worldly powers. This, for many critics, was the "Christ of the fourth estate," whose compassion for the poor and children made him

dangerous. "Anarchist muck" was reputed to be William II's epithet for Uhde's figures. Some critics could see the disciples of the *Last Supper* only as common criminals, convicts, servants, hard laborers, or murderers.[62] Others were disturbed by the barren room, the crude wooden chairs, and the meager table, as well as the unconventional eucharistic scene in which the sad Christ figure is viewed from behind. A liberal Protestant journal published an art review that described the laborers in Uhde's *Sermon on the Mount* as spiritually and intellectually underdeveloped, physically shapeless, degenerate examples of the human race. Another Protestant denounced the Jesus in that painting, sitting by the road talking to farmhands, as "this puny, miserable, repulsive figure of a man." A Catholic art journal condemned the revolting ugliness of Uhde's paintings and the depiction of criminals in his *Last Supper*.[63] The negative responses to these paintings by Uhde were sufficiently widespread to also merit ridicule in poems in Cassius's satirical catalogue about the Third Munich International of 1888.

The intensity and absurdity of some of these denunciations of what became known as "poor-people painting" or "paintings of wretchedness," such as those of Liebermann in 1879, must be understood within the deepening ideological and social conflicts that divided the nation. The mud slung at Uhde should be read against the rifts that disrupted the sense of national identity and divided

Fig. 21 **Fritz von Uhde, *The Last Supper*, 1886. Oil on canvas, 6 ft. 9 1/8 in. x 10 ft. 8 in. (2.1 x 3.3 m). Staatsgalerie Stuttgart. Formerly in the Eduard Arnhold Collection, Berlin.**

Shown in the Berlin Jubilee Exhibition of 1886, the painting was considered a masterpiece in the Paris Salon of 1887 and appeared in 1888 in Fritz Gurlitt's Light-Color Painters exhibition. Accusations by conservatives that Uhde had painted the disciples as if they were common criminals were skeptically dismissed by K. Cassius in his satirical catalog published after the painting was shown in the Munich International in 1888. His poem asserted simply "They were simple fishermen, / The disciples,—it is written—. / But I can find no sign / That they were once jailbirds."

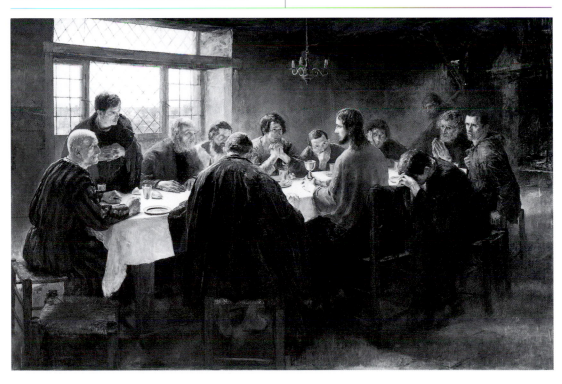

Christian from socialist, Catholic from Protestant, social liberal from conservative Protestant, not to mention the division between upper and middle classes on the one hand and socialists and workers on the other, or the ongoing friction between the party socialists and workers' organizations. These rifts, though running deeply across the nation, were also complicated by contradictory alliances that arose to meet changing social and political reality. One such alliance, born out of anxiety and fear over the rising lower classes, led to Protestants' and Catholic parties' cooperating with the government in 1878 to pass the antisocialist legislation that remained in force until 1890.

For both groups, socialism embodied the political and social menace of the increasingly organized and restless working classes and also the threat of materialism and atheism undermining the power of the churches and the faith of their communities. Not surprisingly, visual signs of socialism infiltrating Christian icons of faith were received by some with a marked level of hysteria. These reactions were complicated by the fact that in the intensified confessional conflict over national culture that the anti-Catholic laws had generated, the Protestant Churches, Lutheran and Reformed alike, turned to art as a means of propagating the faith and combating the influence of both the Catholic Church and the Social Democratic Party. Between 1870 and 1900 whole series of journals, exhibitions, congresses, and organizations were created to promote a popular national, Protestant German art. This was part of the larger national effort that led in 1886 to the formation of the Protestant League for the Defense of German Protestant Interests, whose stated purpose was to raise Protestant consciousness and to fight against the growing power of papal-led Catholics in the empire. The resulting art was dominated by the liberal or cultural Protestant position that combined realistic settings of contemporary life with ethical interpretations of Christian life. What this meant practically was a focus upon themes drawn from the life of Christ that emphasized Jesus as the preacher and teacher of the faithful. In art, Jesus the Good Shepherd became the Protestant answer to Mary, the Mother of God.[64]

The extent to which this cultural Protestant effort had the blessing of the state was manifested in a traveling exhibition organized and commissioned by Thomas Bierck, the art dealer for the court. Opened in the Reichstag building in Berlin during the summer of 1896, *The Image of Christ in German Art* featured paintings by nine well-known contemporary artists, including Uhde, Franz Skarbina (1849–1910), Franz Stuck, Hans Thoma, Gabriel Max, and Arthur Kampf (1864–1950).[65] The investment of the business community in this Protestant art a decade earlier had taken an even more ambitious shape, namely, a panorama of the Crucifixion of Christ. Extolled for its historical and topographical accuracy, it exemplified both the rationalism and historicism of contemporary Protestant theology and the growing interest in Germany for ethnographic studies and archaeological excavations in the Middle East.

Commissioned and financed by businessmen from Munich and Dresden, the panorama was created by Bruno Piglhein (1848–1894), a respected Munich artist whose coloristic bravura painting of Christ on the cross, *Moritur in Deo*, executed in a strongly Catholic baroque style, had attracted attention in the 1879 exhibition. Piglhein marshaled scholarly and scientific research from archaeologists, Oriental classicists, geographers, and biblical scholars before traveling to Palestine with a team that included a photographer, an architect, and artists, who worked for several months photographing sites and drawing up preliminary sketches for the creation of a scene based on authoritative contemporary scholarship.[66] Returning to Munich, Piglhein spent nine months designing and painting the seventeen-hundred-square-meter canvas, which he reached from a scaffold mounted on a railing that circled inside the colossal work. When the

panorama opened in Munich in June 1886, viewers were transported to noonday on 7 April A.D. 34 in a desert landscape in which the crucifixion on the barren hill of Golgotha was only one small incident set in a busy countryside against the distant city walls of Jerusalem with its temple and palaces. Instead of making a religious painting, a contemporary art historian wrote, Piglhein had expanded the image into "a comprehensive cultural-historical total picture, one that was more appropriate for our age." A mark of its suitability for the age was its profitability. Shown from 1886 to 1891 in Munich and then in Berlin and Vienna, this panorama spawned fourteen more Crucifixion panoramas in Europe, England, and America over the next two decades and occasioned major lawsuits over conflicting rights to Piglhein's design.[67]

As commercial sources joined both the Catholic and Protestant Churches, an efflorescence in Christian art with a new Protestant iconography gained serious attention in Germany in the last two decades of the century. Uhde became the leading star, albeit a controversial one, in the new Protestant art that encompassed the work of many others, including his forerunners Wilhelm Steinhausen (1846–1924) and Eduard von Gebhardt (1838–1925).[68] By 1893 the editor of the Protestant *Christliche Kunstblatt* (Christian art journal) could positively claim that "Uhde's art is consciously Protestant. Uhde wants to be as Protestant as Rembrandt." Only four years earlier the same journal had condemned his work as "an aberration," and an ugly one at that. Uhde's continuing problem was that unlike his colleagues, he went too far in identifying Jesus and the disciples with the workers. His work in the 1880s was perceived as promoting Christian socialism, if not Marxist socialism. His realism in social terms was too thorough, and, a second offense, his painting techniques created unaccustomedly light and diffuse images that also carried negative foreign overtones for many observers.

Uhde crossed the boundaries of almost total secularization of the biblical narratives when he exhibited his painting *On the Road to Bethlehem* at the Neumann art gallery in Munich in February 1890 (fig. 22). The painting presented a weary worker, a carpenter, supporting an exhausted woman on a foggy roadway, both unquestionably contemporary German working-class figures, perhaps homeless, trudging to a village in the moors

Fig. 22 **Fritz von Uhde, *On the Road to Bethlehem* (later titled *Difficult Walk*), 1890. Oil on canvas, 46 1/8 x 49 5/8 in. (117 x 126 cm). Bayerische Staatsgemäldesammlungen, Neue Pinakothek Munich.**
Uhde created several versions of this painting, with slightly different titles. This one was shown first in an art gallery in Munich in February 1890 and then in the Second Annual Munich Exhibition that summer. It was purchased by the prince regent for the Neue Pinakothek. Another version, titled *The Road to Bethlehem*, 34 5/8 x 42 7/8 in. (88 x 109 cm), was in the Rudolf Mosse Collection in Berlin and was auctioned as part of that collection by Rudolph Lepke's Auction House in May 1934.

north of Munich. In light of the carpenters' strike in Munich the previous summer, when almost a third of the city's carpenters had been out of work, critics identified the figures as an unemployed worker with his pregnant wife seeking shelter in one of the moor colonies outside of Dachau. Outrage in Munich at the suggestion that these dreary workers could be Mary and Joseph led Uhde to change the title briefly to the inoffensive *Way Home*, and finally to *Difficult Walk*. Under the new titles the work was popular and particularly well received by critics for remarkably capturing the mood and atmosphere of the wintry day.[69]

With this work, Uhde finally established himself in the art world as a significant leader in the movement toward a new art that represented life in contemporary Germany. However, conservative voices among Protestants as well as Catholics continued to be unhappy with the proletarian images in his work well into the 1890s. In a passionate outburst during the debates over the art budget in the Bavarian parliament in March 1890, one of the Catholic Center deputies, Dr. Eugen Jäger, railed against the spirit of materialism and sensuality that infected all of the art exhibitions, serving to promote nudity, prostitution, and socialism. This he connected to the disrespectful depiction of Christ as a mere human being in art. These patterns of association were common in the negative response to the contemporary new art. Materialism, secularization, and socialism were the issues here. Ideologically linked, they formed a complex in which art was both a result and an instigator, a manifestation and a creator of sensuality and secularity. According to Dr. Jäger, Uhde's art demonstrated this in its mockery of the revered disciples and Jesus as common rogues and criminals. A liberal deputy immediately answered his charges on the floor, defending Uhde's depiction of Christ among workers as an expression of strong and profound religious conviction.[70] This interchange expressed again Catholic indignation against what were perceived to be liberal Protestant efforts to hu-

manize and secularize the Christian faith intersecting with conservative middle-class discomfort about naturalist depictions of the dirty lower classes, as opposed to sentimental idealization.

CRITICAL RESPONSES: FROM SOCIALIST BLASPHEMY TO APOSTLE OF NEW ART

These reactions to Uhde's and Liebermann's paintings utilized language evocative of multiple understandings that in itself demonstrated and exacerbated the diverse rifts that cut across the reception of art. The words conjured up associations that obscured more than they illuminated perceptions of the paintings. Describing characteristics ranging from personal (*smelly, dirty, nasty*), social (*vulgar, common, criminal*), and political (*anarchist, socialist*), to theological (*blasphemy*), these pithy words of negation conveyed greater authority and emotional impact than more measured positive assessments. Carried into the realm of aesthetics, these unfavorable connotations coalesced into accusations that an "aesthetic of ugliness" was the hallmark of this naturalist art in which Liebermann and Uhde tried to present their vision of the contemporary world. We, however, should not be seduced by these negative words, nor by the associations that later German history holds for us, into overestimating their role in contemporary criticism. Beginning in the mid-1880s, strong voices were using terms such as *depth, inwardness*, and *high-quality* to convey the greatest approbation of Liebermann's and Uhde's naturalist paintings. At the same time, critics who examined these paintings as exemplars of what they termed new "modern" art forms for Germany tended to write thoughtful, carefully differentiated critiques of the works that did not lend themselves to brisk catchphrases comparable to the negative epithets that clung to the works.[71]

Pecht, in his writing for daily newspapers in 1879, had contributed contemptible and quotable anti-

Semitic phrases to vilify Liebermann's paintings, and in 1883 he did not treat Uhde's work with kindness. By 1885, as he established his own cultural journal to promote an art that would be appropriate for a modern new nation, Pecht had to come to terms with these artists, who were actively engaged in depicting their vision of the modern world. The years 1885–95, *Die Kunst für Alle*'s first decade, were immensely productive for both Liebermann and Uhde. Producing and exhibiting major paintings annually in the great exhibitions in Munich, Berlin, and Paris, as well as showing in private galleries and regional exhibitions, Liebermann and Uhde became almost omnipresent. Pecht recognized this even as he resisted the style in which they presented that vision because the issue of style became entwined in the divisive anxieties over the overt content of these paintings. Open-air, or plein air, painting, as opposed to studio paintings, quite simply was considered to be a direct French import. Many critics, including Pecht, believed that following French artistic practice encouraged an imitative, not a genuine national, style. French art, Pecht insisted, was an expression of the French national character, which he perceived to be marked by dubious femininity and a certain aristocratic decadence. He went so far as to identify French art as courtesan painting, which could only have a deleterious effect upon the nascent German art.[72]

Word of the latest scandalous artistic style coming out of Paris, impressionism, spread slowly into the German art world in the 1880s. In 1883 a gallery in Berlin showed a private collection of paintings by Édouard Manet (1832–1883) and by major French Impressionists. The following year, the prominent *Zeitschrift für bildende Kunst*, despite its art historical focus on the art of earlier centuries, offered a substantive article tracing the artistic career and success of Manet. Based on the catalogue for a memorial retrospective in Paris and a book published shortly after Manet's recent death, the article quoted passages from both of these French sources

claiming that Manet's work, laughed at and castigated by many, had profoundly influenced French art over the last twenty years. The German author of the article, Fritz Bley, however, ridiculed Manet as a sensation-seeking, fame-hungry artist, while scornfully recognizing his role as "the founder of modern 'impressionism'" and acknowledging his undoubted impact in Paris, that "great marketplace of vanity."[73]

Quoting at length from Manet's promoters, Bley described impressionism's mode of operation in terms that determined subsequent discussions of the new open-air art in the German journals. This painting, Bley wrote, must take place outdoors, where the natural scene, whether ugly or beautiful, was copied directly with brutal honesty. The new technique was to "render what they see, how they see, directly, good or bad, without deleting anything, without amplifying." Rejecting the time-honored artistic principle of seeking ideal beauty by eliminating trivial mundane factors, these French admirers of Manet, according to Bley, praised the new school of artists for systematically painting ugliness because of their opposition to the boring surfeit of beautiful images. Bley's response was to sarcastically dismiss this "sensational folly" as acceptable to the fashion-ridden French but without promise elsewhere. Dismayed by the rejection of all past conventions of artistic creativity, Bley securely associated the "art-revolutionary" Manet and French Impressionism with Courbet, the Communard, and with Émile Zola and Charles Baudelaire, whose writings, he said, sought to promote radical fanaticism among the artist proletariat against everything that was noble and harmonious. This, then, was the first serious study published in a major German art journal to examine the revolutionary French Impressionist art and to dismiss that art as at best irrelevant, at worst damaging, for German art.[74]

Adding to this negative and confused view for journal readers was a report by Otto Brandes (born

1844), the Paris correspondent for *Die Kunst für Alle*, on Impressionist paintings in the exhibition of independent artists in Paris in 1886, which he ridiculed as "painterly nonsense." He suggested that the practitioners of this French open-air painting, the Impressionists, were associated with the Paris Communards, who in the public mind were perceived as anarchist incendiaries. Brandes echoed Bley's rejection of the French art, although his understanding of the art was more sophisticated. Reporting in April 1887, again from Paris, Brandes described the French Impressionist paintings as creating a shimmering appearance with a bluish tone. He explained that this effort to re-create external light, not studio light, meant a dissolution of the usual ways of seeing natural reality into a purely optical approach that more nearly provided a true vision of nature. Brandes then discussed the work of Georges Seurat, Paul Signac, Camille Pissarro, and Henri-Edmond Cross, who made use of polychrome dabs and dots instead of mixing colors on a palette. Although he found the results "rather lifeless," he suggested that the theory had the possibility of producing fine work. At the moment, however, he expected this impressionistic manner of pointillism to be a passing fad. Several months later, in August 1887, Pecht picked up Brandes's analysis in an article attacking the "tasteless, barren, and ugly" art of French Impressionism. Pecht believed that these artists were preoccupied with technical exercises that denied imagination, color, and beauty: "Yes, poverty, austerity, and lack of imagination constitute its very nature, because it confuses nature with art, ugliness with beauty, and denies the particularity of technical methods, instead of taking full advantage of them."[75]

In German exhibitions, actual appearances of those French paintings that we associate with the canon of classical French Impressionism (written throughout this text with initial capital letters) were rare before the mid-nineties. As a result, German writers tended to use the term *impressionism* to refer to the work of any French artist who broke away

from traditional academic genres and styles in the latter half of the century. These works shown in German exhibitions ranged from those by Millet to those by Camille Corot and Charles Daubigny or naturalist paintings like those by Jules Bastien-Lepage and Léon Lhermitte.[76] The classical French Impressionist artists—Claude Monet, Edgar Degas, Pierre-Auguste Renoir, as well as Manet—were virtually never mentioned in the journals nor, with rare exceptions, shown in exhibitions for a decade after the 1883 gallery show of French Impressionists in Berlin. Nevertheless, the term *impressionism* (not capitalized) to denote an attitude and technique that broke with past artistic conventions was often applied to contemporary German artists.

This French import, inadequately understood, contaminated the new German art in the eyes of many. Critics were annoyed by the experimental efforts in Germany to capture daylight colors in light and shade, the dissolving of forms seen from a distance, and the lack of interest in careful sketching and clear details. Even supporters regularly described these paintings as dirty, dusty, muddy, chalky, or gray and lamented the lack of pure colors (fig. 23). Here again we encounter language about style meshing with ideological preconceptions. Significantly, as German artists continued to work with these lighter palettes and techniques, the French term *plein air* was naturalized in journal reviews into a variety of German terms meaning "light-color painting," "open-air painting," or "outdoor painting." And in another form of claiming this style as authentically German, critics began to assert that outdoor painting had been a German practice since the early nineteenth century.[77]

In *Die Kunst für Alle* Pecht struggled against these pressures and strains threatening his call for a straightforward, healthy art for the new nation. He alternated, often within a single paragraph, between praising Uhde and Liebermann as the most significant new German artists and chastising them for copying the gray, colorless, poverty-stricken art

of the French, as he understood plein air painting to be. In one of the first issues Pecht singled out the work of Uhde, praising him for assimilating French plein air painting and transforming it into outdoor painting, a profoundly German art. He reinforced this judgment by publishing Reber's two lead articles on Uhde in succeeding issues and including plates of Uhde's paintings *The Barrel-Organ Man Comes* (1883), *The Older Sister* (1885), *Come Lord Jesus* (1885), and *The Sermon on the Mount* (1887), along with double-page spreads of *Suffer Little Children to Come unto Me* (plate 2) and *Holy Night* (1888). In his 1888 review of Uhde's paintings in the Third Munich International, Pecht praised his wonderful "celebration of the modern proletariat" and the genuinely German figures in *Holy Night* and pointed to his achievement in *The Last Supper* (fig. 21) of appropriating the legitimate core of plein air painting without becoming a slave to it. In 1889 Pecht recalled the way in which Uhde's *Suffer Little Children* had announced a new day in German art, albeit a stormy day. Seeing the

work again confirmed his judgment, even though it was difficult to find much that was attractive in the dirt and rags of Uhde's city proletariat. However, he continued, "the deep and beautiful emotions which he expresses there in his children and old people are able to make up even for the lack of nobility in the forms." On the other hand, as late as 1890–91 Pecht published articles that bluntly dismissed both artists as mere imitators of French masters.[78] His ambivalence and his willingness to include in the journal opinions with which he disagreed meant that at the same time that he was dismissing these artists, the journal was regularly printing articles that strongly endorsed the art of Uhde and Liebermann as the valid modern art of a new modernizing Germany.

This argument was made eloquently by the art historian Emil Heilbut (1861–1921), writing under the pseudonym Herman Helferich, in his pioneering articles on Liebermann in *Die Kunst für Alle*, which were accompanied in 1887 by a full-page plate of *Free Time in the Amsterdam Orphanage* (1882)

Fig. 23 **Adolf Oberländer, "From the Heyday of Open-Air Painting (A Contemporary Picture)," *Fliegende Blätter* 90, no. 2284 (1889): 164.**

Oberländer connects the light palette of the open-air style with the leisured middle class and the earlier dark naturalist style with the paintings of the proletariat. In "Song of an Impressionist," in his satirical Glass Palace catalogue of 1889, K. Cassius had the artist dropping his paintbrush and dumping thick layers of white paint and buckets of black asphalt directly onto the canvas. With his typical negative reaction, Adolf Rosenberg complained about Liebermann and Uhde, "these devotees of light," whose paintings were covered with flour dust. He was not surprised that Liebermann, who had always been the most outrageous artist, had rapidly plunged from the black extreme into the white one.

and five illustrations from his sketchbooks. Providing a comprehensive summary of Liebermann's work, Heilbut praised him for his leadership in the new art, which sought to capture the essence of nature, not the appearance. "And that is the starting point of the new art, which is the art that only knows nature through impressions." The ambition of the new art, he wrote, was that it sought to have an elemental effect. "And that is its passion: to capture the object with such vehemence that its portrayal will have an impact upon the viewer. The new art calls that sincerity." In Liebermann's work, he argued, could be found "the hope of contemporary art and its viability for the future." Heilbut eloquently recounted Liebermann's artistic ability to capture light and air, sunlight and green—the full freshness of nature. Emphasizing Liebermann's personal probity, his absolute adherence to visual truth, Heilbut compared him to Zola's anarchists and nihilists, for like them, "Liebermann—the artistic Liebermann—has something intransigent, is the most audacious of German naturalists, unrestrained, uncontrolled, never smooth and contained." All the other artists, Heilbut wrote, had gradually lost their fire, but not Liebermann. "He will not become tame."[79]

Intransigent was the term that had been applied in France to the Impressionists, particularly in the reviews of their 1876 exhibition, to mark their work as politically subversive. By applying the term to Liebermann's painting, which actually was not influenced by the French Impressionists at this time, Heilbut raised the specter of socialist radicalism in Liebermann's work and then assimilated this into a positive quality that substantiated Liebermann's artistic prominence and leadership. Both of his essays ended with the same strong defense of Liebermann as the new modern artist who was the brave forerunner of the new art in Germany.[80]

We cannot, however, leave Heilbut on this positive note. His article, which has been cited frequently for its early support of Liebermann, candidly acknowledged Liebermann's weakness, namely, that he had "a passion for filth." He thus saw Liebermann as "a character of our time," one who, like Uhde, presented in his paintings "a fresh, cheerful—tremendous ugliness," which he endowed with sacerdotal earnestness, without apology or even a little humor. "He is stimulating, of the most modern character." Then came troubling words. Liebermann, observed Heilbut, had no spontaneous feel for nature, but gained his appreciation of nature through his study of Russian novels and French artists. "I find little natural, little of the country in him, little German . . . I find foreign influences, Jewish, Slavic, French traces. As a Jew, he must be more susceptible to stimulation from abroad."[81]

Here, in the midst of this article promoting Liebermann's work as the new modern art and the hope for the future of German art, we have stumbled into the reprehensible side of the search for a national art. These phrases force us to confront not only the poignancy but also the perils of this dream of an art for the new German nation. Ironically, the author later became the influential editor (1902–6) of the journal *Kunst und Künstler* (Art and artists), which strongly promoted both Liebermann and French painting. Our dismay over this passage would not have been shared by readers of that time, readers whose sensibility was not saturated by the reality of later events. Moreover, within five years after it was written, critics agreed, whether with joy or sorrow, that the new open-air styles of painting were driving out the older academic styles and that contemporary and landscapes scenes had triumphed over mythological, historical, and sentimental subjects. Even a cursory glance at the plates in *Die Kunst für Alle* confirms this. Liebermann and Uhde were only the most famous—or infamous, depending again upon one's viewpoint—among the artists who had led the way to the triumph of this new art.

The other major art journals, the scholarly *Zeitschrift für bildende Kunst* and its associated report on current events in the art world, *Kunstchronik*, had slowly followed a trajectory similar to that of *Die*

Kunst für Alle, moving from enraged rejection of Liebermann's art in 1880—"shameless libel," "unbridled realism, which wallows in gray-brown shades"—through slow stages of acceptance that included reproductions of some of his major works beginning in 1881.[82] In the early 1880s Rosenberg disparagingly linked Liebermann and Uhde together as enthusiastic followers of new French developments. Liebermann and Uhde were, as Pecht had made clear in *Die Kunst für Alle*, the most prominent artists to bear the implications of this subversive identity. Rosenberg, who was far more conservative than Pecht, writing in the *Zeitschrift für bildende Kunst*, a journal that focused on the great masterpieces of past centuries, was adamant in his rejection of Liebermann's painting. Uhde's work was initially far more acceptable to him than Liebermann's.

The journal published an Uhde etching in 1885, followed by a substantive article in 1887 analyzing Uhde's work by a professor of art history, Hermann Lücke (1837–1907). Referring to his paintings as undoubtedly the most original and interesting in contemporary art, Lücke characterized Uhde's work as the expression of a unique artistic vision that aroused great interest and intense opposition. The key to Uhde's work, in Lücke's view, was his absorption of French Impressionist influences, which gave his work a new freshness and naturalness. Impressionism, Lücke believed, had generated much superficial art that did not go beyond demonstrating a reflection of optical phenomena in what he considered to be "meaningless, trivial, and soulless products." He believed that Uhde had avoided this pitfall by remaining grounded in the painterly tradition drawn from Rembrandt. Approving Uhde's choice of contemporary settings for his paintings, Lücke emphasized the truthful portrayals of ordinary people in his religious portraits, again referring to the work of Rembrandt. Several months later, in his review of the 1887 Berlin Academy Exhibition, Rosenberg thoughtfully assessed the strengths of Uhde's paint-

ings *Last Supper* (fig. 21) and *Sermon on the Mount* and concluded that there could be no doubt about the importance and productiveness of the new art movement that Uhde led. Still, Rosenberg did not hesitate to reproach Uhde for the poverty and ugliness that his search for visual truth produced: "Is the program of absolute truth, of unshakeable honesty, and the ruthless struggle against beautification to be carried out only by representing the ugliest types of the human race?"[83]

Given his view of Uhde's "ruthless struggle" for visual veracity, it comes as no surprise that Rosenberg's appraisals of Liebermann in the reviews in both *Kunstchronik* and the *Zeitschrift* remained critical until the early 1890s. For example, discussing an exhibit of new paintings at the Fritz Gurlitt Art Salon in 1885, Rosenberg criticized Liebermann's painting of women baking bread for being "the *non plus ultra* of vulgar perception, the absolute negation of everything that can make an artistic creation in any way attractive or successful." More perceptive analysis came from Muther, who, reporting on the Third Munich International of 1888, identified Liebermann, and Uhde with him, as "the apostle of the new movement in Germany, a pathbreaker with whom later art history will have to reckon."[84] It was only in 1893, after Liebermann had received small gold medals from the Berlin Academy Exhibitions in 1888 and 1891 and from the Third Munich International and the large gold medal for *Old Woman with Goats* (fig. 24B) in Munich in 1891, that the *Zeitschrift* featured a lengthy article on the artist spread over two issues. Regretting that for many people Liebermann remained "a one-sided painter of the rotten proletariat," Ludwig Kaemmerer, later director of the Emperor Friedrich Museum in Posen, presented a careful examination of Liebermann's work over two decades in which he stressed the artist's continued exploration of new visual problems. Praising the steadfastness, consistency, and honesty of his creations, Kaemmerer pointed out that the battle over new views on art would always

be decided by the ability of creative fighters to convince their contemporaries of their particular ways and to teach them to see. He believed that Liebermann had emerged from this struggle with honor. Whether one perceived the impressionist movement to be an episode or an epoch in the development of modern painting, "the position of Liebermann in this movement remains without question one of the pathbreakers and leaders of German art." Fourteen years after the tumult over *Jesus in the Temple* (plate 1) Kaemmerer could judiciously speak of that painting as "an achievement in painting of such extraordinary power and of such psychological drama" that it reconciled one to "the caricatured figure of the precocious Jewish boy."[85]

Muther's articles on the Third Munich International of 1888 were one of the first series of articles in the *Zeitschrift für bildende Kunst* to proclaim the ascendancy of the new art in Germany. Declaring that the Munich exhibition was significant for providing a view of the transformation that had taken place in German art within the larger context of changes across all of European art, Muther defined the salient features of the new art to be an intimate view of nature, a concentration on contemporary life, greater technical skills, and a lighter palette—though he hoped the "gray style" would be a passing aspect of this development. He did not hesitate

Fig. 24 **Max Liebermann.** A. *Pig Market in Haarlem*, **1891. Oil on canvas, 43 5/8 x 59 3/8 in. (111 x 151 cm). Städtische Kunsthalle Mannheim.** B. *Old Woman with Goats*, **1890. Oil on canvas, 50 x 67 5/8 in. (127 x 172 cm). Bayerische Staatsgemäldesammlungen, Neue Pinakothek Munich. Reproduced in *Die Kunst für Alle* 6, no. 23 (Sept. 1891): 357.**

When these paintings were shown at the Third Annual Munich Exhibition in 1891, A. G. Meyer, reviewing them in *Kunstchronik*, wrote admiringly: "The *Pig Market in Haarlem* [A] is a splendid work. . . . A similar profusion of air, light, and life is captured in only a few paintings in the exhibition; and this picture of existence that is so lacking in attraction will become a significant piece of cultural history." *Die Kunst für Alle* had reported before the painting was completed that Liebermann in this simple scene was working on another aspect of the problem of capturing light, which he was the first modern German artist to strive to achieve through realistic painting methods.

Characterizing Liebermann as one of the "most modern," artists, Meyer considered *Woman with Goats* (B) to be "an exemplary rendering of linear and light perspective." After receiving the great gold medal in Munich in 1891, the painting was purchased by the Neue Pinakothek from the artist for two thousand marks.

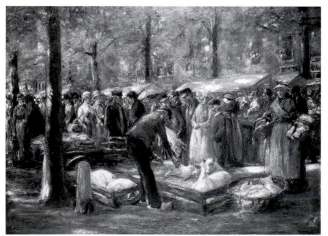

A

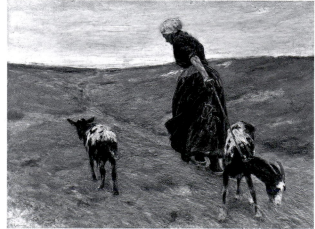

B

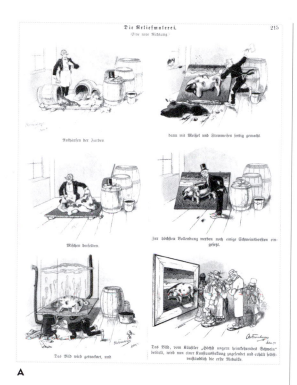

Die Reliefmalerei.
Eine neue Richtung.

Aufhäufen der Farben.

dann mit Meißel und Stemmeisen fertig gemacht.

Mischen derselben.

Zur höchsten Vollendung werden noch einige Schweinsborsten eingesetzt.

Das Bild wird getrocknet, und

Das Bild, vom Künstler „Höchst ungern heimkehrendes Schwein" betitelt, wird nun einer Kunstausstellung zugesendet und erhält selbstverständlich die erste Medaille.

A

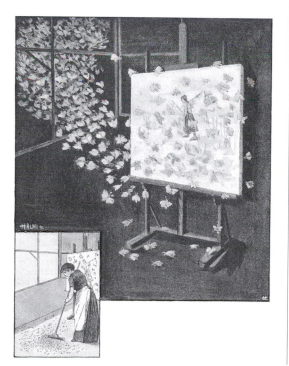

B

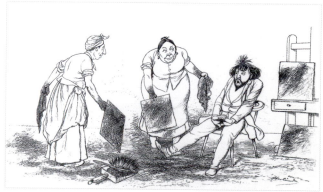

C

Fig. 25 **Cartoons from *Fliegende Blätter*.** *A.* "Relief Painting (A New Movement)," 94, no. 2421 (1891): 215. *B.* **Halmi, "Sensational (Protection against Forest Devastation)," 95, no. 2411 (1891): 136.** *C.* **Adolf Oberländer, "The Pastel Painter: A Real-Life Story," 96, no. 2425 (1892): 25 –26.**

After the Third Annual Munich Exhibition in 1891, *Fliegende Blätter* published satirical commentary in verse, stories, and cartoons about the strange new art with its pronounced impasto and light palette. "Relief Painting" (*A*) tells the story of an artist modeling, baking, chiseling, and coloring thick paint into a sculptured relief painting, "A Pig Reluctantly Returning Home," which was awarded the highest medal in an art exhibition. The cartoon is a parody of Liebermann's creation of *Pig Market in Haarlem* (fig. 24A), whose thick impasto, laid on with a palette knife, was the object of considerable derision by the public when it was shown in 1891 in Munich. By referring to this cartoon in the Bavarian parliamentary debate over art in 1892, Hermann Beckh made it clear that he was speaking of Liebermann without having to name the artist.

The cartoon "Sensational" (*B*) depicts a pastel painting so filled with light that it attracts a plague of moths from the fields; they stick to the painting, transforming it and also freeing the countryside from the plague. Several weeks later Oberländer picked up this frequently repeated theme of the accidental creation of the new art. In his tale (*C*) a despairing artist whose traditional paintings were thoroughly smeared by cleaning ladies is convinced by his friends to submit "these delightful, sprightly color poems . . . as hazy as the French, but much more original," to an exhibition. They are acclaimed as true "color symphonies," the height of modern artistic technique, win applause from the critics, receive the gold medal, and are purchased by a museum.

to credit French painting with leading the way, saying that the French, "our political enemies, have more than once been our teachers in art—a fact that only false national pride could deny." He was, however, convinced that the result of this French influence across Europe would not be an internationalization of art, but a deepening and enriching of national art forms. German art, he asserted, had always been characterized by a wealth of ideas and emotional depth that it would be unfortunate to suppress in the drive toward the new principles.[86]

This view of the necessary transformation of German art under French influence expressed in the journals was echoed and affirmed in the Bavarian parliamentary debates at the end of the decade. Responding to the attack on the new art that Dr. Jäger delivered on 28 March 1890, Minister President Krafft Freiherr von Crailsheim plainly stated that the new directions in art coming out of Paris had far-reaching influence upon all art. This reality, he insisted, could not be ignored if artists in Munich did not want to be left behind in the evolution of art. He argued that although no one could know where this development would lead, it was essential for Munich artists to participate in this transitional stage. In 1892 Minister for Ecclesiastical Affairs and Education Dr. Ludwig August von Müller presented a similar argument after hearing complaints from the Catholic Center Party deputies about pleinairism. Following a serious statement by the Center speaker, Hermann Beckh gave his pithy views on the absurdity of the new art, which looked like it had been chiseled in stucco, and urged his colleagues to look at the cartoons about relief painting and at Adolf Oberländer's tale about pastel paintings in *Fliegende Blätter* (Broadsheets) (fig. 25). Müller rejected Beckh's views with a resounding statement on the inevitable evolutionary nature of art. Beginning with the assertion that art carries its own development within itself and moves through various transitional stages, Müller argued that it would be unwise for the state to interfere in the process. Furthermore,

no one could deny that plein air painting had resulted in great successes, as well as being accompanied by a certain bizarreness, but that situation had been more disturbing three years earlier. Now Müller found that as a result of the plein air painting, the art scene in Munich was moving in a positive, fresh new direction.[87] The moths in the painting in the cartoon may have been ephemeral, and Liebermann's relief painting infamous, but the Bavarian government had clearly chosen to back the new art represented in the cartoons.

PROMOTING THE NEW ART: FERDINAND AVENARIUS AND *DER KUNSTWART*

The extent to which this new open-air art had established itself as the modern German art by the end of the 1880s was demonstrated in a new journal. *Der Kunstwart*, edited and published in Dresden by Ferdinand Avenarius (1856–1923), was one of the cultural reviews that was soon to exert influence in the art world. Avenarius's aim was not unlike Pecht's, but his viewpoint was that of a different generation: a teenager when the nation was proclaimed, Avenarius was only thirty-one when he founded *Der Kunstwart*. He wanted to promote "ideal-realistic" art, including everything from philosophy through literature, theater, music, and the visual arts, or as proclaimed by the subtitle, *Review of All Spheres of Beauty*—all of which would embody ethical, humanistic ideals within a liberal national framework. Seeking to stimulate thinking and to provide a discussion forum for the educated laity, he began in October 1887 on a virtual shoestring with 10 subscribers. Despite this small number, he started with an optimistic first printing of twenty-five thousand. There were only 582 subscribers at the end of the first year, but the number increased slowly for the next decade, reaching 23,000 in 1914. The price was modest: 2.50 marks quarterly, for two issues each month containing twelve pages of tiny print on cheap paper.[88]

Avenarius at first wrote many of the reviews, often under mischievous pseudonyms like Paidogogos or Malevolus, or reprinted current articles from other journals, adding his own comments. Despite financial problems, the journal soon was publishing articles, whether reprinted or original, by well-known authors. These authors tended to be not scholarly experts, as in the *Zeitschrift für bildende Kunst*, but popular cultural writers and critics.[89] He wanted to reach the widest possible literate public by publishing short, opinionated presentations on issues and providing regular features with useful lists of both current journals and recently printed books on the arts. Within the first months, he instituted an opinion section, in which readers could respond to articles. He inaugurated the section with a tongue-in-cheek letter of complaint to the editor from a long-suffering reader, F. Avenarius. Views presented in this section frequently provoked heated discussions on current issues.

The first years of *Der Kunstwart* demonstrated a refreshing attitude toward naturalist and open-air art and distinctly different perceptions of the important issues in the search for an appropriate German art. With few exceptions, the writers accepted as given the significance and dominance of the new art, or as Avenarius preferred to call it, open-air painting. Anxiety over its proletarian bias and lack of respectability was only occasionally expressed. Publishing only a few brief attacks on the works of Uhde and Liebermann as portraying crooked, misshapen people in miserable conditions,[90] *Der Kunstwart* handled them favorably as major artists who were treated seriously in regular reviews. Avenarius himself in September 1888 regretted the absence of French Impressionist artists, especially Manet, from the Third Munich International that year because, as he pointed out, the great progress German art had made in the last two decades had been the result of the influence of French open-air painting. He credited the brilliance of the French painting, beginning with the 1869 Munich exhibition,

which included works by both Corot and Courbet, with pushing German work away from the dark-brown paintings of the past into a light-filled modern art. Thus, he lamented, we could have learned much from Manet and Impressionism.[91] This openness to the new styles meant that *Der Kunstwart* emphasized discussions of "what is modern" in German art rather than "what is the best art for the new nation," as in *Die Kunst für Alle*. This question "what is modern" emerged in two extended debates that appeared both in articles and in the opinion section until the editor brought the discussions to a close.

The first discussion, beginning in March 1888, was sparked by an article written by Avenarius published without his byline. Reacting against a book by Otto von Leixner (1847–1907) reviewing modern art in the Berlin academy exhibitions, Avenarius in this essay positively assessed the current blossoming of modern religious art in Germany and chastised churchmen and artists for their reluctance to have biblical figures depicted in contemporary scenes. Ridiculing traditional biblical types based on the work of early-nineteenth-century German Nazarene artists, Avenarius described them as "these artificial sweet dolls," "thin, over-refined, impossible saints of both sexes," who, pierced with arrows and crucified, were always smiling and pleasant. Against this he upheld Uhde as the only well-known contemporary artist who had succeeded in placing the Christian narrative into the daily life of the poor and oppressed, although he expressed some reservations over Uhde's preoccupation with aesthetic problems. The responses to Avenarius's article took issue with aspects of the argument, but there was an underlying consensus that traditional art forms were no longer viable for the contemporary world and that Uhde's paintings, though acknowledged to be "completely leftist" and still too enamored with the "cult of ugliness," represented a genuine engagement with the modern world. This insistence that modern art must be true to its time, must reveal an

authentic picture of the contemporary world, was a fundamental assumption within the journal. As a report of November 1887 on a contemporary pamphlet crisply stated, "Modern art should closely resemble modern life."[92] What that meant was still a matter of considerable disagreement.

LIGHT-COLOR PAINTING AND THE VICTORY OF THE NEW ART

The next revealing series of articles in *Der Kunstwart* was occasioned by three exhibitions titled *Light-Color Painters* held in the years 1888–90 at the Fritz Gurlitt Art Salon in Berlin. Opened in 1880, the small gallery in the heart of Berlin rapidly developed a reputation for promoting contemporary art. Georg Voss (1854–1932), an art historian who wrote regularly on Berlin events for *Die Kunst für Alle*, reported that Fritz Gurlitt's salon had become a popular gathering place for Berlin society because his art shows were frequently accompanied by lively controversy, particularly those displaying the brightly colored fantasies of Böcklin. Within three years of his opening, Fritz Gurlitt (1854–1893) was responsible for the first public exhibition of French Impressionist paintings in Germany. In October 1883 he showed the personal collection of Carl and Felicie Bernstein, combined with twenty-three paintings from the Galerie Durand-Ruel in Paris. Included were paintings by Manet and the major French Impressionists, Renoir, Claude Monet, Mary Cassatt, Eugène Boudin, Berthe Morisot, Pissarro, and Alfred Sisley. Although the response of Berlin critics and many artists, including Menzel, was largely negative, the Bernstein collection provided the first introduction for many in the Berlin art world to the canonical French Impressionists. From 1883 to 1891 the Bernsteins held weekly salons in their home at which their literary and artistic guests could view the paintings.[93]

Five years after the exhibition of the Bernstein collection, in the spring of 1888, Gurlitt created an-other significant exhibition of modern art in Berlin by juxtaposing works of the "young" open-air painters, whom he called "Light-Color Painters," against the dark paintings of the "old" academic school. The generational terms *old* and *young*, regularly used in discussions of the new art, had little to do with the age of the artists, characterizing instead their attitudes toward traditional, or academic, styles and new styles. Gurlitt, who commissioned one of Uhde's loveliest paintings, *Children's Nursery* (fig. 27B), consulted with Uhde in the planning of this show of the "young ones." In December 1887 Uhde wrote Gurlitt giving his full support and recommending artists whom he had already contacted, including Hermann Schlittgen and Hans Olde (1855–1917). The first rooms of the exhibition featured, among others, the Rembrandtesque studio portraits of Lenbach and popular realistic but sentimental peasant scenes by Carl Gussow. In the rooms opposite these were the works of the light-color painters, including Liebermann's *Rope-Walk* (1887), Uhde's *Last Supper* (fig. 21), and paintings by a dozen others.[94]

Although local reviews were not encouraging, Gurlitt followed this show with two more in the spring of 1889 and the spring of 1890. Major open-air paintings were hung: in 1889, Liebermann's *The Net-Menders* (fig. 19) and Leibl's *Three Women in the Church* (fig. 26), both of which were subsequently purchased by the Hamburger Kunsthalle; in 1890, Liebermann's *Home for Old Women in Leyden* (1889) and *The Bleaching Field* (1883) and Uhde's *Children's Nursery*. The works of painters from across Germany who now constituted the core of the open-air painters appeared again in both years: from Munich, Hugo von Habermann (1849–1929) and Gotthardt Kuehl; from Karlsruhe, Leopold von Kalckreuth and Thoma; from Berlin, Skarbina, with scenes of ordinary urban life, and Lesser Ury, whose fluid, atmospheric cityscapes of Berlin drew considerable criticism (fig. 27A). After the 1889 show the *Berliner Tageblatt* (Berlin daily

newspaper) in a very critical review charged Gurlitt with starting a civil war with the academy.[95] This evocation of battle lines ignored the extent to which the new ideas about art had already begun to infiltrate the academy itself. Among others, Skarbina, whose forthright and light-filled cityscapes drew critics' fire, taught the anatomy class at the Berlin art institute from 1879 and was also openly acknowledged to have been strongly influenced by the work of Manet from his long stays in Paris, most recently in 1885–86.[96]

Avenarius rarely printed explicit reviews of works in exhibits since local newspapers efficiently handled these. *Die Kunst für Alle*, however, published a review by Voss immediately after the first exhibit of light-color painting that began by pointing to the rapid growth in the number of German followers of the new Parisian school, led by Manet and Bastien-Lepage. This new school painted the world with such flooding light that colors disappeared into a chalky fog. Although this style resulted in remarkable paintings with subtle color tones in the hands of the best painters, Voss maintained that many artists who lacked a firm sense of either beauty or color had been attracted to the foglike painting because it covered up their lack of talent. For these artists, "fidelity to nature had deteriorated into a cult of ugliness." Unfortunately, he said, the mass of untalented artists who were thus flocking to the flags of impressionism and of light-color painting

Fig. 26 **Wilhelm Leibl (1844–1900),** *Three Women in the Church*, **1882. Tempera on wood, 44 1/2 x 30 3/8 in. (113 x 77 cm). Hamburger Kunsthalle.**
Leibl's masterpiece, this painting, which took almost three and a half years (1878–82) of solid work to complete, and which sold shortly thereafter for 43,000 marks, firmly established his legendary reputation. A young painter whose work first attracted attention in 1869, Leibl remained resolutely outside the mainstream of German art after he left Munich in the mid-1870s to live in isolation in a remote village. Rejecting academic mythological and historical subjects, Leibl painted rigorously realistic portraits of villagers and farmers that gained him a following among painters, loosely known as the Leibl school, who worked in various experimental modes of realism. Although he submitted works infrequently to the great exhibitions, his paintings, including this one, shown in the German exhibit at the Paris Universal Exposition of 1889, earned him a first prize. By the 1890s Leibl was frequently mentioned in reviews; in 1895 he was given a special exhibit at the Great Berlin Art Exhibition; and he was included in the Berlin Secession of 1899. Six years after his death this painting was purchased by the Hamburger Kunsthalle for 112,000 marks.

Fig. 27 *A.* **Lesser Ury (1861–1931),** *At the Friedrich-strasse Station,* **1888. Opaque watercolor on board, 25 1/2 x 18 3/8 in. (65.5 x 46.8 cm). Stadtmuseum Berlin, purchased with funds from the Museumsstiftung Dr. Otto and Ilse Augustin.** *B.* **Fritz von Uhde,** *Children's Nursery,* **1889. Oil on canvas, 44 1/2 x 30 3/8 in. (110.7 x 138.5 cm). Hamburger Kunsthalle.** *C.* **Gotthardt Kuehl (1850–1915),** *Pont-Royal in Paris,* **1880–85. Pastel on paper, 18 7/8 x 24 3/8 in. (48 x 62 cm). Museum der Bildenden Künste Leipzig.**

These three paintings represent the new preoccupation with daily life in the city that characterized the light-color paintings. In the years following the Light-Color Painters exhibitions at the Gurlitt Art Salon, Uhde produced a substantial body of work that focused on his family, such as this one (*B*), with its unusual perspective into the sun-drenched nursery, and Ury earned a reputation among supporters of the new art for his magnificent use of color (*A*). *Der Kunstwart* called him "the most progressive among our modern painters," and *Die Kunst für Alle* characterized him as "the adroit child of the big city," reveling in the colors and lights of the streets. Oscar Bie, reviewing Ury's impressive paintings in the exhibitions at Gurlitt's, in the 1894 Munich Secession, and in Berlin in 1895, created a contretemps by pointing out that Anton von Werner had refused to allow Ury into the Berlin art institute. Bie's crisp refutation of Werner's subsequent denial gave cartoonists fodder for satirical attacks on Werner.

The influence of the French was most keenly apparent in the work of Kuehl (*C*), who after his return to Germany in 1889 continued to paint impressionistic street scenes similar to this one in Paris. Active in Munich's art politics, he was called to the Dresden Art Academy in 1895, where he became a strong advocate of modern art.

A

B

C

Fig. 28 **Max Liebermann, *Farrowing Pen—Pigpen*, 1888. Oil on canvas, 25 3/4 x 31 5/8 in. (65.5 x 80.5 cm). Nationalgalerie, Staatliche Museen zu Berlin—Preußischer Kulturbesitz.**
In the 1880s and 1890s Liebermann drew, painted, and etched a number of different versions of piglets in pigpens, including one that was in the collection of the newspaper magnate Rudolf Mosse, as well as several paintings called *Pig Market in Haarlem* (see fig. 24A). *Die Kunst für Alle* 12, no. 15 (May 1897): 246, reproduced a scene very similar to this one.

were ruining the reputation of the new school. Voss went on, rather skeptically, to critique the work of the leading painters: Uhde, whose depth of poetic expression was reconciling the enemies to the new movement; Schlittgen, one of the most zealous fighters for the new movement, whose substantial talent in the representation of modern society was lost in the wash of light; and Liebermann, whose shining white pigs in his new painting provided a more joyful and lively scene than his usual muddy country people (fig. 28).[97]

In November 1888 Avenarius reprinted a long, controversial review from the foremost national liberal newspaper in the Rhineland, the *Kölnische Zeitung*, of the current art situation in Germany.[98] The article was written, Avenarius reported, by a prominent scholar of art who did not want to be identified. This anonymous authority argued that only a work of art that was a genuine expression of the artistic vision and sensibility of its own time could have lasting merit. Light-color painting, which was just such a "fresh, genuine modern art movement," was advancing victoriously across all of the cultured European nations except Germany, where it was being relentlessly opposed by the "academic tyranny." The anonymous scholar was certain that the academies in the major art cities would prevent these new works from being included in exhibitions or, if they did manage to get in, they would be presented as

"aberrations of eccentric talents." He then launched a strong attack upon the stultifying effect of academic art and training upon German artists, an attack that was being voiced by other critics who wanted to see the development of a modern art in tune with its time. Turning to museums, he charged that purchasing committees for museums across Germany were so preoccupied with supporting mediocre and outdated German artists that it was virtually impossible to find contemporary non-German art in any of them.

Not surprisingly, this anonymous article rapidly became the subject of intense debate. The *Münchener Neuesten Nachrichten* reprinted the text, and *Die Kunst für Alle*, whose policy excluded reprint articles, requested a similar original article. The author, Wilhelm Bode (1845–1929), had reason for maintaining his anonymity: as a co-director of the Painting Gallery within the Prussian museum system in Berlin (he later became the sole director, and in 1905 he became the general director of the Royal Prussian Museums) Bode was a ranking member of the cultural establishment (fig. 29). Coming from his pen, this article was highly explosive in its criticism of official cultural practices and in its unequivocal support for the new international light-color painting, particularly for its German pioneers, Liebermann and Uhde. Avenarius reported that the article was creating significant opposition and that

a response from a group of outraged artists was to be published in the *Kölnische Zeitung*. Although there was much agreement about the need for reform in the art academies, the question of "academic tyranny" over art exhibitions was much more provocative because many writers were proud of the wide diversity of academies, exhibitions, and museums in Germany.

In the pages of *Der Kunstwart* the discussion continued on the twin issues of what constituted art for contemporary Germany society and whether the light-color painting was that modern art. A friend of Avenarius's and a critic for several Dresden newspapers, Wolfgang Kirchbach (1857–1906) argued in a lead article titled "What Is Light-Color Painting?" in March 1889 that the often-repeated claims for the victory in Germany of open-air painting were mistaken, though he took a different position from Bode's controversial one in the *Kölnische Zeitung*. Kirchbach began with a quotation from a recent pamphlet proclaiming the victory of open-air painting: "Light-color painting is without question the only rightful one for our time, for no other has been born, as it has, out of the contemporary spirit of the times, none embody and incorporate, as it does, the modern striving after truth, light, clarity, candor, freedom—the universal endeavor to press through to the deepest corner of the secrets of existence." Rejecting this claim that the new art had triumphed and mocking the many critics who cried "Victory! Victory! A new art, a modern art!" Kirchbach drew a distinction between impressionism as practiced by Uhde and Liebermann following French and Dutch painting, which captured a fleeting impression by utilizing white crayon and mixing colors on the canvas, and outdoor painting, which he defined as a careful study of nature and of color relationships. His quarrel was overtly about the mistaken use of the terms by critics, but his underlying conservative message made it clear that artists working within the German academic tradition who had been painting out-of-doors for several decades were

Fig. 29 **Max Liebermann, *Wilhelm Bode*. Lithograph. Reproduced in *Die Kunst für Alle* 12, no. 15 (May 1897): n.p.**
With its carefully modeled face and gradations of gray, the lithograph represents well the austere scholar and director of the Berlin museums. Liebermann later painted a portrait of Bode, now in the National Gallery in Berlin, that exemplified the light palette and clarity of this light-color painting.

more honest and true to nature than those who practiced mere technical tricks learned from the French (fig. 30).[99]

In the next issue, *Der Kunstwart* reprinted an article from the *Preussische Jahrbücher* in which a young art historian, Carl Neumann (1860–1934), who later became a professor at Heidelberg, asserted that modern art was no longer concerned with romantic or noble subjects because the young artists were reacting against the false sentimentality of past painting. Furthermore, he contended that the concentration of these new modern artists upon ordinary, everyday life grew out of the tremendous desire to *see* and to capture that unadorned world on the canvas and a complete lack of interest in what the public wanted or was ready to see. One

result was the increasing number of works that appeared to be mere rough sketches, not finished paintings. Neumann called for more education on the part of the public so that it could understand the new art and more attention to basic skills on the part of the young artists.[100]

By mid-August 1889 the highly successful First Annual Munich Exhibition had opened with a large selection of both new open-air German paintings and foreign art. Avenarius responded with another article titled "What Is Light-Color Painting?" written by Cornelius Gurlitt (1850–1938), an art historian and the brother of Fritz Gurlitt, owner of the art gallery that was promoting this art.[101] Presenting a thoughtful analysis of the new ways of seeing the world that were embodied in the new painting, which valued the play of light rather than isolating objects, Gurlitt argued that the great artist was one who made one discover new forms and perceptions of the world. He concluded that the deep rift in the current, often bitter controversy over the new art was over fundamentally different conceptions of nature: the old school believed itself to be above nature, judging what was worthy of representation, while the new artists plunged into nature itself, without judgment, seeking to find beauty everywhere. The old art was a rational art of control; the new, modern art was pantheistic and open.

With this article by Cornelius Gurlitt, Avenarius brought this particular discussion on light-color painting in Der Kunstwart's opinion pages to an end, though not before he had favorably reviewed the First Annual. He praised the work of both the younger German artists and the French artists, who were well represented by fine, light-filled landscapes. It was, he wrote, a serene, quiet exhibition, one in which the young artists did not have to produce life-size proletarian portraits in order to annoy the old boys. They did not have to be provocative because they knew that the new art movement had triumphed. Cassius, however, was mischievously provocative in his second issue of the Mocking-Bird

in the Glass Palace, where he trumpeted the "Open-Air Painters' Victory Song":

The pleinairist am I, truly,
Need no north-light studio,
And the salon this year
First shines with my art.

Light is my life blood;
I sit in the sun,
Until it burns in my crown
The largest hole, Oh joy!

Then my thoughts dry up,
Why do I need ideas?
When future laurel wreaths
Nicely entwine my skull.

Away with color, I dislike
These brown sauces;
Twenty pounds white chalk each day—
Which I love to pound to dust.

What do I care about the public,
Why try to sell?
The public is everlastingly stupid
And wants to run to the beer hall.

If I had the jury
On the side of my painting,
I wouldn't give an empty eggshell
For the people's favor today.

The public pays its entrance fee,
And should keep its mouth shut.[102]

Despite its lighthearted tone, the poem's mixture of self-assurance and disdain for the "everlastingly stupid" public boldly reflected the attitudes that would lead to difficult confrontations between artists and the public in the next decades.

Avenarius, however, continued to celebrate the

Fig. 30 *A.* **Photograph of Max Liebermann painting in the countryside (1894),** *Die Kunst für Alle* **12, no. 15 (May 1897): 225.** *B.* **Hermann Schlittgen (1859–1930), "The Modern Painter in the Country,"** *Fliegende Blätter* **100, no. 2550 (1894): 226.**

One argument against the efforts of the open-air painters to capture what they saw in nature was that this reduced them to making mechanical reproductions that might better be recorded by a camera. This in turn raised the question whether artists were painting from nature or from photographs of nature. Liebermann was charged with using the camera instead of painting directly in the open. Without naming him, in 1888 *Fliegende Blätter* published a long biography, ostensibly written in 1937, tracing the career of a famous artist named "Pazzera" through his "realistic—naturalistic—impressionistic (also called photo-technique) schools." Reproducing a series of images based on Pazzera's first famous theme, "Old Woman Peeling a Radish," it wittily demonstrates the changes that image underwent in each successive style from 1888 to 1896.

Pazzera also painted a portrait of himself standing by a large camera on a tripod as he painted a peasant bending over his work. These sun-filled landscapes were posthumously memorialized, the tale continues, in a monument that cleverly depicted the great artist in the act of photographing the swineherd tying her white apron—his greatest painting.

Echoing the tale from the humor magazine, Liebermann answered the charges that he did not paint in the open by having a photograph made of himself painting his *Striding Farmer* (1894) in the dunes in Holland (*A*). Schlittgen's cartoon (*B*), with the camera on the stool and the tiny photograph pinned to the canvas, is a comment upon that photograph. Liebermann then had the photograph of himself reproduced in the catalogue of the 1897 Great Berlin Art Exhibition, in which he was given a special retrospective. Finally, the importance of this photograph was further emphasized when it was used to illustrate an article about Liebermann published in *Die Kunst für Alle* in May 1897, when his retrospective opened.

A

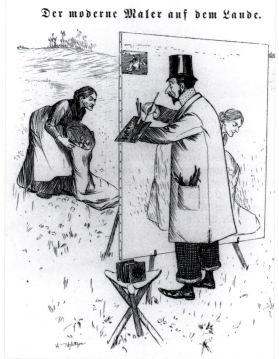

B

new art. In March 1890 *Der Kunstwart* underlined the success of the new open-air painting by reprinting an article titled "The Development of German 'Outdoor Painting,'" by Carl von Vincenti, from *Velhagen & Klassings Neue Monatshefte* (Velhagen & Klassings new monthly), a well-financed and widely circulated conservative cultural magazine. In the article, Vincenti discussed the maturing of the new German school, whose painting could provide a rich, artistically true vision of its time and of the life of the nation. He acknowledged the problems that had developed as a result of the new school's initially presenting a gloomy, ugly view, but he thought that phase was now past. Analyzing the various approaches utilized by the open-air painters, from Uhde's strong religious works to Skarbina's cityscapes, Vincenti pointed with pleasure to the acquisition by the National Gallery in Berlin of Liebermann's *Flax-Scourers in Laren* (fig. 31). Admitting that the German outdoor painters had not yet produced masterpieces, Vincenti concluded that this new painting had the potential to create a revival of German art—"a young-Germany in painting"—which would lead to that genuinely patriotic art for which so many longed. Soon, however, with the opening of the Second Annual in Munich in July 1890, other writers came to less enthusiastic nationalist conclusions, believing that the widespread success of open-air paintings had resulted in stereotyped and superficially pleasant work. In effect, they said, through their very success the painters had turned a reviled new style into a comfortable salon style.[103]

As these articles in *Der Kunstwart* demonstrate, attitudes toward and understanding of the new art forms varied widely. Even those who were skeptical about aspects of the new work, however, recognized that the older, academic traditions were no longer appropriate in the changing social and cultural milieu of the nation. This recognition had been one of the driving factors in Avenarius's efforts to create *Der Kunstwart*. Associated earlier with circles in Berlin that were sympathetic to literary naturalism, with its moderate socialist inclination, Avenarius deplored the intellectual and aesthetic sterility that he perceived to be the mark of the German academic tradition—the word *academic* here referring to the intellectual establishment, not just to the art academies. He intended *Der Kunstwart* as a call for reform against a materialist bourgeois culture. As he wrote in his introductory essay in September 1887, he opposed "the almost absolute over-valuation of rational education," which he believed was carried out at the expense of cultivating emotion and imagination. He argued that sensitivity, intuition, and fantasy were lost in the pursuit of rational knowledge, scholarship, and science, which nurtured the mind but not the soul and the body. The result, he declared, was that knowledge was barren, producing social and religious intolerance, including anti-Semitism.[104]

For Avenarius, then, the search for an art that was appropriate for the nation at this time meant a shift away from the pragmatic portrayal of current social realities, as in the naturalist open-air art of peasants by Uhde and Liebermann or in the exacting, realist paintings of Leibl. He repeatedly insisted that an art of fantasy and imagination was needed to provide an ethical and humane vision against the overwhelming materialism of the empire. Furthermore, he believed that it was necessary to create a broad base supporting art within the life of the people. He rejected the idea that art should be directed primarily at the well-to-do and the educated since those groups' ability to empathize with art had been destroyed by their overintellectualized education. In its first issues *Der Kunstwart* established its support for efforts to improve art education in schools and within the larger public and to promote graphic arts that appealed to the average viewer. Avenarius had no sympathy whatsoever for the academic rationalism of Berlin artists, particularly Werner, whose paintings promoted the pretensions of the Hohenzollern emperors.[105]

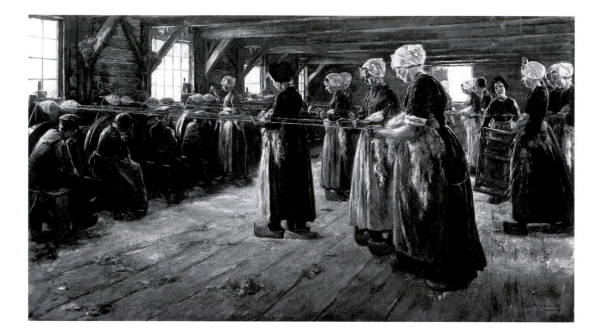

Fig. 31　**Max Liebermann, *Flax-Scourers in Laren*, 1887. Oil on canvas, 53 x 90 7/8 in. (135 x 232 cm). National-galerie, Staatliche Museen zu Berlin—Preußischer Kultur-besitz. Reproduced in *Die Kunst für Alle* 3, no. 23 (Sept. 1888): 361.**

This large work continued Liebermann's exploration of scenes of working-class men and women. In this case his subject was Dutch women performing the tedious task of turning flax into linen yarn in a crude assembly line of spinning wheels run by children. The subject matter of his work remained the everyday activities of working women and men, whether plucking goose down, canning vegetables, digging potatoes, mending fishing nets, tending cows, or feeding pigs. These paintings were easily classified as naturalist art, akin to the writings of both French and German naturalists. Liebermann's manner of painting and the aesthetic treatment of this naturalist subject matter, however, shifted steadily during the 1880s, as he moved to brighter colors—abandoning the dark browns and ochres of the 1870s, derogatorily termed "brown sauce" by many critics—and to a greater concern with capturing the effects of sunshine outdoors and of light from windows inside. Shown in the Paris Salon of 1887 and the Third Munich International, in 1888, this painting was acquired by the National Gallery in Berlin in 1889, when Liebermann in effect donated the painting, valued at 12,000 marks, to the museum for 500 marks.

ARNOLD BÖCKLIN: THE NEW ART OF FANTASY AND PUBLIC DELIGHT

In his search for artistic imagination Avenarius found his genius in Böcklin, whose paintings were belatedly reaching an appreciative audience in the late 1880s and 1890s largely through the efforts of the art dealer Fritz Gurlitt. Böcklin, who had left his native Switzerland in the 1840s to be trained at the Düsseldorf Academy, was an artistic loner who spent most of his life in Italy producing boldly colored mythological landscapes and seascapes filled with nymphs, naiads, centaurs, mermaids, and tritons, painted in a manner that fit into none of the contemporary art styles (plate 3). Although he had exhibited paintings in Berlin, Munich, Basel, and Vienna, his work was generally not well received and was often condemned as eccentric and bizarre. Despite the criticism, a market for Böcklin's work had slowly developed in the late 1870s, and Gurlitt, who signed a contract with Böcklin in 1877, had stimulated that market by commissioning Klinger, a young graphic artist, to create etchings based on Böcklin's paint-

ings. Beginning in 1882 these etchings were successfully marketed to the middle classes and served to create a demand for Böcklin's paintings that accelerated into a veritable craze in the 1890s.

Böcklin's works, which could scarcely find a buyer twenty years earlier—leaving his family often on the verge of starvation—were selling for up to eighty thousand marks apiece by 1900. By the time of his death, in 1901, Böcklin was widely acclaimed as one of the greatest, most truly creative German artists.[106] As Pecht exclaimed in 1887, "Turned away fully from all reality, Böcklin is beyond all dispute now the purest idealist among all the German artists, manifesting nonetheless the most acute observation and the most genuine sense of nature." Another critic gushed in 1897, on the occasion of Böcklin's seventieth birthday: "The fifteenth century gave us a Leonardo, the sixteenth Albrecht Dürer, the seventeenth the great Rembrandt . . . and the nineteenth Arnold Böcklin." This catapulting from obscurity in the seventies to fame in the nineties and then back to obscurity a decade later demonstrated in a drastic way the dynamic fluidity of the art world in Germany in these last decades of the century.[107]

From its very beginning Der Kunstwart upheld Böcklin as the creator of "the most German painting, the genuine imaginative painting." His first one-man show, organized by Fritz Gurlitt, with ten oil paintings and twenty-five graphics and photographs, was held in Dresden in 1883. The following year, Böcklin was expected to receive the large gold medal at the Berlin Academy Exhibition for his Prometheus (fig. 32), an oil painting of massive mountain peaks that merged seamlessly into the gigantic form of the bound Prometheus, which was shadowed by dark clouds, but the jury refused to give him the medal after seeing one of his "bizarre" works hung beside the Prometheus.[108] In his 1887 essay deploring the philistinism of the educated middle classes Avenarius castigated them for their total lack of understanding of these fantastic paintings by Böcklin both in the neglect he had suffered

for so long and in the superficial adulation, expressed in fashionable clichés, that he was beginning to receive.

Over the next decade Der Kunstwart consistently provided articles and reports on Böcklin's work expressing the belief that his painting represented the necessary turn away from surface appearances and historical trivialities toward an art that would resonate with the inner imagination and dreams of the German people. His was a poetic and symbolic art, an ideal art, not scientific or intellectualized, one that could evoke ideals appropriate for contemporary modern Germany. Or as another critic wrote, Böcklin "is the true spiritual leader of the modern ones who strive for the liberation of the individual from the constraint of traditional forms and seek to find their own way." Younger artists responded to Böcklin's works with the ultimate compliments: his nymphs and mermaids splashing in the waves were copied so frequently that in 1892 a critic pointed to "artistic parthenogenesis" in the art exhibitions where Böcklin's paintings had spawned multiple descendants and variations.[109]

A valuable index of the appropriation of Böcklin's work in popular culture is the appearance of his images in cartoons and caricatures. One of the sensational paintings at the Third Munich International in 1888 was Böcklin's In the Play of the Waves (plate 3) in which a triton laughingly pursued a worried mermaid in a wide expanse of deep ocean waves. The figures, interpreted by Avenarius as the symbolic personification of the ocean itself, of the natural forces of sky and water, became sufficiently well known to appear in political cartoons, as well as purely humorous ones.[110] After the exhibition closed, Die Kunst für Alle published a cartoon by Stuck in which Böcklin's mermaid, now very anxious, lies stranded on the floor of the gallery. In pamphlets parodying major works from the 1887, 1888, and 1889 Munich exhibitions, Cassius wittily lampooned Böcklin's paintings from the exhibitions. Fliegende Blätter, the venerable humor magazine published in

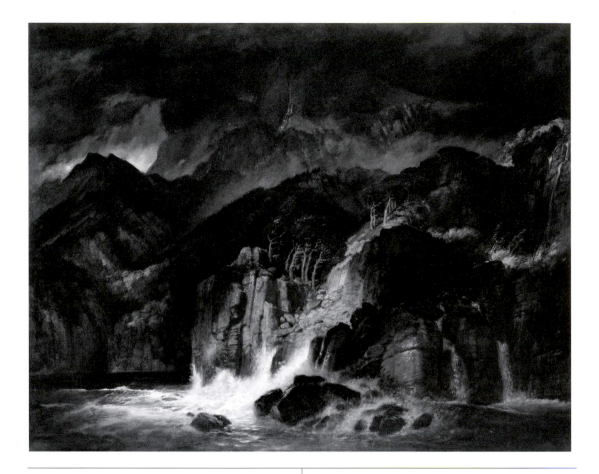

Fig. 32 **Arnold Böcklin, *Prometheus*, 1885. Oil on panel, 38 3/4 x 49 1/4 in. (98.5 x 125 cm). Hessisches Landesmuseum Darmstadt.**
The negative judgment of the 1882 version of this painting by the Berlin jury in 1884 was offset by the adulation of Böcklin in the 1890s that culminated in special exhibitions marking his seventieth birthday in 1897. At that time, over a decade after this painting was completed, Cornelius Gurlitt lauded it as a colossal conception and a wonderful painting that made the traditional depictions of a chained Prometheus being attacked by an eagle seem puny and trivial by contrast.

Munich, featured several cartoons mocking bourgeois figures in Böcklinesque settings (fig. 33). Others followed over the next decade. When Böcklin had become firmly established in the art world, the humor magazines often depicted critics whose nightmares were filled with Böcklin's images. These satires in the humor magazines, with their wide circulation, constituted another medium through which art entered into the popular culture, and they provide us with a populist reading of that art.

The element of playful imagination in Böcklin's work, which made it an ideal target for cartoonists, clearly appealed to the younger generation of critics, who, following Avenarius, began writing seriously in the journals in the 1890s.[111] Böcklin's paintings represented for them the antithesis to the urban bourgeois and industrial society that so many

A

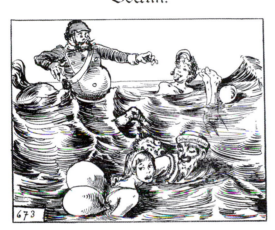

Böcklin.

B

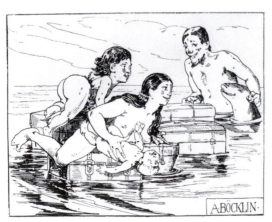

C

Fig. 33 A. **Franz Stuck, "The Exhibition Is Closed: A Vision,"** *Die Kunst für Alle* **4, no. 2 (Oct. 1888): 32.** B. **"Arnold Böcklin. 'Police Raid on the Women's Section of a Sea Bath,'"** in K. Cassius, *Mockingbird in the Glass Palace* **(1888), 28.** C. **"Arnold Böcklin. 'Buchholz Family at the Ocean Bath (Rediscovery of the Faithful Azorl),'"** in K. Cassius, *Mockingbird in the Glass Palace* **(1889), 31.** In Stuck's tribute to the closing of the Third Munich International in 1888 (A), Böcklin's mermaid (see plate 3) is surrounded by figures who, stepping out of the major paintings or down from the pedestals, rejoice in their freedom. Emmanuel Frémiet's *Gorilla* (see fig. 1) is on the far right, beyond the anxious figure of Böcklin's mermaid. In his caricatures of paintings in that exhibition, Cassius's version of *In the Play of the Waves* (B) features Böcklin's centaur as a bewildered policeman being mocked by one of the mermaids. The other mermaid is an anxious young woman wearing water wings to help her learn how to swim, while the leering triton has been transformed into a swimming instructor. The following year, Cassius's satire (C) was directed both at one of Böcklin's painting in the Glass Palace and at the rising tourist traffic and leisure culture, indicated by the trunks upon which the family floats.

of them deplored and as such carried the promise of renewal of the essential inner characteristics that they identified with modern, young, enlightened Germans. Curiously, even though he was not born in Germany and spent his life outside of Germany, Böcklin's own life contributed to his stature as the uniquely German artist, one whose commitment to his own inner vision never flagged through all the years of misunderstood censure, one whose work was not tainted by imitation of others or by painting for commercial success. This aspect of his popularity with critics was thoughtfully noted in a lengthy article of appreciation that appeared in the *Zeitschrift für bildende Kunst* in 1897, on the occasion of Böcklin's seventieth birthday. Böcklin was a generation ahead, the writer observed, but his own generation had now moved away from the philistinism of the previous generation to a higher, more liberated worldview that strove for a noble, free humanity. Böcklin, he said, was a pioneer in presenting the

essence of humanity, not bound by class, nationality, or occupation, a pioneer who had led the way into a new cultural era.[112]

Böcklin was not, of course, the only artist whose work elicited praise for its creativity and fantasy. In almost all of these journals Böcklin was associated with Klinger, a strong artist whom Avenarius linked early in 1891 with Böcklin as the "most masterful painter-visionaries among all the Germans of this century." The art historian Max Lehrs (1855–1938) effusively described Klinger in the *Zeitschrift* in 1895 as another loner who remained a puzzle to most people as he went his own way, working on the questions of life, joy, and suffering. Lehrs explained that as a genius, the equal of Böcklin, Klinger also had to confront "the bitter ridicule and malicious invectives" from both the public and critics that greeted all of his new work. This leitmotif of the rejected genius became explicit in the criticism of the 1890s, where it occupied a logical place in a view that disdained the larger society for its staid rationalism, if not dull stupidity. In an 1897 article in the *Zeitschrift*, a friend of Klinger's writing about his early difficulties quoted the aphorism, "In the eyes of fellow men, every genius appears to be crazy."[113]

MAX KLINGER: THE MODERNISM OF PROVOCATIVE SKEPTICISM

This may not have been an unreasonable response to the work of both men, for while Böcklin sought to capture an imaginary world populated by fantastic beings, Klinger sought to embody in his work philosophical issues that challenged the dominant German bourgeois ethos. Coming from a prosperous Leipzig family, Klinger was able to gain solid artistic training in Germany and spent almost a decade in Paris and Rome before establishing his own studio in Leipzig in 1893. In 1897 he was appointed a professor at the Royal Academy of Graphic Art in Leipzig. He had first attracted critical attention in

Berlin in 1877, at the age of twenty, for his drawings and in 1878 when he exhibited a narrative cycle of drawings, *Fantasy over Finding a Glove*, at the Berlin Art Society and then a bleakly realistic painting, *Surprise Attack at the Wall*, of a young man surrounded by four hostile toughs in an empty lot, and another cycle of drawings, *Deliberation on a Competition on the Theme of Christ*, at the annual exhibition of the Berlin Academy (fig. 34). The reception was not positive; the stark images of Christ were seen as blasphemous, while the uncanny drawings of the glove series, in which the artist portrayed himself as the lover in a series of surreal dream sequences, were disturbing in their frank confrontation of sexual desire and anxiety.[114]

For the next decade Klinger continued to produce expert graphic cycles that probed issues of life and death in narratives exposing ordinary societal ills and hypocritical sexual conventions. His output was stunning in its imagination and inventiveness, rapidly earning him a reputation for his extraordinary technical ability in the graphic arts and for his unsettling vision of the world. Of the eleven graphic cycles completed by 1891, the four that dealt directly with the role of woman within bourgeois society evoked the strongest censure. After creating the cycle *Eve and the Future* (1880), on the fall of Eve through her search for knowledge, Klinger turned to overt social criticism based on a recent notice in a Berlin newspaper. In three plates titled "A Mother," in the cycle *Drama (Opus IX)* (1883), he portrayed the fate of the working-class woman whose only way out of a brutal marriage was an attempted suicide that went disastrously wrong, leaving a drowned child and a rescued, desolate woman facing a tribunal for murder. Klinger effectively depicted only the aftereffects of the notorious plunge "into the water" of proletarian women that would be memorialized in the drawings of Käthe Kollwitz (1867–1945) and Hans Baluschek (1870–1935) several decades later. Since Klinger's representation of the world of proletarian despair, far removed from the social milieu of

art critics, was perceived to be suitably moral in tone, this series was received favorably.[115]

His next two pessimistic cycles, however, cutting closer to the bone, were given a negative reception. In both of these Klinger criticized the seduction and destruction of young women within modern bourgeois society, in which the price of sexual pleasure for women was degradation and death (fig. 35). Although *A Life* (1884) ostensibly presented the conventional story about the descent of the petit bourgeois female into prostitution, Klinger's savage caricatures were directed against the well-off cavalier roués, Ensor-like figures, who preyed upon her, driving her to suicide and annihilation. Moving up the social and historical scale from Eve to the high bourgeois society of contemporary Germany, Klinger's *A Love* (1887) outrageously traced a romantic encounter in which he himself was the lover. The narrative, however, focused on the woman's experience of sexual passion, which deepened into a consummated affair and ended in the inevitable ostracism and death of the woman and her stillborn child.[116]

The outcome of these narrative cycles was as predictable as those of genre scenes about lost women and trashy penny novels about back-stair romances. Yet the sheer aesthetic quality and philosophical conception, following Arthur Schopenhauer, transformed the cautionary bourgeois morality tale into an exaltation of sexual joy and an accusation of social hypocrisy. Many found the cycles to be troublesome, if not downright offensive. The jury of the Berlin Academy Exhibition of 1888 was sufficiently displeased with the "indecency" of one of the plates from *A Love* that they rejected it. Klinger, in turn, refused to allow the cycle to be shown without the offending plate. He sent it instead to the Fritz Gurlitt Art Salon, where, the journals reported, the public could view the most daring and most revolting of the prints.[117]

Inspiration for these visual narratives may have come to Klinger from Scandinavian friends in Berlin in the late seventies, especially Christian Krohg,

Fig. 34 **Max Klinger (1857–1920),** *Return from the Sermon on the Mount,* **from** *Deliberation on a Competition on the Theme of Christ,* **1877. Ink wash drawing, 15 1/4 x 10 3/8 in. (38.5 x 26.3 cm). Kupferstichkabinett, Staatliche Museen zu Berlin—Preußischer Kulturbesitz.** The sheer barrenness of this scene was shocking. Klinger presented a bleak desert scene devoid of any feature. In the foreground, three self-righteous and severe Pharisees are crisply delineated. Behind them Christ leads a lonely line of disciples, who bunch together, their bodies and shadows merging, as they pass the single Roman soldier. On the far hill are the isolated and bent figures of those who gathered to hear Christ's sermon. Their presence is less substantial than the dark shadows they cast.

This "deliberation" by a twenty-year-old art student may have been done, as Klinger himself suggested, just as a quick exercise. It is nonetheless a startling rendition of a scene that was often presented in a softer, more sentimentalized manner.

with whom he shared a studio, and Georg Brandes, the Danish writer who was active in the early years of the women's movement in Denmark. Other contemporaries simply pointed to Klinger's being affected by the current preoccupation in Germany with social issues, above all with the "woman question." Despite the censorious voices, some found the works liberating. Cornelius Gurlitt reported in 1894 that the more critics wailed as the etchings appeared, the more progressive people recognized that here was a strong hand intervening in the shaping of the German people. The power of the etchings lay, Gurlitt believed, in Klinger's "ruthless love of the truth" and in his ability to go beyond the depiction of objects through a discerning understanding of humanity into a haunting new world. Years later, at Klinger's funeral, Kollwitz, who first saw Klinger's *A Life* in the Berlin Academy Exhibition in 1884, offered a tribute to the enduring effect

Fig. 35 **Max Klinger.** A. ***Fettered*, plate 11 in *A Life*, *Opus VIII*, a series of fifteen engravings (Berlin, 1884).** B. ***Shame*, plate 9 in *A Love*, *Opus X*, a series of ten engravings (Berlin, 1887). Both Kupferstichkabinett, Staatliche Museen zu Berlin—Preußischer Kulturbesitz.** Each of these scenes depicts the humiliation of a woman who has violated bourgeois standards of morality by allowing herself a forbidden affair. The outcome for each is abandonment by the man who seduced her. For the lower-class woman (*A*) this meant becoming a prostitute; for the upper-class woman (*B*) it meant pregnancy and death. Both are depicted at the moment of total alienation and humiliation at the hands of a hypocritical bourgeois society. In *Fettered* the prostitute lies shackled to the wings of a bat from hell, fully exposed to the leers of the top-hatted men and the jeering society crone. In *Shame* the woman, stripped of her grace and elegant dress, walks along a bleak blank wall that separates her from the verdant world of her past. Accompanied only by her guilt—a figure that casts no shadow, who gestures toward her slightly revealing shadow—she is exposed to the censure of her social class, now carefully distanced from her.

A

B

his work had had upon her and many others, not simply because of the technical mastery but, more profoundly, through Klinger's "prodigious craving for life," which had driven him to penetrate "the dark depths of life."[118] Criticism of the graphic works did indeed shift steadily into general adulation that perceived the cycles to be "masterpieces of magical fantasy combined with masterful technical ability." By the early 1890s critics in art journals ranked Klinger without question as one of the foremost graphic artists in Germany; Pecht called him "one of the most remarkable artists of our time." Convinced of Klinger's standing as one of the truly great graphic artists, Avenarius promoted Klinger's work in *Der Kunstwart* and wrote introductions to editions of the graphic cycles.[119]

Nevertheless, as Avenarius realized, graphic cycles did not command the attention of the public nearly as much as the huge paintings, which circulated through the exhibitions. Klinger's first colossal painting, *The Judgment of Paris* (fig. 36), brought cries of outrage from Berlin newspaper critics in 1887, when it became the sensation of the Berlin Academy Exhibition. Displayed at the Leipzig Art Society later in the same year, the painting was given a chilly reception with many exclamations of "hideous" and "abominable." At the Third Munich International in 1888 the work again became a sensational focus for the public, along with Böcklin's *In the Play of the Waves*. The Bavarian parliament in 1890 added to this negative attention with an attack upon the painting for portraying the three Graces as jaded charwomen. Criticism in the journals centered upon Klinger's daring violation of the boundaries between painting and sculpture.[120] Over three meters high and seven meters wide, the painting pulled the viewer onto a wide, flat stage where the gods and goddesses of the myth were depicted as nude, contemporary, and un-idealized figures. Klinger's trespassing against the conventional rules for painting was accentuated by an elaborate frame in which painted sculptural figures, including a

silenus, a caryatid, and a giant struggling against a two-headed hydra, surrounded and merged into the bright, clear colors of the painting.

Cornelius Gurlitt, predictably, viewed the painting with enthusiasm, citing it later as one of the first great works of the new light-color painting that had appeared in German exhibitions. He recounted that "never had people been so aghast over a work of art as the Berliners were when this was presented to them: 'The fellow belongs in a madhouse!'—that was apparently the general verdict." The press from all sides, including a lead article in the ultraconservative *Kreuzzeitung*, decried the collapse of morals and respectability. A reviewer in *Der Kunstwart*, despite his sympathy for the open-air painters, labeled the painting "a baroque hallucination of an overexcited fantasy." In his review of the Munich International, Pecht, who viewed Klinger's engravings as the work of a genius, commented that Klinger should stick to graphic art.[121] On a practical level, the furor swirling around the work resulted in the cancellation of a planned purchase of the painting by the Royal Painting Gallery in Dresden.

Undeterred by this daunting experience, Klinger again provoked the public in 1891 with his monumental *Crucifixion of Christ* (plate 4), which was shown for the first time in an exhibition of Klinger's paintings, graphic cycles, and works on paper in a private art gallery located in the building of the Café Luitpold in Munich. Handled by the art dealer Ulrich Putze, the exhibition opened on 11 March. Entrance was by invitation only for the first two days, after which the public was invited through announcements in the local newspapers. A brief note in *Die Kunst unserer Zeit* in mid-March reported that the exhibition with its "very interesting *Crucifixion*" was "an uncommonly great success," and Heilbut declared it to be "a tremendous event." In his laudatory review in *Die Kunst für Alle* Pecht observed again that Klinger's "stupendous painterly talent" was oddly ineffective in his great oil paintings. Positive criticism in the local newspapers commented on

the "uncommon archaeological interpretation" and on the artistic focus on the nude males. The prince regent himself visited the exhibition on 19 March, and the demand, especially from the art community, was sufficient to extend the show until Easter, on 6 April. A major article on Klinger published six months later in a widely distributed journal declared that the Munich exhibition had been "a brilliant success," indeed, a "public success."[122]

Nevertheless, in the following decades critics who supported Klinger came to represent this well-attended and positively reviewed exhibition as a disastrous scandal involving police censorship and critical rejection. In one of the earliest references in the journals to public rejection and official interference, Hans Singer (1867–1957) reported in the *Zeitschrift für bildende Kunst* in 1893 that the great painting had been shown in Munich for three days to those with personal invitations. Only for one day, he wrote, had it been allowed to be shown to the public, and then only while half-concealed by a drape. What exactly happened is not clear. Klinger wrote to his parents that following a "strong suggestion" from the Bavarian cultural officials, he had draped a cloth over the genitals of the naked Christ.

Fig. 36 **Max Klinger, *The Judgment of Paris*, 1885–87. Oil on canvas, 10 ft. 6 in. x 23 ft. 7 in. (3.2 x 7.2 m). Österreichische Galerie Belvedere, Vienna.**
Public opposition to Klinger's paintings in the decade following the first display of this painting consistently thwarted efforts by museums to purchase his paintings. After plans by the Royal Painting Gallery in Dresden to acquire *The Judgment of Paris* fell through, it was purchased in 1895 by an Austrian architect, Alexander Hummel, who proposed to donate it to the gallery, provided Dresden would buy *The Crucifixion of Christ* (plate 4) and *Christ in Olympus* (fig. 37). This proposal came to naught over concern for public opposition. Hummel then turned to Vienna, offering *The Judgment of Paris* to the Austrian Gallery, again provided that it purchase *Christ in Olympus* and build a suitable "Klinger temple" for the three monumental paintings. However, the plans to build a new museum of modern art there were not carried out and *The Judgment of Paris* was moved into storage.

What is evident is the importance of this incident in contributing to the critical—and public—perception of Klinger as the eccentric brilliant artist whose work was rejected by the public and officialdom. Years later, Julius Vogel (1862–1924), who was instrumental in finally obtaining *The Crucifixion* for the Leipzig Museum of Art in 1918, recalled that the shock felt by many when the painting was first shown was an indication of the uncompromising truth of the work. Singer claimed that precisely in the events surrounding the exhibition of *The Crucifixion* Klinger demonstrated that he took nothing into consideration but his own artistic vision and that he was not disposed to make any "foolish concessions" to public taste.[123]

If the draping of the provocative detail in an immense painting became a central factor in later narratives, contemporary writers in the journals, even those who criticized aspects of the painting, were impressed by the work. *The Crucifixion*, shown without any drape, was triumphantly celebrated in a major exhibition of Klinger's paintings at the Lichtenberg/Morawe Art Salon in Dresden in November 1893. The favorable review of the work in *Kunstchronik* mentioned briefly that the painting "was supposed to have provoked indignation" in Munich. The reporter for the Leipzig Art Society's January 1894 retrospective exhibition of Klinger's work—including *The Crucifixion*, whose offending organ had been reluctantly overpainted by Klinger in order to exhibit in Leipzig—recounted the unusual excitement among friends of art who had come to Leipzig to see Klinger's work. The galleries, he wrote, were filled with clusters of people holding lively, intelligent discussions about the works instead of voicing the offhand remarks and hasty judgments that usually accompanied exhibitions. Listening to the conversations, he found opinion united on Klinger as a graphic artist: here was a forceful, even violent artist, striving to soar to his own high goal, whose creations manifested a strange, impressive, visionary magic that left one feeling anxious and fearful,

not uplifted. On the other hand, he acknowledged, many visitors were perplexed by Klinger's paintings. The visionary struggle expressed effectively in the graphics was much more difficult to achieve in the paintings. "His paintings are in no way pleasing, that is, meeting the current desires for pleasure." Nevertheless, after criticizing some aspects of *The Crucifixion*, the reporter concluded that it exerted an aura "that was breathtaking for the faint-hearted and assailed the strong with singular power."[124]

Those who saw Klinger's paintings, graphics cycles, and sculpture in subsequent exhibitions across central Europe must have sensed, with varying degrees of sophistication, Klinger's staggeringly ambitious efforts to visualize the bankruptcy of the fundamental social and intellectual codes underpinning German bourgeois society. If Pecht and Avenarius cried out for an art that embodied its own time, they got it with a vengeance in Klinger's work, which went far beyond representing contemporary life or the collective imagination. Taken together, his four monumental paintings—*The Judgment of Paris* (fig. 36), *Pietà* (fig. 67), *The Crucifixion of Christ* (plate 4), and *Christ in Olympus* (fig. 37)—conveyed an uncompromising message about the impotence of the pillars of intellectual German culture: the Classical tradition and the Christian faith. Bathed in the unflinching clarity of light-color painting, each work confronted the radical secularization—the dead end of transcendence—emerging at the end of a century of rational historicizing of theology and philosophy. From Schopenhauer, Strauss, Friedrich Schleiermacher, and Søren Kierkegaard to Nietzsche, intellectuals pondered the death of God and gods, while both Catholics and Protestants clung more tightly to a revived religious pietism and intolerance. Contemporary critics in the journals quickly linked Schopenhauer's name to Klinger's art. That the cerebral message Klinger strove to convey in his paintings made them unconvincing aesthetically was perhaps inevitable, despite his acknowledged technical and imaginative mastery.[125]

In *The Crucifixion of Christ* Klinger chose to represent the moment of faith within Christian theology when Jesus of Nazareth, through the suffering imposed upon him by the political power of Rome and the religious condemnation of the Pharisees, becomes the sacrificial Christ transcending death. Object of centuries of imagination, images of the crucifixion, along with other biblical scenes, had since the mid-nineteenth century been subjected to the same historicizing scholarship that was transforming theology. Historical accuracy—depiction of

the disciples as Bedouins or orientalized Jews—was sought in paintings, as long as they retained proper reverence. By 1886 Piglhein's "authentic" panorama, produced with painstaking accuracy, was highly praised by both the public and scholars. By contrast, Uhde's violation of this historical accuracy through his effort to place the Christ of faith into contemporary German village scenes resulted in his being castigated for proletarian sympathies in the years immediately before Klinger's *Crucifixion* appeared.[126]

Working as Uhde did within the new light-color painting, Klinger produced a radically different vision, one that revealed jolting discontinuities and ambiguous confrontations. Historical scholarship became a mockery when the accurately depicted cross served to lower Christ, literally to ground level and physically to an all-too-human man. Defiant historical anachronism appeared in Klinger's depiction of a Pharisee in the red robe of a modern Catholic cardinal, the group of Jews in the tradition of Rembrandt, the Roman couple as a Wilhelmine athlete with his friend, and the setting of Calvary

Fig. 37 **Max Klinger, *Christ in Olympus*, 1897. Oil on canvas, central panel 11 ft. 10 in. x 23 ft. 8 3/8 in. (3.6 x 7.2 m), wings each 11 ft. 10 1/2 in. x 2 ft. 9 7/8 in. (3.6 x 0.86 m). Museum der Bildenden Künste Leipzig.**
This painting was only minimally less controversial than Klinger's *Crucifixion of Christ* (plate 4). It was eventually purchased in 1901 as part of Alexander Hummel's arrangements with the Austrian Gallery in Vienna. Because of insufficient space, the gallery in Vienna sent it in 1938 on indefinite loan to Leipzig, where it remains. The lower panel, depicting the revolt of the Titans, was destroyed in World War II and now exists only in photographs.

above the Italian hill city of Sienna with Classical ruins below. More striking, however, was Klinger's violation of the traditional iconography of the Passion. Instead of a suffering historical Jesus twisting cruelly on an elevated cross, he presented a calm, golden male nude modeled on antique Greek sculpture and vase paintings.[127] The resulting central axis of the painting is the intense confrontation between this serene Classical Christ and a rigid Mother Mary, standing alone in ascetic, nunlike anguish, whom one critic characterized as "one of the greatest and most impressive creations in Klinger's art, the modern type of the deeply grieving mother."[128]

Between them Klinger placed a voluptuous Mary Magdalene, whose flaming red hair, rich red dress, and imploring pose heighten her sensuality. Supporting her is John, the beloved disciple, to whom Klinger gave a face modeled on Beethoven's death mask. John's cloak virtually merges with the Magdalene's dress into a single column that forms the centerpiece of the painting. Behind them, in the shadow of the thief's cross, is a pair of nude males suggestive of homoeroticism. In these enigmatic central figures, surrounded by the simultaneously ahistorical and historical accusers and bystanders, here portrayed as the Catholic Church, Jews, and philistine contemporary Germans, we can read the impotence of both the Christian and the Classical tradition. Yet only the central group in this brilliant scene suggests life: with the death of God, were Music and Eros the only hope for truth and transcendence?

In the next few years Klinger worked hard on his *Christ in Olympus* (fig. 37), which was first shown in Leipzig in 1897 to considerable acclaim, as well as condemnation and, in some quarters, adulation.[129] Larger than *The Crucifixion*, with an elaborate mahogany and marble frame enclosing its wings, this painting explicitly portrays the unresolvable confrontation between pious virtues led by a hyperidealized, golden Greek Christ and the unruly decadence of the gods of antiquity surrounding a flabby ancient

Zeus. Below them, in dark Hades, the Titans vigorously begin their revolt against the bright, static world above. Like its predecessors, this painting is suffused with a sense of pessimism reflecting Klinger's own beliefs based on his reading of Schopenhauer. From Schopenhauer he drew his critique of the world as hell, which he also explored in the multiple graphic cycles, where he particularly exposed the hypocrisy of bourgeois respectability, with its exploitative and repressive attitudes. At the same time, the cycles captured his fascination, joy, and anxiety over woman. Within both the cycles and his paintings Klinger expressed directly the fundamental subjectivity of his work. Creativity for him was an affirmation of existence.[130] In the secularization of Christ, his obsession with the darker sides of sexuality and death, and his existential subjectivity Klinger was abrasive, provocative, and modern. Klinger's never-ending search for meaning in the modern world irritated people and confirmed in others the belief in his importance as a trailblazer into the modern world.

CRITICAL RESPONSES: THE MODERN ARTIST AS MARTYR

The criticism of Klinger's work in the art journals, both popular and art historical, was generally positive, propelling Klinger in the early nineties into the leading ranks of modern artists in Germany.[131] An article in the *Zeitschrift für bildende Kunst* found his work to be pathbreaking in its effect upon viewers, moving them from apprehensive shock to head-shaking, scattered praise, and then growing appreciation for the new art. Behind the acceptance of Klinger's work by critics was the recognition that, as one of them wrote in 1893, "we find ourselves in an epoch of artistic revolution in which much will be torn down and demolished; what is better will remain and ultimately art will have to fall back upon it. Only in this way is it possible to bring about a renewal

of art." This recognition of the necessity of radical change within art to keep up with the rapidly secularizing and modernizing society was summarized in an observation made in 1893 about the purchase of Klinger's *Pietà* for the Dresden Painting Gallery. The reporter asserted that the major worth of this painting "for the present as well as for the future lies in the fact that here once again an artist of intense individuality has had the courage to break with the old dead phantoms and to chose those types for the depiction of inner experiences which live in and have taken shape in his own imagination."[132]

Other writers defined Klinger's modernity as his ability to embody the present moment in artistic form. Klinger, one declared, was thoroughly modern, right to his fingertips. The Berlin critic for *Die Kunst für Alle*, Jaro Springer (1856–1915), in a review of April 1894 exclaimed: "A thrilling picture, this *Crucifixion of Christ*. Beyond all patterns and all the shackles of stultifying tradition." He had been delighted to report the previous year that the Berlin newspapers had unanimously damned Klinger's *Pietà*, which was absolute proof for him of how good the painting was. He himself considered the *Pietà* to be Klinger's best work, "unquestionably one of the most eminent that a German painter has managed to achieve." For the journal writers, however, the audaciousness of Klinger's work in disrupting "all patterns and all the shackles of a stultifying tradition" marked him as an artist true to his times—a modern man. As Heilbut expressed it, "Here is the spirit of our own spirits. . . . Klinger stands in the very center of modern life, . . . a most modern person—a fascinating person."[133]

Standing in this center of modern life, Klinger's art was a drastic response to the calls to create an art that was appropriate for its time. He not only broke with the centuries old iconography and nineteenth-century historicism, he disrupted comfortable categories and assumptions. It is not surprising that this was not welcome to many, whether Catholic or Protestant. Hostile public reactions to Klinger's art

and negative newspaper reviews were all too common. Not only were Roman Catholic leaders reputed to be behind the order in Munich to drape *The Crucifixion* but conservative Protestant clergy in Hanover managed at the last moment to prevent the Kestner Museum from acquiring that painting in 1899 despite a plan organized by a group of local citizens who intended to subsidize the purchase. The director of the Kestner Museum made an impassioned appeal to the public for support in which he insisted that Klinger's painting in its cool rationalism and biblical accuracy was particularly appropriate for Hanover, with its long Protestant history. In a talk to the Hanoverian Art Society, Carl Schuchhardt (born 1859) argued that by breaking with the images of crucifixions inherited from the Renaissance and Baroque eras, Klinger's work freed German religious painting from centuries of Catholic domination, bringing fresh air into religious art years after Luther had achieved it for the church. The painting was, he exclaimed, "an epoch-making step in the evolution of German religious painting."[134]

Even with this overt appeal to the current mood of anti-Catholicism in the Protestant sectors of Germany, Schuchhardt's argument failed to halt the opposition. In fact, just the opposite occurred. The municipal council rejected the offer, and *The Crucifixion* was returned once again to Klinger's studio and to its circulation through exhibitions. The prevalent identification of Klinger's paintings with the rationalizing movements within the Protestant Church enabled conservative Protestant clergy in Leipzig, his hometown and the location of his studio, to mobilize the public opposition that prevented the Leipzig Museum of Art from even trying to purchase any of Klinger's paintings during the 1890s. Julius Vogel, who was then assistant to the director of the museum, later wrote of the "crude protests" that emerged in certain sectors to both *The Crucifixion* and *Christ in Olympus* when the director, Theodor Schneider, along with the professor of art history from the university, tried vainly to convince the public

through lectures on the worth of the painting after the Klinger exhibitions in Leipzig in 1894 and 1897. When both paintings were shown in a special Klinger hall at the Saxon-Thuringian Industrial Exhibition of 1897, Protestant clergy in Leipzig mounted an attack from their pulpits on *The Crucifixion*, which one well-known pastor denounced as "a sacrilegious caricature of the Holy One." In addition, two pamphlets, *Kling! Klang! Klung!* and *The Olympian Criticism of Klinger's Painting of Christ in Olympus*, in which the artist "was critically annihilated, ridiculed, and insulted," were published in Leipzig at this time.[135]

The pattern in which Klinger's paintings were praised by critics in the art world and damned by the public was analyzed in class terms by Singer in December 1893. Uhde, he wrote, made his work understandable to the simplest people, but the spiritual renewal that Klinger provided in his great paintings was only intelligible to the cultural elite. This revitalization was dependent on a high level of humanistic knowledge and aesthetic sensitivity in order to comprehend Klinger's transformation of the spiritual suffering of the biblical persons into the mental anguish of modern people. This pivotal assumption that the mass of the people could not—would not—understand Klinger emerged astonishingly in Schuchhardt's exegesis of *The Crucifixion* in Hanover.[136]

His argument began with a lengthy defense of the form of the crosses—their low height and the crossbar seat—and the nakedness of the crucified men. Both of these factors in the painting were found to be offensive. Schuchhardt carefully explained that Roman crosses were designed to cause a slow death that humiliated and tortured criminal offenders. Placed in open spaces where the public could taunt those on the crosses, the criminals were fully stripped to heighten their degradation. Instead of presenting the Baroque vision of crucifixions, whose elevated Christ, writhing in agony, was at the moment of death, Klinger confronted the viewer with the beginning of a slow process of pain and humilia-

tion in which Christ, in the midst of mocking and apathetic people, resisted that debasement. So here, declared Schuchhardt, Klinger had turned this event "into a great symbol, into a lesson for all people and all times: the imbecile crowd thrust away him to whom they owed the most and crucified him." Klinger's uncompromising, austere view of the death of Christ and his unrelenting and bitter depiction of the apathy and hostility of the common herd, Schuchhardt insisted, was what those who were offended by the painting found so scandalous.[137]

This indictment of the common herd, sandwiched between references to indignation and anger from the public that had greeted the painting in city after city, could hardly have been missed. One wonders to what extent it contributed to the municipal council's refusal to purchase the work for Hanover. Certainly, other writers understood the denunciation of those who opposed Klinger's painting. Five years earlier, Cornelius Gurlitt had commented in a short stanza on the suffering of the new artists at the hands of the public and the negative press:

The few, who understood what was there,
Who were foolish enough not to guard their full heart,
To the philistine opened their emotions, their vision,
Have always been crucified and burned.

Of course, he was writing about Klinger and, yes, about the difficult reception of *The Crucifixion*. Only eight years after its first successful public appearance, Max Schmid (1860–1925) could sincerely believe that in Munich in 1891 the public's response to Klinger had been to cry out "Crucify him, Crucify him."[138] By the end of the decade critics had turned Klinger's painting into a metaphor for the modern artist and artwork suffering at the hands of the uncomprehending masses. The great irony is that as opposition to Klinger, as a leader of the new art, intensified within the public in the scandals of 1893–94, Klinger, far from being crucified or burned, steadily rose in the estimation of the art

world. Alfred Lichtwark (1852–1914), the director of the Hamburger Kunsthalle, summarized this paradox in a pithy quotation that expressed the other side of the equation and appeared frequently in reviews: "It is a dreadful fate to be a great artist in Germany. Appreciation and acclamation from the public usually rest on a misunderstanding."[139] Just as scandal and rejection by the common herd of philistines became the necessary stigmata of the artist genius, so the triumphant procession of the new modern art was accompanied by the demeaning of the public. None of this could have happened, however, without the stage provided to both artists and the public by the great and small exhibitions in cities that dotted the German landscape. To those exhibitions we must now turn.

CARRYING ART TO THE PUBLIC

On a warm, sunny spring day, 23 May 1886, Emperor William I led a procession of his court, ministers of state, diplomatic and artistic representatives from all the German states and many foreign lands, and members of the artistic community in Berlin into the great entrance hall of the Jubilee Exhibition of the Royal Academy of Arts in Berlin, which was celebrating a century of regular exhibitions. The procession entered the great iron and glass state exhibition hall, adjacent to the Lehrter Station, which had been built for industrial exhibitions in 1883 on the model of Paxton's Crystal Palace in London. What the dignitaries saw, however, was not a nineteenth-century commercial fair building but a highly decorated Baroque entrance hall surmounted by a profusely painted and sculpted cupola that soared high above them. As Georg Voss, our eyewitness, reported, the architectural transformation of the building announced that the style of Berlin was no longer dominated by the classicism of Carl Friedrich Schinkel but was following now in the steps of Andreas Schlüter (1660–1714), the architect and sculptor whose buildings and statues had shaped the center of Berlin into a royal city for the first Prussian king, Frederick I. That the cupola was modeled on the Parisian Pantheon and the Invalides did not seem to strike him as ironic. Instead, he strained his head backward to interpret the allegorical paintings that reached far above him (fig. 38). There he found "Germania, surrounded by the symbols of imperial power and attended by a joyful cheering throng of artists, advancing toward the capital city of the German Empire, and Art, floating upwards, receiving from the God of light and beauty the promise of a new flowering." The extravagant architectural scenery continued through a high archway into the

hall of honor, where statues and paintings of Hohenzollern electors and kings in gilded frames looked down upon a colossal bust of William I. Alongside paintings of the royal family were hung Adolph Menzel's *Coronation of King William I in Königsberg* (1865) and *Frederick and His Men at Hochkirch* (1856) and Anton von Werner's *Congress in Berlin* (1881) and *Moltke with His Staff before Paris* (1873).[1]

Against this background, Voss compared William I's triumphal entry with his artists into this exhibition to the emperor's earlier triumphal entry into Berlin at the head of his troops after the successful war of unification in 1871. The opening of this exhibition, which would bring Berlin into the front ranks of the international artistic competitions, was a day of honor for art, Voss exclaimed, not only in Berlin and Prussia but in all of Germany. Crown Prince Frederick William, who had been active in his support of the fine arts in the new nation and was honorary president for this celebration, delivered an eloquent opening speech that urged German artists to watch carefully to ensure "that our art would not be unfaithful to the highest calling of humanity, high and low, poor and rich, to become a source of that exaltation and inspiration that reaches towards divinity." The minister of ecclesiastical affairs, education, and medicine, Dr. Gustav von Gossler, spoke about the history of this exhibition, which had been planned to coincide with the display of the German archaeological discoveries in Pergamum and Olympia. The emperor himself then gave a short speech, the text of which was telegraphed to all the newspapers.

The official ceremonies completed, the procession moved into the art galleries, where a historical

exhibition of German paintings from 1786 to 1886 was set apart from the contemporary paintings and sculptures from other European countries. These came largely from England and Austria, with the notable exception of France, which, Voss claimed, had refused to send an official collection because Germany had not participated officially in the Paris Universal Exposition of 1878.[2] The dignitaries then proceeded into the landscaped gardens of the park surrounding the exhibition hall. There the recent prizes of German archaeology and foreign policy were celebrated in a variety of pavilions and reconstructions of Classical antiquity (fig. 39). On the southern side of the park a massive Egyptian temple, forty meters long and twenty meters deep, modeled on the temples of Denderah and Karnak and brightly painted, contained five separate dioramas in darkened rooms that dramatically presented high points from the German conquests in West Africa. Across a spacious plaza that contained an obelisk twenty-nine meters high honoring the emperor was a broad flight of stairs leading to the reconstruction of the east facade of the Temple of Zeus at Olympia. On the stairs below the temple were full-size casts of the Pergamum altar, with its immense frieze of battling giants, which brought to life the ancient glories now appropriated by Berlin. Inside was a semicircular panorama of ancient Pergamum, sixty meters long and fourteen meters high, staged and painted by two experienced panorama artists from drawings made during the archaeological dig at that site. This temple with its panorama remained a popular part of the exhibition complex in Berlin for years.[3]

During the summer the terrace between these ancient temples became the setting for a spectacular artists' festival. Planned by the Society of Berlin Artists for 17 June, the festival was postponed by the strange abdication and death of King Ludwig II of Bavaria, who was noted for his love of artistic and theatrical settings. When it did take place, on 25 July, thirteen hundred artists and friends, including

Crown Prince Frederick and his family, staged an extraordinary triumphal procession of King Attalus II returning victorious to Pergamum from his wars. The procession that wound through the park to the Pergamum altar was attired in historically accurate costumes and props created through careful consultation with archaeologists and classicists. Musicians playing antique instruments led crowds of Greek citizens, behind whom came long lines of prisoners from defeated countries—Syrians, Parthians, Jews—followed by Black Nubian archers and accompanied by massive siege and war machines. Oxen-drawn wagons carrying captive maidens, warriors on horseback, camels laden with booty, whole wagonloads of booty, and chained princes of barbarian tribes marched ahead of a golden chariot surmounted by a sculpture of the goddess of victory, Nike, holding a laurel crown above the triumphant king. Arriving at the Temple of Zeus, King Attalus and his courtiers were greeted by a host of priests and priestesses with a choir of singers, who proceeded to an elaborate sacrificial ceremony in honor of the conquering ruler—all of which produced, as Werner exclaimed, "a painterly mass picture of indescribable beauty."

The text of these festivities was written by Dr. Max Jordan (1837–1906), the director of the National Gallery, and read by one of the professors of the academy. After the ceremony, the captives were released with great jubilation, doves and flowery wreaths were thrown into the air, and ancient games and competitions in honor of the archaeologist Karl Humann, who had discovered the Pergamum altar, began in the forecourt of the temples. Then the fun began: the park turned into a grand bazaar filled, all night, with dancing, booths with Greek and captive maidens serving wurst and beer, and witty sideshows based on Classical themes, such as the Trojan horse that turned into a peep show. Returning to nineteenth-century reality, a report issued by the Society of Berlin Artists in July said that its members had voted against a second festival that had

A

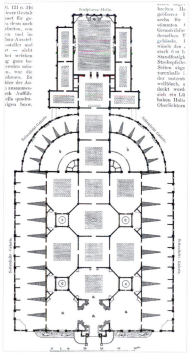

B

Fig. 38 **Berlin Jubilee Exhibition, 1886.** *A.* **Entrance hall, cross-sectional drawing of internal elevation with details of paintings and sculptures, from** *Centralblatt der Bauverwaltung* **6, no. 30 (July 1886): 297.** *B.* **Floor plan of the newly reconstructed exhibition halls showing the entrance hall (a) with its elaborate sculptural structure supporting the cupola, from** *Centralblatt der Bauverwaltung* **6, no. 19 (May 1886): 178.** *C.* **Plan of the exhibition grounds in central Berlin, from** *Grosse Berliner Kunst-Ausstellung 1893, 14 Mai bis 17 September im Landes-Ausstellungsgebäude am Lehrter Bahnhof: Illustrirter Katalog* **(Berlin: Verlag von Rud. Schuster, 1893).**

The new exhibition hall was not only located in central Berlin, it was directly adjacent to one of the principal railroad stations serving the city. The railroad tracks running to the Lehrter Station cut directly across the middle of the grounds, separating the main exhibition building from the extensive park with its gardens, lakes, restaurants, and classical temples. This plan from the 1893 exhibition catalogue (*C*) is essentially the same as the original plan, created in 1886, except that the Kaiser Diorama and the Obelisk do not appear on the later plan. The scale of the elevation drawing of the entrance hall (*A*) gives a sense of the size of the exhibition galleries, designed to accommodate the large crowds that trooped through the exhibition.

C

A

B

Fig. 39 *A.* **View of the Pergamum Panorama and the Obelisk in the 1886 exhibition park in Berlin.** *B.* **A ground plan of the end of the park where the Pergamum altar was located, with details of the floor plans of the temples and restaurant,** from *Centralblatt der Bauverwaltung* **6, no. 20 (May 1886): 186–87.**

This scene, published in a major German architectural journal, shows the central courtyard between the Temple of Zeus, containing the Pergamum Panorama, and the Egyptian temple (not shown in the picture). In the center is the obelisk honoring William I, and halfway up the stairway to the temple is the replica of the massive Pergamum altar, showing the section of the giants fighting the gods. The full-scale re-creation of the original temples demonstrated the cultural, economic, and political significance of these great art exhibitions. The five dioramas in the Egyptian temple, celebrating imperial scenes of colonial expansion, depicted Stanley in the Congo; the burial of the German African specialist Nachtigal on the ship Möwe; Dr. François on an elephant hunt; the sealing of blood brotherhood between the German Flegel and King Massuah; and the German fleet in Zanzibar.

been planned for the summer, news that was greeted with disappointment from the public. Happily, the festival was a box-office success, earning more than fifteen thousand marks in profits from a total intake of seventy thousand marks.[4]

While the opening ceremonies for the exhibition had been filled with pomp and circumstance, the closing ceremony, which had been postponed until the end of October to accommodate the crowds, was light and festive despite the frosty autumn weather. The remarkable success of the exhibition in reaching the public was confirmed by the report of the secretary of the academy, delivered to the members of the academic senate and of the academy, who, along with city and state officials, had gathered again at the exhibition hall. The numbers were impressive: 3,500 works hung; 10,000 season tickets purchased; an income of 660,000 marks in addition to a Prussian state subsidy of 100,000 marks (used largely for renovating the building), a 60,000-mark subsidy from another source, and 100,000 marks from the royal disposition funds; sales ex-

pected to exceed 1 million marks, with purchases of 160,000 marks made by the state using royal funds approved by the emperor.

Gossler, the cultural minister, spoke with pride and joy about the exhibition and expressed sadness that it was closing. "All of us are oppressed by a sense of mourning and sadness, as if we were parting from an old faithful friend, a friend who has refreshed us, not only in joyful hours through merryness and good humor, but also in the serious hours, and raised and lifted us out of the narrowness of daily life." The minister then suggested the significance of this exhibition in overcoming stereotypes and prejudices of other nations. "All of the lands of Europe and many from beyond the ocean have answered our hospitable invitation and have pleased us with their sincere participation and recognition. Many prejudices have been destroyed through their own eyes, many rifts bridged over, clarity and understanding of our particular nature have been spread far beyond the boundaries of art." And finally, in this speech quoted at length in *Die Kunst für Alle*, he stated proudly that "art had gradually taken up its dwelling among us, had found in the north a firm home." Elated by the good news, the final procession wound through the park to the terrace before the Pergamum altar, where a sacrificial flame was tended by a procession of Greek priests and priestesses. Then dinner was served in a great hall before a stage with a *tableau vivant* representing Frederick the Great with his generals.[5]

By the time the gates were finally closed to the public, at six o'clock in the evening of 31 October 1886, well over 1,210,000 members of the public had traveled from near and far to visit this exhibition.

THE BERLIN JUBILEE EXHIBITION OF 1886: THE POPULIST SUCCESS OF THE GREAT EXHIBITIONS

Friedrich Pecht, who traveled from Munich through Dresden to Berlin in May 1886 to attend the opening ceremonies of the Berlin Jubilee Exhibition, began his article written in anticipation of the event with the questions, "Where are we coming from? Where are we going?" No one, he said, should enter this first great exhibition in the heart of the new German Empire without realizing its significance. Up until this point Germany had experienced only three great "epoch-making" exhibitions, which he identified as those in Munich in 1858, Paris in 1867, and Munich again in 1876, all important markers in the formation of German fine arts and crafts. For Pecht, the critical question to be answered by this great exhibition in the German capital was whether fifteen years as a powerful unified nation had brought about a genuine nation embodied in its art. Comparing the contemporary German sections in the exhibition with the historical and international sections "could reliably teach us whether the creative strength of our nation is in decline or is still healthy and unscathed; yes, in the quiet process of growth, whether a new world is coming into being and what of the old has become obsolete."[6]

Pecht's hopes for a unified national art were not fulfilled in the exhibition. Although *Die Kunst für Alle* devoted seventeen feature articles to an exhaustive survey of the works shown in the exhibition, Pecht's disappointment in the Berlin section was undeniable. Pointing out that the Berlin rooms were filled with Oriental harems and fair Italian maidens, Pecht chastised the artists for their failure to depict contemporary life. The exceptions to this, Menzel and Werner, appeared not to have influenced the other artists. As the capital of Prussia, Berlin had produced a scattering of exceptional artists in the course of the century. The legacy of Schinkel and Johann Gottfried Schadow (1764–1850), the presence of the Prussian Royal Academy of Arts, and the eminence of Menzel notwithstanding, Berlin's reputation within the art world by the 1880s was marginal. And despite its pomp, this academy exhibition failed to alter that perception. Except for Max Liebermann, who had recently returned to Berlin from Munich, the Berlin

artists did not make a good showing compared either with the strength of the Munich contingent, including paintings by Fritz von Uhde, or with the elegance of the English works of Edward Burne-Jones, Walter Crane, Frederic Leighton, John Everett Millais, George Frederic Watts, and Hubert Herkomer.[7]

Instead of blending together into a strong national art, art in Germany continued to be characterized by regional distinctions and competition. A factor underlining Berlin's weakness as a city of art was the absence of a serious art journal before 1890. Writing in 1895, Oskar Bie (1864–1938), the new editor of the *Neue Deutsche Rundschau* (New German review), attacked the daily press in Berlin for its failure to provide adequate guidance and criticism of the visual arts, which, he claimed, had led to disinterest on the part of the Berlin public, making it impossible for progressive art to find a foothold in the city.[8] The major art journals of the new empire in fact were not published in the capital. *Die Kunst für Alle* was edited and published in Munich, which remained a monarchy under the Wittelbach dynasty; *Der Kunstwart* appeared in Dresden, seat of the royal house of Saxony; and the *Zeitschrift für bildende Kunst* was published in Leipzig, the center of the book trade, although its editorial offices were in Vienna, where the editor was also the librarian for the Austrian Imperial Academy of Art.

The poor showing of the Berlin artists did not, however, detract from the overall achievement of the Berlin Jubilee Exhibition. The strength of the exhibition lay not in the works of art, although paintings by important artists from elsewhere in Germany and from England were shown. The significance of the exhibition lay, Pecht concluded, in the integration of art within "a great harmonic whole" that conveyed a sense of higher beauty to the public, not only in Berlin but in the entire nation. In the well-decorated galleries and the beautifully landscaped park with its re-creation of Classical buildings, the public encountered art at a profound level, which might alter Berlin's negative reputation in matters of art. Voss, also reporting in *Die Kunst für Alle*, considered the gardens, with the concerts, restaurants, and exotic pavilions, to be a necessary means of enticing the thousands of visitors who otherwise would have remained far away from art exhibitions. Berlin, more than any of the older art cities, Voss thought, needed to reach out to the great masses of the people to educate them about art before the city itself could become a "City of Art." Werner agreed with this assessment when he claimed, years later, that the ten to twelve thousand who had visited the Berlin Jubilee and its park each night that summer had been attracted by the restaurants and the concerts, all of which had remained "inseparable from the enjoyment of the visual arts since then."[9]

Thus, even if it was not perceived as a great artistic moment by some critics, the Berlin exhibition was an emphatic public and financial success, both profitable and popular.[10] The numbers demonstrate more effectively than the aesthetic judgments of critics the social and cultural importance of these great exhibitions in the last decades of the century. When well over a million people flocked to an undistinguished city in order to swarm through the galleries and temples devoted to art, when close to a million marks were poured into the coffers of an art exhibition, not to mention the moneys spent for food, souvenirs, lodging, and transportation, art and its presentation became public matters. Or to put it another way, the public in the 1880s and 1890s became a central factor in an operation that was designed to display and distribute hundreds, often thousands, of works of art to multitudes of people.

The public were an obvious ingredient in this process as the final recipient of the display and as possible patrons, but the necessity of attracting a multitudinous public was a primary consideration in determining the shape and substance of these exhibitions. The centrality of the public was underlined by the essential role of the extensive reviews, reports, and advertisements in journals and newspapers that informed and drew the crowds to view art. Royal pro-

cessions, pageantry, and entertainment were calculated to enhance the social prestige and desirability of attending the exhibitions, beyond the simple act of viewing works of art. The presence of royalty, high officials, and diplomats at the openings endowed the exhibitions with state and national solemnity and significance. The Berlin Jubilee Exhibition of 1886 was exemplary in demonstrating all of these qualities, though it was not alone. Exhibitions dotted the artistic landscape in Germany in these decades. The largest were in Berlin and Munich, with Düsseldorf, Dresden, Karlsruhe, and other smaller cities not far behind in their competition for the public's attention. The journals give one the sense of a hustling, bustling scene that was well integrated into the cultural life of the time, certainly of the middle classes, for whom attending an art exhibition was more prestigious than attending a sporting event.

These great art exhibitions in Germany evolved during the latter half of the century, with the construction of large industrial halls that could accommodate great numbers of artworks, as well as particularly large canvases, and substantial crowds of people. These conditions, combined with a relatively stable artistic population, contributed to the popularity of the salon or exhibition painting, a large canvas with a particularly sensational subject that would attract the attention of the public in the crowded galleries. These were oil paintings packed with larger-than-life mythological or historical scenes that took years to create. Often too large for any but the most palatial villa or museum, they were designed to establish an artist's reputation, bringing commissions or sales for more modestly sized works. The public that streamed into exhibitions in the 1880s went with the expectation of being awed by the newest large canvases of their favorite painters, for example, Wilhelm Lindenschmidt's (1829–1895) gruesome vision of *Alaric's Entrance into Rome* in Berlin in 1886 or Ferdinand Keller's *Emperor William, the Victorious Founder of the German Empire* (fig. 2), which measured five by seven meters,

in Munich in 1888.[11] The Berlin Jubilee Exhibition was, again, an ideal setting for these predictably grandiose artworks.

When visitors to the Jubilee Exhibition like Pecht looked for images forecasting the future, they did not realize that the omens that foretold the new art world were not hanging on the exhibition walls but were pragmatic and technological matters hidden from view. The factors that presaged a new era were to be found in the administrative organization, especially of financial matters and publicity, and in the technical mechanisms, such as well-designed buildings, electric lighting, and heating. Of paramount importance for the development of these great exhibitions were the railroad networks, which enabled works of art to be transported rapidly around circuits of exhibitions and which carried a mass public to the spectacular great exhibitions. For the 1886 Jubilee Exhibition, the extraordinary numbers of visitors were attracted by extensive advertising and special trains arranged for by Berlin authorities to bring visitors to the exhibition from Munich, Cologne, Königsberg, and Breslau.[12] These developments, expanding over the next decade, served initially to strengthen the regional centers of art in Germany by making renowned works of art available to more local exhibitions, as well as bringing more people into cities to view those works. On the other hand, the transportability of artworks and publics served, in the long run, to undermine local, regional, and, ultimately, national particularity. Less than a decade after the Jubilee Exhibition critics complained that exhibitions were beginning to look alike as artists, influenced by what they saw in those exhibitions, began to paint in similar ways.

The transformation of provincial museums catering largely to local populations, except for the wealthy upper strata of society, who could afford to make the Grand Tour, was well under way by the 1880s in Europe. The new world in which great exhibitions attracted tourists from "from all the lands of Europe and from over the seas," as Gossler put it,

had been inspired by the first world's fairs.[13] No art exhibition could hope to attain the attendance numbers of the Paris Universal Exposition of 1889, with 32 million visitors, or the Chicago world's fair of 1893, with its record of 716,000 visitors in one day. Still, the Berlin Jubilee Exhibition in 1886 attracted an enviable number of visitors, bringing profits to both the city and the exhibition's sponsor. That a large proportion of the art-viewing public came from outside the city, whether from Germany or abroad, is apparent from the fact that the total population of Greater Berlin in 1885 was only slightly larger than the number of visitors to the exhibition.[14] The commercial success of the Berlin Jubilee, quite apart from the critical reception of its art, accelerated the competition among the German cities to attract an audience for their art and tourists for their economies.

The following year, the modest Berlin Academy Exhibition, which opened in mid-July 1887 in a much less opulent setting, with few sensational artists to interest the public, was still able to bring in a quarter of a million visitors in two months and to close the books with a solid profit.[15] Coming on the heels of the grandiosely traditional Jubilee, this exhibition unexpectedly brought into its midst portents foreshadowing uncomfortable change. On the walls were hung a fair number of paintings by young artists who were working on contemporary subjects set in bright daylight. The public, said observers, laughed at paintings such as a startling portrait of a woman in red by Hermann Schlittgen, which was also denounced by local Berlin critics who "longed for the good old times." Max Klinger's *Judgment of Paris* (fig. 36), with its stiff nudes and extraordinary sculptural frame, drew negative attention, with even a sympathetic critic rejecting it as "a baroque hallucination." The exhibition also received unexpected publicity occasioned by the jury's rejection of Hermine von Preuschen's *Mors Imperator* (fig. 3) and its subsequent independent showing.

Yet, reviews in the journals of this 1887 Berlin Academy Exhibition were by and large positive, find-

ing its strength in the young artists, whose open-air paintings portrayed people drawn not from Black Forest peasantry or great historical events but from contemporary society caught in the mainstream of life, such as Liebermann, Uhde, Franz Skarbina, Leopold von Kalckreuth, and Friedrich Stahl. Even Adolf Rosenberg reluctantly acknowledged that the paintings of these artists proclaimed a definite turn away from romantic and fanciful scenes toward the light-filled depiction of ordinary life. Ludwig Pietsch, who was one of the most conservative and influential of press critics, and no friend to new art, praised what may have been the most eccentric attempt in the exhibition to bring high art into the modern industrial age: Reinhold Begas's *Electric Spark*, a sculptured lamp in which the electric spark that lit the bulb, hidden in a palm tree, was conducted through the lips of a kissing couple (fig. 40). A review in the *Berlin Börsen-Courier* (Berlin stock market report), however, recognized that this kind of pretty scene was what the open-air paintings in the exhibition rejected. "The era of romantic pages and noble maidens is completely over," the reviewer asserted, "and also the flirting, intriguing chambermaid who, just as false as her lover, the true-hearted lanzer—all are bankrupt." This reviewer was certain that Millet's painting of the farmer-laborer folding his calloused hands for prayer at the sound of the vesper bell had turned all of those ghosts in genre painting into a "ridiculous comedy."[16] The review points to a little-understood aspect of the great exhibitions: they served in these decades as the principal vehicle for delivering the new, modern art to an immense art-viewing public.

THE MUNICH INTERNATIONAL OF 1888: THE NEW ART INVADES THE GREAT EXHIBITIONS

The financial success of these exhibitions of 1886 and 1887 in Berlin and the impressive number of tourists they brought to the city galvanized Munich

A

B

Fig. 40 A. **Reinhold Begas (1831–1911),** *The Electric Spark*, **c. 1887. Marble, life-size figures, height 9 ft. 7 in. (2.9 m). Location unknown. Reproduced in** *Die Kunst für Alle* **3, no. 12 (Mar. 1888): 183, and here from** *Moderne Kunst* **3, no. 1 (1889).** *B.* **"Begas, Reinh., 'A Great Equilibrium Production (Electric Light-Effects in the Evening),'"** **in K. Cassius,** *Mockingbird in the Glass Palace* **(1888), 39.** Begas reproduced versions of this sculpture in a variety of materials and sizes, from a small marble statue of 52 inches to a bronze one over 15 feet high. This photograph (*A*) brought an approving commentary from *Moderne Kunst*: "Here finally a modern sculpture has appeared that fully expresses the ideas of our time with realistic power." K. Cassius gently disagreed with those who praised the sculpture for its modernity. In his caricature of the lamp (*B*), he replaced the romantic nudes with two modern athletes, male and female, demonstrating their physical prowess on the upright bar with its dilapidated umbrella.

to reassert its own dominance with the Third International Art Exhibition of 1888, followed rapidly with the great exhibitions held every year. Until the Berlin Jubilee Exhibition, the most prestigious exhibitions, and the ones with record total sales, had been Munich's international exhibitions.[17] Organized by the powerful Munich Artists' Association, the international exhibitions were held near the center of the city, in the Glass Palace. Built by the Bavarian government for the Industrial and Crafts Exhibition of the German Custom Union in 1854, the Glass Palace was later made available to the artists' organization for these large art exhibitions at no charge (fig. 41). This industrial hall, with its huge flexible space and advanced technology—in 1882 electricity was installed—made Munich the envy of other cities, whose academy and gallery spaces were unable to compete with Munich's (or, after 1886, with Berlin's similar exhibition space). Munich's Glass Palace was not the only physical manifestation of royal and municipal support for contemporary visual arts in the city. An elegant neoclassical exhibition building completed in 1848 on Königsplatz housed the regular smaller exhibitions of contemporary art organized by the Munich Artists' Association from 1872 to 1889; the Munich Art Society maintained continuous short-term sales exhibitions of current local artists in their own gallery at the edge of the Hofgarten; and the New Pinakothek, opened in 1853, was designed to contain the royal collection of contemporary art, while the Old Pinakothek displayed the great masters of the past.[18]

The Glass Palace had enabled Munich to stage an exhibition of international artists in 1869, an exhibition that, with almost forty-five hundred works and one hundred thousand visitors, was the largest in Germany up to that time. More than sheer quantity, it also presented to the German audience a significant view of art from other European nations, above all a collection of contemporary French painting, with a room devoted to Gustave Courbet's

work, as well as paintings by Édouard Manet, Camille Corot, Théodore Rousseau, Jean-François Millet, and others from the Barbizon School. The 1879 International, officially the First International Art Exhibition in Munich, also featured a generous selection of recent plein air and naturalist French painting, as well as paintings of the Hague School. The sensation of the exhibition, however, was Liebermann's painting *Jesus in the Temple* (plate 1). The Third Munich International, of 1888, was intended to reestablish the artistic preeminence in Germany of Munich's international art community. *Die Kunst für Alle*, which was based in Munich and therefore had a vested interest in these exhibitions, began reporting on the plans for the 1888 exhibition within months of the closing of the Berlin Jubilee Exhibition. Keeping its readers well informed about new developments, the journal followed the exhibition closely from start to finish, with nine lengthy lead articles and frequent reports on the financial achievements of the exhibition.[19]

In May 1887 the Munich municipality guaranteed the 15,000 marks needed for the 1888 exhibition. A report in June referred also to funds established by both city and state to build another exhibition hall along the Isar River for the great arts and crafts exhibition that was to be held simultaneously with the 1888 art exhibition. The reporter noted that these funds were insufficient for the project but would serve to encourage banks, heavy industry, hotels, and other capitalist institutions to invest in the new project "because the issue here was over a highly important undertaking for Munich, of whose success, moreover, there was scarcely any doubt, as long as no unexpected calamity occurred." In October the Bavarian parliament budgeted 440,000 marks to establish an endowment fund for purchasing artworks and an additional 60,000 marks specifically for purchases at the Third International. This was in addition to the annual budgeted amount of 8,600 marks for exhibitions. The approval of these special funds was

III. Jahrgang. Heft 19 1. Juli 1888

A

Fig. 41 **Third International Art Exhibition in Munich, 1888, held in the Glass Palace (built 1854; burned 1931). A. Photograph of the main entry hall, with a bust of the royal protector of the exhibition, Prince Regent Luitpold. Reproduced in** *Die Kunst für Alle* **3, no. 19 (July 1888): 291. B. Photograph of the exterior of the Glass Palace, c. 1890.**

motivated in part by the fact that the Prussian budgets supporting art were generally substantially larger than Bavarian budgets. *Die Kunst für Alle* pointed out in the spring of 1888 that the Prussian budget for art acquisitions alone in the coming year was much greater than the entire Bavarian budget for supporting art.[20]

When it finally opened in June of 1888, the Third Munich International was a smashing success. It brought an almost encyclopedic overview of contemporary European art to the more than three hundred thousand visitors who thronged the galleries from June to October. Sales topped 1,050,000 marks, and profits exceeded 100,000 marks.[21] The journals proclaimed its financial success but laid much greater emphasis upon the exhibition's significance in providing a view of the developments that had taken place in German art within the context of changes in the major European art centers. Following the practice in past exhibition, the paintings were grouped in national sections. Since close to half of the artists whose works were hung were non-Germans, the exhibition gave the visitor an extensive

B

survey of contemporary art from the other major European states. This could be compared with both contemporary German art and a special historical section on early-nineteenth-century art in Munich. Readers of the long, detailed reviews in the journals could also follow these developments. The 1888 exhibition had national sections for Austria, Hungary, England, Holland, Belgium, Switzerland, Italy, Spain, France, and the Scandinavian countries. *Die Kunst für Alle* published detailed reviews of each of these sections and devoted the illustrations in ten issues of the journal to reproductions of art from the exhibition.

The reviews in *Die Kunst für Alle*, written by Pecht, enumerated the non-German artists and their works by national categories, while the German paintings were reviewed by subject categories—genre scenes, portraits, soldier images, animals, and landscapes. Thus, a reader of the journal might envision a world of art that was not substantially different from that in previous exhibitions. Careful readers, however, would realize that the exhibition presented a changing art world, a transformation that was emphasized by Ferdinand Avenarius in *Der Kunstwart* and by the young critic Richard Muther in the *Zeitschrift für bildende Kunst*. Major paintings singled out for comments by the reviewers represented a variety of the approaches and styles of the new art, ranging from Liebermann's sober German and Dutch scenes, *Munich Beer Garden* (1883–84), *Old Men's Home in Amsterdam* (1881), and *Flax-Scourers in Laren* (fig. 31), for which he received the small gold medal; Uhde's much-criticized *Sermon on the Mount* and his acclaimed triptych *Holy Night* (1888–89); Arnold Böcklin's imaginary *In the Play of the Waves* (plate 3); Klinger's controversial *Judgment of Paris* (fig. 36); and Gabriel Max's cloying madonnas to Albert Keller's sensually perverse *Witch's Sleep* (fig. 42B) and Wilhelm Trübner's striking portrait *Smoking Moor* (fig. 42A).[22] Most of these were reproduced in *Die Kunst für Alle*, as were the two more traditional

sensations of the exhibit, Emmanuel Frémiet's *Gorilla* and Ferdinand Keller's apotheosis of Emperor William I (figs. 1 and 2). Standing out among many less distinguished salon paintings from other nations were canvases by Benjamin Constant, Corot, Charles Daubigny, Millet, James Abbott McNeill Whistler, and Herkomer. The influence of the lighter colors of the Barbizon School was evident, according to reviewers, in many of the other works. Beyond agreeing on the strength of the artwork exhibited and the centrality of Munich as the "principal seat of German art" and one of the leading art markets in Europe, opinions about the significance of the exhibition varied.

The views of three influential critics in the journals we have followed offer insights into the variety of contemporary reactions. Pecht, in *Die Kunst für Alle*, worried that the increasing similarity of artworks prevented genuine national characteristics from emerging, though he thought that the German artists were less affected by the mannered cosmopolitan tendencies. He was pleased that Germans were showing healthy signs of concern for contemporary issues in their paintings on religious issues—the exhibition had an inordinate number of subjects drawn from the life of Christ, including those of the ubiquitous Uhde—and on the plight of the proletariat, a subject that he believed opened up a whole new world for artists. In his summation, he reiterated his insistent message that German art must remain close to the ideals of the people: "The flourishing of art is not tied to the individual, . . . rather it stands and falls with the whole people, about whose life it is the highest expression." Furthermore, he insisted once again, "art can only be truly healthy when the people take an active and deep part in it." And this, he believed, had taken place in the last decades.[23]

Avenarius, in *Der Kunstwart*, similarly focused on the dominance of religious painting among the younger artists, defending the "leftist" biblical depictions of Uhde. He was critical both of Ferdinand

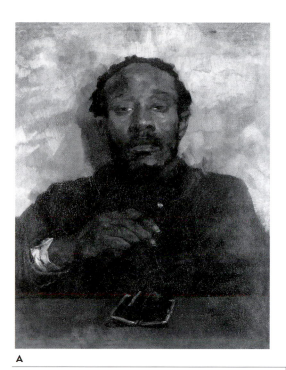

A

B

Fig. 42 *A.* **Wilhelm Trübner (1851–1917),** *Smoking Moor* **(also titled** *Flat Broke***), 1873. Oil on canvas, 24 1/2 x 19 1/2 in. (61.5 x 49.5 cm). Niedersächsisches Landesmuseum Hannover. Reproduced in** *Die Kunst für Alle* **3, no. 23 (Sept. 1888): 369.** *B.* **Albert Keller (1844–1920),** *Witch's Sleep,* **1888. Oil on canvas, 92 7/8 x 74 in. (236 x 188 cm). Location unknown. Reproduced in** *Die Kunst für Alle* **12, no. 13 (Apr. 1897): n.p.**

Trübner was a member of the painter Wilhelm Leibl's circle of friends and followers in Munich during the 1870s. Trübner's early paintings of those years (*A*) were criticized and ridiculed for their realism; critics found them too drastic or experimental in their efforts to reproduce tactile perceptions of surfaces and shapes. By the 1890s his works had come to be recognized as important forerunners to the newer open-air painting. In his paintings Keller (*B*) sought to represent inner mystical reality in contrast to Trübner's focus on the realistic depiction of external surfaces. Deeply influenced by spiritualist movements, Keller was fascinated by the narrow line between life and death, between spiritual and physical reality. His famous early paintings depict the biblical tale of Jairus's daughter rising from the dead and a series of somnambulant and martyred women, as in this painting representing the transcendence of spirit at the moment of death by fire, which was shown in the Third Munich International in 1888.

Keller's *Emperor William,* an unfortunate example of "the unartistic allegorical business, a painterly tumor," and Frémiet's *Gorilla,* "the half revolting, half ludicrous gorilla lady-killer." In a sense, William I presided in splendid processions over both the 1886 Berlin and the 1888 Munich exhibitions. Though he died in the spring of 1888, William I dominated the hall of honor in Munich thanks to Keller's processional painting. Keller's work, however, was not in keeping with the paintings from across Europe that showed the influence of the Dutch Hague and the French Barbizon Schools, both of which were well represented in Munich. Avenarius particularly lamented the absence of the brilliant work of "Manet and his school of Impressionists," which he considered to be important for German artists to study. He was not excited about Liebermann's new work, commenting that Liebermann was stubborn, indeed obstinate, in his technique of using blotches to capture his vision of natural life. Praising Böcklin's *In the Play of the Waves* (plate 3) and paintings by others in the "modern movement," he had little good to say about the older narrative and genre paintings in the exhibition,

including Werner's new painting of high court society.[24] Muther, in lengthy reviews for the *Zeitschrift für bildende Kunst*, also regretted the absence of the most modern French painters, but he praised Munich for obtaining from private collections outstanding paintings of the Barbizon School and especially the work of Jules Bastien-Lepage. Muther was enthusiastic about the significant developments that he perceived in the exhibition. Uhde, Liebermann, and Hugo von Habermann were leading German art in new, positive directions, away from the earlier ugliness of the "poor-people painting" and the extremism of some of the French painting. He approved of the new artists' turning from the theatrically sensational paintings of past great exhibitions to honest and true contemporary scenes.[25]

These three critics, writing for quite different journals, presented distinctly diverse viewpoints at the core of which was agreement: the Third Munich International was a valuable event in the artistic life of the nation, one that merited careful observation. By contrast, much of the art in the Berlin Jubilee Exhibition, considered by itself without the elaborate setting of the park, was marked by a provincialism that was not in accord with a dynamic new industrial state. In the decade that followed, these patterns became more pronounced and more obvious to even casual observers. The annual exhibitions in Berlin, whether planned by the Academy of Arts or by the Society of Berlin Artists, were increasingly perceived to be mediocre and boring, except for the Berlin International of 1891. In the nineties reviewers tended to launch into critiques of the whole academic exhibition system when they wrote their reviews of the Great Berlin Art Exhibitions. On the other hand, the annual exhibitions that followed the Third Munich International became more controversial and lively, with critics disagreeing about the works. In both cities, however, regardless of critical opinions, the public continued to swarm to these great exhibitions, noisily expressing their own views about the works hanging on the walls.

GREAT EXHIBITIONS: THE MATERIAL BENEFITS OF PUBLIC ATTRACTION

There was, however, an opposing trend: the Berlin exhibitions consistently attracted more visitors and were more successful financially through the mid-nineties than the artistically more significant Munich exhibitions. People flocked to the Berlin exhibitions, while critics praised Munich. The Berlin Jubilee Exhibition in 1886 drew well over a million visitors, fully four times the quarter of a million who attended the Third Munich International of 1888. Moreover, attendance at the 1887 and 1888 Berlin Academy Exhibitions also exceeded that at the 1888 Munich International. That the city of Berlin was twice as large as Munich does not account for the surprising difference in attendance, especially given the then current perception that Munich as a city was much more engaged in art and much more open to innovation than Berlin. What is therefore particularly noteworthy is that both the 1887 and 1888 Berlin Academy Exhibitions were modest in size and setting and deliberately featured mostly smaller works, including many watercolors and drawings from the open-air artists.[26]

Voss, reporting as usual on the Berlin exhibitions for *Die Kunst für Alle*, pointed out that these works, which were small, colorful, and pleasant enough to sell, were the works that artists produced to survive, as opposed to the large, dramatic works created for the great exhibitions, which brought fame to the artist but did not sell because they were too big and often too uncomfortable for private homes. Instead, he wrote, the large works joined the circuit of exhibitions and then returned to artists' studios. Voss, however, found the special collections in the 1888 Berlin exhibition of watercolors by Menzel, Skarbina, and Hans Herrmann to be especially fine and thought that Liebermann, "the most thorough-going impressionist," and Arthur Kampf, "the wildest impressionist," had both moderated their painting style in

praiseworthy fashion.[27] Although Voss in this judicious review did not find the light-color painting to be disturbing and was not bothered by the marketable aspects of the paintings, other critics condemned both aspects of this exhibit, seeing the small light-color paintings as further proof of the modern, consumer-oriented mass production that degraded art. Thus among the most vociferous voices that were soon raised, in the name of a new modern art, against the sterility of the art of the great exhibitions in Berlin were competing voices that located that sterility in the very rise and dominance of that new art.

The complexity of individual responses from critics and from the public—although the word suggests a singular collective, the public were far from speaking with one voice—makes it difficult to gauge why the public attended art exhibitions. What we *can* say, however, is that there was in these decades a steady pattern of people pouring into the exhibitions that critics writing in the journals derided and attacked. Continuing over the next decade, this pattern was a sure indication of the troubling divergence between critical responses and public attention to contemporary art. Not only the attendance figures but also the financial records disclose this contrary pattern. A report in *Die Kunst für Alle* in 1893 explicitly concluded that "the Berlin exhibitions continuously have favorable financial results; against this, the Munich generally have deficits; at best, in consideration of the importance of the exhibition, barely mentionable surpluses." Munich, it pointed out, was unable to achieve results that even approached those of Berlin's exhibition of 1886, with its surplus of more than 173,000 marks, or Berlin's profits again in 1891. Officials in Munich attributed Berlin's profits to its success in attracting the public through its parks and entertainment and the stronger tourist traffic of a larger metropolitan capital city. The report in *Die Kunst für Alle*, however, claimed that the business practices of the private artists' association in Munich were less rigorously controlled than was the Prussian state bureaucracy that regulated expenses for Berlin. As an example, it compared the levels of efficiency of advertising in relation to entrance fees in both cities. Munich charged a higher entrance fee, 1 mark, compared with Berlin's 50 pfennigs; both had season passes at various prices. A chart, adapted and reproduced here in part, gave a clear picture of the differences in income and expenditures, as well as the magnitude of these projects, between the exhibitions in the two cities. It also revealed the extent of advertising in journals, newspapers, and posters that was intended to entice people to attend or, at the very least, to attract public attention.[28]

Income and Expenditures	Munich	Berlin
1889		
Advertising and posters	23,747 marks	8,159 marks
Income from entrance fees	85,976 marks	133,693 marks
1890		
Advertising and posters	24,341 marks	8,781 marks
Income from entrance fees	97,502 marks	112,416 marks
1892		
Advertising and posters	65,826 marks	10,849 marks
Income from entrance fees	136,178 marks	146,935 marks

Despite these disjunctures between aesthetic prestige and financial success, the material benefits of these great international exhibitions and the intangible blessings of fame that were bestowed upon the artists and the city together generated the civic support necessary to maintain these large projects. It was obvious that these exhibitions—unlike most of the great traveling exhibitions of the late twentieth century—were not designed just for viewing and

entertainment. They were essentially international marketplaces offering works of art for sale. For the artists, the sale of a painting in the great exhibitions could provide a year's income, as well as enhancing the possibility of further sales. For the city, money flowed in with the art-loving tourists, whose numbers multiplied rapidly as railroads opened up an era of mass travel.[29]

Outside of the opening and closing celebrations, which involved large numbers of local citizens, only a minority of those who viewed the exhibitions were from the host city. Published discussions about the organizing and funding of the exhibitions are threaded through with references to the money brought to city businesses by the influx of wealthy English and American patrons, as well as people from towns all over Austria and Germany (fig. 43). With elaborately decorated galleries and entrance halls, cafés, beer gardens, and popular concerts, the exhibitions became cultural centers in which the massive salon paintings and sculptures of high art were enfolded within popular entertainment. Tainted by popular culture, the art of these exhibitions inevitably lost its appeal for the sophisticated. In effect, this art no longer served as the desirable coin of cultural difference. Once the gates of the exhibition were breached by clerks and shopgirls, the great exhibitions and their outsized canvases became the object of scorn from those with refined taste and high cultural aspiration. Over the decade of the nineties the process of cultural differentiation—which should not be confused with class distinction, though that was an ingredient in the mix—advanced steadily, but not simply.

The disdain expressed by the elite did not, however, affect the appeal of great exhibitions for cities that sought to enhance their prestige and position. On the contrary, the desirability of exhibitions as a means of establishing a reputation was great enough to encourage substantial financial investments from the public and private sectors for decades. Both the municipal and state governments regularly allocated funds to support the exhi-

bitions. Johann Freiherr von Lutz, both minister president and minister for ecclesiastical affairs and education, stated the reason for this continuing support in the lower house of the Bavarian parliament during discussions over the budget for art acquisition in February 1888. Art was absolutely essential, he maintained, to the reputation and well-being of the kingdom of Bavaria and its major metropolis, Munich. "A large part of the splendor and fame of our capital city and with it of our own particular homeland rests on the care of art, which for more than fifty years has been maintained with great success in Bavaria. The prestige which we have attained through art," he insisted, "must be upheld." Two years later, in 1890, in the parliamentary debates over the same budgetary items, the new minister president, Krafft von Crailsheim, was even more forceful in affirming the necessity of financial support for the arts in Munich:

Gentlemen! The care of art absolutely constitutes a vital interest for Bavaria, a specialty cultivated by illustrious rulers which has significantly contributed to secure for the state of Bavaria that position and respect which it holds in the whole civilized world. Munich is a city of art of the first rank; the Munich school is, after the Parisian, unquestionably the first in the world. One can say that Bavaria is an art state, just as there are industrial states and agricultural states. . . . The rank that Munich has maintained up till now as a first-rate art city is of the highest importance. . . . The maintenance of Munich's rank as an art city is not only of interest for Munich itself, but for all of Bavaria, and not just an ideal interest, but also a very considerable material one.[30]

Among the material benefits that Crailsheim then cited were the substantial number of foreign visitors who came to the exhibitions; the business generated for the railroads by the tourists and by the transportation of the artworks; the demands for services in hotels, restaurants, and cafés; the art-related purchases, such as travel mementoes or arts and crafts; and finally the financial benefits for artists

themselves from Munich and Bavaria. A month later, as the debate continued, Prince Ludwig, son of Prince Regent Luitpold and later King Ludwig III, in a lengthy address to the upper house of parliament, also insisted upon the material and ethical value of art for the city and state. Art, he believed, should "awaken the sense for the noble and the beautiful." However, art brought with it substantial material profit. "The sums that flow from abroad into the country for artworks, particularly benefiting the city of Munich," he pointed out, "are truly immense."[31]

Even those who criticized the exhibitions accepted as a given fact that they were an economic boon for the cities. In an 1889 editorial opposing the proposed move to establish great exhibitions on an annual basis in Munich, Pecht acknowledged to the readers of *Die Kunst für Alle* that Munich was unquestionably the major center of German art, with more artists than Berlin and Vienna together, and was the logical place for an annual exhibition because it was centrally located geographically for foreign traffic. He argued, however, that the unquestionable economic returns for local businesses in the city should not be allowed to prevail over what he believed would hurt the local art community. An

Fig. 43 A. **Adolf Hengeler (1863–1927), "A Cheap Substitute,"** *Fliegende Blätter* **98, no. 2483 (1893): 79, with the caption "Mr. Wamperl is cheap! In order to save the entrance fee, when his country cousins came into the city to see the art exhibition, he took them to see the next best show—the street posters."** *B.* **Hermann Schlittgen, "Art and Love,"** *Fliegende Blätter* **83, no. 2085 (1885): 13, with the caption "My dear! How long I have sought for an opportunity to declare my love to you! Will your Mama not hear us?" "Oh, don't worry about that—my Mama always sleeps soundly in art exhibitions!"**

These cartoons and others like them demonstrate the steady emergence of the art galleries and exhibitions as significant public spaces in which the urban dweller could take great pride. These were places particularly well suited to the flaunting of taste, erudition, and social status—or to the lack of them. The cartoons also presented the art gallery as the perfect spot for courting. The first of this pair (A) shows a smart city dweller cheating his innocent relatives; significantly, this interaction between sophistication and ignorance takes place over the display of art. The mark of the city man is his cultural sophistication. The desire of the country man is to partake, even if fleetingly, of that sophistication. To be able to say "I was there" was the desirable goal.

A

B

annual exhibition, he insisted, would result in increased competition, which might hurt sales for local artists and art dealers.[32] Pecht may have been more perceptive about the possible negative economic effect of frequent exhibitions on local artists than his younger colleagues realized. The issue would become troublesome in the next decade. In the meantime, energetic supporters of art, dismissing his views as those of an elderly conservative, promoted the idea of annual great exhibitions in Munich. Others encouraged the spread of the great exhibitions to localities beyond Berlin and Munich.

This conviction that large art exhibitions contributed significantly to the prestige and to the economy of cities, states, and the nation lay behind the increasing numbers of large exhibitions in the decade following the 1888 Munich International and 1886 Berlin Jubilee Exhibitions, both of which had been resounding successes. Exhibitions were perceived not only as a matter of civic or national pride but also as good, indeed big, business. Regular reports in *Kunstchronik* and *Die Kunst für Alle* kept readers informed about the expenses, income, and profits of each of the major exhibitions, including details of amounts and numbers of sales to local, national, and foreign buyers. Reports also drew attention to the support from local industries in building exhibition halls and promoting the exhibitions. These art exhibitions with their attendant buildings became an integral component in the much larger phenomenon of industrial and world's fairs at the end of the century, in which nations flexed their industrial muscles and economic prowess.

THE MUNICH ANNUAL EXHIBITIONS: THE LUSTER OF MODERN ART AND FOREIGN ART

How these exhibitions were to be organized and who was to control them, however, were not simple issues. In the course of the next decade, in city after city, controversy broke out over both questions. Artistic, economic, political, and personal differences fueled the debates in the various art centers over the organization of their exhibitions. In Munich during the summer and fall of 1888, against the immediate backdrop of the eminently successful Third International, the debate within the art world spilled over onto the pages of the newspapers over the question of holding an annual art exhibition in addition to the traditional international exhibition every four years. All of the arguments raised in the Bavarian parliament for funding for the arts were now enlisted in support of annual exhibitions. Although the decision to have the annuals and the ways in which they were to be organized were the responsibility of the Munich Artists' Association, detailed information was provided and published in the journals and newspapers so that everyone could follow the events, indicating again the extent of public interest in the art exhibitions. Dr. Georg Hirth (1841–1916), the owner of an influential local newspaper, the *Münchener Neueste Nachrichten* (Munich's newest news), became a fervent supporter of the project and devoted substantial space to promoting the cause in his newspaper for months. On the other side, Pecht made his opposition clear in his editorials in *Die Kunst für Alle*. But none of the journals mounted a campaign comparable to that of Hirth's newspaper. When the artists of the Munich Artists' Association met in November 1888, they approved the proposal for annual shows, beginning an institution that lasted for almost a half-century in various guises, surviving the better part of two world wars.[33]

While it is unlikely that the general public outside of Munich paid much attention to the scramble that followed in the next few months to pull together a large exhibition, art lovers certainly confronted the changes when the First Annual Munich Exhibition opened in the Glass Palace in July 1889. Viewers discovered that the entire Glass Palace was now devoted to the art exhibition, instead of its being shared with horticultural exhibits. Almost half of the

1015. The gentleman in white.

Fig. 44 **"The Gentleman in White," caricature of Franz Stuck's** *The Guardian of Paradise*, **in K. Cassius,** *Mockingbird in the Glass Palace* **(1889), 12.**
Stuck's paintings frequently inspired cartoons, such as this one of *The Guardian of Paradise* (plate 5) from Cassius's parody of the First Annual Munich Exhibition, in 1889, which transformed the angel holding a fiery sword into a jaunty sailor grasping an oar. Stuck not only won a gold medal for this painting in Munich, he also received honors for it at exhibitions in Berlin, Dresden, and Venice and in the world's fairs in Chicago (1893) and Paris (1900). Named a professor at the Munich Academy in 1895, he became an honorary member of the Berlin, Munich, and Stockholm art academies; he was given medals of honor in Germany and Austria and was ennobled in 1906. His designs for logos were utilized by both the Munich Artists' Association and the Munich Secession, as well as by *Fliegende Blätter* and *Pan*.

exhibitors were foreign, only slightly fewer than in the previous year's international. Paintings were not hung by national school, but on the basis of artistic content and quality. And most importantly, the light colors of "light and air" painting dominated the exhibition. It was a serene exhibition, according to the reviewer from *Der Kunstwart*, with quieter works and fewer life-sized proletarian figures, which upset the "old men," because the "young" artists, knowing their new art had won, were now becoming less strident. This exhibition also introduced Franz Stuck, a young artist—in both years and style—whose distinctly individual paintings became a hallmark of the exhibitions of the nineties across Germany and abroad. His provocative painting *The Guardian of Paradise* (plate 5 and fig. 44) drew praise from critics and elicited much talk in the exhibitions; many, including the reviewer from *Der Kunstwart*, were both fascinated and unsettled by the sultry androgynous angel with its uncanny fusion of sensuality and radiance.[34]

The First Annual Munich Exhibition, of 1889, thus set the stage for the next decade in Munich. The results of changes made that year became the common characteristics of the great exhibitions: large, well-decorated galleries, heavy participation by foreign artists, a handful of sensational works, the prevalence of the new contemporary style that had emerged out of the open-air naturalism of Uhde and Liebermann in the mid-1880s, and a decisive role played by the planning committee and the jury that admitted the works. This last factor constituted a critical shift from earlier exhibitions that, though not obvious to the visitor, was a matter of fierce debate within the artistic community. At issue were changes in the rules governing the admission of works to the exhibition that shifted the basic principle from one of egalitarian fairness to one of selective quality.

The issue was startlingly embodied at this First Annual in a biting painting by Max, a popular exhibitor who had opposed the new policies and whose work usually featured lovely ladies and madonnas.

This time, his painting *Ladies' Club*, later retitled *Monkeys as Critics* (fig. 45), depicted a cluster of supercilious monkeys examining a work of art while sitting on a shipping crate labeled "Munich." A visual satire on the exhibition in which it was featured, the painting was a bombshell.[35] The work amounted to a stinging assault on the increasing role of the jury and the critic as mediators between the artist and the public, a role that was becoming a necessity and, from an artist's perspective, a curse.

Since judgments of aesthetic quality were bound to be subjective, the jury decisions for the First Annual were accompanied by controversy in the Munich artistic community, where artists had depended upon the egalitarian practices of the Artists' Association to provide them with a market for sales. However, the financial success of the exhibition, which resulted in a tidy profit of more than 20,000 marks, muted the criticism. Falling profits in 1890 and 1891 and an increased foreign presence raised the rancor, resulting in the secession of the group of artists most committed to stringently juried international exhibitions in 1892.

The turmoil among the Munich artists was not reflected in the reviews of these annual exhibitions in the national journals until after the third exhibition, in 1891, under the direction of Uhde. Lengthy, substantive reviews were published in *Der Kunstwart*, *Die Kunst für Alle*, *Kunstchronik*, the *Zeitschrift für bildende Kunst*, and, beginning in 1890, the new *Kunst unserer Zeit*, edited by Hans Eduard von Berlepsch (1849–1921) and published in Munich.[36] All of the reviewers, in one way or another, expressed approval of the overall success of the annual exhibitions and the strength of the Munich artists, even if they were critical of specific works. For them and their readers, Munich's claim to preeminence as *the* German city of art was fully established by these exhibitions.[37]

The large number of foreign works was initially perceived to provide a valuable indication of the strength of national art and of the progress that German artists had made in assimilating the new artistic directions. No one questioned the achievement of contemporary French artists who regularly exhibited in the Paris Salons, such as Henri Gervex, Bastien-Lepage, P. A. J. Dagnan-Bouveret, or Léon Lhermitte. Their paintings were frequently shown in Munich and praised, though critics focused on different strands of French contemporary art; and some judged the French paintings submitted to the German exhibitions to be of questionable quality. The Third Annual did actually present a small number of paintings by Manet, Claude Monet, and Alfred Sisley, which went largely unnoticed, as did the Edvard Munch works shown with the Norwegians. In general, critics writing about the Munich annuals thought that German artists had finally attained a level of achievement comparable to that of the work being done in France. The greatest excitement among artists, critics, and the public was, however, generated not by the French but by the colorful and decorative images of the seventeen Glasgow Boys in the Second Annual and the Scandinavian realists and impressionists in the Third Annual, both of whom were received as the most exciting, innovative, and extreme of contemporary artists.[38]

In reviews of the Munich annual exhibitions from 1889 to 1891, *modern* began to take the place of *new* or *young* as the term to describe this art. Even Pecht, whose nationalism was becoming more conservative and intransigent, admitted that one thing was certain: "The era of Bismarck even in art lies completely behind us." The acceptance of the modern in German art was strongly confirmed by another young critic, Momme Nissen (1870–1943), in an article in *Die Kunst unserer Zeit* in February 1891 discussing the beneficial influence of French modern artists upon German art. Arguing that all of the leading German artists except perhaps Böcklin and Hans Thoma had been influenced by Paris, Nissen paid tribute to the early inspiration of Liebermann and Uhde in renewing German art through their attention to French art. "They are," he insisted,

Fig. 45 **Gabriel Max (1840–1915), *Monkeys as Critics*, 1889. Oil on canvas, 33 1/4 x 42 3/8 in. (84.5 x 107.5 cm). Bayerische Staatsgemäldesammlungen, Neue Pinakothek Munich. Reproduced in *Die Kunst unserer Zeit* 10, 1st half-vol. (1899): 17.**

"almost martyrs" who had not had an easy path themselves but had prepared the way for their followers, to whom the future belonged.[39]

These modern artists whose work received discriminating attention in the reviews were the painters of the light-color style, whose work was exemplified by Liebermann's *Net-Menders* (fig. 19) and *Old Woman with Goats* (fig. 24B) and Uhde's *On the Road to Bethlehem*, or *Difficult Walk* (fig. 22). They were the ones whose paintings had been included in the exhibitions of light-color paintings at

Fritz Gurlitt's gallery from 1888–90. An older generation of artists who were now seen as forerunners of the modern movement were given special attention: Menzel, Böcklin, Thoma, Trübner, and Wilhelm Leibl. As the reviewers surveyed the progress of German art in the Munich annuals, they pointed to a movement away from the open-air painting that had focused on proletarian scenes—an aspect of the new art that Pecht still fretted over—to a new form of light-filled work that was roughly described as mood painting or atmospheric painting. Skarbina, Stahl, Joseph Block, and Schlittgen were frequently mentioned as artists whose scenes from urban life conveyed the mood of the times. One critic described them as "mood-landscapes" in which new painting techniques were utilized to probe into visions of contemporary life (fig. 46A). Another group of younger

artists was identified as moving toward coloristic symbolism, following the work of Albert Keller and of Stuck, with his luminous *Innocentia* (1889), fierce dark *Lucifer* (1890; fig. 46B), and agonized *Crucifixion* (1892). The works of all of these artists, which were featured attractions in Munich, became the staple of exhibitions in which the public encountered this modern art in the nineties across Germany.

In an unprecedented series of lead articles on contemporary art in the Munich exhibitions, published in 1891–93 in the art historical *Zeitschrift für bildende Kunst*, Alfred Gotthold Meyer (1864–1904), a young art historian, shrewdly analyzed these new developments, which he believed to be necessary responses to a radically modernizing society. He was critical both of the outdated French art of William Bouguereau and of the sentimental German genre paintings that continued to present amusing anecdotes from a nonexistent German past. These artists, he charged, "anxiously avoid the social ideas that today are the centerpiece of everyone's interest, which future cultural historians will place at the top of their considerations." Meyer enumerated those pressing social issues: the continually growing struggle between capital and workers, the social upheavals that were brewing, the reevaluation of values having to do with the relationship of the individual to the whole, and the overwhelming issues surrounding intellectual and machine work. He claimed that all of these issues were coming to the fore in contemporary literature and deserved greater attention among the artists. Analyzing the work of Skarbina, Schlittgen, and Block, he commended them for making the effort to deal with this revolutionary reevaluation of social values within their paintings. Nevertheless, despite his support of the modern artists who engaged these contemporary social issues, Meyer was well aware of the viewing public's demand for sensational art, as in the painting shown in Munich in 1892 by Georges Rochegrosse (1859–1938), *The Fall of Babylon*, which filled its immense size with a plethora of eroti-

cally reclining female nudes. The response to that work, for all its dubiousness, was, he said, significant as a protest on the part of the public against work that had no meaning, "a battle cry against the empty everydayness" of so much of modern art.[40]

On the whole, the reviewers of these journals presented a positive picture of successful annual exhibitions in Munich. Meanwhile, the artists in Munich were embroiled in controversy over the financial failure of those exhibitions. Sales were relatively stable, but after the modest profits of 1889, the costs outpaced income from ticket sales until 1891 saw a deficit of 14,000 marks, which called attention to the dismaying reality that the foreigners were outselling the Munich artists in the exhibition. The exhibitions had rapidly increased in size from 1,600 works in 1889 to 3,649 in 1891, a growth that reinforced perceptions of these great exhibitions as marketplaces for art. Nonetheless, Munich maintained its reputation for fostering strong new art and for steadily presenting the public with the best overviews of the contemporary art of Germany and of other countries.

BERLIN EXHIBITIONS: IMPERIAL CULTURE AFFIRMED

In 1891 Berlin again tried to challenge Munich's artistic preeminence. After the solid success of the Berlin Academy Exhibitions in 1887 and 1888, which had won critical attention by showing light-color painting and attracting the public, the exhibitions of 1889 and 1890 encountered scathing critiques. Ticket sales, however, again demonstrated that the public enjoyed the exhibitions despite the criticism and that these exhibitions attracted far more visitors than did exhibitions in Munich. The critics, however, declared that Berlin's exhibitions had been completely defeated by Munich. They pointed out in 1889 that the conditions in the exhibition rooms were poor, that the works shown were

A

B

Fig. 46 A. **Friedrich Stahl (1863–1940),** *Pursued,*
**c. 1890. Pastel on handmade paper on board, 10 5/8 x
18 3/8 in. (27 x 46.7 cm). Berlin, Stadtmuseum Berlin.
Reproduced in** *Die Kunst für Alle* **6, no. 7 (Jan. 1891): n.p.**
B. **Franz Stuck,** *Lucifer,* **c. 1890. Oil on canvas, 63 3/8 x
59 3/4 in. (161 x 152 cm). National Gallery for Foreign
Art, Sofia, Bulgaria.**
Although both artists utilized the newer, more impression-
istic painting techniques, Stahl focused in his work upon
bourgeois city scenes (A), while Stuck created fantastic,
symbolic figures with coloristic intensity (B).

weak, and, significantly, that Berlin had returned to battle scenes and tired historical academic painting and abandoned any attempt to show the new open-air art. Writing about the Berlin exhibition of 1890, the respected writer Karl von Perfall (1851–1924) stated in the *Kölnische Zeitung* that even the mildest critic could not ignore the weakness of the art in Berlin or the isolation of the Berlin Academy from the rest of the art world. A reviewer in *Der Kunstwart* put it succinctly: the Berlin exhibitions suffered from an excess of Prussian patriotism, as in paintings with titles like "York before the East Prussian Estates."[41]

This judgment was confirmed in a lavish art journal titled *Modern Art in Master-Woodcuts after Paintings and Sculpture of Famous Contemporary Masters*, which began publication in 1887 in Berlin. Exquisite woodcut plates reproduced paintings by Emperor William II of sea battles; Werner's tributes to both William I and II, including a triple foldout in color of his 1893 painting *The Opening of the Reichstag in the White Hall of the Berlin Palace by His Majesty William II on 25 June 1888* (fig. 104); Kampf's memorials to citizen soldiers in the wars of liberation; battle scenes of Prussian victories; and innumerable depictions of charming ladies and cute children. Filled with lighthearted stories of courtship and damsels in distress and conservative articles on art and on women by Georg Malkowsky, the journal was an excellent model of the imperial culture William II approved and promoted. Moreover, the emperor's claims to being an artist were celebrated in articles on his stage designs and his widely publicized drawings. In 1896 the journal devoted a special issue to the art of Menzel on the occasion of his eightieth birthday, with five full- or double-page plates and a laudatory article by Helene Vollmar (born 1846). This issue demonstrated Menzel's status as the chronicler of the Hohenzollern dynasty and also the efforts of the court to lay claim to the artist whom many considered to be the great German realist of the century. Apart from Menzel's, the late-nineteenth-century art repro-

duced in the journal was comparable to art that was appearing in the Berlin Academy Exhibitions in 1889 and 1890, including paintings from France that were uncontaminated by the modernism that William II considered to be dangerous to the cultural life of the nation.[42]

The 1891 Berlin International Art Exhibition was intended to demonstrate the excellence of this conservative art. Under the guidance of Werner, who shared the views of William II, the exhibition was organized by the Society of Berlin Artists to celebrate its fiftieth anniversary. With the financial and state support that Werner was able to command, the Berlin artists achieved, in the words of a sympathetic critic, "a brilliant victory." Among other things, Werner arranged to have Dowager Empress Victoria, widow of the late Emperor Frederick who reigned briefly in 1888, to serve as the official patron of the 1891 exhibition. In carrying out her role as an unofficial ambassador visiting French artists in Paris in February 1891, Victoria precipitated a brief diplomatic scandal that added to strained relations between France and Germany and foreclosed the participation of most of the French artists in the Berlin International. Bouguereau, whose studio Victoria had visited, was one of the few artists who did not withdraw his promise to participate in the exhibition after the French nationalist newspapers mounted their attack upon her visit. Needless to say, the press coverage increased public interest in the forthcoming exhibition. Further publicity surrounded the pomp and circumstance of the opening ceremonies with the royal family and the entire diplomatic corps in attendance. With more than five thousand works from all the European nations but France, as well as from Russia, Turkey, Japan, and the United States, the exhibition gave visitors a retrospective view of major paintings from previous decades. However, as *Der Kunstwart* matter-of-factly reported, it did not give them any sense of the contemporary state of the art world. Still, Avenarius judged the exhibition to be an important step forward for Berliners, whose isolation

from the rest of the art world was legendary. The weakness of Berlin's artists was unmistakable. The critic for *Die Kunst für Alle* commented tersely that "light-color painting is not yet presentable at court," while Avenarius concluded that the art of Berlin was dominated by the mentality of the court, the salon, and the stock exchange.[43]

Notwithstanding these critiques, the crowds poured into the exhibition. It closed with a profit of 110,000 marks for the Society of Berlin Artists, whereas Munich's Third Annual, of that same year, ended with a deficit of 14,000 marks; even more devastating, sales for the Munich exhibition were 200,000 marks below those for the exhibition in Berlin. The pattern, begun in the 1880s, continued throughout the 1890s in Berlin: the criticism in the journals ranged from scathing to totally dismissive, but the great exhibitions remained crowded. While one reviewer characterized the work of Berlin artists in the Berlin Academy Exhibition of 1892 as a grimly tedious, Prussian, and mediocre collection of cheap imitations—examples of "artistic partheno-genesis"—well over 300,000 visitors entered during the seventy-eight days the exhibit was open. The 1893 Great Berlin Art Exhibition brought in 800,000 members of the public to see the paintings of the new, modern artists from Munich. The 1894 exhibition, which according to the reviewers remained untouched by the modern movement, was not a financial success, although it had a particularly large attendance. The 1895 exhibition, featuring conservative salon paintings from France as well as newer work from Munich, drew close to 500,000 visitors and produced a profit of 100,000 marks.[44]

Several observations might be made about these figures. We can read the attendance numbers as an indication of the growing discrepancy between critical judgments and public responses, but we must then immediately temper that idea by pointing to the disparity between critical opinions on the local level and those of critics writing in journals with national circulation. Critics writing for local newspapers were regularly charged with clinging to the comfortable and the traditional, while being unduly nasty about innovations on the art scene. Should we thus attribute the extra-large crowds at the Great Berlin Exhibition in 1893 to an eagerness on the part of the public to become spectators at a well-publicized exhibition of paintings from Munich that many found to be outrageous? Despite the ambiguity surrounding these numbers, we can posit that passionate, blood-pressure-raising negative criticism was highly effective in motivating the public to throng through art exhibitions. Scandal activated public attendance, while boredom shrank it.

GREAT EXHIBITIONS: EXPANSION AND CRITICAL DISDAIN

From the public point of view, the great exhibitions in Munich and Berlin brought people, money, and perhaps fame to the cities, enhancing Munich's position as the art capital and Berlin's as the political capital. Not surprisingly, other cities with long histories as centers of art in Germany followed their example.[45] The roll call of major exhibitions and new exhibition halls that opened in the 1890s reinforced the cultural traditions of separate states that preceded the German unification. Dresden, with its well-established Royal Academy of Art, in 1887 organized its first International Exhibition of Watercolors, Pastels, Drawings, and Engravings, in which serious attention was directed to media that were not generally considered for the great exhibitions. Watercolors and drawings from "half of Europe" were shown, giving a strong sense of the aesthetic shift that was occurring across the continent. The reviewer in *Der Kunstwart* praised Dresden's second international exhibition of works on paper, in 1890, because the smaller size encouraged the experimentation essential for the development of open-air art. The Dresden critic for *Die Kunst für Alle* stressed the importance of these exhibitions of works on

paper for artists and art lovers alike. By bringing together an exceptionally large number of works from Germany and abroad whose size and price made them practical for hanging in homes, the Dresden exhibitions served to enlarge the circle of those interested in art and to increase the numbers of those who collected art. The impressionistic style of sketching was well represented in these exhibits, including drawings by Liebermann, Lesser Ury, and Karl Köpping (1848–1914). Graphics by Klinger— "creations of utmost fantasy, free of bizarre effects and faultless in technique"—Thoma, Dora Hitz, and Cornelia Paczka-Wagner were among those singled out for praise. Above all, the critic cited the exceptional quality of the French section, with its masterworks by Gustave Courtois, Dagnan-Bouveret, Albert Besnard, and Lhermitte. Reviews of the third Dresden exhibition of watercolors, in 1892, noted that of the 2,472 works by 540 artists, 200 were works by 75 women artists, among them serious works by Hitz and Linda Kögel (1861–1940). Further, since most of the major artists in Germany had sent pastels or watercolors, this Dresden exhibition was deemed to provide an excellent opportunity to see the latest in contemporary German art.[46]

The same could not be said of the exhibitions held in the Dresden Academy of Art's new building on the Brühl Terrace in 1894 and 1895; both were dismissed by the journal critics as undistinguished. Before the end of the decade Dresden built a new glass exhibition palace in the large city park, where the First International Dresden Exhibition opened in 1897. With electrified galleries, gardens, and an Art Nouveau room created by Siegfried Bing based on Henry van de Velde's (1863–1957) designs, the small, elite exhibition represented a departure from Munich's and Berlin's massive exhibitions and was widely regarded as surpassing both of their 1897 exhibitions in quality. Under the leadership of Gotthardt Kuehl, the Dresden exhibition skillfully combined the decorative arts with oils, watercolors, graphics, and sculptures. The many years Kuehl

had spent in Paris and his close association with other modern artists were evident in his inclusion of paintings by Bastien-Lepage, Monet, Edgar Degas, and Camille Pissarro, as well as works by the established artists Klinger, Liebermann, Uhde, and Leibl and the rising artists Walter Leistikow and Max Slevogt. Sculptural highlights were Auguste Rodin's sculpture *Victor Hugo* and a special gallery of Constantin Meunier's heroic workers and coal miners. The show opened in May with announcements of gold medals, including one for Liebermann; by the closing date in October sales of artworks had exceeded 400,000 marks.

The response from the press and the public in Dresden was enthusiastic. In a delighted review in *Der Kunstwart*, Avenarius described in detail the design of the galleries—the most splendid he had ever seen. Attendance was high at the lectures held to educate the public about modern art. Concerts in the well-lit park attracted others. The reporter for *Kunstchronik*, however, pointed out tongue in cheek that it was not clear whether the Dresdeners' enthusiasm was a response to the modern art or to the fireworks or the presence of the king of Siam at the exhibition.[47]

This model of integrating modern decorative styles with the paintings and sculpture of the new art was followed to further acclaim in the German Art Exhibition in Dresden in 1899. Planned by a commission representing all of the city's art associations and art institutions, as well as the city government, schools, and businesses, the exhibition had exceptionally well-designed interior decoration. A special historical exhibition of Lucas Cranach's paintings complemented an exhibition devoted to Klinger's work, including his newest work, *Christ in Olympus* (fig. 37). The financial success of this exhibition, with an income of 241,245 and sales of art at 333,881 marks, was taken as proof that Dresden had established itself again as an art market ranking alongside Munich and Berlin.[48]

Other cities across Germany hastened to join the

league of international exhibitions in the 1890s. None was as large as the Munich or Berlin exhibitions, and they differed in terms of organization and character. The royal family of Württemberg was very much involved in planning the first Stuttgart International Painting Exhibition, of 1891. The initial impetus came from King Charles, while Prince William, heir to the throne, chaired the committee, and the director of the art school organized the exhibition. The exhibition was designed not to compete for the newest work with the great art markets but as an elite international exhibition that would give the people of Stuttgart an overview of contemporary art from the major European countries. *Kunstchronik* reported with pleasure that the lowly pessimistic "shadow side of life" was not represented in the paintings in the exhibit; in other words, the choices were safe and traditional, with places of honor in the French section going to the madonnas of Bouguereau and Dagnan-Bouveret and to Alfred Roll's nudes; and in the German section, to Franz von Lenbach's portraits of famous men and Franz von Defregger's (1835–1921) cheerful peasant scenes. Almost the only exceptions were the works of Uhde and Jozef Israëls, whose paintings of the "sorrowful and the poor" were singled out as precursors of the new painting. Attendance was heavy and sales were brisk.[49]

In marked contrast to Stuttgart's conservative exhibitions were the great international exhibitions held in Hamburg in 1894 and 1895, where, as *Die Kunst für Alle* reported, "the most modern among the modern" from France and Germany were to be seen. Under the progressive directorship of Alfred Lichtwark, the Hamburger Kunsthalle was emerging as one of the most innovative museums in the nation. By mobilizing the considerable economic wealth of the city through the Society for Friends of Art in Hamburg, Lichtwark was able to build a substantial collection of nineteenth- and twentieth-century German and French art. The International Exhibition of 1895 was entirely an invitational exhi-

bition, the first such exhibit in Germany, that featured modern French and German work, as well as a number of carefully chosen significant forerunners. The German section led from Menzel to Skarbina, Leistikow, Hitz, Liebermann, and Stuck. The French Impressionist section was, according to the report, both the most fascinating and the most repulsive to those who attended this startling great exhibition. The reviewer in *Die Kunst für Alle* favorably discussed Courbet and Manet as the first true modernists and commended good work by Sisley and Pierre-Auguste Renoir. In his judgment, Monet and Pissarro, "the most recent pathbreakers," had finally succeeded in creating a "genuinely free open-air painting." Their works in the exhibition, including a small painting by Monet of a poppy field, "produce the highest that has yet been achieved in the artistic effort to capture the whole quivering, floating, sunlight-saturated atmosphere." Despite—or because of—these provocative paintings, the exhibition attracted enough visitors to end with a substantial net profit.[50]

An incident a year later, however, indicated that vocal persons in Hamburg did not share the enthusiasm of the reviewer for the new art. Visitors had also reacted negatively to a showing in 1894 of Klinger's painting *The Blue Hour* (1890), which did, nevertheless, find a buyer. According to the published report in 1896, an assault against the "new direction in art" that was being led by Lichtwark was launched by a Hamburg merchant who was so provoked by a poster designed for the 1896 Hamburg exhibition that he stirred up press articles and provocative demonstrations at the local art society meeting in protest. Although certain that this philistine response would not hinder the course of the new art, the reporter expressed concern that Lichtwark's positive developments in Hamburg might be damaged and that the vulnerable young artists would be hurt. Lack of interest on the part of the public embitters artists, he wrote, but unwillingness to understand really hurts them.[51]

In Düsseldorf, where the dominance of its academy in the mid-nineteenth century had left a conservative—many referred to it as moribund—art establishment, the necessary space for holding a great exhibition only became available after the turn of the century through close cooperation between the art establishment in the city and heavy industry. Throughout the 1880s and 1890s only small exhibits could be held. At last, in 1902 a great new art palace was built along the Rhine to house the German National Art Exhibition, which, held in conjunction with the Industry and Crafts Exhibition for Rhineland and Westphalia, featured special halls for heavy industry, including one that the reporter called the "Krupps Fortress." This close connection between German industry and German art was picked up by the young artists of Düsseldorf in 1893, when the Düsseldorf Society of Artists held a festival to raise money to support impoverished artists and widows of artists. The festival theme, inspired by the Chicago world's fair of 1893 and carried out in elaborate decorations, was a parody of international expositions and art fairs.[52]

Serious doubts about the efficacy of these great exhibitions had cropped up much earlier. In 1887 Otto von Leixner, a conservative Berlin critic, published a book in which he launched an all-out attack upon art exhibitions: "The fundamental principles on which art exhibitions are now carried out are equally detrimental to art, artists, and the education of public taste," he wrote. "They breed mediocrity; they have sunken down to market places, become palaces of amusement where half the world gads about devoid of any sense or taste but always ready with great sounding judgments. They arouse and awaken neither a sensitivity to art nor an understanding for art, but breed only a deluge of words that pours through the daily and weekly papers and finally fizzles out miserably in the desert of salon gossip."[53] His recommendation for rectifying this miserable state of affairs was to establish elite, small triennial exhibitions rotating through Vienna, Berlin,

and Munich. The organization would be handled by the imperial governments through appointed juries, with artists participating only by invitation. The exhibitions would be open for limited visitation in quiet surroundings; all county-fair types of entertainment and music would be banished. Poetry readings and noble music would help elevate these events into a "German Pan-Athenaeum." Leixner's book and its summary in *Der Kunstwart* were important, for it contained the whole litany of complaints that were to be endlessly debated in the coming decades: the difficulties artists faced, the unfairness of juries, the mediocrity of the art, the lack of taste on the part of the public, the shallow clichés formulated by the press and bandied about the galleries, the vulgarity of the public entertainment, and the indignity of treating works of art as mere market products for purchase and consumption.

A lengthy article voicing these same themes appeared in *Der Kunstwart* in October 1888, just as the Third Munich International was closing. Heinrich Steinhausen (1836–1917), a professor of theology and philosophy in Berlin, argued that too many sensationalized paintings and too many strange modern works undermined the serious contemplation of art in the great exhibitions. Instead of encouraging serious understanding, he said, the exhibitions spawned "the cold reflection of the aesthete, the sterile admirer of artistic dexterity, or the voracious hunger of the cultivated rabble after material for amusement and salon gossip." He then launched into a diatribe against the newly erected exhibition palaces, with their pleasure parks and beer gardens (fig. 47). He was outraged by the booths at the Pergamum celebration in the Berlin Jubilee Exhibition park, inscribed in Greek-looking letters with slogans like "Black is the Styx, other than Schnaps is there nix." Furthermore, he complained, now that there were electric lights in the galleries, one had to look at paintings accompanied by the strains of Strauss waltzes from evening concerts outside. The great exhibitions had reduced art to entertainment, and its consumption

Fig. 47 *A.* **Photograph of the Osteria at the Berlin Jubilee Exhibition, from** *Die Kunst für Alle* **2, no. 3 (Nov. 1886): 44.** *B.* **"In the Exhibition Restaurant,"** *Fliegende Blätter* **105, no. 2677 (1896): 196.**
The Italianate cafe (*A*) was built by the Society of Berlin Artists on the grounds of the 1886 Berlin Jubilee Exhibition. Meant primarily as a social center where artists could gather, it was also open to the public during certain hours. A much larger restaurant, designed to handle the crowds coming to the exhibition, was built in a central location between the lake and the temple area. The cartoon (*B*) captures what became a commonplace scene: a crowded restaurant outside the entrance to an exhibition. In this case, a patron complains to a waitress about the poor quality of the beer provided for the public.

A

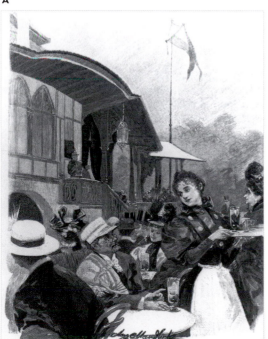

B

had become a type of sensory amusement. His solution, agreeing with Leixner, called for state intervention to establish elite exhibitions designed for serious viewing without the distractions that attracted an unsuitable public.[54]

Yet another voice was rapidly joined to this chorus in *Der Kunstwart*. The novelist Max Kretzer (1854–1941), after visiting the 1888 Berlin Academy Exhibition, was depressed by the large mass of "truly meaningless and unimportant" works of art, including those by mediocre open-air painters, who used color to compensate for the poverty of their ideas. Venting his spleen upon the "compact majority" of unoriginal artists, he argued that "the great leveling machine" of mass production had invaded art:

So we see that even in painting and in sculpture the great leveling machine accomplishes its task daily, producing wonder and admiration in the gaping people who want to buy art. Astonishment would be actually more appropriate. From time to time—the Royal Academy of Arts in Berlin undertakes annually—a great market—oh! excuse me, an exhibition—is held in order to dispose of the products and to provide joy and pleasure to the public. Sometimes not—who cares! The result is always the same, at least for the last few years—: inside, a lot of bad paintings and bored faces and outside at the inviting sounds of a Strauss waltz a grand promenade of the compact majority of the concert goers, who consider "art" as a pleasant addition to the "mixture" of Drehers beer and Hefters hotdogs. Why stand before the *dead* pictures when on the "scandalous walk" around the artificial pond much more interesting and lively scenes unfold.[55]

The editors of *Der Kunstwart* noted here that Kretzer's manuscript had arrived before the Steinhausen article appeared in print and thus had been independently inspired by visiting the Berlin exhibition.

Kretzer was a writer whose novels had attracted attention for their realistic depictions of the contemporary struggle for existence in the poor districts of Berlin. His first popular novel, in 1882, had

examined the desperation, economic and aesthetic, that beset young artists. With his personal experience of poverty, Kretzer was in a position to recognize that these great exhibitions with all of their glitter and excitement merely masked a frequently desolate life for the artists who produced these works. In his article, Kretzer went on to sound another alarm, namely, that these mediocre artists were the product of the art academies, which he branded "breeding institutions for the art proletariat," a proletariat of mediocre artists who had nothing to say, whose existence was only to provide sales material for the art dealers, and whose uninspired work might as well have been cranked out by "the giant leveling machine" (fig. 48). Not unexpectedly, these articles elicited more letters and responses, some agreeing, others defending the large exhibitions, their works of art, and their entertainments as a means of attracting a public that might not otherwise become interested in art. One writer offered a solution in which private businessmen would come to the rescue of artists by building flexible exhibit spaces and renting them to artists so they could hang their own exhibits.[56]

Avenarius picked up the argument several months later when he made a crucial distinction. The heart of the controversy, he argued, lay in the belief on the part of many art lovers that art was a matter only for a small intellectual minority. He, on the contrary, insisted "that a true sense of art can certainly be awoken and cultivated in the broad ranks of the people." He agreed, however, that the exhibition system was in need of reform because the great exhibitions, with their confusion, only served to perpetuate ignorance of art among the people. These voices in *Der Kunstwart* in 1888 were obviously not enough to deter the steamroller effect of the great exhibitions. They did, however, serve to voice the discomfort felt by members of the cultured bourgeoisie at the transformation of art into a form of entertainment that appealed to the crowds of uncultured people. To put it another way, these articles raised the "problem of the public."[57]

Fig. 48 **Franz Stuck, "The Painting Machine,"** *Fliegende Blätter* 89, no. 2240 (1888): 10–11.

Published at the same time as a review by Max Kretzer complaining about the increasing number of mediocre paintings, this cartoon indicates the level of anxiety over the production and reproduction of art in this period of mushrooming great exhibitions. A lengthy caption written by Stuck states that an invention of great importance has just been patented. "A painting machine," he explained, "was invented by an artist who, fearing the rage of his colleagues, asks that his name not be revealed. The machine is capable of rapidly producing paintings in every possible style in a very short time. In pressing cases, one may also wait for the painting. To order a work, it is only necessary to state the artist and the theme. Portraits may be ordered by letter, telegraph, or telephone. The machine will deliver entire galleries of old and new masters, with a price reduction for quantity. The sole owner of the machine is an art dealer who has acquired all the rights from the inventor for 100 marks. The machine master is a leading art critic who knows exactly what is necessary for a good painting and exactly how the desired masterpiece should be painted. New styles are of course excluded, which solves the chief dilemma of the critic and the public. The public no longer will need to be confused—it will know exactly what to think about every painting. Also, the chief complaint of art dealers, that they cannot find any good paintings, will be silenced, since the painter is now totally superfluous and, at the most, his signature will be used. In relation to this devastating fact, we can only advise the poor painters to become sculptors, since a machine for sculpture has not yet been invented."

On the machine are signs explaining that tubes of paint and siccative are to be dropped in the hopper at the top; a blind critic controls the machine, and the art dealer—owner collects the thousands of marks from the client as he pulls the painting out of the machine. The painting in the illustration evokes one of Stuck's own works, *The Guardian of Paradise* (plate 5), which was shown in Munich in 1889. What is disturbing is the anti-Semitic depiction of the art dealer as a crooked-legged, long-nosed, capitalist Jew. The message is unmistakable: art and artists were being destroyed by mechanical reproduction and capitalism in the hands of Jews.

When Pecht in *Die Kunst für Alle* and Avenarius in *Der Kunstwart* expressed their confidence in the "people," their conception was contained in venerable German words—*Leute* and *Volk*—whose usage stemmed from the centuries-old agrarian society with its connotations of local stable communities and whose meaning had not yet become the property of the conservative right wing. By contrast, *public—Publikum*—was a relatively new word in German. Like the word *modern*, it was reported by Grimm's dictionary in 1889 to have come from France in the eighteenth century; and closely associated with the arts, the word was primarily defined as referring to the audience for various cultural activities, as in "theater public" or "music-loving public."[58] "Public" was thus an urban concept, carrying a slight taint of its foreign origins and appropriate to the great exhibitions held in urbanized settings, attracting mass audiences and transient populations from the tourist trade. In their diversity, anonymity, and magnitude the public of the great exhibitions were a disturbing manifestation of the industrial society out of which they had risen. It is not surprising that the public became the foil for those anxious and pessimistic responses to the great exhibitions by these critics to whom Avenarius, with his different conception of the people, responded affirming his faith in the importance of art for the people.

ART SOCIETIES: CREATION OF THE CULTURED BOURGEOISIE

The great exhibitions of the late nineteenth century were the culmination of a social and economic process that had begun a century earlier. Their evolution from small local academic salons to huge international bazaars hawking monumental paintings and sculptures corresponded to the transformation from capitalism involving small local merchants and craftsmen to high industrial capitalism with its national and international networks of finance, trade,

and production. The conjunction of art exhibitions and industrial fairs in the same or adjacent sites by the end of the century functionally demonstrated the integration of both into the changed economic structures of localities and regions. The initial economic purpose of these exhibitions—the sale of works of art—remained the same, but the mechanisms and scope were profoundly transformed.

Great exhibitions did not provide the only opportunity for people to encounter contemporary objects of art. Local art societies existed in most of the cities and larger towns in Germany. Founded in the early-to-mid-nineteenth century by cultivated members of the bourgeois, including artists as well as lovers of art, the art societies developed networks of small exhibitions in towns and cities across Germany. Although the local art societies received much less attention than the great exhibitions in the journals in the 1880s and 1890s, they constituted the second significant system in Germany, complementary to that of the great exhibitions, for delivering contemporary art to the people. As such, they encountered the same social forces that had generated the great exhibitions, manifesting similar expansions of their economic base and activities.

Above all, the public, the audience recipient of the exhibitions, were similarly transformed over the course of the century. The liberal conception of the public, resting on an ideal of the enlightened educated man in the early years of the century, became increasingly attenuated by the late nineteenth century. The educated burghers and aristocrats who attended the early small exhibits held in local academies and social halls were overwhelmed by the urban middle-class populations, whose steadily mounting income and leisure enabled them to travel to the international exhibitions. The public that enjoyed art in the local art societies in 1815, 1848, or even 1871 simply were not the same public of the great exhibitions of the 1890s. In a very real sense the great exhibitions fulfilled a century of liberal economic and social expansion in which an

increasingly democratized and assertive mass public could lay claim to the artistic culture that had once been the prerogative of a small educated elite.[59]

Artists were not passive actors in this transformation of the art world. They had a central role not only in the obviously necessary acts of creation but in the building of organizations and exhibitions for the dissemination of their artworks to the public. Ideals of artistic self-definition were also transformed in ways that corresponded to the larger social and economic changes the artists confronted. In the course of the nineteenth century artists managed to define themselves, their organizations, their products, and their market in increasingly specific, stringent, and exclusionary ways. They moved from an ideal of the master craftsman closely associated with the cultivated educated bourgeoisie at the beginning of the century to that of the full-time professional artist at the end of the century, from a localized market based on personal patronage to the massive anonymous markets of the great exhibitions. Then, in response to the increasing ineffectiveness of those great market fairs, they established their own small salons by the turn of the century to attract a new elite public that would support new art forms.

Against these overarching developments, we need to examine the seminal position of the art societies in the nineteenth-century conversion of art from the preserve of the church, royalty, and aristocracy into the recreation of the people. Art societies that originated in the first half of the nineteenth century in Germany were voluntary bourgeois groups that gathered together based on a common enjoyment of the arts, at a time when sketching and painting were desirable skills for the cultured bourgeois, not limited to the professional, the genius, or the bohemian. These cultivated individuals from the wealthy and propertied middle class formed societies that provided a social setting and an economic link between recognized artists and those who enjoyed or dabbled in art. Meeting first informally in clubs or homes of members, the groups eventually

rented or built their own art houses, in which both social evenings and art exhibits could be held. As a critic for *Die Kunst für Alle* pointed out in 1890, these art societies were "a creation of the bourgeoisie, when the task of taking care of art fell to it." Thus, the membership of the art societies was made up of artists and art lovers, who were civil servants, businessmen, publishers, and writers. As the century wore on, the art lovers came to outnumber the artists in most of the societies. Loosely modeled on the principle of the joint-stock company, the art societies generally required new members to make an investment in the society by buying lots or stock, for which they then received dividends in the form of one or more works of art, depending on the size of their holdings and the luck of the draw in annual artwork lotteries. By its nature, then, the art society drew on the monied middle classes. Although membership in the societies was technically open to any man, the annual membership fees were just high enough to discourage "inappropriate" applications from the lower classes.[60] In most of the art societies the wives and families of the regular members were able to participate in special events. The art galleries and exhibitions organized by the societies were open to the public.

These art societies established the first systematic mechanisms and networks for the purchase and distribution of contemporary artworks to the public across Germany in the nineteenth century. First, they maintained exhibition rooms and held weekly exhibitions that served as a regular local art market for artists and buyers and at the same time provided an income to the society from the commission for the sale. Second, the societies purchased works of contemporary art from artists and then passed them on to their members via annual lotteries. In later years open lotteries were held; individuals from the general public could simply purchase lottery tickets at the great exhibitions. In 1897, for example, the Seventh International Art Exhibition in Munich advertised a special lottery for artworks,

certified by the Bavarian government, in which two hundred thousand lottery tickets, each costing one mark, were issued for the public to purchase. The odds were fair: every tenth ticket was guaranteed to win an artwork, among which were four hundred large prizes with a total value of eighty thousand marks. Advertisements for these lotteries appeared in most of the cultural journals. In addition, most of the art societies distributed an annual gift to members; these tended to be graphic reproductions of popular paintings or Old Masters until the graphic revival in the 1890s produced original engravings and etchings appropriate for gifts. Some of the art societies commissioned or underwrote public art projects. For example, the monumental paintings by Alfred Rethel (1816–1859) for the town hall in Aachen were commissioned by the Art Society for Rhineland and Westphalia.[61]

The first art society was formed in Karlsruhe in 1818, and by 1882 fifty-seven cities had at least one society. Membership increased rapidly in most of them, bringing with it a preponderance of lay members. By midcentury, artists themselves became frustrated by the dominance in and, often, the control of the societies by the art lovers and amateurs, whose interests did not always coincide with the needs and concerns of the professional artists. Although the art societies provided the major market outlet for artists through the middle decades of the century, the desire to control their own exhibitions led to the formation of local artists' associations, in which membership was restricted to professional artists and whose policies were determined by the artists. Already by the 1850s the General German Art Association was formed to coordinate the activities of these professional artists' organizations. Artists within each organization collectively laid down the rules for membership and for the right to exhibit in their exhibitions. These regulations were essentially egalitarian and flexible in their acceptance of a broad category and variety of artists, as well as a diversity of styles and types of

art, including anecdotal genre scenes from daily bourgeois life, unlike the more rigidly defined categories that were acceptable in the academic exhibitions. In other words, artists defined themselves in these associations as a distinct group who had attained a discernible level of technical competence in the creation of visual works of art. And they set about creating inclusive exhibitions to market the largest possible number of products by their members to the largest possible number of new consumers in a capitalist market. These, of course, were the great exhibitions that dominated the late 1880s and 1890s.[62]

How the artists' associations were integrated into the local art scene varied. In Munich, for example, in 1863 the Royal Academy willingly handed over management of the Glass Palace exhibitions to the Munich Artists' Association, which was granted a royal charter five years later. For the next three decades the artists' association had almost complete control in Munich over the great international exhibitions and the annual exhibits that began in 1889. Berlin, on the other hand, presented a more complicated structure. There two artists' associations were formed, sharing virtually the same membership: the Society of Berlin Artists in 1841 and the local chapter of the General German Art Association in 1856. The Society of Berlin Artists, which had established a visible presence with its own modest Artists' House in Berlin, was able to open small exhibitions after 1869. In the next decades the artists' society occupied more elegant quarters near the Potsdamer Platz, in the center of the city, where it held weekly exhibitions of members' works and later established a permanent exhibit of new German and foreign works. It also occasionally honored an artist with a special retrospective show, such as those for Liebermann and Ludwig von Hofmann in 1898. The annual Berlin exhibitions, however, were the prerogative of the Royal Academy and were held successively in the academy rooms, then in improvised quarters on Museum Island until in 1886 the state made the new exhibition

hall near the Lehrter Station available to the academy. With this grant of space came government oversight from the Prussian Ministry of Ecclesiastical Affairs, Education, and Medicine. In 1893 the Berlin artists' society, after extended negotiations, became a partner in the management of what were now called the Great Berlin Art Exhibitions.[63]

The increasing complexity and competition among societies, associations, and academies over exhibitions, the growing number of art dealers, and, above all, the popularity of the great exhibitions of the 1880s and 1890s raised serious questions about the viability of the original art societies. At the general meeting of the Saxon Art Society in Dresden in January 1887 Theodor Paulsen reported on a furious debate precipitated by a motion brought in by thirty-five members, mostly artists, calling for stringent attention to the quality of works hung in the art society's exhibits or purchased for its lotteries. Opponents argued that greater selectivity would cause suffering to artist members who had no other source of income or opportunities to market their works. The motion was defeated. Pointing out that similar complaints were coming from other parts of Germany, Paulsen laid the blame upon the artists themselves, who, in their struggle for existence, had turned to teaching and had opened their own painting schools for women. The result was a blossoming of dilettante artists, especially women, who turned from being consumers of art into producers of mediocre works that competed in the art society's exhibitions with the work of the genuine artist members. Calling this dilettantism a cancerous wound that must be cut out by the societies themselves, Paulsen urged all the art societies to establish stricter controls over the quality of the exhibits because, he insisted, they played an important role in Germany's art life. In the mid-1890s Pecht gave a more positive assessment of the situation when he wrote in Die Kunst für Alle that the great exhibitions and independent art dealers had challenged the Munich Art Society, which was beginning seriously to stagnate, but he thought that the decision to build a new society house with galleries and social rooms, dedicated in 1890, had reinvigorated the society.[64] What lay behind the opinions of both Paulsen and Pecht was the early ideal of the art society as a gathering of educated men in an organization that promoted art through sociability. The importance of the elegant home for art, with its convivial rooms, located in a good section of town underlined both the bourgeois and the masculine aspects of the societies.

Other influential voices were raised in the 1890s pointing to stagnation within the art societies or dismissing them as antiquated institutions that, having lost their contact with contemporary life, were no longer important factors in the German art world. Among the most vocal critics was Lichtwark, director of the Hamburger Kunsthalle, who pointed out in a speech at the end of the century that a major problem for the art societies was the sheer monotony of their weekly exhibitions, which, he said, the best-known artists were avoiding. This meant, Karl Voll (1867–1917) wrote in his review of Lichtwark's talk in Die Kunst für Alle, that the societies' exhibits were filled with the works of mediocre artists and dilettantes. Furthermore, a problem for the societies was the support of older or impoverished artist members, whose works the societies chose for the regular exhibits or purchased for the lottery as a means of providing them with an income. Voll commented that as admirable as these welfare efforts were, these artists' works should not be given preference over works of higher quality.[65]

A report in Der Kunstwart in 1892 recounted that many people considered the societies to have a negative influence on the development of art. Though some of the art societies were considered to be progressive, others were popularly called "Societies for the Care and Promotion of Incompetence." Four years later a letter in Der Kunstwart's correspondence section dismissed the societies as the "playground for petty bourgeois megalomania and

the most dreadful breeding ground for incompetence." These disparaging descriptions of the art societies rested upon the accusations that they catered to the philistine taste of a petit bourgeois public and therefore completely failed to promote the progressive movements in the art world. The evidence supporting these charges was not difficult to find, particularly in the centers where the new art movements gathered strength and support in the 1890s. In Hamburg, where the Kunsthalle under Lichtwark's direction was actively promoting modern artists, both German and foreign, the local art society became the forum for strident attacks against the new movements in art. Yet strong voices rose in defense of the art societies. In his article on the Munich Art Society, Pecht argued that the struggle over the future of art was going on in the halls of the art societies, for thousands were now visiting the society galleries every week to examine the works of art. In short, he said, here, specifically in the art society, one could learn better than anywhere else "what a living, genuine popular national art is."[66]

A more pragmatic defense appeared in the journal *Deutsche Kunst*, founded in 1896 as the central organ of the German art and artists' societies. Flaunting its support from all of the major artist and lay societies, as well as state art administrations, the weekly journal was edited by Malkowsky in Berlin and was devoted to providing news about the activities of the societies and associations across Germany. Its list of contributors by the second year was impressive, including, among others, the museum directors Lichtwark, Jordan, Justus Brinckmann (1843–1915), Karl Woermann (1844–1933), and Theodor Volbehr (1862–1931) and the art historians Jacob Burkhardt, Cornelius Gurlitt, Franz Servaes (1862–1947), and Voss.[67] The fourth issue, dated 24 October 1896, was devoted to a defense of the task and performance of the German art societies. Theodor Seemann (1837–1898) began by defining the task of the art societies: first, to spread the appreciation of art among the educated public and to raise the level of interest through permanent and changing exhibitions; second, to provide a quick market for artists to find buyers and by supporting them materially to enable them to contribute to the further development of a national art. He then presented sales totals for the major art societies as an indication of the strong support given by the lay public through the art societies to artists. In 1879–80 alone more than 725,000 marks was distributed to artists by forty of the art societies from sales in their galleries. Although his statistics for more recent years were less complete, he concluded that general sales and membership figures had risen in the previous twenty years, indicating the continuing strength of the art societies. The art society in Düsseldorf, for example, had sales in one year, 1894, of 109,052 marks, with total sales since its formation amounting to more than 3.7 million marks.[68]

From the point of view of the artists, these were not negligible amounts. The annual amount budgeted by the Bavarian parliament for purchases of contemporary art in the late 1880s was only 20,000 marks. These sums from the art societies may have benefited a larger number of artists than comparable sums spent at the Glass Palace. Seemann provided no evidence of this, but it is unlikely that works shown in the art societies could command four- or five-figure prices or that the members of the societies and local citizens had the means of the visitors to the great exhibitions in the summer. In other words, the prices for individual works of art were lower in the art societies than in the great exhibitions. Moreover, a large proportion of the purchases made at the art societies' galleries were made by the societies themselves to be distributed through their annual lotteries. Sales in the art societies were, in a very real sense, bread and butter for many artists.

These statistics, however, did not answer the primary complaints leveled against the art societies, because sales alone gave no indication whatsoever of the quality or type of artworks being displayed

and sold. Seemann turned directly to the complaints about stodgy and incompetent art, reminding his readers as he did so that the history of German art in the past century had been reflected in the acquisitions of the societies. He argued that the task of the art societies was not to promote new art forms but to provide material support for artists. In instances where a society promoted new movements in art without concern for public taste the result was always declining membership, poor attendance at exhibits, and reduced income for the artists. The prevailing taste, he concluded, could only gradually be turned in new directions. Seemann's position was conservative, nationalist, and not unpopular.

In the final installment of his study, published in December 1896, Seemann took a sharp stand against the presence of foreign artists in the international exhibitions, which, he was certain, had had damaging effects upon both the art and the artists' economic situation in Germany. He pointed out that foreign artists had sold close to 3 million marks' worth of art to mostly German patrons in the last twelve international exhibitions, money that should have gone to German artists. It was, he maintained, the duty of the art societies to counter the influence of the international exhibitions by limiting their exhibits and purchases to the works of German artists.[69] This insistence upon the unfair encroachment of foreign art, particularly French art, upon the German market was a leitmotif that accompanied many of the arguments over art, especially in the 1890s, when an increasing number of artists in Germany faced economic hardship.

Nevertheless, it is important to emphasize that the nationalist conservatism represented by Seemann's article did not preclude, in fact was actually a witness to, the increasing openness to new movements and styles within the German art world. Although Seemann published his defense of the art societies in the journal that was the central voice for those societies and recommended that the societies take a conservative stance to counteract the nega-

tive impact of foreign art, the journal itself featured the artists who were considered to be the most modern in Germany. Filling the better part of *Deutsche Kunst* in its first years were featured articles on Böcklin, Leibl, Trübner, Uhde, Skarbina, Klinger, and Liebermann, the last with photographs of Liebermann in his studio. The sole foreign artist featured was the Belgian Symbolist Félicien Rops (1883–1898), who had acquired substantial notoriety in Germany after his death. As the editor wrote, the journal wanted to present "an unbiased, practical relevant organ for artists and friends of art." In December 1896, when attacks by nationalist critics were mounted against the new purchases of French Impressionist art, including Manet's *In the Conservatory* and works by Degas and Monet that were being shown in the National Gallery in Berlin, *Deutsche Kunst* strongly defended the director Hugo von Tschudi (1851–1911) for making these purchases. The article insisted that Manet, "the father of modern international naturalism," was worthy of being represented in every public collection. Tschudi, it concluded, should be praised for collecting these important "artistic documents."[70]

Despite the accusations of critics and the defensive stances of the apologists, the art societies themselves prospered at the turn of the century as part of the larger phenomenon in which all types of specialized interest groups emerged on the local level. The existence and continued growth of these decentralized art markets, which formed a network across the nation, were significant in enlarging the public that paid attention to and supported art, whether as active participants in a society or as visitors in the galleries. That these societies were locally based contributed immeasurably to the uneven but unquestionable encroaching of the modern artists upon the territory of the art societies, which many considered to be irredeemably philistine. This seemingly contradictory proposition was yet another demonstration of the multiplicity and diversity of the public. From city to city, from region to region, by class or religion

within cities, the public were of many minds. Thus, where one society cautiously continued sentimental village scenes, another could be prodded—by its leaders, an ambitious dealer, a cosmopolitan patron—into exhibiting more daring contemporary work. The evidence crops up in the fine-printed notes in the art journals about art societies in unexpected places proudly exhibiting unexpected art, indicating the process that facilitated the rapid acceptance of modern art across Germany in the years during and immediately after World War I. Several developments within these societies are important to consider in this context: the substantial size of the membership rolls in the 1890s, the close relationship with art dealers, the creation of circuits for traveling exhibitions, and the appearance of works by artists considered to be modern in provincial exhibitions.

FROM COLOGNE TO LIEGNITZ: LOTTERIES AND PUBLIC PATRONAGE

Among the oldest societies, the Munich Art Society, granted a royal charter in 1823 and officially dedicated in 1824, grew to fourteen hundred members by 1834. By that time, claimed Pecht, writing on its seventieth anniversary in 1894, the Munich Art Society had become "the supporter of national and realistic art in opposition to academic classicism, champion of progress, and center of the genuinely national artistic life." After successfully establishing their exhibitions in the arcade along the Hofgarten, in the center of Munich, with the help of a local art dealer, Johann Michael von Herrmann, in the 1860s the society was able to move into its own headquarters, which formed a social and cultural base for its members, who numbered fifty-four hundred in 1869. By 1888 the Munich Art Society claimed to be the largest and most active of all the German art societies. During the 1894 anniversary year, it reported its highest membership, six thousand, with each member paying an annual fee of twenty-one

marks; the gallery displayed more than six thousand artworks; its annual income rose to well over one hundred thousand marks; and it purchased seventy-four thousand marks' worth of art to distribute through the lottery to its members. The continuing prosperity of the society was noted in *Die Kunst unserer Zeit* with photographs of the interior renovation in 1894 of the society's building.[71] For the rest of the decade the position of the society remained steady. Under the leadership of Lenbach, the immensely successful society portrait painter, a new, more opulent society building with larger galleries was dedicated in 1900, although the debt incurred by the building hampered the society for years.

The Munich Art Society maintained its strong position throughout the century. Facing the competition of the great exhibitions of the 1880s, the society began holding special one-person exhibitions for recognized artists, both "old" and "young." Among these exhibitions was a controversial showing of Trübner's paintings in early 1891 (fig. 49). Individual shows like this one for Trübner were generally arranged by art dealers for the artists whom they handled. Over the years, the Munich society was associated with art dealers who helped arrange the weekly exhibitions, including adding paintings from their artist clients to the society exhibitions. This close working relationship between the art dealer and the society was a mutually profitable one in that the society did not have to worry about the organizational and financial arrangements and the dealer established contact with a significant number of the artists of the city. Such an alliance was not unique to the Munich organization. Similar partnerships were made, to cite a few, in Hamburg with George Ernst Harzen and J. M. Commeter; in Hanover with the court art dealer C. Schrader; and in Berlin, where in the 1870s Louis Sachse worked with several different societies.[72] Establishing an effective arrangement with a dealer often became a critical factor in the success or failure of independent artist groups in the decades before World War I.

Patterns of organization varied from city to city, but all the societies showed growth in membership and income in the 1890s, even as they were being denigrated by critics. The Saxon Art Society reported from Dresden that fifteen thousand visitors and twenty-five hundred members had brought their income up to seven thousand marks in 1896. The society attributed this satisfactory rise in income and visitors to new rooms and improvement in the quality of the exhibitions achieved with the help of several local art dealers. Moreover, crowds had been attracted by a lecture sponsored by the Dresden society in December 1896 by Woldemar von Seidlitz (1850–1922), director of the Royal Saxon Art Collections, entitled "The Development of Modern Painting." In his lecture, reviewed in *Die Kunst für Alle*, Seidlitz traced the evolution of modern painting from its beginning with Manet and the Impressionist exhibition of 1871 in Paris. This lecture was so well received by such a large audience that Seidlitz gave another lecture, entitled "Open-Air Painting." The reporter for the society commended Seidlitz for presenting a moderate view of modern art that had reassured listeners the new art would not dethrone the great masters of the past. In Leipzig, the Society for Friends of Art held regular lectures on art in 1895, including one on Hans von Marées (1837–1887) and another by Heinrich Wölfflin (1864–1945), in which slides were shown to large audiences. Exhibiting the works of artists from beyond the city, the Leipzig society showed not only contemporary work from Munich but also the colorful and, for some, shocking works of the Glasgow Boys. With membership rising to twelve hundred, the society gave a good part of its profits to support the Leipzig Museum of Art.[73]

Cooperation between the society and the museum marked the Hamburg Art Society, first founded in 1825, which transferred its collection to the municipal Kunsthalle when the museum first opened in 1869. The society held its continuously changing exhibition of contemporary artworks in the Kunsthalle

until 1884, when, with the hiring of a business manager, the society's exhibition was moved into rooms in the center of the city and smaller, retrospective exhibits of renowned artists, Menzel in 1896 and Böcklin in 1898, were added. Prospering through the 1890s, in 1899 the society opened its own house, with galleries that allowed for a greater variety of contemporary artists and artist groups to be shown. The following year, over three thousand works of art were exhibited. The numbers of visitors ranged from

Fig. 49 **Wilhelm Trübner, *Studio Scene*, 1888. Oil on canvas, 40 7/8 x 34 5/8 in. (104 x 88 cm). Germanisches Nationalmuseum, Nuremberg.**
A brief review of a Trübner show in *Die Kunst für Alle* 6, no. 11 (Mar. 1891): 172, predicted that those in the societies who, carrying a rigid "aesthetic dagger," raised their outcry against naturalists, realists, and painters of ugliness would not be able to appreciate Trübner's unique talent. This painting demonstrates his controversial combination of realistic, detailed presentation with unconventional, often ambiguous scenes.

five thousand to ten thousand annually over the decade 1895–1905, though the special retrospectives each brought in well over thirty thousand visitors and buyers. The art society's membership, standing at two thousand in 1888, however, sank in the next decade, when, after the appointment of Lichtwark as director of the Kunsthalle, tensions accelerated between the conservatives in the society and Lichtwark over his aggressive support both for new movements in art and for a plethora of new art organizations in Hamburg itself.[74]

Symptomatic of the fragmentation that developed in the German art world in the mid-1890s, the problems of the Hamburg Art Society could also be read as confirming Seemann's warning against dictatorial efforts to foist modern artists upon the largely conservative art societies. Nevertheless, Lichtwark's efforts in the 1890s did establish the Kunsthalle as the premier German museum in the commission and purchase of modern art. Almost as influential was his creation of new forms of voluntary organizations affiliated with museums, which enlisted high-society leaders, especially women, to become actively involved in arts programs and in the support of the museum, and his promotion of the museum as a center of art education. Both of these developments would divert attention away from the older, traditional art societies in later decades.

Those developments lay in the future. While the Hamburg Art Society was troubled by the confrontation in 1896 between its conservative members and Lichtwark over his support of new art, other art societies were thriving. In Düsseldorf the Art Society for Rhineland and Westphalia in 1896 reported a membership of six thousand and reserves of seventy-three thousand marks. From 1829 to 1902 Düsseldorf purchased and distributed to its members more than 2 million marks' worth of art through its lottery. Hanover's art society, founded in 1832, expanded its membership so rapidly in these years that it became the largest in Germany. Its membership went from close to five thousand in

1894 to more than ten thousand by the end of the century. Its annual exhibition, held from February through April, attracted more than twenty thousand visitors to exhibitions of paintings selected by tough juries; in 1895 six hundred works were hung, with an equal number rejected. In Stuttgart, the Württemberg Art Society, making plans to build its own house in 1887, reported fifteen hundred members and seventy-three thousand visitors to its exhibits in 1889; by 1901 its membership had almost doubled. At the same time the Society for the Promotion of Art in Stuttgart reported on two studio buildings that it provided for artists and on various public works and monuments that it funded in the city.[75]

In 1889 the Cologne Art Society provided a useful summary of its financial activity over its first half-century, decade by decade from 1839 through 1888, with a total income in those years of almost 2 million marks. Total sales of art from its galleries during those years amounted to 2.5 million marks; of that sum, the society itself purchased close to eight hundred thousand marks' worth of art to distribute in its members' lottery, another five hundred thousand came from purchases made by private individuals, the city, or the museum, and the final 1 million marks' worth of artworks were sold by lottery to raise funds for completing Cologne's Gothic cathedral. All of this was reported in detail in *Die Kunst für Alle*, which proudly concluded that these official figures proved the extent to which the old love of art was still at home on the Rhine.[76] More was revealed by this report than the pride of one city. The amount of space *Die Kunst für Alle* devoted to these reports indicates how important they were for contemporary artists and reflects the interest in the societies on the part of readers of the journals. *Die Kunst für Alle* also regularly published the announcements from the societies of upcoming exhibitions, along with instructions to artists for submitting their works.

A 1989 report on the activity of the Cologne Art Society over the 170 years by the closing date in

October of its existence also provides statistical evidence, in this case evidence of the "victory of the new art" that the reviewers of the Third Munich International claimed had occurred in that 1888 exhibition. A careful perusal of the artists who showed works in the Cologne society's annual exhibitions from 1839 to 1925 reveals a startling break after 1888. Of the artists who exhibited in the 1880s a large number, more than fifty, had appeared in more than ten previous years. With only a few exceptions, none of these artists appeared after 1888. Of the artists who showed in the decades from 1890 to 1925 fewer than twenty appeared more than three times. These rough statistics demonstrate the fundamental shift that occurred in these years, from a stable world of fairly well established artists to a large, heterogeneous, and rapidly changing art scene. This shift is further demonstrated by the fact that on the 1890–1925 lists the artists who had more than a regional reputation were those who would have been counted as new or modern artists, including major names of the 1890s: Liebermann, Lovis Corinth, Leistikow, Stuck, Kollwitz. The statistics also show that membership in the society was at its highest sustained level in its long history during the period 1881–95. From slightly more than three thousand members in 1881 its membership climbed to thirty-four hundred in 1894. By 1901 it had dropped to two thousand.[77]

Evidence of the slow but definite shift from the old artists of the 1870s and 1880s to the artists of the new movements of the late 1880s and 1890s was not confined to art societies in the western regions of Germany. A lengthy note in 1899 in *Die Kunst für Alle* from Breslau, the third largest city in Germany in 1885, reported that the Liegnitzer Art Society was the first art society in Silesia to make an effort to promote modern art. It approached the difficult task of convincing artists to exhibit in Lower Silesia by demonstrating enthusiasm for the work and promising substantial purchases of paintings. An exhibition in 1897 was successful enough to be followed by another in 1899—actually the society's eighth exhibition—in which paintings, graphics, and a large collection of modern posters were shown. Among the works were modern landscapes from the Worpswede artists' colony and from other modern painters, including drawings by Liebermann. In an effort to make the exhibition accessible to local residents, electric lights were installed so that the galleries could remain open at night. Local art dealers cooperated with the exhibition by concurrently showing modern arts and crafts. The Breslau Art Society had itself cooperated several years earlier with the Theodor Lichtenberg Art Gallery to stage a display of oils and drawings by the controversial painter Giovanni Segantini, whom the reviewer for the *Deutsche Kunst* described as a unique artist, tied to no tradition, whose technique of painting with tiny dots produced a marvelous impression.[78] These reports from the eastern border district of Silesia demonstrate that by the last years of the century even an art society in a provincial town might champion contemporary artists that were still perceived with disfavor in some quarters. Liegnitz was not, however, the only isolated outpost where contemporary art was being shown. One of the remarkable contributions of the art society movement in the nineteenth century was its organization of networks of traveling exhibitions that crisscrossed Germany.

THE ART SOCIETY CYCLES OF TRAVELING ART

Cooperation between art societies began in the first years of their formation, with the exchanging of membership privileges and lottery tickets. This soon led to societies' linking together to create exhibitions of paintings for sale that traveled through regular cycles of cities. In its first issue, in 1885, *Die Kunst für Alle* reported on three permanent cycles of contemporary art that were functioning successfully. The oldest, the pathbreaking Federation of

South German Art Societies, was formed in 1852 by art societies in the major cities in southern Germany. Its success in sparking an interest in art in new circles and creating markets for the sale of art inspired other cycles that became important outlets for the work of young and lesser-known artists. Not only were works of art being circulated to new audiences but, the journal noted, these traveling cycles also encouraged the production of smaller paintings, which were both easier to transport and more attractive to private consumers. The German Exhibition Federation (Berlin, Hamburg, Bremen, Düsseldorf, Cologne, Frankfurt am Main, Munich, and Leipzig), was formed in 1883 by cooperation between the most important local art societies to circulate sales exhibitions, again of contemporary works, to the major art centers in Germany. Considered a valuable entry into the art market, this cycle accepted works only by recommendation or invita-

Fig. 50 **Maps published in *Die Kunst für Alle* showing the exhibition sites for 1888 and 1899, indicating the basic cycles of art societies.**

According to the keys to the maps, a white circle indicates a periodic exhibition; a black circle, a permanent art exhibition; a black dot within a circle, a city with both permanent and periodic exhibitions; and an underlined city name, a city with exhibitions held at a dealer's gallery. The annual maps demonstrate the expansion of the traveling exhibitions in the mid-1890s, followed by the consolidation into a smaller number of strong tours. At the same time, the number of cities with dealers' galleries almost doubled over the decade.

Advertisements inviting artists to enter works in the traveling exhibitions appeared in the journals, especially in *Deutsche Kunst*. The announcement of the South German Federation of Art Societies for 1897, for example, pointed out that sales were strong on this tour, usually about one hundred thousand marks annually, and informed the artists that the Württemberg Art Society, in Stuttgart, was handling all entries as well as organizing the jury. Deadlines and information for shipping were included.

A

B

tion. A regular exchange cycle between Mannheim and Heidelberg was also established before 1885.[79]

Die Kunst für Alle annually published calendars and a map taken from the *General Art Exhibition Calendar*, put together by the Munich art-transport firm Gebr. Wetsch, which provided the schedule and information for all of these exhibitions (fig. 50). *Kunstchronik* similarly produced full-page listings of exhibitions for its readers. The *Deutsche Kunst* also published regular information on the traveling cycles, beginning with a description of those that were actively functioning in 1896. Several cycles were organized so that the cooperating societies only hosted the exhibition every other year: the North German Federation (Bremen, Lübeck, Rostock, and Stralsund), the East German Art Federation (Bromberg, Memel, Tilsit, and Thorn), the Federation of Art Societies East of the Elbe (Danzig, Königsberg, Stettin, Breslau, Elbing, and Görlitz), and the Art Societies West of the Elbe (Hanover, Magdeburg, Halle, Dessau, Gotha, Cassel, Halberstadt, Braunschweig, Nordhausen, and Weimar). The Rhenish Art Society Cycle (Baden-Baden, Karlsruhe, Darmstadt, Freiburg, Hanau, Heidelberg, Mainz, and Mannheim), founded in 1837, took place every year from 1 March to 31 October, with the exhibitions staying at each city for four weeks. The oldest cycle, the Federation of South German Art Societies (Augsburg, Stuttgart, Wiesbaden, Würzburg, Fürth, Nuremberg, Bamberg, Bayreuth, and Regensburg), took place in a fixed order beginning every year on 1 January. In addition to these cycles operating in 1896, the maps in *Die Kunst für Alle* show a Westphalian Exhibition Cycle (Münster, Dortmund, Minden); a Palatine Cycle (Kaiserlautern, Zweibrücken, Primasens, Dürkheim, Neustadt, Germersheim, Frankenthal, Ludwigshafen, Speyer); and one, sometimes two, cycles in Switzerland.[80] All of these cycles operated successfully through the 1880s and 1890s despite considerable shifting of cities from one cycle to another.

Sales of artworks in the societies along the traveling route were substantial, and profits were frequently reported in the journals. Even the humor journals had fun with the image of traveling paintings trundling past viewers (fig. 51). As works were sold along these cycles, more works were added, although the last cities on the tours often saw severely depleted exhibits. In many of the cycles the order of cities was changed each year in order to maintain some level of fairness. The art societies were themselves the major purchasers at these exhibits. They bought paintings, graphics, and small sculptures for use in their annual lotteries for members and in some cases for their own permanent collections. These regular touring cycles remained active into the first years of the twentieth century. In 1893 the societies in the German Exhibition Federation united with several art societies from the Rhenish Art Society Cycle to form a large new traveling circuit of art organizations in eleven cities that reported favorable sales in the next years. As the most powerful society with the strongest artists in this cycle, the Munich Art Society annually received more than eight thousand marks from fees from the other sites. Also in 1893, a conference in Gotha of the Art Societies West of the Elbe announced that their previous cycle had sold more than 145,000 marks' worth of artworks.[81]

What all of this information amounts to is that Germany was a pioneer in institutionalizing the circulation of contemporary artworks between cities and across the nation. That this was achieved through the active cooperation of local private art societies in the strong regional centers only enhanced the distinctive decentralized character of the German art world. It also accentuated the integration of works of arts in the capitalist marketplace as consumable and movable objects available for private purchase by anyone with the means to do so. Already in the late 1880s individual artists, working through the art societies and dealers, began to tour their works, especially ones that had attracted notoriety in the great exhibitions. Carl Marr's large

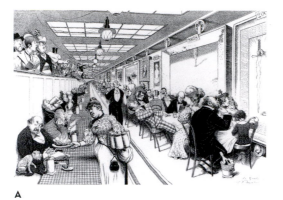

A

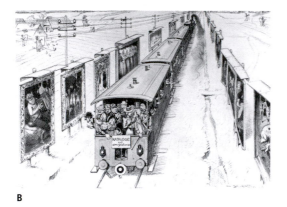

B

Fig. 51 *A.* **Th. Gratz, "Up-to-Date Improvements,"** *Fliegende Blätter* **101, no. 2571 (1894): 167.**
B. **H. Stockmann (1867–1938), "Up-to-Date,"** *Fliegende Blätter* **110, no. 2805 (1899): 202.**

A commentary on the phenomenon of traveling exhibitions of paintings, the first cartoon (*A*) carries the idea of circulating paintings to the extreme: the paintings travel past the viewers, thus not interfering with their more important pleasures, eating and drinking. The paintings in this contemporary gallery are definitely from the new modern movement, with the closest one being a direct depiction of Stuck's *Guardian of Paradise* (plate 5). The bored wealthy patrons are seated at the places of honor with their catalogues and fine wines, while the lower classes gesture enthusiastically from the balcony. In the middle, guzzling beer at tables with checked cloths, are the middle-class bourgeoisie. A band or orchestra in the middle adds to the atmosphere.

The caption to the second cartoon (*B*) offers a different solution to the problem of overflowing exhibitions, saying that artists had declared themselves willing to display their paintings along boring sections of railroad tracks. With catalogues for the exhibition available at all railroad stations, the train moves slowly past paintings that include Franz Stuck's happy satyr, Walter Leistikow's landscape of trees, Max Liebermann's pigs, and Paul Hocker's nuns.

painting *The Flagellants* (fig. 52), which had won great acclaim in the First Annual Munich Exhibition, began a tour arranged by a Munich art dealer as soon as the annual exhibition closed. Opening first at the Augsburg Art Society, it traveled around the major cities of Germany before being sent the following spring to the United States. Similarly, Preuschen, who had acquired a controversial status with her large symbolic paintings *Mors Imperator* and *Irene von Spilimberg on the Burial Gondola* (figs. 3 and 88), had exhibitions at the Munich Art Society in 1894 and in 1896. The latter collection of forty-eight oil paintings made a tour of German cities, including Metz and Dresden.[82]

By the end of the century artists and new artist groups, including foreign artists, were making use of these traveling tours to promote their particular varieties of modern art in towns and cities across

Germany. The influential editor of the *Zeitschrift für bildende Kunst*, in an 1890 editorial surveying the current state of art, pointed to the internationalization of contemporary art, which he attributed, without question, to modern industrial transportation. Iron railroad tracks, he said, proved to be stronger than nationalism. Reports about the traveling exhibitions say little about the quality or type of art, suggesting that much of it was probably fairly undistinguished, but pleasant, saleable work. This meant a predominance of moderate open-air landscape paintings by the mid-nineties. Every so often, however, mention was made of unusual works, namely, the work of new artists, that were attracting attention on these circuits. For example, after an abrupt closing of his 1892 show at the Berlin Artist Society, Munch toured his paintings with successful sales in seven cities. In the decade before World War I a

vigorous new art dealer in Berlin, Paul Cassirer (1871–1926), arranged a series of traveling exhibitions of paintings from the van Gogh estate that were held both in dealers' galleries and in the homes of art societies in major cities of Germany and Austria.[83]

In effect, this nineteenth-century system of delivering artworks to patrons across Germany provided the essential infrastructure for the rapid spread of modernism. Dealers working with the traveling cycles of the art societies organized a substantial number of exhibitions for innovative young artists in the first years of the twentieth century. Fascinating artists and enraging the public, a large exhibition of French Post-Impressionists made a major circuit in Germany; Dresden's young expressionist group, the Bridge, established itself through a series of traveling cycles; the paintings of Wassily Kandinsky and his friends similarly toured German cities, followed by a cycle of paintings by the Fauves and Cubists; and Herwarth Walden successfully promoted the

Fig. 52 **Carl Marr (1858–1936), *The Flagellants*, 1899. Oil on canvas, 13 ft. 8 in. x 25 ft. 11 in. (4.2 x 7.9 m). Collection of The City of Milwaukee, on loan to The West Bend Art Museum, West Bend, Wisconsin. Reproduced in *Die Kunst für Alle* 5, no. 1 (Oct. 1889): double-page spread.**

The monumental size and notoriety of this painting warranted a solo tour to galleries run by art dealers or art societies, rather than its being part of one of the regular traveling cycles. When it was hung in the First Annual Munich Exhibition, in 1889, it attracted both public and critical attention. Friedrich Pecht normally had little good to say about the creation of historical scenes from earlier eras. However, he praised Marr's work at length, pointing out that this virtuoso historical painting set in an Italian Renaissance hill city actually represented a prophetic statement against the sybaritic materialism of contemporary German society. The extent of the painting's travels suggests that audiences found its grim subject as compelling as Pecht did.

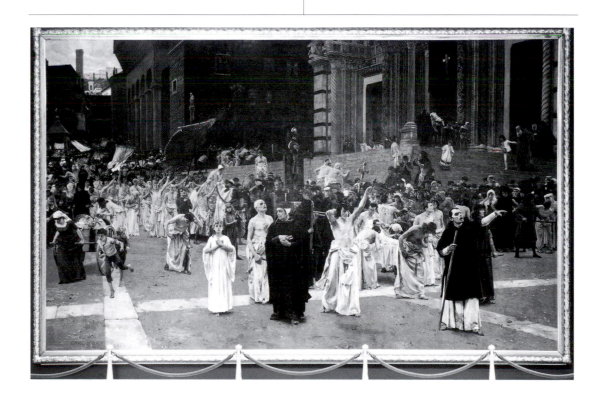

expressionistic art through traveling exhibitions in Germany and then abroad.[84] These traveling exhibitions and the local exhibitions of the art societies, despite their significance in establishing a widespread interest in and market for contemporary art, tended to operate without attracting notice beyond the immediate localities where they were shown. The national journals occasionally included brief notices but did not provide reviews. By their nature, the traveling exhibitions were not only constantly moving but also changing their contents as works were sold and added during the tour. Their function was to provide a way for the local public to view and acquire art, not to attract critical attention.

Considering the number of art societies that were functioning in the 1890s, and I have written here about only a fraction of them, the creation of yet another one may have seemed superfluous. Nonetheless, in December 1892 some of the most powerful leaders in the German museum world spearheaded the founding of the German Art Society in Berlin to bring together artists and friends of art since Berlin's already existing societies separated artists from art lovers. With an executive committee composed of distinguished bankers and businessmen, including Rudolf Mosse, founder of a liberal Berlin publishing house, the elected president was Minister of State Heinrich von Achenbach and the vice president was Jordan, director of the National Gallery. The goal of the new society replicated a goal of the far older societies, namely, to support artists, but the emphasis here was upon young promising artists, who were facing a depressed art market. The annual fee was twenty marks for a single lottery ticket and the annual gift of art; artists could join for five marks without receiving either benefit; patrons of the society were welcomed at a minimum of one thousand marks a year. Contradictory news releases from the early months indicate that there was some confusion over whether the society would promote the new modern movements.[85]

Membership in the new society increased rapidly

in the following months, with many prominent figures from all sectors of Germany entering as patrons. The director of the Royal Painting Gallery in Berlin, Wilhelm Bode, who had been active in the planning, also became one of the chairs of the society. The first annual lottery, in February 1894, distributed more than twenty-four thousand marks' worth of paintings, bronzes, and graphics purchased from contemporary artists. By the end of the decade the German Art Society exhibitions at the modern art gallery of Keller & Reiner in Berlin and its annual lottery featured works by Leistikow, Skarbina, Stuck, and Kampf. The annual gifts when Tschudi, the next director of the National Gallery, was the chairperson were definitely on the modern side.[86] Using the traditional and familiar structure of the German art societies, the German Art Society was a prominent example for groups that in later decades sought to use the art society model to promote contemporary art and cultivate interest and understanding for that art on the part of the public, that is, to generate a market for modern art.

The question remains, however, whether the art societies in the heyday of their expansion in the 1890s were detrimental to the creation of public appreciation of the visual arts. Were the critical voices raised against the societies in the art journals correct in their view that most of the societies' activities served to degrade the visual taste of the public? The many notes in the journals conveyed to their readers the societies' significant accomplishments in selling a large quantity of artworks to support artists and in displaying and distributing art for the edification of their members. Given the absence of reviews, however, the quality of works shown and sold in their galleries was not discussed in the journal reports. This remarkably extensive circulation of paintings through one locality after another remained in the shadow of the great exhibitions with all their attendant publicity and reviews.

The reconstruction of local records, such as those of the Cologne Art Society, provides no simple

conclusion. On the one hand, the Cologne records confirm the scathing attacks upon the triviality of the reproductions that were distributed as annual gifts by this strong society in the 1880s and 1890s; on the other hand, the record of modern artists whose works were shown in the Cologne gallery by the end of the century is a testimony to the profound transformation occurring during those same years. It seems clear that in these years of rapid change and unsettled styles the art societies were faced with a fundamental contradiction in their dual task of supporting contemporary artists and promoting an appreciation of art on the part of the public. The market imperative would surely have influenced the anonymous organizers of those touring cycles to chose the safe works in familiar styles rather than cart new art whose sale might be chancy around the entire cycle. Similarly, as Seemann insisted, the local art societies could not fail to sell works of their artist members or afford to offend their own membership; hence conservative exhibitions that reinforced comfortable traditions and cultivated the petit bourgeois tastes that some critics scorned as philistine. And as one critic crisply stated, "The philistine does not love the new." Yet, the triumph of the new art that all the critics conceded was dominating the great exhibitions slowly filtered down to the art societies. The notes in the journals of modern works cropping up in even remote locations by the end of the 1890s are a definite indication of the change taking place in the art offered in the societies.

From 1885 to 1900 the great exhibitions and the art societies complemented each other as the basic institutions for disseminating art to the public. Expanding in size, numbers, and complexity to meet the demands of an emerging mass society, both of these nineteenth-century organizations flourished even as their fundamental functions were being threatened. These challenges came from the heart of their enterprise: the artists and their art. The rapid transformation from time-honored artistic conventions in style, content, and method to transient styles, ephemeral subject matter, and unconventional techniques meant substantial alterations in the display of art, adjustments that both institutions were able to make in the course of the 1890s. Whether the public—wherever and whoever that might be—were prepared for change was a critical issue that flared into the controversies of the mid-1890s.

part II

THE PUBLIC AND THE CRITIC

In the autumn of 1893 a small booklet delivered an indignant denunciation of the public thronging through the art exhibitions and galleries that dotted the German cities (fig. 53). Raising a considerable furor in the art world, the booklet, titled simply *Schaupöbel*—a succinct German word meaning

"exhibition rabble," with all the derogatory connotations of unwashed riffraff or common vulgarity— left a lasting legacy.[1] Writing with the passion of one who had recently awakened to the beauty and wonder of the new art of Max Klinger, Franz Stuck, and Ludwig von Hofmann, the writer Eugen von Franquet was enraged by the stupid comments and insensitive reactions of the crowds to new paintings shown that spring at the Eduard Schulte Art Salon in Berlin and in the summer at the first public exhibition of the new Munich Secession, at the Great Berlin Art Exhibition. And according to other witnesses, the laughter, lousy jokes, and exclamations of "Terrible!" coming from the Berlin public were definitely raucous.

Franquet's wrath, however, was directed particularly at critics—"the educated rabble"—who, opposing the new modern art forms, catered to the public by giving them easy negative phrases to reject art that might disturb or challenge traditional ideas and who coddled the public by calling for comfortable works of art to be displayed in the exhibitions. "Our indignation," he exclaimed, "rises even more over these spokespersons for the crowd, whom we hear at every opportunity speaking about the 'legitimate demands of the public' or calling for 'the consideration that the purchasing public deserves' and who in every third sentence refer to 'what the public wants' and what 'the public demands.' The 'Public'—over and over again 'The Public!'" No one forced people to look at or buy paintings that they did not like. "What the public wants," he insisted, "is completely *irrelevant*."[2] This antagonistic view of the public was a marked departure from the optimistic belief of Friedrich Pecht and Ferdinand Avenarius in the 1880s that the people would become the informed patrons of the new art

of the nation. The dream of "the people as patrons" had turned into the nightmare of the schaupöbel.

Had the young writer's voice been a lone one crying in the wilderness, the booklet would have rapidly disappeared into oblivion. Instead, within months of its publication an experienced spectator of the German art scene noted that the difficult relationship at this time between the public, on the one hand, and the artists, on the other, had led to the enrichment of the German language through the creation of the new words *Schaupöbel* and *Kunstpöbel*. Not only did the pamphlet produce the new words to apply to the German art scene, its intemperate language also created quite a stir. Avenarius commented that watching the Berlin public making jokes about art of which they had no sense whatsoever, with no doubts about their own ideas, was enough to make anyone agree with Franquet, if not with his reckless pronouncements. Indeed, other reviewers expressed their dismay over the behavior of the Berlin public in the rooms displaying the work of the open-air artists from Munich and from France.[3]

Karl von Perfall, who was delighted that this new art had finally appeared in the Great Berlin Art Exhibition in 1893, regretted the ignorance of the Berlin public, who, influenced by negative newspaper reports, reacted with hostility to work they did not understand. Ignoring works that were not sensational, the public searched for examples that confirmed their delight in condemning the new art forms. In the midst of the crowd, he reported, old bespectacled men, unintentional comedians, rushed around declaring with loud pedantic voices in front of impressionistic paintings that nature did not appear in such daubs and flecks. Perfall, who regularly argued that a creative interaction between artists and viewers was a necessary prerequisite for the development of strong art, found no sign of such positive factors in Berlin. Instead, he delivered a stinging indictment of the public in Berlin, charging that they did not have a clue about what modern art was: "What I heard in eight days in Berlin was the height of

philistine dullness, artistic small-townness, and intellectual lackluster."[4]

THE PHILISTINE PUBLIC

Attacks on the philistine public obviously were not new. The critical articles about public behavior during the Munich and Berlin exhibitions of 1887 and 1888 had already raised the basic points of contention. Although those critics had pointed to the public's negative response to the new open-air art, their displeasure with the public centered heavily upon uncouth behavior in the galleries and the extent to which the great exhibitions catered to the public's taste for sensation and their desire for vulgar entertainment (fig. 54). In Munich in 1888, Heinrich Steinhausen had condemned the craving of "the cultivated rabble," who looked for conversation and "salon gossip" in the exhibitions. Two years later in Berlin, Hermann Bahr (1863–1934), recently returned from several years of reporting on

Fig. 54 **H. Stockmann, "Good Taste for Art,"** *Fliegende Blätter* **109, no. 2783 (1898): 224. The caption reads: "Now pay attention to what I say. Because we couldn't get in the zoo today, let's go to the art exhibit tomorrow!"** In his critique of the art world published in *Die Kunst für Alle* in October 1895, H. E. von Berlepsch had complained that vulgar entertainment had taken the place of the enjoyment of art; in fact, he wrote, visiting art exhibitions was the same for the public as going to the zoo.

art in Paris, bemoaned the dreadful impression made upon him by "the gaping rabble," who could only repeat tired clichés as they marveled over sensational salon paintings. Moreover, he was astounded that an exhibition in the capital city would offer so much "secondhand junk" to the public. His response to both the exhibition and the public, he claimed, was an overwhelming sense of indignation and national shame. Adolf Rosenberg, writing for the *Zeitschrift für bildende Kunst* about the same Berlin Academy Exhibition of 1890, came to similar conclusions. Complaining of the mediocre quality of most of the works, he acerbically commented that the number of visitors would remain high because the pleasures in the parks around the building would attract the public from both home and abroad. Thus, he pointed out, the crowds increased as the external entertainment increased, but the level of art steadily sank. Part of the reason for the weak showing of this Berlin exhibition, Rosenberg claimed, was the strength of the Second Annual Munich Exhibition, occurring at the same time.[5]

Alfred Gotthold Meyer, however, in his glowing review of that 1890 Munich exhibition, with its strong contingent of foreign artists, also found it necessary to address the issue of people's behavior when they stepped into the color-filled rooms of paintings from the Scottish school known as the Glasgow Boys. These disturbing experimental works, according to Meyer, caused the public and critics alike to become uncommonly agitated. Recalling Émile Zola's depiction of the Parisian public in the Salon des Refusés of 1863, Meyer described the "sudden indignation and scarcely controlled laughter, then lively defense, even enthusiastic praise." Yet Meyer was cautious about this. Trying to be fair, he explored the difficulties that accompanied the presentation of radical new work to the public, whose praise could so rapidly turn into scorn and derision. He concluded that it would be better to show revolutionary or bizarre art only to viewers who were knowledgeable about art, not to the general public.

Profound distrust of the public's response to art was also vehemently expressed in an anonymously published pamphlet, *Art Comprehension Today*, appearing in 1892. The author, Wilhelm Trübner, an experienced artist who was experimenting with new ways of painting, argued in this pamphlet that art by definition fell into two categories: popular art, which the public could appreciate, and pure artistic efforts, which only a small minority could understand. He insisted that given this reality, efforts to satisfy the public demand could only result in mediocre and fashionable works' dominating the art scene, while the uncomprehending public ridiculed genuine artistic work.[6]

Class bias and elitist snobbery underlay these critiques in which the connoisseur from the cultivated middle class expressed dismay over the invasion of common folk, whose greatest joy was reputed to lie only in a glimpse of sensational paintings followed by a bottle of beer in the garden pub. The middle-class critic was equally scornful of those socialites who simply wanted to see and be seen by others at the exhibitions and scoffed at the newly rich merchants whose only interest was in purchasing a fashionable work of art for their drawing room. In the first years of the 1890s these people—the uncultured public—far from being seen as capable of becoming educated patrons of art, were increasingly perceived as debasing and degrading art exhibitions by their overwhelming numbers and crude tastes. As the artist Benno Becker (born 1860) put it in 1893, the great exhibitions, with their huge number of paintings, were having a negative effect upon art and artists. In these great marketplaces, Becker insisted, all of the works must satisfy the taste of the buyer, however garish or trivial. As a result, artists had become the slaves of the art rabble, serving only to please the instincts of the masses, instead of trying to raise the taste of the public.[7]

This harsh assessment of the negative impact of the public, with its plebeian taste and crass purchasing power, was an unmistakable response to the

steady emergence of new social groups within the new mass society in Germany. New organizations and parties formed by these social groups threatened to shake the social and cultural dominance of the respectable bourgeoisie, which had consolidated its position within the public sphere earlier in the century. Not only were workers' clubs and unions becoming more powerful but other activist societies, from local to national organizations, brought visibility to concerns and demands that were easily perceived as disruptive and divisive.[8] The proliferation of these interest groups, as well as mass political parties with their competing agendas, in the 1890s presented a severe test to the liberal nationalist ideals that undergirded the elusive hope of the art journals in the 1880s for a national art supported by a strong unified public. That hope had been predicated upon an understanding of national identity based on the cultural and political dominance of Protestant, male, bourgeois voices. When new groups of outsiders emerged on the public scene, national identity became a contentious issue. During the decades after unification, German identity became both more intensely sought after and more conflicted.

A major challenge to the liberal bourgeois ideal of national identity was manifested on the national political scene by the rise of anti-Semitic political parties, which achieved their largest victory, with sixteen deputies elected to the Reichstag, in 1893. The success was not repeated in succeeding elections, as inept leadership led to the marginalization of the overtly anti-Semitic parties until the war years. More damaging during the 1890s was the calculated exploitation of xenophobic and anti-Semitic views by newly formed right-wing nationalist and conservative pressure groups who sought to mobilize public opinion on issues created by the transformation of Germany into an expanding, modern industrial society. One of the targets of these new demagogic forms of political mobilization was peasants, who were increasingly voting in local and national elec-

tions, contributing to the strength of confessional and ideological political parties. Particularly active in 1893 were the Agrarian League and the German-National Commercial Employees' Union, for both of whom anti-Semitism was useful, if not central to their goals. Some Catholic organizations, reacting to their own troubles during the Kulturkampf of the 1870s and 1880s, also adopted anti-Semitic rhetoric. Among these were the Center Party itself, various Catholic peasant associations, and the People's Association for a Catholic Germany, founded in 1890. Responding to anti-Semitic attacks, Jewish communities in turn organized to defend their rights as citizens by forming the Central Association of German Citizens of the Jewish Faith in 1893.[9]

Another disquieting development challenging the bourgeois consensus was the growing number of organizations intent on altering the definitions of gender roles. Women's organizations questioned the societal constraints that severely limited women's roles within the public realm. In 1894 sixty-five different bourgeois women's organizations, with more than fifty thousand members, joined together to form the League of German Women's Associations. In the same year, the first large rally for women's suffrage took place in Berlin. Also in Berlin, in 1896, was held the first International Women's Congress on Tasks and Goals of Women, at which the enterprising artist Hermine von Preuschen delivered an address in which she asserted her belief in women's emancipation: "It is in the air, it is modern, inexorable." In the next year, again in Berlin, Magnus Hirschfeld (1868–1935) organized the highly visible Scientific Humanitarian Committee, which campaigned for ending the legal criminalization of homosexuality. The challenges presented by increasingly visible women and homosexuals within the public sphere by the 1890s galvanized the formation and growth of powerful morality leagues to counter social changes sought by both these groups.[10]

Less startling to bourgeois society, but no less disturbing, was the relentless rise of industrial workers in

numbers and visibility throughout Germany. Struggling to control their working conditions through labor unions, workers asserted their electoral rights through the Socialist Party and participated in their own richly diversified alternative culture. While the Social Democratic Party steadily showed greater success in elections after 1890, strikes increased, spreading from miners in the Saar in 1892–93 to beer workers in Berlin, who organized an eight-month beer boycott in 1894. Worker educational associations and recreational clubs were considered sufficiently dangerous to the established social order to merit continuous government surveillance and police harassment. Adding to the numerical dominance of industrial workers in the urban centers were the new white-collar workers, with their organizations and their consumption of new forms of commercialized urban culture. Contributing to the social unrest was the influx of laborers from the rural areas into the industrial centers, where, in the perception of some commentators, the corruption of the metropolis transformed sturdy peasants from picturesque villages into unruly workers whose coarse tastes fueled the cheap-entertainment industry.[11] Without question, shopgirls, clerks, servants, artisans, tradesmen, and factory workers did swell the beer-saturated music halls and taverns of Munich and Berlin. Apprehension that these lower-middle-class groups were also being drawn by the beer gardens surrounding the great exhibitions into invading the galleries themselves lurked behind the writing of the critics condemning the coarse behavior of the public at the exhibitions.

Critics writing for the art journals were not the only members of the art world who were concerned about the incursion of uncultivated behavior into the exhibitions. The artists who created the cartoons for the satirical magazines, particularly those in Munich who drew for *Fliegende Blätter*, began to express their views of the public in mildly humorous cartoons, often with pointed commentary. In these cartoons the attitudes expressed by critics in art journals were essentially reinforced through an easily accessible visual medium. These humor magazines also reached a wider portion of the middle class, from the petit bourgeoisie to the upper bourgeoisie, since their circulation figures and total readership ran far higher than those of the art and cultural journals. *Fliegende Blätter*, founded in Munich in 1844, by 1893 was reaching ninety-five thousand subscribers, a figure that included public outlets such as cafés or taverns, where a large number of people read each issue. A subscription to the eight-page weekly *Fliegende Blätter*, 6.70 marks for a half-year, was slightly less than a subscription to *Die Kunst für Alle*, 3.60 marks for a quarter, an indication that their readerships were drawn from a similar social base.[12]

The combination of its mass circulation, its longevity, its lighthearted treatment of bourgeois social life, and its determined avoidance of political issues made *Fliegende Blätter* a significant contributor to the social perceptions of the middle classes in the latter decades of the nineteenth century. This fact was acknowledged by the art journals in well-illustrated tributes published about *Fliegende Blätter*, in reviews of its chief artists, and in positive references to the magazine as the place where many artists first received recognition. By the end of the 1890s, original drawings from the magazine were featured in exhibitions of graphic art.[13] The visual impact of cartoons, particularly in such a widely disseminated magazine, was both more direct and potentially more insidious than that of written criticism. Visual messages could make connections to negative stereotypes—consciously or unconsciously—that were not present in the linear arguments of written text. This was true when the cartoons visually delineated the public that in writing were condemned as schaupöbel. A warning here: the direct clarity of the cartoons can also be misleading. The types of faces that artists put on the schaupöbel in

the cartoons could carry a strong message, but they did not necessarily refer to the same types that the critics in the art journals intended.

In 1889 a cartoonist highly regarded in the art world, Adolf Oberländer, presented his *Fliegende Blätter* fans with a satirical view of the modern enjoyment of art exhibitions in which people are sleeping, gossiping, flirting, or reading art reviews but no one is looking at the paintings that line the walls of the crowded gallery.[14] Hermann Schlittgen, one of the active new painters who supported himself by doing elegant society scenes for the humor magazines, also gave a cynical portrait of the art-going public in both cartoon and poem (fig. 55). These

mocking views of the public, coming from the pens of artists of considerable contemporary stature and conveying to the reading public a discouraging image of public behavior in art exhibitions, were not the only cartoons depicting the public's interaction with art.

Beginning in the 1880s and continuing into the next decades, artists and art exhibitions provided a consistent subject for a large proportion of the hundreds of drawings and cartoons that were published regularly in the humor magazines. Two-thirds of the weekly issues in the folksy, stylistically conservative *Fliegende Blätter* from 1889 to 1899 carried an art-related cartoon, a fact that at the very minimum conveyed the importance of art in Munich to its

Fig. 55 *A.* **Adolf Oberländer, "The Modern Enjoyment of Art,"** *Fliegende Blätter* 91, no. 2312 (1889): 178.
B. **Hermann Schlittgen, "At the Art Exhibition,"** *Fliegende Blätter* 93, no. 2356 (1890): 102.
The caption to Oberländer's cartoon (*A*) is a poem titled "How Paintings Are Contemplated": "At the art exhibition I was recently. / Such an art treat is most satisfactory. / There one can always meet acquaintances. / She is also often there with her aunt! / In these rooms, gossip goes so well. / On the sofas, one can rest and dream! / Even if one scarcely notices the paintings, / To contemplate them is not necessary. / Reviews are printed to be read— / You can still say: 'I was there!'" The caption to Schlittgen's (*B*) reads: "How they stroll and roam about, / Joking, shoving, and flirting! / Only a few in the crowd notice / That paintings also hang in the hall!"

Oberländer's drawings appeared in *Fliegende Blätter* for more than fifty years. In a tribute for his seventieth birthday in 1915, Georg Jacob Wolf compared him to Wilhelm Busch (1832–1908) as one of the best-known and most popular artists in Germany, whose cartoons were the reason *Fliegende Blätter* was read all over Germany. Oberländer's drawings were frequently included in exhibitions, including those of the Berlin Secession, along with work by artists of the stature of Adolph Menzel, Max Liebermann, Fritz von Uhde, Franz Stuck, and Arnold Böcklin. In 1904 he was granted an honorary membership in the Berlin Secession, an award granted to only a few prominent artists.

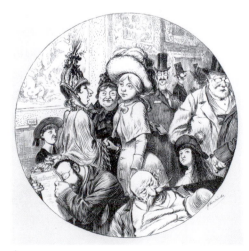

A

B

readers. The artist outranked the soldier, the professor, and the writer, though not the Bavarian peasant or the small-town dweller, as a comic figure in this journal. Within the other satirical magazines published in Berlin, *Kladderadatsch* and *Lustige Blätter*, and later in Munich's *Simplicissimus*, images drawn from popular works of art, particularly those of Stuck and Arnold Böcklin, were often utilized to caricature political issues.

Both the frequency of art as a topic and the artistic images adopted in caricatures indicate that the public reading the humor magazines were drawn from the largely middle-class crowds that thronged the art exhibitions: first, these cartoons could only have been fully appreciated by readers who were familiar with the original images, and second, the editors of the humor magazines must have assumed that treating art as a comic subject would appeal to their readers. Both points are further confirmed in the wicked parodies of the great exhibitions in Munich and Berlin that appeared regularly in these pa-

pers.[15] *Fliegende Blätter*'s repeated portrayal in cartoons of people with perplexed or bored reactions to paintings thus deserves close attention as one indication of the perceptions of painting and of the public itself that were regularly conveyed to that actual art-viewing public. This is the crucial point: the popular magazine not only informed its readers about the art world but also presented them with their own image—the public as seen through the eyes of the cartoonists and critics. In so doing, cartoons in the magazines acquired a normative function, influencing the behavior of their readers by

Fig. 56 **Adolf Oberländer, "The Painter in the Countryside,"** *Fliegende Blätter* **93, no. 2353 (1890): 74–75. The caption in the last panel reads: "O my, O my! Last year the crop failure and now the — painter! Is this ever a cross [to bear]!"**
Oberländer's scenes represented various encounters between overeager and naive open-air painters and exasperated farmers. In the process, Oberländer poked fun at both the open-air painters and a female artist.

demonstrating how one should *not* behave. That most of the cartoonists were artists who were struggling to establish or maintain their own artistic careers contributed a further layer of subjective, often jaundiced perception.

One of the favorite themes of cartoons in *Fliegende Blätter* was the encounter of the lower classes—peasants, townspeople, servants, and workers—with art and artists. In their own settings on farms and in villages the rural figures inevitably clashed with and often triumphed over the new open-air painters, who absurdly struggled to capture, on canvases set on bulky tripods, their impressions of angry cows and picturesque farmers (fig. 56).[16] In art exhibitions, however, the lower classes were distinctly strangers, puzzled by the paintings, anxious and uncertain about proper behavior. A common reaction of the uneducated viewer, according to these cartoonists, was to respond in an inappropriate fashion to paintings, as in the case of the provincial who broke into yodeling in front of a mountain landscape, or the fearful elderly peasants who mistook heat from a radiator for heat from a summer scene, or the housewife whose only interest in a naturalist landscape was in identifying the vegetables in the foreground (fig. 57).[17] The not so covert message carried by these supposedly comic moments to the magazine-reading public was that an unspoken code of behavior was expected within the bourgeois world of art. An understanding of that message was accompanied by the realization that unacceptable responses to an exhibition marked one as uncultivated, as a philistine, and as the object of ridicule.

In a further twist of this theme, *Fliegende Blätter* in 1898 presented a series of cartoons featuring couples whose desire for societal acceptance made them particularly anxious not to do anything in the exhibition galleries that would mark them as outsiders. The figures of ridicule in this group of cartoons were depicted with the stereotyped stance and profile of nouveau riche Jews (fig. 58).[18] This linking of Jews, art, and social climbing was a new variation on a motif that had emerged in the cartoons in the

Fig. 57 *A.* **A. Staehle, "Too Anxious,"** *Fliegende Blätter* **102, no. 2607 (1895): 26, with the caption, "Kathi: 'Sepp, look here, they have knocked the arms off of the statue!' Sepp: 'Oh, let's get going, or else they will think we did it!'"** *B.* **"The Misunderstood Central Heating,"** *Fliegende Blätter* **114, no. 2908 (1901): 198, with the caption, "Hey, old woman, that picture is really well painted—there is heat coming out of it!"** *C.* **"Unexpected Effect,"** *Fliegende Blätter* **89, no. 2247 (1888): 66, with the caption, "The new seascape by the artist Stormybird was so overpowering that all of the viewers became seasick. Because of this, the painting unfortunately had to be removed from the exhibition."**

Not only do these cartoons demonstrate naive and inappropriate responses in the art galleries, whether from the unschooled lower classes or from the uncultured middle classes, but they are predicated on the traditional view that the artist's highest achievement was the flawless reproduction of natural scenes.

A

B

C

Fig. 58 *A.* **Edmund Harbürger, "The Art Parvenu,"** *Fliegende Blätter* **108, no. 2760 (1898): 247, with the caption "Else, don't stand there so long, or people will think it is our first time in an exhibition!"** *B.* **"At the Art Exhibition,"** *Fliegende Blätter* **109, no. 2772 (1898): 107, with the caption "(Reading the catalog) '"Dido takes her own life!" What kind of an explanation is that! Die do! Why and who is she?'"**

These cartoons focused on features that were considered to be characteristic of nouveau riche Jews. Men were portrayed as short and corpulent with large flat feet, facial hair, often overdressed; women as ugly, tall, and overdressed; and both with the telltale "Semitic" nose. Their behavior betrays their lack of culture, as shown in their failure to understand the classical myths.

A

B

empire: the successful Jew who, seeking assimilation, acquired an honorary title—commercial councillor—and purchased property, often a former aristocratic villa or estate, to demonstrate his wealth and standing in society. In rare cases, for exceptional services rendered to the empire the emperors raised Jews above the lower ranks of honor into the aristocratic ranks (fig. 59).[19] It is important to understand that Jews constituted a minority among the rising upper class of newly wealthy industrialists and businessmen who sought prestige through entertaining, social contacts, and the acquisition of luxurious villas. The wealthy Jewish elite were, however, more active in their support of culture and the arts. This, combined with the existing Jewish stereotypes, made them a visible target for cartoonists.[20]

Mocking efforts to assimilate, cartoon after cartoon in *Fliegende Blätter* in the 1880s and 1890s presented the scene in which the proud Jew showed off his gallery of ancestral portraits obviously newly purchased from an impoverished aristocrat, portraits that, far from enhancing his assimilation into German society, overwhelmingly accentuated the irreconcilable differences. The contrast between the tall, elegant, idealized aristocrats in the portraits and the Jews emphasized the radical otherness of the latter, with their stubby figures, prominent noses, and broken German—all stereotypical markers in the arsenal of both ethnic comedy and anti-Semitic propaganda (fig. 60).[21]

This image of the collector of art was so frequently presented to the readers of *Fliegende Blätter* as a form of light humor that it functioned instead to consolidate a stereotypical perception: here was the Jew as the philistine outsider who could not recognize the absurdity and futility of his art collection even when he tried to have the paintings altered.[22] Trivial as these repeated cartoons were, they helped to establish in the minds of a wide-ranging reading public a nexus between art collecting and Jewish wealth. A drawing published in 1889 in *Fliegende Blätter* made explicit the racist stereotype hidden in

Fig. 59 *A.* **Adolf Oberländer, "The Commercial Councillor before and after Receiving His Honorary Title,"** *Fliegende Blätter* **81, no. 2053 (1884): 173.** *B.* **Eugen Kirchner (born 1865), "Genteel,"** *Fliegende Blätter* **102, no. 2587 (1895): 98, with the caption "'Oh, Elise, I want to buy one of these paintings!' — 'But, husband, surely we won't buy something ready made! You should order one to be made for you!'"** *C.* **Schewpp, "Power of Habit,"** *Fliegende Blätter* **104, no. 2639 (1896): 78, with the caption "I want to buy a picture, Mr. Painter—but the price is too high for me! Couldn't you give me a picture with a small defect?"** *D.* **Edmund Harbürger, "Egotism,"** *Fliegende Blätter* **104, no. 2655 (1896): 217, with the caption "'Your garden is splendid, Commercial Councillor . . . and this wonderful air!' — 'Yes, my air is good!'"**

In these cartoons the artists have emphasized the acquisition of works of art, as well as bourgeois manners and dress, as a means of assimilation into German society. Oberländer's drawing (*A*) neatly evokes the sartorial transformation of an older Jew into a German citizen, proudly displaying the new rank and title that mark his step up the ladder of honors awarded by the Prussian state. The cartoon by Kirchner (*B*), made a decade later, asserts the conspicuous consumption by the parvenu couple in their outlandishly elaborate clothing and in their desire to acquire the cultural trappings of wealth without understanding the distinction between clothes bought off the rack and paintings purchased from an art gallery. By contrast, the cartoon of the Jew dressed as if he had come straight from a Polish ghetto (*C*) reminded viewers of the allegedly deep-rooted penchant of Jews for haggling over everything, even works of art. Harbürger's cartoon (*D*) mocks the pride of the Jewish parvenu. Caustic in his depiction of new Jewish wealth, Harbürger captured the complacent self-satisfaction of the wealthy commercial councillor in his new villa adorned with statues and paintings.

A

B

C

D

A

B

C

Fig. 60 A. **Emil Reinicke (1859–after 1930), "The Gloomy Tale of Macho Typter and Moses Rypter,"** *Fliegende Blätter* **80, no. 2013 (1884): 57–59, final panel in the story.** B. **Adolf Oberländer, "The Ancestral Portrait,"** *Fliegende Blätter* **97, no. 2451 (1892): 23, final panel.** C. **Eugen Kirchner, "Difficult Task,"** *Fliegende Blätter* **112, no. 2860 (1900): 246, with the caption "Baron (newly ennobled, to a painter whom he has summoned to his 'ancestral' castle): 'Mr. Müller, you are a great artist! . . . Look carefully at my old paintings, because I want to ask you a confidential question. Could you discreetly renovate them into a family likeness?!'"**

Reinicke's illustrations for a satirical poem in 1884 (A) set the pattern for cartoons about Jews purchasing collections of ancestral portraits from impoverished aristocrats. Wittily set in ancient Egypt, the poem recounts the sad fate of Macho Typter, an Egyptian nobleman who, having squandered his inheritance through riotous living, turns to Moses Rypter, an ambitious Jew, who lends him money at 80 percent interest. As security for the loan, Macho gives Moses the entire collection of his ancestors' mummies and coffins, which are forfeited when the hoped-for death of his cousin does not occur. Macho dies of a broken heart, and Moses adds Macho's mummy to what is now his collection of ancestors, which he, weeping, displays to his visitors. The tale ends with the report that "soon Moses Rypter was raised to a 'Baron' because he had a great deal of money and even more ancestors."

In 1892 Oberländer illustrated another tale of an extravagant aristocrat (B), in this case a Spaniard who had gambled away all his money. He also turned to a wealthy Jew, Aaron Hirsch, to whom he sold an ancestor portrait painted by Velázquez. Although this tale involved a famous artist, most cartoons in this genre focused on the assumed absurdity of the Jew's claiming the portraits of non-Jewish ancestors as his own lineage. The humor of this situation was based entirely on the stereotype of the crass Jewish capitalist for whom money was all powerful. Other variations included the parvenu Jew who wanted to alter the acquired portraits or commission a series of "ancestor" portraits. That the topic appeared as often as it did, with endless variations skewering behavior allegedly common to Jews, rested on both widespread acceptance of that type and also reinforced that stereotype.

these cartoons. Titled "The True Businessman," it presented a nasty image of a Jew named Salomon Itzig—with a huge nose, prominent eyes, ringed and gesturing fingers, large grasping hands, bow legs, flat feet, and a wide-lipped mouth clenching a cigar; wearing spotted pants, a fur-collared coat, and a watch chain across his waistcoat; surrounded by huge moneybags (fig. 61). This archetypal image, drawn by a well-known member of a prominent artists' social club in Munich, was virtually identical to the stereotypes of Jews being published in anti-Semitic broadsheets of that time. Although the full image did not appear again in *Fliegende Blätter* in the 1890s, it cannot be dismissed. It lurked in the later simplified formulaic cartoons linking Jews with art collecting. Furthermore, the ludicrous scenes of Jews claiming others' ancestral portraits suggested the nightmare of the crooked alien usurping the cultural heritage of Germany (fig. 62).

This nightmare was not the creation of the humor magazines. Growing out of the centuries-old religious prejudice against Jews, this stereotype of the Jew was a nineteenth-century development in Europe that reached ugly levels in the 1880s. From Heinrich von Treitschke, with his lectures at the University of Berlin, to Saxon peasants who supported anti-Semitic politics, the Jew embodied Germany's "misfortune." With the decline of the anti-Semitic political parties in the mid-nineties, however, anti-Semitism became less visible as an open political force and more pervasive throughout German society. From obviously racist fears to lighthearted jokes in respectable society, anti-Semitism became, as a recent scholar has written, "quintessentially popular," and many at that time did not consider it particularly dangerous.[23]

The transformation of the ugly face of the Jew into the inoffensive philistine collector in *Fliegende*

Fig. 61 *A.* **Adolf Hengeler, "The True Businessman,"** ***Fliegende Blätter* 90, no. 2279 (1889): 111.** *B.* **Adolf Oberländer, "At the Show Window of a Book Dealer (A Physiognomic Study)," *Fliegende Blätter* 80, no. 2014 (1884): 71.**
The Hengeler drawing (*A*) accompanied a story about a Jewish matchmaker convincing a young woman that ugly, bowlegged Salomon Itzig, with all of his wealth, would be the perfect match for her. To illustrate the tale, Hengeler

fell back on Jewish stereotypes dating to the eighteenth century. This pictorial defamation, however, emerged in this particularly nasty form in the years following the outbreak of anti-Semitism in the 1880s. A comparison that helps measure the malice in Hengeler's image is a drawing of physiognomic types by Oberländer from 1884 (*B*) in which the Jew on the left is unmistakably, but not maliciously, stereotyped.

A

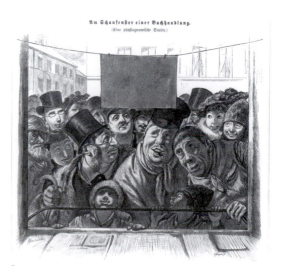

B

Blätter might be viewed as a parallel process of diffusion or dilution in which anti-Semitic images were aestheticized toward the end of the nineties in a popular new journal, *Jugend*. Such anti-Semitic references, however, were not to be found in the criticism in the art journals of the early 1890s. Nor was anti-Semitism present in the critical attacks on the public in the art journals in those years. The attitude of the art journals corresponded to the decline of anti-Semitic agitation from its height in the early 1880s. This is not to say that anti-Semitic attitudes toward art were not to be found, particularly in the local press. H. E. von Berlepsch reported, for example, in *Der Kunstwart* in July 1895 that "a widely distributed newspaper" in Munich had published an attack on modern art from which he quoted: "The art of the Secession is the right art for the stupid Berliner,

Jews and their ilk—why not let it go to Berlin?" Asking how someone with a healthy mind could write such a thing, Berlepsch cited this offensive statement to support his lament that the public in Munich failed to understand or to support its own artists. Apart from brief references to anti-Semitic accusations that Jews supported modern art, art journals were much more concerned about the failure of the public to understand and support art, as Berlepsch's response to the newspaper article suggests.[24]

Articles raising the problem of the public's behavior at art exhibitions appeared most frequently, not surprisingly, in the early 1890s in those journals whose stated mission was to promote support for contemporary art among the people, *Die Kunst für Alle* and *Der Kunstwart*, particularly in the latter. The first serious effort to examine the way an ordi-

Fig. 62 **Hermann Vogel (1854–1921), "Modern Poetry,"** *Fliegende Blätter* **94, no. 2387 (1891): 149.**

Vogel, a popular artist whose frequent work for *Fliegende Blätter* drew upon German and Nordic legends and fairy tales, created this painterly illustration for a poem in which the poetic muse, searching through shards of past culture, lamented the contemporary destruction of the great German classical tradition of beauty in the arts. The scene shows a motley crowd leaving the theater, descending past stately pillars and down great staircases. But the sculptural images on the building reveal a degenerating world: a sexy Nana; a statue of a mad man and woman tied together on a pillar on which a poster announces, "Today: The Executioner of Berlin"; and a death's head with snakes curling through its eyes. In the midst of these symbols of sexual degeneration and death is a theatrical mask transformed into the head of a Jew, spotlit above the crowd and surmounted on the pillar by the evil figure of a toad.

nary person walking into an art exhibition looked at the works of art was, however, published in the newer journal *Die Kunst unserer Zeit*. The editor, Berlepsch, and his writers were committed to modern art—called "open-air painting," "light-and-air painting," or "light-color painting"—which had emerged triumphant at the Third International Art Exhibition, in Munich in 1888. The art historian Cornelius Gurlitt, who was one of the earliest German advocates for that modern art, wrote a lengthy article in which he sought to view the Sixth International Art Exhibition, of 1892, in Munich through the eyes of a friend who, as he put it, was representative of those in the nation who were not art lovers and who did not know how to react to this modern art, whether to pay attention to their own taste or to what others said about it.

Now, Gurlitt began, people always seemed to enjoy what was beautiful even if they knew nothing about art. In this exhibition, however, Gurlitt's friend found precious little that gave him pleasure. Shaking his head as he wandered the galleries, this representative of the people wondered whether there was a special beauty apparent to the specialist that was totally inaccessible to him (fig. 63). He then reflected on the exclusion of many older, established artists from current exhibitions, men whose pride made them keep quiet in the face of the new coterie in charge of things. And, he was certain, if one really raised up the German people as judges, if the prize jury were made up of millions, and if the worth or unworth of each painting were decided by a people's vote, then the whole scene would change. Anyone who paid attention to the public, said Gurlitt's friend, would know that "that art which is now leading in our exhibitions finds only minimal approval in the nation."[25]

This led Gurlitt to assert that art did not and should not exist just for the artists. He agreed with his companion that a decade earlier the situation had been quite different. Then the public had found great pleasure in wandering through exhibitions of

Fig. 63 **Adolf Oberländer, "The Housewife at the Art Exhibition,"** *Fliegende Blätter* **117, no. 2977 (1902): 79. This drawing portrays the profound alienation of the two women from the modern scribbles in the paintings, one of which has won the top medal in the exhibition. Quiet and preoccupied, the women walk past the works of art without responding to them.**

German art. Then people had felt comfortable, knowing that their judgment coincided with professional judgments. Now they were upset and angry when they found the highest awards granted to the paintings they thought were the ugliest. Furthermore, Gurlitt commented, it was an insult now to say of a work of art that the public liked it because that meant that a work was only conventional, not modern. Turning back to the exhibition they were viewing, Gurlitt tried to explain to his companion "the great revolution" that had taken place in German art. He pointed to all that was absent from the walls: the sweet, homey genre paintings, the salacious salon nudes, the depressing naturalist scenes of rural poverty, the huge bravado historical scenes and battle paintings. Paintings that told stories had been replaced by works that were painted for the eyes, not for the ears. Gurlitt then tried to explain how one should learn to see the new modern paintings; he pointed out the ways Fritz von Uhde, Stuck, Franz Skarbina, Hofmann, and Gotthardt Kuehl sought to convey moods and nuances of light and color.

Receiving only bewildered reactions from his friend, Gurlitt pondered the profound difficulty of

Hochmodern.

Fig. 64 **R. Griess, "High Modern,"** *Fliegende Blätter* **115, no. 2922 (1901): 51. The caption reads: "'Tell me, what does this painting really mean? I don't understand it!' — 'But please, look at what it says below!' — 'Sure, as if I could read that!'"**
The exasperation of the public when faced with unintelligible subjects in paintings is neatly captured in this cartoon. Griess not only ridicules the strange imagery often found in modern paintings, he also mocks the elaborate sculptural frames that both Franz Stuck and Max Klinger created as integral parts of their paintings.

changing people's minds or of approaching the world with open eyes since, he said, people looked at the world through the patterns imposed by the visual conventions learned long ago. In the end, he had no answers, except the oft-repeated call for artists and critics to slow the pace of their ten-league boots, to reduce the overwhelming impact of the huge exhibitions, and to give people time to adjust to the inevitable changes in art that were necessary if it was to progress.

A year later, in late summer 1893, Gurlitt accompanied another friend who knew little about art to the independent secessionist exhibition held by the artists who had broken away from the Munich Artists' Association the previous year. As an advocate of the newest forms of art, Gurlitt judged this exhibition to be an exceptional and wonderful demonstration of the current developments in contemporary art, while his friend found much that was dreadful enough to raise his wrath (fig. 64). Gurlitt had to face the reality that the discrepancy between

their reactions was unbridgeable. Rendered speechless with anger over Lesser Ury's glimmering streetscapes, which had drawn public criticism at the exhibition of light-color painters in 1889, his friend found the painting *Evening Peace*, by Hofmann, to be "downright scandalous" and an "irresponsible mess." Gurlitt commented ironically that he would like to hang that work over his desk because it was so peaceful.[26]

Whether these visits that Gurlitt recounted at

great length were actual experiences or constructed scenarios, they demonstrated the shift that had occurred since the Third Munich International in 1888. The exasperation of critics with the popular entertainment that attracted the masses and undermined attention to the art in the exhibitions had shifted to condemnation of the public, the schaupöbel, for their failure to understand or appreciate contemporary modern art. Moreover, the critical acceptance of the new art was demonstrated through the common use of the inclusive word *modern* in most reviews and reports by 1893 instead of the various hesitant labels of the earlier years. Confirming these shifts in perception, Gurlitt and his friend represented figures standing on either side of the widening chasm that divided the art world in these years. On the one side were the new modern artists with the critics who supported their work; on the other side, the schaupöbel, which included artists who clung to older styles and the large number of critics supporting them, as well as the infinitely larger public who failed to understand the new art. Decisive in this oversimplified schema was the temporal divide: those on the first side claimed the present and the future; the others honored the comfortable past or sought to rise above temporal restraints into realms of transcendent beauty.[27] These perceptions haunted the upheaval that, surfacing sharply in 1893, turned into an unfathomable gap dividing the modernists from the public.

OUTRAGE IN BERLIN AND DRESDEN, 1893–1894

What did happen in 1893? What triggered the polemical outburst of Franquet in his published assault on the schaupöbel? The immediate occasions were the exhibition of the Berlin Society of Eleven in March 1893 in the showrooms of the art dealer Eduard Schulte in Berlin and the special exhibition of the Munich Secession at the Great Berlin Art Exhibition during the summer. Both the Eleven and the Munich Secession had been formed in the previous year because of dissatisfaction with current exhibition policies. Among the members of both groups were recognized modern artists from the older generation as well as the rising young stars of the modern movements, notably Hofmann and Stuck. Despite the differences between these artists, wrote the critic Jaro Springer in *Die Kunst für Alle*, "they all want to be modern. Modern has today become, incredibly, a battle cry, yes, a swear word." When the word was used, those who insisted on maintaining traditional ways could only hear "the threatening steps of the worker battalions" because, as he explained, the central issue of the day was the social question and anything modern was perceived by the conservatives to represent a socialist or communist tendency. Springer then singled out the work of Hofmann to be the most modern in its wondrous "cloud burst of light" and "chaos of color," while the rabble singled out his paintings for laughter and called him idiotic.[28]

Writers in *Kunstchronik* joined the public in its condemnation of Hofmann, with Rosenberg refusing even to discuss Hofmann's "grotesque fantasies." Several months later the Düsseldorf correspondent described Hofmann's paintings and pastels shown in Schulte's salon as childish experiments and accidents that were "unfinished, shabby, crazy and—'hysterical.'" On the other side, the critic Albert Dresdner (1866–1924), writing in *Der Kunstwart*, focused his review on Hofmann, praising him as an authentic German modern artist, a fairy-tale poet whose unrealistic, dreamlike scenes offended the pack, who jabbered scornfully over the unconventional use of color in the *Symphony in Blue and Red*. The jeering shouts of the schaupöbel against Hofmann, Franquet exclaimed indignantly, had turned Schulte's salon into a fun house of laughter.[29] This laughter left its mark. It spread that summer to assault the paintings of Klinger and Stuck, as well as Hofmann's work. Six years later, in a laudatory article on Hofmann, Paul Schultze-Naumburg (1869–1949)

Fig. 65 *A.* **Arthur Langhammer (1854–1901), "At the Art Exhibition," *Fliegende Blätter* 100, no. 2537 (1894): 111, with the caption "A certain Mr. A. painted pointillist / And symbolist, or mysticist. / Some find it wonderful, / For others, it is not."** *B.* **Ludwig von Hofmann, *Lost Paradise*, 1893. Oil on canvas, 76 3/8 x 51 1/4 in. (195 x 130 cm). Hessisches Landesmuseum Darmstadt. Reproduced in *Die Kunst für Alle* 9, no. 19 (July 1894): full-page plate.**

Franquet's booklet *Schaupöbel* railed against the derisive response of the public to Hofmann's color-drenched landscapes shown in 1893 and 1894 in Berlin and in Munich. One of the paintings, titled *Evening Peace*, which was shown in the first exhibition of the Munich Secession in 1893, produced a spirited argument between the art historian Cornelius Gurlitt and his friend, which Gurlitt recounted in an article that examined the difficulties the public had in understanding the new art. Hoffman's *Lost Paradise* (*B*), remembered by critics later as a painting of the Fall of Adam and Eve, was equally controversial for the public when it appeared in the Munich Secession exhibition of 1894. Langhammer's cartoon (*A*) captures the varied responses of the schäupöbel—from ecstatic adoration to gesticulating anger—to the painting. The title beneath the caricatured painting in the cartoon, "Rush of the Wave . . . Symphonic Color Poem," is a direct reference to Hofmann's characterization of his paintings as color symphonies. Langhammer was himself a respected artist who participated in the Dachau artist colony.

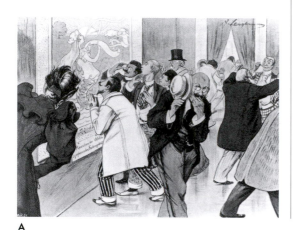

A

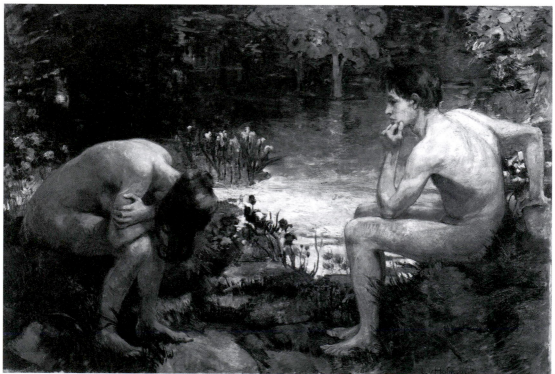

B

recalled those days rather grimly: "The whole art world was thrown into ferment. The whole undertaking was perceived more as a disturbance than as a serious effort, and people expected a great many spontaneous jokes from the exhibition. The secessionists were looked upon as a band of dissatisfied rejections, anarchists, or half fools. The German people showed itself as the public from its loveliest side, and the word *schaupöbel* was coined. The sensation of the exhibition was a picture by Hofmann, *The Fall of Adam and Eve*. People were simply revolted by it" (fig. 65). Others reported the public's hooting over the strange symbolic paintings of the Belgian Ferdinand Khnopff (1853–1921) and the Dutch-Malaysian Jan Toorop (1858–1928) in the Munich Glass Palace exhibition that summer and splitting their sides laughing over the huge pig, painted in shades of blue and green, in Hubert von Heyden's (1860–1911) *Morning Walk* in the Great Berlin exhibition.[30]

More serious was the controversy that swirled around the paintings of Klinger and Stuck that summer and fall. Unlike Hofmann, who was a new arrival, both Klinger and Stuck had already established their notoriety with paintings that had exasperated the public and divided critics. Franquet was incensed by the public's derisive rejection of Klinger's *Pietà* and *The Blue Hour* and Stuck's *Crucifixion* in the Munich Secession section at the Great Berlin, the exhibition where Perfall had so roundly condemned the behavior of the crowds. Stuck also presented his most provocative work, *The Sin*, along with eight other paintings in the first Secession exhibition in Munich (fig. 66). His sultry siren with her reptile familiar, enshrined in a golden altarpiece, attracted crowds, repelled many critics, and established itself as an icon of fin de siècle Munich. It was not, however, the center of the controversy that followed. Instead, Klinger's *Pietà* (fig. 67), praised by critics and rejected by the public, became the focus of attention when reports circulated that the Royal Painting Gallery in Dresden intended to purchase it.[31]

The background to the negotiations involved the initiative of art dealers in Dresden, who actively promoted modern art. In April and May of 1890, as part of a series of art historical shows, Adolf Gutbier, owner of the Ernst Arnold Art Salon, mounted an exhibition of photographs of paintings by major French painters from Théodore Gericault and Eugène Delacroix through Jean-François Millet, Charles Daubigny, Jules Breton, and Camille Corot to Jules Bastien-Lepage and P. A. J. Dagnan-Bouveret. In October 1892 Theodore Lichtenberg, whose art dealership was based in Breslau, opened a Dresden branch and gallery and began a series of exhibitions, carefully balanced between historical paintings and modern works. The mixture was important because, as the dealer stated, viewers "who protect themselves from open-air painting as if it were poison" might become accustomed to those works when they were mixed with more comfortable ones. That winter Lichtenberg featured, among others, Liebermann's *Potato Harvest*, a special Stuck exhibition in April that included his *Crucifixion*, and paintings by Uhde, a native of Dresden. As a tribute to their most celebrated artist, the Royal Painting Gallery also purchased and exhibited Uhde's triptych *Holy Night*, an action of the acquisition committee that generated disparaging opposition among followers, both laity and artists, of the older art tradition in Dresden.[32]

In November 1893 the correspondent from Dresden reported that the Lichtenberg Art Salon, under a new director, Ferdinand Morawe, had intensified its commitment to showing modern paintings by bringing to Dresden the paintings of the Munich artists who had caused controversy in Berlin. Working with a small active group who supported Klinger in Dresden, Morawe managed a triumphant exhibition in November 1893 of Klinger's oil paintings, crowned, according to the *Kunst-chronik* reporter, by the first open public exhibition of the great *Crucifixion* (plate 4), which had provoked indignation in Munich and which was shown

here in its magnificent anatomic perfection—"fully naked, without the usual drape." The reporter, H. A. Lier (1857–1914), also praised the leadership of the royal art museums for taking a decisive, friendly stance toward modern art, in contrast to the conservativeness of both Berlin and Munich museum directors. The energetic efforts of the Lichtenberg Art Salon put pressure on the other art organizations in Dresden to bring in more modern paintings. As a result, in November 1893 the Ernst Arnold Art Salon opened a new permanent gallery to display works from the Munich Secessionists in a downtown location, although critics pointed out the inadequacy of the space for the new art. Dissent had appeared during the summer in the ranks of the Dresden artists themselves; forty-five leading members of the art community had organized a new Free Association of Dresden Artists, with plans to hold a special exhibition in the fall.[33]

Within this context of steadily increasing visibility for modern art and signs of disgruntled opposition in Dresden came the news of the Royal Painting Gallery's intention to purchase Klinger's *Pietà*, a decision that received strong support from the art editors of the local Dresden newspapers and opposition from vocal members of the public. The result was an uncommonly lively conflict that generated serious discussions in the intellectual and cultural circles of Dresden over the worth or lack of worth of modern painting. At the same time, Franquet's booklet, published in Leipzig, not far from Dresden, caught the attention of the German art world with its intemperate criticism of the public, who wanted modern art relegated to the junk pile. These people, Franquet wrote, "demand that art, instead of edu-

Fig. 66 A. **Franz Stuck, *The Sin*, 1893. Oil on canvas, 37 3/8 x 23 1/2 in. (95 x 59.7 cm). Bayerische Staatsgemäldesammlungen, Neue Pinakothek Munich.** *B.* **A. Roeseler (1853–1922), "Punishment Intensification," *Fliegende Blätter* 109, no. 2784 (1898): 236, with the caption "Public Prosecutor: 'I make a motion, that *modern paintings* shall be hung in the cells of criminals to intensify their punishment.'"**

Stuck's painting (*A*) was acquired as a gift by the Neue Pinakothek soon after it was shown in the exhibition of the Munich Secession in 1893. The donor paid 4,000 marks for the work. It rapidly became emblematic for modern art in the caricatural language of these years, as in Roeseler's cartoon (*B*) depicting the horrific effect of modern art upon even hardened criminals.

A

B

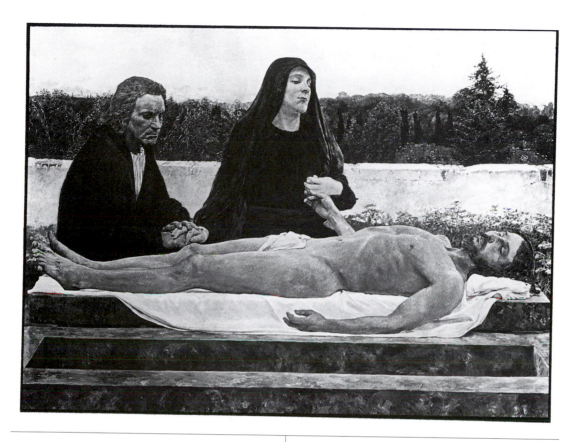

Fig. 67 **Max Klinger, *Pietà*, 1890. Oil on canvas, 59 x 80 5/8 in. (150 x 205 cm). Formerly in Gemäldegalerie Neue Meister, Dresden; destroyed in war. Reproduced in *Zeitschrift für bildende Kunst* 29, n.s. 5 (1893–94): 49, and *Die Kunst für Alle* 10, no. 5 (Dec. 1894): double-page plate.**

cating and uplifting the masses, should lower itself down to the taste of the schaupöbel and allow itself to be led by those who have no understanding or judgment." After all, he said, "we should not be surprised: the great herd has always sought to level and trivialize the world." However, he was certain, jubilantly so, that the modernists were already victorious and that all the anathemas of the schaupöbel were doomed to failure.[34]

As if to confirm Franquet's hopes, the Royal Painting Gallery in Dresden held a showing in December of its newly acquired works of modern art, including, significantly, not only Klinger's *Pietà* but also three other paintings, by the Scandina-

vians Christian Krohg and Bruno Liljefors and the American Alexander Harrison, all of whom had been singled out in reviews that summer for their uncomfortably modern presentations. In response, a reviewer in the *Zeitschrift für bildende Kunst* commended the directors of the gallery for recognizing their responsibility to promote new work and for resisting the negative public pressure. In so doing, "they endeavor to lead the public; it does not satisfy them to gain the praise of the majority of the people by presenting only the common pleasant art commodity."[35]

The acquisition of Klinger's *Pietà*, together with Franquet's condemnation as philistine rabble all those who doubted the brilliance of the art of the moderns, such as Klinger, Stuck, and Hofmann, predictably brought a counterattack. A Dresden painter, Carl Ehrenberg (born 1840), fired the next volley in the battle over the new modern art. Ehrenberg, a

moderately successful artist with a history of eccentric publications, launched his furious answer to Franquet's booklet in a series of short articles in a new, weekly muckraking paper in Dresden. Railing against the Royal Painting Gallery for its purchase of Klinger's *Pietà* and the three foreign paintings, as well as against several local newspapers for their positive encouragement and extensive coverage of those purchases, Ehrenberg engaged in such wild accusations that, according to Avenarius, he undercut his own arguments. Nevertheless, Ehrenberg persisted and turned his articles into an anonymous pamphlet, *The New Art and the "Schaupöbel" by a Member of the Schaupöbel*, in which he expressed the "bitter disillusionment, disgust, and deepest anger" that he felt when he stood before Klinger's *Pietà*. He judged Klinger's *Crucifixion* to be "in every respect a desolate and remorseless painting, vexing in its technique, hard in its colors, full of serious formal errors, psychologically repulsive and untrue."[36]

Although Ehrenburg's charges did not deter the strong supporters of modern art in Dresden, his accusations did produce repercussions in the Saxon parliament. As Woldemar von Seidlitz later wrote, "Brochures whizzed back and forth, the parliament found time to occupy itself not only with Social Democrats, but also with art." One of the deputies, assuming that Ehrenberg's pamphlet represented all of the Dresden artists, introduced a motion in the second chamber of the Saxon parliament on 9 February 1894 limiting the rights of the Royal Painting Gallery's acquisition committee and requiring that all works under consideration for purchase be publicly displayed. Within three days a petition was sent to the chamber by fifty of the most respected Dresden artists opposing these measures and expressing great appreciation for the purchases of the current commission. With no support from his colleagues, the lone deputy withdrew his motion.[37]

In the next decade, Dresden continued its engagement with modern art, even while Avenarius, whose base was in Dresden, continued to complain about the lack of public support for the new works. In the immediate aftermath of these events, Lichtenberg held a show of the Berlin Eleven; Ernst Arnold displayed recent drawings by Adolph Menzel and a large collection of paintings by Norwegian painters, including the decorative, archaic depictions of Norse folktales by Gerhard Munthe. In 1899, furthermore, the Ernst Arnold Art Salon presented an exceptional overview of Impressionist artists from France, Belgium, and Germany that included works by Édouard Manet, Edgar Degas, Pierre-Auguste Renoir, Camille Pissarro, Claude Monet, Alfred Sisley, Berthe Morisot, and Gustave Caillebotte, as well as the Neo-Impressionists Georges Seurat, Paul Signac, Théo van Rysselberghe, and finally Henri de Toulouse-Lautrec, followed by an exhibition of contemporary British artists, including, among others, James McNeill Whistler, Edward Burne-Jones, and Walter Crane.[38]

While the art world in Dresden resumed its activities, the pamphlet warfare over the public's response to modern art shifted back to Berlin, where the next acrimonious attack on modern art came from a highly placed scientist, a privy councillor of medicine and professor of anatomy at the University of Berlin, Dr. Gustav Fritsch, whose stature gave scholarly weight to his book *The Shape of Our Bodies in the Light of Modern Art*, written after visiting the Munich Secession exhibition at the Great Berlin exhibition in 1893. Fritsch began with a lengthy consideration of the increasingly bitter rift between the public, which could not understand modern art, and the proponents of that art, who condemned the public for their inability to accept new forms. He then launched into an extended analysis of modern artists' violation of natural laws in optics, anatomy, and physiology, using as his examples paintings of artists shown in the Great Berlin exhibitions of 1892 and 1893, especially Klinger and Stuck. Arguing that these errors produced a caricature of nature and a mockery of the human form, Fritsch declared that modern art was the product of an epidemic of defective

vision and unbalanced minds producing distorted art, which corrupted the public. Despite his academic stature and vehemence, Fritsch's book was trounced in the art journals. Avenarius, writing in *Der Kunstwart*, characterized the book as a mixture of professorial presumption and ignorance on the part of the Berliner, written in a manner that could only be called loutish. Lier, commenting from Dresden, said that he had never encountered such a misunderstanding of the actual issues or such an ignoble attack. With no understanding of art, he wrote, Dr. Fritsch had examined the naked figures in the paintings of Klinger, Stuck, Hofmann, and Julius Exter and condemned them all for anatomical inaccuracies.[39]

Fritsch continued his provocative attack upon the modern artists at a special session of the Anthropological Society on 13 January 1894 in Berlin, in which he projected photographic slides to demonstrate the errors of the artists' depiction of the human form. These high-handed assaults motivated a response from another professional. August von Heyden, a former professor at the Royal Institute for Fine Arts in Berlin, replied with a judicious short book in which he argued that Fritsch had misunderstood the purpose of art. Quoting Goethe and Schiller, he upheld the right, indeed necessity, of artists to violate scientific laws of nature in order to achieve their aesthetic goals. Fritsch, in turn, blasted back with a pamphlet whose lengthy title—*Ne sutor supra crepidam! Reply to Some of My Particular Well Wishers within Art Criticism, Answer to Mr. von Heyden's Open Letter, Titled "Of the Proper Laws of Art," Together with Affirmative Judgments of the Daily Press and Opinions of Acknowledged Natural Scientists about My Writing "The Shape of Our Bodies in the Light of Modern Art"*—manifested the arrogance that Avenarius continued to denounce. This form of polemic, he said, was offensive and unfruitful. He suggested that Fritsch's book was only interesting as a sign of the times, when specialists, highly educated in one field, thought they had a right to judge everything, even things about which they knew noth-

ing. Five years later Avenarius would again tersely condemn "the arrogance of the German educated rabble" concerning contemporary art.[40]

THE GROWING RIFT BETWEEN THE PUBLIC AND MODERN ART

Avenarius's reviews revealed an emerging trend in the condemnation of the public, namely, the identification of particularly obstinate sectors of the schaupöbel. The kunstpöbel—art rabble, a variant on schaupöbel—stood high on the list of opponents for many champions of modern art. For those supporters of modernism, the kunstpöbel were all those whose knowledge of past art made them reject new forms: the connoisseurs who opposed new measures of quality, the artists whose lifeworks were negated in the new forms, the juries and museum bureaucracies that controlled the commissions, the dealers who preferred the older masters of genre and history painting. Hans Schliepmann, writing in 1891 in *Der Kunstwart*, had argued that art connoisseurs and experts constituted a major obstacle to the development of new art forms. "It is quite clear that we find ourselves on the way from an outmoded to a new art," he asserted; "however, the new suggests itself only in seeds, which certainly merit the highest attention, but still do not have the beauty of a full-grown blossom." Because of this state of becoming, "the connoisseur as formalist, as 'knower,' can precisely *not* know the new, that which is still unknown; his chief pleasure fails him here." He thus believed that the connoisseurs, the professionals, and the experts would always support the old art, whose rules were understood, and that those who were able to become patrons would not buy new art. He further asserted that when a modern artist did arouse the enthusiasm of the art experts, one could be sure that that artist was not an innovative master, creating original forms, but one who was reaping fruits of an already developed

Fig. 68 **Hermann Schlittgen, "At the Art Exhibition,"** *Fliegende Blätter* **104, no. 2644 (1896): 163. The caption reads: "Lieutenant (meeting a friend): '. . . Evening, Comrade, how goes it? Also *pretending* to look at art?'"**

not knowing anything about art, they made loud declarations based on current Berlin prejudices against modern art. At the opening of that show everyone who counted in Berlin society poured in, "and then it began, in that scandalized tone that is characteristic of the Berliners, over the poor paintings. It was mad, and for the lieutenants it was great fun, and who will blame them for it?" Some years later the commandant of the Berlin garrison, however, took a less benign view of his officers' contact with dubious modern art; he forbade them to wear their uniforms when they visited a gallery of modern artists whose work the emperor condemned. Along with others, the lieutenants directed their heaviest criticism against Klinger's *Crucifixion* (plate 4). Strongly defending the paintings, Springer concluded that the exhibit was a great success and expressed confidence that the "garbage" that would be written in the newspapers could not alter that success. Prussian lieutenants, themselves regular objects of ridicule in the humor magazines (fig. 68), were a popular satirical foil for those who spoke out against the rude taunts of "botching," "imbecilic," and "blasphemy" that were directed against modern art.[42] The most significant figure, however, was the art critic himself, whose role in influencing the behavior of the schaupöbel was a matter of serious discussion and controversy in the journals.[43]

In 1891 a full-page cartoon from England published in *Die Kunst für Alle* playfully depicted a deep, rocky chasm across which artists flamboyantly sought to mount an attack upon art critics, who, barricaded behind great tomes of classical criticism, defended their learned citadel, "Art Criticism" (fig. 69). On the left side of the gorge the front ranks are filled by the critics, armed with quill pens and ink, who dash off quick, easily forgotten columns for the widely disseminated daily newspapers; directing them from behind is their shabby, shaggy-haired doyen, John Ruskin, on his horse. Above, overseeing the battle from their lofty perch on great books of knowledge, are the critics of the monthly journals, whose reviews

style. In conclusion he called on friends of art to be guided by their emotional response to art, not by their expert learning.[41] This insistence upon the primacy of heart over mind in the reception of modern art became a leitmotif in the journals in the 1890s.

Another subgroup of the schaupöbel that approached modern art with a closed mind, if not with informed intelligence, was identified by Springer in his review of an 1894 exhibition of a group of Berlin modern artists in the Schulte Art Salon in Berlin: the narrow-minded Prussian lieutenants who, he said, were a strong presence among the young Berlin gallery audiences. The polite, upstanding Prussian lieutenants were frustrating, he observed, because,

were weightier, read by fewer people, and therefore more honored. On the right side, artists, armed with paintbrushes and brandishing paintings condemned by the critics, swarm down the mountainside, ready to join the assault on their enemies. Motley and disorganized, the artists are egged on by Whistler, the embodiment of the modern painter.

This English drawing of the embattled camps facing each other across the great divide was accompanied by a spirited defense of the importance of the contemporary art critic by Emil Heilbut, the future editor of the most prestigious journal supporting modern art in Germany in the first decades of the twentieth century, writing under his pseudonym, Herman Helferich.[44] His lengthy and tortuous argument, derived in part from the English article from which the drawing was taken, concluded that there was no reason for such enmity between perceptive critics and creative artists, despite artists' general hostility toward critics. The critic's function was not to influence artists but to serve as a mediator between the artist and the public. The critic's pen, he wrote—"the nasty, nasty pen"—was there for the public, to teach it to understand, love, and even collect art. No, he insisted, the great divide did not lie between the artist and the critic; it lay between the artist and those writers whose education and expertise in other areas made them think they were qualified to act as critics of art but who in fact only misled their readers with baseless opinions. The genuine critic had an impossible task that only a few were able to achieve:

It takes an intense *love* of art and an intimate familiarity with the history of the field; an exact talent for observation of nature; good *taste*; fine antennae in order to appreciate all the subtle questions of aesthetics; good *eyes*, which immediately discover not only the artist's errors but also his deliberate illusions; —and then such a universality that the critical writer can sympathize with every mood of every decent artist, as different as their moods and work may be. In addition, the critic should have a consciousness of his re-

sponsibility, enough humility to nourish serious work with respect, enough modesty of heart to bear the sense of his fallibility. In addition, he must also (good grief!) be endowed with an indispensable lack of nervousness, in order to listen to what many artists say to him, and he must at the same time always ignore whatever ill-treatment of *his* feelings may be offered in the course of the conversation by the artist. Moreover, he must. . . .

And the list of desirable qualities went on. By the end of the article the description of the intelligent, sensitive critic had shifted to a self-serving first person: "We stick our nose into the oil paints so that the public will be informed. We travel from exhibition to exhibition; we dare not become tired, and if

Fig. 69 **Harry Furniss, "Art Criticism." Reproduced in *Die Kunst für Alle* 6, no. 11 (Mar. 1891): 164.**

we make a mistake, we are reprimanded. That is our calling."[45] This smug self-adulation and confidence in the validity of the critic's own judgments lay at the heart of the extended debates over the critic's position and responsibility to the public in the following years.

At stake was the alienation of the viewing public from contemporary developments in modern art. Heilbut could deny that a gulf existed between the genuine critic and the modern artist, but a chorus of voices from the journals in the next years insisted that critics themselves, particularly those who wrote for newspapers, had helped to create a more serious chasm, the chasm between the artist and the public. Among the most influential newspaper critics was Rosenberg, whose antipathy to modern art was perceived by many to carry substantial weight in determining the educated public's attitude toward modern art. His delighted affirmation of Fritsch's attack on modern art provides a glimpse of the intemperate language that was acceptable for newspaper critics. Appearing in the 11 January 1894 issue of the conservative Berlin daily, the *Post*, the review praised Fritsch for his book, which "tore off the mask hypocritically claiming to be true to nature from the painted face of art that is thoroughly infected with the sickness of the century." Concealed behind this mask, Rosenberg asserted, were "foolish visions, indolent stupidity, cynicism, complete impotence, delight in creating scandals, secret joy in radical subversion and anarchy and such."[46]

While most of the critics supporting modern art directed their disparaging reproaches at those who, like Rosenberg, opposed the new art, one respected writer presented another scenario. Perfall, whose authoritative reviews in the *Kölnische Zeitung* in support of the new art had frequently chastised the public viewing the exhibitions, articulately identified a different set of issues in an article published in *Der Kunstwart* in 1890. Examining a new form of art criticism that had originated in Paris and was now entrenched in Munich, Perfall pointed out that, first,

these critics were totally committed to the most modern efforts in art. Indeed, he remarked, the most bizarre expressions of this art seemed to inspire the greatest enthusiasm from them. Second, the polemics of these critics not only were directed against the artists and critics supporting the older forms of art but particularly targeted the public, the "philistines," a term he explicitly used with quotation marks. Before he analyzed the problems with this situation, Perfall made it quite clear that he stood among those who believed a positive new artistic development was coming out of the current ferment, one that would spread throughout the world. He was, however, disturbed by the barrier growing between the artists and the public in Germany and was convinced that in the long run this would damage the artists as well as discourage those who might have supported modern art.[47] In essence, Perfall turned the argument we have been following on its head: the problem modern art was facing in Germany was caused not by the schaupöbel but by the critics, with their intemperate support for modernism and their attacks upon the public. His argument is worth considering closely.

Perfall began with a brief but important observation that this new criticism was frequently expressed in messy, tangled, cliché-ridden prose, which he compared to the "worst excesses of the aesthetic cabalism of the former Hegelians." Given his insistence upon meaningful communication between the critic and the public, this was not an irrelevant point. He was convinced that these new critics were caught up in the sheer excitement of the hunt for the very newest styles of art. Instead of calmly mediating between the new and the old art, between the public and the artists, they had become the standard-bearers of the revolutionary styles, encouraging artists to experiment in radical ways and lashing out against the public for their "philistine" failure to appreciate those new forms.

Perfall argued that raising the public understanding of art was particularly necessary at this

time since increasing prosperity and urbanization were producing a greater interest in art. This task could not be left to the schools or museums, whose interests were tied to promoting the aesthetic ideals of the past rather than those of the present. False assumptions and outdated education hampered the public understanding, in part, he acknowledged, because the German public had been confronted suddenly with the newest art instead of watching it develop gradually as it had in France. Thus, many older art lovers were bewildered by the prospect that everything they valued in art might be overthrown. Perfall believed that since understanding modern art was the urgent need, the most modern forms of communication, namely, newspapers and journals, should be used to reach the public. Any resistance to the new art on the part of the lay public and art lovers could be overcome if critics writing in journals and newspapers made it their task to explain the new art and to give people the keys to understanding it. Instead of doing this, he reiterated, the critics in their excitement over the most modern art had assaulted the "philistines" as the enemy of the new art and as a hindrance to its development.

A significant consequence of rejecting the public, Perfall argued, was the closed circle in which sympathetic critics communicated only with modern artists and with other friends of modern art. That reviews were often confusing, as well as disdainful of the public, only served to intensify the public dislike of the art itself and to increase the gap between the public and modern art, or as he eloquently expressed it:

Quite in a romantic manner, a barrier is erected in this way between the world of the "geniuses," who speak their own language, and the world of the "philistine," who hates them. They [the partisan critics] recklessly shatter as worthless shards what was valuable to the others and what only recently had been commonly held to be valuable; they stand before the most bizarre, most difficult to understand expressions of art and declare these to be the most sublime creations, which the "philistine" is too dumb to

understand; in the name of artists they speak insolent provocative language which conveys that the "philistine" should humbly accept the new wisdom about art or he can go to the devil, for they do not need him, they are sustained by the enthusiasm of the young.

Perfall contended that this partisanship of the critics had blinded them to the sad reality that the artists whose work was most innovative continued to face a difficult struggle. Artists, he said, would welcome critical support in reaching, not antagonizing, the public. Conversely, he was certain that the public, who traveled miles to spend hours studying works of art in exhibitions, would welcome being provided with thoughtful interpretations instead of the mistaken practice of treating them all as an undifferentiated "philistine" mass. Both the public and the artists suffered from the failure of critics to mediate for them. He reminded artists and critics alike that the art world was dependent upon the wealthy bourgeoisie, including the too easily ridiculed nouveau riche. These were the people who, through immense goodwill and often sacrificial giving, created galleries, supported museums, and purchased art for their own collections. Finally, he reiterated his concern that the continued reckless enthusiasm of hotheaded critics for "brilliant" new art might actually turn the art-loving sectors of the public away from modern art.[48]

Perfall's article must have raised the eyebrows, if not the ire, of his colleagues. Only two months earlier, in September 1890, he had published a vehement denunciation of the Berlin public that anticipated his later indictment of the public in the summer of 1893. In these articles he grappled with the sources of public behavior, which unquestionably exasperated him just as it disturbed most of his colleagues. They, however, continued to deplore the behavior of the schaupöbel and to blame that behavior upon hostile, inept, or wrong opinions expressed by critics who did not support the new styles of art. Strong supporters of the new artists, Bahr,

Gurlitt, Dresdner, and Berlepsch all included comments in their reviews rebuking the public and the conservative critics for their failure to appreciate modern art.[49] Others pointed out that critics were unable to guide the public because they themselves were no longer certain what constituted good art.

Overwhelmed by the rapid succession of new styles in these years, some critics lost their footing on what had once been solid historical foundations. Their bewilderment was captured in stories and cartoons. A strange little parable appeared in *Die Kunst für Alle* in 1894 about the trials of an art critic who, having dared to write a strong negative review of an exhibition, was hounded in nightmares by the images he had criticized and by the artists whose lives he had destroyed (fig. 70). Distraught, he turned his reviews into raving praise for all the artists. This brought him the wrath of English and American patrons who had spent fortunes to come to see the exhibits he had praised so highly, of art dealers who had gone broke buying works that turned out to be worthless, and of the great old masters—Dürer and Rubens—whose reputations had been sullied by his exalting untalented artists. Confused, the critic appealed to higher powers, only to be ordered by God to print only the "Truth," while Satan commanded him to print "Nothing."[50]

Fig. 70 A. **Adolf Oberländer, "At the Painting Exhibition,"** *Fliegende Blätter* 92, no. 2332 (1890): 122, with the caption "First Critic: 'Exorbitant Truth!! . . . What do you think, Knollmeyer?' Second Critic: 'A triumph of naturalistic technique! Clear to apprehend! . . . What does it actually represent?'" *B.* **A. Reinheimer, "Dream of a Critic,"** *Fliegende Blätter* 113, no. 2889 (1900): 285.

Oberländer frequently made fun of new art and artists. His portrayal here (A) of pretentious critics who mask their inability to comprehend the new art with pompous phrases mirrors a critique of art critics published in *Der Kunstwart* by Karl von Perfall in 1890. Reinheimer's cartoon (B) conveys well the confusion felt among critics by the succession of styles that cascaded through the art world in the nineties. Representations of these rapid changes ranged from comic absurdity to despair. In this case the critic is beset by nightmarish images from paintings by Arnold Böcklin or Franz Stuck, all of whom are attacking the critic in their own way: the draped figure rises from the *Isle of the Dead* (fig. 75) to haunt the critic; *The Guardian of Paradise* (plate 5) stabs him with the great sword; the snake slithers from *The Sin* (fig. 66A) to strike him, as do *Medusa*'s snakes; the unicorn from the *Stillness of the Forest* joins his horn in the attack; the bronze *Amazon* wields her spear; one of Stuck's many centaurs rushes out to grab the dreamer; and Böcklin's *In the Play of the Waves* (plate 3) pours water over his bed.

A

B

CRITICS AND PUBLIC DISCONTENT

If critics were distressed by the problematic alternative of discerning true art from nonsense, the public seemed to be giving up making any judgments. That, at least, was the opinion expressed by some of the critics who earlier had been exasperated with the schaupöbel for their raucous rejection of the new art. By the second half of the 1890s, attacks on the schaupöbel were increasingly replaced by laments about the indifference and alienation of the public from the new art forms. Sometimes these laments represented a conservative turn in the thinking of a critic who now saw the root problem not in the ignorant behavior of the public, but in deliberate provocation by young artists. Some of those whose commitment to modern art remained strong began to reaffirm the necessity of rebuilding the connection between the artist and the public. In 1896 Count Eduard von Keyserling, a writer active in the modern literary and artistic circles in Munich, published a strong case for the necessity of artists' stepping out of their narrow circles and listening to the lay public. A work of art, he argued, should be judged by its effectiveness in expressing a lyrical mood that touched the depths of the appreciative viewer. This aesthetic experience could be better judged by the layperson than by other artists or critics, who viewed art in terms of its technical artistic achievements, for, he asserted, a technical innovation that failed to arouse a sensitive response in viewers had no aesthetic value. He was therefore critical of the current scornful rejection of the public as incompetent to understand works of art.[51]

Similar issues concerned Schultze-Naumburg, a rising young artist and critic who strongly supported the new art, though he was pessimistic that artists could bridge the gap. Writing in *Der Kunstwart* in 1896, Schultze-Naumburg was convinced that there was virtually no possibility of communication or understanding between the artists and the people, even those who were considered to be well educated, whom he characterized as the "intellectual mediocrity who has been baptized with the name 'cultivated.'" The people had withdrawn from art, he said, and art had withdrawn from the people. Each year the protests against the modern art had declined, he claimed, because the public had lost interest as pure painterly work dominated in the exhibitions. Paintings of great spectacles had always attracted the crowds, who could make bad jokes about them, but these paintings were disappearing from the exhibitions, and the remaining art said nothing to them. How, he asked, could this dreadful break between art and the people be closed? Claiming that art must go its own way, he held the people responsible for the chasm that stretched between them and the world of art. Despite the market and the great exhibitions, despite the large number of art journals and art societies, despite the effort to democratize art to take the place of princely patronage, he wrote, the people simply did not care about art anymore.[52]

Later that year, writing in the *Zeitschrift für bildende Kunst*, Schultze-Naumburg made this point in a more concrete way. In 1890, he recounted, no one, from vociferous critic to the quietest observer, could avoid being drawn into the battle between the old and the young. No one was neutral. Everyone flocked to the opening day at the Glass Palace in Munich. And what controversy! Whole families, guests in the cafés, critics, reporters, all divided into pro and contra. Everyone eagerly awaited Cassius's *Mocking Bird*, with its satirical parody of the most controversial paintings. "Today," he complained six years later, "how quiet it has become. The great annual fair that amused us so much is gone; the great variety show has been driven out of the temple. What is there to do now in the exhibitions? They have become boring." The only place where the excitement and excesses of modern painting could still be found was, he commented, in *Fliegende Blätter* cartoons (fig. 71).[53]

Fig. 71 **R. Griess, "From an Art Exhibition,"** *Fliegende Blätter* **108, no. 2760 (1898): 249.**

Griess specialized in cartoons that took the new art styles to ridiculous extremes. This is a particularly good illustration of Paul Schultze-Naumburg's comment that *Fliegende Blätter* was the place to find exciting art exhibitions. In this wall from an imaginary show Griess features the highly decorative, linear Jugendstil, which had come into vogue in journals, interior decoration, architecture, and painting at the end of the decade. The titles, which appeared in the caption, were (clockwise from upper left): *The Mountain Spirit, Idyll, ??,* and *Still Water,* which received the medal of honor. The caption states (tongue in cheek, as befitted the drawing): "We want especially to direct attention to the last painting (IV), which is so masterfully painted that even the name of the artist is mirrored in the water." Each painting is given a label describing its sales status, from (clockwise from upper left) "almost sold" to "unsaleable," "information in the office," and "sold."

Despite his bleak view of the lay public, he devoted a considerable portion of his life to trying to communicate with that public. In two articles on contemporary German art critics published in 1895 Schultze-Naumburg emphasized the necessity of critical writing whose sole purpose was to enable the public to appreciate new art forms. Without this literary mediation, he insisted, the current victory of modern art would never have been achieved so rapidly and so effectively. He himself, therefore, incessantly wrote articles published in journal after journal and books designed to teach students, as well as laypeople, how to understand and judge modern art. Whole chapters of these books were reprinted in the art journals, making them even more accessible to the reading public, which must have displeased conservatives. One of them, Wolfgang von Oettingen (1859–1943), the secretary of the Royal Academy of Arts in Berlin, writing in the *Zeitschrift für bildende Kunst,* berated Schultze-Naumburg for his completely one-sided approach. Using strong language, Oettingen pointed to the "terrorism" that all the modern artists wielded against both the unmodern and that which was not explicitly modern in their battle against the art of the immediate past. Schultze-Naumburg's terrorism did not fall into the most brutal category; nonetheless, Schultze-Naumburg was, said Oettingen, so quietly certain that modern art had conquered all art from the past that he ignored the views of the laity.[54]

Oettingen went on in his article to denounce the art journals and popular daily press, which he perceived to be united in their cool assurance about the superiority of modern art, or as he put it, "the gospel of the modern." From his point of view, the very journals that had carried the hope of making art accessible to the people of the nation had misled and betrayed the lay public. Oettingen's essay raises a genuine historical problem. The art journals, few in number and printed on high-quality paper, are accessible for study a century later, yet the daily press was undoubtedly far more influential in the lives of

ordinary people in these decades. Its sheer numbers were overwhelming: in 1885, 3,069 newspapers were published in Germany, with circulation figures ranging from under 1,000 to more than 150,000. They ranged from tiny local papers to big city, regional, and national ones, such as the liberal *Vossische Zeitung* and the national liberal *Kölnische Zeitung*. Germany, as a recent historian has put it, was a nation for whom reading the newspapers was an important daily task, one that influenced both consciousness and behavior. And the daily or weekly newspapers were only a fraction of the popular press to which Oettingen referred. There were also more than 3,300 journals and magazines, including family magazines like the *Gartenlaube*, with its circulation of over 400,000, or the *Berlin Illustrirte Zeitung*, with its circulation of 100,000. All of these carried, whether regularly or irregularly, reports of the great exhibitions or special features on popular artists, though the newspapers would have provided the only publicity and reports for most of the local art societies and traveling exhibitions.[55]

Oettingen's review was published in the midst of a spate of journal articles in the mid-1890s on the negative influence of the popular press. Most of the authors of these articles believed that, far from supporting modern art as Oettingen believed, the daily newspapers were biased against new art and contributed significantly to the crude or indifferent behavior of the public. As one writer tersely put it in an article that castigated the Berlin daily reviews, newspapers infected the ideas of the public with the poisonous bacillus of dragons. The commonly cited representative of invidious attacks upon new art by the daily press was Ludwig Pietsch, whose fundamental dislike of any modern developments marked his forty years with the *Vossische Zeitung* as one of the most powerful and visible newspaper critics in Germany, a tenure that lasted into the first decade of the twentieth century. In two articles published in 1895–96 Oskar Bie began his examination of the state of newspaper art criticism with a direct attack on Pietsch, "the most sprightly of old men," who, Bie said, wrote about modern color and poetry painting from "the ancient point of view" that valued paintings created in a drawing style. Unfortunately, Bie pointed out, the judgment of the propertied bourgeois class in Berlin about art was largely determined by Pietsch and his colleagues in the other Berlin dailies—the *Berliner Tageblatt*, whose inept criticism often drew laughter from the artists, and the *Post*, whose critic, Rosenberg, who also wrote for the *Zeitschrift*, had no more understanding of an open-minded approach to viewing contemporary art than did his teacher, Pietsch.[56]

Bie acknowledged that critics, especially in local newspapers, were under pressure to write reviews that featured artists' names and descriptions of their works; however, he insisted that reviews should be written for the public, not for the artist. The critic should above all strive to interest the greater public, which now had the responsibility to support art since the princes and nobles had retreated from the front ranks of patronage and power. With the increasing gap between the supply and demand for artworks in the all-encroaching capitalist society, the wise critic, Bie claimed, could play a crucial mediating role in the economic relationship between the artist and the public.[57]

As the recently appointed editor of a cultural journal, the *Neue Deutsche Rundschau*, which under his direction strongly supported international modernism in all of the arts, Bie was not a neutral observer of either the art or the newspaper scene. Nonetheless, his view that serious problems existed in the daily papers' criticism of art, which he noted had become a major industry, was shared by others writing in the journals. Art reviews in the newspapers spread "a wretched, superficial cultivation, a dreary half-informedness," with its damaging effect on art, pronounced an article in *Der Kunstwart* in 1896. Instead of encouraging the public to go to the exhibitions, this writer contended, these negative reviews were always hastily written and poorly conceived,

discouraging the public from actually looking at art and contributing towards the layperson's rejection of art as worthless. For those who still did attend the exhibitions, he insisted, the reviews stood between the viewer and the art, sometimes functioning as a bridge but more often serving to further deepen the chasm. An enthusiastic review by Alfred Freihofer (1856–1907) of the Munich Secession exhibition of 1893 ended with the comment that the public did not know what to make of all these new paintings. They only knew, he concluded, from their newspaper critics that they should condemn Uhde or Liebermann. All the rest was chaos to them, so they fled back to their familiar *Gartenlaube* images.[58]

Critics also blamed old-fashioned, sentimental images from the popular family magazines for the problematic taste of the public. Their complaint, raised repeatedly during these years, was that cheap mass reproductions of poor art were overwhelming and confusing the public. Schultze-Naumburg added his voice in 1893 with an article charging that the reproductions of works of art in newspapers and magazines had significantly altered the relationship between art and the public. Recognizing that the illustrated newspapers provided the primary contact between the people and works of art, Schultze-Naumburg criticized the illustrated papers for feeding the public sentimental kitsch and old-fashioned, phony historical paintings—mostly from France and Italy—instead of educating them to recognize good contemporary art. Picking up the litany, Berlepsch insisted that the taste of the cultivated classes was as deeply affected by the baleful influence of the illustrated magazines as was that of the lower classes. Another writer suggested that the only way to improve the taste of the public was to convince mothers not to raise their children with the "grotesque distortions" from the humor magazines, from *Struwelpeter* or *Fliegende Blätter*, which helped to shape the philistine—that dreadful figure who kept the Germans lagging behind all the other cultured nations.[59]

By the mid-1890s this concern over the influence of cheap newspaper reproductions of art also extended to the mass-produced prints that were routinely distributed by the art societies as annual gifts to their members. Efforts for reform were channeled into the wide variety of graphic societies and clubs that became part of the art education movement in Germany. Another phenomenon of the mass-consumer society that was taking shape in Germany was also drawn into this larger debate over the public's attitude towards art: the shop-window display. An article on this topic was featured in *Der Kunstwart*. Observing that people passed by the Schulte Art Salon windows, with their expensive oil paintings, but crowded around the windows of the Photographic Society or Amsler & Ruthardt to examine photographic reproductions of paintings, the writer concluded that people were drawn to the art forms they could afford. Asserting that one should never think that the ordinary person was apathetic about art, he urged that good-quality, inexpensive reproductions be made available to educate the public.[60] Within the next decade Avenarius mobilized the resources of *Der Kunstwart* to establish a national organization, the Dürer League, which provided reproductions of modern art suitable for unpretentious middle-class and petit bourgeois families.

The outreach to the public that lay behind these educational efforts at the turn of the century did not, however, quiet the skepticism and disdain for the public that supporters of modern art continued to express. The rift between the world of modern art and the schaupöbel had not closed; it was simply a fact of life that was no longer questioned and that was periodically deepened by an explosive outburst on the part of the schaupöbel.[61] The normalizing of this great divide was revealed in a list published in *Die Kunst für Alle* in 1898. Reprinted from the *Hamburgischer Correspondenten* after much publicized opposition in 1896 against Alfred Lichtwark's promotion of modern art in Hamburg, the list comprised appropriate comments for use when visiting the modern section of the art exhibitions and museums:

1. They paint everything out of one pot (treat them all alike).
2. My five-year-old could do that better!
3. If I spilled a pot of paint, I could get the same effect.
4. That is pure scribbling!
5. I know nature, and it doesn't look like this, it isn't so green.
6. I expect art to say something to me.
7. I'm certainly in the madhouse here.
8. I expect an artist to paint a beautiful person, not such ugly ones.
9. A work of art should lift my spirits.
10. I want paintings to be more idealized.
11. I expect a painting to attract me through its subject.
12. If I splattered my paintbrush over my shoulder at the canvas, it would look like this picture.
13. You shouldn't paint everything that you see!
14. If I look closely at a picture, I want to be able to recognize something, but there is nothing here!
15. A work of art should not violate the eternal rules of beauty.
16. There's no sky in that picture!
17. I don't like the "spinach pictures," the meadows are too green.

Fig. 72 A. **Eugen Kirchner, "Children and Fools,"** *Fliegende Blätter* 100, no. 2539 (1894): 121, with the caption "Else (in the exhibition, before a painting of the most modern style): 'But, Papa, are you *allowed* to *paint* like that?!'" *B.* **Edmund Harbürger, "The Public Prosecutor at the Art Exhibition,"** *Fliegende Blätter* 109, no. 2785 (1898): 243, with the caption "That picture is supposed to present a landscape?!! The man should really be indicted 'on the charge of *false pretenses*'!"

In the cartoons of the 1890s, all levels of the art-going public, from curious children to mature public officials, were shown as bewildered by the new art. The question in Kirchner's cartoon (*A*) was supposedly asked by a child standing in front of a new artist's work in Hamburg. It provided the key ammunition used by Robert Wichmann in his effort in February 1896 to mobilize public opinion against Alfred Lichtwark's promotion of young modern artists and modern art in Hamburg.

Kirchner and Harbürger, both of whom were active within the artists' community in Munich, depicted current works from exhibitions in these cartoons. On the back wall of the gallery in Kirchner's drawing is a copy of *The Blind Woman*, painted in 1889 by Bruno Piglhein, whose panorama of the Crucifixion had been so highly acclaimed in 1886. The presence of this painting by one of the respected leaders of the first major secessionist group in Germany authenticated the exhibition in this cartoon as both serious and controversial. Harbürger's public prosecutor (*B*) cast his judgment upon a work that could have been lifted from the pages of either of the luxurious and fashionable new art journals at the end of century, *Jugend* and *Pan*.

A

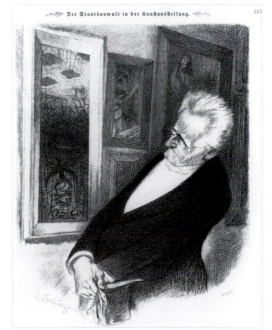

B

18. Those trees have been cut off.
19. The perspective is all wrong.
20. The foreground tilts.
21. That can't be hung in a decent room!
22. Are you really allowed to paint something like that?
23. The highest principle of art is to please.
24. Now—let's get out of the horror chamber!

Originating in Hamburg, where Lichtwark's special collection of paintings commissioned from leading modern artists was popularly known as a chamber of horrors, each phrase was a two-edged sword.[62] The two dozen exclamations codified the opinions that the schaupöbel—from the lowest housemaid to the pinnacle of society—were alleged to express against modern art: pure scribbling, crazy, ugly, colors all wrong, that's not how I see it, my kid could do better, a horror chamber. At the same time, the statements succinctly expressed the anger, disbelief, and demands of those who rejected modern art: they wanted an idealizing art, one that uplifted people, that followed absolute rules of beauty. Cartoons and jokes appeared with great regularity in the humor magazines, as well as in *Jugend* and *Simplicissimus*, in the next decades that played on these fundamentally divergent perceptions dividing the public from the artists (fig. 72). Depending upon the particular twist given the cartoon, either the schaupöbel or the artists might end up looking foolish.

ARTISTIC HEIGHTS AND THE FLATLANDS OF THE CONTEMPTIBLE MOB

Six years after Franquet published his pamphlet defining the schaupöbel and explicitly marking the battle lines on either side of the rift cutting across the art world, the debate emerged full-blown into a glare of publicity at the highest levels of the imperial government. In a formal speech, titled "Art and the Public," at the annual celebration of Emperor William II's birthday at the Royal Academy of Arts in

Berlin in 1899, the director of the National Gallery of Art stated politely but firmly that the emperor's well-known views on art—views that were virtually the same as the taste of the public, particularly the patriotic Berlin public—were wrong. To be sure, Hugo von Tschudi made no reference to the emperor, nor did he utilize the term schaupöbel. Nonetheless, William II had been so outspoken in his opposition to the new art movements that it would have been difficult for listeners to miss the connection. Georg Gronau (1868–1937), who reported from Berlin for *Die Kunst für Alle*, preceded his summary of Tschudi's talk with telling remarks. Pointing to current dissatisfaction within the art world, especially in Berlin, Gronau reported that artists in particular complained about the lack of interest and understanding about art among the public, even among the best-educated people. One despaired, he said, when one heard comments from the public at the exhibitions, expressions of preference for mediocre art. Worse, the lack of understanding was accompanied by an absolute certainty of being right, of knowing "what I like."[63]

Following these comments with high praise for Tschudi's recent speech, Gronau launched into a summary of the speech. Tschudi had begun by asserting that the great political changes in Germany had not been accompanied by a comparable development in the visual arts. Although the exhibitions demonstrated that artists had a greater audience than in any previous period, this modern public was characterized by an uneven composition and its lack of culture in artistic things. As a result, the artists had lost their connection with the public, while the public were judging art on the basis of outdated elementary school rules, which paralyzed their ability to respond to modern art. Condemning patriotic art, Tschudi rejected both universal laws and popular conceptions of beauty, claiming that "what appears in the taste of the larger public to be beautiful, is almost always artistically worthless."[64]

Believing that the public had no appreciation of

artists' efforts to solve new artistic problems, Tschudi discussed the qualities of the new art that constituted artistic progress. He recognized, however, that the relationship of the public to the great masters of its time was almost always tragic because the very strength of the most talented lifted their performance above the public's ability to comprehend. "The tragic lot of genius is to be misunderstood, apart from a small number of supporters." And, Tschudi asserted, those crucial supporters were missing in contemporary German society. He concluded with an expression of hope for the support of art that could come from the emperor. Gronau's report discreetly did not mention that the emperor and his entourage had not been pleased with Tschudi's address. Another Berlin correspondent did, however, report in *Die Kunst für Alle* in July that gossip in the art circles in Berlin claimed that Tschudi, as a result of this talk and later disagreements, had fallen out of favor with the emperor, who made no secret of his dislike of modern art.[65]

William II's opposition to modern art was legendary. Endowed with minor artistic talent, given art lessons by Anton von Werner, and holding strong ideas about what kind of art was appropriate for his empire, William II involved himself to an unusual degree in the politics of art in Berlin. Among his various acts against the new art, he had forbidden his court in the early 1890s to visit any exhibition of Klinger's "immoral" works. His ideas were viewed with considerable humor, if not scorn, by many of his contemporaries. The art journals varied in their treatment of his activity. *Moderne Kunst*, published in Berlin, was sycophantic in its homage to the emperor, demonstrated by its excellent reproductions of his watercolors of naval scenes, allegorical drawings of the nation, and designs for theater sets. Taking a middle road, *Kunstchronik* reported noncommittally on William II's statements and actions. For example, when the emperor, in a meeting in Rome with professors from German art academies on 27 April 1893, criticized contemporary architecture and art, his statements created a furor in the German daily press. The *Berliner Tageblatt* quoted him referring to the new Reichstag, designed by Paul Wallot, as "the pinnacle of tastelessness." *Kunstchronik*, however, eschewed commentary by resorting to an eyewitness account taken from the *Vossische Zeitung* portraying the emperor in a relaxed conversation with comfortable colleagues. According to the account, when someone jokingly referred to open-air paintings, William evidently smiled, shook his finger, and said, "The open-air painters don't have a good time with me in Berlin; I keep them under my thumb."[66]

Other journals were also cautious in their criticism of the emperor himself, but their writers in the 1890s were steadily more scornful of official art policies in Berlin, charging them with maintaining a stultified art scene despite the large amounts of money that Prussia invested in painting and monuments. *Die Kunst für Alle* expressed its displeasure over William II's interference in national monument competitions and the awarding of medals, was dismissive in its treatment of Berlin court art and the Berlin public, and was less than enthusiastic about his artistic efforts. Pecht himself wrote a cautiously equivocal review of William's two famous sketches that were transformed into polished photoengravings by the artist Hermann Knackfuss and were then distributed by the thousands across Germany (fig. 73).[67]

Avenarius, on the other hand, was unabashed in his outspoken criticism in *Der Kunstwart*. In the first years, he published a variety of views on William II's taste and was also routinely critical of Wilhelmine monument building, particularly blaming William II for the "fiasco" of the national monument for William I. In the summer of 1893 Avenarius reported to his readers that the remarks about art made by the emperor while on his recent visit to Rome were creating quite a stir in the daily press. He, however, insisted that it was inappropriate to take those remarks about art any more seriously than those of any other layperson. To do so would be an insult both to the art world and to the emperor. Nevertheless, *Der Kunstwart* drew attention some months

later to a book that scathingly condemned the entire Berlin art scene under the aegis of William II and Werner. Writing and publishing from the safety of Switzerland, the author impudently assaulted the official art of Berlin, ridiculing the emperor's taste, which supported both sentimental "uplifting" kitsch and Werner's quasi-photographic glorification of the new empire. Along with witty, jeering descriptions that bordered on lèse-majesté, he spat ridicule at the "cultivated and uncultivated art gallery-pöbel," whose ever more "corrupt and fickle" preferences were nurtured in the "stagnating swamp" of Berlin art, where Liebermann, Klinger, and Hofmann were dismissed as radical artists by "servile court lackeys."

In his review of the book, Avenarius agreed with the major points but questioned the effectiveness of the audacious derision.[68]

Within months of this review, however, Avenarius dropped his judicious tone and called William II a dilettante whose minor talent was inflated by the dishonest flattery of his byzantine courtiers. The end results, Avenarius reported in a series of brief mocking notes, were unfortunate, because as emperor he had the power to have his meager ideas for drawings, sculpture, and song turned into questionable works of art. By the turn of the century, as modern artists attained a dominant position in cities across Germany, Avenarius spoke out in major arti-

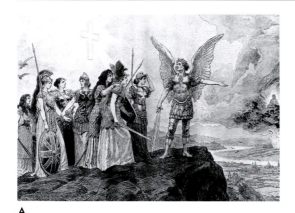

A

Fig. 73 A. **William II, *People of Europe, Protect Your Most Holy Possessions*, 1895. Photoengraving created by Hermann Knackfuss (1848–1915) and distributed by Amsler & Ruthardt. Reproduced in *Die Kunst für Alle* 12, no. 7 (Jan. 1897): 111.** *B.* **F. Hass, "People of East Asia, Protect Your Most Holy Possessions," *Jugend* 1, no. 5 (Feb. 1896): 76–77.**

Reproduced as supplements to the *Leipziger Illustrierte Zeitung*, William II's drawings as re-created by Knackfuss (A) became the basis for innumerable cartoons over the next two decades, particularly in the Berlin satirical journals that followed current political issues, *Kladderadatsch* and *Lustige Blatter*, as well as Munich's *Simplicissimus* and the less political *Jugend*. Hass's caricature (B) of this one was an ironic commentary upon the hoped-for opening up of Asian markets to German goods.

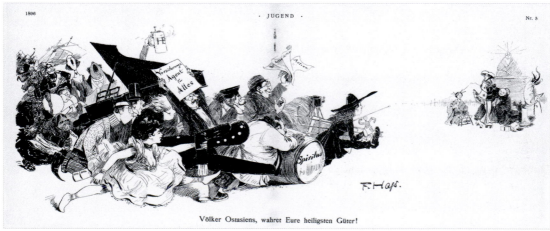

B

cles against the art of the court, particularly the Siegesallee, or Triumphal Avenue, statues, whose only purpose was to glorify the dynasty. Recounting all of William's efforts to create his own style of bombastic art, Avenarius charged that no one was willing to confront his embarrassing taste. In private, he was laughed at and scolded; in public, he was treated as an artist or even a genius. At issue for Avenarius was not William's private preference for artistic styles that harkened back to an ossified academic tradition but the effort to enforce his taste as official Prussian art policy and to take action against new forms of modern art.[69]

What is striking is the extent to which the emperor's official statements, as well as his offhand comments, affirmed and reinforced the attitudes toward modern art within the public that critics had already labeled as schaupöbel. Phrases from his much-quoted speech given at the dedication of the avenue of white, pseudoclassical statues of Hohenzollern ancestors in Berlin in 1901 recalled the views expressed in the list of comments published two years earlier for those attending a modern art exhibition: that true art grew out of an eternal law of beauty and harmony, that art should uplift and inspire the lower classes, that it should not be depressing or ugly, and that it should foster national ideals. All of this could only be achieved, the emperor insisted, in a statement that echoed for years through the German art world, "if art holds out its hand to raise the people up, instead of descending into the gutter."[70] Interfering and autocratic, the emperor stood beside the schaupöbel on one side of the great chasm that divided them from the creators and promoters of modern art.

The image of figures posed on high cliffs above an abyss is appropriate here because the protagonists on both sides of this divide were determined to claim the high ground and fearful of being dragged down to the lower plains of commonness. Consider Franquet's accusation against the schaupöbel, who debased art, who "demanded that art, instead of

educating and uplifting the masses, should lower itself down to the taste of the schaupöbel." Compare his contempt for the great herd that dragged artists down to William II's condemnation of art that descended into the gutter. From opposite sides of the debate over modern art came the same image: that art must strive for the heights, resisting the temptations of mediocrity and of popularity that appealed to the crowds (fig. 74). The ideal of the romantic genius coalesced in the 1890s with Friedrich Nietzsche's intoxicating poetry of Zarathustra ascending the icy high mountains to acquire wisdom and descending to the plains to seek out disciples from among the complacent herd tarnished by mass culture. With this came the language of heights or depths marking the true artist and of lowland cities tainted with the mediocrity of the rabble. While modernist critics deplored the fate of the artist who sank from the heights of creativity to become the slave of the mob, the emperor charged that the modern artists chose to work in the gutter rather than ascend to the transcendent peaks. Both views operated within the Nietzschean metaphors in which the flatlands occupied by the rabble—the pöbel—represented the corruption of the artist's high calling.[71]

Nietzsche's "flatlands of the contemptible mob": here was the conceptual metaphor for attitudes toward the public during a period of anxiety-producing challenges from lower classes and outsiders to the accepted social patterns of the bourgeoisie.[72] Zarathustra provided artists and critics alike with the language to construct their understanding of this new world. Instead of the optimistic, nationalist outlook of the older generation of art critics, with their bourgeois confidence in education, culture, and civic virtue, the critics of the 1890s found in Zarathustra's pronouncements an aesthetic salvation that was predicated upon the renunciation of ordinary society:

But once I asked, and I was almost choked by my question: What? Does life require even the rabble? Are poisoned

A

B

C

Fig. 74 *A.* **Fidus [Hugo Höppener, 1868–1948],** *Prayer to Light*, 1913. Color lithographic version of original 1891 painting, 24 3/8 x 17 in. (62 x 43 cm). *B.* **Georg Kolbe (1877–1947), "Go not to the people nor remain in the wasteland! Go instead to the animals!" (Nietzsche),** *Jugend* 6, no. 35 (1901): 574. *C.* **Hans Thoma (1839–1924), "The Youth and the Incredible Birds,"** *Jugend* 6, no. 47 (1901): 775, and in *Zeitschrift für bildende Kunst* 37, n.s. 13 (1902), as a color plate on heavy stock.

wells required, and stinking fires and soiled dreams and maggots in the bread of life?

Not my hatred but my nausea gnawed hungrily at my life. . . . And, holding my nose, I walked disgruntled through all of yesterday and today: verily, all yesterday and today smells foul of the writing rabble!

Like a cripple who has become deaf and blind and dumb: thus have I lived for many years lest I live with the power-, writing-, and pleasure-rabble. . . .

What was it that happened to me? How did I redeem myself from nausea? Who rejuvenated my sight? How did I

fly to the height where no more rabble sits by the well? . . . Verily, I had to fly to the highest spheres that I might find the fount of pleasure again. . . . And here is a life of which the rabble does not drink. . . .

For this is *our* height and our home: we live here too high and steep for all the unclean and their thirst. . . .

On the tree, Future, we build our nest.[73]

Power-rabble, writer-rabble, pleasure-rabble, art-rabble, exhibition-rabble—the words were a siren call and a battle cry. For those artists and critics who read *Thus Spoke Zarathustra*, the message was clear. Zarathustra, the creative one, leaving his high mountain and descending into the marketplace to share his gifts with the crowds, was received with jeering and derision. Not understanding him—"they look at me and laugh, . . . There is ice in their laughter"—the crowd turned to watch a rope-walker, whose precarious progress across an abyss was fatally interrupted by the mockery of a jester, who then taunted Zarathustra, driving him away from the town.[74] Rejecting the marketplace, the "realm of the pöbel"— "Of what concern to me are market and pöbel and pöbel-noise and long pöbel-ears"—Zarathustra sought companions who would follow him to the heights. Insisting on the dominance of the rabble—"pöbel above, pöbel below," the "pöbel mish-mash"—in the cities and the plains, Zarathustra returned to the mountain to attain creative mastery.[75]

Nietzsche's accusations against the rule of the philistine rabble was not limited to *Zarathustra*. In an early essay republished in 1893 Nietzsche caustically described the cultivated philistine who, equating Germany's victory over France in 1871 as proof of German cultural superiority, complacently affirmed traditional cultural norms instead of striving for new, uncomfortable truths.[76] In his later works Nietzsche continued to condemn those who sought "the universal green-meadow happiness of the herd" and those who called for equality, which for him meant that "all become rabble."[77] Nietzsche's

censure of emerging mass society as the age of plebian vulgarity fueled the rejection of the public by the young modern artists, who hoped to experience the "icy laughter" of the crowds as the mark of their genius. Furthermore, Nietzsche had elliptically written about "Germans as artists" needing to "rise into the sphere of rapture and sublimity" if they were to achieve the beautiful and depart from the clumsy and ugly behavior of the rabble.[78]

An anonymous commentator on "Nietzsche and His Significance" in *Der Kunstwart* in 1895 exclaimed: "What indescribable confusion have the seductive and brilliant works of the fashionable philosopher caused in the heads of the young generation of writers!" Almost visibly shaking his head over their enthusiasm, the author, who himself found Nietzsche to be at once dangerous and delightful, recognized that these young men believed they could carry the imprint of the distinguished philosopher if they threw around his catchphrases and looked down with disdain upon the "universal green-meadow happiness of the herd." Disapproving of this attitude, the writer continued, "What an attraction for weak persons, to claim as their own the reckless utterances of an unrestrained individualism and to become drunk on the ideal of the blond Aryan beast, of the exulting monster with the maxim, 'Nothing is true, all is permitted.'" Those who idolized Nietzsche, he wrote, were matched by those who bitterly denounced his writing as subversive and blasphemous. The vehemence of both groups was startling when one realized that less than a decade earlier the public had never heard of Nietzsche. Now, even the staid *Kreuzzeitung* charged that this "extraordinarily poetic," "devilish pseudo-philosopher" had attained an untoward influence among educated young people, students, faculty, artists, and the literary intelligentsia.[79]

The appeal of Nietzsche to the younger generation was vigorously countered by Max Nordau (1849–1923), a German physician and journalist living in Paris who published a thorough critique of

the irrationalism of modernist writers in 1892. Writing from a firm belief in the liberal bourgeois ideals of reason, discipline, and progress, Nordau devoted a lengthy chapter to the analysis of Nietzsche's pessimism and his megalomaniac language, which Nordau perceived to be marks of degeneration. He characterized Nietzsche's lofty pronouncements as "delirious ideas" of a madman "having their source in illusions of sense and diseased organic processes." Analyzing the irrationality of Nietzsche's writing, Nordau scoffed, "This 'solitary one,' this 'dweller on the highest mountain peaks,' exhibits by the dozen the physiognomy of all decadents. He who is continually talking with the utmost contempt of the 'herd' and the 'herd-animal' is himself the most ordinary herd-animal of all. Only the herd to which he belongs, body and soul, is a special one; it is the flock of the mangy sheep." Nordau saw in Nietzsche's high-flown rhetoric a brutal contempt for humanity and a perverse rejection of the Enlightenment ideal of human perfectibility and progress.[80]

This was the enthusiasm and consternation that lay behind the generational shift in attitudes toward the public that marked the 1890s. It surfaced in the art journals in reviews of Nietzsche's books, in evaluations of artists, and in articles on the state of German culture. Nietzsche's phrases, aphorisms, and words became embedded in the critical language during the years before World War I. Responses to the work of artists were often affected by the critics' attitude toward Nietzsche. This was the case for Hofmann and Klinger, both of whose works were regularly cited as mirroring Nietzschean philosophy and who were rewarded with the icy laughter of the rabble. The journals varied in their attention to Nietzsche. *Der Kunstwart* under Avenarius's direction presented a modified but steady Nietzschean critique of Wilhelmine German society. In the other journals the attention given to Nietzsche depended upon the individual writers and critics, but in all of them Nietzschean ideas were

present, especially in the evaluation of the public.[81]

In a three-article series that introduced Nietzsche to the readers of *Die Kunst für Alle* in 1895 Georg Fuchs (1868–1949) identified one of the important issues addressed by Nietzsche as "the relationship between the public and the creative genius." An influential promoter of Nietzsche, Fuchs reveled in Nietzschean aphorisms that corresponded to the rhythmic, soaring freedom of spirit that he found in the paintings of Böcklin—"like an Olympian god before an angel choir"—and Klinger— "whose art resurrected [Zarathustra's] poetry in incomparable magnificence" (fig. 75). For Fuchs, however, the taste of the schaupöbel, the art rabble, was trapped in dreadful artistic provincialism and materialism that demanded sensational realist art to arouse astonishment, howling, and teeth gnashing.[82]

Nietzsche's poetic flight from the rabble was given an insidious impetus by a book whose appearance in January 1890 was hailed as "a herald's cry to the rising young German generation that represents the future." Five weeks later Avenarius informed his readers that this "remarkable book," *Rembrandt as Educator*, was creating great excitement, occasioned in part by the determined anonymity of the author, who was identified only as "a German." Noting that the book was already in its third edition by the first of April, Pecht in *Die Kunst für Alle* commended the book to his readers for its wealth of ideas about the future of art in Germany.[83]

Pointing out that the erudite author's views coincided with those that he, Pecht, had been promoting for years, he printed lengthy excerpts directly from the book, with only a brief introduction. The sections, drawn only from the first 35 pages of a 356-page book, stressed the necessity of artistic individualism that was rooted in local German culture and landscape, as Rembrandt's life had been rooted in Holland. "A true artist can not be local enough. . . . A true art can only arise out of the manifold, nuanced and yet integrated character of the people. The defects of certain modern art move-

ments prove this." Furthermore, the book was critical of the academic, museum world for holding on to the sterile art of the past. "The modern time has modern needs and requires a modern art." These statements from the book were only a restatement of the art journals' endlessly repeated test of authenticity. However, the anonymous author insisted—also following current views—those needs dictated that any true art must be rooted in the German character and localities. Developing the argument further, the author argued that if impressionism, imported from France, were appropriately infused with German folk character, it would become an authentic art.[84] For Pecht and many others these ideas affirmed the widely accepted understanding that art should emerge out of the contemporary reality of each nation while being strengthened by artistic impulses from other nations.

Avenarius also recognized the importance of the book in gathering together current ideas about art and culture. He was critical of the book, however, for its chaotic organization, lack of clarity, one-sided views, failure to consider contemporary social problems, and lack of humor. He warned that the book was significant as a record of a personal search for a coherent worldview and should definitely not be approached as a scholarly book. Nonetheless, he recognized that the book presented a "liberating word" for many readers, and he praised it for exposing cultural weaknesses in Germany. Avenarius considered three themes in the book to be important: the bankruptcy of the scientific culture that denigrated

Fig. 75 *A.* **Arnold Böcklin, *Isle of the Dead V*, 1886. Lacqueur on wood, 31 3/4 x 59 in. (80.7 x 150 cm). Museum der Bildenden Künste Leipzig. Reproduced in *Die Kunst für Alle* 3, no. 2 (Oct. 1887): n.p.; and *Die Kunst unserer Zeit* 5, 1st half-vol. (1894): n.p. *B.* Max Klinger, *Prometheus Unshackled*, 1891. Plate 41 in *Brahmsphantasie, Opus XII* (1894). Engraving, etching, and aquatint, 10 7/8 x 14 3/8 in. (27.7 x 36.2 cm). Kupferstichkabinett, Staatliche Museen zu Berlin—Preußischer Kulturbesitz.**

Georg Fuchs believed that this painting by Böcklin (*A*) in February 1896 was the visual realization of Nietzsche's "Tomb Song" from *Thus Spoke Zarathustra*, pt. 2, no. 11: "'There is the isle of tombs, the silent isle; there too are the tombs of my youth. There I wish to carry an evergreen wreath of life.' Resolving this in my heart, I crossed the sea." Whether Klinger's conception of his print (*B*) in 1891 was influenced by Nietzsche is not clear, although by 1894,

when the suite was completed, Klinger had read *Zarathustra*. Fuchs found Klinger's work to magnificently manifest Nietzsche's symbolism in part 4 of *Zarathustra*. Earlier passages from that work also illuminate Klinger's singular interpretation of Classical motifs, in this case the myth of Prometheus: "And when he reached the height of the ridge, behold, the other sea lay spread out before him; and he stood still and remained silent a long time. . . . I recognize my lot, he finally said sorrowfully. Well, I am ready. Now my ultimate loneliness has begun. Alas, this black sorrowful sea below me! Alas, this pregnant nocturnal dismay! Alas, destiny and sea! To you I must now *go down!*" ("The Wanderer," ibid., pt. 3, no. 1, translations by Walter Kaufman).

A

B

fantasy and emotion and the hope that a new era of humanity would replace the current era of professors; the importance of cultivating the whole personality, not just the mind; and the necessity of individualism as the foundation of German art.

Quoting, as Pecht had, from the first pages of the book, Avenarius agreed that "individualism is the root of all art, and since the Germans are undoubtedly the most peculiar and individualistic of all people, so are they also—if they succeed in clearly representing the world—the most artistically significant of all people." Summarizing the book, Avenarius stated that the most important current task was to bridge the growing abyss between the educated and the uneducated and at the same time to protect the German people from their enemies, the academics and the doctrinaire, and from plebianism, which expressed itself in art as coarseness and in scholarship as specialization. Concluding his review, he pithily asserted: "The pöbel is not the people."[85]

Avenarius was acquainted with Julius Langbehn (1851–1907), who was identified by mid-1890 as the author of *Rembrandt as Educator*. Langbehn, who lived in Dresden from 1885 to 1892, met Avenarius through his friend and patron Seidlitz, the art historian and museum director. The two men met and corresponded. Later Avenarius suggested that Langbehn had taken ideas from him and from *Der Kunstwart*. He also questioned whether Langbehn was entirely of sound mind. Whatever the case, Langbehn's views were far more flamboyant and incendiary than Avenarius's, particularly in his definition of the pöbel. Listen to Langbehn's words:

Genuine and false, nobility and rabble, truth and lies stand in irreconcilable opposition to each other. Today it is still a question of the same separation as before: in Paris the rabble still rule, even if it appears otherwise; in Germany the nobility should still rule, even if it appears otherwise. All life is struggle; so also the life of Germans; it is a struggle between people's character and plebian charac-

ter. . . . Love the people and hate the pöbel—so says the new German Gospel.

Condemning "trivial modernity," Langbehn launched into ever-broadening condemnations of all that was common, plebian, and opposed to the aristocratic spirit of the German people. Here he moved into realms that were neither raised nor addressed in the art journals.[86]

The *Zeitschrift für bildende Kunst* did not acknowledge Langbehn's book at all, nor did *Die Kunst unserer Zeit*, which had just begun publication. *Kunstchronik* chose to print extracts dealing with museums and art education, particularly emphasizing the author's insistence that art, growing out of its own time and place, should be viewed organically. None of these journals covered the long, rambling discourse that filled the bulk of the book. Jumbling together individualism, nobility of spirit, and Germanness in the last pages, Langbehn slid into an irrational exaltation of Aryan blood and idealistic German youth and a condemnation of "professorism" and Jews as the insidious plebians who contaminated contemporary German culture. Calling for German idealism, faith, and aristocracy to struggle against Jewish materialism, skepticism, and democracy, Langbehn's book, which began as a "herald's cry" for artistic renewal, ended in its successive editions as an increasingly vitriolic anti-Semitic harangue for Germanic rebirth.[87]

The art journals did not inform their readers about Langbehn's central assault upon German culture beyond his arguments about art that fit each editor's particular perspective and that I have outlined above. Nor did they endorse his conclusions. Rarely was his name mentioned after the first excitement, nor did they devote further articles to his book.[88] However, a note in *Die Kunst für Alle* in May 1891 commented on the immense popularity of the Rembrandt book. It informed readers that the book had already gone through twenty editions and that four books responding to it had already been pub-

lished. Among those rejecting Langbehn's book was Nordau, who dismissed it as an "imbecile book" and a "monstrous travesty."[89]

Explanations for the dissemination of ideas within a society are always awkward and unsatisfactory. Pointing to numbers of books sold is unconvincing, and tracing the spread of ideas is impossible. Reading the journals, I can only affirm what other scholars have concluded: that Langbehn captured the imagination of at least part of the literate public, though it is unlikely that many read the book thoroughly. Nevertheless, taken together, Nietzsche's and Langbehn's influence, meshing with current ideas, permeated the artistic world. They shaped the attitudes of modernist artists and public toward each other and toward what was acceptable within the art world. Whereas Nietzsche lyrically celebrated the abyss between the rabble and the creative artist, Langbehn was obsessed with the irreconcilable gulf between the materialism of the rabble and the nobility of the German people. Langbehn pitted ephemeral, decadent urban values against authentic, enduring rural values, while Nietzsche raised the artist to the heights above the lowly crowds. Both of these cultural critics defined the public in ways that had unforeseen consequences for the future of art in Germany.

In these first years of the nineties the concept of the public within the art world was transformed from a progressive entity helping to build the culture of the new nation into a fractured force threatening the creativity and integrity of the national culture. The elitist and modernist degrading of the public from the democratic patron of a national art into an irresponsible, alienated rabble became entangled with an effort to elevate the concept of the German people as creators of a distinctly Germanic art. Images of the jeering crowds, laughing at modern art, blended irrationally with those of the Jewish art collector, the shady dealer, and the stuffy academic. The terms were vague enough to encompass contrary resentments, resentments that multiplied as modern art expanded its strength and dominance within the art world in these decades at the end of the century. The very extent of the conservative reaction against modern art was an index of how successfully new modern forms of art and art organizations had established themselves in the mainstream. The shape of this new art world is examined in the story that follows in the next chapters.

THE FRAGMENTING OF ART
AND ITS PUBLIC

1893–1899

In early summer 1889 Max Liebermann raised his wineglass for a toast at the banquet held in Paris honoring the French and foreign artists who had helped organize and had participated in art exhibitions at the Paris Universal Exposition, a fair celebrating the centennial anniversary of the French Revolution. *Die Kunst für Alle*, which had already reported on Liebermann's role in soliciting contemporary German paintings for the international exhibition and serving as a member of the admissions jury, announced in July that Liebermann, representing the German artists at the banquet, had proposed a toast to "the grandeur of art and the collegiality of artists." The immediate response in German daily newspapers, according to Liebermann's first biographer, was stimulated by a mistranslation that in itself revealed animosity to the artist. The influential, ultraconservative *Kreuzzeitung*, asserting that Liebermann had raised his glass "to art and the fraternal collaboration of all nations,"[1] condemned him for his presumptuous disregard of the German government's policy on the fair.

This tempest over a wineglass was only one of many newspaper attacks in both Germany and France over the participation of German artists in the exhibitions of the Paris Exposition of 1889. Germany, along with several other monarchies, had refused to collaborate in the celebration of revolutionary and republican France. This caused conservative nationalists in Germany to condemn Liebermann's acceptance of the French invitation to orchestrate the unofficial participation of German artists. Liebermann did not work alone in this task; Karl Köpping and Gotthardt Kuehl, both of whom had resided in Paris for some years, helped with the organization of the German section. Official pressure in Berlin made

several artists withdraw their work, although Adolph Menzel refused to do so. Articles in the daily press charged the artists with disloyalty and lack of patriotism and directed anti-Semitic slurs against Liebermann. These defamatory views were not universal. Among others, the *Vossische Zeitung* and Georg Voss in the *National-Zeitung* reported with approval on the success of the German art at the fair and on its positive reception in Paris—in contrast to its castigation in the official press and some of the German daily press. In fact, not only did forty-five of the leading open-air artists in Germany submit paintings to the exhibition but the French jury granted awards to more than half of them: Wilhelm Leibl received a first prize; Liebermann, Fritz von Uhde, and Köpping, all of whom had helped organize the German section, received medals of honor; and Uhde and Liebermann were granted the Legion of Honor, although the Prussian government refused to allow Liebermann to accept the medal. In the following year Uhde, Liebermann, Kuehl, and Paul Höcker were also elected to membership in the newly formed French National Society of the Fine Arts.[2]

Unlike the daily press, the art journals were enthusiastic about the success of the German artists. Each devoted considerable attention to the exhibitions at the fair with an emphasis on the participation of the Germans: *Die Kunst für Alle* published short notices of events and awards in addition to articles by Otto Brandes, its regular Paris correspondent; *Der Kunstwart* and the *Zeitschrift für bildende Kunst* printed lengthy reviews; *Kunstchronik* ran regular reports throughout 1889. The reviewers from Paris sent back measured judgments of the art from the nations that finally participated in the fair. In both *Die Kunst für Alle* and *Der Kunst-*

wart the critics acknowledged the continuing pre-eminence of French artistic capability and sophistication but pointed out that the best German works—Liebermann's *Net-Menders* and Uhde's *Last Supper*—were recognized by all to be superior achievements. Two conclusions marked the reviews in these journals: that none of the art from any of the exhibiting nations had escaped the struggle, originating in France, between the older academic tradition and the new open-air painting, and that the highest achievements in open-air painting now came from the Scandinavian countries. Clear to observers of the fair was the fact that plein air painting had conquered the world of art. Telling testimony to this came from Anton von Werner, whose elegant installation of German art at the 1878 Paris Exposition, discretely sanctioned at the highest levels of government, had featured realistic and monumental academic work, including Menzel's *Iron Rolling Mill*. In his report on the 1889 fair, however, Werner characterized the exhibition of contemporary art as "the official annunciation of the new gospel" of open-air art, conveyed to Germany with a "flourish of trumpets."[3]

Not everyone welcomed this annunciation. For some, the message from the centennial of revolutionary France that scrambled together foreigners, disloyal artists, and new artistic ideals rang more like the destructive blast of the last trumpet. This sense of a world crumbling under the impact of the open-air art represented in the Paris Exposition was conveyed in a grim, painterly drawing published a year later, in the autumn of 1890, in *Fliegende Blätter*. It filled an entire page and was accompanied by a harsh poem, "Heartfelt Lament of a German Painter":

Oh false art! Paying homage to foreign gods,
Forcing yourself into the sacred forest of our German
 legends,
Like a coarse fishwife
Trampling all under your wooden clogs!

You have turned away from the banquet of the gods
And call "true" that which to us is vulgar.
In shadowless fraudulent open-air brightness,
Audaciously you drag ideals through the muck.
Oh, if only the true master would soon come
To hurl the lying spirits into the abyss,
Until through nature, transfigured in the light of beauty,
Art may delight and reconcile us!

The young Saxon artist Hermann Vogel had been featured by Friedrich Pecht in a lead article in *Die Kunst für Alle* the previous summer as "a genuine successor to Ludwig Richter," whose romanticized paintings and illustrations of German myths and fairy tales had made him one of the most beloved artists in nineteenth-century Germany.[4] An autodidact, Vogel followed closely in Richter's and Moritz von Schwind's footsteps, drawing sentimental illustrations of sweet village children and legendary woodland scenes. Living alone in the hilly countryside outside of Dresden, Vogel extolled the world of nature that inspired his work, which he said would never survive the harshness of Berlin's asphalt streets.

In this drawing of a deep-forest scene, Vogel visualized the devastating intrusion of modern art upon the Germanic world of Grimm's fairy tales, represented by the imaginative figures that Schwind and Richter had created and by the shields honoring Albrecht Dürer and Peter Cornelius (fig. 76). From the dragon crouching in his lair over "German Idealism" to the icy Snow Queen, the forest creatures apprehensively flee from the apparition that has appeared in their midst: a crone whose face is a pig's snout, in coarse peasant dress, drunkenly wielding a huge paintbrush to obliterate a painting shaped like a wayside shrine on which "Schwind" is still legible under the roughly stroked whitewash. Above her figure, in the place of honor before a radiant sun but surmounted by crowned black crows, is a seal mocking the awards granted at the Paris Exposition. The heraldic symbols on the shield are

Fig. 76 **Hermann Vogel, "Heartfelt Lament of a German
Painter,"** *Fliegende Blätter* **93, no. 2365 (1890): 186.
Reproduced in** *Die Kunst unserer Zeit* **5, 1st half-vol.
(1894): full plate.**

wooden clogs; the ribbon holding the badge of honor bears the legend "Legion . . . Pleinair"; flanking the seal, the sign states: "Flemish cap, Foreign shoes—German art, how *German* are you!" In the center, the crucial confrontation between modern open-air art and romantic Germanic art takes place as three huge hogs lumber past the pig-faced artist to trample over the recumbent form of a German prince, recalling Siegfried with his fallen shield, Schwind's *Boy with the Magic Horn*, or Schiller's beautiful youth gouged by the boar and lamented by the gods in the refrain "Beauty also must perish!" Here is the violation of the enchanted fairy-tale world of fair, elegant German princes and knights by the multilayered image of the dark austere Jew in league with foreign powers, who is transformed into a tawdry, aggressive female pig, a sow (fig. 77). The message was unambiguous: Max Liebermann, the Jewish swine—the modern *Judensau*—was desecrating German culture and art.[5]

Liebermann, with his monumental paintings of Dutch peasants in clogs and glistening white pigs, with his Legion of Honor for helping the French, with his coarsely brushed open-air paintings, was attacked here through a dehumanizing, feminized image of aggressive obscenity that began in thirteenth-century Germany and continued into the twentieth century in popular vernacular and doggerel, as in the oft-cited one preceding the assassination of Walther Rathenau in 1922.[6] Though the visual image of the *Judensau* was not utilized in the anti-Semitic agitation of the 1880s, the derogatory term was kept sufficiently alive in the language to serve Vogel for this drawing in a popular journal.

An artist in his mid-thirties who made his living illustrating children's books, Vogel disclaimed any interest in what critics wrote or in whether "Pleinairism or Byzantinism was the current fashion," "Byzantinism" being a common reference to the workings of the imperial court. His drawings for *Fliegende Blätter* suggest otherwise. The attack on Liebermann was one of Vogel's first drawings for the magazine. With

it, Vogel moved into the ranks of a popular reaction against the new modern art. His ancient Germanic forests and folk appeared with increasing regularity in the magazine during the 1890s, interspersed with complex scenes filled with highly pessimistic symbolism depicting the desolation wrought upon the lost world of poetry by the combative world of modern art. In this new world, Liebermann's white hogs rooted and trampled upon Classical symbols, danced in a bleak industrial landscape where skeletons carried coffins and corpses hung from street lanterns, and served as Liebermann's weapon in the struggle of the "moderns" against the "ancients."[7]

This celebration of a legendary Germanic world endangered by an alien—Jewish—modernism earned Vogel regular commissions from *Fliegende Blätter*, with its wide base of readers. In 1896 he was commissioned to produce twelve monthly drawings heralding the changing seasons and, significantly, marking the increasing conservatism of the humor magazine. His sentimental world of German folktales stood in stark contrast to the impudence of a modernized cupid in a monthly series by the young Franz Stuck published only seven years earlier, in 1889, in the same humor magazine (fig. 78). Of a similar age and humble background, these two artists represented not only opposing sides in the battle of tradition against modern and in the confrontation between the images of Germanic and of Classical antiquity but also in the artists' struggle for economic survival. While Vogel, in his conservative Germanic dream world, churned out endless drawings for a humor magazine, Stuck, with his scandalous modern paintings evoking a Dionysian Classical world, skyrocketed to fame and wealth.

OVERPRODUCTION, THE MARKET, AND THE JURY

Vogel at least had an income from *Fliegende Blätter* and his book illustrations. Many young artists were

A

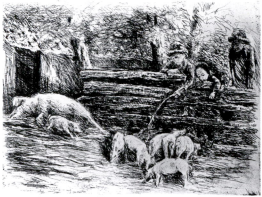

C

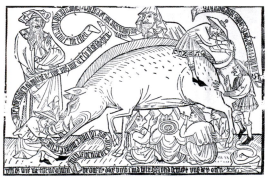

D

B

E

Fig. 77 A. **Moritz von Schwind (1804–1871)**, *The Boy with the Magic Horn*, c. 1850. Oil on canvas, 10 1/2 x 15 1/2 in. (49.5 x 39.4 cm). Bayerische Staatsgemäldesammlungen, Munich. B. **Moritz von Schwind**, *The Captive Princess*. Oil on canvas, 41 3/4 x 23 3/4 in. (106.3 x 60.5 cm). Bayerische Staatsgemäldesammlungen, Munich. Reproduced in *Die Kunst für Alle* 11, no. 10 (Feb. 1896): 146. C. **Max Liebermann**, *Baby Piglets*, 1890. Etching. Kupferstichkabinett, Staatliche Museen zu Berlin—Preußischer Kulturbesitz. D. *The Great Judensau*, fifteenth-century block, printed c. 1700. Germanisches Nationalmuseum, Nuremberg. E. *The Frankfurt Judensau*, seventeenth-century woodcut. The British Museum, London.

Schwind's medieval world was filled with leafy, gnarled trees, rustic forest huts, and dreamy castles. These nostalgic settings in a nonexistent world were populated by beautifully garbed, long-haired maidens and lithe youths, wise old hermits, gallant crusaders, and garlanded children, as well as quaint elves and dragons. Schwind, who illustrated many of the favorite German folktales, died a famous man in 1871. *The Boy with the Magic Horn* (A) one of his best-known paintings, was based on the song collection edited by Clemens Brentano and Achim von Arnim. In Vogel's drawing (fig. 76) the fallen youth, older and more elegant, with his hunting horn at his side, evokes Schwind's famous figure and with it the romantic folk tradition. The setting and position of the central figures are derived from another Schwind painting, *The Captive Princess* (B).

Vogel also had paid attention to Max Liebermann's work (C). The crone in Vogel's drawing was a closely modeled caricature of the women that appeared in many of Liebermann's paintings. Liebermann drew, etched, and painted white pigs and piglets throughout the 1880s and 1890s (see figs. 24A and 28). The two best known of these paintings, *The Pig Market in Haarlem* of 1891 and 1894, were created after Vogel's drawing, but Liebermann's penchant, perhaps ironic, for painting pigs was already well known—sufficiently so that Erich Hancke, who became his close friend and biographer, reported that he expected to find a pigpen filled with baby pigs in Liebermann's studio when he first visited him in 1893.

These were the visual ingredients that Vogel brought to his attack upon Liebermann and his art. To make sense of them, we need to understand the long tradition of visual denigration of Jews within Germany. The woodcut *The Great Judensau* (D) falls into the category of profane woodcut "shame pictures," which were circulated in the fifteenth century to publicly disgrace individuals convicted of wrongdoing. This often-copied image, however, was an offensive defamation of Jews as a whole, presenting them in an obscene relationship with the animal held within their own tradition to be unclean. Engaged in suckling milk or eating excrement, the Jews were identified here as a subhuman species belonging to and nourished by the sow. Scholars have traced the various permutations on this theme through the centuries, including Martin Luther's interpretation of the sow in his tracts against Jews. A popular variant of a painting in the Old Bridge Tower in the city of Frankfurt, the seventeenth-century broadsheet (E) includes the devil, who oversees the Jews riding and suckling the sow.

The image of the *Judensau* was also linked in the seventeenth century to the legend of the ritual murder of the Christian child Simon of Trent, alleged to have occurred in 1476 at the hands of the Jews. Although the last known image of the *Judensau* in Germany was published in 1823, Vogel, with his focus on medieval imagery, certainly encountered these images. Indeed, his depiction of the fallen German hero, whose clean-cut face is about to be slobbered over by a hog, is also reminiscent of the figure of the martyred Simon. A potent ingredient in anti-Semitic agitation, charges of ritual murder erupted again in 1891 in the Rhineland and in 1900 in East Prussia.

not so lucky. The very success of the great art exhibitions and of the art societies in promoting the visual arts as both entertainment and marketable objects in the late 1880s and early 1890s contributed to an unprecedented rise in the number of artists. In his controversial anonymous critique of the art academies in the *Kölnische Zeitung* in 1888, Wilhelm Bode had warned against the overproduction of artists, who would either go under entirely or turn to menial art tasks, like retouching photographs or producing tourist postcards, thereby dropping to the economic level of the proletariat. In fact, enrollment at the art academies had increased substantially since the 1870s. The enrollment of the Royal Academic

Fig. 78 **Franz Stuck, "Cupid's Mission in the Twelve Months of the Year: June,"** *Fliegende Blätter* **90, no. 2289 (1889): 197.**

Stuck was already an established illustrator when he received the commission to provide a cover drawing for this humor magazine for each month of 1889. In this same year Stuck made his appearance at the First Annual Munich Exhibition with his *Guardian of Paradise* (plate 5), *Innocentia*, and *Battling Fauns*. His drawings had first appeared in *Fliegende Blätter* two years earlier. This series of cover drawings is characterized by a Cupid's playful activity as a mischievous young boy carrying out his mission in modern settings. In June he rides an engine in the shape of a fire-breathing dragon that pulls a long train, presumably filled with vacationers, away from a modern urban railroad station.

Institute for the Fine Arts in Berlin exploded from only 77 students in 1875 to 350 in 1887, when a cap was established that stabilized the enrollment at between 200–250 men through the 1890s. The Munich Academy of Art enrolled between 350 and 407 men in its winter sessions throughout the 1890s. While Berlin and Munich had the most prominent academies, male students could attend art academies in Düsseldorf, Königsberg, Dresden, and Karlsruhe; ducal art schools in Stuttgart and Weimar; municipal or provincial art schools; private art schools established by artists; or an increasing number of schools of arts and crafts. In these decades the growing number of artists in the major urban centers reflected the upsurge of students in secondary schools and higher education. The number of persons reporting themselves as full-time painters and sculptors in Munich grew from 943 in 1886 to 1,180 in 1895 and 1,882 in 1907; in Berlin, from 1,159 in 1886 to 1,475 in 1895; and in all of Germany, from 8,890 in 1895 to 13,959 a decade later. Of these latter figures, 969 in 1895 were women, with a twofold growth in a decade to 1,874, after already doubling in the previous decade.[8]

As the number of artists mounted, the number of artworks escalated, flooding the market. The specter of overproduction in a capitalist market haunted the art world and entered into the pages of the art journals, bringing with it the mood of pessimism and xenophobia that undergirded Vogel's drawings. The problems of distribution and overproduction were not peculiar to the German art world. With the expansion of world markets through new modes of transportation and communication in the second half of the nineteenth century, politics in the European states were punctuated by debates and shifting policies over free trade and protectionism. In the 1870s, Germany, along with other European states, had established trade barriers that, in their turn, came under increasing criticism by the early 1890s, when a continuing stagnant economy, despite vigorous industrial growth, produced a variety of compet-

ing powerful economic interest groups in Germany. Organized to fight for the opening up of markets or, conversely, for protectionist measures against foreign competition, these groups' conflicting positions again demonstrated the complexity of establishing unified policies in the socially and economically diverse nation. The regional economic competition between the art centers within Germany manifested itself in Munich's eagerness to maintain its dominance in the foreign art market and in other centers' efforts to acquire a share.

Thus, a particularly disturbing action for the German artists was the decision in 1883 by the United States to establish a 30 percent customs duty on works of art, since German artists had found the American market to be one of the most lucrative, especially through the Munich exhibitions. The year before the tariff was put in place, Americans imported more than $390,000 (1.6 million marks) worth of artworks from Germany. Thereafter the exports declined, though Paul Drey, an economist who in 1910 published one of the earliest scholarly studies of the economics of art production and marketing in a capitalist society, suggested that one reason for the decline was that Germany had exported too many kitschy peasant scenes to American buyers. In 1890 rumors circulated that the Washington Tariff Conference was calling for the tax to be reduced to 15 percent. The following year, the sales again climbed to $300,000, only to drop drastically, a drop *Der Kunstwart* attributed to the financial crisis of 1892 in America, as well as to an increasing competition in America from photogravure reproductions of popular French subjects. Concluding that Germany consistently imported more art than it exported, Drey's systematic analysis confirmed anxieties voiced in the art journals, especially in the first half of the 1890s, before the economy as a whole entered a period of expansion and growth.[9]

A strong indication of this anxiety over foreign art's upsetting the market for German art appeared in an article in the 15 May 1890 issue of *Die Kunst*

für Alle. Reviewing a gallery showing of a large collection of French sketches, Pecht took the German dealer to task for his efforts to sell them. Questioning the appropriateness of selling unfinished sketches to an uninformed public and angry over what he described as the promotion of overpriced pieces for pure speculation and profit, Pecht argued that these imports constituted a serious danger in that they diverted German money away from German artists and turned Germany into a dumping ground for cheap studio works cast off by the French themselves.[10]

Significantly, the rhetoric employed by Pecht became commonplace in the attacks upon French-inspired modern art over the next decades. He himself returned to the theme in the fall of 1890 after foreign artists had walked off with 56 percent of the total sales at the Second Annual in Munich, much to the chagrin and anger of the Munich art world. Here was a concrete demonstration of the menace of foreign art for local artists. Deploring the German penchant for chasing after foreign fashions and objects, Pecht laid the blame upon the German consumer, who preferred to purchase French paintings and in so doing led German artists to imitate French styles. "The public wants it so! The public! Its taste determines the direction of artistic activity instead of being forced by the artists to follow their way. Sad but true, in Germany more than in any other nation, the laity influences the artist!" In another article in *Die Kunst für Alle* he pointed to another factor that exacerbated the situation of the artist: the increasing number of exhibitions was causing a glut of mediocre works of art produced by too many German artists, who were struggling to survive in a market in which auctioneers and dealers pandered to poor public taste (fig. 79).[11]

Foreign art glutting the market, the oversupply of artists and the overproduction of art, philistine public taste and choice—these problems coalesced during the first years of the 1890s in varying degrees of intensity into the complaints of critics and

Ein moderner Kunstfreund.

Fig. 79 **Edmund Harbürger, "A Modern Art Lover,"** *Flie-gende Blätter* **92, no. 2328 (1890): 84. The caption reads: "'What kind of painting does your honor wish to purchase?' 'Very large, very expensive, but by one of the very newest artists, who does not yet have such an oversold name.'"** Harbürger concisely presents the art dealer's pandering to the taste of the wealthy client who is interested only in the financial aspects of the work in which he plans to invest.

resentments of artists against the market-driven exhibition system. For artists, these factors loomed large since they influenced the likelihood of their economic survival and were complicated by rapidly shifting artistic styles. Within a market economy, artistic identity became both more imperative and more elusive than it had been in a stable hierarchic society with well-defined patterns of institutional patronage and training. For the few who achieved acclaim and notoriety, the financial rewards were great. For the majority, a decent existence became more problematic.

The three annual exhibitions in Munich, in 1889, 1890, and 1891, marked the public threshold in Germany between an ordered world of institutional patronage and an amorphous, increasingly unpredictable art world of production and consumption. Concerns about overproduction, hypersensitivity to the integrity of German art and the competition of foreign art, and anxiety over public reactions emerged in reviews and in arguments sur-

rounding the annual exhibitions, particularly in the controversies within the art community in Munich itself. A vocal observer of that scene, H. E. von Berlepsch, explored some of these anxieties in a review in *Die Kunst unserer Zeit* while the Third Annual was still open. Tellingly, he began his article by relating a nightmare about visiting an exhibition; then, after strong words of approval for the high quality of the new modern art dominating the exhibition, he raised the problem of foreign artists' taking the lion's share of the sales away from the Munich artists. Insisting that much of the unjuried foreign art—in 1891 Scandinavians, Scots, and English artists were heavily represented—was aesthetically mediocre work produced for the market, Berlepsch called for German exhibitions to refuse to be dumping grounds for foreign art: "All superior works from abroad will always be welcomed, but never again shall our exhibitions become a bazaar for mediocre foreign goods."[12]

Ferdinand Avenarius reprinted in *Der Kunstwart* Berlepsch's article, with its statistics about sales and artworks by nationality and its critical view of jury policies that extended privileges to foreign artists. However, Avenarius went on to refute his argument, insisting that foreign art could inspire German artists. Responding in *Kunstchronik*, Berlepsch pointed out that at the Third Annual 706 foreign artists showed 1,876 works, while the 661 German artists showed only 1,258 works. This imbalance not only denied possible sales to German artists, he wrote, but it occurred at a time when the number of German artists was increasing at an alarming rate. What, he exclaimed, would become of them? Since society now had no fundamental need for art, and the market economy had produced a complete reversal of the relation between production and demand from the patterns of patronage in the past, Berlepsch could only foresee a massive proletariat of artists reduced to poverty by creating art objects for which there was no hope of sales.[13] Such gloomy predictions, often linked to negative views of the

modern styles, were voiced with enough frequency in the press to gain attention in the humor magazines.

A lighthearted poem in *Fliegende Blätter* satirizing Munich's 1891 exhibition asked what qualified a painting to be accepted. Was it the sheer aesthetic quality? Or did the jury favor particular styles? The answer was simple:

What counts most,

Is to come from another country.

From other lands they bring paintings

Easily twenty at a time,

Thus for the *best* of our own

No more space!

On the other hand, a tongue-in-cheek article in *Kunstchronik* mocked conservative claims that German art would be contaminated by foreign paintings or that money should only be spent on German artists, whose paintings, rooted in the soil, could uplift the people. Ridiculing *Rembrandt as Educator* and Franz von Lenbach's portraits, the anonymous writer concluded with the cry: "Art proletariat rally around! Freedom for the artist! Equality of paintings and prices is the solution!"[14]

Writers in the press had the freedom to voice their opinions, write clever pamphlets, and argue over exhibition policies and sales statistics. Artists had to deal with the hard monetary consequences. If they considered the published statistics for the Third Annual, artists had to face the fact that only one out of every nineteen German pictures shown was sold; equally depressing was the average sales price for German paintings, only 1,659 marks, compared with 2,197 marks on average for foreign works. And this occurred in Germany's leading art market. Furthermore, compared with the figures from the immensely successful Third Munich International, in 1888, at which German works sold for an average of 2,295 marks and a German artist had a one-in-twelve chance of his work's being sold, artists just four years later could only be discour-

aged. Not only were the odds against sales increasing but the price had dropped by more than 600 marks, and that was only the average price. When top prices for a few favored paintings were factored in, it became clear that many paintings had sold for only several hundred marks. Yet the artist whose work was exhibited in the annual exhibitions was among the fortunate ones, for a significant number were rejected by the juries. At the annual exhibition of 1895, held by the Munich Artists' Association, for example, only 20 percent of works submitted were accepted by the jury.[15]

As early as 1887 in Berlin and 1888 in Munich, dissatisfaction over the number of rejected works stirred efforts to hold an exhibition for rejected works. Both plans fell through because, as *Der Kunstwart* reported, artists were not brave enough to allow their names to be stigmatized as rejected. In 1892 *Der Kunstwart* again reported that a number of artists rejected by the jury of the Great Berlin Art Exhibition were holding an anonymous exhibit. The announcement stated that in order to give the public the opportunity to make their own judgments, artists' names would only be provided after the sale of works. This plan also never materialized. The immediate object of anger in all of these cases was, of course, the jury, who, if the rejections were too high, could be charged variously with favoritism, with bias toward conservative styles, or, as was the case in 1891 in Munich, with being too radical (fig. 80).[16]

In June 1893 the artists who were rejected by the annual Great Berlin Art Exhibition organized a Free Berlin Exhibition, in which four hundred works were hung in the restaurant of the Hohenzollern Panorama, near the Lehrter Station. The poster that had been designed by Ludwig von Hofmann for that annual exhibition and had been rejected was appropriately used to publicize the Free Berlin Exhibition. Only a small portion of the works actually rejected by the official jury was submitted to this jury-free exhibition, according to a review by Jaro Springer in *Die Kunst für Alle*. Hence, the organizing committee

Praktischer Vorschlag.

had opened the exhibition to submissions from other artists. That many of these paintings and sculptures, sent directly to this unjuried exhibit, were respectably good works deserving a place in the exhibition was an indication, Springer claimed, of the considerable overproduction of artworks in Berlin. Turning to the other obstacle facing the artist, he devoted considerable attention to the problem of unfair juries. Springer pointed out that most of the rejected works deserved to be returned. Only two works, both by Edvard Munch, had without question been treated unfairly by the Great Berlin jury. Since both were fine modern works, mild and nonthreatening, their rejection, Springer maintained, had been due solely to the hostility of Berlin juries against modern developments.[17]

The fact that juries played a critical function in determining an artist's fate made the choice of juries a major source of conflict within artists' organizations. For the artist, the decision to follow the new trends of the nineties complicated the already tenuous likelihood of success and resulted in many artists' organizing new exhibiting groups to enhance their possibilities of gaining an advantage in the art market.

"POVERTY SITS BESIDE THE EASEL"

From the point of view of the public, outside the politics of the art world, the issue of the juries was not at the forefront of perceptions about the life of the

Fig. 80 **Adolf Oberländer, "Practical Proposal,"** *Fliegende Blätter* **92, no. 2344 (1890): 230–31.**
In June 1890 Oberländer made this "Practical Proposal" to prevent untoward influence and bias in the exhibition juries. The caption points out that the problem of jurors' being too easily swayed by their most influential members could be solved by isolating each juror in a box that only allowed him to view the painting and place his vote silently.

A long article entitled "The Jury," by "Not an Artist," published in *Der Kunstwart* in June 1890, discussed how

journals and newspapers created great expectations of exhibitions through their anticipatory articles and calls for stricter juries. The excitement and speculation generated among the public was then manipulated by journalists who portrayed the distraught artists whose works were rejected. After raising the question of the jury as an invidious form of censorship, the article ended with a cynical description of a judging session in which the jury carelessly rejected an entire group of paintings without looking at them before adjourning for dinner.

artist. Poverty was. Or as one writer put it in 1893, "Poverty sits beside the easel, not as a benevolent teacher, but as a pale, terrible vision that kills even the last remnants of joyful creative power."[18] Not only did the starving artist in the garret continue a long tradition that defined the artist genius, articles in the journals deploring the fate of artists in the current state of overproduction and underconsumption reinforced the image of the poor artist. Early in the century, in a graphic cycle of 1834 (fig. 81), Menzel had chronicled the troubled pilgrimage of the artist from sterile academic training, through tedious painting of portraits to support his family, to his exhausted death, after which fame was bestowed belatedly upon his great painting. Based on Goethe's poem "Artist's Mortal Pilgrimage," Menzel's fourteen lithographs transformed the poem into an ironic commentary upon the life of the artist in nineteenth-century bourgeois society, including images of a bleak struggle against poverty during his life

and of strangers collecting the posthumous profits from his painting.

Sixty years after Menzel's lithographic parable appeared, not only had Pecht drawn attention to Menzel's images in an early issue of *Die Kunst für Alle* but cartoon images of the artist in a spare room painting endless portraits for ungracious patrons or starving in his attic appeared with some regularity (fig. 82).[19] In the mid-1880s a lugubrious fable in the tradition of Wilhelm Busch, wryly illustrated by Adolf Oberländer, appeared in *Fliegende Blätter*. Filling three pages, the tale recounted the dismal life of the Dembumsky family, whose poet father and fourteen musician and artist children, industriously practicing their arts, die of starvation. Other scenes, less witty, appeared in the nineties (fig. 83). Though these cartoons suggest that the life of the artist in his studio had not changed much since Menzel's lithographs, the world the artist encountered was not the same. On a fundamental level, Germany's extraordinary

Fig. 81 **Adolph Menzel, *Reality* and *Posthumous Fame*, plates 5 and 6 of *Artist's Mortal Pilgrimage*, 1834. Lithograph, 8 x 11 7/8 in. (20.2 x 30.1 cm). Kupferstichkabinett, Staatliche Museen zu Berlin—Preußischer Kulturbesitz.** Menzel was inspired to create this lithographic series by his reading of Johann Wolfgang von Goethe's poems "Artist's Mortal Pilgrimage" and "Artist's Apotheosis." In these two plates Menzel presents the raw reality of the painter's life, showing him (*A*) reduced to painting portraits of ugly women for wealthy patrons in order to support his wife and small children. On the walls of his barren studio are the paintings he has not been able to sell of saints, the three Graces, and a battle scene. After his death the unsold paintings are discovered and exhibited in a gallery (*B*), where eminent figures, among whom Menzel included Goethe, admire his work. On the right, a man collects the money for the sale of the great painting.

A

B

Gerechtfertigte Bitte.

Fig. 82 *"A Justified Request," Fliegende Blätter* **93, no.
2366 (1890): 196. The caption reads: "Please, Mr. Dauber
—not too much nose!"**
An artist painting portraits of demanding women is one
of the most common images in the 1880s and 1890s in
Fliegende Blätter, appearing in endless variations in which
the skinny, usually cowed artist patiently copes with the
sitter, who is rarely portrayed positively. In this case, the
wealth and the power of the Jewish woman stand in stark
contrast to the emaciated artist.

industrial and commercial expansion had steadily
transformed the face of German cities and reached
into the countryside. The arcadian rural setting that
Vogel extolled in his drawings was inexorably dis-
placed by a world of technological innovation. Car-
toons with double images representing "Past and
Present" became popular. Intended to be humorous,
these cartoons not only yearned for the idealized
harmonic countryside that was vanishing under the
impact of industrial growth and technological ad-
vance; they also represented the perception that the
world of the artist was drastically changing, and for
too many artists, not for the better (fig. 84).

The tocsin bells had sounded provocatively in

the late 1880s, warning that art and artists were en-
dangered by the capitalist mentality taking over the
art exhibitions. One of these alarms appeared in a
popular series of books, *Against the Current*, in
which a Viennese critic argued that the world of the
artist had changed for the worse. The ideal situa-
tion, in which patrons entered into studios and par-
ticipated with the artist in the creation of new works,
was being replaced by a market system, in which
patrons bought already finished work. The results,
he insisted, would be deleterious for artists. With no
sense of the desires of the buyer-patron, the artist
was reduced to producing mediocre popular art
commodities in the hope of attracting sufficient
sales to survive. Caught between mindless saleable
art and impoverishment, artists would, he feared,
become embittered revolutionaries seeking to over-
turn society through their art. In his jeremiad over
the 1888 Berlin Academy Exhibition, Max Kretzer,
the author of a series of novels on proletariat life
and art in Berlin, claimed that an art proletariat had
already inundated the large cities.[20] These warnings
subsided in the next few years, when the annual ex-
hibitions in Munich promised to improve sales op-
portunities for artists. The unfavorable sales for
German artists in the Third Annual, in 1891, how-
ever, turned the attention of the journals back to the
difficulties artists were facing.

A short note titled "On Art Profiteering" in *Der
Kunstwart* in July 1892 alerted the journal's readers
to the practice of unscrupulous art dealers who
bought paintings from needy artists for the proverbial
song and sold them with exorbitant markups. Citing
an unnamed dealer who warned a purchaser who
had paid five hundred marks for a painting not to
seek out the painter, to whom the dealer had paid
only twenty-five marks, the report claimed that this
"dreadful exploitation" of artists happened in large
art centers almost daily. To fight this practice of
cheating artists of their rightful income, the journal
asked artists to provide it with verifiable evidence
about such art profiteers, which it then intended to

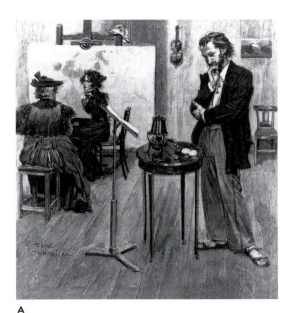

A

B

Fig. 83 A. **René Reinicke, "Strong Imagination,"** *Fliegende Blätter* **107, no. 2718 (1897): 86, with the caption "My husband is** *overjoyed***! In my new still life, I paint his** *favorite dish***, lobster and salmon."** *B.* **Richard Schauff, "The Thrifty Artist's Wife,"** *Fliegende Blätter* **109, no. 2767 (1898): 58, with the caption "(On Monday morning) 'Adular, you must use the colors carefully! You won't get any more this week!'"**

These cartoons represent variations on the theme of poverty: the artist whose art is dominated by hunger and the artist barely surviving. Another frequent theme, usually presented in a cartoon strip, was that of the poverty-stricken artist who tricks a wealthy man into damaging one of his paintings and then demands compensation for it.

publish. No further reports on this matter appeared in the journal; however, this note conveyed to the readers the vulnerability of the artist who was willing to sell a painting at such a loss. It was also a concrete demonstration of the vagaries of the art market, where income was dependent upon a product whose monetary worth was based on subjective factors, on uniqueness in a mass market of similar objects, and, sometimes, upon the shrewd manipulation of that market. In succeeding months, articles in the journals examined the causes and consequences of the "extraordinary overproduction of artwork in Germany." Some writers blamed the surplus of artists and art upon the excessive expansion of art

exhibitions and art schools, as in articles published by J. Janitsch, director of the Silesian museums. Otto Brandt concentrated on the negative effect upon the quality of art produced when so many talented artists were unable to find buyers. Springer's reports on art from Berlin in *Die Kunst für Alle* regularly mentioned the problems of overproduction and competition among artists.[21]

The journals also reported on steps taken by artists during these years to augment their income. In March 1892 seventy-five young artists submitted a formal petition to the magistrates in Berlin requesting that an annual sum be placed in the city budget to support artists. Although the petition was

Fig. 84 **A. Roeseler, "On the Road: Past and Present,"** *Fliegende Blätter* 101, no. 2565 (1894): 119.
In the image representing the past, a farm couple take their pigs and produce to market, stonecutters trudge along the road, peasants guide draft horses pulling a huge load of hay, a goose girl tends her flock, and a farmer coaxes his cow down the road. Two hikers strolling through this unhurried scene hail a smart horse-drawn carriage, which provides more rapid transportation for the gentlefolk past the village inn and fields of grain. Two other characteristic figures mark the scene: the Jewish peddler and the artist comfortably seated at his easel in a flowery meadow.

Technology and haste determine the present. The highway is now paved to accommodate the new modes of transportation. Instead of the great trees, this urban scene is determined by telephone, telegraph, and electric wires. The people, now transformed into bourgeois city folk, are either on wheels or running. The couple rides a tandem bicycle. The hunter, with his gun mounted on the bike, has two dogs running behind him. The hikers have changed into racers on foot or on a unicycle. An early automobile replaces the carriage. New officialdom has emerged to regulate society: the policeman with his gun on a bike, the upright officer, and the mounted officer in the distance. The Jewish peddler is now a milkman on a bicycle. Along the highway, trains packed with commuters or travelers pour into a wrought-iron station. In the background, a wall of posters advertising cocoa and a panopticon merges into a landscape of smoking factories that produce coal briquettes and artificial butter. Hiding behind a lamppost on a sidewalk lined with barbed wire to keep pedestrians from stepping on the grass, a small, businesslike artist records the scene with his camera.

rejected, the cause was taken up by a city official, who urged the city to take steps to deal with the urgent need of young artists. Similarly, a Reichstag representative sponsored a resolution to establish a special category in the imperial budget to provide stipends for talented young artists. Berlin artists also pressured the state government to create a museum collection of contemporary art, a step already taken by other art centers, such as Breslau, Dresden, Hamburg, Leipzig, and Munich. In Karlsruhe, faculty members at the art academy, led by Leopold von Kalckreuth, encouraged young artists to produce original lithographs as a means to support themselves. Students from the Munich Academy of Art demonstrated publicly in 1890 when the Center Party failed to approve a government request to increase the line item for acquisitions in the art budget. During subsequent debates in the Bavarian parliament, in which a compromise was reached, a Center Party spokesman accused the professors at the academy, particularly the director, Friedrich August von Kaulbach, of inciting the students' noisy demonstration.[22]

One effect of the decline of the market from 1892 to 1894, *Kunstchronik* reported, was the prolif-

Fig. 85 **"A Benefactor of Humanity,"** *Simplicissimus* **2, no. 21 (1897–98): 165. The caption reads: "One still starves as a painter. — I'll simply open an art school."** The association of the economic plight with painters' schools was quietly reinforced by this cartoon in the highly popular new journal *Simplicissimus*, which conveyed a liberal, reformist position to a widespread audience.

eration of private art schools in both Berlin and Munich taught by well-established painters as a means to supplement their income from sales. In Berlin, more than twenty new art schools had been created; Munich had almost sixty by 1914. Commenting on this new "branch of the art industry," the reporter said that opening private art schools as a means of coping with the problems of overproduction only made the problem worse by producing more artists, whose works would further swamp the market (fig. 85). This was not a new phenomenon, although it was exacerbated in the 1890s. Theodor Paulsen had complained in 1887 about the opening of private painting academies in cities across the country by artists who were in financial trouble. An article in the *Magdeburger Zeitung* claimed that a famous Berlin professor earned an income above thirty-six thousand marks from his sixty women students, who would only swell the ranks of dilettantes.[23]

Another effort to improve the material situation of artists was made in Munich, where an exhibiting union was organized with the goal of promoting Munich art through cooperative entry in exhibitions in other cities in Germany and abroad. Their first successful cooperative exhibition was held at the Frankfurt Art Society in November and December 1894. Responding in December 1892 to the artists' complaints about the "bitter crisis" they were facing, Bode, along with other officials in the Prussian cultural ministry, organized the new German Art Society, designed as a long-term solution to promote active support of contemporary artists by well-situated members of the public. A news release in March 1893 stressed that the basic aim of the society was to cultivate the appreciation of art in the widest circles of the public in order to increase income for artists and to enable German art to become competitive on the world market. Despite some initial confusion over goals and leadership, the new society received substantial publicity and rapidly attracted a strong, prominent membership that remained active well into the next century.[24]

These articles and notes were constant reminders to the reading public, particularly in the hard years 1892–94, that artists were confronted with a dilemma of supply and demand that appeared to be inevitable within the capitalist market. The impoverishment of large numbers of artists was, however, made much more explicit by a report published about the inordinate number of bankruptcy sales of art held in Munich in the course of 1892. In his report, Michael Georg Conrad (1846–1927) explained that in the Munich jurisdiction during that year more than five thousand oil paintings had to be auctioned off to meet demands of creditors. Of these, forty-five hundred were confiscated directly from the studios of artists. These figures did not include sketches, engravings, sculptures, cloth, costumes, or any other confiscated studio materials. "This," Conrad wrote, "is the crushing reality: the existence of the modern artist hangs in the balance

and ends, if all goes well, in the bankruptcy court."[25] Several months later, in February 1893, in the *Fliegende Blätter*, Hermann Schlittgen portrayed the peculiar scene that might occur when a court bailiff entered the studio of a modern artist whose symbolist and pointillist paintings were beyond his ability to assess (fig. 86). Although his cartoon mocked the public perception of the new modern styles, Schlittgen, who had himself been criticized for his experiments with the effects of light in paintings and who belonged to Munch's circle of friends in Berlin, presented the basic dilemma here of legal authorities trying to sell paintings in order to satisfy the creditors to whom an artist was indebted because he had not been able to sell those same paintings in the current art market.

For readers of these journals, bankruptcy was not the only specter haunting the impoverished artist. As Conrad implied in his cynical comment, bankruptcy

Fig. 86 *A.* **Hermann Schlittgen, "In the Studio of a Modern Artist, or, The Perplexed Bailiff,"** *Fliegende Blätter* **98, no. 2498 (1893): 213.** *B.* **"The Most Valuable,"** *Fliegende Blätter* **107, no. 2724 (1897): 146, with the caption "Landlord to the painter: 'If your rent is not paid by noon, I shall seize your . . . frames!'"**

Schlittgen's scene (*A*) depicts stereotypical artistic poverty: a barren attic studio with a simple iron bed and meager stove as the only amenities. The paintings filling the room are outrageous exaggerations of modern art that mock the incomprehension of the philistine public—represented here by the bailiff with his armload of legal papers. The bleakly empty studio in the second cartoon (*B*), some years later, conveys both the devaluation of contemporary paintings and the perception of utter artistic poverty, when all that is left of any worth is the empty frames.

A

B

would be the end result "if all goes well." In November 1894 Springer reported in *Die Kunst für Alle* about his depressing visit to studios of young artists in Berlin. He wrote that artists were discouraged by the absence of buyers for already prepared work and by a lack of commissions for public art. As he reluctantly made his rounds, he discovered that artists everywhere were discussing, cautiously or openly, the recent suicide of an artist named Henning, a painter of animal scenes. During the winter, Springer continued to report on the situation of artists in Berlin. In January he pointed out that despite an increasing number of exhibitions and gallery shows, the market for art was not increasing as rapidly as the production, making it more difficult to sell a painting than to create one. In February he found that while numerous government commissions for public monuments and murals were creating activity for sculptors and a few history painters, the majority of studios still had no work. The number of empty studios rose as bailiffs confiscated the art or as artists, unable to pay their rent, vacated them. Even many recognized artists were having difficulty obtaining the basic necessities for sustenance. They were, he said, futilely offering to sell for only a few hundred marks paintings for which they were used to receiving several thousand marks. "When," he exclaimed, "will this crisis for our artists end?"[26]

SOCIALISM AND THE ARTIST PROLETARIAT

One answer to Springer's question had been offered in a series of articles written by members of the Social Democratic Party and published in *Der Kunstwart* in 1893. Their answer was direct and simple: since the majority of artists fell within the ranks of the proletariat, their situation would only improve when social democracy triumphed over capitalism. As one of the writers put it, the masses of the artist proletariat were being ruined by their

suffering under the current economic system. Only when the proletariat was freed from oppression would artists be able to create a genuine art for the people. The articles included *Der Kunstwart*'s reprint of an article from the *Bildhauer-Zeitung* (Sculptor newspaper) in which Franz Mehring (1846–1919), a sophisticated intellectual newly won over to the party, reflected upon the light-color paintings shown at the Berlin Academy Exhibition of 1890. He argued that this modern, impressionist art was the product of a decadent period in which capitalism, past its peak, was on a downward slope, and he warned the working classes not to embrace modern art too rapidly.[27]

This warning elicited further discussion from another socialist leader, who wrote in an unsigned letter to *Der Kunstwart* that the Social Democratic Party was one of the chief supporters of art in the various German parliaments because the party recognized that whenever it discussed improving the position of the worker, it was also talking about the art proletariat. However, this writer was certain that most artists were so totally dependent upon support from the wealthy ranks of society and from the "military-police-state officials" that they did not dare express their socialist convictions. As a result, artists did not produce art for the working masses. Instead, the art created for the bourgeoisie was incomprehensible, often hostile, to the working classes and almost always beyond their means. Looking forward to the revolution, which would enable a genuine art for the people to arise, he assured artists that they had nothing to fear from the victory of social democracy because the party considered art to be an important weapon in its arsenal of social and political propaganda.[28]

These essays were published three years after the repeal of antisocialist legislation in 1890, when the Socialist Party and trade unions flexed their muscles in political action, demonstrations, and strikes, while the imperial government under William II devised different strategies to control the working classes

and wean them from socialism. This continuing confrontation between a dynamic working-class party and a government intent on breaking the power of the socialists and workers spilled into the art world in 1894–95 when the Prussian minister of the interior presented a bill to the Reichstag intended to counter internal subversion in Germany. Directed against agitators and terrorists, the bill was amended in the legislature to include measures for censorship against obscenity, free speech, and new art forms that could be perceived as revolutionary. All of these measures would have had a chilling effect on free expression among writers and artists. In March 1895 the editors of *Der Kunstwart* wrapped the current issue with an emergency flier alerting readers to the dangerous clauses that "the police-like spirit of Berlin" had placed before the Reichstag and calling for active opposition to the bill. Fortunately, opposition from liberals and socialists, regional opposition in the southern states, public demonstrations and 22,118 petitions, as well as opposition from intellectuals, artists, and architects, resulted in the defeat of the bill.[29]

Against this background, an article trying to convince artists to join in common cause with the socialists appeared in *Der Kunstwart* in August 1896. Once again, the argument was made that in a capitalist society, where only two classes existed—employers and workers—artists belonged to the working class. The anonymous writer insisted that artists were among the most heavily exploited workers in the current market system; indeed, in many cases they were caught in "plain and simple debtor-slavery" to dealers. Pointing to the impracticality of artists when it came to money matters, he admitted that artistic poverty had always existed but said that this misery had never been so great as it had become when the capitalist vampire extracted all the profits from the artist's work. Sounding the familiar refrain, he maintained that most artists, whether consciously or not, stood on the side of the proletariat. Only the emancipation of the proletariat would free artists; and in the future classless society artworks would

cease to be luxurious objects of consumption subject to the vagaries of the market. Commenting on this utopian view, Avenarius admitted that artists were turning in larger numbers to social democracy. Many of them were genuine idealists who were tired of the excuses of the ruling classes and believed that "it can not get worse than it is now; let us hope that it will be better after the 'revolution.'" This appeal of socialism for artists in these difficult times, Avenarius declared, must be taken seriously.[30]

What is notable in these articles is that the socialist writers, despite a diametrically different social vision, attacked the same aspects of the art scene that conservative writers attacked: the capitalist market based on supply and demand, the demeaning of the artist into producing consumer commodities, the exploitation of artists by dealers, and the impoverishment of artists. The similarity on these issues between political arch-enemies became even more apparent at the Social Democratic Party congress at Gotha several months later, in October 1896. Among the matters debated at the congress was the portrayal of the working classes by naturalist writers following in the tradition of Émile Zola and Henrik Ibsen. The reporter wrote, again in *Der Kunstwart*, that his readers might be surprised to find that the socialists had condemned the naturalists with almost the same language as that used by reactionary political journals. He quoted oft-repeated phrases: "excrescences of naturalism," "stinking filth," "sexual vulgarity," and "indecency of their art." Pointing out that the socialists had the same lack of understanding of modern aesthetics as reactionary critics, the writer went on to say that the naturalists were essentially bourgeois writers who had written out of their shock at discovering the "underworld" of poverty they had not known existed.[31]

This recognition of the bourgeois-class origin of naturalist writers could well have been directed against contemporary artists. The leading artists accused of producing ugly "proletarian" art in the 1880s, Liebermann and Uhde, were certainly from the upper levels of society. In the troubled years of

the nineties the label "proletarian" was transferred from works of art to the plight of the artists themselves. The issue of class identity, however, remained. Nine out of ten students who attended art schools and academies ended up in working-class jobs in the applied arts, as lithographers and engravers, for example, or descended into the ranks of the proletariat with, at best, marginal jobs as tourist guides or bartenders. Many of those at the bottom were reduced to drawing postcards or watercolors for tourists or were drawn into the shady realm of forgery and mass production of false "original" paintings. Reports circulated about unscrupulous dealers who hired artists for meagerly paid piecework, for example, making dozens of identical copies of a sunset. According to a report in *Die Kunst für Alle*, factories operated in which artists were employed in an assembly-line process to produce "original" works of art by popular artists. By breaking the task into discrete parts, each painted by a different person, the factory rapidly produced dozens of the same "original" work. Signed, framed, and given phony authentication, these "originals" would be exported or auctioned for substantial profit to the entrepreneur, while the artists received only piecework wages.[32]

Could these artists, drawn largely from the middle classes, acquire a proletarian or working-class identity within the stratified class society that was Germany in the nineties? Exploring this issue, Paul Schultze-Naumburg wrote a book that was excerpted at length in 1896 in the *Zeitschrift für bildende Kunst*. In the book, designed to alert young people considering a vocation as an artist to the discipline and effort that would be required, he claimed that it was the aura of a bohemian life that attracted so many. For these romantic young people the world of the artist was a fantastic dream of luxurious studios with big cushions and tapestries on the walls, charming models, and a lighthearted life of parties. Repudiating these fantasies, Schultze-Naumburg painted a grim picture of life on back streets in barren grey studios

with cold northern light, a life dominated by hunger and exhaustion, in short, a proletarian life. Still, he believed that good artists with sufficient hard work could achieve a decent life but that for the true genius recognition would only come posthumously. Schultze-Naumburg did not seem to recognize that the persistence of the myth of the unrecognized genius only served to undermine his own efforts to puncture the unreal bohemian dream. The myth of poverty and suffering as the necessary prelude to exceptional creativity, taken together with the bourgeois ideals and attitudes about education and training in the academies and art schools, militated against impoverished artists' accepting the socialist call to enter into working-class solidarity. Instead, those that truly fell to the bottom were more likely to merge into a marginal existence similar to, but not the same as, that of the unemployed and social outcasts within the industrial cities.[33]

What was the actual economic and social reality of these unfortunate artists? Were the figures as grim as these articles suggest? Schultze-Naumburg estimated that one in ten would-be artists might attain a decent economic level. Was there a self-conscious art proletariat marked by bitterness and revolutionary anger that writers were certain was inevitable for those who failed? Evidence on the income of this large sector of artists is fragmentary and anecdotal. Information on sales tended to be given in aggregate numbers, with details only on the most expensive sales. The fears of writers cited in the journals may have been overblown. On the other hand, anxiety over the fate of impoverished artists was certainly presented to the public through the journals in these years of economic crisis following the crop failures of 1892. *Kunstchronik*, which as a supplement to the art historical *Zeitschrift für bildende Kunst* provided coverage of contemporary art, including auction information, published a lengthy report in 1896 about the weakening art prices in both France and Germany. The analyst pointed out that despite recent studies, little was

Fig. 87 **"The First Munich Painting Crematorium,"** *Jugend* 4, no. 14 (Apr. 1899): 232.

This cartoon in *Jugend*, the journal of young Munich artists, was accompanied by a mordant commentary on the over-production of art. It announced that a new corporation had been formed in Munich to create a monumental oven to cremate paintings. Oil paintings, pastels, and watercolors mounted in gold frames would be accepted. The service would enable those who were swamped by paintings—whether inherited, annual art society gifts, or unwise pur-chases—to dispose of them in an honorable fashion. More important, the report stated, was the economic imperative to prune excessive growth from the severely depressed national art market and allow new growth to take the place of the old.

The corporation expected immediate demand for its services and foresaw large state contracts to handle entire museum collections and art exhibitions one day. Operations were about to begin, with friendly cooperation from govern-ment agencies, though it was possible that religious works would be excluded. Services of a chromatically harmonious choir and two well-known art critics to offer funeral orations would be provided. A famous artist—clearly a caricature of Franz von Lenbach—was handling the interior decoration, which would include the most expensive tapestries, gilded surfaces, and careful lighting.

understood about the mechanism of art prices. His own analysis concluded that prices, although sub-ject to supply and demand, were essentially deter-mined by the process of critical reception and reputation and rose markedly once an artist's work achieved sufficient stature to be placed in a mu-seum. It followed that when the subjective nature of this process was combined with the current oversup-ply, it was virtually impossible for an artist who sank into oblivion to sell anything.[34]

Other commentators believed that German artists were unable to sell their paintings and thus were falling into poverty because they insisted upon prices that were far higher than those of their for-eign competitors. In an influential article written in 1902 on art prices, Konrad Lange argued that this was true even of young artists with no reputation, who therefore did not sell anything at all. He was equally critical of those who, in their desperation to sell something, charged too little. Lange's judg-ments were part of a long article that emphasized the continued problem of overproduction in the art market, which he insisted was not limited to the "hungry proletariat." It was, as he put it, an open secret that even well-known painters had not been able to sell a painting for years. Unsold paintings were piling up both in the attics of poor artists and in the comfortable studios of the most famous mas-ters, whose paintings normally went for exception-ally high prices (fig. 87). Yet it was the continued German practice of setting high prices that Lange believed had frightened away the public and con-tributed to the damaging effect of overproduction.[35]

In his exhaustive analysis of the mechanisms of art production and dissemination in Germany from 1890 to 1910 Drey reaffirmed Lange's conclusions while stressing that the situation for artists in the last decade had further deteriorated into "a calamity of exhibitions and overproduction." Drey contended that the basic problem lay in the fact that artists painted for themselves, in total indifference to pub-lic interest or desire. The discrepancy between the

type of work produced and the type the public wanted resulted in the large stockpile of unsold works. This dangerous gulf between artistic production and public demand, or, to put it another way, the alienation between the artist and the public, Drey maintained, served to intensify the disastrous economic situation for artists. "What we are faced with," he wrote, "is the perspective of terrible misery and the worst poverty, a picture of distress and bitterness, of lost strength and shattered talent." Within a year, in 1911, Drey's sober warning found its fulfillment: Carl Vinnen, an artist whose promise in the early 1890s had failed to materialize into the expected success, bitter at high prices being paid for modern French paintings, launched a notorious pessimistic, xenophobic attack on modern art in Germany. This was not Vinnen's first protest against contemporary practices in the art world. In 1894, while he was experiencing success, he had published a pamphlet charging that the increasing poverty among artists was a consequence of inbred and incompetent training in the art academies, where genuine talent was destroyed.[36]

In 1889 Carl Neumann, a young art historian, had warned about potential dangers for new artists from a public that did not understand their work. In 1896 he published a book that examined the relationship between art and the public across five centuries, concentrating upon the current tension between the artist and the public. For Neumann, the central problem in the nineteenth century was the dogma of the unbounded sovereignty of the artist. In his view, the extraordinary inflation of artistic self-confidence was a result of an "entirely unhealthy and abnormal relationship between art and the public." The public's lack of interest in art and the artists' sense of not being understood had produced a mixture of bitterness and defiance among artists that was manifested in contempt for the public. Even the most eminent of the new artists, Neumann asserted, demonstrated this contempt, coupled with the most arrogant faith in themselves. This, he in-

sisted, was the hallmark of the contemporary condition in which two kinds of art had developed: one pandering to the public taste with clean and smoothly painted objects and pleasant subjects, the other, polemical art whose creators scorned all other forms as mere consumer ware. Given the hostility between the modern artists and the public, artists faced the harsh alternatives of fawning before the broad public or scorning it. The result was the huge number of paintings that remained unsold in exhibitions and studios. Neumann concluded that a public with no interest in art was barbaric but that an artistic world in which artists ignored the laity and painted only for other artists could not survive. Having laid out this scenario of contemptuous artists and a disinterested public, Neumann voiced his own conservative views of contemporary modern art. Characterizing the new art as "a morphinism of modern painting" created by "nervous, velvety, almost feminine" artists, he hoped it was only a passing phase.[37] With his reference to feminized artists Neumann raised a troublesome subject, one that others had identified with the economic crisis undermining the livelihood and identity of artists, namely, that women painters were contributing to the overproduction.

WOMEN ARTISTS: DILETTANTE OR PROFESSIONAL?

Women artists were quietly but steadily becoming a visible presence in the art world, which traditionally had been dominated by men. Gaining the attention of critics and writers in the journals, the work of women artists was often discussed with reference to the surplus of art. In one of his regular reports on the Berlin art scene for *Die Kunst für Alle*, Springer approached with considerable reservation the exhibition of the Berlin Society of Women Artists and Friends of Art in July of 1892. He questioned the fairness of limiting an exhibition to women given

that the public exhibitions were open to them. And he pointed out that well-known examples demonstrated that lady painters understood far better than male artists how to turn the rejection of their paintings into useful advertisement for their work. Although he mentioned no names, the reference to Hermine von Preuschen, notorious for her orchestration of publicity for her rejected works, was unmistakable (fig. 88). He claimed to have nothing but praise for the aims and achievements of the society, especially its art school, which offered impecunious young women the means to earn their modest daily bread. However, when women artists created a considerable and not always honest competition with men, then he objected to this exclusive exhibition and approached it without the indulgence that he usually granted to lady painters.[38] The language of this review—"lady painters" carried the clear message "mediocre dilettante"—expressed well the condescension and prejudice that confronted women's efforts to gain recognition as artists.

In a startling turnaround published the following spring, in March 1893, again in *Die Kunst für Alle*, Springer changed his mind about "lady painters." Covering women's art at the gallery of the well-established art dealer Amsler & Ruthardt in Berlin, he began with the pronouncement: "There are masculine and feminine ages. . . . At the present we find ourselves without question in a strong feminine period." This new era was demonstrated by the number of serious women who were moving into activities that formerly had been the domain of men. A sign of the emerging feminine dominance in art was, he asserted, the fact that the best painter in Dresden was a woman, Dora Hitz. In general, however, Springer admitted that the prospects for women artists were not good because most people did not take women's art seriously, treating it as a form of dilettantism. The astonishing work in this exhibition, he wrote, forced him to recognize that "these ladies" could create extraordinary paintings, better even than the men. Within months Springer

reiterated his support of these serious women artists and his concern for the difficulties they faced. One of the obstacles for these women, he believed, was the large number of dilettantes, women who were not economically dependent upon their art and whose work did not even attain a level of mediocrity. He was therefore critical of exhibitions that accepted work made by dilettante ladies, which harmed the professional women artists who relied upon art for their livelihood. The next spring, when he reviewed the 1894 exhibition of the Berlin Society of Women Artists and Friends of Art, Springer expressed even stronger concern over the quantity of work being shown, since many of the women had no other resource than the proceeds from the sale of their work. That the quality of their work was high, with only a smattering of dilettantism, only made the situation more serious in light of the overproduction.[39]

Later that summer of 1894, Springer combined an annihilating attack on the Great Berlin Art Exhibition with a positive assessment of the paintings of the women. Calling the exhibition the most unedifying he had ever seen, he said that even the Berlin newspapers admitted that this one, with all its patriotic historical paintings, was utterly tedious. The only saving grace, Springer claimed, was the "ladies' painting," which appeared to be better than ever. Perhaps, he mused, that was only because the male artists were so weak, and perhaps the explanation for the emergence of strong women was that they appeared in those times when men became disturbingly effeminate. Of all of the women painters, he insisted again, the foremost was Hitz. He then gave her the ultimate accolade that critics granted to outstanding performances by women, but one that simultaneously expressed ambivalence. "One would like to call her a man," he said, if she were not "so fine and so eminently feminine" (plate 6). Two years later, in February 1896, Springer exclaimed again over "the eerily rapid growth in the number of professional women artists" in his review of an exhibition of women artists held at the prestigious Gurlitt Art

Salon in Berlin. Reflecting on the overall achievement of the women in this show, Springer declared that a significant number of first-rate women artists, who should no longer be called "painting ladies," were now achieving their place in the history of art.[40]

We could dismiss this progress from condescension to recognition of women artists as the idiosyncratic response published in one journal by a single critic, albeit in a widely read journal and by a critic who steadfastly supported the new developments in art. To do so would be to ignore the striking upsurge of attention to women artists in the nineties. From its first issues, *Die Kunst für Alle* had published occasional announcements and reviews about the Berlin Society of Women Artists and Friends of Art and the Munich Society of Women Artists. References to paintings of women artists were scattered in a routine fashion, with no mention of the artists' gender, in the long series of brief descriptions that constituted reviews of the large Berlin and Munich exhibitions at the end of the 1880s. In 1892 wider attention was drawn to women's art when the Fritz Gurlitt Art Salon held an international exhibition of outstanding paintings by women at the same time as the annual exhibition of the Berlin Society of Women Artists and Friends of Art. Reviews, articles, and specific references to women artists multiplied in the art journals as the major dealers in Berlin began to show their work. The paintings of Hitz, Tina Blau-Lang, Luise Begas-Parmentier, Clara Siewert, and Linda Kögel, among many others, received judicious appraisals, often genuine praise (fig. 89). Remarkably, Adolf Rosenberg, in all of his conservativeness, had declared in his review of the Berlin Academy Exhibition of 1890 that women artists, who were already entering into energetic rivalry with men in the area of portrait painting, would soon attain the highest palms in other, traditionally male fields. Rosenberg's comment followed his positive assessment of portraits by a number of women artists whose work fell into the conservative mold he preferred. However, he singled out Vilma Parlaghy,

Fig. 88 **Hermine von Preuschen, *Irene von Spilimberg on the Burial Gondola*, before 1890. Oil on canvas, 6 ft. 6 in. x 11 ft. (2 x 3.4 m). La Cour d'Or, Musées de Metz, Metz, France.**

The critics' treatment of Preuschen is an indicator of the resistance in the 1890s to women artists, a resistance that was complicated by genuine artistic debates. Whereas Friedrich Pecht, with his conservative views on art, had supported her work in the 1880s, a new critic in 1894 began a very negative review of her symbolist paintings with a snide attack upon her marital status, referring to her as "Frau Hermine Telmann, divorcée Schmidt, born von Preuschen. A bad exchange." In his judgment, her talent was only sufficient for painting flowers. Preuschen's paintings with their dramatic subjects were popular with the public, judging by the negative remarks in the journals about the reception of Preuschen's exhibitions in 1894 and 1896 at the Munich Art Society and the subsequent tour of the paintings. *Deutsche Kunst* noted very critically that the popular reception of her work in Metz was enthusiastic enough to motivate the city gallery to purchase this painting of Irene von Spilimberg. Avenarius at least twice referred negatively to Preuschen's ability to generate press coverage of her work.

The popularity of her work with the public was sufficient cause for modernist critics to reject it. Hermann Bahr, known later for his promotion of expressionist art, followed his attack in *Der Kunstwart* upon the "gawking rabble" at an exhibition with a disparaging reference to the gallery in which Preuschen's "colorful disgrace" had created an uproar. *Der Kunstwart* consistently published critical articles that insisted upon the limited nature of her talent, in other words, her dilettantism. In the opinion of these reviewers, the tie between dilettantism and popularity with the public was unmistakable.

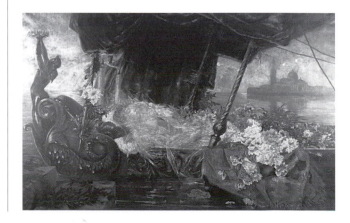

whose portraits of her mother and of the Center Party leader Dr. Ludwig Windthorst were awarded the small gold medal that year, for criticism, calling her portraits "overdone black paintings."[41]

As often happened in the criticism of paintings by women, Parlaghy's conservative, pseudo-Rembrandt portraits were accused of being merely derivative of the work of her teacher in Munich, Lenbach. Despite this, or perhaps because of this, Parlaghy's portraits were in great demand by heads of state, including, years later, Theodore Roosevelt.

She established herself as a sought-after portraitist through a shrewd use of controversy that rivaled Preuschen's own use of the same. These controversies are intriguing examples of the intersection of imperial interests, journalistic reporting, the politics of the art world, and the efforts of determined women artists. Parlaghy first gained widespread publicity with brief announcements in the art journals that William II had purchased for twenty thousand marks a portrait she had painted of his chief of staff, Field Marshal Helmuth von Moltke, shortly be-

Fig. 89 A. **Tina Blau-Lang (1845–1916),** *Tuilleries, Sunny Day,* **1883. Oil on wood, 7 x 10 5/8 in. (18 x 27 cm). Österreichische Galerie Belvedere, Vienna.** B. **Luise Begas-Parmentier (1843–1920),** *View of Venice,* **n.d. Etching and aquatint, 15 3/8 x 12 3/8 in. (41.5 x 31.5 cm). Kupferstichkabinett, Staatliche Museen zu Berlin—Preußischer Kulturbesitz.** C. **Clara Siewert (1862–1944),** *Self-Portrait with Palette,* **n.d. Lithograph, 10 3/4 x 6 1/2 in. (27.4 x 16.4 cm). Kupferstichkabinett, Staatliche Museen zu Berlin—Preußischer Kulturbesitz.**

A

B

C

fore his death in 1891. Subsequent accounts reported that the painting had been rejected by the jury of the Berlin International; nevertheless, when the exhibition opened in the summer of 1891, the painting was hanging "by the highest order" in the hall of honor.[42]

The jury was not happy with this turn of events, and the response in the journals to the emperor's interference in the jury process was not positive. In *Die Kunst für Alle*, Springer, who thought the jury should not have rejected her portrait, compared Parlaghy's experience to that of Preuschen in 1887, pointing out that both women had handled the rejection effectively to generate publicity. Parlaghy had exhibited her portrait of Moltke for several days at Schulte's gallery, he wrote, before the emperor purchased it and ordered it to be hung in the hall of honor out of respect for Moltke, not for its aesthetic achievement. Critics agreed that this was not Parlaghy's best portrait, but rumors circulated that the jury had only rejected the work because Werner, the head of the exhibition committee, did not want any competition with his own portrait of the general. In response to these reports and rumors, the jury issued a detailed statement insisting that they had followed correct procedures and charging Parlaghy's husband with trying to obtain jury-free status for her portrait by claiming that she had a received a great gold medal in Vienna. Checking with the Viennese authorities, the Berlin committee ruled that the medal she had received did not qualify her for jury-free status in Berlin. The jury stated further that at this point her husband had withdrawn her painting from jury consideration, though they had already voted to reject the work. The public scandal over the Moltke portrait and its hanging in the hall of honor came to an end with the closing of the exhibition; however, the curious tale of the painting continued in the form of a complicated bureaucratic dance over which imperial or Prussian state fund was actually going to pay for the emperor's purchase.[43]

Parlaghy's notoriety did not end with this incident. Three years later, in another controversial decision, Parlaghy was awarded the great gold medal at the 1894 Great Berlin Art Exhibition. This recommendation, as the journals quickly discovered and publicized, did not come from the award jury, which had recommended the architect Paul Wallot. The process required the cultural minister to forward the recommendations of the jury to the emperor, who made the final decisions. In this case the official announcement of awards was delayed for months after the closing of the exhibition. Further complicating matters, the ministry informed Parlaghy herself two months before the official announcement was made. In the interim she sent out her own news release to daily newspapers informing them that she had received the gold medal, bringing scathing criticism from the journals for her improper act of self-promotion. Once again scandal paid off. Beginning in 1892, Parlaghy was commissioned to paint no fewer than seven portraits of the emperor (fig. 90). In 1895 he personally opened her large retrospective exhibition in a private house in central Berlin. None of the imperial portraits were considered to be as effective, according to the critics, as her fine early portrait of Windthorst, which was reproduced in May 1891 in *Die Kunst für Alle*.[44]

Parlaghy's problematic successes illustrate both the increasingly visible presence of women artists and the continuing resistance to accepting them as competent artists. Another useful indication was the appearance of stereotypes of women artists in the humor magazines. These cartoon images skillfully employed humor to subvert women's efforts to become artists. Although cartoons also suggested the general ineffectiveness of male artists, none conveyed the deliberate message that men by their nature could not become artists. *Fliegende Blätter* portrayed three types of women artists: the lovely dilettante, the comic open-air spinster, and the domineering woman artist (fig. 91). An unprecedented number of cartoons dealing with artists, female and

male, appeared in the 1887 volume, after more than a million people had swarmed to the art galleries and ancient temples of the Berlin Jubilee Exhibition the previous summer. Moreover, 1887 was the year in which the "Yellow Brochure" intensified controversy over the woman question with its call for upgrading the training of girls and young women by putting their education into the hands of women teachers.[45]

The issue of women's emancipation from contemporary social constraints was addressed in *Fliegende Blätter* cartoons chronicling the transformation of fair maidens, for whom medieval knights slew dragons, into haughty, trouser-clad feminists courted by servile weaklings. The message that wove together women's emancipation and women artists materialized in a long, illustrated story that occupied three issues of the 1886 volume. "The Sorrow and Joy of a Landlady" related the trials and tribulations of an art-loving lady who rented her cozily decorated rooms in Munich to emancipated young female artists whose unconventional paintings and energetic activities, creating chaos in the tidy household, left the landlady almost speechless. This narrative neatly juxtaposed the stereotypical expectations of gentility in the lady painter to the supposedly eccentric behavior of the practicing woman artist.[46]

These perceptions of women who painted were acerbically set forth in an article by "H.M." in *Die Kunst für Alle* in 1890. Stating that painting had become the rage for women in Berlin, the author defined three groups. For the largest group, women without a vocation, the writer produced a malicious caricature of the young, beautiful, modern ladies who spent their time pretending to be artists by taking expensive studio lessons in one of the many painting schools for ladies run by impecunious professors. The second group, women with the wrong calling, were stingingly described as "haggard, shriveled-up" spinsters or unhappy wives, embittered and prudish: "Why couldn't these deplorable creatures satisfy their stunted needs in a field other

than art?" The writer defined the third group as women with a professional commitment, for whom art was neither "a pastime nor morphine for deluded hopes." These harsh distinctions were made by an articulate woman artist and critic, Henriette Mendelsohn (born 1856), who signed her articles with only her initials until late in the 1890s. Having vented her spleen against dilettante women, she turned to a sober analysis of the hurdles facing women who were competing in male domains. Sarcastically rejecting the current "scientific" explanation for the absence of great women artists, namely, that woman, as a deformed version of man, short of leg and intellect, lacked all creativity, she proclaimed that the fault lay not in the women's ability but in the

Fig. 90 **Vilma Parlaghy (1863–1924),** *Portrait of Emperor William II*, **1895. Oil on canvas, 52 x 35 3/8 in. (132 x 90 cm). Nationalgalerie, Staatliche Museen zu Berlin—Preußischer Kulturbesitz.**

Fig. 91 *A.* **Ernst Fischer-Cörlin (born 1853), "Toni Müller, the Woman Painter,"** *Fliegende Blätter* **83, no. 2109 (1885): 203.** *B.* **Emil Reinicke, "Mischievous Put-down,"** *Fliegende Blätter* **87, no. 2200 (1887): 111.** *C.* **Hermann Schlittgen, "Portraits of Life from the World of Women: The Woman Painter,"** *Fliegende Blätter* **87, no. 2208 (1887): 187.** *D.* **L. Balzer, "The Dilettante's Prayer,"** *Fliegende Blätter* **83, no. 2106 (1885): 184.**

These four cartoons provide a valuable view of the resistance in the late 1880s to the possibility of women artists moving into the male-dominated art world. Balzer's drawing (*D*), with its accompanying poem, mocked the expectation that young daughters of good bourgeois families in late-nineteenth-century Germany should dabble in music, poetry, and art but never become serious about any of them. Some reformers within the art world believed that encouraging dilettantism—particularly among women, who would apply their skills to the decoration of their homes—would also increase the level of sophistication of the art-viewing public. In this cartoon, the lovely young woman longs to sing scales and lieder; paint dishes, canvas, and porcelain; write a paean to spring, and pound the piano until people's hair stands on end.

In an illustrated fable of 1885—created by a colleague of Anton von Werner—about women artists (*A*), Toni Müller, a talented painter who, in her determination to paint Nero poisoning his slaves, poisons her model with Prussian blue to gain the absolute realism of his death throes. "Sensational, realistic, / Wonderfully painted to order, / Fully modern, truly pessimistic. / Receives the golden medal." Body found, Toni executed, painting sold to a chamber of horrors. And the moral: "Females, paint no paintings!"

Reinicke's unsympathetic caricature (*B*) of the unbearably ugly lady painter hiking up to an alpine meadow with her paints, portfolio, and impractical parasols embodies the stereotype present not only in the humor magazines but also in contemporary prejudices against women artists. That only undesirable and unmarriageable women would seek a profession of any kind was still a common prejudice. The poem by von Miris accompanying Schlittgen's drawing is almost as scathing as Reinicke's cartoon. It was the first of a series of poems titled "Portraits of Life from the World of Women," all of which disparage the efforts of women to become educated or leave the confines of the middle-class household. Ironically, Schlittgen's drawing (*C*) of the serious young woman hard at work on her paintings did not fit the negative message of the poems.

A

B

C

D

fact that it was virtually impossible for women to receive proper training. Excluded from the Berlin and Munich academies, women were relegated to expensive painting schools for ladies, which "H.M.," obviously angry, described and dismissed.[47]

Mendelsohn's attack on dilettantism and education was well placed. The course of any woman striving to gain acceptance and recognition as an artist was peculiarly complicated by the widespread

association of women with dilettantism in the arts, an association that simultaneously facilitated superficial acquisition of skills and precluded genuine achievement or recognition. This tradition encouraged amateur accomplishment in the fine arts as an indispensable attribute for upper-middle-class young women who hoped to marry but also regarded the determined pursuit of artistic skills as suitable only for the spinster. Pragmatically, this meant that the social and educational structures channeling prospective young males into art as a profession simply did not exist for most women. The assumption was that bourgeois women turned to art as a profession only when they were faced with financial necessity, not because of artistic talent or drive.[48]

Sympathetic critics recognized that since most women were unable to obtain the systematic training men received, many women found it necessary to produce cheap trivial paintings in order to survive while they tried to attend inadequate art classes. The alleged cause of this situation, in which increasing numbers of dilettante women were forced onto the marketplace of art, was the demographic surplus of women in Germany. The liberal economist Max Haushofer (1840–1907), in *The Marriage Question in the German Empire*, argued that a careful analysis of the figures from the census of 1885 demonstrated that there was a surplus of almost 3 million women of marriageable age, sixteen years and older, in Germany. This statistical oversupply of young women was further exacerbated within the educated classes by men's deferral of marriage until they were financially established and by the deliberate choice of many professional men not to marry. Although he believed that all women should have the opportunity to marry, Haushofer insisted that it was impossible given the current demographic reality. Thus, even young bourgeois women who hoped to marry should be given the proper education to enable them to be gainfully employed.[49]

WOMEN ARTISTS: PRESENCE AND PRESSURES

This perception of the woman question as a matter of the redundancy of women had first appeared after the Prussian census of 1863 opened up the debate over women's capabilities to move outside of the home into the public realm. Thus, controversy over access to education was one of the driving forces that led to the formation in the late 1860s of organizations to improve women's position within Germany society. The Berlin Society of Women Artists and Friends of Art, part of this larger women's movement, was founded in 1867. From its beginning the society aimed to support women in their struggle for recognition as professional artists and to provide training enabling young women to become serious artists, not dilettantes. Nevertheless, dilettantism continued to haunt the women's art societies and served to make many of the women artists hesitant to engage in artistic experiments that might be perceived as insufficiently disciplined. Although the number of women artists in the Berlin society was initially small, in less than two years the society had put on the first biennial exhibition of women's art, opened a school to train young women to become serious artists, and established a scholarship fund. Within a decade the society had gained official recognition with an annual subsidy of fifteen hundred marks from the Prussian government, and its exhibitions, held in the Royal Academy of Arts building, were attended by the emperor and the imperial family, who also purchased paintings there. Juried competitions with money prizes and lotteries for the members became regular events. By 1880 the female students at the society's school numbered more than three hundred, and more than three hundred works of art were shown in the society's exhibitions.[50]

In Munich a Society of Women Artists was organized in 1882, with its Ladies' Academy founded in 1884. The Women's Art School in Karlsruhe was es-

tablished in 1885 under the protection of the grand duchess. In Paris the Union of Women Painters and Sculptors was established in 1881, holding its first all-woman art exhibition the following year. *Die Kunst für Alle* reported in 1889 that the Berlin society had 212 regular artist members, of whom 129 lived in Berlin; 30 honorary members, both male and female; and a large number of friends. The society's finances included a loan fund and a retirement fund.[51] Among the women painters who were consistently mentioned in reviews in the late 1880s and early 1890s were Preuschen and Begas-Parmentier, who specialized in Italian landscapes and architectural studies.

Beginning in 1891 the Berlin society held astonishing, elaborate costume balls in the Berlin Philharmonic Hall, in the center of the city. Open only to women, these balls drew as many as three thousand women and served both as fundraisers and a source of publicity for women artists. The Munich Society of Women Artists also put on annual carnival balls from which men were excluded. A splendid one in 1899 re-created the world of seventeenth-century artists, with costumed women representing characters from the paintings of Rembrandt, Rubens, and other masters. The festival newspaper, edited by Kögel, included essays by such society members as Hitz, Käthe Kollwitz, and Cornelia Paczka-Wagner. Demonstrating the conviviality expected of artists, these festivals signaled to the public that the women's art societies had become genuine artistic organizations.[52]

Growing attention to women artists in the journals after 1892 was based on these expanding activities and on the growing numbers of women artists. In the years from 1892 to 1895 the Württemberg Society of Women Artists was started in Stuttgart; the Munich Artists' Association announced that its regular membership of 1,020 artists now included 72 women; 82 women had 120 paintings accepted and hung at the 1893 Great Berlin exhibition; and in 1893 the Berlin Society of Women

Artists and Friends of Art, with 565 members, of which 214 were artists, celebrated its twenty-fifth anniversary and the opening of a new building for its art school. Situated in the center of the city, the building housed both the art school and the prestigious Victoria Lyceum, which under the protection of Dowager Empress Victoria provided lectures by university professors for women. By 1894 the Berlin society was one of thirty-four organizations united in the League of German Women's Associations. In Saxony, women artists, organized under the protection of Queen Carola, held their exhibition in November 1892 in the exhibition hall used by the Royal Academy of Art in Dresden. Three years later there were enough women artists in Leipzig to establish their own Society of Women Artists and Friends of Art.[53]

In that year the census calculated that in Germany 969 women were full-time artists, with 97 others working in closely related areas (compared with 8,312 men). Of these, 200 were full-time artists in Bavaria (compared with 1,986 men). Drey figured that the number of professional women artists had doubled between 1882 and 1895 and that roughly one out of ten full-time artists in Germany in 1895 was a woman. That proportion is borne out in a catalogue of the 1894 Glass Palace exhibition in Munich, which listed 52 women artists among the 597 exhibitors. Furthermore, in the next decade the number of female artists grew almost twice as fast as that of male artists. In Bavaria, for example, there was a 106 percent increase in the number of women artists between 1895 and 1907, compared with a 57 percent increase for men.[54]

These figures alone were enough to trigger anxiety in an art world plagued by overproduction. By 1895, however, artists and critics in the German art world were not facing statistics; they had to deal with the steady encroachment of women artists into what had been men's territory and with the accompanying danger that female accomplishment in a field produced a form of feminine contamination. As Springer suggested in his review of 1894, when

women acquired mastery, men became effeminate. Moreover, to complicate matters in the early 1890s, women artists gained their first modern suffering artist-genius: Marie Bashkirtseff (1860–1884), who, refusing to be deterred from her desire to paint, died of consumption at the age of twenty-four in Paris, leaving behind her paintings and her diary as testimony to her struggle for her art. This was the fabric out of which posthumous fame could be crafted, and Cornelius Gurlitt did just that in a laudatory tribute published with illustrations of her drawings in *Die Kunst unserer Zeit* in 1892. Gurlitt picked up on two themes from her diary: her frustration at her lack of freedom as a woman to learn and experience life as fully as men could and her passionate drive to work. Here was the appropriation of the myth of the promising artistic genius by a young woman with most unladylike ambition, who valued freedom to work above marriage. Despite his championing of this female artist-martyr, Gurlitt demonstrated current social ambivalence about women professionals by emphasizing that this talented and intense young woman paid the ultimate price for her ambition because her constitution was too weak to sustain the stress induced by attempting to carry out masculine activities.[55]

By the mid-1890s the presence of professional women artists could no longer be ignored. The conservative, patriotic *Moderne Kunst* leveled its first broadside against the "modern woman," and specifically against the new painting ladies, in articles published in 1895. Written in a tone of snobbish nastiness by Georg Malkowsky, the message was straightforward: women should be beautiful, charming, quiet, and dutiful wives who cared for their husbands, their households, and their fashionable clothes. Imperial Germany, he asserted, had no room for emancipated females and certainly did not want either educated women or competent, strong women. As far as women artists went, Malkowsky rejected them as undesirable, not because they only had the ability to create imitative forms of decorative

beauty, but because they were forcing their way into an area already suffering from overproduction. This attack on women from a journal that embodied the imperial views on contemporary art must have created some interesting moments in the circles of royal women who were protectors and patrons of the women's art societies and schools.[56]

A more sympathetic treatment came in the *Kunstchronik* review of the 1892 exhibition of the Berlin women's society, probably written by Rosenberg, who pointed out that women artists, for financial reasons, were forced to paint landscapes, flowers, and portraits because these sold well in the middle-class art market. Although he thought the work of women was getting better every year, he judged that the women would always remain within limited boundaries unless they gave up their femininity, as many of their Parisian colleagues had done. Two years later Rosenberg was much more critical of the dilettantish flower paintings, but again he recognized that these works were probably the result of the serious economic difficulties that forced many women artists to churn out paintings quickly for the market instead of striving for higher-quality works.[57]

The growing presence of women as creative agents in the art world, not merely as objects of artistic creativity, was articulated in *Die Kunst für Alle* in the mid-nineties with the inclusion of plates and illustrations of paintings by and about active women (fig. 92). Serious and thoughtful images, these paintings were a far cry from the stereotypes of lady painters that characterized the cartoons in the humor magazines. Furthermore, in 1895 a strong defense of women artists was published by Voss, who as an art historian was working at the Technical Institute in Berlin. Part of a series titled "The Struggle for Existence of Women in Modern Life," Voss's book analyzed the obstacles women still had to overcome in order to become artists. Beginning by discussing the contemporary social inequities that prevented women from excelling as artists, Voss discussed the various educational possi-

A

B

C

bilities that had recently developed for young women art students in Germany and in Paris and concluded that the cost of a thorough education for six years would be more than eighteen thousand marks, a prohibitive amount for all but wealthy young women. To underscore his analysis of the barriers against women's achievement, Voss printed a long letter from Hitz, who had opened her own art school in Berlin in 1894, in which she indicated her distress over seeing so many young women trying to become artists. Most of them, even if talented, would not make it. Nonetheless, she gave her recommendations about the best course of study for a serious young woman. Voss ended his argument by demonstrating that women were, despite all, making considerable inroads into the field, as shown in an eight-page listing of noteworthy contemporary women artists.[58]

As women artists became more numerous and more established, they had to reckon with professional criticism from those who were sympathetic to women's rights, as well as those who opposed them.

Fig. 92 A. **Clara von Dreifus,** *In the Studio,* **in** *Die Kunst für Alle* **9, no. 9 (Feb. 1894): 135.** B. **Alexander Goltz (born 1857),** *Portrait,* **in** *Die Kunst für Alle* **9, no. 20 (July 1894): 308.** C. **Michaela Pfaffinger (born 1863),** *Self-Portrait as Painter,* **in** *Die Kunst für Alle* **10, no. 15 (May 1895): n.p.**

These portraits and self-portraits of women artists published in 1894–95 were open tributes to the newly emerging professional women artists. Also appearing in *Die Kunst für Alle* in the mid-1890s were paintings of active bourgeois women. For example, a painting exhibited in the Munich Secession exhibition in 1895 of elegantly dressed women waltzing with one another in a parquet-floored ballroom to piano music played by a woman conveyed a sense of intense intimacy and energy among the women. In a different key, Sophie Pühn depicted a contemporary young woman writing an intimate letter; Michaela Pfaffinger, who specialized in portrait painting, presented a contemporary Lutheran deaconess reading a book; and Franz Simm painted his daughter as a vigorous young woman ready to step onto her bicycle and ride away.

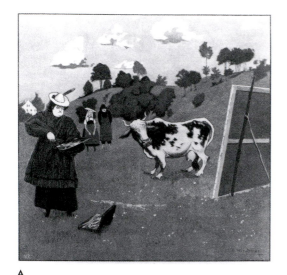

A

B

C

D

Fig. 93 *A.* **Eugen Kirchner, "The Sick Cow,"** *Fliegende Blätter* **112, no. 2859 (1900): 230, with the caption "If you are a modern woman artist, you may not paint my cow! Recently she was painted by one of those modern ones and then she didn't produce milk for two weeks!"** *B.* **Hermann Schlittgen, "The Best Direction,"** *Fliegende Blätter* **107, no. 2722 (1897): 127, with the caption "In the Women's Art School: 'So, Caroline, have you finally decided on a definite direction [for your art]?' 'Oh yes— yesterday I got engaged!'"** *C.* **"Painting Partners,"** *Fliegende Blätter* **111, no. 2814 (1899): 11, with the caption "Woman painter (to her husband): 'Go take care of dinner, dear hubby—I can paint** *that* **much better!'"** *D.* **"The Don Juan,"** *Fliegende Blätter* **104, no. 2639 (1896): 80, with the caption "'You know, Miss Clothilde, how much I love and adore you! . . . Will you be mine?' 'But I already turned you down a week ago!' 'Oh, was that** *you*—**?'"**

In the late 1890s, women artists again cropped up in *Fliegende Blätter*, most of them still condemned to endless humorous variations on the spinsterish outdoor painter (*A*) or to scenes emphasizing that any pretty young women would chose marriage over an artist's life (*B*). Occasionally the dominant artist and her henpecked husband appeared, as in this cartoon (*C*) in which the wife asserts that she is better able to complete a painting of a strong, energetic woman. There was also a grudging recognition of the serious woman painter, who, interestingly, was usually presented in the more modern painterly style that Friedrich Stahl and Hermann Schlittgen had introduced to the magazine. In this drawing (*D*), the point of the joke is to mock the negligent suitor, but the visual message is of a serious young artist seated at her work in a well-appointed studio. Dressed in sober, not frilly, clothes, with a stack of paintings beside her, she concentrates on her canvas.

Although reviews of exhibitions were rare in *Der Kunstwart*, several evaluations of women artists were published in the journal. In 1890 Voss had criticized the work in the exhibition of the Berlin Society of Women Artists and Friends of Art for being too conservative and academic, while Albert Dresdner reported that in the 1896 exhibition of more than forty women artists at the Gurlitt Art Salon in Berlin he could find scarcely one whose work was marked by individuality or originality. Despite Pecht's own favorable reviews of the work done at the art school run by the Society of Women Artists in Munich, *Die Kunst für Alle* published articles that questioned how ambitious or successful women should or could be as artists (fig. 93). In one of these the argument was made that although art schools were filled with female students, women artists could not advance as far as their male colleagues because they were necessarily distracted from the full pursuit of their art by their family responsibilities. This reminder of the traditional obligations facing women artists was not unrealistic. Statistics suggest that although most of the women artists remained single, they still carried substantial familial duties that made it difficult for them to find time or space for their own work. The figures also confirm the frequently voiced lament that women were prevented from doing original or interesting work because of these pressures. On an individual level, this was true of the Berlin painter Sabine Graef-Lepsius, whose heavy social and financial responsibilities for her family meant that she had to put most of her energy into commissioned portraits rather than working on painterly issues she wanted to pursue (fig. 94). About her need to work she commented ruefully that a woman who had to work for money risked losing social respectability.[59]

But despite severe economic pressures and a limited market for their work, women, like men, continued to paint and sculpt. In Berlin the fifteenth exhibition of the Society of Women Artists, in 1896, featured 350 works by 172 women, including Symbolist paintings by Anna Gerresheim (born 1852)

and prints by Paczka-Wagner, one of which was reproduced as a special graphic plate in *Die Kunst für Alle* (fig. 95). In 1898, 199 women artists from across Europe participated in the sixteenth exhibition of the society held in Berlin. By the end of the century the Berlin society had 800 members, of whom one-third were professional artists. In Munich in 1898 the Chamber of Deputies increased the state subsidy for the art school of the Society of Women Artists to provide support for training young women from the middle class who were not married and did not come from wealthy families. Reporting 463 members the next year, the society moved into its own house in the center of Munich.[60]

Most important from a professional point of view, in January 1897 the General German Art Association met with three hundred delegates from the major cities to discuss policies for supporting their members. One of the actions taken was to

Fig. 94 **Sabine Graef-Lepsius (1864–1942), *Self-Portrait*, 1885. Oil on canvas, 33 x 25 in. (83.7 x 63.5 cm). National-galerie, Staatliche Museen zu Berlin—Preußischer Kultur-besitz.**

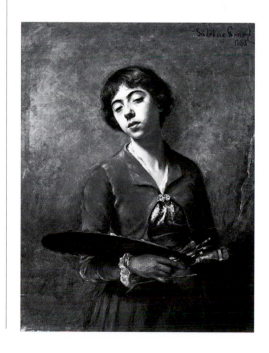

Fig. 95 **Cornelia Paczka-Wagner (1864 –after 1930),** ***Death and Superman*, 1898. Algraphy, 17 1/2 x 24 1/4 in. (44.5 x 61.5 cm). Hungarian National Gallery, Budapest. Reproduced in *Die Kunst für Alle* 14, no. 7 (Jan. 1899): special logo plate.**

When prints by Paczka-Wagner were hung in the Second International Dresden Exhibition of works on paper in 1890, Paul Schumann called them "brilliant" and included her in the same paragraph with Adolph Menzel and Max Klinger. Twenty-six years old at the time, Wagner had turned to drawing, and later graphics, under the tutelage of Karl Stauffer-Bern at the Women's Art School in Berlin. Following Stauffer-Bern to Rome, Wagner worked with Max Klinger and married a Hungarian artist. Her work was perceived to be part of the symbolist neo-idealism that, influenced by Klinger's graphic vision, was highly valued in the later 1890s. The Nietzschean reference in her title for this print was characteristic of much of this neo-idealism.

define membership in the association as resting with groups, not individuals. This action accommodated the growing number of cities in which more than one artist group was active. It also left the decision to admit women to professional membership up to the individual groups. Readers of the journals, particularly of *Die Kunst für Alle*, were kept apprised of all these changes, as well as reading about further significant developments in the last years of the decade: Frau Weber-Petsche opened a Sale Hall for Women Artists in Munich; Kögel formed her own art school in Munich, adding another private school for women to Hitz's school in Berlin; and Helen Zimmern (born 1846), Mendelsohn, Anna L. Plehn, Anna Spier, and Helene Vollmar joined the critics writing feature articles for *Die Kunst für Alle* and *Die Kunst unserer Zeit*.[61]

As the woman artists gained confidence, some of them moved into the newest artistic territories. Crit-

ics at first saw the women as capable of painting only still lifes, flowers, and portraits, all but the latter genre condemning them to endless dilettantism. With the movement maturing and more of the instructors in the art schools engaged in forms of modern art, the spectrum of women's work widened perceptibly. Already in 1894 a reporter for *Die Kunst für Alle* drew attention to the decisive talent of a new group of young modern women artists, including Clara Sievers, Anna Bernhardi, Kögel, and Kollwitz, whose work had received severe insults at the 1893 Free Berlin Exhibition. Five years later a reviewer for *Kunstchronik* exclaimed about an exhibition of fifteen women held at the Keller & Reiner Art Salon in 1899 that the women had taken up the radicalism of the most daring male artists.[62] Among these modernist women artists were Blau-Lang, whose landscapes were profoundly indebted to the classical French Impressionists; Clara Rappard (1857–1912) and Preuschen, who developed their own version of symbolism; and Hitz, who made steady changes in her work based on current French painting.

With only a few exceptions, recognition and modest praise in exhibitions did not result in financial security for these artists. Poverty and proletarianization continued to be serious in the art world during the second half of the nineties, although the issue of overproduction was no longer given much attention in the journals. In part this was a result of the increasing number of exhibiting and sales possibilities. Rival exhibitions challenged the dominance of the great exhibitions; new, smaller exhibiting groups and societies formed in many cities; and new art dealers handling contemporary art appeared on the scene. The pages of the journals were filled with the activities from all of these, and, in the last years of the century the economic problems faded from public view. Nonetheless, overproduction and overcrowding continued, and the possibility of sales worsened after the turn of the century. Georg Habich (1868–1932) referred briefly, but decisively, in *Die Kunst für Alle* in 1899 to the undeniable con-

tinued growth of the artist proletariat. Artists, both men and women, were affected.[63]

Despite accusations that women dilettantes were able to sell their works to a public that preferred the mediocre and familiar to the original and innovative, observers pointed out that women artists were more likely to fall into destitution because, despite the efforts of the women's societies, their resources were simply not sufficient to provide security. Even though the art societies and associations had established a variety of welfare funds for artists and their widows, these were also inadequate.[64] Since they were not defined as workers, artists generally were not included in the social-security measures established by the imperial government in the 1890s. The public—readers of journals and visitors to exhibitions and galleries—thus found themselves in the late nineties observing an art world that was booming with exhibitions and galleries, where new artistic directions multiplied as fast as new groups were formed, where women were challenging the very identity of artists as male, and where most young artists faced a prospect of only modest survival or quite possibly complete failure.

PAINTER-PRINCES AND THE PUBLIC IN MUNICH

In the 1890s, Menzel's image of the long-suffering, impoverished artist ignored or demeaned by his potential patrons collided with new factors: the uncomprehending public and the implacable capitalist market. Reinforcing the myth of the starving artist in the garret, the journals and humor magazines produced in text and cartoons a more layered perception of the contemporary artist, encountering public misunderstanding and struggling within a capitalist market characterized by overproduction, complicated by international trade, and manipulated by those who controlled the marketplace. Once again, as in the double cartoon images of "Past and

Present" (fig. 84), the artist was perceived as functioning in an overwhelming, overcrowded new world; however, tempered by tribulation, the artistic genius would attain his—the pronoun is deliberate—well-deserved acclaim and fame. Thus, the image of the painter-pauper had its antithesis in the image of the painter-prince (fig. 96). Both were understood to be products of the forces of public opinion and of the market economy, though the contrary impact of those unpredictable factors hastened the death of the pauper and blessed the painter-prince with favor and wealth.

In 1891 an article in *Die Kunst für Alle* on contemporary young artists, written by Mendelsohn, began with a comparison between the romantic image of the artist, who was poor, wearing a soft-brimmed hat and voluminous cape to provide warmth in the

Fig. 96 **Bahr, "Two Studios,"** *Fliegende Blätter* **93, no. 2359 (1890): 133.**

No caption was needed to explain this double image ironically linking the painter-pauper and the painter-prince to the perception that dirty proletarian figures dominated the paintings that were favored in the great exhibitions at the end of the 1880s. In the lower drawing, Bahr depicted the poverty of the painter in stock clichés: the attic festooned with a giant spider web; the only window a broken skylight; a cot with a rough blanket covering straw; an empty iron stove covered with ice, its stovepipe almost collapsing. Huddled in a blanket, an empty plate and broken jug at his feet, the painter is emaciated and haggard. On the easel, the painter's desperate desire is incarnated in a Baroque masterpiece of an opulent, fleshy goddess surrounded by fruits, flowers, jewels, and other appurtenances of luxurious living, including putti emptying a cornucopia of delights.

The painting itself provided a clever jest for those readers who were even minimally informed about the world of art since it was modeled on paintings by Hans Makart (1840–1884), particularly his Cleopatra series. An immensely popular painter, Makart was enticed away from Munich to Vienna in 1869 by Emperor Franz Joseph, who provided the artist with a house and a studio decorated at the cost of 127,000 gulden in tapestries, rugs, and hundreds of art objects and massive paintings. Created as a sensual work of art inseparable from his paintings, Makart's studio became the legendary symbol of the painter-prince. It was opened periodically from 4:00 to 5:00 P.M. for public viewing.

The upper drawing here represents a modest variation on Makart's studio, with its mélange of dried flowers, Chinese vases, antique weapons, and draperies. The artist—dressed in a white waistcoat, a crisp high collar, and a velvet-lapeled jacket, with shining hair, a well-manicured goatee, and an upturned mustache—is well fed. Standing within close reach of iced champagne, wineglasses, and cigars, he contemplates his latest masterpiece—two ragged, starving children in a bleak field.

cold garret, and the image of the modern painter, living in an opulent studio fit for a Persian king. The prototypical princely studio had been created in Vienna two decades earlier by Hans Makart, whose taste for extravagant clutter had been formed during his study at the Munich Academy of Art. Munich had its own painter-princes in the first decades of the empire, particularly Franz von Defregger, whose historical scenes of Tyrolean peasants captivated Munich, critics and public alike, in the 1870s and 1880s; and Edward Grützner (1846–1925), whose popular paintings of beer-drinking monks were frequently reproduced in the illustrated newspapers and were also available in cheap copies for the average home.[65]

The artists in Munich who drew for *Fliegende Blätter* understood well the phenomenon these wealthy artists represented. In the summer of 1887 a full-page cartoon prominently placed on the last page of *Fliegende Blätter* presented a succinct vision of the painter-prince. The creator of the cartoon was Oberländer, the artist whose imaginative drawings were eagerly received both by the Munich art community, which he knew so well, and by the general readers of the magazine. Casting the fate of the artist in terms of a Greek comedy, Oberländer depicted the artist as the coryphaeus, the powerful leader of the chorus in Greek drama, whose stature, overblown by sycophantic adulation, has reached unrealistic heights (fig. 97). Around him dances a chorus of importuning stock figures, including a government official and a high court functionary. The other central characters in the drama are an art dealer on his knees, desperately clutching the leg of the artist, beseeching him to sign the contract that is tucked, suggestively, in his tailcoat, and a capitalist Jew obsequiously offering bags of money, each at least six figures, to the artist. The scene takes place in an ornate studio with a rich tapestried curtain, an oriental rug, and a large palm. On the salon-sized canvas is a swirling scrawl surmounted with the words "I strike." Outside, buildings display black banners of mourning, and, stunned by the artist's

decision to cease painting, the public anxiously crowds around the door, filling the square, awaiting the outcome of the bargaining that is going on around the master artist. Meanwhile, the knowledgeable critic, excluded from the action in the studio, hunches desolately in a corner, ignored by the public except for one puzzled little man. Ink has spilt over the pages of his criticism, printed in the papers at his feet, and the pen has fallen from his hand. In this new marketplace of art, with its elevation of celebrity, his judgments mean nothing.

Whatever occasioned this cartoon in 1887, Oberländer seriously misjudged the role of the critic in the emerging market-oriented art world. He did not, however, underestimate the prestige, power, and wealth of the small handful of painter-princes in Munich; he himself was to be painted by one of these men, Lenbach, in 1889. These painter-princes lived in palatial villas whose designs were closely integrated into their artistic style and consorted with high, often royal society. Acquiring the status of millionaires through the sale of their paintings, they enjoyed unprecedented publicity and popularity among the public that reached well

Fig. 97 **Adolf Oberländer, "The Strike of the Master,"** *Fliegende Blätter* 87, no. 2188 (1887): 21.

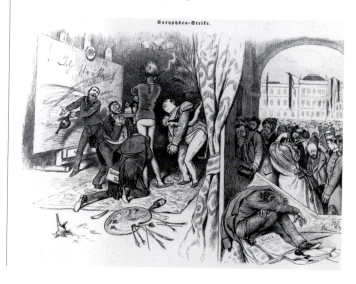

beyond the city limits. *Die Kunst für Alle* conveyed this fame to readers outside of Munich. Lead articles featuring these artists contained not only reproductions of their paintings but also photographs of their villas and studios. Kaulbach, the aristocratic director of the Munich Academy of Art from 1886 to 1891, for example, was featured in the leading articles in two successive issues in 1899. All of the plates and illustrations of both issues were by or about Kaulbach, including a reproduction of his portraits of royalty, among them one of William II, and a series of photographs of the richly decorated interior and facades of the palatial Villa Kaulbach.[66]

The diplomatic ability to cultivate connections with highly placed individuals and heads of state was an essential ingredient in the rise to social and artistic prominence of Lenbach, son of a master mason in a small town in the Tyrol. In the first two decades of the empire, Lenbach painted individual portraits of all three German emperors and their wives, the king and the prince regent of Bavaria, the queen of Spain, the prime minister of England, the pope, the leading imperial ministers, politicians, and generals, and the most prominent scientists, scholars, and composers. Above all, he painted countless portraits of Otto von Bismarck. His artistic services to the powerful were rewarded with personal ennoblement in 1882, with numerous royal honors and awards, and with friendship (fig. 98). Not only did Lenbach become a frequent visitor at Bismarck's estate in Friedrichsruh but he made arrangements, including underwriting a special train, to bring the former imperial chancellor to Munich for a two-day visit in June 1892 to stay in Lenbach's new Italianate villa. Local newspapers were filled with news of the palatial residence, with its electric lights in every room and its elegant quarters for eminent visitors. Despite local Bavarian suspicion of this Prussian who had orchestrated the unification of Germany, Bismarck was given a reception in Munich worthy of royalty that began with a torchlight parade through the streets of the city to the villa. The papers followed in detail the visit of the Prussian statesman with his painter-prince host as they attended civic festivities and a celebratory dinner in the artists' club, Allotria. Included was an official visit to the Sixth International in the Glass Palace, at which Lenbach had organized a special exhibition of works by Baroque and Renaissance masters from private collections.[67]

Within two years of this visit Lenbach again made headline news with two sensational trials in the mid-nineties in which the crowd of observers and reporters forced a change of venue and the need for entrance tickets. The cause of his notoriety this time was his penchant for producing scores of portraits to finance his lavish lifestyle. The trials involved charges that 217 portraits had been stolen from his studio and then sold along with 128 forged copies at knockdown prices to local art dealers, who, in turn, had sold both stolen and forged works to reputable collectors for substantial prices. Not only did newspapers in Munich, Berlin, and Paris cover the trials but the *Münchner Neueste Nachrichten* also provided accurate, largely verbatim reports of trial proceedings. Georg Fuchs, who reported for Berlin newspapers during the trial, later recounted that rumors about Lenbach's financial difficulties and speculation over his own role in the illicit sales appeared in the papers. After all, as Fuchs wrote,

The central figure in the whole scandalous affair was no one less than the world-famous master, . . . intimate friend of the house of Bismarck, related by marriage to the house of Moltke, connected through a thousand friendly and social ties to the princely houses, the high nobility, the industrial and financial aristocracy, to the celebrities of nearly the whole world: Europe had not experienced such an affair! All the newspapers were full of it. . . . The press in Paris was delirious, as if hallucinating over a collapse of the entire German culture, from a "Panama" in the art world that would have just as disastrous results for the international art market as the corruption scandals of the Panama [Canal] Company for the world stock market.[68]

A

C

B

Fig. 98 *A.* **Photograph of the interior of the Lenbach Villa, Munich. Städtische Galerie im Lenbachhaus, Munich.** *B.* **Franz von Lenbach (1836–1904),** *Portrait of Otto Prince Bismarck in Civilian Dress***, 1888. Oil on canvas, 54 5/8 x 40 in. (139 x 101.5 cm). Museum der Bildenden Künste Leipzig.** *C.* **Friedrich August von Kaulbach (1850–1920), "Lenbach as Painter of Bismarck," in** *Die Kunst für Alle* **9, no. 1 (Oct. 1893): 9.**

In celebration of Lenbach's sixtieth birthday, the lead article and all the plates and illustrations in the December 1896 issue of *Die Kunst für Alle* were reproductions of his portraits and photographs of his villa (*A*). Lenbach's first portrait of Bismarck was painted in 1879, followed by the many versions (*B*) that inspired this caricature (*C*) by Kaulbach, director of the Munich Academy of Art.

The trials did not have a shattering effect upon the art market, but they did expose the workings of that market in the life of a painter-prince in a manner not unlike that of Oberländer's cartoon (fig. 97). As in that scene, the central issue was economic, though anxiety in the cartoon over underproduction and scarcity was replaced in the trials by overproduction and the flooding of the market with inferior, underpriced works of art. In both the cartoon and the trials the public, in all of their diversity, avidly followed the proceedings. Mirroring the painter in the cartoon, Lenbach revealed an imperious anger over the forging of his signature and the sale of his reputed paintings far below the ten thousand to twelve thousand marks he normally charged for a large painting. Indeed, the trials revealed a troublesome willingness on the part of the art dealers to authenticate questionable paintings and to make excessive profits on works purchased for a pittance. After the announcement of the verdict acquitting the art dealers, Avenarius published a note in *Der Kunstwart* calling for the public to demand from the entire guild of art dealers that they provide an unambiguous declaration of what were acceptable and unacceptable practices for dealing in art. Although Lenbach was supported by other successful artists, including Defregger and Stuck, his reputation with the public—and perhaps with less successful artists—was tarnished after the defendants attacked his reliance upon photography for his portraiture and the carelessness of the work that had created his ostentatious wealth.

Notwithstanding these revelations, Lenbach's stature and power in the Munich art world increased substantially in these years. Through all of this, as Berlepsch stated in celebrating Lenbach's achievements on his sixtieth birthday, Lenbach persisted, despite the light-color trends of the 1890s, in painting conservative and popular portraits in his own version of a German Renaissance manner, with the focus on photographic realism in the features of the face, accompanied by sketchy treatment of hands and

clothes against dark backgrounds. With these portraits in their magnificent gilded frames gracing all of the major exhibitions in the late 1890s, including ones that he aggressively organized, his name dotted the journal reports and reviews. He continued to garner the medals and honors that carried with them elevation to the nobility from the monarchies in Bavaria, Belgium, Württemberg, Spain, Sicily, Sweden, Austria, Italy, Hungary, Russia. In 1901 he received the French Legion of Honor, and he received multiple medals in international exhibitions and membership in academies across Europe. By his death in 1904 Lenbach's fee to paint a portrait had skyrocketed to sixty thousand marks.[69]

From 1895 to 1900 Lenbach wielded power within the politics of the Munich art world that was due less to his artistic creativity than to his shrewd political sense, his network of contacts, and his indefatigable energy. Serving as the lifelong chair of the most influential artists' social club in Munich, Allotria (Skylarking), elected to the presidency of the Munich Artists' Association in 1896, heading the arrangements for the Seventh Munich International Exhibition in 1897, and raising funds for lavish reconstruction and redecoration of the Munich Artists' House kept Lenbach constantly in the public arena. His great public triumph—equal to the Bismarck visit—came, however, in his conception and organization in 1898 of the celebrated artists' festival "In Arcadia," in which high society was transported into a mythic Grecian world.[70]

Elaborately staged artists' festivals were not new. Organized as official functions under Ludwig I early in the century, artists' festivals became an integral component in the relationship between the citizens of Munich and its artists, as well as in the mythology of the city itself. Theatrical masked processions through the city streets and balls held during Carnival, the pre-Lenten period of the Catholic liturgical calendar, were supplemented by spring or May forays into the country, by festivities celebrating royal events or birthdays of revered artists, and by parties

held in the various social clubs of artists or by the art students from the academy. Festivals were also used to raise money for projects of the artists' societies. Although Munich could claim, as a writer in *Die Kunst für Alle* did, that it was the preeminent festival city, artists in other German cities also created fantastic festivals and processions. These festivities were particularly well organized in Dresden by the artists' society Mappe (Portfolio) and in Düsseldorf by the artist' association Malkasten (Paintbox), dating from 1848. In 1886 alone *Die Kunst für Alle* carried articles about a winter artists' festival in Munich; summer celebrations held by Düsseldorf's Malkasten and by Dresden's Mappe; festivals honoring artists, including one for Menzel in Berlin; and the great Greek procession and all-night festival around the temples at the Jubilee Exhibition of the Royal Academy of Arts in Berlin.[71]

At least five major festivals were arranged by the artists in Munich in the 1890s. Citizens were invited by students from the academy in 1891 to a fantasy-filled night "At the Bottom of the Sea" and in February 1893 to a ball held in the great hall of a brewery that featured a series of ambitious scenes based imaginatively on fairy tales and sagas. The hall was kept open for a second night to enable the public to see the elaborate scenery. Later that summer, a two-day festival celebrated, on the first day, the laying of the cornerstone of the Munich Artists' House, a clubhouse conceived in the lavish style of Makart's and Lenbach's studios; the dedication of a monument to Schwind; and a dinner for fifteen hundred guests to celebrate the twenty-fifth anniversary of the founding of the Munich Artists' Association. On the next day, a rose festival took place at the shore of Starnberger Lake, where thousands of participants and onlookers, including Prince Regent Luitpold and the royal entourage, arrived by train and carriage to watch scenes on water and processions on land that were filled with sea creatures and fairy-tale beings out of the paintings of Arnold Böcklin and Schwind. Romantic and popular, this fantasy

world, which echoed the drawings by Vogel for *Fliegende Blätter*, flourished among the philistine populace and was scorned by the elitist modern artists. On 5 February 1896 students at the academy celebrated Carnival with an otherworldly Festival of Hell in a popular beer hall.[72]

In Munich's Arcadian festival, in 1898, Lenbach deliberately turned away from the Germanic fairy-tale world, with its great popular and patriotic appeal. He chose instead to connect to the national fascination with the archaeological discoveries of the glories of Classical Greece and of the Hellenistic world. Using as his model a well-known painting by Leopold von Klenze, Lenbach re-created the Acropolis in Athens for the festival. In so doing, Lenbach reasserted Munich's claim to being the center of art and culture in Germany and, at the same time, aligned himself, and the Munich Artists' Association, which he headed, with conservative voices in the art world who upheld the Classical ideals of a universal transcendent conception of beauty. A firm believer in the ideals of art that had originated in fifth-century Athenian sculpture and architecture was the emperor, William II. His personal backing of archaeological expeditions to uncover and acquire artifacts from sites in Asia Minor contributed significantly to public awareness of ancient art in the 1890s, even as his speeches attacking modern art forms extolled the laws of beauty and harmony expressed in the "magnificent remnants of Classical antiquity." To re-create for a night one of the central icons of that antiquity, Lenbach enlisted the help of Adolf Furtwängler, Munich's eminent archaeologist who had established his reputation on the dig at Olympia in Greece and whose books on Greek and Roman sculpture were contributing in the 1890s to a growing interest in Classical art in the schools. In 1897, the year before Lenbach's festival, Munich newspapers drew attention to a conference held in Munich on the value of archaeological instruction in the schools to enhance the visual education of students in the classics.[73]

The preparations for the festival were thorough. With his energy and diplomatic skills, Lenbach brought together artists from the competing groups that constituted Munich's art world in 1898 to work together on this project. To ensure the historical authenticity of the festivities, artists advised by scholars prepared an extensive display of costumes and accessories, including appropriately dressed puppets, in the Artists' House, which was opened daily from 5:00 to 7:00 P.M. for weeks before the event to help guide celebrants in the correct apparel. The local department stores carried special stocks of necessary materials. Under scholarly direction from the archeologists Furtwängler and Heinrich Bulle and the architectural historian Joseph Bühlmann, the great stage of the twenty-six-hundred-seat National Theater was transformed into a terraced forum surrounded by temples, behind which rose the temples of the Acropolis (fig. 99). An outsized Pallas Athena, symbol of Munich's artists, presided over the scene from the heights of the Acropolis. The festival play, written by the artist Benno Becker, with music composed by Karl von Perfall, the *Kölnische Zeitung* critic, and staged by Ernst von Possart, the artistic director of the National Theater, brought the god Bacchus to life. Surrounded by dancing maidens and youths and greeted by bacchants, satyrs, nymphs, and fauns, Bacchus led the thousands of costumed guests, including the prince regent and his family, in a jubilant celebration. Following Orpheus and Eurydice, processions of singers trooped into the hall, accompanied by priests, philosophers, and peoples from all of the countries known to the Athenians: Egyptians, Assyrians with their golden calf, Phoenicians, black Africans, yellow Asians, and blond Hyperboreans.

According to all reports, the meticulous preparation and infectious revelry not only resulted in a tri-

Fig. 99 *A.* **Joseph Bühlmann, stage setting at the National Theater in Munich for "In Arcadia," the artists' festival, 1898. Original photograph by Karl Hahn, Munich.** *B.* **Friedrich August von Kaulbach, souvenir sheet for "In Arcadia." Both reproduced in *Kunst und Handwerk* 47, no. 8 (1898): n.p.**
Bühlmann's stage design was based on the great painting by Leopold von Klenze of the Acropolis of Athens (1846).

The photograph of the scene created on the stage shows Franz von Lenbach's orchestration of the grouping of figures (*A*). Leading members of the artists' social club Allotria—including Franz Stuck, Adolf Oberlander, Adolf Hengeler, and Kaulbach—designed postcards and graphic sheets as souvenirs of the festival (*B*). These drawings, along with photographs of the festivities, were also reproduced in *Die Kunst für Alle* 13, no. 13 (Apr. 1898).

A

B

umph for Lenbach but aroused an "aesthetic joy" on the part of the participants. And, indeed, the reporter for *Die Kunst für Alle* declared that for many participants the evening had revealed the captivating splendor of Classical antiquity. Far from being outmoded, he claimed, the Classical world revealed itself to be fully in harmony with contemporary life. After describing the exultant event, the commentator concluded that the richness of its aesthetic stimulation would serve to raise the taste of the public and would call forth new creativity in artists.[74]

The triumphant evening in Arcadia, however, masked only briefly the fundamentally conservative character of Lenbach's position. Six months earlier, in *Der Kunstwart*, Schultze-Naumburg had lambasted the conception and installation of the 1897 Munich International by Lenbach, "the sworn enemy of everything modern." Skeptically viewing Lenbach's creation of ostentatious neo-Renaissance settings for the exhibition rooms, particularly the retrospective rooms featuring his own portrait paintings, and critical of his call for a return to the norms of the Old Masters, Schultze-Naumburg flatly rejected his work as outdated and unauthentic: "Lenbach's theories are that of a Winkelmann *redivivus*, who believes in absolute beauty—a tenet that all our new aestheticians have long since rejected on the basis of empiricism." Conceding that the artist-prince's influence with the public would be sufficient to set back their slowly developing appreciation for modern art, Schultze-Naumburg nevertheless was certain that he could not succeed in turning back the victories already attained by the modern artists. This new art, he claimed, was not showy splendor created for princes but simple and unpretentious, suited to the needs of ordinary people. Certainly, the Arcadian festival, which incorporated a romantic love of Greece worthy of Winkelmann, was not populated by ordinary members of the public, despite the more than two thousand persons who attended it. Even ordinary artists were unlikely to be able to afford the cost of costumes and the substantial entry price.[75]

The great success of the festival, although firmly credited to the work of Lenbach, served to enhance the reputation of Stuck, whose rapid rise to the ranks of painter-prince in the 1890s also challenged Lenbach's preeminence and power. Stuck, who attended the festival as the Roman god Zeus with his wife as Hera, had already established himself as one of the leading painters of Munich's neoclassical modernism (fig. 100). His integration of motifs from Greek antiquity into striking, often erotic modern images was actually far more in tune with the satyrs, fauns, and centaurs of the festival than were Lenbach's own neo-Renaissance portraits. *Die Kunst für Alle* implicitly acknowledged this with its publication of a plate of Stuck's *Centaur and Nymph* (1895) to accompany its article on the festival.

Born into the family of a Catholic farmer and miller in lower Bavaria, Stuck acquired his first of many gold medals and prizes with his *Guardian of Paradise* (plate 5) in 1889 at the age of twenty-six. Six years later he was appointed a professor at the Munich Academy of Art, a position that Lenbach never achieved. His appointment brought fresh life into the painting studios; students, including Wassily Kandinsky and Paul Klee, flocked to study with him. In 1893 Otto Julius Bierbaum (1865–1910), a controversial critic among the supporters of modernism in Munich who was a founder of the Modern Life Society and, later, one of the first co-editors of the journal *Pan*, published a book on the thirty-year-old Stuck with one hundred reproductions of his art. In a review of the book, the editor of the *Zeitschrift für bildende Kunst* characterized Stuck as far more than a pathbreaker for modern art: "He is its trumpeter, its poster designer, its grotesque acrobat, and at the same time one of its most wondrous poets—all in one person." Creating powerful, playful, and sensual images, Stuck was compared to Böcklin in his creation of fantastic beings from Classical mythology that were simultaneously perceived to be utterly modern, free spirits. Not only was his poster of Pallas Athena the recognized symbol of the modern

movement in the visual arts but his best-known paintings repeatedly appeared in cartoons and advertisements (fig. 101).[76]

Stuck's sensuous painting *The Sin* (fig. 66A) captured the imagination of writers. Shortly after its disruptive appearance in the Munich Secession exhibition in the summer of 1893, a fable was dedicated to it in *Die Kunst unserer Zeit*. Reflecting curiously the almost symbiotic relationship between Lenbach and Stuck, the journal had published in February of that year a full plate of Lenbach's painting *The Serpent Game*, accompanied by an enigmatic story about an artist whose life was destroyed by creating a sensual painting of a nude with a huge snake wrapped around her—the subject of Lenbach's work as well as Stuck's. Anton von Perfall, a popular novelist of the period, published a novel titled *Sin*, directly inspired by Stuck's painting,

Fig. 100 **Franz Stuck, *Franz and Mary Stuck*, 1900. Oil on wood, 19 1/4 x 19 1/2 in. (49 x 49.5 cm). Städtische Galerie im Lenbachhaus, Munich.**

which was reproduced in a full plate in the book. The review in *Die Kunst für Alle* claimed that the novel gave an exceptionally good depiction of an artist's life and creativity. Stuck's painting was utilized in advertisements for the novel, which appeared regularly in the journals. Stuck's notoriety was further enhanced by police action banning the display in a show window of a photographic reproduction of his *Kiss of the Sphinx* (fig. 123A), an action that, combined with the sensuality of *The Sin*, may also have influenced Thomas Mann's well-known story *Gladius Dei*.[77]

By the time of the Arcadian festival in 1898 Stuck had fully established himself on the public scene as Munich's latest painter-prince with the completion of his neoclassical villa at the edge of a park along the Isar. He designed the villa to evoke, on the exterior, Böcklin's painting *Villa on the Sea* and, on the interior, rooms from antiquity. The importance of the artist's studio in validating him as Munich's new painter-prince was demonstrated in *Die Kunst für Alle*, which devoted its lead article in July 1899, with photographs, to a discussion of the Villa Stuck as a complete work of art that fully expressed the aesthetic ideals of its creator (fig. 102). In a further sign of Stuck's exceptional accomplishment at a young age, *Die Kunst unserer Zeit* dedicated a lead article to Stuck's work by the art historian Franz Hermann Meissner, an article that became the basis of the third volume in Meissner's series The Artist Book. Popular and widely distributed, this series, subtitled "A Small Selected Series of Artist Monographs," had featured Böcklin and Max Klinger in the first two volumes and later included volumes on Hans Thoma and Uhde. *Die Kunst für Alle* also honored Stuck with lead articles in two consecutive issues, an honor that had been granted previously to only four other painters. Written by Fritz von Ostini, the articles were accompanied by fifty-seven plates and illustrations of Stuck's best-known paintings, drawings, and sculptures, images that occupied a substantial portion of the annual volume. Ennobled in 1906 and given a torchlight

procession by Munich artists and friends for his fiftieth birthday, Stuck taught at the academy until his death in 1928. While he remained an honored painter-prince in Munich, his stature in the modern German art world did not survive the onslaught of the avant-garde in the first decade of the new century.[78]

PAINTER-PRINCES IN BERLIN: OFFICIAL VERSUS MODERN ART

Although the rapidly changing styles that marked the new modern art in the decades before World War I meant the demise of the painter-prince phenomenon,

Fig. 101 *A.* **A. Reinheimer, "Poster (after a Famous Example)," *Fliegende Blätter* 114, no. 2897 (1901): 64.** *B.* **Franz Stuck, *Fighting Fauns*, 1889. Oil on canvas, 33 7/8 x 58 1/2 in. (86.2 x 148.5 cm), Bayerische Staatsgemäldesammlungen, Neue Pinakothek Munich.** The cartoonist wittily caricatured Stuck's painting of fighting fauns (*B*) by combining it with a well-known slogan for cream sold by the Court Barber Haby, which enabled men to cultivate the mustache style worn by Emperor William II. In this case (*A*), the slogan—"It is achieved!"—is applied to the "Uncrushable Top Hat."

A

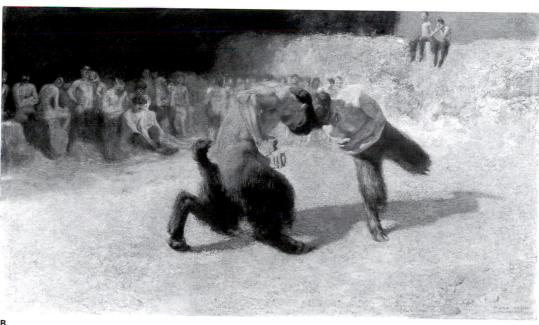

B

Fig. 102 **Villa Stuck, Munich, completed 1898. Reproduced in *Die Kunst für Alle* 14, no. 19 (July 1899): 289.**

with its nineteenth-century trappings of wealth, elegant studios, and prominent villas, a handful of artists in the 1890s could be counted as painter-princes, particularly Klinger, with his large, functional, and isolated studio in Leipzig, and Werner and Liebermann in Berlin. Though virtually the same age, Werner and Liebermann represented a similar pattern to that of Lenbach and Stuck. With his close connections to the court and the cultural bureaucracies in Berlin and his multiple positions within the Berlin art world—among others posts, he was director of the Institute of Fine Arts, head of both the Society of Berlin Artists and the General German Art Association, and a member of the Prussian Art Commission—Werner by the 1890s wielded more power than Franz von Lenbach in Munich, and his reputation was more notorious. Both men were satirized in the cartoons of the era for their repetitive paintings, Lenbach being known for his multiple portraits of Bismarck and Werner for his meticulous portraits of endless numbers of officials wearing high military boots (fig. 103).

Berlin, however, was not Munich. Berlin, whose population had mushroomed from well under 1 mil-

lion in 1871 to more than 2.7 million inhabitants by 1900, was a major industrial city, the political center of an increasingly powerful empire, and the locus of significant scientific and scholarly research. With a drastic disparity in privilege, comfort, and class between districts, Berlin's population was not only far larger than Munich but also more diversified, with a higher percentage of industrial workers, military personnel, office clerks, and government bureaucrats. Functioning in the space bounded by a flourishing commercial urban entertainment world, a wealthy new class of entrepreneurs and industrialists, an unwieldy working class, and an influx of immigrants from the rural areas and from the East, the art world was both less central to the city's life and, given the aesthetic strictures of William II's court, more controversial than in Munich.[79] As a result, despite his prominence within the Berlin art world and his court role as cultural confidant of the emperor (fig. 104), Werner could not attain the public eminence of a painter-prince that was possible in the much smaller Munich, which had not yet moved into the secularized, industrialized world.

Werner did not have the public flamboyance of Lenbach or Stuck; rather, his prominence derived from his disciplined loyalty to the crown and the nation and his concern for the mass of artists. His version of the painter-prince was as a skillful Prussian administrator and a bureaucratic negotiator with solidly bourgeois ideals and behavior.[80] Yet, his skill notwithstanding, as the years of his administration mounted up, criticism of his stance within the art world became more overt and angry. The opposition to Werner was given a strident public voice in the pages of a new journal designed for artists, *Das Atelier* (The studio). Some accused the editor, Hans Rosenhagen, of carrying out a public vendetta against Werner, but Rosenhagen claimed to be representing current attitudes among artists in Berlin.

The most prominent voice raised against Werner's policies was that of Bode, director of the painting collections of the Berlin museums. Bode, who

had been publicly critical of the role of the art academies in producing too many weak artists, in 1896 again insisted on the need for reform. To prepare students to better cope with economic realities, he called for more stringent and elitist instruction in the academies for outstanding students and for funneling the less able students into crafts and industrial arts schools. Published in *Pan*, a new journal in Berlin whose subscribers included many influential officials, the article was read as an attack upon Werner's more egalitarian policies. No less aggressive than Bode, Werner responded with a counterattack on Bode's scholarship. In the ensuing months this animosity between two powerful figures in Berlin's art world spilled into the newspapers and journals.[81]

Analyzing the controversy in *Der Kunstwart*, Paul Schumann pointed out that the central issue was Werner's resistance to any form of modern art. Determined to keep the "poison of modern progress" away from the Royal Academic Institute for the Fine Arts, Werner valiantly, said Schumann, upheld ideal art and the Old Masters, while he mocked the "specialties and silly tricks" of the open-air paintings. Again that year, Werner devoted his annual talk to students at the institute to attacking modern art by comparing it negatively with the great artists of the past. Reporting on this talk, the *Tägliche Rundschau* (Daily review) rather laconically concluded that it was unlikely that his talk had much effect on the students. Despite this controversy, Werner's colleagues in Berlin demonstrated their respect for his diplomatic and bureaucratic expertise by electing him chair of the fine arts section of the Royal Academy of Arts.[82]

If Werner was Berlin's painter-prince by virtue of his official positions within the Prussian cultural bureaucracy, Liebermann was the painter-prince of the opposition, his prestige lying in his determined pursuit of new modes of painting. Born a Berliner, Liebermann acquired an enviable reputation for his paintings in Paris, and his triumphant showings in Berlin in 1886 and Munich in 1888 established his reputation as the acknowledged pathbreaker of the new German art and the leading master of contemporary modern art in Germany. Awards and gold medals followed: Paris in 1889, Munich in 1891, Venice in 1895, the French Legion of Honor in 1896, and finally, after repeated shabby treatment in the Berlin exhibitions, his own special retrospective exhibition and the great gold medal at the Great Berlin Art Exhibition of 1897. With Werner's

Fig. 103 **Monogrammist [Arpad Schmidhammer], "Anton the Painter of Boots as Champion of the Temple of Pure Art,"** *Jugend* **2, no. 37 (Sept. 1897): 627.**
Posed in front of a decrepit National Gallery, which is surmounted by a German military helmet and has cracks plastered over with official orders and state contracts, Anton von Werner holds up a banner inscribed with his ideas—"Only the strength of genius penetrates the soul"—and flourishes his great painting of military boots. A bootlicking critic from *Vossische Zeitung* polishes Werner's boots with the aid of "Imperial ink," while an art student kisses his cloak.

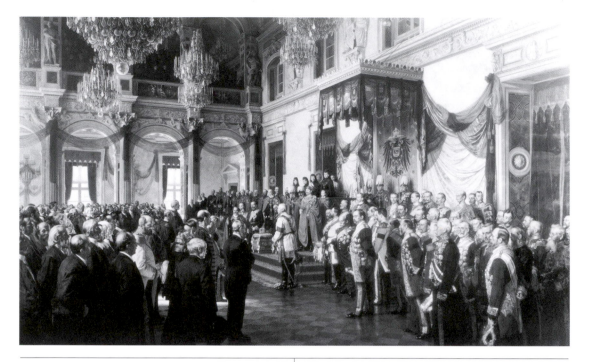

Fig. 104 **Anton von Werner, *The Opening of the Reichstag in the White Hall of the Berlin Palace by His Majesty Emperor William II on 25 June 1888*, 1893. Oil on canvas, 12 ft. 8 3/8 in. x 21 ft. 3/4 in. (3.9 x 6.4 m). Staatliche Schlösser und Gärten, Potsdam-Sanssouci.**
Reproduced in *Moderne Kunst* 10 (1896), in a black-and-white plate that was a triple foldout, the wood-engraving reproduction, executed by A. v. Baudouin, was large enough that all of the figures in the foreground and many in the background were recognizable as portraits of prominent politicians and courtiers. A text accompanying the reproduction identified all the major personages.

support, Liebermann was named a professor at the Royal Academy of Arts in Berlin, and he was elected to its membership the following year.[83]

These victories were celebrated in the journals not merely as his personal ones but also as triumphs for the modern movement in Germany. His paintings were selling, both to private patrons and to museums, with the prices rising substantially during the 1890s. Two paintings, *Free Time at the Amsterdam Orphanage* (1882) and *Shoemakers Workshop* (1881), which had been purchased by a French collector in 1882 for five thousand marks, were sold to museums through the Cassirer Gallery in 1900, the first for thirty thousand marks to the Städel Institute in Frankfurt, the second for twenty-four thousand marks to the National Gallery in Berlin. By the turn of the century his portraits were fashionable, despite widespread controversy in the early 1890s over his severely honest portrayal of the patrician mayor of Hamburg. By 1899 Liebermann had also acquired the necessary settings of the painter-prince: a celebrated studio built on the roof of the family house on Pariser Platz, overlooking the Brandenburg Gate; a studio that simultaneously expressed his spare modern style and his disciplined bourgeois life (fig. 105); and, a decade later, a garden villa on the shores of a lake.[84]

Liebermann's acknowledged achievements as the trailblazer of modern movements in Germany and his continued eminence in the art world were easily gauged by the frequency with which his work was discussed in the journals. From the hostile denunciations of his paintings in the early years to the critical acclamation and honors of the late 1890s,

Fig. 105 **Max Liebermann, *In the Studio*, 1902. Oil on canvas, 26 3/4 x 31 7/8 in. (68 x 81 cm). Kunstmuseum St. Gallen, St. Gallen, Switzerland. Reproduced in *Die Kunst für Alle* 19, no. 7 (Jan. 1904): 159.**

Unlike the photographs of the studios of Franz von Lenbach and Hans Makart, which were showplaces filled with objects of art but devoid of human life or of any indication of the artist's creativity, Liebermann's painting presents a spacious room that is integrated into his life and work. Unostentatious, quietly ordered, the studio is flooded with light from high windows that accents the artist's working tools in the foreground. Again unlike Stuck, who painted himself as a commanding presence working at his easel, Liebermann chose to present himself as a distant image in a mirror, while his wife and daughter occupy a more visible position. Hanging on the walls along with his own paintings are paintings from his collection, including a large Manet over the archway.

his paintings provoked lively discussion, and his reputation as being constantly in the vanguard of progressive art was solidly established. Even the conservative *Moderne Kunst*, despite its subservience to William II's taste, had only words of praise for Liebermann's work in his retrospective at the Great Berlin Art Exhibition in 1897: "His realism breathes such a poetry, his industrious people are so genuine and true, the mood of his creations is so deep and enduring, the strength of his coloring so stunning, that his fame appears to be well founded."[85]

As Rosenhagen pointed out in *Die Kunst für Alle* in 1904, no name was more frequently mentioned in the struggle over the new art in Germany than Liebermann's. Rosenhagen then thoughtfully analyzed Liebermann's development, speaking of the

Fig. 106 **"Battle of the Giants (Pergamum in Berlin),"** *Lustige Blätter* **17, no. 4 (1902): 8–9. The caption, in the form of a poem, reads: "Thus began the mighty battle of the defiant giants / Against the Thunderer himself and his holy followers. / Breathless in amazement the world watched. Only Zeus, the leader, / Already knew exactly the outcome and judgment of posterity."**

constancy of his observation and his steady concentration on reducing his paintings to the most essential elements of movement and light. Refusing to dwell upon appearances, he wrote, Liebermann sought to capture impressions. "He became an impressionist," wrote Rosenhagen, not in the sense of following a movement, but in the sense of following his own logical development. It was erroneous, Rosenhagen insisted, to think that Liebermann's impressionism was indebted to Manet, even if the artist himself claimed to have learned much from Manet's work. Liebermann, he concluded, was valued abroad for his strong individuality and in Germany for maintaining the best German tradition.[86]

This spirited defense of Liebermann by a younger critic addressed a recurrent charge that kept Liebermann, after more than two decades at the forefront of German art, from receiving the public adulation granted to the Munich painter-princes. A decade earlier, in 1887, Emil Heilbut, his first significant critic and most vehement supporter, had raised the issue: "I find foreign influences, Jewish, Slavic, French traces. As a Jew, he must be more open to stimulation from abroad." In his drawing of 1890, Vogel had viciously elevated this charge into the accusation that Liebermann, by his Jewish heritage and by his modernist art based on foreign sources, was destroying authentic German art. Nevertheless, in a meditative article ten years later, Heilbut declared that Liebermann had attained the highest status and influence in the German art world. More than a painter, Liebermann now was recognized as a cultural phenomenon, the bearer of the new art. This was demonstrated by the current competition between German museum directors to obtain a major Liebermann painting for their collections. Among these directors, "Liebermann has become fashionable," wrote Heilbut; however, "he is still not at all popular with the public." While the directors admire his work, the public respond, "We don't like it." Lenbach, with his staid, brown-toned neo-Renaissance portraits; Stuck, with his brilliant-colored, imaginative evocations of a neoclassical Greek world; and Werner, with his fastidiously accurate contemporary paintings, could achieve a level of public and official acclamation that in Liebermann's case was often grudging and tainted.[87]

In the last decade of the century artists young and old faced an art world in which all of what had appeared to be certain truths and conditions were in flux. As exhibitions attracted ever larger numbers and more diverse crowds, more young artists entered into the competition for a place in those exhibitions. As the art world expanded into the big business of great exhibitions, economic insecurity, always

present for artists, seemed to become more acute. Not only were more men competing but women were invading the marketplace of art. Success seemed to be both more extravagant and more elusive—the artist was either a prince or a pauper. The road to success for artists appeared to be far less clear as critics argued over what constituted art, or German art, or art for the modern age. That the art world was growing and changing was an accepted truth, but that growth and change were open to all kinds of interpretation.

The *Lustige Blätter* seized upon the opening in 1902 of the Pergamum Museum, with its great frieze, to envision the world of art as the site of a battle for supremacy between giants and the gods (fig. 106). Werner is portrayed as the embattled defender, on his knees before the onslaught of a sea-giant Böcklin and a Classical Stuck with his serpent; Thoma grapples with a faceless Hermann Knackfuss (who turned William II's sketches into works of art); the Berlin bear and the Bavarian lion are deep in the fray; and Liebermann rather ineffectively fires a broken arrow from the sidelines. These were struggling giants at the end of the century. Their identity had by no means been clear at the beginning of the 1890s, a decade in which the succession of styles was matched by the proliferation of new groups of like-minded artists breaking away from the old art associations in search of new markets, new audiences, and new publics.

MODERN ART FOR AN ELITE PUBLIC

Addressing his readers in October 1894, at the beginning of *Die Kunst für Alle*'s tenth year of publication, Friedrich Pecht contemplated "the total revolution" that had taken place in the art world in Germany during that decade. Clinging to the journal's founding guideline "that art must be for the whole nation and not just for the rich lovers of art," Pecht ruefully acknowledged the uncertainty that characterized the contemporary art scene, where "stormy youth" and "sharp individuality" created constant change.[1] Since Pecht was unable to embrace the revolution that he recognized, his conservatism replicated in the journal itself the larger rift in the art world between those who sided with the new and those who opposed it. The pages of his own journal in the mid-nineties were dominated by a new generation of critics—some born half a century after Pecht—who had no hesitations about the new art. For these young critics Max Liebermann, Fritz von Uhde, and Max Klinger were no longer new, but simply the established artists. They welcomed the distinctive presence in Munich exhibitions of the newer Symbolist and neo-idealist paintings from England (Edward Burne-Jones, Walter Crane), Belgium (Félicien Rops), and France (Gustave Moreau, Pierre Puvis de Chavannes). This acceptance did not, of course, mean that older forms disappeared from the exhibitions or were no longer created by diligent and competent artists. In the journals, new paintings shared space with serious historical and pleasant genre scenes.

Older critics wrestled with the problems that these changes posed. Some admitted their own bewilderment as the new art they had championed became established and then, apparently, was superseded. The forty-year-old Jaro Springer ex-claimed, "Am I old? Is my friend Relling old?" Reacting negatively in 1896 to the neo-idealist art that was, in his opinion, a backward step from the fresh naturalism and light-filled painting of Liebermann and Uhde, for whom he had fought, Springer protested that he was being shoved aside by the young artists and scorned as reactionary.[2] Springer's plight was symbolic of the art scene in the 1890s, when the revolution in the art world that had resulted in the triumph of the new art of light-filled paintings was complicated by the emergence of new artistic styles and new artists' groups. This fragmentation of the art world intensified and multiplied the divisions that separated modern artists and the schaupöbel. At the same time, the avenues through which the public could learn about the new art significantly expanded, just as the number of artists and works of art escalated. Great exhibitions proliferated in the cities; art societies stepped up their activities for growing memberships; new art dealers opened galleries in the major cities, from the Rhineland to East Prussia; and a new style of cultural journal was created with a modern visual aesthetic for elite audiences. Through all of this wound a leitmotif of transience, producing excitement, energy, and despair.

THE NIGHTMARE OF TRANSIENT ARTISTIC STYLES

If poverty and overproduction troubled the artists' daily lives, their nightmares were haunted by the multiplicity and transience of contemporary artistic fashions. This, at least, was the fate of artists presented to the public through the pages of humor magazines in the decade of the nineties. The

cartoons captured the essence of modern contemporaneity: if art must be true to its time, an art that faithfully represented a world in a continuous process of dynamic transformation would by definition be caught in constant transience. This phenomenon of change to fit the times, reinforced by the desirability of sensationalism to attract attention in a market economy and by the popularizing of ideas of progress and evolution, produced a dogma of the necessity of evolving artistic styles. Modern art was a process of continuous striving, of becoming. The artist who failed to understand this would be left behind. Liebermann expressed this succinctly: "Art is a continual coming into being; a continual coming into being and fading. Petrified into dogma, art would die." The corollary to this "continuous reevaluation of art," Liebermann recognized, was that "what is laughed at today, tomorrow will be gazed at with wonder and admiration."[3]

Thus, the fundamental tenet of contemporaneity was itself transposed into a different key. Whereas in the 1870s and 1880s the principle "art must be of its time" defined efforts to represent contemporary social and visual reality, in the 1890s the necessity of contemporaneity shifted to the form of presentation. Repeated like a mantra, "art must be of its time" was assimilated to an evolutionary progression of styles. The manifestations of that belief were implicit in the reviews published in the journals in this decade, but the cartoons in the humor magazines were far more blatant than the critics. They drew the logical, visual conclusions.

Hermann Schlittgen, whose work hung in the first exhibition of light-color painting at the Gurlitt Art Salon in 1888, captured the artist's nightmare in a full-page drawing for *Fliegende Blätter* in September 1894, in the immediate aftermath of the pamphlet war begun by Eugen von Franquet in Berlin and Dresden. In the drawing an artist writhes in his sleep as his studio is invaded by five women, each of whom represents a current style of art (fig. 107). The women vie for dominance, each flaunting the

weapon appropriate to her artistic domain. In the central position, standing astride the artist in his bed, is "Naturalism," Liebermann and Uhde's Dutch woman in clogs and white linen cap, drawn with crude, heavy pencil strokes. Looking both powerful and anxious, she brandishes a crude wooden stick against a "Mystic" angel, who, with her slender, feminine body in a filmy gown, glorious wings, and flaming sword, is an innocent version of Franz Stuck's famous *Guardian of Paradise* (plate 5). Rising above the bed, a medusa-like woman with snakes wreathing her head, the coils of her long black hair wrapped around her naked body—a hideous combination of Stuck's temptress *Sin* and his *Medusa*—spouts the imprecations of "Symbolism" as she gesticulates with grotesquely elongated fingers toward

Fig. 107 **Hermann Schlittgen, "Dream of a Painter after Visiting the Art Exhibition,"** *Fliegende Blätter* **101, no. 2563 (1894): 92.**

Fig. 108 **Hermann Schlittgen, "Metamorphosis, or The Genesis of a Modern Painting,"** *Fliegende Blätter* **103, no. 2608 (1895): 30.**

The story is told by Painter Pastosinsky in answer to Painter Daubler's inquiry why Schwachmaier had taken five years to paint a simple female portrait. Pastosinsky replies that the answer is very simple, and he outlines the artist's successive efforts to present a painting in the currently fashionable style.

Metamorphose, oder: Entstehung eines modernen Bildes.

Maler Kleckjel: „Wie ist es nur möglich, daß Schwachmaier zu seiner einfachen weiblichen Figur fünf Jahre gebraucht hat?"

Maler Pastosinsky: „Die Sache ist sehr einfach! Angefangen hat er das Bild unter dem Einfluß des französischen Naturalismus. Er brachte es zur Aus-

mußte ein Jahr lang arbeiten, bis das Bild in's Italienische übersetzt war. Aber er hatte wieder fürchterliches Pech, denn

stellung nicht fertig — da wurde die holländische Richtung Mode. Er übermalte seine Figur dementsprechend. Nun kamen die Italiener und machten Furore. Er

Metamorphose ꝛc.

das nächste Jahr machten die Schotten ganz kolossales Aufsehen, und nun begann sofort das Uebermalen in schottischer Manier.

Aber wie es das Unglück will, die Schotten konnten sich kaum ein Jahr halten — da erschien im Siegeszuge der Präraphaëlismus. Schwachmaier, schon dem Wahnsinn nahe, rafft sich noch einmal auf, nimmt alle Kraft zusammen und malt, da er das Riesenglück hat, daß diese Richtung ein ganzes Jahr Mode bleibt, das Bild neuidealistisch um. Er bringt es diesmal rechtzeitig zur Ausstellung fertig, wo es einen fabelhaften Erfolg erzielt, und ist er bereits auch von der Jury zur großen Medaille vorgeschlagen worden!"

H. Schl.

31

"Impressionism." A buxom woman in a flouncy dress, "Impressionism" is portrayed as a mass of tiny dots, perceived by German critics since the late 1880s as the significant characteristic of the most modern French artists. She is vigorously pulling the long, curling locks of "Idealism," a willowy woman in a flowing gown with flowers around her shoulders and crowning her head, a figure whose overwhelming hair looped in miraculous ways through the drawings of the Dutch-Malaysian Jan Toorop, particularly *The Three Brides*, shown in the 1893 exhibition of the Munich Artists' Association in the Glass Palace.[4]

These were the competing styles confronting the artist in 1894 as viewed by a modern artist in Munich. Powerful influences came from Belgium and France, while at home Liebermann and Stuck were equally compelling models. From the vantage point of the public, the five figures became the icons epitomizing the conflicting and, for many, absurd movements of modern art. For those many, the only sane figure in the drawing was a pretty maiden holding a rose and wearing an elegant Renaissance costume. Puzzled by the fracas, this maiden, called "Kitsch," is relegated to the background.

The drawing by Schlittgen concentrated on the battle of current artistic styles. A year later he produced a commentary on the art scene in which he stressed the transience of contemporary styles (fig. 108). In this story, told in five panels, the artist tries to catch up with current art so that he can impress the exhibition jury. Beginning with a bucolic scene of a woman herding pigs in the style of French naturalism, he was unable to finish it before the Dutch movement became all the rage. Naturally, he had to overpaint the work, but before he had completed it, the Dutch gave way to a vogue for Italian painting. Again he transformed the portrait, only to discover that the Scottish had swept the Italians away. Furiously he repainted in that style, which in less than a year was superseded by Pre-Raphaelitism. Finally, almost mad, the painter gathered his strength and changed the portrait once more. This time, he was

lucky. The movement lasted for a whole year, enabling him to submit a neo-idealist painting to the exhibition, where his five-year ordeal was rewarded with the great gold medal.

A more detailed satirical set of images demonstrating the temporary nature of contemporary styles appeared in the journal *Jugend* in 1896, its first year of publication. Eight self-portraits, one in each of the eight artistic modes popular in Munich since 1875, ostensibly had been created by the painter "Modeslaw Manierewicz" (fig. 109). Described in the clichés that had accompanied each style, the portraits traced Manierewicz's evolution from the "good old style" of 1875 through the brown "hollandaise sauce" (1880), to the chalk and spinach green of "pleinair" (1885), on through the seven spectral colors of "impressionistic" (1888) to the portraits "à la Lenbach" (1890), the sensitive naiveté of "symbolistic" (1892), and the prismatic vibrancy of "pointillistic" (1894), ending with *Jugend*'s graphic presentation of humanity at the end of the century.

Clever and amusing, these cartoons transmitted to the public better than any written review or critical treatise the confusing choices facing artists as they strove to gain admission to exhibitions or galleries. Paradoxically, the tremendous pressure on artists to achieve the recognition necessary to raise them above the mass required that they simultaneously conform to the newest mode and yet distinguish themselves from it. To be contemporary and new had become trump. To be so continuously was the challenge. Recognition of this lay behind an illustrated story published in *Fliegende Blätter* in 1898.[5] Written as a broadside attack upon the impermanence of modern styles, it summed up the plight of the artist in a time of rapid change. By 1898 the story about an artist of the "old school" who struggles to adapt to the new, "progressive" school and is foiled when the style suddenly changes was neither new nor profound. Still, the narrative contained witty details connecting it to the Munich art scene and suggested the tension between artistic integrity and

Fig. 109 **"The Self-Portraits of Painter Modeslaw Manierewicz,"** *Jugend* 1, no. 43 (Oct. 1896): 694–95.

Each painting is accompanied by a caption describing its style in fulsome phrases that supply readers with the language needed to demonstrate their sophisticated knowledge of art the next time they visit exhibitions and galleries. Beginning with the four paintings on the left, the captions read (clockwise from top left): (1) "M. Manierewicz has, as can be seen in these eight portraits, gone along with all of the acceptable painting methods since 1875 in Munich. First we see his self-portrait from the year 1875 (good old school). Motto: 'I too was a youth with curly hair!'"; (2) "Here is his portrait highlighted in the Munich manner (1880). Hollandaise sauce. Cozy studio mood. Brown in brown. Masterful handling of still lifes. Unmistakable influence of Defregger"; (3) "1885: Pleinair: in chalk and spinach. All brown anxiously avoided. 'Slogan: Less beautiful than true; exact, as if it were made by a camera.' (See the right hand!) The artist's simple love of nature manifests itself already in the frame, which is fashioned out of a plain box lid"; 4. "1888: Impressionistic: arrangement in the seven spectral colors. One receives exactly the impression that the portrait makes if one looks first directly at the sun at sunset for five minutes, then at the model, and then at a white wall. Baroque frame in greenish gold on strawberry-colored plush"; (on the right page, clockwise from top left) (5) "1890: à la Lenbach. Created under the influence of Lenbach's collective exhibition at the Glass Palace. The best, three-hundred-year-old gallery tones. Soulful painting. One should note the expression of the eyes! The newest, antiqued frame"; (6) "1892: Symbolistic. Aniline-chromatic process. Naive, intimate, tender, and richly sensitive. The seriousness and depth of the artist manifests itself in the monogram"; (7) "1894: Pointillistic! Vibristic. Prismatic colors with virtuosic utilization of complementary oppositions. Should be viewed from a considerable distance with half-closed eyes through a cupped hand"; (8) "1896: As title page of *Jugend*. Self-portrait of the artist next to a depiction of the whole of human life and several adjacent items. Graphic art of amazing psychological depth from the end of the century." A note at the end of the captions states that these painting were made available to *Jugend* by A. F. Seligmann, Vienna.

critical acclaim. Moreover, whereas many cartoons and anecdotes suggested that painting in modern styles could be achieved by effortless and accidental means, this story underscored the fundamental shift in perception and conception that was necessary. The final defeat of the perplexed artist, who transformed his work from nice, pretty pictures to wildly crazy ones, came about when the "leader of the moderns" decided that "insanity was no longer trump." Realizing that he could not return to his pretty pictures, the painter hung himself. The narrator ended with the deadpan comment that successful artists were those who understood and easily adapted to the inevitable stylistic changes.

This cautionary tale, related in cheery tones and simple drawings, can only have served to reinforce the public attitude toward art cited by a Munich critic in 1896: "The philistine does not love the new." Disturbed by the multiplying forms of new art in the 1890s, the public's confusion and behavior had earned them the patronizing designation schaupöbel and derogatory treatment by critics who supported the new styles. As the gap between the successive new art movements and the public widened, Karl von Perfall offered a sober analysis of the rapidly changing styles. He believed that younger artists appropriated new, revolutionary styles in order to reject the older generation but also because they were afraid to create work that would mark them as old-fashioned or philistine. Significantly, Perfall raised nationalist considerations, charging that these young modern artists acted as heroic universalists: they "no longer lived in the era of national restraints," yet they lacked the courage to be themselves. "For one must be modern, because one is young, and modern is just simply that which is not German—today the French, tomorrow the Norwegians, day after tomorrow the Japanese. Obviously there is no question that everything foreign is better, more important than that which one has at home." Here Perfall linked the fear of being caught on the side of the philistines, of being out of date, with a re-

jection of one's own heritage, tradition, and nationality. To be fashionably modern, Perfall believed, was to be alienated from one's own being. He insisted, however, that "true art must grow out of the flesh and blood of the artist"; it could not be a matter of contemporary fashion.[6]

Not only were artists and the public confronted with the rapid succession of art movements in this decade, they had to cope with a multiplicity of new places to view art. New art exhibitions, new galleries, and new groups of artists rapidly encroached during the nineties on the domain of the established art associations and societies and disrupted the dominant patterns of the great exhibitions of Munich and Berlin, with their sensations and entertainment. Paradoxically, the great divide between modern art and the crowds who flooded the great exhibitions was one of the factors that lay at the heart of this expanding world of art. Fueled by the desire to escape the exhibition halls crowded with the indifferent and unappreciative schaupöbel, artists left the artists' associations in the hope of creating smaller exhibitions to attract a more discriminating public and more affluent patrons. The searches for new publics, new markets, and new art forms were ineluctably entwined. Viewing this scene, a Munich critic argued that these phenomena were inevitable when art was true to its time. "A new era generates cultural elements, emotions, and a range of ideas that no previous era possessed." Yet the public, dwelling in the comfort of the past, were not ready to accept the necessity of progress, while the art world itself was moving ever more rapidly into artistic politics, where schisms and divisions meant endless battles in which every faction and personage endeavored to achieve dominance in the world market.[7]

SECESSIONS: "ART TO ARTISTS!"

"Art to artists! That is the secessionist program!" These words summed up H. E. von Berlepsch's view

of the new groups of artists that emerged in the nineties. No one, he wrote in May 1894, could doubt the vitality of this principle enlivening exhibitions in both Munich and Berlin; even though the negative response to these exhibitions had produced the notorious new words *Schaupöbel* and *Kunstpöbel*. The derogatory words rapidly spawned the brochures in which those ridiculing modern art were alternately chastised and applauded. Berlepsch, however, cheerfully declared the irrelevance of all opinions, critical or not, to the inexorable evolution of art. "Artistic movements are not arbitrarily created; they are part of the eternal laws of the thrusting out of the old and the creation of the new." Failure to recognize this inevitability led to "narrowminded philistine views" held by "bone-headed," "ossified" supporters of the "old" art forms, the "old" exhibitions, and the "old" art associations. To accept the necessity of change was fundamental to being modern and progressive, Berlepsch asserted, as he cited the legendary dissenters in German history, Galileo and Luther, to justify artists' splitting away from the established art societies and clothed them in the garments of progressive reform, heroic virtue, and German resistance to archaic institutions. Just as the Protestant Reformation had returned "faith to the faithful," he insisted, the secessions returned "art to the artists."[8]

That, at least, was the lofty message Berlepsch's article conveyed to readers of *Die Kunst für Alle*. Critics who promoted the new groups agreed with many of his judgments: the inevitability of change, the moribund nature of the great exhibitions and the old artists' associations, the fresh contemporaneity of the new art, the return of art to pure aesthetic qualities, the new life brought into the German art world by the new groups, and the philistine stupidity of those who failed to recognize these virtues. Strikingly absent from his article were the issues Berlepsch had himself raised three years earlier: the economic problems facing artists and the inadequacy of the current exhibitions to address

these problems. Yet these economic factors were crucial for the new groups, as a new Berlin critic for *Die Kunst für Alle*, Richard Mortimer, stated tersely at the end of the decade. Mortimer maintained that "the slogan of new and old" did not constitute the real grounds for the schisms in the artists' associations that spread across Germany; "the major point that was at stake was the management of the exhibitions."[9]

The management of exhibitions, of course, was crucial for the livelihood of artists. Whose works were chosen, where they were hung, who was not juried, whose works were photographed, who was mentioned by critics—not only were these urgent matters with critical financial implications for artists but they affected the presentation of art to the public as well. Ultimately, decisions made over exhibitions resulted in both a proliferation of often transient artists' groups and the fragmentation of the public for art. Debates over the rules governing exhibitions took place regularly in the meetings of the artists' associations in these years and were reported in considerable detail in the art journals, as well as in the local papers.

Without dwelling on these economic factors, the description of the new elite exhibitions that spread across Europe in the 1890s stressed that the primary concerns were artistic quality and individuality, not the promotion of any particular new style or movement. According to a leading secessionist Benno Becker, "Not modern, but artistic, was the motto." Furthermore, "no paintings created merely to sell, no trivial slapdash work; only a limited number of paintings displayed in intimate settings."[10] These new exhibitions, in other words, sought to eliminate the conditions of the great exhibitions, in which thousands of artworks competed for the attention of the masses, forcing the artist to become the slave of the rabble, satisfying the instinct of the masses with degraded and trivial paintings. That the elite exhibitions with a small number of attractively displayed paintings enhanced the possibility of

sales was a logical corollary. Practically, this meant that artists began to search for possibilities outside of the exhibitions organized by the artists' associations and the local art societies. The search for new venues did not necessarily mean a break with the established organizations.

The obvious locations for possible exhibitions were private art galleries, which, having already established their usefulness to artists, were steadily expanding in both size and number at the end of the century. An early effort to present a series of exhibitions by a group of like-minded new artists was the exhibitions of the works of the light-color painters organized by Fritz Gurlitt at his Berlin art salon in the winters of 1888, 1889, and 1890. The initiative behind these exhibitions came from Gurlitt, as a dealer, not from a group of artists. Linked by their light palette, the artworks Gurlitt gathered together from Berlin, Munich, and Karlsruhe constituted a new style that had not yet found favor with the public. The artists involved were not a self-conscious group seeking exhibition space. That quest did not begin seriously until the impact of the economic difficulties of the early 1890s was manifested in the depressing sales records of German artists at the Third Munich International in 1891 and the issue of tedious mediocrity came to a head in the massive Berlin exhibitions of 1891 and 1892.

Signs of the first major fissure in the system of great exhibitions in Europe appeared in the journals, with reports of a secession from the Society of French Artists by a group of artists in 1890. Led by Ernest Meissonier, the group split over rules governing the annual Paris Salon and the participation of foreign artists in the Salon. By the following summer, reviews, including a substantial one by Otto Brandes, appeared in the journals covering the Salons of the new and the old societies in Paris. All of the reviewers agreed that the Meissonier Salon was more important for German visitors because it showed more contemporary work done by "the modern sect of artists . . . which jealously excludes from its works everything that appears to be a dramatic or poetic motif." As occurred so often in matters of German art, the example from France, despite the disapproval of conservative critics, was cited frequently as a positive catalyst for the German schisms.[11]

The first signs of group dissent in Germany appeared in reports that an opposition group had formed in Düsseldorf as a result of contention about the annual exhibition. Because of its preeminence as an art center in the mid-nineteenth century, Düsseldorf could still command attention for its artistic activities. The journals thus gave substantial coverage to the events and exhibitions that followed in the city's art community. In the mid-April issue of 1892 *Die Kunst für Alle* ran its first review of simultaneous rival exhibitions in a German city as its lead article. The annual exhibition of the Düsseldorf Society of Artists was held in the Düsseldorf Kunsthalle, while the dissenting group showed its work in the rooms of the art dealer Eduard Schulte. The reviewer objected to the newspaper reports that characterized these as the old art against the new art. Pointing out that there was a considerable mixture of styles in each, the writer commented that discussion about the cause of the split was inappropriate since it was essentially an inner-group quarrel.[12]

At a general meeting of artists in June 1892 forty-six artists formally withdrew from the Düsseldorf Society of Artists to form their own group, the Free Society of Düsseldorf Artists and Its Friends. In December a brief report in *Die Kunst für Alle* referred to the Free Society as Düsseldorf's secessionists, a claim that was proudly reasserted two years later: "We also have our Secession—what is more, we were the first [in Germany] to have one." A review in *Kunstchronik* of the second annual exhibition of the Free Society, in March 1893, maintained that although Düsseldorf suffered from having no influential artistic leaders and no art periodical to provide serious criticism, its artists still confronted new art earlier than artists in any other city. The new society continued to exhibit annually at Schulte's

well into the next decade, with reviewers consistently finding its members' work stronger than that of the older society's members.[13]

In December 1892 another new organization of Düsseldorf artists opened its exhibition at the Schulte Art Salon. Named the St. Luke's Club, it self-consciously claimed ties to the early-nineteenth-century Brotherhood of St. Luke, which sought religious and national renewal through art. Viewed as Düsseldorf's elite group, the artists of the St. Luke's Club exhibited together while remaining members of the Free Society. They maintained, as other groups would, that the only program of the club was to enable individual members to pursue pure artistic quality, not to follow a particular stylistic tendency. In the following years, the journals provided readers with extensive reviews of the St. Luke's Club exhibitions, which took place each December. Although the group remained small, their exhibitions were the only ones with international participation. Beginning in 1896, they regularly featured well-known artists from Germany, Belgium, Holland, England, and Italy.[14]

By the end of the decade, however, reviewers reported that the art scene in Düsseldorf was not doing well. Some blamed the economic problems on the lack of an adequate exhibition hall to compete with those of Berlin and Munich, though one writer said that the level of art was so low that even a great hall could not help. In 1898 a further split and an additional rival exhibition resulted in the formation of the Düsseldorf Artists' Society 1899, an even more elite group that held its exhibition of forty carefully chosen pictures from its thirteen members in a tastefully decorated studio designed to show art in a totally artistic setting. This arrangement, repeated the following year, was attractive enough to earn a photograph in *Die Kunst für Alle*.[15]

News of the initial opposition in Düsseldorf and of the artists' independent show surfaced in the national journals in March 1892. Achieving neither increased membership nor significant creativity, the

Free Society and its offshoots were rapidly eclipsed by events in the major art centers. Within a month, a flurry of reports in *Der Kunstwart*, *Kunstchronik*, and *Die Kunst für Alle* announced the formation of a splinter group, the Society of Eleven, in Berlin and a new society of artists, the Secession, in Munich. Although the Free Society of Düsseldorf Artists held its first show at the Eduard Schulte Art Salon before either of the other groups received public attention beyond its local community, further actions of the Düsseldorf splinter groups and their reception were definitely influenced by the events in Munich. Only after the far larger group of Munich artists seceded from the Munich Artists' Association and announced the formation of a new society did the Düsseldorf artists formally take the same steps.

By the end of the year the term *secession*, which had been informally applied to the Munich withdrawal, became both the common name of the Munich group and the label applied to the phenomenon of groups splintering off from the established artists' associations. The use of the term suggests a greater coherence among the various groups than was actually the case. The major common denominator was artists' desire to organize and control their own exhibitions in order to improve their position within a severely depressed market. Beyond that, local circumstances and individual personalities resulted in a widely diverse collection of artists' groups by the end of the century.[16]

BERLIN: ARTISTS' GROUPS TURN TO ART DEALERS

The first reports in the art journals on the Berlin Society of Eleven, or XI, and the Munich Secession reflected the fundamental difference between these two groups. Initial news of the Munich Secession came in the form of organizational announcements. A series of statements spelled out the reasons for the split, the members of the newly formed

executive committee, their new statutes governing exhibitions, and their efforts to negotiate with municipal and state authorities, including those outside of Munich, to find an appropriate exhibition space. By contrast, the reports of the Eleven were reviews of their group exhibition at the Schulte Art Salon in Berlin in April 1892. The Eleven, in other words, did not secede from the Society of Berlin Artists. Instead, eleven artists who had already gained a measure of success and were unhappy with the conservative juries and annual exhibitions in Berlin banded together to present their work in the more gracious galleries of an art dealer, where a few select paintings by each artist were tastefully hung. Though not all the members were considered progressive, the Eleven were "a small, particularly combative group" that the reviewer for *Der Kunstwart* expected would serve as the leaven Berlin art badly needed. Liebermann, who served as the leader, showed several paintings, including his *Woman with Goats* (fig. 24B) and "a distinguished and original portrait" of the Mayor of Hamburg, Carl Friedrich Petersen (fig. 110).[17]

As might be expected, responses to this "small, particularly combative group" were polarized from its beginning. Opinions in the Berlin daily newspapers ran the gamut from praise to condemnation. Paintings described as "filthy" and "insane" in one paper were perceived as the highest revelation of beauty by another. Presenting a strongly negative view in *Kunstchronik*, Adolf Rosenberg judged the first Eleven exhibition in 1892 to be the most recent example of "bizarre art scams." To combine the "extreme, desolate naturalism" of Liebermann with the "hallucinations" of Ludwig von Hofmann had, he sneered, resulted in such a "thorough fiasco" that his review probably would turn out to be an obituary. Rosenberg, like other conservative critics, was incensed by the portrait of Lord Mayor Petersen. As long as Liebermann confined his palette-knife style to smearing paint on cowherds, shepherds, and net menders, it was not worth getting upset, Rosenberg

Fig. 110 **Max Liebermann, *Mayor Carl Friedrich Petersen*, 1891. Oil on canvas, 81 1/8 x 46 7/8 in. (206 x 119 cm). Hamburger Kunsthalle. Reproduced in *Die Kunst für Alle* 8, no. 24 (Sept. 1893): 376.**

Liebermann was commissioned to paint Petersen's portrait in 1890 by Alfred Lichtwark, director of the Hamburger Kunsthalle. This was part of a large project that Lichtwark had created to obtain contemporary paintings of scenes from Hamburg and portraits of prominent men in the city. Artists commissioned to contribute to the collection included not only German artists but also the French artists Pierre Bonnard and Edouard Vuillard. Liebermann's experience with this commission was difficult from the start, as objections were raised to his painting the portrait. When it was completed, with Petersen himself offended by this depiction of him a tired old man, indignation over the dishonoring of the mayor was vehement in Hamburg. First shown with the Eleven in 1892 in Berlin, the work appeared, also to strong criticism, in the first Munich Secession exhibition, in 1893.

declared, but the demeaning of an honorable elder statesman in such a reckless manner called for decisive protest. He had little good to say about Walter Leistikow, the leading spirit and organizer of the Eleven, but he commended Franz Skarbina for his realism.[18]

Reviewing the same exhibit, Springer, whose verdict on the current Berlin Academy Exhibition as an "exhibition of old fogies" proclaimed his allegiance to the modern artists, welcomed the Eleven as "without doubt the best and most interesting that we have been offered here for a long time." In his concise analysis he did not hesitate to criticize Liebermann's oil portrait of the mayor, while he pronounced the artist's pastel portrait of Count Keyserling "one of the best to be created recently in Berlin." His strongest compliments went, however, to Hofmann, whom he deemed the "most original and most startling" artist among the Eleven, one whose shimmering and lyrical landscapes set him apart as one of the "most divinely gifted" landscape artists (plate 7).[19]

Vigorously disagreeing, Rosenberg resorted to stronger language of condemnation in his review of the Eleven's second exhibition, in the spring of 1893. Declaring that the group stood under the "sign of secession," he described them as "extreme naturalists" who, more "obstinate, fanatic, and formless" than ever, produced indecipherable hieroglyphs. Liebermann was, as usual, condemned for his heavy impasto, while Rosenberg said that Hofmann's "grotesque fantasies" were neither original nor worth taking seriously.[20] This was, of course, the exhibition where the derisive reaction to Hofmann's paintings aroused the wrath of Franquet. The jeers and laughter of the public—critic and crowd alike—inspired Franquet's diatribe about the schaupöbel. His pamphlet and the angry responses to it in Berlin and Dresden broke into the news in the month immediately before the third annual exhibition of the Eleven, in March 1894. This exhibition, with Klinger's *Crucifixion* (plate 4) as its sensational cen-

ter and Hofmann's *Springtime* and *Lost Paradise* (fig. 65B), was, if anything, more scandalous than the previous ones.

Scandal, controversy, and the participation of several of the most celebrated modern artists in Germany—Liebermann, Klinger, and Skarbina, as well as the infamous Hofmann—established the reputation of the Eleven as marvelously or, for others, dreadfully modern. The Eleven became very newsworthy. Already with its second exhibition *Die Kunst für Alle* devoted a full article to the group, instead of a shorter report in its section devoted to gallery reviews. Much of that article, written by Springer, was devoted to an analysis of the current fears about modernity in the arts; he was convinced that the future belonged to these "energetic modernists" who were creating a new culture. *Der Kunstwart* also gave lengthy coverage to the second Eleven exhibition, in the form of an extended, glowing review of the magical fantasy of Hofmann's paintings that was a deliberate response to the negative criticism.[21]

The ridicule of Hofmann and Liebermann and the polemical contentiousness that accompanied Klinger's paintings attracted crowds to Schulte's annual spring shows of the Eleven. *Die Kunst für Alle* reported that everyone who counted in Berlin society, including many in uniform, attended the opening of the group's third show. A month later *Kunstchronik* announced that Schulte's would be changing exhibits every three weeks in order to satisfy its constantly growing clientele, leading other dealers to do the same. A Berlin critic claimed that because of the controversy, Schulte became chic overnight and the Eleven became the most successful representatives of the modern art trends in Berlin. Over the decade, these fashionable and elegant shows attracted a strong new affluent clientele, who bought paintings, far removed from the undistinguished crowds frequenting the great exhibitions. Notoriety and laughter turned Hofmann into a successful artist whose paintings were eagerly purchased. Other observers confirmed the success

of the Eleven in this critical task of creating a new market that catered to the less traditional tastes of a new elite public.[22]

The public attracted to the new, socially respectable milieu of art dealers' galleries in Berlin may have been more educated and affluent; however, the raucous reception at Schulte's salon that resulted in the use of the epithet *schaupöbel* indicated that scorn for the modern was not the exclusive preserve of the masses who visited the great exhibitions. On the other hand, the perception of the Eleven as combative moderns only enhanced their appeal to those who were unsympathetic to the official conservatism of William II. It was precisely the control that Anton von Werner and conservative juries wielded over official exhibitions, combined with the emperor's increasingly vocal views condemning experimentation in the visual arts, that forced any innovation to seek outlets independent of Berlin's official system.

Given the substantial increase in new wealth in Berlin, particularly concentrated in banking and new industries, the city had a potential clientele for art that was not constrained or satisfied by either official taste or traditional forms and was, therefore, open to what was fashionable or new, from Parisian gowns to scientific discoveries or technological innovations. For well-to-do Berliners, whose social life tended to be contained primarily within class boundaries, whether the lavish entertainment of the wealthiest high bourgeoisie or the more modest visiting of the upper middle classes, the well-decorated galleries of art dealers offered an attractive, socially discreet alternative to the crowded philistine diversion of the annual exhibitions. As a result of this tension between official policies supporting academic and mediocre art, on the one hand, and new wealth and social aspirations, on the other hand, dealers who were willing to show contemporary, fashionable, or controversial works of art flourished in Berlin.[23]

The two leading art galleries, Fritz Gurlitt's and

Eduard Schulte's, both showed contemporary paintings and sculpture. Moving in 1892 to a new location in central Berlin, Gurlitt featured French and modern artists. Schulte both favored older, established artists and provided a showcase for new artists' groups, not only in his Berlin gallery but also in his Düsseldorf and Dresden galleries. The relationship between the Eleven and the Schulte Art Salon in Berlin was mutually satisfactory. Annual exhibitions were held each spring until the Eleven dissolved after its spring show in 1899. Another older firm, Amsler & Ruthardt, became the chief promoter of Klinger's works, including his sculpture and paintings, even though the firm primarily dealt with prints and watercolors. At the end of the decade these dealers were joined by two energetic and committed promoters of modern and French art, Keller & Reiner and the Cassirer Gallery, prompting the Berlin critic of *Die Kunst für Alle* to report that offerings of contemporary art at Berlin galleries were richer than in any other city in Germany.[24]

The controversy, publicity, number of visitors, and sales that the Eleven brought to Schulte's salon apparently inspired other artists in Berlin, discouraged over the sluggish art market in 1892–94, to band together. One new group demonstrated a shrewd sense of publicity by identifying itself with the wealthy western sector of Berlin, from which it could draw patrons. Under the name Artist West Club twenty-eight artists held their first group show in February 1894 at Schulte's, shortly before the third Eleven exhibition opened. Referring to the current vogue for forming artists' groups, critics found the art of the Artist West Club unexceptional but thought that it provided a fresh and valuable addition to the Berlin art scene. Its annual shows at Schulte's over the next four years demonstrated effort but, according to some reviews, little creativity. A group with strong members who cut across the various distinctions and regions was the Society of German Watercolorists, which began holding exhibitions at Amsler & Ruthardt in 1892 and continued to show annually

throughout the nineties. A lead article in *Die Kunst für Alle* on the importance of watercolors at the First International Dresden Exhibition, in 1897, singled out Berlin as the German center of innovation in this medium, citing particularly the work of Liebermann, Leistikow, and Ludwig Dettmann (1865–1944). Also exhibiting annually at the Schulte salon in Berlin during these years was the November Society, begun in 1894 as the Society of Four by Dora Hitz, Philipp Franck (1860–1944), Curt Herrmann (1853–after 1923) and the sculptor Henny Geiger-Spiegel (died 1898)—all of whom, having absorbed new ideas in Paris, were recognized as strong modern artists—and soon expanded to include well-known artists, particularly Wilhelm Trübner.[25]

Another group of Berlin artists, calling themselves the Society of Free Art, exhibited in the Gurlitt Art Salon in the late winter of the years 1896–99, displaying work that was characterized by some as experimental, by others as bizarre. *Deutsche Kunst* dedicated an entire issue to the group's third annual exhibit, in 1898. The reviewer, who viewed the great exhibitions as "death chambers" for young artists, welcomed the six artists of the Society of Free Art as "strong artistic personalities" who brought maturity to their work. Regretting their choice of name, because *free* always conveyed something revolutionary in Germany and immediately produced enemies, the critic thought they would have received a better reception if they had exhibited under the banner "No Program." The last of these artists' groups, organized in Berlin during the nineties in order to gain gallery space with an art dealer, was the Society 1897, which held its first, and perhaps only, exhibition at Schulte's. *Die Kunst für Alle* reported that since the artists in this group had come together by chance and had nothing in common, the group would probably disappear as fast as it had appeared.[26] How many other groups formed and dissolved in Berlin is an open question. The journals only covered those that showed sufficient promise or staying power to gain the attention of the critics.

Nonetheless, that there was a significant increase in art activities produced by artists working in conjunction with dealers is undeniable. And, obviously, the steady rise in the number of groups of artists working with dealers contributed significantly to an emerging market for modern art in Berlin in the nineties.

THE MUNICH SECESSION: MODERN, ELITE, AND INTERNATIONAL

Significant as this shift by small artists' groups to dealers' salons, with their affluent public, was, it was not perceived to be nearly as important and newsworthy as the secession of larger groups of artists from the established artists' associations. In Munich, discord had racked the artists' association following the discouraging sales at the Third Annual in 1891. Rumors of an impending secession were abetted in the pages of the *Münchener Neueste Nachrichten*, a local daily newspaper with a circulation of 65,000, by its publisher and editor-manager, Georg Hirth, whose criticism of the leadership of the Munich Artists' Association was sufficiently acerbic to result in a well-publicized trial in late 1891. Hirth also encouraged the formation of a new group by publicly offering to raise supporting funds. Finally, in April 1892, press reports that a large number of artists had withdrawn from the Munich Artists' Association and were forming their own society broke into the pages of the journals.[27]

The new Society of Visual Artists of Munich (Secession) was organized on 4 April at a meeting attended by more than one hundred artists who were dissatisfied with changes made by the Munich Artists' Association for the upcoming summer exhibition. The letter of 16 April in which seventy-eight artists renounced their membership in the association was printed in full in *Die Kunst für Alle*. The text of a lengthy memorandum issued on 21 June by the executive committee of this new group explaining

its position was published in *Der Kunstwart* and *Kunstchronik*. After announcing that the new society had been officially recognized by the old association with an invitation to a joint festival, *Die Kunst für Alle* assured its readers that these Secessionists were participating in the current summer exhibition. The artists' justification of their action to the public through letters and announcements in the press revealed both the weight of their decision to secede from the established art association and its exhibition and the urgency of establishing a favorable public image. The Munich Artists' Association also felt that it had to make its position clear to the public, and in May it began to publish its own newsletter, the *Report of the Munich Artists' Association: Organ for the Interests of Visual Artists*. By the end of the summer an observer described a duel between the association newsletter and the *Münchener Neusten Nachrichten* for the attention of the public, a duel in which the language was growing steadily rougher.[28]

In the letter sent to the artists' association on 16 April the executive committee of the new society stressed that the fundamental reason for secession was that the association no longer adequately represented the interests of Munich artists. They attributed this to the fact that as the association had grown rapidly, the balance of power had shifted from productive to nonproductive artists. A letter written by an anonymous Secessionist to *Der Kunstwart* emphasized that the new group hoped to "gather together all the significant German artists and younger serious elements," while excluding the "over-ambitious and profit-oriented artists." He emphasized that the society did not intend "to favor a so-called *modern*—the word begins to be terrible— movement." Interestingly, he went against the official Secessionist statements in declaring that the new society would be a *German* artists' group, not one that drew on foreign artists. By claiming this, he clearly intended to appeal to nationalist sentiments but also demonstrated the divergent opinions and

styles brought together in the new society, whose executive committee included such innovative painters as Stuck and Uhde, while its newly elected chair, Bruno Piglhein, was best known by the public for his historicist panorama of the *Crucifixion*.[29]

The tension between the desire for a German identity and the need for an international reputation was, in fact, a central issue in the controversy that resulted in the Munich Secession. The lengthy memorandum published in late June stated concisely that the purpose of the new society was "to form an energetic, right-thinking group of artists of all orientations who will mount annual international exhibitions and who, disregarding all personal benefit, will unreservedly embrace the principle that Munich exhibitions must be elite exhibitions." Affirming the importance of a strong foreign presence, this statement represented a rejection of the unwieldy size of the Munich Artists' Association, with it membership of more than a thousand, three-fifths of whom had not exhibited in the last three annual exhibitions, and, equally, a rejection of the "excessive expansion" of those annual exhibitions because they accepted too many mediocre works. The Munich Secession exhibitions were to be small, elite, high-quality, and international. Membership invitations were sent to artists across Europe. The June memorandum was accompanied by the names of 107 regular and 67 corresponding members, all men, among them leading representatives of modern painting from outside Munich: Klinger, Liebermann, Hofmann, Gotthardt Kuehl, Lesser Ury, Skarbina, and Schlittgen. As *Der Kunstwart* pointed out, in terms of the significance of their members the Secession could easily hold its own against the far larger Munich Artists' Association.[30]

In severing their ties with the Munich Artists' Association, with its substantial municipal and state support, the Secessionists knew that they were also renouncing access to the two best exhibition sites in the city: the Art and Industry Exhibition Building on Königsplatz and the Glass Palace. However, the

group was led by a small core of shrewd and pragmatic men, including Hirth, with his newspaper, and the former business manager of the artists' association, Adolf Paulus, whose commitment to artistic quality was matched by their assessment of the current economic realities. Eighteen ninety-two was not a promising year for artists. Despite crowds at the great exhibitions and the critical success of the Third Annual, sales lagged in Munich. Too many artists were scrambling for sales in a limited marketplace. The old association and the Secession met these problems in profoundly different ways. Securely entrenched financially in the current structures of state and municipal government, the Munich Artists' Association allowed every member equal opportunity in the submission of works to the jury and maintained huge exhibitions admitting as many artists as possible. Critiquing this approach as a recipe for artistic mediocrity, as exemplified by the Berlin Academy exhibitions under Werner's aegis, the Secessionists aimed for greater success for a small, select group of artists. Simply put, the difference was between, on the one hand, a state-financed market that functioned as a quasi-democratic welfare system to support artists and, on the other, an international free-market system in which the most able could succeed. The Secessionists were well poised in Munich to try this risky approach to the troubled art market. Unlike the Eleven, who as a small number of individuals maintained their position in the established societies while exhibiting as a group with an art dealer, the Munich Secession chose to withdraw entirely and establish its own independent, elite organization.[31]

The radical nature of this break with the established association was not lost upon observers. The full impact of the secession was, however, postponed for a year while both groups maneuvered to adapt to the new conditions. The journals followed in considerable detail the efforts of the Secessionists to forge a new course. In the negotiations that followed, the Secessionists held firmly to their central purpose of fully controlling their own elite, selective

exhibition. To do so meant finding a suitable location. Since the new group was too large to consider the galleries of an art dealer—none of whom in Munich seriously handled contemporary art—the executive committee sought unsuccessfully to gain space and financial support from the Bavarian and municipal governments. Both governments were adamant that splintering the Artists' Association and establishing a second international exhibition would seriously damage Munich's position as the foremost city of art in Germany. After negotiations to move the Secession exhibition to Dresden or Frankfurt also fell through, arrangements were made with the commission planning a newly reorganized Great Berlin Art Exhibition to grant the Munich Secessionists a fully independent show in the state exhibition hall for its 1893 summer exhibition, to be held from mid-April through mid-September.[32]

In the meantime, in a move that was more consonant with their aims, the leadership of the Secession had turned to the private sector for support. With financial backing from Hirth and his colleague Thomas Knorr and a donation of land centrally located on one of Munich's fashionable boulevards, the Secession was able to build its own private exhibition hall and forge ahead with plans for its first exhibition in Munich. By the time the doors opened on 15 July 1893 the Secession had achieved what many had thought impossible. Not only had it gained the necessary backing from private sources and, finally, from the city to finance an exhibition in its own building on its own terms that featured an impressive list of foreign artists along with its own prominent members, but the Secession was exhibiting simultaneously in Munich and Berlin. Both exhibitions generated enviable amounts of controversy and publicity. Inspiring delight and disgust, the Munich Secession was unquestionably the sensation of the 1893 summer art season.[33]

Despite the repeated statements by its members that the Secession favored no particular movement or style—to repeat Becker's phrase, "Not modern,

but artistic, was the motto"—the reception by the public, particularly at the Great Berlin in 1893, left no one in doubt that the Munich Secession represented the newest modern art. As Perfall tersely commented, in this exhibition of the Munich Secessionists, who were joined by the Düsseldorf Free Society, the Eleven, as well as French and Scottish artists, "modernism executed a powerful attack" against Berlin art. Gathering together these artists, along with the major names associated with new art forms in Germany, the Munich Secession exhibitions presented a more concentrated vision of the modern than had been seen before in Germany. Concern over the Berlin public's unpleasant response to this new art was expressed in the positive reviews in the art journals. Some thought that the experience of viewing this substantial collection of modern art would be instructive; others were exasperated with the philistine rabble, the schaupöbel. Speaking of the "vigorous opposition" of the public to work they did not understand, one *Die Kunst für Alle* reviewer pointed to the cultural divide in Germany, across which an aesthetically naive public of "un-culture" confronted the "over-culture" of artists. The responses of the schaupöbel to the Munich Secession in the Berlin exhibition once again confirmed that controversy paid off. Six thousand visitors daily purchased twice as many paintings as in the previous year; profits were expected to reach seventy thousand marks. The Munich Secession's exhibition in its own building in Munich was so successful that entrance fees alone were expected to cover its costs; moreover, almost a fifth of the works offered for sale were purchased.[34]

Fig. 111 *A.* **Drawing of the Munich Secession gallery, Munich, 1893, in *Über Land und Meer, Deutsche Illustrierte Zeitung* 70 (1893): 785.** *B.* **Franz Stuck. Poster for the First International Exhibition of the Society of Visual Artists of Munich (Secession), July to October 1893. Lithograph, 24 1/4 x 14 3/8 in. (61.5 x 36.5 cm). Münchner Stadtmuseum.**
Located on the corner of Prinzregentenstrasse and Pilotystrasse, the exhibition hall of the Munich Secession was rapidly constructed in order to open with the first Munich exhibition in July 1893. Inscribed above the entrance archway was the official title: Society of Visual Artists of Munich. This drawing of the triumphant opening (*A*), with flags fluttering above the guests, who arrive by foot or in horse-drawn carriages, accompanied an article on the new group. Stuck's poster for the exhibition (*B*) utilized his stylized head of Pallas Athena. The striking image established the modernism of the Secession even as it claimed to represent the artistic heritage of Munich. A colossal statue of Pallas Athena, the goddess of wisdom and the patron saint of Munich artists, crowned the new building for the Munich Academy of Art upon its completion in 1885.

A

B

The Munich Secession gallery was a symbolic affirmation of the principles of this new group. The building was located on an elegant avenue in a stylish neighborhood, and the main portal, with its massive columns, high archway, and boldly chiseled name, served as a triumphal entry through which visitors moved into a new realm of art (fig. 111). The outer appearance of the building, with its clean lines and compact form surmounted by the wide octagonal dome, anticipated the light, airy appearance of the galleries, where paintings and watercolors were hung at eye level in a single row against light-colored walls. About half of the 340 artists whose work was shown were foreigners, with the largest contingents being French, Dutch, English, Scottish, and Scandinavian artists. Compared with the elaborately decorated halls of the association exhibition, in which almost 3,000 works of art covered its endless walls and cluttered its corridors, the arrangement of the first Munich Secession show was, for Germany, as innovative as the art. Since the Secession did not have the official backing of the Bavarian government, the opening ceremony was notably brief, emphasizing the private, middle-class nature of the new society, in contrast to the usual spectacle of royal and municipal officials at openings of exhibitions in the Glass Palace. Fashionable without ostentation, the Secession opening, gallery, and exhibition embodied a judicious display of wealth more congenial to the stylish, well-situated bourgeoisie than the great exhibitions, with their boisterous crowds. Furthermore, the selective nature of the paintings in these galleries provided reassuring authentication of value for potential buyers. As one perceptive writer noted, "One had the definite feeling, despite the very modest opening, of standing at the beginning of a new era."[35]

The qualities that distinguished the modern exhibition from its old-fashioned predecessors were described by one critic as "clear, delicate, lustrous colors instead of grey, heavy, dull ones; fantasy instead of naturalist subjects; a far greater diversity of individuality." These attributes were, for critics, surface manifestations of the fundamental transformation of art for a modern era. And once again the refrain, "Modern artists are modern people, and vice versa." Surprising confirmation of the critical success of the Munich Secessionists as the model of artistic modernity in 1893 came from Carl von Lützow (1832–1897), founder and editor of the *Zeitschrift für bildende Kunst*. In an editorial written in October 1893 praising the "new course" of the Secession, the venerable art historian concluded that "one thing is certain: the future belongs to the Munich Secessionists; those who do not follow them will sink irretrievably into deadly tedium."[36]

SECESSIONS IN MUNICH: MODERN ART ASSIMILATED BY NATIONAL IDENTITY

Only a year earlier Lützow had been less sanguine. Viewing the dissension over international participation in the Munich exhibitions, Lützow had come down in favor of emphasizing the national. As he put it, "Without deep roots in our domestic soil" neither art nor exhibitions would flourish. Far from settling this anxiety over German identity, the success of the Munich Secession, with its heavy international presence in Berlin and Munich, raised the issue more insistently. Even among the critics who were enthusiastic over the triumphant achievements of the Secession, terms of praise foreshadowed a conservative turn that became pronounced after the turn of the century. This can be seen in a review by Alfred Freihofer, who praised the controversial step of hanging paintings by foreign artists next to works by German artists, which, he said, expressed the Secessionists' commitment to the international character of art but also raised possible invidious comparisons. Freihofer, however, was pleased to discover that the German paintings were clearly *German* paintings, not because the artists used German nationalist themes or old German techniques but "quite simply through

the manner of seeing, as it appears for a good German artist under the particular conditions of our climate, and through the honesty and truthfulness in the human representation, which for us in paintings by German artists also reflects German types, German nature and customs." The great achievement of the Secessionists, for this critic, was the strength and independence of their work. The prediction that modern approaches would lead to "anarchy and brutalizing" of art, he asserted, was refuted by the Secession. No longer faltering and stumbling, these artists had moved beyond experimentation; they now constituted, he was pleased to report, "a core troop of modern German artists."[37]

In this paradoxical twist, the pleasure over the triumph of modernism firmly linked to internationalism simultaneously gave rise to an upsurge of nationalist sentiment. Once again, these views were neither isolated nor new. Associated with older or conservative critics, particularly Pecht, the principle of contemporaneity subsumed a necessary identification not only with one's time but also with one's place and heritage. As the seemingly inevitable dominance of modern art became accepted in the exhibitions, it became more urgent to claim this art as authentically German, as no longer a foreign import. The process of assimilation was particularly marked in *Der Kunstwart*, where Ferdinand Avenarius simultaneously upheld, on the one hand, modern art and the necessity of international artistic exchange and, on the other, the integrity of German art rooted in the land and the people—who, he insisted, should never be confused with the rabble. Arguing that the inspiration for modern developments in German painting, originating in France, conveyed a fully German spirit, he explained that spirit as "the transfer of beauty from the outward appearance to the inner being, from the physical to the psychological."[38]

Articles appearing in the immediate aftermath of the Munich Secession exhibitions in 1893 presented similar arguments. Lamenting the alienation of modern artists from the people, articles reprinted in *Der Kunstwart* from the *Tägliche Rundschau* insisted that to be "a true modern" was not incompatible with "national rootedness" or "down-to-earth populism," because to be "modern" meant to grow organically out of the past into full maturity in the present. Following up these ideas, Avenarius published a long, two-part review of a new book, *What Art History Teaches Us: Reflections on Old, New, and the Newest Painting*, by Karl Woermann, director of the Royal Painting Gallery in Dresden, as a basic introduction to art. Woermann defined the essential criteria that determined quality in paintings as "being true to one's own people's ways, one's own time, and one's own individuality." All great masters, he asserted, were in tune with the spirit of their own times and their own people. Avenarius agreed, pointing out that "like an individual, a people can *learn* from another, without being thereby in the least hindered in the development of its own styles." Significantly, Woermann then proceeded to demonstrate that the new modern art, growing out of French plein air painting, had been fully assimilated into contemporary German modes, at first in the form of the open-air painting, the unmediated viewing of nature of Liebermann and Uhde, and now, in the mid-nineties, in the rapidly developing forms of fantasy, led by the work of Arnold Böcklin and Klinger. With Avenarius concurring, Woerman asserted that the art of the future for the German people would grow out of the blending of Germanic fantasy with direct, individual representations of nature.[39]

These efforts to incorporate international forms of modernism into the vocabulary of national identity were yet another indication of the great rift that cut across the landscape of the visual arts. There appeared to be little doubt among art journal editors and writers that the future lay with the artists of the Secession—from Liebermann to Stuck and Hofmann—not with those of the older Munich Artists' Association. The public at large obviously had not

been won over. Signs of the continued resistance to new forms were not difficult to find. *Der Kunstwart* editors were inundated by negative responses to a feisty series of articles by Julius Elias (1861–1927) in defense of the "young" artists of the Munich Secession. In answer the journal published several editorial statements clarifying its position; at the same time, however, Avenarius vigorously affirmed the necessity of paying attention to those artists with whom the future lay. For its part, the Munich Artists' Association tried to meet the competition from the new Secession in the summer of 1893 by bringing in a substantial number of foreign artists, some of whose symbolist paintings were more radical than those in the Secession, and within a year the Artists' Association instituted some of the reforms that the Secessionists had tried vainly to achieve in 1892.[40]

These reforms by the association were greeted in the journals as marking the moral victory of the Secession. In an unusual review of both Munich exhibitions in 1893, a young literary critic, new to the visual arts, sought to go "beyond Association and Secession." He argued that the primary difference between the two was one of proportion: with a small collection of stringently chosen works and a large percentage of international artists, the Secession had a larger proportion of striking new work, while the Glass Palace overwhelmed one with its massive number of mediocre works, among which were buried fine new paintings and a substantial number of innovative foreign paintings. The crucial issue for this critic was the presence in both exhibitions of the most modern artists, whom he identified as singular in expressing their own souls, their own personalities, and their own times in their art. More profoundly, from the point of view of the public, the Secession's influence became ever more evident in coming years, as the great exhibitions attempted to become more selective, featured smaller special galleries with retrospectives of major artists, and improved the hanging of paintings. Soon Pecht began to complain that the summer exhibitions of the Mu-

nich Artists' Association and the Munich Secession were looking too much alike.[41]

By the end of 1893 the Munich Secession had successfully established itself as a vigorous, elite artists' group whose activities were followed in the journals. In December the executive committee announced that in addition to its next international exhibition the following summer, the Secession would participate in a series of external exhibits, including one at the Museum of Visual Arts in Stuttgart and regular ones at the Ernst Arnold Art Salon in Dresden. An early spring exhibition was scheduled in Munich to display the paintings, particularly those of Munich artists, before they were sent out and, not incidentally, to give the members another sales opportunity. Following a practice already utilized by individual artists and by the Free Society of Düsseldorf Artists, the Munich Secession issued a photogravure collection of paintings and drawings available for one hundred marks or, in a luxury portfolio edition, three hundred marks. In 1895 the Munich Secession held an eminently successful exhibition in Vienna. Attended by the Austrian emperor, as well as by an enthusiastic purchasing public stimulated by the contradictory news reports, the Viennese showing won strong praise even from *Kunstchronik*.[42]

The Secessionists' aggressive marketing through multiple appearances in smaller elite exhibitions had actually begun before its first exhibition in Berlin. Calling themselves the Twenty-four and openly identifying themselves as Munich Secessionists, a group of the leaders, including Uhde, Trübner, Piglhein, and Schlittgen, put on a show in February 1893 at the Eduard Schulte Art Salon in Berlin. While local critics in Berlin denigrated the Twenty-four as mere drinking partners from a Munich beer hall, reviews in *Der Kunstwart* and *Die Kunst für Alle* welcomed the arrival of the new group in Berlin. The public reception, however, was similar to the one that greeted the Eleven and the summer Secession exhibition. According to Springer, the bulk of the visitors rejected the work and did not hesitate to express their

opinions loudly in coarse language. Another critic, however, delighted over the excitement created by the Twenty-four, thought the public were surprised and somewhat disappointed to discover that these Secessionist paintings were not wildly extravagant. Stimulated by the public response, the Twenty-four continued to hold annual shows in Schulte's Berlin rooms through the end of the decade. Some of the later events were disappointing to its supporters, who found them disorganized and inconsistent.[43] What is noteworthy about the early shows of the Twenty-four is the effort on the part of the Munich Secessionists to gain a foothold with a major dealer in the independent Berlin art market, which was already far more active than in Munich. As the Munich society gained government support and moved back into the shelter of state financing, its need to break into the capitalist market became less urgent, especially since the major artists of the group were able individually to command shows with art dealers.

The fragmentation of Munich's art world begun by the Secession continued throughout the nineties. In the next secession a handful of Secession members withdrew to form a more selective modern group. News of the split in February 1894 accompanied a report that the Munich Secession's initial financial success had been overestimated and that, perhaps as a result, six of the radical artists were returning to the Munich Artists' Association to exhibit as a separate, unjuried group at the Glass Palace. Subsequent reports indicate that the membership of the Artists' Association rebelled at the news that their executive committee planned to offer special, jury-free status to the prodigals. As a result, the new Munich Free Society withdrew its request and turned to the Fritz Gurlitt Art Salon in Berlin. Deeming these six members of the Munich Free Society to have been among the strongest artists of the Secession, the reviews of their first show in Berlin during April 1894 were mixed. They focused on paintings by Trübner, Hans Olde, and Lovis Corinth, who represented "the healthy, robust, but also brutal move-

ment in our modern German art," while Hans Rosenhagen berated the younger members, Th. Th. Heine and Otto Eckmann (1865–1902), for producing paintings that he said looked like overblown *Fliegende Blätter* cartoons.[44]

The second Free Society exhibition at the Gurlitt Art Salon, in 1895, included works by modernist artists from Belgium, Denmark, and Finland. The ornamental paintings of the Danish Symbolist Jens F. Willumsen were sufficiently weird, according to one reviewer, to make "the philistine seethe in pure rage and furiously clench his fists." Another referred to the "raw archaism" and "wild caricatures" of these Scandinavian modernists, especially Axel Gallén, who was concurrently showing with Edvard Munch in a controversial exhibition whose slightly sinister, eye-catching poster was plastered all over Berlin.[45] Anchored by the brash energy of Corinth, the single-minded independence of Trübner, and the decorative formalism of Eckmann, the Munich Free Society represented to the public an elite group of modern artists who were pursuing their own artistic vision, making little concession to public taste (fig. 112).

Through the mid-nineties the art scene in Munich was dominated by the Secession in its building; the Free Society and the Twenty-four, with their respective Berlin dealers; the Artists' Association in the Glass Palace; the older Art Society, with its weekly exhibits in its own building; and the artists' social club Allotria, with Franz von Lenbach wielding power at its head. Another round of secessions took place in the last few years of the decade. Again precipitated by a dispute over exhibition arrangements, a major fracture shook the Munich Artists' Association just as plans were being laid for its joint participation with the Secession in the Seventh Munich International Exhibition, in 1897, marking the reconciliation, but not the reunification, of the two groups. Reports surfaced in January 1897 of stormy meetings of the Munich Artists' Association at which an effort by the executive committee to tighten

requirements for submitting works to the upcoming exhibition had been soundly defeated. This led to the resignation of the executive committee and the secession of 135 of the stronger artists, who formed the newest group, named after their meeting place, the Café Luitpold. Charges and countercharges followed in angry meetings and press releases. Those who remained in the Artists' Association, who were openly identified in the journals as mediocre artists, elected Lenbach to assume the presidency (1897–1900) and organize the 1897 exhibition.[46]

These developments, ironically, brought Lenbach to the pinnacle of his power in Munich, where he demonstrated both his ability to maneuver within politically volatile situations and, as several writers pointed out, his fundamentally conservative position as "the sworn enemy of everything modern." The Luitpold Group demanded the same rights as the Secession: to have a separate group show with its own jury at the 1897 Glass Palace exhibition. This time, having learned from the experience of the first Munich Secession, the Bavarian minister of church and school affairs, Robert von Landmann, interceded in the dispute by supporting the right of the Luitpold Group to exhibit independently in the Glass Palace. Thus, the 1897 Munich International without question manifested a pattern that had been building during the decade in which the monolithic great exhibitions were divided into elite group shows, each competing for the attention of the public (fig. 113). Along with the Secession, the Luitpold Group, and the Munich Artists' Association, Lenbach organized a special exhibit of five hundred years of Western art, featuring largely artists from France—paintings by both Édouard Manet and Claude Monet were included—and the Low Countries. That this splintering into special group shows did not mitigate the immensity of the

Fig. 112 *A.* **Lovis Corinth (1858–1925),** *Walter Leistikow,* **1893. Oil on canvas, 49 x 39 3/8 in. (124.5 x 100 cm). Berlin, Stadtmuseum Berlin.** *B.* **Thomas Theodor Heine (1867–1948),** *The Fisherman,* **1892. Oil on canvas, 24 x 40 in. (61 x 102 cm). Städtische Galerie im Lenbachhaus, Munich.**

Artists identified as members of the Munich Free Society varied from one published report to another. Lovis Corinth, Otto Eckmann, Thomas Theodor Heine, Wilhelm Trübner, Hermann Schlittgen, and Hans Olde, along with Carl Strathmann and Max Slevogt, formed the core of the group. Others mentioned in reviews were Julius Exter, Peter Behrens, Hans Thoma, Carl Lührig, and Wilhelm Leibl. Corinth's friendship with Walter Leistikow, the leading young artist of the Eleven in Berlin, led first to this portrait (*A*) and later to Corinth's departure from Munich to join the modern artists in Berlin. Heine, a painter active in the Munich art scene in the 1890s (*B*), became famous for his striking caricatures and cartoons in the Munich journal *Simplicissimus,* which began publication in 1896.

A

B

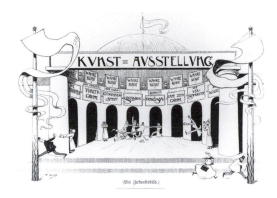

Fig. 113 **"A Scene from the Future,"** *Fliegende Blätter* **106, no. 2689 (1897): 59.**
In a building that mocks the Munich Secession gallery on Prinzregentenstrasse, with its cupola, massive pillars, and tall arched entrance, the art exhibition of the future is taking place. In this vision of the future the Secession has split into eight groups, each claiming—in large letters above their entrances—to be the "True Art." The groups include: The Classicists, Violet-Group, Association, Secession, Franzi-Hall, Café Zeus-Group, The Forgotten, and The Wild Ones. In fact, this 1897 prediction was conservative. Two years later the Glass Palace featured a total of twelve groups exhibiting simultaneously. The cartoon graphically presents the competition for viewers by the proliferating new groups. Here the guards are literally fighting over the unwary visitor who approaches the doors, while several other members of the public run rapidly past the building, gesturing their displeasure.

Fig. 114 **Raffael Schuster-Woldan (1870–1951),** *The Woman Painter*, **in** *Die Kunst unserer Zeit* **10, 1st half-vol. (1900): n.p.**
Among the best-known artists of the Luitpold Group were Schuster-Woldan, Carl Marr, Friedrich August von Kaulbach, and Julius Exter. With portraits of women and mythological scenes predominating in their work, the Luitpold Group artists gained a reputation for their modern handling of traditional symbolic themes. A critic for example writing in *Die Kunst unserer Zeit* described with appreciation Schuster-Woldan's painting *Odi profanum vulgus et arceo*, from Horace 3.1, showing a nude woman with harp reclining on a bed, accompanied by a contemporary woman in a beautiful dress; between and behind the women was a warrior with a golden helmet. In the background a burning castle in the midst of a quiet landscape contributed to this "hymn of beauty."

Glass Palace exhibitions was shown two years later when twelve separate groups in addition to the Munich Artists' Association were represented, leading one critic to refer to the "horror and helplessness" of these chaotic "monster exhibitions."[47]

By the opening years of the new century the Luitpold Group had established a reputation for producing agreeably modern and solidly German paintings. In addition to the group's regular exhibitions in the Glass Palace, these artists turned to one of the prominent Munich art dealers, the Heinemann Galerie, a conservative one that did not usually handle contemporary art. From 1899 until well into the 1920s the Luitpold Group's exhibitions were regularly welcomed events on the Munich art scene. As the reviewer for *Die Kunst unserer Zeit* explained, the members of the Luitpold Group understood how to make the modern developments in painting acceptable to the public. Eschewing experimental studies, he wrote, the older painters in this group produced "competent, skillful, and intimate views of

nature" that, with their rich colors and pleasant scenes, appealed to the viewer (fig. 114). Another critic characterized the Luitpold Group's paintings as an elegant blend of figure compositions with a strong impressionist approach to nature.[48]

At the end of the decade, the group was joined in capturing the attention of the public by younger circles of Munich artists whose decorative, linear style and strong colors like those one might find in a poster had developed through their interest in the applied arts and through work on fashionable new humor magazines. In February 1898 fifteen of these men, all of whom had been members of the Munich Secession, showed together as the Ring at the Ernst Arnold Art Salon in Dresden. A second group of like-minded members was longer-lasting and more influential. Naming themselves the Plowed Earth, these artists worked in modern design modes to express a fresh, often controversial view of German life, culture, and countryside. Striving to create a new art out of engagement with contemporary German life, the artists of Plowed Earth served, according to Avenarius, an important role in popularizing modern art among a far wider public in Germany.[49]

BERLIN: DISCORD AND OFFICIAL STAGNATION

"Precisely in this time of discontent and anxiety, mediation between artists and the outer world is of particular importance and, without doubt, a necessity." With these words, in October 1892, Rosenhagen officially began his tenure as editor of *Das Atelier*, a slim, semimonthly journal of twelve to fourteen pages, a quarter of which were filled with announcements for artists. Published in Berlin, the journal reported on the politics of Berlin's art world in considerable detail.[50] As a professional journal formed two years earlier to address the needs of artists, it represented a significant shift away from

the aims and ideals of a decade earlier, when *Die Kunst für Alle* entered the art scene. The apparent congruity of Rosenhagen's statement of purpose with Pecht's objective of acting as a mediator between artists and the ordinary people of the new nation is misleading. For Pecht, the goals were the edification of the public to make them enlightened patrons of art and the nurturing of a new art befitting a newly unified nation. For Rosenhagen, the purpose was to inform artists of current developments in the profession and to encourage reform of existing institutions. From the earliest issues of the journal, two presuppositions emerged: support for modern artists and concern mixed with disdain for the public—"the common plebians" or "the great uncomprehending masses."

Thirty-four years old in July 1892, Rosenhagen belonged to the cohort of influential young men in Berlin, including Fritz Gurlitt and Springer, who had actively promoted the new light-color art of the 1880s and were now certain of its predominance. When he took over as acting editor that summer, he deliberately took a stand supporting the demands of artists for "free development" and promised to pay close attention to the "new movement" in the art world. Emphasizing the journal's independence from any art society or organization, Rosenhagen insisted that it would never become the voice of a particular group. Nonetheless, from the beginning of his editorship he was a vehement supporter of the new movement against all the established art institutions. Beginning in May 1892 his attention was focused on the secession emerging in Munich. Viewing the events there as a struggle between moribund, senile artists and creative, striving artists, Rosenhagen, seconded ably by his chief writers, Max Schmid and Karl Voll, rooted enthusiastically for the Secession in its dealings with, as he perceived it, the powerful, intransigent Munich Artists' Association.

Reports of the Munich saga in Rosenhagen's regular editorial column inevitably turned into a commentary upon the greater difficulties facing

young artists in Berlin, the weakness of the local art scene, or the autocratic actions of Werner and the Society of Berlin Artists. In his July "State of Affairs" column Rosenhagen praised the Secession for struggling to maintain artistic quality above financial interest and then launched into an attack upon the public in Berlin for having little pride or interest in their own artists. Condemning both artists and the public in Berlin for preferring shallow art, he blamed the public for the grave economic situation of Berlin artists. In August, lauding the Munich Secession for its fight against the power of the association, city, and state, he predicted a similar split in Berlin after a recent action by Werner. The pattern remained the same throughout the year. By October 1892 Rosenhagen believed that the state and municipal authorities in Munich had come to their senses and were doing their best to keep the Secession in Munich; by contrast, he found the Berlin situation getting worse: "The state without genuine interest, the city without understanding, the community of artists without hope. One asks again and again: must it remain like this? Can nothing happen to give our dull city the magical splendor that art has woven around the name of Munich?"[51]

Concerned about the deepening frustration of young artists whose petition of March 1892 to the Berlin magistrates for financial support had been futile, and discouraged about ineffective efforts to create a new art society to support young artists, Rosenhagen repeatedly called for artists to unite against the "dull mediocrity that dominates the Berlin art world." In effect, he campaigned openly in the pages of the journal against Werner's secure control over Berlin's official art institutions and exhibitions. Rosenhagen's exasperation in these months centered upon Werner's plan to create a new committee that would be responsible for organizing the annual Berlin exhibitions. Vehemently opposing the plan, Rosenhagen reported that increasing opposition to Werner over this issue finally burst into bitter confrontations in meetings of the Society of Berlin

Artists in the early fall of 1892, resulting in the revival of the effort to create a new art society.[52] In the midst of all of these battles, as Rosenhagen reported with great satisfaction, the "Munch Affair" created an explosion whose impact shattered the tedium and utter mediocrity of the society. Commenting that Munch's paintings were not exactly *comme il faut*, he found some of the work striking and original but considered many of the sketches plainly the worst perversions of impressionism. He was, accordingly, hopeful that the shock experienced by the conservative artists when they saw the Munch exhibition would lead to positive change.

Munch had, at the official invitation of a committee of the Society of Berlin Artists, brought a large collection of his paintings and engravings to Berlin, where he arranged and hung them in the gallery of honor at the society's headquarters. As one critic later commented, Munch's paintings demonstrated an "excess of naturalism" such as Berlin had never before seen. Opening on 5 November 1892, the show was closed a week later by a narrow vote taken at an acrimonious emergency meeting of the society chaired by Werner. The committee responsible for the invitation was forced to resign, and about seventy members, protesting on principle the closing of an exhibition of an invited guest artist, walked out to form a new group, the Free Society of Berlin Artists. "And so," concluded Rosenhagen with pleasure, "we now also have our Secession." The fallout from the visual bomb blast continued to occupy Rosenhagen in his reports to his artist readers. From his perspective, the events should have marked the end of the "Werner Era" and the weakening of the old artists' society. Within a short time, with more than 150 paying members, the new Free Society had organized under the leadership of the graphic artist Karl Köpping. Its published program, Rosenhagen enthusiastically noted, made a central point of supporting individual artistic freedom and encouraging artistic connections, both at home and abroad, to strengthen Berlin's artistic life.[53]

Rosenhagen was mistaken in the short run. Far from ending the "Werner Era," the Munch affair consolidated Werner's position in the politics of official Berlin. Responding to the dissidents' published statement condemning on the grounds of common decency the closure of the exhibition, Werner observed tartly, "Civility had nothing to do with it; it was important to show who was really the master of the house." And he set about demonstrating that he was, indeed, still the master. By mid-January Werner had been reelected as chair of the Society of Berlin Artists; under pressure from Werner and his colleagues, three academy professors who had signed the protest and joined the Free Society had resigned their positions; and Werner's recommendations for reorganizing the planning committee for the annual Berlin exhibitions had been put into effect by the cultural ministry.[54]

Remaining as an oppositional group of members inside the Society of Berlin Artists, the Free Society did not turn out to be Berlin's answer to the Munich Secession. After the Free Society announced a spring festival at a prominent Berlin hotel, news of its activities was eclipsed by the controversial exhibitions of the spring and summer of 1893 in Berlin. In the months that followed, Rosenhagen repeatedly expressed disappointment over the failure of the artists of the Free Society to back efforts for change within the older society. His disappointment over this group was mitigated by news in December 1892 of the formal inauguration of the new German Art Society, with more than five hundred members and an amazing roster of eminent Berliners among its leaders. Original plans for this organization had been laid in April 1892, in the wake of the magistrates' rejection of the young artists' petition. Convinced of the necessity of finding new sources of support for young artists, a sympathetic official gathered a group of older artists and prominent citizens to create a comprehensive art society that would encourage patronage of art among Berlin's wealthy classes. Under the leadership of bankers, publishers, and museum directors, the society flourished. By contrast, the Free Society continued to hold meetings for its members but remained well outside of the politics and publicity of the art world.[55]

The tempest around the Munch exhibition did, however, focus the attention of the art journals upon the mounting tension in Berlin's art world. Their thoughtful reviews of Munch's work served to emphasize the provincial conservativeness of the official Berlin art. The account in Der Kunstwart of the happenings in Berlin opened with a sarcastic reference to graveyards: the Munch exhibition had destroyed the "peaceful rest" of Berlin's art world. Outlining the events, the report maintained that the problem was not Munch's paintings but the more fundamental issue of limiting artistic freedom. Avenarius then printed two favorable reviews that discerned an uncommon artistic talent in Munch's sketches. Commending his fresh observation, sure color, and good use of the play of light, both critics analyzed specific works that conveyed marvelous moods and a deeply subjective inner life. They acknowledged that philistines of Berlin would be offended by the sketchy abstraction of some of the more radical work. But as one of them put it, such a passionate artist could pose a threat to art only in Berlin, where his work would rudely shake the comfortable fanatics out of their stylistic easy chairs.[56]

Writing from Berlin at the end of the year, Springer viewed Munch's combination of exceptionally fine work and unfinished sketches to be the accidental catalyst for a storm that had been brewing for some time. In general, he wrote in Die Kunst für Alle, people felt that the crux of the scandal was not about Munch; rather, it was about combating the uncomfortable ideas of the young artists. "So now," he exclaimed, "the Berlin artists also have their Secession!" Although pleased at the prospect of change, Springer regretted that this was not a friendly division but one that had been mishandled until it had become a bitterly hostile rupture. This hostility was fully expressed in Rosenberg's diatribe in

Kunstchronik in which he hoped the "gross aberrations" of Munch's "scribbles" would convince the Society of Berlin Artists to have nothing more to do with such experiments.[57]

An unexpected measure of the animosity and pressures generated by these events in the Berlin artists' community appeared in Rosenhagen's editorials. In little more than a month after his enthusiastic welcome of the Munch exhibition as the end of the Werner era, Rosenhagen had to defend himself, in a long, convoluted statement, against charges of acting under foreign influences. Although the "garbage snoopers" seemed to think they could uncover his motives for writing by examining foreign newspapers, Rosenhagen found it necessary to insist that his actions were grounded in wanting the best for Berlin artists. In the same issue he published a harsh attack upon Munch—"he suffers from a fashionable disease, the 'milieu disease'"—and upon his paintings—"coarse servile copies of his French masters," although he thought it premature to deny that Munch had talent.[58]

Of one thing he was certain: Munch was using his martyr's halo to attract the scandal-loving public even though they would find the paintings unintelligible. Four months later Rosenhagen was angered by Munch's application for membership in the Berlin Society of Artists. Referring to him as a "superfluous person," not really an artist, the critic charged him with having already caused a catastrophe for the Berlin society and returning to create another fiasco. Whatever the reasons for this turnabout in his view of a foreign, French-influenced artist, Rosenhagen also backed off from his steady criticism of Werner until October, when another controversy erupted in the artists' society. Whether or not he felt pressured to demonstrate his loyalty to German artists, in January he published an article by Voll, "German Art," that, beginning with a lament about the Germans' peculiar need to imitate other people's art, celebrated the steadfast Germanness of the "national-German artist," Hans Thoma.[59]

It was in the aftermath of these divisive and acrimonious events that the Berlin artists and public encountered modern art on a scale that was impossible to ignore. Munch's small retrospective of fifty-five paintings had shocked only the small number of people, mostly artists, who frequented the gallery of the artists' society. In the spring of 1893 the second show of the Eleven, "much slandered and harshly insulted," proved to be more startling than the first and more heavily attended. Hard on its heels came the Munich Secession, with its foreign contingent, who, unknown in Berlin, increased the irritation against the new art forms that were now dominating the international art scene.

Those who expected the Secession to enlighten a provincial audience were unprepared for the vehement vocal response of Berlin's public, with their laughter and raucous remarks. The invitation to the opening of the Eleven, designed by Hofmann, impertinently depicted a frog in a swamp listening to a putto playing on his flute. The critic for *Das Atelier*, Schmid, had no difficulty reading this image as a warning that the Eleven exhibition was not for those who clung to outworn aesthetic ideals. He interpreted the frog in the swamp as a metaphor for indolence and idleness, for stagnating intellectual ordinariness. "Why," he wrote, "does a frog—this stereotype of the endlessly croaking crowd, of the mass of the people called the public—creep out of its swamp?" Nevertheless, he urged those who resisted the new art to go to Schulte's and make the effort to understand the paintings of Skarbina, Liebermann, and even Hofmann. Yet his pessimism broke out: "Never has that public, which has claimed the honorary title of 'cultivated,' demonstrated itself to be so thoroughly uncultivated as before these works, where it outdid some of our 'most worthy' critics in its lazy avoidance of thinking and its lack of sensibility." Also shaken by the public ridicule of the Eleven artists and of the Munich Secession in May, Rosenhagen was outspoken in his condemnation of the barbaric ignorance of the public, the

new society also inspired the Grand Duke of Hesse Ernst Ludwig to create an artists' colony, Mathilden-höhe, which flowered with brilliance in the first years of the new century.[66]

The formation of the Dresden Secession was for Rosenhagen yet another promising sign that aspiring artists everywhere were working to free themselves from "non-art." Although his expectation of a secession in Berlin appeared premature at this time, he remained confident that these emerging secessions could unite to form a powerful new force for reform. As early as the fall of 1892 he had advocated the formation of a national federation of secessionist groups that would draw together "all the

modern, aspiring elements" in order to build a powerful, centralized force driving the new ideas. This "German Secession," he stressed, would make possible the rapid "crystallization of the modern" into a vital, unified German art. Writing in imperial Berlin and addressing artists, many of whose embedded resistance to change had been demonstrated in the Munch affair, Rosenhagen tempered his ongoing commitment to the contemporary art of the Munich Secession with nationalism. Triumphantly comparing the Munich Secession to the French, the Scots, and the English, Rosenhagen proclaimed: "Once again we have *German* painting."[67]

This process of absorbing secessionism, despite all its reputed radicalism, into national identity was not difficult to accomplish given the common rhetoric among critics of all persuasions about the individuality, inner depth, and sensitivity of the German character. These very qualities were mirrored in the language of the secessions and their apologists, as exemplified by a voice from Dresden in 1893 defining the secessions as the gathering of freethinking men, without any preconceived artistic orientation, whose fundamental principles were "artistic skill, individual sensitivity, and expressive power."[68] These rhetorical parallels enabled critics such as Rosenhagen or Avenarius to endorse and promote the secessions as the vehicles of renewal and reform that simultaneously upheld the highest German ideals.

Fig. 116 **Leopold von Kalckreuth (1855–1928),** *The Rainbow*, **1896. Oil on canvas, 28 x 39 3/8 in. (71 x 100 cm). Bayerische Staatsgemäldesammlungen, Neue Pinakothek Munich.**
Ferdinand Keller, a senior professor at the Karlsruhe Academy and the dominating conservative leader within the Karlsruhe Artists' Association, has been compared to Lenbach in Munich and Werner in Berlin. His opposition to changes in the academic curriculum and in exhibition policies led Kalckreuth, Robert Poetzelberg, and Carlos Grethe, all newer professors at the Karlsruhe Academy, to form the new Karlsruhe Artists' League, which they preferred to call a "league" rather than a "secession." Three years later all three left Karlsruhe to accept positions at the art school in Stuttgart, where they soon formed another new group, the Stuttgart Artists' League.

MODERNISM: ACCEPTANCE AND RESISTANCE

In August 1894 a lengthy article on Franz Stuck appeared in an established cultural review. The article was notable for two reasons: it was written by a woman, Anna Spier, and in it she laid out the argument that the German art world had achieved a level of rich diversity and tolerance. Introduced by full-page reproductions of Stuck's paintings, the article began with an extended reflection upon the revolution affecting all sectors of cultural life in Germany in the last decade. Discussing the responses to the challenge posed to traditional painting and to the often hidebound academy by contemporary developments in painting, Spier asserted that the decisive battle had taken place during the previous summer. Then, the public, whose taste remained anchored in the comfortable art of past eras, had apprehensively watched the struggle unfold over the Munich Secession, expecting the old art to be consumed by a great conflagration, out of which would arise, phoenixlike, a radically new art. When, however, the Glass Palace and Munich Secession exhibitions opened, the public discovered old artists and young ones, conservative painters and radical extremists, hanging side by side in both exhibitions. The unexpected outcome of that "battle-ridden" summer, she wrote, was the lifting of the dreaded notion that a brand-new art based on an intolerant stylistic program would totally displace the old. Instead, Spier maintained, both Munich exhibitions had confirmed the organic continuity of artistic evolution, even as those who genuinely expressed the new era and the new times in their art also demonstrated that there was no single approach in the new art.

Spier was insistent on the rights of artists who lived in this time "pregnant with new ideas" to choose not to follow those ideas. Equally, she pleaded for the legitimacy of eclectic artists who appropriated and modified new ideas to appeal to the marketplace. If their work met the public desire for beauty, it should not disturb modern artists, for "the motley crowd needs gaudy pictures." Convinced of the sanctity of individualism and individual rights, Spier argued, "We have today finally come so far . . . that one can be tolerated without ruining the other." Contemporary extremes and differences visible in the paintings in the exhibitions could coexist under "the rule of newly strengthened tolerance and pluralism. . . . Differentiation," she wrote, "is the sign of our times." With greater complexity and sophistication in the modern world, greater diversity had become an essential condition in the world of art. Confronted by the multiplicity of impressions in the modern world, artists had to abide, Spier believed, by the law of individual freedom and the sovereignty of individuality.[1]

Spier's affirmation of tolerance and of individual difference as the essential qualities of modernity represented an idealistic and at the same time realistic view of the contemporary art scene in the latter half of the 1890s. Her liberal vision encompassed a pluralistic world of art in which Max Liebermann's light-dappled orphanage scenes could coexist with Vilma Parlaghy's conservative portraits of royalty, Hans Thoma's meticulously painted German families, Stuck's sensual centaurs, and Gotthardt Kuehl's impressionistic cityscapes. This is what was actually taking place in the large exhibitions. The diversity in style and in content of works available to the viewing public was exceptional. As the rebels of the eighties became established figures without

whose work no comprehensive exhibition was complete, the best of the older genre painters, with their finely modeled figures and warm brown tones, as in the Tyrolean village scenes of Franz von Defregger and the cheerful rotund monks of Eduard Grützner, maintained their popular appeal to the exhibition-going public. The superbly modeled apes of Gabriel Max vied with Albert Keller's luminous paintings of crucified female saints and elegant ladies, while the light, bright landscapes of meadows and tree-lined brooks, captured on hundreds of canvases, provided a dominant theme. On top of these came the new symbolist figuration of a younger generation following in the footsteps of Arnold Böcklin and Max Klinger. This variegated scene was enhanced by the large number of foreign artists, whose styles ranged from dreary conservatism to startling radicalism and whose art became an increasingly significant presence in the great exhibitions and the art dealers' galleries as the decade wore on.

All this activity in the German art markets should have delighted those whose liberalism extended to the economic ideals of the competitive market. Diversification and international exchange of products were fundamental characteristics of late-nineteenth-century industrial economies, and in the 1890s internationalization inexorably pervaded the European art world, with its great exhibitions, traveling artworks, and dealers' market.[2] In this expanding world, the proliferating diversity and transience of styles were increasingly accompanied by the liberal tolerance that Spier perceived to be central to modernity. At the same time, the concern for national identity that had been a regular companion of the search for a modern art continued to assert itself; and with nationalism came attitudes of intolerance, even as the unquestioned triumph of modern diversity bred its own forms of prejudice. Manifesting all of these interlocking forces, contradictory and complimentary, an extraordinary German art journal with the all-encompassing Dionysian name *Pan* began publication in Berlin in 1895.

PAN: ELITE AND MODERN

Nothing about *Pan* was ordinary, just as everything about *Pan*—its formation, its internal struggles, its content—represented the pluralistic state of the German art world in the mid-nineties. Above all else, *Pan* was exquisitely elegant and outrageously expensive. Innovatively printed in multiple typefaces with exceptional care upon handmade paper, the journal incorporated contemporary poetry and prose fragments into boldly conceived graphics designed by modern artists. Original engravings on heavy, cream paper and fine reproductions of artworks on appropriately tinted paper, each covered by delicately patterned rice paper, filled each issue. Individual issues had either forty or sixty pages of illustrated text and twelve to sixteen art plates. During its five years the journal published prose and poetry by 180 writers and featured 150 artists.[3]

If the luxurious design of *Pan*'s first issues was breathtaking, the incongruity of its creators and supporters was even more startling. The idea for a journal uniting contemporary literature and art was hatched in a small, international, bohemian circle that gathered in the early nineties at a Berlin wine cellar happily named At the Black Piglet. Fascinated by irrationalism and eroticism, these intense, anarchic émigrés were joined by young German aesthetes, mostly writers, who shared their obsession with sexuality. Among the regulars were the artist Edvard Munch and the writers August Strindberg and Stanislaw Przybyszewski, who dominated the group with his demonic, orgiastic ideas. Out of this heady, literary atmosphere three writers emerged: Julius Meier-Graefe (1867–1935), a little-known young writer; Richard Dehmel (1863–1920), a symbolist poet celebrating erotic life; and Otto Julius Bierbaum, an experienced writer and editor. Determined to create a new aesthetic journal devoted to the best of modern art and literature, these three men from Berlin's literary bohemia allied them-

selves with two young aristocrats, Baron Eberhard von Bodenhausen (1868–1918) and Count Harry Kessler (1868–1937), through whose contacts and influence they were able to gain the support of an astonishing roster of the social, financial, governmental, and cultural leaders in Germany.[4]

Appealing to the frequently voiced desire of critics to separate art from the marketplace, the organizers set up a nonprofit, limited-liability company in which individuals interested in the arts could buy shares each worth one hundred marks. The goal of the company, legally registered in June 1894, was to establish a minimum capital fund of one hundred thousand marks to enable a high-quality modern journal to operate free of advertising and financial pressure, or, more significantly, free from the need to satisfy the taste of the public. The pattern, not unlike that of the nineteenth-century art societies, was an ambitious capitalist undertaking defined by the official civil code, which was regularized for all of Germany in 1896.

This most un-bohemian, entrepreneurial plan succeeded within a year. By April 1895 the requisite funds had been raised from 350 members, who almost without exception were drawn from the upperclass establishment and from new commercial and financial wealth. This successful campaign, which would have been impossible twenty years earlier, was a strong indication that modern art had become socially acceptable. Members' names, along with their occupations and cities of residence, were published regularly as a public acknowledgment of their patronage of this sumptuous presentation of modern art. Three heads of state—the kings of Saxony and Württemberg and the prince regent of Bavaria—headed the list of patrons in the first issue. By the third volume the names of the emperor, William II, along with the king of Sweden and his heir, had been added to the roster of royal patrons. State and municipal officials, members of the royal courts and nobility, lawyers and free professionals formed the backbone of support for Pan, with their

numbers increasing from one-fifth of the patrons for the first volume to one-third for the third volume. Artists, directors of major museums, and other art officials constituted the next largest group and held the majority on the board of directors, which legally controlled the company. Industrialists, financiers, academics, established writers, and a small number of military officials made up the remaining patrons.[5] The Pan Company represented a remarkable gathering of influential cultural officials and wealthy individuals willing to underwrite a journal devoted to modern art. These elite supporters unquestionably inhabited a profoundly different social and cultural world from the world of those who conceived of the journal, a not uncommon phenomenon for patrons of artists. In this case, however, because of the public nature of the patronage and, more fundamentally, because of the corporate structure of the Pan Company, the divergence of conceptions surrounding modern art and its public became the source of contention.

The first issue of Pan, in April 1895, defined its goal succinctly: founded on the conviction of the "exclusive character of art," Pan was to be "a purely artistic publication that is not guided by the wishes of the general public." Thanks to the freedom provided by members' financial investment in the Pan Company, the journal was dedicated to "creative art in the widest sense . . . without a particular point of view on art." According to this editorial statement, the journal would provide an organic view of the whole realm of contemporary artistic production, embracing the old and the modern in the visual arts, as well as literature, theater, and music. To carry out this ambitious goal meant, as the editors made clear, addressing the journal only to those circles of people who were already committed to supporting the arts. Thus, artistic diversity was to be achieved at the expense of economic or social diversity.[6]

The mechanism for ensuring the desired elite audience was simply to make Pan expensive and in so doing to increase its desirability in the highest social

circles. Issued quarterly, the journal was produced at three levels of quality: general, luxury, and artist editions. Nonmembers could subscribe only to the general edition, at an annual fee of 75 marks, or the luxury edition, at 160 marks. By contrast, the annual subscriptions for *Der Kunstwart* and *Die Kunst für Alle* were 10 marks and just under 15 marks, respectively. Even an annual subscription for two folio volumes of *Die Kunst unserer Zeit* cost only 36 marks. Subscription prices for members of the Pan Company varied on a sliding scale depending on the

number of shares held. As it turned out, the journal achieved a more exclusive audience than the editors had expected. Although sixteen hundred copies were printed for each issue in the first year, the number of subscribers at its height in 1897 was less than half that number.[7]

The sheer cost of the journal and the overall elegance of its design figured prominently in the skeptical, ambivalent reviews that greeted the first issue. *Pan* was perceived to be an expensive luxury for connoisseurs and art lovers. Those who fought for a

Fig. 117 *A.* **Franz Stuck, "Pan."** *B.* **Paul Scheerbart, "The King's Song," with drawings by Axel Gallén (1865–1931). Both reproduced in *Pan* 1, no. 1 (Apr.– May 1895): cover and pp. 2–3, respectively.**
The title *Pan*, with its intimation of a cosmic, all-encompassing being, was particularly suited to a journal that intended to cover all of the arts. The striking image by Stuck of the Greek god, half-human and half-goat, that appeared on the cover of every issue of the five volumes (*A*) also strongly emphasized the Dionysian cult exalted by Nietzsche. The first issue opens with a parable by Nietzsche, "Zarathustra before the King," with drawings by Hans Thoma, immediately followed by the double-page spread of "The King's Song," in which a young couple raised above the earth on a high throne are caught in a swirling dance of stars (*B*).

The editors could scarcely have found a more effective way to convey their Nietzschean aspirations. The design of the first two issues brilliantly evokes Nietzsche's description of the ideals of his "gay science": "light feet; humor, fire, grace; grand logic; the dance of the stars; exuberant spirituality; the shimmering light of the South; the smooth sea—perfection" ("Der Fall Wagner" [1888], in *Gesammelte Werke*, 17:32). Count Harry Kessler, a co-founder of *Pan* and a fervent follower of Nietzsche, ensured that fragments of Nietzsche's writing and images of the writer continued to be published in all five volumes.

Whether created inadvertently or deliberately, Stuck's cover drawing of the shaggy-goat-headed god of the woods and fields, who enticed humans into Arcadia by playing on his wooden pipes, could be seen as a jovial version of the seventeenth- and eighteenth-century anti-Semitic caricatures of a horned Jewish devil.

A

B

modern art accessible to the public found *Pan* to be a pretentious "salon and studio-paper" whose price and elegance made it unavailable to anyone not blessed by great wealth. Publicly voiced disapproval of the cost and opulence of the journal was echoed by founding members of *Pan*'s editorial committee. Both Bodenhausen and Dehmel addressed the problem in print. Bodenhausen sent an article titled "Art for the People and *Pan*" to *Das Atelier*, which was reprinted in *Der Kunstwart*, in which he admitted that *Pan* was a collector's item, unsuited for a genuine mass publication, but justified it as reaching those influential people whose patronage could have an impact on the art world. In a letter written in March 1895, shortly before the first issue of *Pan* appeared, Dehmel had argued that "art for the people" was a beautiful idea but an unrealistic one since most people did not have the means to appreciate art. He thought that until the time came when the people could support art, it should be made available to those groups who understood its value. Now, writing in the second issue of *Pan* itself about the "deep hunger" among the people for art and culture and lamenting the failure of society to satisfy that hunger, Dehmel implicitly criticized the journal for its blindness to the cultural desires of the masses.[8]

Pan's sumptuousness was not the only quality that disturbed critics. The editors' understanding of what constituted the best in modern art was at the heart of the controversy that gathered over the first two issues. As the originators and founders of the Pan Company, Meier-Graefe and Bierbaum had been appointed by the board of directors, who were legally responsible for establishing the policies, to be the first co-editors, assisted by an editorial board on which both Bodenhausen and Dehmel served. The first issues unmistakably represented the editors' aesthetic predilections formed in the circle of the Black Piglet. Celebrating their ideological debt to Friedrich Nietzsche's Zarathustra, with his romantic disdain for the masses and his call for the artist's withdrawal to the heights, they combined

symbolist and neo-romantic writing with paintings and drawings by artists, a considerable number of whom were relatively unknown before their appearance in *Pan* (fig. 117). Meier-Graefe's and Bierbaum's fascination with sensual and symbolic imagery meant that they ignored the work of most of the established modern artists who served on the board of directors. Only those whose work fell into the fantastic or symbolist realm were included in the first issues by the editors. The integration of poetry and graphics on each page was also given a significantly international tone. A poem by Stéphane Mallarmé was accompanied by an enigmatic drawing by Fernand Khnopff; Otto Eckmann created stylized borders for a poem by Paul Verlaine; an original engraving by Félicien Rops followed a plate of Böcklin's *Dragon-Killer*; Ludwig von Hofmann illustrated Novalis's "Hymn to the Night"; and Joris-Karl Huysmans wrote about Matthaeus Grünewald's *Crucifixion* (1515).[9]

Symbolist and international, the first issues were pervaded by the sensuality associated with the French poets who called themselves Decadents and came to be known as Symbolists in the Paris of the 1880s. These writers were introduced to the educated public in Germany through Max Nordau's strongly biased reports from Paris and his influential book *Degeneration*, published in 1892. Nordau gave lengthy descriptions of the literary work of the Symbolists, including Huysmans, whose novel *À rebours* (Against nature, 1884) defined the decadent antihero, and Verlaine, whose sordid life contributed to his reputation as, along with Mallarmé and Arthur Rimbaud, one of the legendary creators of French Symbolist poetry and one of the "accursed poets."[10]

Although Nordau admired the lyrical quality of the poetry, which he quoted extensively, particularly Verlaine's "pearls among French poems," he was severely critical of the moral and social attitudes expressed in this writing. Relying upon the latest social and psychological studies, Nordau, with his liberal

A

B

Fig. 118 *A.* **"Modern Literature: Woman—You Eternal Mystery!"** *Fliegende Blätter* **107, no. 2712 (1897): 30.** *B.* **R. Griess, "The Painter's Lament,"** *Fliegende Blätter* **109, no. 2767 (1898): 63.**
The *Fliegende Blätter* cartoonists frequently made fun of *Pan*'s aestheticized layout, with its outer borders of swirling forms, entwining animals, fish, and plants, which enclosed texts and complex images of distraught women and despairing men.

ideals about reason and progress, argued that the French poets manifested symptoms of mental regression and emotional instability in their pessimism, mysticism, and perverse sensuality, which were contributing to a disturbing strain of degeneration that was spreading across Europe. Nordau's polemical book rapidly became a bestseller, going quickly through multiple editions and translations, creating the intellectual setting within which *Pan* was received when it began publication three years later. Meier-Graefe's and Bierbaum's finely tuned success in interweaving works by these French poets with those of like-minded German writers such as Nietzsche, Scheerbart, and Dehmel and symbolist artists from Germany, Belgium, and Norway only served to demonstrate the far-reaching potency of this newest aesthetic movement.[11]

Pan's presentation of these Symbolist writers—most of the French poems were not translated—in elegantly stylized formats, in which a different typeface on each page merged into the graphics, elicited from Ferdinand Avenarius an exasperated epithet: it was, he wrote, a chaotic collection, an "allegorowitsch-Symbolizetti-Mystifizinski" mess (fig. 118). His complaints about *Pan* that produced this mischievous transformation of words were voiced in a lead article in *Der Kunstwart* written almost immediately after *Pan* first appeared. There, in a mixture of admiration and envy—we can imagine him thinking, "If only I had had such financial backing, think what I could have accomplished"—he argued that *Pan* failed to convey an intelligible or comprehensive view of modern art to the reader, that its artwork did not represent either the newest or the best of modern art, and that the serious work of major modern artists had been neglected in order to promote an idiosyncratic view of fantastic themes. When the second issue appeared, Avenarius characterized it as "honestly meant artistic tomfoolery" and "affected foppishness," even as he conceded that the journal was a valuable addition to the German art scene. Avenarius was not alone in his ambivalent response to *Pan*'s

sensual presentation of the newest European trends in decorative and symbolist art. In its review, *Die Kunst für Alle* welcomed the "thoroughly original artistic impression" created by *Pan* but expressed reservations about the layout, which, though sophisticated, tended toward a motley gaudiness. Nevertheless, the writer hoped the public would support this new journal, which could contribute significantly to cultural life in Germany.[12]

If the critics were not happy with the new journal, neither were powerful members of *Pan*'s board of directors. Rumblings expressed in private letters surfaced in the first issue, where Meier-Graefe and Bierbaum openly rejected views expressed by board member Wilhelm Bode about the design and production of *Pan*. The second issue showed further signs of disagreement in the ranks of the board members, as both Dehmel and Alfred Lichtwark raised questions about the type of art and the appropriate audience for the journal. Others were uneasy about the hedonistic and esoteric nature of the poetry and short stories; particularly upsetting for some was Dehmel's Dionysian poem "The Drinking Song," with its framing drawing of a drunken orgy of satyrs, men, and women. The dissatisfaction on the part of the board led to the ouster of both editors in September 1895. The third issue carried a discreet notice that fundamental differences between the editors and the board of directors had led to the resignation of the editors and the division of responsibilities between a newly constituted commission responsible for editing the journal and a small committee overseeing the business affairs. The modern corporative structure enabled the board to assert its legal right to control the journal. Through their zeal for the newest French writers and artists, their certainty in their own judgment, and their financial mismanagement, Meier-Graefe and Bierbaum had fatally ignored the realities of their position in relation to the influential figures they had recruited for the board.[13]

This controversy over the content of *Pan* distinctly

manifested the transience, diversity, and contradictions in perceptions of modern art at this time. Transience was reflected in the ironic position of the modern German artists—men who had fought for their new vision of light-color painting in the 1880s and early nineties—whose very positions on the board of a high-profile journal dedicated to modern art marked their successful transformation of German art. Now their work was being passed over by younger advocates of the newest decorative styles, with their symbolist and erotic overtones. Faithful to the goal of creating a purely artistic journal that maintained the exclusive character of art for a limited appreciative public, Meier-Graefe and Bierbaum as young editors of *Pan* tangibly demonstrated the continuing transformation of modern art in Germany through their absorption with these newest styles. In this, however, they violated *Pan*'s stated goal of presenting creative art "without a particular point of view."

This idealization of diversity—of undogmatic artistic movements that allowed for the free play of creativity and for the emphasis upon pure quality—was a common theme in contemporary critical writing and in the programmatic statements of the secessions. From this vantage point, Meier-Graefe's and Bierbaum's two initial issues of *Pan* could be condemned as presenting only one facet of a richly articulated field of modern art. On the other hand, these issues could be praised as superb demonstrations of Symbolism's challenge to both the stylistic preoccupation with open-air painting of the established modern German artists and the social conventions of the bourgeoisie. Whatever the intention, the audacious foregrounding of Symbolist decadence combined with internationalism in this display of a pan-European literary and artistic style was, finally, the breaking point between the editors and their board.

The third number of *Pan* openly exhibited this fundamental disjuncture between the editors and the board. Accompanying the announcement of

the new editorial arrangements, a brief statement notified the readers that the former editors were responsible for this issue, in which foreign authors and artists dominated. Particularly controversial was an original lithograph by Henri de Toulouse-Lautrec of the Parisian *variété* dancer Marcelle Lender. In the midst of this display of international art was an article by Lichtwark in which he bluntly asserted that "*Pan* must be a *German* art journal." Insisting that an international journal was inappropriate because Germany was already flooded with influences from abroad, he argued that Germany's cultural strength lay in its multiple centers, where local traditions, customs, and people could nurture an authentic modern art. The task of *Pan*, he reiterated, should be to strengthen national culture, not to weaken and dilute national artistic integrity by propagating international art. To this end, he proposed that *Pan* should focus on regional diversity by devoting entire issues to creative contemporary work in the historical cultural centers.[14]

Lichtwark's article opposing the promotion of international art was starkly juxtaposed to the internationalism in this issue of *Pan*. Nevertheless, the passion of his argument here should not be read as a rejection of his own significant role in exhibiting and commissioning Impressionist and Post-Impressionist French artists at the Kunsthalle in Hamburg. It was instead an expression of the convictions held by many of his colleagues that, on the one hand, the true sources of art were local and regional, and on the other, art must be viewed in an international perspective. Thus, receptivity to foreign art was always in tension with the fear that foreign art, rather than inspiring authentic local art, would destroy it. The complexity of Lichtwark's stand was demonstrated by the fact that his call for the Germanizing of *Pan* was published only a few months after his organization of the first great exhibition in Germany featuring French Impressionists along with modern German artists at Hamburg's International Exhibition in 1895 and as he was facing increasing local opposi-

tion for his championing of modern art. For Lichtwark, the presentation of the best of foreign art was always to be balanced by the cultivation and support of outstanding local artists. *Pan* under its first co-editors violated that balance in its wholehearted internationalism. This clash of viewpoints was emphasized by a note in the journal informing readers that Lichtwark's article had been written as a polemic before the departure of the former editors and was to have been followed by a response from them explaining their dissenting position. Those views were obviously no longer necessary.[15]

For the next four years *Pan* was overseen by members of a new editorial commission working with two new editors. After two lackluster issues, the second volume began with a new statement of purpose: "*Pan* is a German journal for art and literature and will not serve any single movement." Recognizing the "decentralized nature of our culture," the journal announced a new program that would present "the artistic life of Germany in its manifold diversity." Concentrating in successive numbers on Berlin, Dresden and Leipzig, Munich, and Hamburg, the journal featured paintings and graphic works of established modern artists, as well as reports on the secessions and the new artists' groups, such as the Eleven and the newly founded Hamburg Artist Club. Foreign art, in accordance with the new nationalist orientation of the journal, was to be included only "when it appears to be fruitful for German art" and then was placed at the end of the issue. This fundamental shift from an international conception of the arts to regional nationalism, orchestrated by Lichtwark, was accompanied by a taming of the graphic design and page layouts, producing a more serious yet still elegant journal.[16]

Although the succeeding volumes were not as extravagant as the first one, the journal maintained its reputation for excellence, attracting influential conservatives to membership, including William II, despite his reputation for opposing modern artists. Liebermann and Hofmann were added to the edito-

rial board, which already included the cosmopolitan, internationally minded Kessler. Under their influence, Lichtwark's regional model was dropped in favor of featuring individual German artists and a steadily growing emphasis upon foreign artists. The distinguished membership of the journal served to authenticate the position of modern artists, whether new, young ones or older, established ones. Artists whose works appeared regularly and who were also given the honor of being featured artists—Böcklin, Klinger, Liebermann, Hofmann, and Leopold von Kalckreuth—were all at the height of their popularity in the last years of the decade.[17]

The editors' belief that they were representing the finest German artists was matched by their attention to the upsurge in Germany of interest in and exhibitions on French Impressionist and Neo-Impressionist artists. In the 1897 volume, a special section on recent French art presented an article on Gustave Moreau and his followers and another one by Woldemar von Seidlitz on Edgar Degas, occasioned by the purchase of a Degas pastel by the National Gallery in Berlin. In the July 1898 issue, at Kessler's insistence, equal attention was given to Böcklin and to French Neo-Impressionist artists, with a lengthy article by Paul Signac. When Liebermann was the featured artist in December 1898, the important essay on Degas that he had written was also published. French Symbolism again was featured in several articles accompanied by poems in translation. And then, remaining true to its elitism, in its last issues *Pan* effusively honored Rops and Aubrey Beardsley as the consummate modern artists, even as writers explicitly defined their art as esoteric pleasure unsuitable for the public.[18]

In its last years *Pan* settled into a predictable pattern. Beginning with a variety of poetry and prose fragments with refined graphic frames or headings, the journal moved to essays on art, frequently written by members of the editorial committee, especially Bode and Seidlitz, and then to reports on art at home and, frequently, abroad. The anxiety over national identity expressed by Lichtwark abated as the editorial committee, dominated by senior officials in the museum world, turned the journal into an elegant showpiece for Germany's foremost modern artists, recognizing also the importance of foreign artists. Nonetheless, *Pan* was unable to sustain its position as the elegant art journal for the social elite. Membership rolls sank, notwithstanding the support of a disproportionate number of highly placed aristocratic men and women. Expensive, *Pan* was not in a position to adapt to the rapidly changing cultural scene at the turn of the century.

In the last issue, of May 1900, Bode presented a melancholic assessment of the state of the visual arts. Dispirited by the affectedness and incomprehensibility of symbolism, the ineffectiveness of naturalist painting, the low state of monumental sculpture and architecture, and the absurdity of efforts to devise a national art, he viewed the current scene as "a stewing and bubbling, a searching and straining everywhere, uncertainty and doubt, disorder and formlessness, stylistic contrariety as the foundation of an ostensible new style!" Nonetheless, he resolutely concluded with the expectation that the modern movement would regain its early sense of direction and strength and not fall back into conservatism.[19] A significant factor contributing to the uncertainty on the German art scene and, at the same time, providing an impetus to the search for new stylistic possibilities was the steadily increasing visibility in the late nineties of French Impressionist and Neo-Impressionist art in Germany.

FRENCH MODERNISM AND THE RETREAT FROM THE PUBLIC

Since the early nineties paintings by modern French artists had made scattered appearances in the great exhibitions: in Munich, Édouard Manet, Claude Monet, and Alfred Sisley in 1891, Degas and Monet in 1893, Sisley and Camille Pissarro in 1895 and

1896, Toulouse-Lautrec in 1896, and Monet and Manet in 1897; in Hamburg, Manet, Monet, Pissarro, Sisley, and Pierre-August Renoir in 1894. Reviews in the journals mentioned their presence, generally with positive comments. Public attention was aroused, however, in the winter of 1896, when Hugo von Tschudi, the recently appointed director

Fig. 119 **Édouard Manet (1832–1883), *In the Conservatory*, 1878–79. Oil on canvas, 45 3/8 x 59 in. (115 x 150 cm). Nationalgalerie, Staatliche Museen zu Berlin— Preußischer Kulturbesitz.**

In June 1896, shortly after he was appointed director of the National Gallery, Hugo von Tschudi traveled to Paris with Max Liebermann to examine French paintings at the Durand-Ruel Art Salon. Impressed with this oil by Manet, he made arrangements in Berlin to purchase it, along with a landscape by Claude Monet and a pastel by Edgar Degas, with private donations. William II gave his official approval for the transaction. In December the three French Impressionist works were shown in the first exhibition of Tschudi's new acquisitions, which included more than thirty paintings by internationally recognized modern artists of the 1880s and 1890s. The majority of these had been purchased at the International Berlin Exhibition of 1896 with funds provided by the emperor. Largely landscapes, the paintings represented Scandinavian, Italian, and French artists, as well as artists of the Hague School. Tschudi had also purchased several by John Constable, Gustave Courbet, John Lavery, and Giovanni Segatini, but the most radical ones were the three French Impressionist paintings.

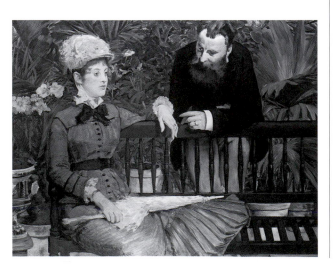

of the National Gallery in Berlin, arranged a public exhibition of newly acquired international paintings, among which were three impressive ones by Manet, Monet, and Degas (fig. 119). In the next two years, Tschudi added significant work by Pissarro, Signac, Sisley, and Paul Cézanne—his first purchase by a museum—as well as important paintings by contemporary Scandinavian, Italian, English, Dutch, and nineteenth-century French artists.[20]

Criticism in the journals was largely affirmative, although like many conservatives, Adolf Rosenberg in *Kunstchronik* was dubious about purchasing these modern foreign works for a "national" museum. A year later, a critic in the same journal commented that Tschudi's actions disturbed the "fearful chauvinists," but he welcomed the "museum for modern art" that Tschudi was creating. Similarly, a reporter in *Die Kunst für Alle* expressed his delight over the Tschudi additions in a long review analyzing each of the paintings to demonstrate the strong diversity of contemporary modern art in Europe. In *Der Kunstwart* Paul Schultze-Naumburg approved of Tschudi's purchases of French and German modernists and of his brilliant reorganization of the National Gallery in 1897, transforming it from a dreary Prussian collection into an international art gallery. The academic, historicist paintings that had been the backbone of the collection were relegated to the large central rooms, which, as one reviewer put it, those who loved art could easily avoid. The museum now featured special Adolph Menzel and Böcklin rooms; a gallery of contemporary German artists, including Liebermann, Wilhelm Leibl, Wilhelm Trübner, and Dora Hitz; and carefully arranged small galleries of French Impressionist and other international modernist paintings.[21]

This public affirmation of the international modernist movement by one of the royal museums—the only one dedicated "To German Art"—served to accelerate what some conservative nationalists perceived to be the "invasion" of Germany by radical foreign art, raising public protests and heated de-

bate over the acquisition of that art in the Prussian parliament. That this trend may also have been perceived by some to be acceptable to the emperor—after all, the National Gallery stood under his aegis, and his name headed the membership of *Pan*, with its promotion of the troublesome foreign artists—may have contributed somewhat to the rapid spread of interest in French modernists. From another standpoint, for some, turning to French modernism may have been an expression of dissatisfaction with the well-known conservative views of the emperor, who two years later curbed Tschudi's transformation of the National Gallery. This speculation on attitudes aside, twice in 1897 the Parisian art firm of Durand-Ruel found it worthwhile to bring to Berlin a collection of French art from Millet to Degas. Exhibited in the Hotel Kaiserhof, eighty-seven paintings in all were for sale, though visitors who were not purchasers were allowed to view them. Reviewing Durand-Ruel's choice offerings, Jaro Springer commented that "it is now well worth importing modern French paintings to Berlin" since private collectors were following Tschudi's example. Indeed, the market for French art grew rapidly until, according to *Die Kunst für Alle*, the Berlin dealers' galleries were almost entirely filled with works from France in the fall season of 1899.[22]

This high visibility of French modern artists in Berlin was due in no small measure to two new art galleries. Joining the Gurlitt Art Salon, with its reputation for showing a variety of French art, the art salon of Keller & Reiner opened in October 1897 and, renovated the next summer, introduced a new luxurious style modeled on Parisian salons to the Berlin art scene. Designed by Henry van de Velde and other proponents of the new decorative arts to resemble elegant parlors, the art salon became a popular gathering place for artists and writers, as demonstrated by a series of poetry readings organized by Dehmel in 1899. A second, equally refined but smaller and more intimate gallery, also designed by van de Velde, was opened in October

1898 by Paul and Bruno Cassirer. Both of these galleries were conveniently located near the older art galleries, Gurlitt and Schulte, along the east and south sides of the Tiergarten, where they were easily reached by their wealthy clientele. The journals enthusiastically reported on these new galleries, especially noting that both were featuring paintings by French modernists.[23]

Opening with a small, select exhibition of works by Liebermann, Degas, and the Belgian sculptor Constantin Meunier, the Cassirer Gallery forthrightly announced its international program. At the same time, Keller & Reiner held a major exhibition of French and Belgian Neo-Impressionist paintings, followed in the next month by an exhibition of paintings by Monet, Renoir, and Pissarro, both of which, reviewers pointed out, caused great interest among the Berlin public. The catalogue for the Neo-Impressionist exhibition was an offprint of Signac's essay "Neo-Impressionism," which had been published in the July 1898 issue of *Pan*. Théo van Rysselberghe, Henri-Edmond Cross, and Signac, whose paintings were among the plates in *Pan*, were singled out as exceptional artists of a style that one critic characterized as "extremely bizarre, but still very interesting work." Simultaneously with these exhibitions of French art, Schulte and Gurlitt began their winter season with the artwork of Hofmann and Klinger, both of whom were regularly shown by Keller & Reiner.[24]

The graceful refinement of both of these new galleries and their overt commitment to the most modern German and European artists conveyed a clear message. This was an exclusive art, designed for an informed, art-loving public. As *Die Kunst für Alle* reported, "Cassirer began in a most promising fashion," in a small building that was "discreetly secluded, as if made for the most intimate art," with an interior that was "noble, gentle, and simple, somewhat erotic, to be sure, so that one would not want to always live there, but perfect for the purpose" of creating the milieu for "the witty painterly

delicacy" of Degas or the "unique intractableness" of Liebermann. This was not for the masses, for the philistine, for the pöbel. No matter how many philistines lived in this city of 2 million, another critic exclaimed, there was "a community of esoterics" who alone constituted the significant public for the art that was being shown in these dealers' galleries.[25]

In these cultivated settings French modernists, judiciously mixed with the more familiar German artists, were displayed in Berlin frequently during the course of the next year, 1899. *Die Kunst für Alle* related in January 1899 that Keller & Reiner was showing a Monet along with Hofmann paintings, while Rops was the centerpiece at Cassirer, followed in April by coverage of the "extraordinary" work of Manet, Monet, and Giovanni Segantini. *Kunst-chronik* in February reviewed a showing of Monet's *Portrait of a Woman* and Manet's *Déjeuner sur l'herbe* sent by Durand-Ruel. In May the journals reported on a Neo-Impressionist exhibition with works by Signac, Cross, and Maximilien Luce at the Bons Art Salon in Königsberg. Considerable attention was given that spring to the large Dresden exhibition at the Ernst Arnold Salon, with its historical overview of French Impressionism from Manet through Seurat and Signac. A summer show of drawings at Cassirer included designs and studies by Degas, Jules Chéret, and Théophile-Alexandre Steinlen, as well as Leibl, Menzel, and Liebermann. In the seventh international exhibition of the Munich Secession, Degas drawings and Monet landscapes evoked the highest praise from the reviewer for *Die Kunst für Alle*. The vogue for French art in Berlin impelled Schulte to install a collection of intimate landscapes and interiors by French salon artists in the fall of 1899, while the Berlin Academy held a show of what the reviewer viewed as mediocre, academic French art. Finally, in October–November 1899 Cassirer mounted an exhibition of seventeen paintings by Manet, an equal number by Degas, and thirty-five by the young Munich artist Max Slevogt. At the same time, *Die Kunst für Alle*

published a heavily illustrated assessment of Manet by Meier-Graefe that began with comments on the recent rapid rise in prices for Manet's paintings—his large works were commanding 100,000 francs—fueled, he argued, by purchases in the German art market.[26]

Writing before this turn to French art in Berlin had begun, Schultze-Naumburg had concluded an essay on the failure of the public to understand the new art with a gloomy vision of art as a hothouse flower tended by a small aristocracy of intelligent people.[27] Viewed in 1899, this vision apparently had not been wrong. Taken together, the retreat of the best German artists to their own shows, the exclusivity of *Pan*, the new, stylish galleries, with their imported French modernism, and the reports of soaring prices for paintings were incontrovertible signs of the withdrawal of the modern artists from the uncomprehending schaupöbel. Those who had dreamt that the German public might become the patrons of a new contemporary art for the unified German nation had to acknowledge the shattering of the ideal of a collective public and the fracturing of the German art world into proliferating styles and artistic camps.

Although Friedrich Pecht remained the managing editor of *Die Kunst für Alle* until his death at the age of eighty-nine in April 1903, his vision of a national art faded as younger voices filled the journal with reports on, depending on the writer's perspective, a richly diversified or sadly fragmented art scene. The journal revealed its shift away from the great exhibitions, with their mass public, to the exclusive dealers, with their privileged public: in 1888 more than seventy pages, one-fifth of the journal, were devoted to the Third Munich International at the Glass Palace; a decade later only five pages covered the Glass Palace, while more than forty pages were devoted to reviews of art dealers' exhibitions. The remaining pages dealt with secessions, artists' organizations, exhibitions across Europe, articles about artists, and other special topics.[28]

From the beginning, *Pan*'s retreat from a concept of a national art reaching the general public had meant explicitly redefining that public in exclusionary terms as those cultivated few who were capable of understanding art. The directors and editors of *Pan* were consistent in addressing only an elite art-loving public that could appreciate the best in German and international art. They dismissed the possibility of aesthetic sensitivity among the masses. In the words of one writer, "the obstinate, obstreperous, arrogant, and pretentious philistine" would require patient cultivation before he would be genuinely receptive to art. Convinced that the educated classes were largely philistine, he wrote, the task of *Pan* was to cultivate the artistic sensibility of a small wealthy circle whose taste would be exemplary for others. Reflecting the editors' consciousness that they were functioning in the realm of high art for the connoisseur, their choice of artworks, from esoteric French and Belgian Symbolist to French Neo-Impressionist, intensified the perception of the inaccessibility of modern art and, despite its avowed nationalism, accentuated the identification of German modern art with foreign sources.[29]

Der Kunstwart followed a different form of redefinition and withdrawal from the ideal of "art for the people." The effectiveness of the journal lay in Avenarius's unquestioned ability to articulate perceptions firmly rooted in his own educated middle-class mentality. Faced with the much-debated question who constituted the public for modern art, Avenarius carefully defined that public, not as the masses, but as those people who were receptive to learning and who were marked by gentility of character, not by wealth. For Avenarius and his middle-class readers, a mass, populist understanding of the public was incomprehensible. To accusations that the public, in their negative response to modern art, had turned into a proletarian rabble, Avenarius responded with the deceptively simple statement that "the rabble is not the people." In so doing, he reconfigured the art public as the people—the *Volk*—whose capacity to

understand art was formed not by class or wealth but by sensitivity, inner character, and local and national identity. "What do we mean by the people," one of his editors wrote, "when it comes to art, . . . roughly the community of all those who harbor a need for artistic impressions. . . , people who are interested and receptive to art."[30]

Thus, whereas *Pan* concentrated upon the exclusive nature of art and its high-born or wealthy patrons, Avenarius in *Der Kunstwart* continued to insist on "art to the people" by redefining the people as a middle-class community of shared values and national identity whose interest in art could be enriched and uplifted. Rejecting the dichotomy between art as luxury for the few and art as popularly appealing to the masses, Avenarius argued that pathbreaking art created by the artistic genius, while not intelligible to many, was the essential foundation for an art that nourished the people. Believing that art "is not a luxury, it is bread," whose purpose was the cultivation of the inner being, Avenarius became an outspoken proponent of art education for the people.[31]

To provide education in the arts and to meet the increasing competition of attractive new journals, Avenarius reformatted *Der Kunstwart* in 1897 to make it more readable. The journal's shorter articles, smaller size, better type, fresh layout, and special reproductions of art were designed to attract a wider audience. In fact, the number of subscribers, which had been at a modest one thousand in 1897, swelled to eight thousand by 1900. To encourage this community gathered around the journal, Avenarius published from January 1898 through July 1899 a series of articles by Schultze-Naumburg pointedly titled "About the Nurture of Art in the Middle Ranks." Using a pre-Marxist term to identify the solid burghers of an earlier historical era, he reinforced the national and class identity essential to Avenarius's definition of the people who would fight "for a healthy, strong, pure, for a German art, which one can love." Full-page plates introduced in 1898

represented this honest, sincere art: they were all by contemporary German artists, with Klinger's work being most favored in the first two years.[32]

Each in its own way, these journals moved away from the idea of a mass public. The large public that continued to troop through the great exhibitions became virtually invisible in the pages of the journals. Now attentive to more limited or exclusive audiences, the journals concentrated on the manifold appearances and variants of the now-established modern art. Once again the central question was reframed. If, at least briefly, the question What is modern? had been satisfactorily settled, the question cropping up with greater insistency was, Is it German? One answer that began to appear in all the journals was the art of Thoma. A corresponding member of the Munich Secession, Thoma, considered to be a loner, complained often of his neglect by critics. When, however, in 1890 the fifty-year-old artist was given an exhibition by the Munich Art Society, he was received with rave notices on all sides. *Der Kunstwart* greeted his work with the ecstatic statement, "We can again believe in German art, for we suddenly have a German painter. German above all else is Hans Thoma. . . . The German nature of his inner being has turned to the German nature outside." Exhibited regularly during the nineties, his work was perceived to be a modern version of Albrecht Dürer's and was praised for its quiet, poetic portrayal of German village life and the German countryside (fig. 120). In 1896 Thoma, along with Menzel, was honored with a special show at the 1896 Glass Palace exhibition in Munich.[33]

Thoma's sixtieth birthday, in 1899, brought widespread recognition, provoking assertions that he, along with Böcklin, was now the mode in Berlin. His drawings had decorated Nietzsche's parable on the first page of *Pan* in 1895 and continued to appear throughout the volumes of the journal; poetic tributes came from Dehmel and the well-known poet Detlev von Liliencron. The Cassirer Gallery held a large exhibition of Thoma's works in March 1899,

which Gurlitt balanced with a joint exhibition of Böcklin, Klinger, and Menzel, all of whom were considered quintessential German artists. Reviews of Thoma's work were consistently filled with rhapsodic language about the effect of the works on the viewer. Albert Dresdner, reporting on the Gurlitt showing of more than fifty works in 1895, wrote that he finally understood that "Thoma lived among us moderns like a child from a long past time." Nevertheless, Dresdner insisted, Thoma was completely modern in his search for "an unmediated relation to life and nature," through which he was able to capture so powerfully "the infinite fullness of being that our consciousness of life will be heightened, our inner being enriched, our expectations enlarged." This sense that Thoma's paintings and lithographs of German landscapes and people "spoke" directly to the viewer met the oft-repeated calls for an art serving to nourish the people. Thoma himself defined his paintings as simple art communicating genuine sentiments to ordinary people, in his words, "the art of the people."[34]

Thoma's reputation as a true German artist is not difficult to understand. His peaceful landscapes and happy children playing in meadows represented a world that rarely, if ever, existed, yet they met the emotional needs of many who daily confronted an overwhelming urban environment. Less easy to comprehend was the critics' enthusiastic embrace of Böcklin, with his paintings of Classical groves and energetic mermaids, as another genuine German artist. Furthermore, Böcklin, a Swiss citizen, had lived most of his life in Italy with his Italian wife. Nonetheless, the coterie of supporters whom Fritz Gurlitt had gathered around Böcklin in the early 1880s grew steadily until in 1897 his seventieth birthday was celebrated with great acclamation across Germany and Switzerland. Adulation of Böcklin was everywhere, from popular papers to the aristocratic *Pan*, which, as one critic noted, had been founded "under the sign of Böcklin" and thus paid more attention to him than to any other artist.

Major exhibitions and celebrations were held in Basel, Hamburg, Berlin, and Munich. At the official banquet in Basel the art historian Heinrich Wölfflin eulogized "the universality of the artist, the wonder of his appearance, the manliness, from which all [his] creations are interwoven"; and the official exhibition for Basel's honored artist-son attracted twenty-five thousand spectators. That record was surpassed in the Böcklin retrospective of ninety-three paintings at the Berlin Academy, where sixty thousand respectful visitors passed through the narrow halls, with more than four thousand crowding in during the last two days.[35]

In a witty review, Springer thought it wonderfully ironic that Böcklin's centaurs and nymphs were frolicking merrily in the staid Berlin Academy, which he had always defied. Mocking the critics who had condemned Böcklin in the past but were now tumbling over one another to honor him, Springer was skeptical of the crowds attending the Academy

Fig. 120 **Hans Thoma, *Taunus Landscape*. Reproduced in *Die Kunst unserer Zeit* 4, 2nd half-vol. (1893): opp. 118.** Thoma, whose best-known paintings were created during the 1870s and 1880s, lived much of his life in Frankfurt, away from the major artistic centers. Working in a soberly realistic style, he celebrated life in the German countryside, conveying a sense of a quietly disciplined world where people worked close to nature and in settled relationships to each other. As his art was extolled in the 1890s for its depiction of genuine German ideals, it became increasingly self-conscious in its heavy symbolism and pedantic idealism. This became painfully apparent after his appointment in 1899 as the director of the ducal Kunsthalle in Karlsruhe, where he created paintings and frescoes combining classical and Christian images for a templelike room in the museum that was dedicated upon his seventieth birthday, in 1909. Critics called Thoma the "painter-poet," but poets were also inspired by his painting. Detlev von Liliencron wrote the following short stanza for Thoma's sixtieth birthday in 1899, answering the question what Thoma meant for the German people: "Who are you for him? His German painter. / Love has joined you, / And thankfully we bend our knees / Before you, you quiet, faithful hero."

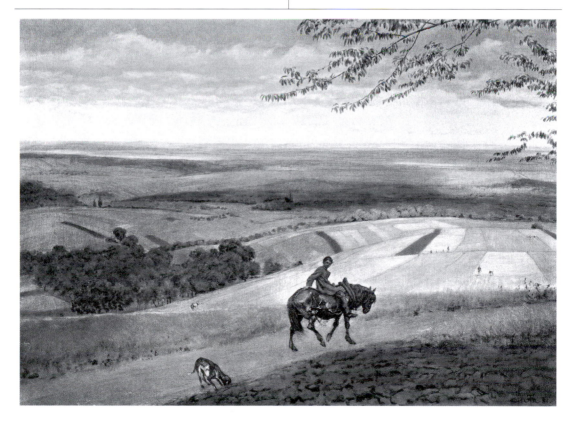

exhibitions, commenting, "If Böcklin is unacademic, he is even more un-Berlinish." On the other hand, *Der Kunstwart* reported on the thoroughly proper behavior of the public at the academy exhibition compared with the rude response Böcklin had received years earlier from the public and many critics. Lichtwark similarly watched with astonishment the enthusiastic crowds at the Kunsthalle retrospective in Hamburg. Judging that the crowds were much younger than usual, he optimistically interpreted this as a sign of growing appreciation among the youth for the modern German art that the older generation had rejected in the past. However, he observed in *Pan* how many of the longtime advocates of Böcklin's art were disconcerted by the artist's current popularity and not particularly pleased with the crowds that turned out for his exhibitions.[36]

This uncanny "capitulation of the majority," critics and public alike, before the work of Böcklin prompted much discussion. Lichtwark, in another article, attributed the earlier scorn and ridicule to the failure of people to realize that intellectual intelligibility was not the only response to a work of art, that equally important was an emotional sensitivity. Empathetic sensibility was also perceived to be the most significant criterion in the creation of authentic German art. At the height of his fame in these few years before his death, in 1901, Böcklin's paintings represented for critics the free play of imagination blended with an emotional integrity increasingly praised as the essence of German art. His enthusiastic reception uniting all people of all shades of sophistication and ignorance, from commoners to kings, into an appreciative public seemed to confirm this sense that Böcklin had indeed achieved the hallowed ground reserved for the true German artist: Böcklin's art had become the art of the people.[37]

But for those supporters of modernism who disdained the philistine public, Böcklin's startling popularity, as Lichtwark observed, led to his fall from grace in their eyes. The most notorious case of this came in a broadside attack four years after his death

from one of his eager supporters, Meier-Graefe, who had honored him a decade earlier in *Pan*. Writing in 1905 as an exponent of international, particularly French, modernity, Meier-Graefe denigrated Böcklin's art as a bombastic, crass embodiment of the worst aspects of German culture. This led to a passionate and angry debate played out in the journals, newspapers, and lecture halls across Germany. Turning into ugly personal attacks, including anti-Semitic slurs against Liebermann, this pitting of the supporters of international modernity against supporters of Böcklin and German art deepened the great rift between modern art and the public. It further resulted in decisively aligning those who sought a German art on the side of the philistine public that stood across the great divide from those who supported modern, international art forms.[38]

NEO-IDEALISM AND SALOME

The image of the great divide between the contemptible mob and modern art, despite its undeniable oversimplification, was a useful metaphor for the 1890s, one that reached far beyond the pen-and-paper skirmishes of art critics envisioned by Emil Heilbut in 1891. Augmented by intersecting branches and gullies of discontent, the rift cut ever deeper—between the people and the privileged, nationalists and internationalists, optimistic rationalists and pessimistic irrationalists, women and men, Christians and Jews. In the rapidly changing urban society of these years, aspirations and anxieties intertwined to produce new social possibilities, triggering resistance and fear. Curiously embodying these tensions, Symbolist or neo-idealist art represented, in varying degrees, an overt negation of modern bourgeois society through its self-conscious use of disturbing archaic, erotic, and decadent images. Spreading from France and Belgium into Germany in the early 1890s, with a strong appearance in both Munich exhibitions in 1893, neo-idealism

fascinated elite and bohemian circles alike, as shown in the first issues of *Pan*, and, significantly, revealed attitudes of these circles toward the public and toward women.

Initial responses to this new artistic phenomenon, marked by its foreign origin and decadent reputation, were often quite hesitant. After attending the 1891 Salon of the Rose + Croix, Heilbut reluctantly reported that some of the newest French Symbolist painting was very good. He was, however, convinced that the organizer of this Parisian Salon was a charlatan, and he warned German artists to stay away from this uniquely French artistic fashion. A brief notice of the mystical and Symbolist collection being shown at the Rose + Croix exhibition in

1893 was followed the next year by a lengthy review in *Der Kunstwart* in which Karl von Perfall expressed considerable misgiving over the cultic nature of the artists whose works were shown in these exhibitions. In his eyes, this escapist French fantasy was morally dangerous and unlikely to produce a creative response among German artists.[39]

The first major Symbolist exhibition in Germany, held at the Gurlitt Art Salon in Berlin in January 1894, faced continuing skepticism. Hans Rosenhagen characterized the mixture of Belgian, English, and German paintings as a combination of "profundity and nonsense, of hollow phrases and high poetry, of charlatans and artists." A harsher critic, Dresdner, judged the exhibition to be filled with "hallucinations of an uncreative, tortured fantasy" and feared that this new style would soon be imitated in Germany. Expressing similar doubts, Springer seconded these vocal supporters of German modern art in their view that neo-idealism or symbolism represented a regression from the principles for which they had fought. Added to this were concerns that young German artists would be caught up in the imitation of the decadence of the foreign Symbolists, who in Belgium and France were producing "dreadful" and "grotesque" art.[40]

Once again, critics insisted upon the necessity that art grow out of an artist's own experience and

Fig. 121 *A.* **R. Griess, "In the Studio of a Modern Stylist,"** ***Fliegende Blätter*** **106, no. 2698 (1897): 146.** *B.* **"From a Modern Gallery,"** ***Fliegende Blätter*** **108, no. 2757 (1898): 221.**
Symbolism became a fertile source of endless cartoons in *Fliegende Blätter*. In the first drawing (*A*), Griess makes fun of the artificiality of symbolist paintings. The second drawing (*B*), with its long aisle of cypress trees, can be seen as a lighthearted version of Max Klinger's bleak country lane lined with trees in *The Highway*, from *Four Landscapes*, *Opus VII* (1883), and again in *On Death*. *I*, *Opus XI* (1889). The borders, however, were inspired by *Pan*, while the bicycle-riding figures are straight out of *Jugend*, as are the puffy lambs radiating from the sun's rays.

A

B

culture. They were critical of those who appeared to be pale imitations of foreign Symbolists and claimed that Böcklin, Stuck, and Klinger were true neo-idealists who continued Germany's long tradition of idealism. Thus, Böcklin's immense popularity was based on his symbolic paintings, which foreshadowed this newest art style, as well as his paintings of sea creatures, which entertained the public trooping through his exhibitions (fig. 121). Stuck's joyful centaurs and sinfully lovely sphinxes and sirens also benefited, as did Albert Keller's beautifully painted erotic witches and hynotized madwomen. Klinger, however, was considered by all the critics as Germany's master of Symbolism in his graphic cycles on life, love, and death.[41]

A new generation of graphic artists followed Klinger in the nineties. A young Russian-German artist from Dresden, Sascha Schneider, caused a short-lived sensation with his foreboding images evoking unconscious emotional states or totally unconventional visions of Christ set in an ornately orientalized world of desolation (fig. 122). When these mural-size drawings were first presented to the public at the Lichtenberg Art Salon in Dresden in the winter of 1894–95, the reviewer commented that Schneider's work had left the philistines speechless. Shown in Munich, at Fritz Gurlitt's in Berlin, and in 1900 at the Munich Secession's international exhibition, the drawings, with their "ideal of powerful masculinity," were considered outstanding exam-

Fig. 122 **Alexander (Sascha) Schneider (1870–1927).** *A. **Meeting Again (Judas before Christ). Reproduced in Die Kunst für Alle 10, no. 15 (May 1895): full-page plate.** B. **The Consciousness of Dependency. Reproduced in Die Kunst für Alle 10, no. 8 (Jan. 1895): 116.***
Publishing an unusually lengthy review of Schneider's show in Dresden, *Die Kunst für Alle* contributed to the enthusiastic reception of this unusual work—unusual both in its content and in its format of life-size drawings preparatory to frescoes. The four-page review was accompanied by reproductions of five drawings, including one (*A*) that was given a full-page plate, an uncommon tribute to a young, unknown artist. Although these particular drawings were not turned into frescoes, several were re-created as paintings. Schneider's surrealistic drawings were a curious variant of the revival of religious art in the late 1890s. In his work, traditional biblical scenes were transformed into an eerie wasteland inhabited by sinister monsters aided by mocking crowds. The second drawing (*B*), with its pre-Freudian sense of foreboding psychological constraint, became a vehicle for political caricatures, as in a cover drawing for *Kladderadatsch* in May 1896 depicting the conflict between the reformist minister Hans Hermann von Berlepsch and the reactionary conservative leader Carl Ferdinand von Stumm-Halberg.

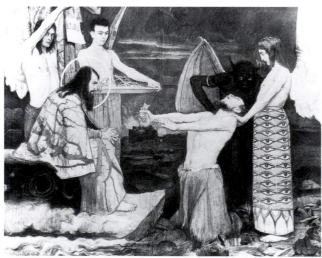

A

B

ples of the new fantastic idealism. Describing this style as seeking to render the inner realm of ideas through careful observation of the rich world of appearances, Dresdner asserted that it was "the form to which German art, following its particular nature, had always turned, whenever it had not submitted to foreign influences or educational ideals."[42]

The nationalism inherent in these efforts to redefine Symbolism as a uniquely German style was only one of the contemporary social tensions reflected in the art of the nineties. Equally profoundly, Symbolist art demonstrated the complex interweaving of distress over sexual identity with the tension between privileged and populist understandings of art. In these images aristocratic blasphemy overrode bourgeois chastity, original sin ridiculed liberal belief in progress, Eve destroyed Adam, and Satan flaunted his female pawn. In all of these, the image of the modern woman constituted the fundamental artistic leitmotif. No artist's work rendered this leitmotif with more vitriol than Rops, whose art became the rage for an exclusive audience in Germany in the late 1890s. A private exhibition of Rops's graphic works in Munich in 1895 sent H. E. von Berlepsch into raptures. The public, he recognized, was certainly not ready for these nightmarish, syphilitic apparitions, which could only be understood by a small privileged circle; in fact, he wrote, moralists would burn these "artistic-pathological" images if they were shown publicly.[43]

Berlepsch's insistence upon the private nature of the exhibition reflected a growing debate over obscenity in the arts. Recent legal scholars and high court decisions had declared sexual subjects to be acceptable, even essential, for serious artists as long as their works pursued a higher goal and were viewed only by the culturally sophisticated. If sexually suggestive high art was made accessible to the general public, it entered the realm of vulgar obscenity or pornography since the untutored mind could only perceive the titillating qualities. This constituted, in effect, a legal endorsement of the aesthetic divide between the philistine public and enlightened art lovers. Based on class prejudices about the sexually volatile lower classes, these court decisions protected art like Rops's, which was esoteric, expensive, and unavailable to the general public.[44]

After his death in 1898, Rops's popularity soared in Germany as his work, still viewed in private or dealers' galleries, traveled from city to city, while newspaper critics acclaimed him as the greatest graphic artist of the century. The art journals were generally cautious about directly discussing his work. Despite the shield of its high price and exclusive audience, *Pan* chose to reproduce an uncharacteristically mild engraving by Rops in its first issue, which coincided with the 1895 private exhibition in Munich. Even in the obituary acknowledging his exceptional talent, *Die Kunst für Alle* warned that his graphic works were not suitable for the general public. *Kunstchronik* merely referred to his work being shown at a winter exhibition of the Munich Secession, and both journals mentioned Cassirer's carefully chosen display in 1899 of Rops's graphics, which *Die Kunst für Alle* said seemed to be "a pornographic presentation of a dreadful dance of death."[45]

Exceptions to this reticence on behalf of readers were two articles in the late issues of *Pan* focusing on the esoteric satanism of Rops's degenerate and tyrannical female nudes. One critic, an art historian, analyzed Rops's portrayal of the female in Darwinian terms as an animalistic being who could sustain degenerate behavior without disintegrating, while perverse behavior in the male resulted in rapid decay. Driven by insatiable lust, the female was the demonic seductress whose lascivious body worshipped the male while destroying him. At the same time, the critic—who wrote in a reverential mode, honoring Rops's genius as a modern artist who followed in the literary footsteps of Charles Baudelaire and Huysmans—concluded that his art, bringing to visual consciousness the deepest unconscious drives, had

a liberating, not a pornographic, effect upon the viewer. A similar judgment was made in the second article, in which the author commended Rops for his tough honesty in the portrayal of "the carnality of sin, the brutality, the wantonness, the orgiastic."[46]

The celebration of this artist as the complete modern artist in his ruthless depiction of the "demonstrable" and "characteristic" natures of male and female was always accompanied by the acknowledgment that this art was meant not for the masses but for a discerning and perceptive audience. These brilliant portrayals of the female animal contributing to the degeneration of the race were meant for the small circle of aesthetically oriented persons, such as the readers of *Pan*, who could appreciate the radical modernity of the art. This was also the conclusion reached by Schultze-Naumburg in a review of the paintings of Khnopff, the "extremely modern" artist whose exquisite, dreamlike work focused entirely upon "the ancient unsolvable Sphinx riddle of the female."[47] The satanic females of Rops and the inscrutable Sphinxes of Khnopff, designed for private pleasure, not mass appeal, were, however, matched by a rash of paintings of dangerous ladies holding decapitated male heads and graphic cycles of demonic females that appeared in the exhibitions and dealers' galleries.

The battle of the sexes became a major theme in art across Europe in the late nineties. Germany was no exception. The encroachment of women into activities that were considered the prerogative of men, especially in the middle and upper classes, threatened to shake the foundations of the social order as surely as did the rising expectations of the lower classes. That artists nurtured on the misogynist ideas of Arthur Schopenhauer, Richard Wagner, and Nietzsche became fascinated by the "grim ladies" of the ancient myths in this decade when women's associations were increasingly active was hardly surprising, especially in light of the steady advances women artists were making. Images multiplied of Eve with her snake, of the vigorous Judith triumphantly wield-ing her sword to behead Holofernes, of a deceitful Delilah emasculating Sampson by cutting his hair, of Medusa, Circe, and the Sphinx entrapping and destroying men.[48]

No deadly female in the contemporary visual arts, however, could challenge the preeminence of Salome dancing for the head of John the Baptist. More than fifty major artistic visualizations of this archetypal figure of demonic woman in Germany alone, created between 1895 and 1910, were illustrated or cited in a book published in 1912. Innocent and sensual, lithe and voluptuous, sadistic and jaded, Salome with her veils and the bloody head of John the Baptist captured the imagination of this era in literature, theater, opera, and art. Among the most influential evocations of the enchanting dancer, contributing to her popularity, was Oscar Wilde's play *Salome*, published in French in 1893, in English with Beardsley's drawings in 1894, and first performed in Paris in 1896 in honor of Wilde's release from jail after his notorious trial for homosexuality, which had been widely covered in the German daily press.[49]

In the eyes of his fellow countrymen, however, the most commanding image of Salome was Klinger's multicolored marble sculpture *The New Salome*, completed in 1893 (plate 8). First shown at the major Klinger exhibition at the Lichtenberg Art Salon in Dresden in November 1893, the work elicited reviews that were astounding in their insistence upon the universal symbolism of the image. Avenarius exclaimed that this was not simply Salome; rather "she is the demonic incarnation of the female as the absolute annihilator of man," who had existed from the days of the ancient bloodthirsty queens to the present day. He went on to describe the severed head at her side as the head not only of John the Baptist but of all those mistaken youths who had sacrificed themselves for a woman, while the "ghastly distorted face" of the old man on the other side was the head of the lifelong libertine. Reviews in *Kunstchronik* also found Klinger's statue

A

B

Fig. 123 A. **Franz Stuck, *The Kiss of the Sphinx*, 1895.
Oil on canvas, 63 x 57 in. (160 x 144.8 cm). Museum
of Fine Arts, Budapest.** B. **Lovis Corinth, *Salome II*, 1899–
1900. Oil on canvas, 50 x 57 7/8 in. (127 x 147 cm).
Museum der Bildenden Künste Leipzig.**
Stuck presented his man-devouring Sphinx (A) in a bone-
crushing embrace with the hapless male in a painting of
dark browns and blacks that is drenched in an overwhelm-
ing lurid red. Corinth's first smaller version of this paint-
ing—now at Harvard's Busch-Reisinger Museum—based
on Wilde's play, was begun in 1897 and completed in 1899.
The second and final version of Corinth's painting (B) was
shown in the second summer exhibition of the Berlin Seces-
sion in 1900, after being rejected by the Munich Secession.
Brilliantly illuminated with jarring colors, Salome leans over
the platter, her bare breasts almost touching John's beard
as she pries his eye open with a ringed finger.

to be the modern embodiment of "the demonic, fa-
tal power of the female" and of the "type of a mod-
ern prostitute with cold eyes" who despised her
victims. Agreeing, Springer called her "a modern
she-devil, one of those rapacious and insatiable
prostitutes that Paris produces," while Cornelius
Gurlitt saw her as a vampire gorging on the hearts
of her victims. Julius Vogel recalled that neu-
ropathologists perceived the "uncanny beauty" of
Klinger's Salome to be marked by "depravity" and
"diseased sexual perversity." All this notoriety was
abetted by superb photographic reproductions of
the sculpture in all the art journals, including two
different full-page views of this "modern beast of
prey" published in *Pan*.[50]

Other artists rapidly presented their vision of this
"modern she-devil." In the 1895 Munich Secession
exhibition, Slevogt depicted Salome dancing with to-
tal abandon before excited Jewish elders. In the
same exhibition, Stuck showed his "archetype of
brutal sensuality" in *The Kiss of the Sphinx* (fig.
123A), whose violent embrace brought death to
man. This painting joined other Stuck images in be-
coming so familiar that it was frequently parodied in
cartoons. In 1897 *Die Kunst für Alle* featured four
plates of the daughter of Herodias exulting over the
head of John the Baptist, including an agitated
beauty created by Hugo von Habermann. Lovis
Corinth's version of Salome, shown in Berlin in May
1900, was one of the "most original and interest-
ing," Rosenhagen claimed, even as it manifested the
increasing perversity attributed to the "voluptuously
barbarous" daughter of the king (fig. 123B).[51]

These artistic images of the archetypal modern
female fascinating, emasculating, and destroying
men were the antithesis of the Nietzschean ideal of
artistic withdrawal from the crassness and cruelty of
the rabble. Encased in armor, the lonely knight on
his white horse climbing to the high mountains was
the artistic counterpart to Salome in the frenzied
lowlands. Tempter and dominatrix, the female di-
verted the artist from the heights of creativity (fig.

124). In the last years of the century, woman in her earthbound sensuality and dangerous sexuality became a power to be contained and a contamination—syphilis, perceived to be at epidemic levels in Europe, did not spare artists and poets—to be controlled before she wrecked havoc on the high aspirations of men. Efforts at containment were twofold: on the one hand, woman was reduced to the decorative embellishment of bourgeois life, and on the other, she was damned as the spawn and pawn of Satan. Neither of these imaginary females could be conceived as a professional who might threaten men's social and economic positions.

Whether an artist painting a Judith or a Medusa consciously considered his subject as a response to or rejection of the women's movements and of women's emergence into the world of art is a matter of speculation. Nevertheless, we should note that Klinger titled his statue *The New Salome*, with its overtones of *New Woman*, a term that came into usage in the 1890s. And as one writer queried, how was it possible that artists who less than a decade earlier had scorned any mythological narrative in their art now turned to these representations of mythical deadly ladies?[52] Even Liebermann sought to depict Delilah triumphantly cutting off Sampson's

Fig. 124 *A.* **Hans Thoma, *The Ride to the Gralsburg*, 1897. Oil on canvas, 47 5/8 x 47 5/8 in. (121 x 121 cm). Galerie Neue Meister, Staatliche Kunstsammlung Dresden. *B.* Max Slevogt (1868–1932), *Lady Adventurer*, 1894. Oil on canvas, 50 3/8 x 33 7/8 in. (128 x 86 cm). Städtische Galerie, Städelsches Kunstinstitut, Frankfurt am Main.** Dark blue and grays predominate in Thoma's evocation of the romantic knight on a quest through the dark forest (*A*). Coming upon the wide lake with its lone white swan, the knight is inevitably drawn to the golden city shimmering upon the heights of the mountain. In marked contrast to the knight surrounded by solitude is Slevogt's painting (*B*), whose title in German, *Frau Aventuire*, suggests the muse who inspired the heroic adventurer of medieval epic poetry. In Slevogt's hands the inspiration of the muse is transformed into a deadly struggle between an almost nude female temptress and a fully armored knight—a confrontation represented in a number of other paintings and graphics, including Corinth's self-portrait in armor with his wife and several scenes by Arnold Böcklin, who also painted a solitary adventurer in armor riding his horse across a shoreline littered with human bones.

A

B

hair in a large painting that he worked on for years before showing it in 1902, his first return to a biblical subject since the disastrous response to his *Jesus in the Temple* (plate 1) twenty-three years earlier. These images hardly represented a search for new solutions to formalistic problems. Did the explanation lie in the need to present a sensational piece of art in the next exhibition? Was it the desire to outdo other artists in the imaginative re-creation of a popular theme? Or was the fascination with woman as carrier of life and death simply "in the air," as another writer claimed?

Whatever the individual motivation for the creation of these images, the reality of this visual assault upon women was unmistakably presented to the public in exhibitions and in the journals. In *Die Kunst für Alle* it was also apparent in the disappearance from the journal of portraits and self-portraits of women artists, previously featured in the mid-nineties. The depictions of active, serious women were replaced in 1896 and 1897 with the images of the deadly females Salome and Heriodias. This visual assault on women was intensified by the revival in 1897 of Albert Keller's *Witch's Sleep* (fig. 42B), along with his new series of paintings of crucified, nude female saints. The sadism of these acts of retribution against strong women was heightened by the description of Keller's grisly anatomical realism: to accurately portray a crucified woman, he obtained a female cadaver, lashed and nailed it to a cross, then painted feverishly day and night until its decomposition became intolerable. In this intense dedication and discipline, commented the reporter with approval, Keller expressed well the powerful manly nature that characterized his paintings. This masculine ideal of rigid discipline was reinforced a month later by *Die Kunst für Alle*'s reproduction of Böcklin's painting of a mounted knight in full armor riding over a skull-strewn seashore. Further variations on the theme of dangerous women, whether destroying men or paying the price for their beauty, were featured in paintings of nude savage women

enticing warriors into drugged indolence with the lotus flower, shown at the Munich Glass Palace exhibition in the fall of 1896.[53] To be sure, these paintings constituted only a small portion of the total number of illustrations in these volumes, and furthermore, this theme had deep roots in the tradition of mythological narratives. Nevertheless, the shift in the journal from images of women artists to sensuous deadly or dead females was striking.

This eclipse of visual representations of women artists in *Die Kunst für Alle* occurred, not coincidentally, at the time when women artists were gaining greater visibility in the art world. More women were showing successfully in the great exhibitions; art by women appeared with greater frequency in galleries across Germany; art schools for women run by women were flourishing. At the same time, the refusal to accept women artists was still unquestionably strong. The Munich Secession listed no women among its 284 members and corresponding members in 1893, although a few women were later mentioned in reviews of the spring exhibitions. At the end of the decade, however, in 1899, when the Berlin Secession was finally formed, 4 women—Hitz, Sabine Graef-Lepsius, Ernestine Schultze-Naumburg, and Sophie Wolff—were included among the original 65 members.[54]

Among the journals, *Die Kunst für Alle* was unusual in the attention given to women artists. Although the visual presentation of women artists disappeared, the journal continued to review and on occasion to illustrate women's paintings without pejorative comment on the artist's gender, even as it reported upon and illustrated the artistic preoccupation with treacherous female beauty. Women critics and writers also became more visible in the journal in the last few years of the nineties. Herein lay the paradoxical nature of the processes of social change that marked the emergence of women into male professions. The growing numbers of accomplished women artists only served to raise the level of resistance to their presence. Thus, by the end of the

decade readers of *Die Kunst für Alle* were confronted simultaneously with evidence of women as professional artists and with visual condemnations of woman as the embodiment of depraved sexuality. In a telling confirmation of this, the voice of Springer supporting women artists was replaced at the end of the nineties by the highly critical and often downright nasty response of Rosenhagen to the art of women.[55]

Other journals were less receptive to women artists. Works of art by only five women were included among the many artists in *Pan*, while Hitz was one of only two German women artists listed as subscribers to the journal. Except for an article on Cornelia Paczka-Wagner as an artist whose graphic cycles demonstrated masculine strength (see fig. 95), women as artists were virtually invisible in *Pan*, buried under the elaborate border designs in which female figures entwined with lilies and snakes became mere decorative ornaments for the poetry and writing of men. From the exquisite plates to line drawings, representations of women portrayed them as sensual, ethereal, innocent, chaste, dancing drunkenly with satyrs, wandering in utopian meadows, and dying of unrequited love. The pages of *Pan* were filled with woman in all her guises—except that of a thinking, creative human being. After the exuberance of female and male nude figures in the first few issues, the imagery became somewhat more chaste and masked, but the underlying stereotype of woman remained consistently the irrational, emotional being, whether the soft nudes that inhabited Hofmann's prelapsarian world or Klinger's amoral Salome. In the last volumes the seductive deadly female emerged more prominently, as in a grotesque Salome by Wilhelm Volz that was utilized in the annual prospectus of 1897 and of 1898 or in the celebration of the art of Rops and Beardsley.[56]

The prejudice against women who broke with conventions defining their socially limited role was also expressed in the literature published in *Pan*. In a comedy fragment by Otto Erich Hartleben, Diogenes, who has extolled his life of freedom from con-

straints, is astounded when Aspasia under his influence walks away from her wealth and all her suitors. His response to this female bid for freedom is, "Good God, what was that?" To which a drunken beggar replies, with the final words in the play, "Bah—that was—a female." A modern version of this by Anselm Heine depicts a young woman refusing to marry in order to become a doctor. The melancholy final words here are, "The doors have been opened for you,—now you are condemned to freedom."[57]

The condescension toward women communicated in both word and image in *Pan* was an integral part of the disdain its editors expressed for the public. Neither women nor the philistine public could yet attain the intellectual levels of accomplishment and understanding that the readers of *Pan* were assumed to demonstrate by their wealth, education, and social standing. As manifested in *Pan*, this condescension, if not outright contempt, was closely associated with the promotion of modern art forms that began to take on a masculine coloration in the writing of critics in these years. In the decades after the turn of the century, this phenomenon, visible in *Pan*, became more pronounced, while some major critics and promoters of international modern art forms became vocal opponents of women artists. In those years, which are beyond the scope of this study, the resistance to women became more intense, even as women artists achieved the status of a major international exhibition devoted solely to their work. The new generation of modern artists continued to be fascinated by Salome and her malevolent sisters, and modern critics published essays and books claiming creativity to be the natural attribute of men, whereas women were by nature incapable of any form of aesthetic creativity.[58]

JUGEND: MORALITY AND NATIONALISM

Woman as a disruptive element in society had also become a sign of the moral disorder of modern urban

society for a significant sector of middle-class men. Beginning in the mid-1880s, moral purity associations were rapidly established in cities and towns across Germany, leading to the formation of a national association, the General Conference of German Morality Associations, in 1889. Led by Protestant clergymen associated with Adolf Stoecker, whose outspoken anti-Semitic views had entered into mainstream politics in the 1870s, these new moral purity organizations called upon men to join in a crusade to regain the values that upheld the family and, beyond, the social order. Troubled by the emerging industrial society, in which traditional patterns of behavior were collapsing under new economic and social conditions, these male morality leagues were convinced that society was falling into a state of decay, manifested most clearly in working-class vice and sexuality and in implicit challenges to the bourgeois belief in the gender roles of male dominance and female subordination.[59]

The men who joined these associations were drawn from the same educated middle class that formed the backbone of the public attending art exhibitions and galleries. Included were civil servants, professionals, businessmen, and military officers, but the majority were schoolteachers and Protestant pastors, whose secure positions in their worlds were being encroached upon by women who were actively entering both elementary and secondary teaching and were professionalizing charity or social work as a woman's field. Preaching chastity and condemning all forms of vice, the morality associations focused their attack upon prostitution and pornography in the 1890s. The increasing visibility of prostitutes, accompanied by a rising number of single young women working in the major industrial centers, represented for these bourgeois associations the work of the devil, enticing society down the road of sinful behavior, which had destroyed great civilizations from Babylon to France and was now ruining Germany. Pornography, from cheaply produced drawings to luxurious erotica, similarly flourished in a new and

massive way in the industrial nations as a result of new reproduction techniques.[60]

Whereas in the name of purity men loathed the prostitute and pornography as instruments of the devil, in the service of art artists were creating stunning visualizations of the satanic female (fig. 125). Sharing the obsession with that dreaded female, artists and moral purity organizations alike were manifestations of a crisis of masculine identity that

Fig. 125 **Otto Greiner (1869–1914), *The Devil Displays the Female to the People* (1898), plate 3 in *Of the Female* (1898–1900). Lithograph, 21 x 18 in. (53.3 x 45.8 cm). Museum Ostdeutsche Galerie Regensburg.**
This cycle of five plates by Greiner presents a bizarre view of the progression from the ancient gods' creation of woman, through Eve's collusion with Satan, to this scene in which Satan displays the Female to the lustful crowds. The fourth scene shows two devils crushing female bodies in a vast mortar with a massive phallus-shaped pestle. In the final scene Death and the Devil torture the crucified Christ at Golgotha while Romans soldiers and females dance lasciviously in the foreground.

became particularly evident in the years 1890–1914. All of these groups, however divergent in their motivation, represented a response to the energy of middle-class women, whose early charity organizations were turning into activist associations that aimed to reform social ills and, at the same time, to open new opportunities beyond women's accepted bourgeois role in the home. These women were only one of the disturbing elements that troubled these men, but their personal proximity in the same levels of society intensified the potential threat to acceptable masculine and feminine behavior. The increasing visibility of Jews in the higher levels of society and the greater awareness of the not always covert presence of homosexual men, along with women who flouted the ideals of chastity and heterosexual marriage, added to the unsettling of the social boundaries. As the late George Mosse has written, "The enemies of modern, normative masculinity seemed everywhere on the attack: women were attempting to break out of their traditional role: 'unmanly' men and 'unwomanly' women . . . were becoming ever more visible."[61]

This vulnerable state of the traditional ideals of bourgeois behavior was sensationally exposed in 1891 by a notorious murder trial involving a pimp and a prostitute in Berlin. And when, in the wake of the trial, revisions were proposed at the highest levels of the German government to tighten laws against prostitution and against obscenity, artists found themselves in direct confrontation with the moral purity associations over the nature and limits of art. What began as an effort to control the problem of prostitution was turned into a moral crusade against the corruption of society by obscene and pornographic visual images, literature, and theater. Mobilizing public opinion through their many local associations, the Protestant morality leagues joined forces with conservative parties, anti-Semitic leaders, and the Catholic Center Party to push for legislation carrying a serious potential for censorship of the arts. Agitation for the law known as the Lex Heinze—

named for the pimp in the 1891 trial—increased during the decade until an aroused coalition of artists, writers, publishers, and left-wing politicians staged public agitation and massive demonstrations during the early spring of 1900 that were successful in preventing the enactment of the most disturbing proposals into federal law by the Reichstag.[62]

In the course of the decade-long crusade, however, two disturbing tendencies emerged: for many, obscenity became synonymous with depiction of the nude in the arts, and Jews were accused of creating and promoting pornography. Not only did these prejudiced views intensify the abyss between the philistine public and the modern artists but they would help to stoke the fires of the next century. The elision between these ideas was demonstrated in the annual art debate of May 1896 preceding authorization of the budget for cultural affairs in the lower house of the Bavarian parliament. *Die Kunst für Alle* reported that members of the Catholic Center Party raised questions about nudity in the arts and described as shameful the allowing of women students into live-model classes, where their moral sensitivity would be harmed. The minister of culture, Robert von Landmann, responded that nude drawing classes were necessary for the proper study of art and could not harm the morals of the students. Georg von Vollmar, the leader of the Bavarian Socialists and an ardent supporter of modern art, then pointed out that this fuss over nudity was not based on religious beliefs but had grown out of fear. In response to Vollmar's statement, one of the deputies asserted that the Jews were responsible for the development of modern art, a claim that led to a debate over the Jewish question.[63]

This progression from women artists, to nudity in art, to fear, to Jews is revealing of the association of ideas that characterized these debates over moral decay. Speaking in the Reichstag debates over the Lex Heinze in March 1900, a leader of an anti-Semitic party who was also a moral purity activist openly denounced Jews as the power behind the

spread of pornography, while his party newspaper claimed that a conspiracy of Jewish businessmen had organized the thriving importation of pornographic art and literature into Germany in order to poison German youth. This connection between Jews and pornography was not peculiar to German thinking; in his onslaught against Jews published in 1886 the French anti-Semite Édouard Drumont had accused the Jews of creating pornographic art in order to undermine Christian societies.[64]

Neither these anti-Semitic charges nor the Lex Heinze found favor in the art criticism in the journals. Early in the decade, Avenarius published a long article in which he strongly rejected the increasingly insistent demands by anti-Semitic groups for state interference in the arts and pointed to the difficulty of establishing any intelligent public consensus on what constituted immorality in art. Two years later, in 1894, he reprinted a legal statement from the German Supreme Court holding that the determination of obscenity in the depiction of the nude was dependent upon the circumstances of its presentation. The court further stated that aesthetic factors were of paramount importance in making the decision. At this time in 1894 Der Kunstwart began to run advertisements for a brochure opposing censorship in the visual arts, as well as continuing to advertise The Nude: One Hundred Model Studies, from photographs by a Professor Max Koch. Emboldened by the expectation that the Reichstag would soon approve the Lex Heinze, a spate of censorship incidents occurred in 1899, including a Prussian Railroad ban on Hofmann's poster for the first Berlin Secession exhibition. In response, Avenarius published another strong argument against censoring the visual arts, again taking his stand against the Lex Heinze. Shortly thereafter a more serious violation of an exhibition jury decision took place when a painting by Slevogt, Danaë (1895), portraying the daughter of Acrisius, king of Argos, as an ordinary prostitute, was removed from the 1899 Munich Secession exhibition before the open-

ing day, although the journal reports insisted that there was nothing indecent about the painting.[65]

Both Der Kunstwart and Die Kunst für Alle reported on the debates over art in the Reichstag, with Die Kunst für Alle providing quotations from the liberal opposition to the proposed bill. Both journals also reprinted an article by Perfall from the Kölnische Zeitung in which he accused the Reichstag deputies of being woefully uninformed and outdated in their views on art; their taste, he charged, was still stuck in the 1870s. In September 1899 Die Kunst für Alle also published a substantial excerpt from a book on the beauty of the female body in which the author argued flatly that the equation between the naked body and immorality being made by many in Germany was simply false: immorality lay not in nakedness but in the eye of the beholder.[66]

During the crucial days in the early spring of 1900 Avenarius took an active part in organizing the resistance to the Lex Heinze, addressing the protest meeting of artists in Dresden and publishing the text of his talk, as well as further articles opposing the bill, in Der Kunstwart. In March the generally conservative Kunstchronik joined the opposition against the bill with a lead article on nudity and morality in art written by the editor of the Zeitschrift für bildende Kunst, followed by reports on the protest meetings. A lengthy article by Karl Voll in the April 1900 issue of Die Kunst für Alle critically attacked the Lex Heinze, arguing that art could not and should not be separated from sexual passions and concluding that the laws would give officials dangerous power to control or suppress expressions of culture that they did not understand or approve. Disturbed that the work of artists and poets was included in a bill dealing with prostitutes and pimps, Voll worried that the stormy sessions in the Reichstag and the tactics of obstruction used to prevent passage of the portion of the bill affecting the arts not only boded ill for the future but also demonstrated how nasty the reality would have been if the measures against the arts had been passed. At the same time as the controversy over

Lex Heinze, members of the Reichstag became involved in a stubborn fight over decorations for the new Reichstag building designed by Paul Wallot, particularly the integration of nudes into a frieze of paintings by Stuck and on sculptural urns by Adolf Hildebrand. Taken together, these two issues only consolidated the journals' portrait of the philistinism of the Reichstag deputies, who demonstrated, in Avenarius's view, not only "a total lack of judgment" in artistic matters but also "the arrogance of the German educated rabble."[67]

The most vigorous opposition to this philistinism, conservatism, and anxious morality, however, came

Fig. 126 **Fritz Erler (1868–1940), *Jugend* 1, no. 1/2 (Jan. 1896): cover.**
Jugend's colored covers were initially drawn by the artists themselves on multiple single-color zinc plates; after 1900 these covers were made by color photographic reproduction.

Münchner illustrierte Wochenschrift für Kunst und Leben. — G. Hirth's Verlag in München & Leipzig.

from two new weekly journals that began publication in 1896, *Simplicissimus* and *Jugend*. Joining a growing number of magazines started in these years, both could be seen as Munich's response to a Berlin publication. Following Berlin's witty satirical paper *Kladderadatsch*, with its staunch national and liberal position, *Simplicissimus* represented a more radical liberal and aesthetic focus on the political scene than did its fifty-year-old predecessor.[68] Although *Simplicissimus* featured incisive and memorable drawings created by artists who raised political cartoons to a scintillating modernist art form, satirizing the political scene remained its primary objective.

Sharing the liberal orientation, Georg Hirth, whose newspaper had provided indispensable backing for the Munich Secession, founded *Jugend: Münchner Illustrierte Wochenschrift für Kunst und Leben* (Youth: Munich's illustrated weekly for art and life) as a joyful celebration of youth. Rejecting a defined program as petit bourgeois philistinism, Hirth and his editor, Fritz von Ostini, promised to delight those who were young at heart by publishing "everything beautiful, good, lively, characteristic, and genuinely artistic."[69] This enthusiasm was expressed above all in the high-spirited and imaginative drawings that graced the covers, with a new colored image appearing each week. *Jugend*'s advent as Munich's answer to Berlin's *Pan* was announced on the first cover by an energetic young man in fur-trimmed winter garb racing across a snowy landscape with the towers of Munich on the far horizon and holding aloft a large oak branch against which the golden flames of a torch spelled out the journal's title (fig. 126). This dynamic young German Michael, created by Fritz Erler, became the symbol for the journal, one that stood in striking contrast to Stuck's ironic satyr (fig. 117A), whose head remained unchanged on the cover of *Pan* throughout the five years of that journal's existence.

Erler's youth conveyed more than an excitement over "everything beautiful, good, and lively," how-

ever; as an updated, reinvigorated version of an old familiar folk figure, Michael also demonstrated that a basic ingredient of the journal was to be its Germanness, or as Hirth put it, *Jugend* was to be created with both "an open worldview and German national convictions." That *Jugend* was "German to the core" was acknowledged by a review in *Kunstchronik*, even as it charged the new journal, with its aggressive mockery of traditional values, with being unsuitable for most of the public. For exactly the same reasons, Avenarius greeted *Jugend*—"a playground for youthful energy"—with pleasure, endorsing its fight against "prudish modesty and well-heeled philistinism."[70]

Financed by a single individual, without an editorial board made up of eminent personages, *Jugend* was from the beginning produced by the collaborative efforts of a group of young, unknown artists brought together by Hirth and Ostini. Combining the skills of entrepreneur, art patron, and publisher, Hirth sought to attract both a wide public readership and a broad range of young artists. The cost of the sixteen-page weekly, with its colored title page and at least one full-color double-page spread inside, was modest: three marks for a quarter of thirteen issues and thirty pfennigs for a single number. With a print run of twenty-two thousand in 1896, which had doubled to forty thousand by 1898, *Jugend* was distributed to the better hotels, railroad stations, restaurants, and coffeehouses, where the editors estimated—generously—that multiple readers numbered a half-million. Not coincidentally, *Jugend* also carried a substantial number of advertisements for hotels, spas, and other middle-class vacation sites. Utilizing advertisements, as did other humor magazines, the journal catered to the tastes of its middle-class consumer audience while underwriting its expensive color pages of art.[71]

To implement his ambitious plan of producing a journal lavishly illustrated with newly created works of art, Hirth held regular competitions in which artists, known and unknown, were invited to submit paintings, graphics, caricatures, cartoons, and photographs on every possible contemporary subject, whether handled seriously, satirically, or humorously, but always with a positive, lighthearted tone. That the visual aspect of the journal was far more important than the literary contributions was emphasized by a long poem in the one-hundredth anniversary number thanking and naming all the artists but not the writers. Hirth also paid well for each drawing, especially for the colored title pages.[72] These pragmatic aspects of its formation and dissemination established *Jugend* as a popular journal read by a substantial number of the educated middle class; a modern journal that encouraged participation by a large number of young and not so young German artists; and a German journal that would represent a vital national sensibility through its high-spirited fantasy.

In all of these ways *Jugend* was Munich's buoyant answer to Berlin's *Pan*, with its stance of elitism, of artistic withdrawal from the public, its internationalism—despite Lichtwark's efforts—and its serious, even melancholic and pessimistic views. Emphasizing its different conception of art and life, *Jugend* did not hesitate to lampoon the symbolist borders and literary themes of *Pan* (fig. 127). Nonetheless, *Jugend* was unquestionably influenced by *Pan*'s stylistic innovations; its style might well be described as a middle-class version of *Pan*'s page design, with similar borders and illustrations printed on much less expensive paper; in fact, some of the most inventive borders in both journals were produced by the creative Munich decorative artist Otto Eckmann. However, whereas *Pan* had imprisoned the image of women in its entwining border designs, reducing the female figure to an element of flora and fauna, *Jugend* gloried in the female figure, nude or clothed in billowing dresses, dancing or playing in flower-drenched meadows, picking or wearing flowers, women in water, on water, beside water. Exuberant, joyous, innocent, these women represented a contemporary idyllic world of free-spirited youthfulness in which,

Fig. 127 **Carl Strathmann (1866–1939), "The Maiden Sniffs the Lily,"** *Jugend* 1, no. 3 (Jan. 1896): 47. Strathmann's drawing in the third issue of *Jugend* was accompanied by a poem: "The maiden sniffs the lily, / The fragrant symbol of the Virgin, / And thinks thereby of the newest / Symbolic cauliflower. / The cabbage has a deep / Poetic-mystical meaning: / The secret of love of the Symbolists / Is hidden therein."

or indoor world did, however, depict the contemporary social life of bourgeois couples—here modern men did appear, often as the necessary but weak foil or accessory for the central figure of the woman. Women in these contemporary society events and street scenes were treated as elegant, beautiful, materialistic, empty-headed fashion plates, interested only in clothes and in capturing or manipulating a wealthy husband.[74]

Given this unremitting representation of charm, innocence, and shallowness, it is surprising to discover that the first serious essay in the journal, caught between short stories, anecdotes, and light poetry, was a determined defense of women's rights written by Hirth. Predicting that solving the woman question would be the central issue of the twentieth century, Hirth insisted that the real barriers to equal rights would come from men, who would produce "scientific" principles to bolster their "hypocritical" and "egotistical presumptions," citing the current claim by a famous professor of anatomy that women's brains were too small to handle a university education. Acknowledging that he would be considered a traitor to the secrets of "masculine science," Hirth went on to present evidence to support his position that "the entire teaching about the inferiority of the female brain is a pious myth." Nevertheless, he warned that women would have to engage in bitter battles before they wrestled equal rights from men.[75] Printed as a lengthy text in the second issue of *Jugend*, this strong affirmation of current efforts by women to gain access to education and jobs was diluted and compromised in succeeding issues by multiple, equally commanding images that affirmed, cast doubt on, or rejected women's liberation, as well as the traditional images of woman as temptress—Eve, Circe, or Sphinx.[76]

Most arresting among these images is a half-page illustration of an earnest, middle-aged woman doctor in male attire begging a frivolous, elaborately dressed young man to marry her. The accom-

curiously, men were largely absent. When male figures did appear, they tended to be shown in medieval scenes, as knights in armor slaying dragons or as young princes in soft garb wooing fair maidens.[73] The romanticism of these archaic scenes extended to another category of images: scenes of vigorous, healthy peasants working with horse-drawn plows and hayracks in fertile fields (fig. 128). The factories and railroads of Germany's accelerating industrialization rarely intruded upon the hills and valleys of this delight-filled landscape. Scenes set in the urban

A

B

Fig. 128 *A.* **Ludwig von Zumbusch (1861–1927),** *Jugend* **1, no. 12 (Mar. 1896): cover.** *B.* **Hans Rossmann (1868–1915),** *Jugend* **2, no. 16 (Apr. 1897): cover.**
Frequently reproduced as symbolic of the journal, this cover drawing by Zumbusch (*A*) on the twelfth issue can be interpreted either as a metaphor for the vitality of youth against old traditions or more specifically as an assertion of Munich's modern art sweeping away Berlin's old tired art. In the latter case, the figure of the little white-haired dwarf can be read as a caricature of the Berlin artist Adolph Menzel, who at the age of eighty-one still commanded great respect. A sentimental view of German peasants and landscape dominated Rossmann's drawings for *Jugend* (*B*) and was typical of others who followed this vision, one that became more prominent after 1900.

panying story presents a complete reversal of gender models in which the silly, vain little man primps, pouts, simpers, and plays hard to get, while the woman asserts her ability to support him in the style he is accustomed to and promises to care for him forever (fig. 129A). The absurdity of the image and the wicked wit of the dialogue can be read as a devastating attack upon the stereotyped gender roles that were endlessly repeated in the full-page cartoons of bourgeois society women in *Jugend* itself; the gender reversal could be understood as emphasizing the artificiality of conventional social expectations. Conversely, an opposite interpretation is also plausible: the ridiculous role reversal could be seen as a biting critique and derision of women's efforts to enter the domain of the male professions.

The ambiguity that suffused the juxtaposition of all of these varied images of women represented in *Jugend* continued in the next volumes. Dismissals of women's rights jostled against drawings such as one claiming that strong women might as well drape their men around their necks like a feather boa since men were becoming so weak and limp, or a drawing by Hofmann of a nude young woman playing games with tiny men before beheading them. Over beer in their pub, heavy, stolid Bavarian men asserted their right to be master of the house, while

A

B

their women met on the street to exchange exciting news about women's rights. Nude females wrapped in snakes and males dragged down by apes struggled with their identity, while bright young schoolgirls assumed that the woman question was a marriage proposal.[77]

Hirth did not reassert his position on women's rights until the fifth volume (1900), when he again wrote about his support for the cause. Publishing a letter addressed to friends in the women's movement, Hirth raised a new concern. The women's struggle for their rights would be more effective, he suggested strongly, if they placed a greater emphasis upon their duties as Germans. Comparing the German movement to those in other countries, especially America and Britain, he found the German women to be lacking in German-mindedness. Ultimately, he wrote, the German woman would only attain those rights that could be gained by demonstrating to men her own German sensibility. Despite these cautionary words, this volume welcomed the new century with a series of drawings predicting that by midcentury women would outnumber men in universities—dueling, drinking beer, and smoking cigars, that socialist women would be elected leaders in the Reichstag, and that women clergy would fill the pulpits.[78]

Over the next few years Hirth intensified his aggressive stance by attacking opponents of women's rights, particularly the sexologist Dr. Paul J. Möbius,

Fig. 129 *A.* **Julius Diez (1870–1957), "Sweet Love Loves in May,"** *Jugend* 1, no. 18 (May 1896): 279–80. *B.* **Bruno Paul (1874–1968),** *Jugend* 1, no. 35 (Aug. 1896): cover. Diez's illustration (*A*) for the parody of gender role reversal that is set a century in the future, namely, 1996, captures the infantilization that takes place when a person has no responsibility except to look beautiful enough to attract a mate. The little man is reduced to a mindless child, while the man-woman has become patronizing and overly solicitous.

For Paul and other artists, the bicycle became a positive symbol of new modern women who broke through traditional gender boundaries both in dress and action. In Paul's cover drawing (*B*) the energetic young woman, dressed in pants similar to those of the man accompanying her, takes an unladylike tumble on a country road but, being a modern young woman, is not dismayed. Paul also created a strong series of images showing the wheel as an instrument increasing woman's labor, such as a peasant woman pulling a plow on wheels through the soil or a lady sitting beside a spinning wheel laboriously producing thread for clothes, but then as a bicycle providing freedom from constraints for young women (*Jugend* 1, no. 21 [May 1896]: 335).

who had recently published a book titled *On the Physiological Feeblemindedness of the Female*, which Hirth rejected as pure nonsense. Identifying himself as a feminist, Hirth opened his journal to the writing of Dr. Helen Stöcker, an eminent radical feminist, who in turn supported *Jugend* against conservative accusations that it was a pornographic journal.[79]

Hirth's scandalous views on women's rights, not to mention the unabashed presence of frolicking female nudes in *Jugend*, were sufficient to raise the hackles on the heads of morality league members, as Avenarius had predicted. Hirth, however, did not

A

Fig. 130 *A.* **Otto Seitz, "To the Pure Everything Is Pure, To - - - -,"** *Jugend* **1, no. 18 (May 1896): 288–89.** *B.* **"Watch Out, Beast! Are You Again Coming Out of Your Black Hole?"** *Jugend* **2, no. 8 (Feb. 1897): 129.** Seitz's drawing (*A*) was accompanied by a long poem on the beauty of God's creation of the world and of humans who lived in innocent nakedness in the garden of Eden. Now, the poem lamented, the world was marked by sin and by cries of men for fig leaves to cover their nakedness. Clearly a response to the moral purity organizations, the statue in the drawing demonstrates the purity of art through its elegant lines, its unsullied whiteness, and its elevation in the rose-filled garden. Its purity is endangered by the pink hogs that have invaded the garden. To make sure that no one missed the point, the poem indicates that these hogs represent men with salacious imaginations, who assume that all others share their unchaste thoughts. The use of the hogs here in *Jugend* as a metaphor for the morality leagues trampling over the beauty of art constituted an ironic twist on Hermann Vogel's use in *Fliegende Blätter* cartoons of rooting, slobbering pigs to represent the destruction of idealistic German art by Jewish modernism (fig. 76).

The other full-page drawing (*B*) depicts the youthful German Michael fighting to drive the ugly beasts of repression back into their cave. The multiheaded monster in the center is the Lex Heinze, with its multiple paragraphs against obscenity in the arts, here represented as snakes' heads. One of the snakes wears the black shovel hat of the Catholic priests, which was transformed in *Jugend* cartoons into a sinister symbol of subversion. On either side of the monster are repressive laws that had been defeated earlier in the Reichstag.

B

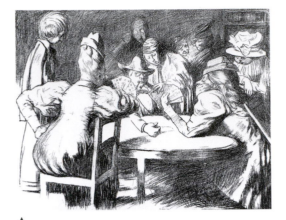

A

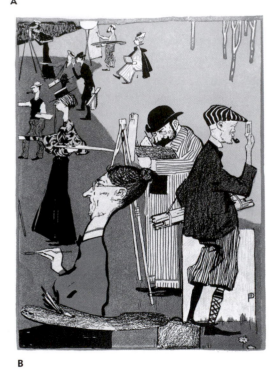

B

C

Fig. 131 *A.* **Rudolf Wilke (1873–1908), "The Regulars at the Women Artists' Table in the 'Blue Stocking,'"** *Jugend* **1, no. 11 (Mar. 1896): 171.** *B.* **Bruno Paul, "The Painters' Meadow,"** *Jugend* **2, no. 19 (May 1897): 301.** *C.* **Adolf Münzer (1862–1953), "The Artist Marriage,"** *Jugend* **6, no. 16 (1901): 249, with the caption "For four long weeks I have sat for you for this Madonna painting, and you have not managed to complete anything. Now at least sit still, you bungler!"** *D.* **Reinhold-Max Eichler (1872–1947), "The Martyrdom of the Woman Painter,"** *Jugend* **6, no. 3 (1901): 39.**

All of these cartoons were created in the artists' idiosyncratic signature styles, which became closely associated with *Jugend* but also with *Simplicissimus*, since all of them also contributed drawings to the latter. Wilke (*A*) portrayed emancipated women artists in a female pub engaged in the unladylike behavior of playing cards in a smoke-filled room rather than gathering around a dainty tea table. Sporting monocles, pince-nez, and broad-brimmed artist hats, the women wear clothes that are messy, unstylish, or downright masculine. Their crude features, gestures, and ways of sitting or standing are ungracious and aggressive. In fact, Wilke has created here neither men nor women as they were socially defined in those days. These are indeterminate persons, moving in a threatening zone between genders.

Paul's drawing (*B*) destabilized the boundaries in a more subtle fashion. The meadow is filled with women artists depicted in various states of awkward spinsterhood. In the foreground are an unmistakably ugly spinster artist and a spindly-legged male carrying his easel and looking through the miniature frame he uses to compose his painting. With his plus fours, which were often worn by women cyclists, this artist has an effete look compared with that of the solid, immaculately clad artist who is industriously working at his easel painting. This figure at the center of the drawing could well be identified with Max Liebermann, who was captured in a well-known photograph painting

Das Martyrium des Malweibes

D

outdoors (fig. 30A), nattily dressed in hat and suit with handkerchief arranged in his pocket. Yet in this scene, with its wide-open expanse of meadow, the well-established artist is being curiously crowded, almost eclipsed by the spinster artist and the other, perhaps trendier artists. Scattered across the grass are a few other men, each showing a certain debonair quality; the women, however, are more serious and more numerous.

Münzer's caricature of an artist couple (C) forecasts the ultimate degradation of the male artist at the hands of his dominating artist wife. She is the creative one, able both to bear the child and to complete the painting of the Madonna. Faced with her energetic power, he accepts the role of a passive incompetent, dressed like a phony Madonna. In other words, the male artist is reduced to being a mere female.

Eichler's image of the woman painter, with its ambiguously ironic title, departed from the more frequent negative representations of women artists. Here a scene in soft blues and browns shows a woman in a long dress with a painter's smock, carrying a knapsack, huge canvas, and tripod across rain-swept, newly plowed fields; in the far distance she works at her canvas under an umbrella. Below, surrounded by the thorny crown of martyrdom, she completes the painting by candlelight in her bed. Noteworthy here is the positive presentation of the woman as a determined and serious artist, not as a dilettante.

stop there; his editorial cartoonists launched an all-out attack upon the forces in Munich that were too eager to find obscenity and immorality in the arts. In the first months of its publication the journal published a full-page drawing with the title "To the Pure Everything Is Pure, To - - - -," accompanied by a poem that plainly declared its position on the issue of obscenity (fig. 130). Thus, a *Jugend* cover could feature a procession of lithe, nude women carrying lighted torches through a woods without any pornographic intent, unlike the prurient-minded moral purity leaders depicted on the editorial pages as sour-faced women and black-garbed Catholic priests bustling into museums to drape huge black fig leaves over Classical statues and Old Master paintings. Cartoons ridiculed the morality crusaders with absurd scenes showing the police arresting Stuck's *Sphinx* (fig. 123A) and forcing all of its breasts into corsets, condemning Liebermann's *Women Plucking Geese* for its sexual suggestiveness, or swimming with fig leaves into Böcklin's *In the Play of the Waves* (plate 3) to arrest the mermaids.[80]

In the debate over the Lex Heinze, with its anti-obscenity paragraph, Hirth's *Jugend* laid the blame for Bavarian support of the law upon ultramontanist clergy taking orders from the pope and on politicians of the Catholic Center Party. As early as February 1897, well before the arts community was aroused against the bill, he published a cartoon attacking the law; this was followed, particularly in the first months of 1900, by an unremitting satirical campaign against the law and by derisive caricatures of its supporters. In the first week of March 1900, just before the decisive vote in the Reichstag, the journal solicited and then printed responses from a host of important cultural officials, artists, and academics tersely condemning the proposed law.[81] As a liberal nationalist Hirth was active in organizing the demonstrations in Munich and petitions that finally resulted in the Reichstag's passage of a moderate version of the Lex Heinze.

The liberal and feminist stands of the publisher,

however, did not determine the ideology or the contents of the journal. Maintaining the dual—and contradictory—principles of an enthusiastic, open worldview and a German sensibility meant that a wide range of opinions and attitudes were represented in the visual images, as well as in the less impressive texts. Hirth's views did, however, ensure that more than twenty-five women artists had their drawings or graphics published in the first decade of the journal; some of them—Julie Wolfthorn (1868–1944) and Otolia Countess Kraszewska (born 1859)—appeared relatively often. In 1898 a whole issue was created with images and texts only by women artists and writers.[82]

At the same time, several of the principal male artists, who formed the core of *Jugend* and established both the success of the journal and their own reputations, revealed quite different views in a handful of cartoons (fig. 131). One of the first of these appeared not long after Hirth's first feminist declaration in the 1896 volume. In it, Rudolf Wilke, who contributed keen caricatures of Munich's citizenry to both *Jugend* and *Simplicissimus*, presented female artists as exaggerated examples of masculinized, emancipated women. Using masculine dress and characteristics to mock women's aspiration for equality was a common ploy in both journals, but Wilke invested the women with a peculiar nastiness that is uncanny and almost inhuman, pointing to the destabilizing of gender boundaries that women artists represented for many people. The dowdy female artist painting in a meadow had become a cliché in the *Fliegende Blätter*; in *Jugend*, Bruno Paul turned this comic figure into a sophisticated drawing suggesting the intrusive and potentially dominating presence of women artists in the male domain. By the turn of the century, when Hirth was engaged in attacking the scientific views that women were incapable of creativity, Adolf Münzer produced a cartoon brutally displaying a nightmare vision of the effeminacy and impotence that creative women artists could inflict upon male artists.

Moving from disparaging women who presumed to claim masculine prerogatives, to viewing women as unpleasant intruders into male space, to seeing women as a fundamental threat to masculine creativity, these cartoons visualized for the reader of the journal possible resentment and fears of artists for whom the creative process was always a difficult and precarious endeavor. On the other hand, several of the major *Jugend* artists taught regularly at the Ladies' Academy in Munich in the late nineties and had firsthand knowledge of women's work and ability. A sense of this knowledge was apparent in an ironic though not unsympathetic drawing by Reinhold-Max Eichler in which the difficulties a woman encountered on the way to becoming an artist were effectively pictured.[83]

Striking cartoon drawings such as these, combined with the fanciful depictions of a lighthearted world, resulted in rapid popularity for *Jugend*, manifested in the growing number of readers and subscribers. In its first decade the journal published work by an amazing number of contemporary German artists, along with a handful of the most popular foreign artists. Böcklin, of course, was well represented, as were Klinger and Thoma; a small number of Liebermann's sketches and portraits were published. Works by Ernst Barlach, Emil Nolde, and Ferdinand Hodler, whose reputations were made in the twentieth century, were included. Apart from these, the roster of German artists reads like a compendium of the middle generation, following in the footsteps of the modern pioneers who broke the hold of academic history and genre painting. Dominating the decade from the mid-nineties into the next century, these artists prepared the way for the advent of the radical new Expressionist groups, which, in turn, fully eclipsed them. An indication of the popularity achieved by this middle generation of modern artists was the remarkable sale of reproductions of drawings and paintings by 440 artists published in the first decade of *Jugend*. Within a few years more than 200 million of these

Fig. 132 *A.* **Fritz Erler, "I demand a hearing for the tale of the hallowed races. . . " (*Edda, The Wise Prophetess*), *Jugend* 2, no. 5 (Jan. 1897): 76–77.** *B.* **Reinhold-Max Eichler, "The Serious Study," in *Jugend* 4, no. 16 (Apr. 1899): 255, with the caption "All sorts of rubbish appeals to those city folks!"**

The central cohort of *Jugend* artists, out of which the Plowed Earth group was formed, comprised Fritz Erler, Walther Georgi, Reinhold-Max Eichler, Max Feldbauer, Adolf Münzer, Leo Putz, Julius Diez, Fidus (Hugo Höppener), Angelo Jank, Rudolf and Erich Wilke, Paul Rieth, Richard Pfeiffer, and Albert Weisgerber. Eichler's drawing (*B*) wryly juxtaposes the pragmatic Bavarian farmers striding through the snowy farmland to the artist in his shelter from wind and sun, who is trying to capture a wintry version of Claude Monet's haystacks. Eichler always focused on images from Bavarian city and rural life.

Erler's paintings, frescoes, and wall murals of calm heroic figures out of Nordic and Germanic legends were popular with the public and acclaimed by critics as a new monumental style. *Jugend* featured many of his works in double-page color reproductions, such as this drawing of an ancient prophetess with her lyre (*A*). His statuesque murals graced both public buildings and private mansions in the decade before World War I. Serving as a war artist, Erler transmuted his decorative style into a somber depiction of anonymous but resolute soldiers marching and dying under fire. His portrayal of the modern German soldier outfitted with steel helmet, gas mask, and hand grenades became one of the best-known posters of the German war effort. Scorned by the modernist establishment in the Weimar Republic, Erler's work was easily accommodated into the "new healthy spirit" and ideal racial types of National Socialist ideology and practice in the 1930s. A famous portrait of Hitler as a productive, creative leader marked the culmination of his career before his death in July 1940.

B

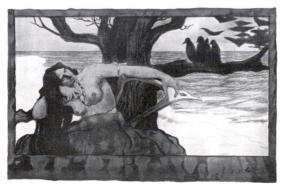

A

reproductions were sold for the minimal price of fifty pfennigs or one mark each. The mechanism of sale was a substantial catalogue in which small black-and-white illustrations of more than three thousand works were listed by artist; indexes and order forms were included.[84]

Among this large number of German artists whose work demonstrated its liberation from the constraints of traditional and academic forms was a smaller group of artists whose work determined the idiosyncratic style and character of the journal. Hirth attributed the success of *Jugend* to this cohort of artists, almost all of whom, born between 1868 and 1873, were in their twenties when Hirth brought them together to work on the journal. Moving in the direction of simplified lines, emphatic color, and flattened space, their vibrant art was easily read by their public audience. At the same time, all of these artists established their own recognizable signature styles, which, taken together, became famous as the *Jugend* style, or Jugendstil, Germany's version of the decorative Art Nouveau (fig. 132). Collaborating on the production of the journal, several of these young artists were included in an exhibition of original drawings held at the Cassirer Gallery in the spring of 1899. Showing as Group G at the Glass

easily viewed," all of the work demonstrating clear individual artistic effort, without having to adhere to a particular style, or as Liebermann put it, affirming the cardinal secessionist claim that talent alone counted. Perceiving the Berlin Secession as the culmination of a process of artistic renewal—"a prodigious revival of German art"—already taking place in the other German cities, Mortimer did not hesitate to point out that this "liberating solution" had come late to Berlin because the emperor was "well-known as an outspoken enemy of modern art."[89] This meant that the Berlin Secession was cutting itself off from all state support. The necessity of relying upon private individuals and ultimately upon the market had also been an aspect of the other secessionist movements, though in Berlin the break from state support remained more stringent.

Nevertheless, the first Berlin Secession exhibition in the newly completed building, with its galleries and offices financed by private donors, was successful, both financially and in terms of the number of visitors from the well-to-do residents of western Berlin.[90] Reviewers in the journals, whose support for the new art had been consistent through the nineties, expressed quiet satisfaction over Berlin's joining the roll call of secessions. Although this step was widely perceived as confirming the complete triumph of modern art in Germany, the reviews treated the Berlin events in a routine, positive fashion, taking it for granted that the Berlin modernists needed to establish their own exhibition space. The tense excitement that had followed events in Munich in 1892 and 1893 was moderated here by a sense of the inevitability of the break in Berlin given the powerful academic opposition there.

One area in which this first Berlin Secession exhibition did not follow the expected secessionist principles was in the inclusion of international artists. Even as the Berlin Secession opened, the Munich Secession was showing Degas and Monet. Liebermann explained that the new Berlin society wanted to begin with an overview of the contemporary state of German art; foreign artists would be welcomed in the future. Whether or not this was a shrewd move to defuse the expected criticism that foreign art raised in Berlin, it was effective. Even Rosenberg, who was usually curmudgeonly in his reviews of modern art, approved of the gathering of German artists from the major secessions—Munich, Karlsruhe, Dresden—in this exhibition, as well as the special emphasis on their predecessors in the modern movement. Like others, he noted that the well-established Berlin painters—Liebermann, Hofmann, Skarbina—did not show their best or new work, but he found the work of younger artists—Leistikow, Slevogt, Corinth—impressive.[91] The exhibition was measured, aesthetically moderate, without scandalous images, and modest in size. Since most of the artists were represented by only a few works, the Berlin Secession maintained the selectivity, with its aura of exclusiveness, initially established by the Munich Secession.

Once again, however, both the success and the resistance to the Berlin Secession marked a further deepening of the great divide separating those who opposed and those who supported modern art, as well as severing the philistine public of the great exhibitions from the cultivated visitors to the elite secessionist galleries. In the six years since the raucous laughter against the Munich Secession and the Eleven had produced the contemptuous epithet *schaupöbel* against the public at the great exhibitions, the belief, whether welcomed or deplored, that the modern artists of the secessions had triumphed over academic, realist, and traditional art was everywhere present in the journals and humor magazines. This was apparent in the reviews of the Great Berlin Art Exhibition taking place at the same time as the first Berlin Secession exhibition. *Die Kunst für Alle* dismissed the great exhibition, saying that only a small portion of the paintings, namely, those in retrospectives for four older artists—Leibl, Menzel, Thoma, and Lenbach—were worth seeing and that the rest of the works were fairly grim. Representing a

different perspective, *Kunstchronik*'s review acknowledged the weakness of the Berlin exhibition but blamed it on the secessionists, who not only had withdrawn but also had managed to win over the major artists' groups outside Berlin, thereby denying them to the official exhibition.[92]

Yet despite the critical rejection, the crowds continued to pour into the great exhibitions to marvel at the massive spectacle of paintings and sculpture, even as two thousand guests from the upper levels of Berlin society, as well as government dignitaries, attended the opening of the Berlin Secession.[93] The fracturing of audiences for art was not, however, simply a matter of social class, education, or wealth. The art world continued to be affected by social forces extraneous to its creative process yet integral to the meaning and reception of its art. Above all, these years were driven by nationalism, intensified internally through growing anti-Semitism and right-wing politics and externally by aspirations for world power and competition over colonies. Heightened nationalism meant that more critics began to insist that artists should create an art that grew out of German particularity, however that could be defined in a period when the art world, like Germany itself, was profoundly divided.

As had happened before, a drawing in the ever-popular *Fliegende Blätter* provided its nationwide readers with a harsh view of the forces of modern art battling against its sentimentalized view of authentic Germanness. From his forest studio in Saxony, Hermann Vogel perceived the secession in Berlin as a further attack by alien elements against a deeply rooted Germanic world of homely legends. In a full-page drawing published on 3 June 1898, soon after the news of the long-awaited secession reached the art journals, he depicted the onslaught of the "moderns" against the "ancients" (fig. 134). Led by Liebermann and Stuck, representing the joint power of the newly constituted Berlin Secession and the established Munich Secession, the forces of the modernists are reinforced by the bulldog and devils of

Simplicissimus and by Carl Strathmann's highly stylized, flat female in *Jugend*, all of whom brandish their paintbrush weapons and palette shields against a small band made up of an armored knight, a Munich child-monk, and little cherubs vainly defending past traditions. Liebermann, the urbane Jew standing astride a large palette, wields a pig by the tail, while his huge hog assaults a rose-bedecked cherub; Stuck, transformed into a centaur carrying a shield emblazoned with the amazon of the Secession's poster, drives his maulstick through a painter's dummy; and a large *Simplicissimus* devil drenches the defending knight with white paint. Against this modern storm carried out on the cloudy heights, the cheery clown from *Fliegende Blätter* provides a safe haven in his fairy-tale hut to a distraught Red Riding Hood despite the threat embodied in *Jugend*'s half-nude maiden leaning over the artist's easel. Over the whole scene, Munich's Athena raises her arms in rage as a little devil delightedly twirls an eighteenth-century fop by the pigtail of his curled wig, another devil brandishes an upside-down version of Leonardo da Vinci's symbol of humanistic balance—the overturning of man as the measure of everything—and a confused mermaid is swept up in the dark storm instead of basking in her usual sunny, Böcklinesque world.

In all of this, Vogel's pessimistic conviction that foreign or alien modern ideas were triumphing over old Germanic values is conveyed not only by the overwhelming number of modern protagonists but also by his depiction of the animalistic and unnatural characteristics of the modernists compared with the idealism of the knight, the religious aura of the Munich child, the innocence of the rose-wreathed cherubs, and the purity of the fallen Classical sculpture. Vogel once again, as in his 1890 drawing of Liebermann as the *Judensau*, concentrated his ire against the Jewish artist—with his pigs—as the chief enemy of idealistic German art.

Another expression of this belief that German artistic ideals were being trampled by the proponents

of modernism appeared at almost the same time in an article titled "The Art in Leather Apron and Smock," published in the *Frankfurter Zeitung* and reprinted in *Der Kunstwart*. Referring to the anxiety in artistic circles occasioned by the annual debate in the Bavarian parliament over the art budget, the reporter declared that the unusually fierce tone of the discussions that year demonstrated "what a deep schism runs through the art world, how much rancor exists on the one side and how much arrogance on the other." Charging the art world with being dominated even more than ever before by a "ring," or clique, whose opinions and favor determined an artist's success, the report described an incident in which the "matadors of art administration" refused

Fig. 134 **Hermann Vogel, "The 'Moderns' and the 'Ancients,'" *Fliegende Blätter* 108, no. 2758 (3 June 1898): 232. The caption reads (in a Bavarian dialect): "The moderns and the ancients. What a struggle that is! What fun it is to watch them go at it!"**

to approve the purchase of a sculptural group that realistically depicted a working-class couple mourning the death of a child, a work said to have deeply moved those laypersons who had viewed it.[94] Although the accuracy of this account was questioned, it illustrated the perceived existence of an elitist group in powerful positions whose aesthetic tastes were antithetical to the art that moved and pleased most members of the public.

A more pertinent example of this administrative bias in support of modernism was the fate of the painting by Leistikow whose rejection had led to the Berlin Secession. Rapidly purchased and donated permanently to the National Gallery by a Berlin patron, the painting was prominently exhibited by the director, Tschudi, in one of the central galleries of the National Gallery even as the Great Berlin Art Exhibition from which it had been excluded was taking place. Not only did this transaction deliberately flout the decision of the official jurors but Tschudi followed it with his well-publicized address "Art and the Public," delivered in January 1899, which reinforced the conviction that powerful museum administrators disdained the opinions of the public, including the emperor, in their acquisition of art. In fact, by 1899 supporters of modern art were serving as directors of the major art museums in Germany: Lichtwark, whose nationalism had not precluded his purchases and support of French Impressionist works at the Kunsthalle in Hamburg since 1886; Tschudi, whose appointment in 1896 inaugurated an impressive era of controversial purchases of modern European art for the National Gallery in Berlin; Gustav Pauli, called in 1899 to the Kunsthalle in Bremen, whose purchase in 1910 of an expensive van Gogh raised a notorious protest among artists; and Seidlitz, general director of the royal collections in Dresden, with Karl Woermann heading the painting gallery, Max Lehrs in graphics, and Georg Treu in sculpture, all actively promoting modern and foreign artists.[95]

The suggestion that these museum directors

were discriminating against good German artists was not surprising given the certainty on the part of many that cliques controlled the art scene. From 1892 to 1897 Rosenhagen, for example, in his journal *Das Atelier*, had regularly accused a clique led by Werner of hampering the progress of modern art in Berlin. More serious were the suspicions attributing the ascendancy of modern art in Germany to Jewish influence and manipulation. These charges linking Jews to modern art became more common in the late nineties, as indicated by Hermann Vogel's drawings in *Fliegende Blätter*. A telling incident involved a prominent Munich art collector who, objecting to the modernist journal, returned Stuck's cover of the first issue of *Pan* in 1895 to the editors. With a few pen strokes he had transformed Pan's head into the head of a Polish Jew with earlocks and a top hat.[96]

The Berlin Secession inadvertently fueled these perceptions, which were to fester into anti-Semitic charges of a Jewish conspiracy on the eve of World War I. Among the secessions and groups that had formed in the nineties, the Berlin Secession was the only one in which the participation of Jews was significantly visible, in part because Berlin had the largest upper-class Jewish population. In addition to Liebermann's being elected president of the Secession and the Cassirer cousins' being chosen to be its singularly important business managers, the financial support for the Secession came from a group of wealthy Jewish patrons and collectors of art that included Walther Rathenau, Richard Israel, Julius Stern, and Carl Fürstenberg, one of whom had also donated Leistikow's painting to the National Gallery.

Largely assimilated into contemporary German culture and active in Berlin society, these members of the wealthy elite Jewish circle of bankers, businessmen, and industrialists contributed significantly to Berlin's cultural life. They amassed celebrated collections of art, from medieval to modern French and German art, in their Berlin palaces and villas and demonstrated their loyalty to the nation by making substantial donations to the royal museums, such as a whole collection of Renaissance art donated to the new Kaiser-Friedrich-Museum by James Simon. Among the most distinguished Jewish collectors were Rudolf Mosse, the millionaire publisher of Berlin's liberal newspapers, with a museum of late-nineteenth-century German art in his mansion; Eduard Arnhold, a heavy industrialist and privy commercial councilor, with an impressive collection of French Impressionist works, as well as German modern art; and Liebermann, with one of the earliest collections of French art, from Daumier to Cézanne.[97]

The presence of foreign modern art in dealers' galleries and private collections in Berlin was not a matter of great concern during most of the nineties; however, when Tschudi began to acquire French Impressionist art for the National Gallery with funds provided by this circle of wealthy Jewish bankers and industrialists, the scene changed. His first purchase, Manet's *In the Conservatory* (fig. 119), was made on a trip to Paris with Liebermann and underwritten by Arnhold, Hugo Oppenheim, and Ernst and Robert von Mendelssohn, all from prominent Jewish families. As Tschudi built a substantial modern collection of German and foreign art, the list of donors became a roll call of affluent Berlin Jews. Reports in the journals mentioned with approval these private donors who made the acquisitions possible without identifying them either by name or as Jewish. Still, these acquisitions served to solidify the association of Jews with modern art, especially foreign modern art.

After Tschudi reorganized the National Gallery and placed older German paintings into storage to make room for these modern works, some angry deputies in the Prussian parliament in 1898 insisted that foreign works did not belong in this "national sanctuary of art"; others in debates in March 1899 were disturbed by the alarming increase of foreign art; and one called for that art to be purged from the National Gallery. An ensuing visit by William II

on 11 April 1899 to view Tschudi's controversial reorganization of the museum—where he encountered and contemptuously dismissed Leistikow's painting (fig. 133)—was followed later in the summer by rumors that the emperor had ordered an end to the "frenchifying." Responding to these rumors in July, Mortimer, the Berlin correspondent for *Die Kunst für Alle*, charged that *"painful* would be far too weak a word to characterize the agitation and slander" launched against Tschudi by certain influential circles close to the emperor, who had also been responsible for tarnishing Menzel's participation in the first exhibition of the Berlin Secession. However, the emperor himself, the reporter wrote, had shown no animosity toward Tschudi during the April visit. Even though the emperor made no secret of his repugnance toward modern art during his visit to the National Gallery, his conversation with Tschudi, according to Mortimer, had been amiably conducted without unpleasantness or ill temper.[98]

The gap between the early April visit and the reports that quite deliberately tried to defuse rumors in July that were clearly intended to undermine the mounting success of modern art in Berlin is noteworthy. Between mid-April and July the journals had openly proclaimed the success story to their readers. *Die Kunst für Alle* alone had featured Hofmann as the leading German artist; lauded the Cassirer Gallery as the most exciting; published Tschudi's lengthy critique dismissing the taste of the public and the emperor; praised Darmstadt for its venture promoting modern artists; pointed out that French Impressionists were showing in Dresden and Neo-Impressionists were showing in Königsberg; called for a radical reform in the art societies; criticized the Reichstag for refusing to accept the work of modern artists; reviewed Liebermann's book on Degas, printed by Cassirer; praised Klinger's *Christ in Olympus* (fig. 37), showing in Dresden; damned the Great Berlin Art Exhibition— "could it possibly get any worse?"—but praised the women artists in that exhibition; and, finally, decisively asserted that the future belonged to

the Berlin Secession, which had opened to acclaim in May.

Is it any wonder that high-level opposition mobilized its forces? In early summer came rumors directed against the foreign-born Tschudi, a Swiss citizen in charge of the *German* National Gallery, and the rumors that the emperor wanted to rid Berlin museums of "frenchified" art. By the end of the summer William II had taken action to assert his control over the National Gallery, issuing an order that works by German artists, which conveyed a sense of national identity to the viewer, should be returned to prime locations in the galleries, while modern works, especially those of foreign artists, should be hung in less prominent places, and further that his approval was needed for all purchases or donations to the National Gallery.[99]

These events documenting the steady deepening of the rift between those who were firmly convinced that modern artists had prevailed and those who were fighting with mounting vehemence against modernism signaled the end of the formative stage of modern art in Germany. Eighteen ninety-nine marked both the triumph of modern art, with the success of the Berlin Secession, and the strong emergence in public debate of xenophobic anxiety about that art. Overt anti-Semitism linking the Jewish patrons with modern art had not yet appeared in the journals; indeed, major modernist collections were created by non-Jewish Germans, notably in these years Kessler and Bodenhausen. Nonetheless, the groundwork had been laid for the perceptions that would transform the rift between the tradition-loving public attending the great exhibitions and the modernist artists in their elite galleries into an ominous animosity in the following decades.[100]

It would be a mistake, however, to oversimplify this division or to underestimate the pull of nationalist sentiments among those who had fought for modern art in the nineties. An illustration of this tension between the commitment to modern art, with

its international orientation, and the ideal of an authentic German art appeared in a review of the Berlin art scene written by Rosenhagen exactly a year after his long defense of Liebermann. In his years as editor of *Das Atelier*, struggling against the hegemony of Werner in Berlin, and then as a critic for *Die Kunst für Alle*, Rosenhagen consistently promoted the necessity of modern Impressionist art for Germany, was a loyal supporter of the Berlin Secession, and regularly extolled exhibitions at the Cassirer Gallery. Yet, reviewing an exhibition at the Cassirer Gallery of the "extraordinary" work of van Gogh, Rosenhagen presented an analysis of contemporary German art that could well have been written by Werner or William II in 1899.

"If limits are to be set to the triumphal march of French art through Germany," Rosenhagen wrote in *Die Kunst für Alle* in January 1905, this could only be achieved by determining which artists created authentic modern German art. He then divided German artists into three categories. The first he dismissed as those whose Germanness took the form of mannered copying of German masters, particularly Dürer, but naively, without skill, and with no artistic merit. At the center were the true German masters, like Thoma, who combined a German sensibility with a highly developed artistic ability that enabled them to learn from the modern French and then develop a genuinely German modern art. The third group were the frenchified Germans, who produced skillful art following recent French styles but, because they lacked the German sensibility, produced only imitations of French art. These, he charged, were those who regularly showed at the Cassirer Gallery, whose German landscapes all looked as if they were on the shores of the Seine or the coast of Normandy.[101] For Rosenhagen, this was a review of specific artists currently showing in the Berlin galleries; however, the implicit distrust of foreign styles and the anti-Semitism inherent in his definition were soon to become dominant factors in the public reception of modern art in Germany.

JEW, EMPEROR, AND PARANOIA

Since the process we call history is, as Max Lieber-mann wrote about art, a "continual coming into be-ing and fading," three tales bring my narrative to an end, but provide no conclusion. Rooted in the past and linked to the future, these passing narratives are suggestive, cautionary, and possibly illuminating.

January 1903. On the cover of *Jugend* one of Franz Stuck's lusty female fauns leapfrogs energetically over a bald-headed man dressed in a black suit who raises his hands in surprise to protect himself (fig. 135A). From the towers of Our Lady's Church, iden-tifying Munich on the distant horizon, a stream of black birds swarms threateningly around the man. The high-spirited young faun, a symbol of Munich's artists, easily rises above the staid figure, who could be read as Liebermann, the embodiment of modern art in Berlin. This cover, characteristic of the irrever-ent humor of the journal's artists, would not have puzzled readers who followed the simmering con-troversy that had set modern artists in Munich against their colleagues in Berlin. The dispute be-gan in 1901 with the publication of articles by the Berlin critic Hans Rosenhagen in which he argued that Munich's position as the preeminent center of German art was in danger of being lost to Berlin. The dismay and anger in Munich over Rosen-hagen's articles, fueled by an uneasy awareness that the city's best artists were moving to Berlin, produced mounting tension that finally resulted in the Munich Secession's withdrawing from its annual participation in the Berlin Secession exhibition. In his report on this action, *Jugend*'s editor was scathing in his condemnation of another statement by Rosenhagen, in which the Berlin critic charged that the Munich Secessionists had pulled out be-

cause they simply were not good enough. Accord-ing to the Munich Secessionists, they had withdrawn because the Berlin Secessionists, led by Lieber-mann, had refused to meet their demands for space.[1] The energetic faun was *Jugend*'s impudent visual rejection of Rosenhagen's charge that Mu-nich's art had become tired and retrograde.

But its defense did not rest there; instead, *Jugend* launched a further attack against Liebermann and Rosenhagen, one that was couched in disquieting anti-Semitism. In a full-page caricature (fig. 135B) Liebermann was depicted as a bulky Secessionist innkeeper lamenting that he and his doorkeeper Rosenhagen had looked forward to throwing out the Munich guests but they had left of their own accord. The contemporary perception of the close relation-ship between modernism and Jews in Berlin was un-mistakably demonstrated by the inn's sign, which consisted of the Star of David combined with the well-known logo from the Berlin Secession's 1901 poster. More troubling is the transformation of the tall, ele-gant Liebermann into a bow-legged, overweight Jew with long, apelike arms and bejeweled fingers. The intent of the caricature was to score a point in a controversy over art, but the message was conveyed by facile anti-Semitic references linking modernism to Jews. This powerful visual image—the Jew as innkeeper dispensing Impressionism—revealed the anti-Semitism, both casual and passionate, that was to haunt modern art in Germany in the next century.[2]

December 1901. While the Berlin Secession under Liebermann was successfully establishing Berlin as the exciting new center for modern art in Germany, William II unveiled his extravagant revival of pseudo-classical sculpture in Berlin. Whereas in 1888 his

A

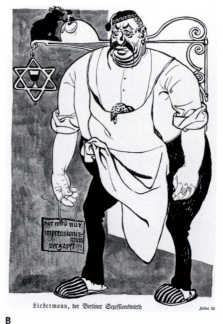

B

Fig. 135 A. **Max Feldbauer (1869–1948), cover.** B. **Julius Diez, "Liebermann, the Berlin Secession Innkeeper," with the caption "What great fun it would have been for me and my porter Rosenhagen to throw out the Munich guests— now they have left the pub on their own accord!" (p. 97). Both from** Jugend **8, no. 6 (1903).**

The drawing by Feldbauer (A) not only evokes the joyful vigor of Stuck's many fauns but also recalls the use of threatening flocks of black birds filling the sky in Stuck's landscape paintings. In (B) the sign that Liebermann carries reads, "Here only Impressionism is on draft." The bear and the young woman artist on the sign for the inn were first created by Thomas Theodor Heine for the poster of the third exhibition of the Berlin Secession in 1901. In outline form, the pair became the most frequent symbol of the Berlin Secession in cartoons or advertisements.

grandfather had been apotheosized in the great painting by Ferdinand Keller, William II now glorified the lineage of his forebears, from Albrecht the Bear to William I. Thirty-two larger-than-life white marble statues of princes of Brandenburg and Prussia were installed along a pedestrian promenade cutting across the great green park in western Berlin, within comfortable walking distance of the modern art galleries. "They stood," according to an adulatory article in *Moderne Kunst*, "in perfect harmony" with the emperor's promotion of artistic beauty. Avenarius, however, described these figures, the earliest of which were dubiously "conjured out of the darkest past into the lightest marble," as statues devoted to "the greater glory of the dynasty."

The first three statues along this Triumphal Avenue were unveiled in 1898 on William I's commemorative birthday, but not before objections had been raised in the press about changes made to the original plan, which had called for statues of leading citizens flanking each ruler. These figures had been downgraded to busts or medallions on the marble benches that formed a semicircle around each ruler, prompting Avenarius to quip that aesthetic reasons would probably be found to reduce non-noble men to mere buttons on the coats of the rulers.

By the time these outmoded imperial sculptures were completed in 1901, they had become the target of jokes and caricature, including an imaginative advertisement in which glistening white Odol

toothpaste bottles replaced the statues in a photograph of the promenade vista. The humor magazines also mocked the parade of rulers in their unlikely sculptural portraits. A cartoon in *Lustige Blätter* transported "the famous model" to tenement-lined streets of working-class north Berlin, with the busts of porters and cleaning women flanking the statues of landlords.[3] *Jugend* was also wickedly direct in its ridicule of the emperor's project and once again made use of anti-Semitic stereotypes to subvert the purity of William's pseudoclassical ideal (fig. 136).

Criticism of the emperor's ideal was not, however, limited to these comic satires. The Berlin public was amused by the marble procession; art historians and many critics were not amused either by the pseudoclassical objects or by the prospect of the emperor's enforcing his tastes across the empire. This was the specter raised by his address at the dedication of the imperial statues in December 1901, in which he summarily dismissed all forms of modernism,

Fig. 136 **"After a Famous Model," *Jugend* 6, no. 29 (1901): 475. The caption reads: "Baron Veilchenstein decided to create a 'Triumphal Avenue' in his park to honor his house."**
The ancestral figures (each surrounded by a curved bench) represent Moses, a thin peddler with a huge bag over his shoulder, holding the bell of an itinerant peddler in his hand and wearing the long beard, earlocks, and skullcap of the Polish Jew; Feiwe, a prosperous storekeeper with shorter hair and a top hat, selling soap and suspenders; Commercial Councillor Isidor, a fat capitalist with a gold watch chain across the waistcoat of his frock coat; and finally the wealthy Baron Veilchenstein, with his monocle and huge medals of honor on his chest.

Nach berühmtem Muster
Baron Veilchenstein beschloss in seinem Park zu Ehren seines Hauses auch eine „Siegesallee" zu errichten.

upholding Classical art as the highest art form, worthy of honor. Facing this imperial challenge, *Die Kunst für Alle* asked for a response from a professor of art history whose position in a South German state allowed him to speak freely. Worried about aesthetic directives coming from Prussia, Konrad Lange systematically critiqued "this modern avenue of sphinxes" and rejected William II's views, which he said would return art to a position held by the "stragglers of classicism from the middle of the last century." Stating that the emperor was surrounded by antediluvian reactionaries, Lange claimed that William II had no sense of what was actually being done by modern artists.

Responding later to an article defending the emperor's views, Lange invoked the authority of "all the respected art historians, particularly all the museum directors who have taken their stand on the side of the modern movement." Although he was confident that even the emperor could not hinder the inevitable evolution of German art, Lange made it clear that his defense of modern art was based on the work of the established modernists—Liebermann, Böcklin, Leibl, Uhde, Thoma, Kalckreuth, and Klinger. He was himself appalled by the "desolate aberration of the Symbolists" as shown in *Pan* and *Simplicissimus*, and the extravagant decadence of foreigners like Toorop and Khnopff. Nonetheless, he concluded by saying that those who did not accept modern art were "veritable dinosaurs who will be buried by history," even as he refused to accept the next generation of modernists.[4]

Despite the ridicule and criticism of William II's pseudoclassical sculpture, this was not the last time modern German leaders would find security in spurious classicism. Adapted to a future-oriented ideology rather than the historicism of the emperor, white marble sculptures displaying the ideal of a masculinized beauty were to grace the halls and ampitheaters of the National Socialist Empire. Believed to embody immortal, immutable beauty, not subject to the vagaries of fashion or time, unlike the tran-

sient and ephemeral modernist art, the pseudoclassical statues of both empires crumbled under the onslaught of Allied armies.

─────

Carnival 1896. An even more illusive form of art was celebrated in a witty article in *Die Kunst für Alle* proclaiming the primacy of the individual vision of the creative artist. In an ostensible review of the "Non-Exhibition of the Art Society Paranoia" the critic pointed out that this was a unique and path-breaking exhibition for the future of art. Believing that the most profound aesthetic vision could not be realized in a material form, the members of this new art society had pledged themselves not to desecrate the purity of art by producing objects for the public to view and critics to judge.

The Non-Exhibition, organized by Paranoia, was held in the vaulted rooms of an abandoned warehouse, where the critic paid an expensive fee for entrance. A young artist dressed in subtly dyed silk led him into a gallery draped in rose-red fabric, where an invisible harmonium played soothing music. Sinking into a deep armchair, the artist melodiously described in exquisite detail the paintings of ineffable love that he would paint. But, he told his viewer,

"I do not paint. None of us paint. Our artistry rests on absorbing, experiencing, conceiving, on a certain strong will that never allows itself to be trapped into the intensity of completion. For us there is no disappointment, only personal pleasure. We satisfy ourselves." The masterpiece that currently occupied his thoughts, he explained, was going to be a painting—which he would, as explained, never paint—of how the human spirit, freed from all materiality, receives the kiss of genius. Then he sent the viewer on to the next galleries. In a Nile-green room a landscape artist in fire-red antique Venetian garb overwhelmed the reporter with his evocation of landscape moods that surpassed any actual experience of nature. In the third gallery, swathed in cherry red satin, dimly lit and lavender-scented, a hidden quintet of woodwinds played Beethoven's Ninth Symphony. In this setting the president of Paranoia elaborately analyzed his unattainable masterwork, a sculpture of Beethoven, whose titanic genius could only be comprehended by an intensive will—his will. Overwhelmed by this conceptual brilliance, the critic left the Non-Exhibition.[5]

Art incomprehensible to the public and unsullied by the philistine—a parody, a parable, or a prophecy?

Notes

Prologue
Ape, Apotheosis, and Scandal

1. Out of consideration for readers without a knowledge of German, names of organizations, institutions, and titles are given in English in the main text and illustration legends. The major exceptions to this practice of translation into English are the titles of the journals that appear frequently in the text. An English translation of the title is supplied at the first mention of each journal in the text. The notes contain German names and titles, as well as providing greater detail on events and issues mentioned in the main text. Unless otherwise noted, all translations from the German texts are my own.

The short story retold in the text is J. V. Widmann, "Der Gorilla: Eine Pariser Künstlergeschichte," *Die Kunst für Alle* 4, no. 1 (Oct. 1888): 12–14. Photographs of both works were printed in ibid.

2. Friedrich Pecht, "Die Münchener Ausstellungen von 1888: Die Bildhauerei," ibid., 5, on Frémiet's gorilla; idem, "Die Münchener Ausstellungen von 1888: Die deutsche Historienmalerei," ibid. 3, no. 19 (July 1888): 291. Pecht was disappointed that the Keller apotheosis arrived ten days after the opening of the exhibition. The second review, "Die Malerei auf der Münchner Ausstellung," *Der Kunstwart* 2, no. 2 (Oct. 1888): 22–23, was by [Ferdinand] Avenarius.

3. In his report on the Paris Salon in 1887 Otto Brandes judged Frémiet's *Gorilla* to be "unquestionably the most significant work of the exhibition . . . a masterwork." He recounts that in 1859 the "pompier" members of the Salon jury had found a previous sculptural group by Frémiet too outrageous to be acceptable; however, the work was shown as a result of the personal intervention of Nieuwerkerke, Napoleon III's director of fine arts. Brandes also reported that the current sculpture was made from a cast of a 360-pound gorilla that had been sent from Africa in a cask of alcohol to the natural science museum in Paris (Brandes, "Der Pariser Salon 1887," *Die Kunst für Alle* 2, nos. 19–20 [July 1887]: 289–92, 312–16). Information on Frémiet can be found in Ulrich Thieme, *Allgemeines Lexikon der bildenden Künstler* (Leipzig, 1916), 12:416–17. For a brief discussion of this exhibition and an English text of Pecht's review, see Elizabeth Gilmore Holt, *The Expanding World of Art, 1874–1902* (New Haven, Conn.: Yale University Press, 1988), 304–7.

4. *Die Kunst für Alle* 2, no. 20 (July 1887): 319; 2, no. 23 (Sept. 1887): 367; and 3, no. 1 (Oct. 1887): 15. The artist's name was regularly spelled Hermine at this time. Careful archival documentation of these events is provided by Annette Dorgerloh, "'Ich werfe meinen künstlerischen Ruf getrost in die Waagschale!' Eine Künstlerin in Berlin am Ende des 19. Jahrhunderts," *Kunstverhältnisse: Ein Paradigma kunstwissenschaftlicher Forschung* (Berlin: Akademie der Künste der DDR, 1989), 79–84. A concise biographical résumé and a short list of her publications can be found in Sophie Pataky, ed., *Lexikon deutscher Frauen der Feder: Eine Zusammenstellung der seit dem Jahre 1840 ershienen Werke weiblicher Autoren nebst Biographieen der lebenden und einem Verzeichnis der Pseudonyme* (Berlin: Carl Pataky Verlagsbuchhandlung, 1898; facsimile reprint, Bern: Herbert Lang, 1971), 2:153. See also Carola Muysers, "Warum gab es berühmte Künstlerinnen? Erfolge bildender Künstlerinnen der zweiten Hälfte des 19. Jahrhunderts," in *Profession ohne Tradition: 125 Jahre Verein der Berliner Künstlerinnen*, by Berlinische Galerie, exh. cat. (Berlin: Kupfergraben, 1992), 31, including a reproduction.

5. In 1890 another large symbolist painting, *Irene von Spilimberg auf der Beerdigungsgondel* (La Cour d'Or, Musées Metz), was hung in the Berlin Academy Exhibition. For a negative critique of that work, see Ulrich Klein, "Kritische Betrachtungen eines Berliner Ausstellungsbesuchers I," *Der Kunstwart* 3, no. 22 (Aug. 1890): 345. A biting critique of a later painting appeared in A[venarius], "Dresdner Bericht," ibid. 10, no. 12 (Oct. 1896): 29–30. Dorgerloh cites the *National-Zeitung*, the *Vossische Zeitung*, and the *Kreuzzeitung* as following the controversial events in July and August 1887. The next year a booklet parodying the paintings in the Third Munich International printed a poem addressed to Hermine von Preuschen: "Die Jury nahm deinen 'Mors' nicht an— / Fürwahr, sie hat recht gehandelt. / So geht's, wenn in histor'schen Elan / Das Stilleben sich verwandelt" (see K. Cassius, *Spottvogel im Glaspalast: Epigramme in Wort und Bild auf die III. Internationale Kunstausstellung in München 1888* [Munich: Commissionsverlag von Wilhelm Behrens, 1888], 18).

6. A helpful, extended analysis of the changing conceptualization of the term *modern* can be found in Hans Ulrich Gumbrecht, "Modern, Modernität, Moderne," in *Geschichtliche Grundbegriffe: Historisches Lexikon zur*

politisch-sozialen Sprache in Deutschland, ed. Otto Brunner, Werner Conze, and Reinhart Koselleck (Stuttgart: Klett-Cotta, 1978), 4:93–131. See also Deutsches Wörterbuch von Jacob und Wilhelm Grimm (1885; facsimile reprint, Munich: Deutscher Taschenbuch, 1984), 12: col. 2446. All of the examples given here were cultural: "moderne art, moderner geschmack, die moderne kunst, wissenschaft u. ähnl., moderne sprachen, in gegensatz zu den alten. . . ." This edition of Grimm's dictionary used lowercase letters for all substantives. For an illuminating discussion of the concept of contemporaneity in France in the early nineteenth century, see George Boas, "Il faut être de son temps," Journal of Aesthetics and Art Criticism 1 (1941): 52–65. Writing in 1863, Charles Baudelaire formulated the following understanding of the transience of modernity: "By 'modernity' I mean the ephemeral, the fugitive, the contingent, the half of art whose other half is the eternal and the immutable." Although Baudelaire was influential in France, few German critics seemed to be aware of his work before the last years of the century. Gumbrecht, "Modern, Modernität, Moderne," 120–26, argues that with the increasing emphasis upon transience, instead of simply on the new, the word modern was emptied of meaning, leading to the forging of a new concept from the existing military term avant-garde.

7. [Avenarius], Der Kunstwart 1, no. 4 (Nov. 1887): 44, states that "modern art should resemble modern life" in a review of Albert Ilg, Moderne Kunstliebhaberei (Vienna: Graeser, 1887). The two reviews cited were Karl Freiherr von Perfall, "Die Berliner Kunstausstellung," Der Kunstwart 6, no. 17 (June 1893): 265, reprinted from the Kölnische Zeitung; and Alfred Freihofer, "Die Münchner Kunstausstellungen III," Der Kunstwart 7, no. 1 (Oct. 1893): 11.

8. This is not the place to try to cite studies from the exceptionally large number of books and articles that have examined and argued over the meaning of modernism in recent years. One study, however, Robert Jensen's Marketing Modernism in Fin-de-Siècle Europe (Princeton: Princeton University Press, 1994), is particularly pertinent for this book in its emphasis upon the Central European contribution to the formation of the canon. Privileged to read Jensen's manuscript early in my own work on this book, I want to acknowledge his influence upon my thinking, even though our approach and, often, our conclusions are fundamentally different.

9. A lively and illuminating treatment of the "problem of the public" and of the construction of concepts of the public in polemics about the art of the eighteenth-century French Salons is presented in Thomas E. Crow, Painters and Public Life in Eighteenth-Century Paris (New Haven, Conn.: Yale University Press, 1985), 1–23.

Not long ago I discovered a kindred spirit in a dissertation completed in 1933 in Heidelberg. Ernst A. Franke was led by the same curiosity to seek to understand the role of the crowds, whose voices, silenced, were accessible only through their critics and accusers. Or as he concisely stated: "Over this public the most contradictory opinions of scholars, critics, and artists prevail, a cacophony in which only one voice is missing—that of the public itself. If one could allow them to voice their own defense, they would have a difficult time, for all of the others are wholly united on one thing: that this public understands absolutely nothing about art" ("Publikum und Malerei in Deutschland von Biedermeier zum Impressionismus" [Ph.D. diss., Ruprecht-Karls-Universität zu Heidelberg, 1934], 9). Inevitably, we share the same methodology, working through the art journals, though he relied more heavily on memoirs and accounts written after the events. The chronological range of his work is far wider, covering the entire nineteenth century of German painting, requiring an analysis through a series of topics. His aim was to demonstrate that, given the "headstrong stance" of many artists and critics in pursuit of purely artistic ends, the public bore only minimal blame for "today's almost complete alienation" between painting and the public (iv). My argument is less direct or censorious because our assumptions and perceptions are, perforce, determined by the separation of more than half a century of racism, holocausts, world wars, international crises, domestic conflicts, and politicization of artistic movements. Nevertheless, Franke's plaint over the profound alienation of the public from "today's newest art" retains its resonance at the beginning of this century.

Part I, Chapter 1
Contemporary Art for the Modern Nation
1. Citing Max Jordan, director of the Berlin museums, York Langenstein reports that the painting was commissioned by the Society for Historical Art (Verbindung für historischer Kunst), which paid 20,300 marks for the work (Der Münchner Kunstverein im 19. Jahrhundert: Ein Beitrag zur Entwicklung des Kunstmarkts und des Ausstellungswesens [Munich: UNI-Druck, 1983], 186). The Prussian minister of culture then acquired the painting for Kaiser William II through the lottery. Anton von Werner reported in his memoirs that William II saw the work when it was exhibited in the academy building in February 1889 and ordered that it be purchased for the National Gallery (Werner, Erlebnisse und Eindrücke, 1870–1890 [Berlin: Ernst Siegfried Mittler und Sohn, 1913], 555). For a careful identification of the figures, both historical and allegorical, see Friedrich Pecht, "Die Münchener Ausstellungen von 1888: Die deutsche Historienmalerei," Die Kunst für Alle 3, no. 19 (July 1888): 292–93; for a double-page plate of the painting, see ibid. 4, no. 24 (Sept. 1888).

the function of these reviews and journals in creating a public for art can be found in Michael Bringmann, "Die Kunstkritik als Faktor der Ideen und Geistesgeschichte: Ein Beitrag zum Thema 'Kunst und Öffentlichkeit' im 19. Jahrhundert," in ibid., 253–78; and Birgit Kulhoff, *Bürgerliche Selbstbehauptung im Spiegel der Kunst: Untersuchungen zur Kulturpublizistik der Rundschauzeitschriften im Kaiserreich (1871–1914)* (Bochum, Germany: Universitätsverlag Dr. N. Brockmeyer, 1990).

23. Friedrich Pecht, "Vor Eröffnung der ersten Münchener Jahres Ausstellung 1889," *Die Kunst für Alle* 4, no. 19 (July 1889): 289–90.

24. Friedrich Pecht, "Buonaventura Genelli," in *Süddeutsche Zeitung* 190 (13 Apr. 1862), quoted in Michael Bringmann, *Friedrich Pecht (1814–1903): Maßstäbe der deutschen Kunstkritik zwischen 1850 und 1900* (Berlin: Gebr. Mann Verlag, 1982), 101. Pecht's call for making art "the common property of all of the people" was in direct opposition to the views of the influential critic Conrad Fiedler, whose significant assertion that only the educated, cultivated elite could understand or appreciate genuine art and that democratizing of art would result in sheer mediocrity was published in his article "Über Kunstinteressen und deren Förderung," *Deutsche Rundschau* 6 (Oct. 1879): 49–70, analyzed and cited in Kulhoff, *Bürgerliche Selbstbehauptung im Spiegel der Kunst,* 47–54.

25. The scholarly world already had its professional art historical journal, the *Zeitschrift für bildende Kunst* (Leipzig), edited by Carl von Lützow (1832–1897), begun in 1866, which increasingly covered major contemporary artists. Circulation figures are from Bringmann, *Friedrich Pecht,* 224, citing Klaus Achim Hübner, "*Die Kunst für Alle,* Ein Beitrag zur Geschichte der Kunstzeitschrift" (Phil. diss., Berlin, 1954), 51, 53. Of the leading reviews, *Die Gesellschaft* (Munich, 1885–1902) had a circulation of 1,000 in 1890; *Die Gegenwart* (Berlin, 1872–1931) and *Deutsche Rundschau* (Berlin, 1874–1942) each had a circulation of fewer than 5,000 after 1888; and *Freie Bühne* (Berlin, 1889–1922) reached 1,000 subscribers by 1898. Further circulation figures and information about these reviews are available in Syndram, *Kulturpublizistik;* Heinz-Dietrich Fischer, ed., *Deutsche Zeitschriften des 17. bis 20. Jahrhunderts* (Pullach bei München, Germany: Verlag Dokumentation, 1973); and Fritz Schlawe, *Literarische Zeitschriften, 1885–1910* (Stuttgart: J. B. Metzlersche Verlagsbuchhandlung, 1961).

26. For a contemporary biographical account, see F. v. Reber, "Friedrich Pecht: Zu seinem 80. Geburtstage, 2 Oktober 1894," *Die Kunst für Alle* 10, no. 1 (Oct. 1894): 2–6. Further biographical information, an extended analysis of his ideas, and a full bibliography of Pecht's writing are to be found in Bringmann, *Friedrich Pecht,* which stoutly, and correctly, defends the journal under Pecht's direction against facile charges in current scholarship regarding his editorial treatment of the modern movement. Friedrich Pecht, "Anton von Werner und das Jahr 1870," *Die Kunst für Alle* 1, no. 14 (Apr. 1886): 193–98, discusses the Sedan panorama and includes plates of two of the dioramas. On national monuments, for example, see Pecht's coverage of the first competition for the William I monument in Berlin in ibid. 5, nos. 4 (Nov. 1889) and 7 (Jan. 1890) and 7, no. 1 (Oct. 1891).

27. Friedrich Pecht, "An unsere Freunde," *Die Kunst für Alle* 1, no. 7 (Jan. 1886): 92–94. Werner Hofmann, in the exhibition catalogue for the Menzel exhibition at the Washington and Berlin National Galleries, cited the title of George Boas's article "Il faut être de son temps," from the *Journal of Aesthetics and Art Criticism* 1 (1941): 52–65, in his discussion of the centrality in nineteenth-century painting of "the clear uncompromising creed expressed in the maxim 'one must belong to one's time.'" Boas's title, which originated with Daumier, became, Hofmann argues, a "moral imperative, giving contemporaneity all the aura of an article of faith." In France this had led to "the doctrine of Impressionism, an exclusive approach that sacrificed everything beyond the scope of immediate visual experience" (see Werner Hofmann, "Menzel's Universality," in *Adolph Menzel, 1815–1905: Between Romanticism and Impressionism,* ed. Claude Keisch and Marie Ursula Riemann-Reyher, exh. cat. [New Haven, Conn.: Yale University Press, 1996], 91).

That the demand for contemporaneity took on "the aura of an article of faith" was certainly true for Pecht and for most other critics at the end of the century. The source of disagreement lay in how one defined and expressed that contemporaneity. This doctrine of contemporaneity drove Pecht's argument for a national art but meant for him not a sacrifice of everything beyond the immediate optical experience but an enhancement of everything having to do with the life of contemporary people within the nation. This understanding of the "demand for contemporaneity" is admirably presented by Linda Nochlin in "'Il faut être de son temps': Realism and the Demand for Contemporaneity," in *Realism* (New York: Penguin Books, 1971), chap. 3, in which she explores the various meanings and manifestations of contemporaneity as "one of the central issues, if not the very crux, of nineteenth-century Realism." Her definition of the Realist understanding of contemporaneity expresses well Pecht's view: "confronting the concrete experiences and appearances of their own times with an earnest and serious attitude and a fresh, appropriate imagery—was the only valid approach to creating an art of and for their own epoch."

28. For Pecht's views on academic art, see, e.g., his "Die beiden Münchener Ausstellungen für 1888," *Die Kunst für Alle* 2, no. 13 (Apr. 1887): 195, and "Anton von Werner und das Jahr 1870," ibid. 1, no. 14 (Apr. 1886): 193.

29. Friedrich Pecht, "Zum 70. Geburtstage Adolf Menzels," ibid. 1, no. 5 (Dec. 1885): 62. Articles, catalogues, and books published on Menzel during his long lifetime and in the century since his death are extensive. It will suffice to cite a handful from the journals of this period, including those commemorating his death in 1905 and the major retrospective held shortly afterward in the National Gallery in Berlin: Max Jordan, "Adolf Menzel," ibid 20, no. 12 (Mar. 1905): 265–71; Franz Wolter, "Erinnerungen an Adolf Menzel," ibid., 273–76, all plates and illustrations in this issue being Menzel's works; H.R. [Hans Rosenhagen], "Die Menzel-Ausstellung in der Nationalgalerie zu Berlin," ibid., no. 15 (May 1905): 361–64; A[venarius], "Adolf Menzel," *Der Kunstwart* 9, no. 5 (Dec. 1895): 71; Max Schmid-Aachen, "Adolf Menzel," *Zeitschrift für bildende Kunst* 31, n.s. 7 (1895–96): 49–69; G. [Walther Gensel?], "Menzels Begräbnis," *Kunstchronik*, n.s. 16 (Feb. 1905); "Die Menzel-Ausstellung in der Berliner National-Galerie," ibid. (Mar. 1905); H[ugo] von Tschudi, "Adolf Menzel," *Pan* 2, no. 1 (1896): 41–44; Max Jordan, "Menzel und die Nationalgalerie," *Moderne Kunst* 20 (1905–6): 97–99; H[elene] Vollmar, "Adolf Menzel: Zum achtzigsten Geburtstag," ibid. 10 (1895–96): 54–60; idem, "Adolph Menzel," ibid. 19 (1904–5): 177–81; idem, "Menzel in Kissingen," ibid. 20 (1905–6): 101. For one of the few publications on Menzel in English, see the excellent essays and full-color plates in Keisch and Riemann-Reyher, *Adolph Menzel*.

30. [Friedrich Pecht], "Unsere Bilder," *Die Kunst für Alle* 4, no. 12 (Mar. 1889): 186, with a full-page plate of the painting. A useful and well-illustrated study of genre painting in the late nineteenth century in Germany including a color reproduction of the Schwabe work is Martina Sitt and Ute Ricke-Immel, *Angesichts des Alltäglichen: Genremotive in der Malerei zwischen 1830 und 1900*, exh. cat. (Cologne: Böhlau Verlag, 1996).

31. See Friedrich Pecht, "Die Münchener Ausstellungen von 1888," *Die Kunst für Alle* 3, no. 18 (June 1888): 276, for Pecht's reference to plagues; and "Zum Beginn des zehnten Jahrgangs," ibid. 10, no. 1 (Oct. 1894): 1.

32. On the Kulturkampf, see Michael B. Gross, "Kulturkampf and Unification: German Liberalism and the War against the Jesuits," *Central European History* 30, no. 4 (1997): 545–66; Smith, *German Nationalism*, 19–49; Margaret Lavinia Anderson, "The Limits of Secularization: On the Problem of the Catholic Revival in Nineteenth-Century Germany," *Historical Journal* 38 (1995): 647–70; Ronald Ross, "Enforcing the Kulturkampf in the Bismarck-

ian State and the Limits of Coercion in Imperial Germany," *Journal of Modern History* 56 (Sept. 1984): 456–82; Jonathan Sperber, *Popular Catholicism in Nineteenth-Century Germany* (Princeton: Princeton University Press, 1984), chaps. 5–6; and, on actions in the southern states, Ellen Lovell Evans, *The German Center Party, 1870–1933: A Study in Political Catholicism* (Carbondale: Southern Illinois University Press, 1981), chap. 3. On the antisocialist laws, see Vernon Lidtke, *The Outlawed Party: Social Democracy in Germany, 1878–1890* (Princeton: Princeton University Press, 1966).

33. Sperber, *Popular Catholicism*, 222–33, has a good description and analysis of the mass demonstrations, pilgrimages, and celebrations that formed the heart of Catholic resistance to the anti-Catholic measures.

34. See Smith, *German Nationalism*, 50–113; and Ronald J. Ross, "Catholic Plight in the *Kaiserreich*: A Reappraisal," in *Another Germany: A Reconsideration of the Imperial Era*, ed. Jack R. Dukes and Joachim Remak (Boulder, Colo.: Westview Press, 1988): 73–94. The Protestant Church protested against the reintroduction in 1896 of Catholic processions in Heidelberg, Pforzheim, and Mannheim, according to Helmut Walser Smith, "Religion and Conflict: Protestants, Catholics, and Anti-Semitism in the State of Baden in the Era of Wilhelm II," *Central European History* 27, no. 3 (1994): 295.

35. Pecht described Menzel's painting in detail twice: in "Unsere Bilder," *Die Kunst für Alle* 7, no. 16 (May 1892): 249, accompanying the double-page spread, and earlier in ibid. 1, no. 5 (Dec. 1885): 70. The work was shown in official exhibitions in Berlin in 1880, 1882, 1885, 1886, 1892, and 1895 and in Munich in 1891. Pecht also published a double-page spread of another religious procession, Karl Marr's *The Flagellants*, which he approved of highly despite its historical setting in an earlier era and country (see Pecht, "Die erste Münchener Jahres-Ausstellung 1889, II," ibid. 4, no. 20 [July 1889]: 306, and for the plate, ibid. 5, no. 1 [Oct. 1889]).

36. P.S., "Karlsruhe," ibid. 7, no. 14 (Apr. 1892): 218. The Elvehjem Museum of Art at the University of Wisconsin reports in *artscene* 2, no. 3 (1998), that Theodore Esser's *Strike of the Blacksmiths* (1892) was purchased by a University of Wisconsin political scientist who taught in Berlin and Leipzig in 1911–12 and was donated to the university by a later owner.

37. On Pecht's attitudes toward socialism, see Bringmann, *Friedrich Pecht*, 160–61. For Pecht's discussion of Béraud's painting, see *Die Kunst für Alle* 6, no. 2 (Oct. 1890): 30. There is a certain irony in Pecht's reproach of German artists: Joris Karl Huysmans had similarly

criticized French artists a decade earlier for their failure to follow the lead of Menzel in painting factory scenes, according to Gabriel Weisberg, *The Realist Tradition: French Painting and Drawing, 1830–1900*, exh. cat. (Cleveland: Cleveland Museum of Art, 1981), 4. Pecht also wrote about workers (see, e.g., *Die Kunst für Alle* 4, no. 23 [Sept. 1889]: 354–55, a discussion of Bockelmann's *Streikszene*; and ibid. 6, no. 7 [Jan. 1891]: 106, 108, with a reproduction of a painting on class conflict by the Danish artist Axel Helmsted, *Stadtratssitzung*).

38. A well-documented and well-illustrated catalogue examining the artistic responses to the European-wide phenomenon of strikes in the nineteenth century is Agnete von Specht, *Streik: Realität und Mythos*, exh. cat. (Berlin: Deutsches Historisches Museum, 1992). On strikes, see Lidtke, *Outlawed Party*, 299, 301–5, 245 n. 13, 292–93, where he gives the number of striking miners in the Ruhr in 1889 as 120,000. In 1891 the socialists changed the name of their party to the Social Democratic Party.

39. Friedrich Pecht, "Vor Eröffnung der zweiten Münchener Jahres-Ausstellung 1890," *Die Kunst für Alle* 5, no. 19 (July 1890): 291–92.

40. Bringmann makes this point in *Friedrich Pecht*, 161.

41. For example, Herman Helferich [Emil Heilbut], "Studie über den Naturalismus und Max Liebermann," *Die Kunst für Alle* 2, nos. 14–15 (Apr.–May 1887): 212, 224, explicitly connected Liebermann to Courbet and to Zola's anarchists. A decade later, with memories of the Paris Commune fading, Courbet's appearance in the Munich exhibition in 1869 was interpreted much more positively (see J. E. Sattler, "Courbet in Muenchen," *Pan* 2, no. 3 [Nov. 1896]: 241–42). A thorough examination of Courbet's reception in Germany is Werner Hofmann and Klaus Herding, eds., *Courbet und Deutschland*, exh. cat. (Hamburg: Hamburger Kunsthalle, 1978). The bloody suppression of the Commune and the subsequent vilification of the working classes in the international press is treated at length in Albert Boime, *Art and the French Commune: Imagining Paris after War and Revolution* (Princeton: Princeton University Press, 1995), 1–26, 186–208. A discerning analysis of contemporary perceptions of the relationship between Bohemia and the Commune is presented by Jerrold Seigel in *Bohemian Paris: Culture, Politics, and the Boundaries of Bourgeois Life, 1830–1930* (New York: Viking Penguin, 1986), 181–212. On the preoccupation with respectability, see George L. Mosse, *Nationalism and Sexuality: Respectability and Abnormal Sexuality in Modern Europe* (New York: Howard Fertig, 1985).

42. Friedrich Pecht, "Die Münchener Jahres-Ausstellung von 1891," *Die Kunst für Alle* 6, nos. 22–23 (Aug.–Sept.

1891): 337–38, 354. The portrait of Bleichröder was probably one painted by Emile Wauters in 1888, reproduced in Fritz Stern, *Gold and Iron: Bismarck, Bleichröder, and the Building of the German Empire* (New York: Random House, Vintage Books, 1979).

43. In *Die Kunst für Alle* from 1885 to 1909, lead articles were published on the following: Böcklin, 1887, 1893, 1895, 1897, 1901 (2), 1902 (4); Liebermann, 1887 (2), 1897, 1901, 1904, 1907; Klinger, 1894 (2), 1895, 1902 (2), 1909; Uhde, 1886 (2), 1899, 1901, 1907; Lenbach, 1896, 1902, 1904; Menzel, 1885, 1895, 1905; Thoma, 1897, 1904, 1909; Stuck, 1899, 1903 (2); F. A. Kaulbach, 1899 (2), 1904; A. Keller, 1897, 1905, 1908; Leibl, 1892, 1901; Richter, 1885–86 (2); Habermann, 1898, 1906; Hofmann, 1899; and Werner, 1886.

44. Otto von Leixner, *Die Ausstellung von 1877*, vol. 1 of *Die moderne Kunst und die Ausstellungen der Berliner Akademie* (Berlin, 1878), 53, quoted in Friedrich Gross, *Jesus, Luther und der Pabst im Bilderkampf 1871 bis 1918: Zur Malereigeschichte der Kaiserzeit* (Marburg, Germany: Jonas Verlag, 1989), 352. A succinct summary of the critical acceptance of Liebermann's early work with useful documentation from newspapers and contemporary books is Stefan Pucks, "'Talentiert, aber schmutzig': Max Liebermanns Frühwerk im Spiegel der deutschen Kunstkritik," in *Max Liebermann: Der Realist und die Phantasie*, ed. Jenns E. Howoldt and Birte Frenssen, exh. cat. (Hamburg: Dölling und Galitz Verlag, 1997), 58–63. For discussion of the myth of the *pétroleuses*, women of the French Commune who allegedly acted as incendiaries in the burning of Paris, see Boime, *Art and the French Commune*, 38–39, 196–99.

45. Helmut R. Leppien, *Der zwölfjährige Jesus im Tempel von Max Liebermann* (Hamburg: Kulturstiftung der Länder in Verbindung mit der Hamburger Kunsthalle, [1989]). For an analysis of Liebermann's early work and of the conflict over *Jesus in the Temple*, see Paret, *Berlin Secession*, 42–49. A friend of Liebermann's, Erich Hancke, wrote an extended account of this affair in his indispensable book *Max Liebermann: Sein Leben und seine Werke*, 2nd ed. (Berlin: Bruno Cassirer, 1923), 131–42. The essays in Sigrid Achenbach and Matthias Eberle, eds., *Max Liebermann in seiner Zeit* (Berlin: Nationalgalerie, Staatliche Museen Preußischer Kulturbesitz, 1979), provide historical documentation of Liebermann's career, as well as excellent plates.

The most complete guide to Liebermann's paintings is Matthias Eberle, *Max Liebermann, 1847–1935: Werkverzeichnis der Gemälde und Ölstudien*, 2 vols. (Munich: Hirmer Verlag, 1995), including a thorough documentation of *Jesus in the Temple* (1:159–62). Other recent exhibition catalogues and books include several published on

the occasion of the commemoration of Liebermann's birth date: Angelika Wesenberg, ed., *Max Liebermann— Jahrhundertwende*, exh. cat. (Berlin: Ars Nicolai, 1997); Howoldt and Frenssen, *Max Liebermann*, with a short study titled "Der zwölfjährige Jesus im Tempel: Ein Bild zwischen Kritik und Anerkennung," 105–14; Dorothee Hansen, ed., *"Nichts trügt weniger als der Schein": Max Liebermann, der deutsche Impressionist*, exh. cat. (Bremen, Germany: Kunsthalle, 1996); and Günter Meißner, *Max Liebermann*, 4th rev. ed. (Leipzig: E. A. Seemann, 1998).

46. Only a few of the derogatory phrases directed at the painting, these are cited in Bettina Brand, *Fritz von Uhde: Das religiöse Werk zwischen künstlerischer Intention und Öffentlichkeit* (Heidelberg: Bettina Brand, 1983), 231n; Günter Busch, *Max Liebermann: Maler, Zeichner, Graphiker* (Frankfurt am Main: S. Fischer, 1986), 38; Paret, *Berlin Secession*, 44–45. Hancke, *Max Liebermann*, 133–34, provides a lengthy excerpt from Pecht's article. Pecht then praised paintings by Ernst Zimmermann before returning to the other two paintings Liebermann exhibited in Munich that year, *Gänserupferinnen* and *Arbeiter im Rübenfeld*, in which Pecht referred to "eine Anzahl Damen, deren Häßlichkeit nur durch die seiner, in einer Reihe, wie die Spatzen auf einem Telegraphendraht, aufgestellten Runkelrübenjäterinnen übertroffen wird."

47. The quotations from the stenographic reports of the Bavarian Landtag, 15 Jan. 1880, p. 595, appear in Ludwig Leiss, *Kunst im Konflikt: Kunst und Künstler im Widerstreit mit der "Obrigkeit"* (Berlin: Walter de Gruyter, 1971), 97–99. Maria Makela includes a translation of part of Dr. Daller's speech in *The Munich Secession: Art and Artists in Turn-of-the-Century Munich* (Princeton: Princeton University Press, 1990), 33; and her chapter "The Politics of Parody: Some Thoughts on the 'Modern' in Turn-of-the-Century Munich," in Forster-Hahn, *Imagining Modern German Culture*, 185–207, contains a brilliant analysis of the dynamics of Munich's art world. George L. Mosse wrote extensively on the relationship between anti-Semitic stereotypes and the high value placed upon bourgeois concepts of respectable behavior. A good introduction to his analysis is "Jewish Emancipation: Between *Bildung* and Respectability," in his *Confronting the Nation: Jewish and Western Nationalism* (Hanover, N.H.: Brandeis University Press, 1993), 131–38.

48. Hancke, *Max Liebermann*, 131–34, related the story of Luitpold's visit, and printed the full text of the parliamentary debate, 139–40.

49. See David Blackbourn, "Progress and Piety: Liberals, Catholics, and the State in Bismarck's Germany," in *Populists and Patricians*, 143–67; Shulamit Volkov, "Anti-

semitism as a Cultural Code in Imperial Germany: Reflections on the History and Historiography of Anti-semitism in Imperial Germany," *Leo Baeck Institute Year Book* 23 (1978): 25–46; Smith, "Religion and Conflict," 298–314; and idem, "The Learned and the Popular Discourse of Anti-Semitism in the Catholic Milieu of the Kaiserreich," *Central European History* 27, no. 3 (1994): 315–28. An illuminating description of Protestant and Catholic newspaper allegations of the Jewish corruption of German society can be found in Stern, *Gold and Iron*, chap. 18, esp. 502–3 on Catholic linking of Jews with the Kulturkampf. On Treitschke's article, see Andreas Dorpalen, *Heinrich von Treitschke* (New Haven, Conn.: Yale University Press, 1957), 240–47. The article, titled "Unseres Aussichten," appeared in *Preussische Jahrbücher* 44 (Nov. 1879): 572–73. An English translation of parts of the text can be found in Peter G. J. Pulzer, *The Rise of Political Anti-Semitism in Germany and Austria* (New York: John Wiley and Sons, 1964), 249.

50. Leppien, *Der zwölfjährige Jesus*, 21–25, describes Liebermann's unpleasant reception in the beer halls, where he was reviled as the "Herrgottsschänder." Hancke, *Max Liebermann*, 133, also recounts the difficulties Liebermann encountered before he finally fled Munich. Stoecker's sermon is cited in Jenns E. Howoldt and Birte Frenssen, "'Der zwölfjährige Jesus im Tempel': Zwischen Kritik und Anerkennung," in Howoldt and Frenssen, *Max Liebermann*, 108, quoting Gudrun Kummich, "Max Liebermann 'Der zwölfjährige Jesus im Tempel': Das christliche Bildthema eines 'jüdischen' Malers im Spiegel der Kritik" (M.A. thesis, Eberhard Karls Universität Tübingen, 1994), 105.

51. A significant new understanding of the painting has emerged in Katrin Boskamp's "'Der zwölfjährige Jesus im Tempel': Zur Geschichte eines ungeliebten Bildes," in her *Studien zum Frühwerk von Max Liebermann mit einem Katalog der Gemälde und Ölstudien von 1866–1889* (Hildesheim, Germany: Georg Olms Verlag, 1994), 75–115; her meticulous examination of the work now hanging in Hamburg established that Liebermann altered the original work by overpainting. Boskamp cites the French comment about the "little girl" in the painting hung in the 1884 exhibition at the Galerie Georges Petit in Paris, comparing it with the negative descriptions in the German reports. Hancke, *Max Liebermann*, 133 and 454, quoted the comment about "talking with his hands" from the French critic Edmond Duranty in his 1879 review of the First Munich International published in *Les Beaux Arts Illustrés*; Hancke also reported on the 1907 exhibition.

52. Werner, *Erlebnisse*, 557. A reproduction of Menzel's lithograph appeared in 1895 accompanying an article written by Richard Graul for Menzel's eightieth birthday in

Die Kunst für Alle 11, no. 6 (Dec. 1895). A careful analysis of Menzel's deliberate utilization of eastern European Jews as models for his "realistic" anti-Semitic stereotypes and of Liebermann's equally deliberate rejection of Jewish models and stereotypes is Peter Dittmar, "Der zwölfjährige Christus im Tempel von Adolph Menzel: Ein Beispiel für den Antijudaismus im 19. Jahrhundert," in *Idea. Werke. Theorien. Dokumente: Jahrbuch der Hamburger Kunsthalle, VI*, ed. Werner Hofmann and Martin Warnke (Munich: Prestel Verlag, 1987), 81–96. For a contemporary view of Menzel's depiction of modern Jewish types, see Max Jordan, *Das Werk Adolf Menzels, 1815–1905* (Munich: Verlagsanstalt F. Bruckmann, 1905).

Cartoons developing the stereotype of the Jew appeared with great regularity in the early 1880s. In addition to those shown in the illustrations, see the following examples from *Fliegende Blätter*: "Eine vorsichtige Mutter," in 75, no. 1884 (1881): 79; "Schaufel-Fuchs," 75, no. 1885 (1881): 82–83; "Wie du mir, so ich dir," 75, no. 1892 (1881): 144; "Neue Krankheit," 75, no. 1897 (1881): 181; "Ein Prozesshansl," 75, no. 1896 (1881): 173; "Ueberflüssiger Respekt," 75, no. 1899 (1881): 196–97; 76, no. 1902 (1882): 14; "Nach eigenem Maß," 76, no. 1916 (1882): 124; "Lohn und Strafe," 77, no. 1941 (1882): 115; "Marcus der Täufer," 80, no. 2021 (1884): 121–23; and "Falsch verstanden," 81, no. 2049 (1884): 139.

53. Boskamp, "Der zwölfjahrige Jesus im Tempel," develops a sophisticated interpretation of Liebermann's intentions based on her examination of the creation and composition of the painting, to which I allude only briefly here.

54. For my comments here I am indebted to David Blackbourn's superb study, *Marpingen: Apparitions of the Virgin Mary in Bismarckian Germany* (New York: Random House, Vintage Books, 1995).

55. The first major articles on Liebermann were by Herman Helferich [Emil Heilbut], "Studie über den Naturalismus und Max Liebermann," *Die Kunst für Alle* 2, nos. 14–15 (Apr.–May 1887): 209–14, 225–29. A decade later, at the time of Liebermann's first great retrospective in Berlin, Heilbut wrote another strong endorsement of Liebermann's work with the same title under his pseudonym in ibid. 12, no. 15 (May 1897): 225–28.

56. F[ranz von] Reber, "Fritz von Uhde," *Die Kunst für Alle* 1, nos. 15–16 (May 1886): 207–11, 219–23; Dr. Karl Voll, "Neues von Fritz von Uhde," ibid. 14, no. 15 (May 1899): 226–28; Franz Wolter, "Fritz von Uhde's neuestes Werk," ibid. 16, no. 8 (Jan. 1901): 183–86; Fritz von Ostini, "Fritz von Uhde," ibid. 23, no. 1 (Oct. 1907): 1–15. A full-page reproduction of Uhde's *Christus und die Jünger von Emaus* was included in the inaugural issue of *Die Kunst für Alle*, 1, no. 1 (Oct. 1885), opposite 14. Pecht's article in the *Allgemeine Zeitung* in 1883, a review of the Second Munich International Art Exhibition in Munich, is cited in Brand, *Fritz von Uhde*, 39. Reber's "Fritz von Uhde" was a carefully reasoned article in which he traced Uhde's development and discussed each major painting at length. He was, however, also critical of Uhde's first few naturalist paintings, especially *Die Trommelübung* and *À la campagne* (both 1883), which he found to be unfortunate experiments in relentless realism.

57. Max Liebermann, in "Jozef Israëls," *Zeitschrift für bildende Kunst* 36, n.s. 12 (1900–1901): 145–56, recorded his deep appreciation for the work of Israëls. For analyses of Liebermann's long fascination with seventeenth-century Dutch painting, Dutch landscape, and community life, see Angelika Wesenberg, "Holland als bürgerliche Vision: Bode und Liebermann," in *Wilhelm von Bode als Zeitgenosse der Kunst*, ed. Angelika Wesenberg (Berlin: Nationalgalerie, Staatliche Museen zu Berlin, 1995), 43–54; Margreet Nouwen, "Malheimat Holland," and Holly Richardson, "Landschaftsmalerei ist die schwerste Kunst. . . ," in Howoldt and Frenssen, *Max Liebermann*, 11–20 and 21–31; and Barbara Gaehtgens, "Holland als Vorbild," in Wesenberg, *Max Liebermann—Jahrhundertwende*, 83–92.

58. Hans Rosenhagen, *Uhde: Des Meisters Gemälde in 285 Abbildungen* (Stuttgart: Deutsche Verlags-Anstalt, 1908), xxvii, xxx.

59. Reber, "Fritz von Uhde," 222.

60. Fritz von Ostini, "Fritz von Uhde," *Die Kunst für Alle* 23, no. 1 (Oct. 1907): 12. In 1895, Paul Schultze-Naumburg pointed out in "Deutsche Kunstkritiker," ibid. 10, no. 11 (Mar. 1895): 166, that Ostini, as editor of the art section of the *Münchener Neuesten Nachrichten* from 1887 to 1895, was among the earliest supporters of Liebermann and the Munich Secessionists. After the turn of the century he became increasingly conservative. His continued strong support of Uhde was demonstrated in his monograph *Uhde* in the popular series Künstler-Monographien (Bielefeld, Germany: Velhagen & Klasing, 1902).

61. Adolf Rosenberg, "Die akademische Kunstausstellung in Berlin von 1884, III: Die Malerei," *Zeitschrift für bildende Kunst* 20 (1884–85): 94, with a plate of Uhde's drawing of the child with Jesus; idem; "Die Jubiläumskunstausstellung in Berlin, III: Die Münchener Schule," ibid. 22 (1886–87): 10–11. See also K. Cassius, *Spottvogel im Glaspalast: Epigramme in Wort und Bild auf die Münchener Jahres-Ausstellung 1889* (Munich: Verlag von Ulrich Putze, Kunsthandlung, 1889), 26.

62. Brand, *Fritz von Uhde*, provides a thorough analysis of these works and their reception, particularly within Protestant circles. A contemporary assessment is "Religiöse Kunst," *Der Kunstwart* 1, no. 12 (Mar. 1888): 154–56. Herman Grimm, an art historian, strongly opposed painting that interpreted the Gospel stories in terms of current social issues in "Armeleutemalerei," *Deutsche Rundschau*, excerpted in *Der Kunstwart* 7, no. 2 (Oct. 1893): 27. Hermann Lücke, "Fritz von Uhde," *Zeitschrift für bildende Kunst* 22 (1886–87): 355, used the phrase "Christus des vierten Standes," though he did not give it a negative connotation. Wilhelm Lübke, however, characterized Uhde's disciples at the Last Supper as "famosen alten Zuchthausknaben" with "Mörderphysiognomie" in his article "Neueste Kunst," *Westermann's Illustrierte Deutsche Monatsheft* 37, half-vol. 74 (1893), 43, cited in Brand, *Fritz von Uhde*, 98. Brand points out that the figure of Peter at the left of the painting was actually a portrait of the composer Anton Bruckner. One of Germany's most popular art historians, Lübke published *Geschichte der deutschen Kunst von den frühest Zeiten bis zur Gegenwart* (1888) and *Grundriss der Kunstgeschichte* (1869), which went through eleven editions.

63. Brand, *Fritz von Uhde*, 103, cites the Protestant critiques by von Soden, "Unsere Kunst, 7. Die religiöse Kunst I," *Die Christliche Welt* 2:64–65, and by Heinrich Merz, "Die neue 'realistische' Schule und Herr von Uhde," *Christliche Kunstblatt* 31 (1889): 33–38. The critique from a Catholic journal was by Paul Keppler, "Gedanken über die moderne Malerei," *Zeitschrift für christliche Kunst* 28, n.s. 4 (1892–93): 243, quoted at length in Urban Rapp, "Kirche und die Kunst der Zeit 1888–1920," in *"München leuchtete": Karl Caspar und die Erneuerung christlicher Kunst in München um 1900*, ed. Peter-Klaus Schuster, exh. cat. (Munich: Prestel Verlag, 1984), 55.

64. On the formation of the Protestant League, see Smith, *German Nationalism*, 50–61; on the effort to develop a new Protestant art, see the essay by Ekkehard Mai, "Programmkunst oder Kunstprogramm? Protestantismus und bildende Kunst am Beispiel religiöser Malerei im späten 19. Jahrhundert," in Mai, Waetzoldt, and Wolandt, *Ideengeschichte und Kunstwissenschaft*, 431–59.

65. See *Die Kunst für Alle* 11, no. 19 (July 1896): 300; and "Die Biercksche Christus-Ausstellung," ibid. 13, no. 20 (July 1898): 305–9, with illustrations from the exhibition throughout the issue. Opening in Berlin, the exhibition traveled across Germany in 1897, including stops in Hamburg, Hanover, and Breslau. The exhibition in Breslau, sponsored by the Schlesische Kunstverein and held in the Theodor Lichtenberg art gallery, was received with great interest, according to reports in *Deutsche Kunst* 1, nos. 15–16 (Jan. 1897): 177, 186–87. Brand, *Fritz von Uhde*,

184–88, provides reproductions of the paintings from the exhibition, as does Gross, *Jesus, Luther und der Pabst*, 246–51, with a lengthy analysis of the exhibition. See also Wolfgang Kirchbach, "Religiöse Kunst," *Die Kunst unserer Zeit* 9, 1st half-vol. (1898): 97–136.

66. This artistic and commercial venture for the panorama had been preceded only four years earlier by an official archaeological expedition to Palestine funded by the Prussian education ministry. The intellectual and political developments surrounding these archaeological expeditions to the Middle East in the 1880s and 1890s are laid out coherently in Suzanne L. Marchand, *Down from Olympus: Archaeology and Philhellenism in Germany, 1750–1970* (Princeton: Princeton University Press, 1996), 192–99.

67. See Richard Muther, "Bruno Piglhein," *Zeitschrift für bildende Kunst* 22 (1886–87): 167–72, from which the quotation is taken; v.B., "Das neue Münchener Panorama," *Kunstchronik* 12 (June 1886): cols. 617–20; and Max Bernstein, "Von einem Panorama," *Die Kunst für Alle* 2, no. 7 (Jan. 1887): 105–10. The panorama crowned Piglhein's artistic career, won him the title of professor, and established his position within the Munich art world; in 1892 he became the first president of the Munich Secession. Insured for 90,000 gulden, the panorama was moved in 1892 from Munich to Vienna, where it burned not long after its installation (*Die Kunst unserer Zeit* 3, 1st half-vol. [May 1892]: unpaginated notes). *Das Atelier* 2, no. 37 (May 1892), reported that the panorama was valued at 200,000 marks when it burned.

For a contemporary assessment of the importance of Piglhein's work and for information about his trip to Palestine and the later legal proceedings regarding the panorama, see the lengthy obituary by Gottfried Böhm, "Bruno Piglhein †," *Die Kunst unserer Zeit* 5, 2nd half-vol. (1894): 84–86, as well as "Bruno Piglhein †," *Die Kunst für Alle* 9, no. 22 (Aug. 1894): 342; R. [Hans Rosenhagen], "Bruno Piglhein," *Das Atelier* 4, no. 15 (Aug. 1894): 1–2; and the tribute in A[nna] Spier, "Die Ausstellung der Münchener Secession 1894," *Die Kunst unserer Zeit* 5, 2nd half-vol. (1894): 102–4. *Die Kunst für Alle* 6, no. 15 (May 1891): 237–38, published a long report on the lawsuit in London. See also Oettermann, "Das Panorama von Jerusalem und die Kreuzigung Christi," in Oettermann, *Das Panorama*, 216–19, accompanied by a three-foot-long color photographic reproduction of the Crucifixion panorama; the English edition has a small black-and-white version, fig. 4.46.

68. Catholic art also flourished, as did the building of new churches, requiring monumental art in both confessions. Two articles in Mai, Waetzoldt, and Wolandt, *Ideengeschichte und Kunstwissenschaft*, discuss the Catholic

for example, in n.s. 1 (Nov. 1889): col. 69 or ibid. (Feb. 1890): col. 259, where he refers to Uhde as "der Hohepriester der Gemeinde." The two reviews from 1887 are Hermann Lücke, "Fritz von Uhde," *Zeitschrift für bildende Kunst* 22 (1886–87): 349–58; and Adolf Rosenberg, "Die Akademische Kunstausstellung zu Berlin," ibid. 23 (1887–88): 51.

84. A.R. [Adolf Rosenberg], "Berliner Kunstausstellungen," *Kunstchronik* 20 (1885): col. 399; see also his critique of Liebermann in "Die Jubiläumskunstausstellung in Berlin, IV," *Zeitschrift für bildende Kunst* 22 (1886–87): 46. Muther is quoted from R[ichard] Muther, "Die internationale Kunstausstellung in München," ibid. 23 (1887–88): 291–92, with the illustration *Altmännerhaus in Amsterdam*.

85. Ludwig Kaemmerer, "Max Liebermann," *Zeitschrift für bildende Kunst* 28, n.s. 4 (1892–93): 249–57, 278–86, quotations from 250–51, 257.

86. Muther, "Die internationale Kunstausstellung in München," ibid. 23 (1887–88): 290–91, 308–14, 329–33, quotation from 330.

87. Ludwig, *Kunst, Geld und Politik*, 41, 51, 53. See Alfred Gotthold Meyer's brief reference to the complaints that were being made about the thick, relief-like application of paint in Liebermann's *Schweinemarkt in Haarlem*, in "Dritte Münchener Jahresausstellung," *Kunstchronik*, n.s. 3 (Dec. 1891): col. 103. In the 1892 parliamentary debates the speakers used the Germanized French terms *Pleinairismus* and *Pleinairmalerei*.

88. Gerhard Kratzsch, *Kunstwart und Dürerbund: Ein Beitrag zur Geschichte der Gebildeten im Zeitalter des Imperialismus* (Göttingen, Germany: Vandenhoeck & Ruprecht, 1969), 113–33. Kratzsch reports that in 1888–89 Woldemar von Seidlitz, later director of the Dresden museums, provided desperately needed financial support to keep the journal going but that the journal remained in shaky condition until 1894, when Georg D. W. Callwey, in Munich, took over the financial side of the publication, leaving the editorial side to Avenarius. Kratzsch's book is an invaluable source of information about the journal, though the weight of his book is on the period after the Dürerbund (Dürer League) was formed in 1902. Another important study, specifically on the reception of art in the journal, is Ingrid Koszinowski, *Von der Poesie des Kunstwerks: Zur Kunstrezeption um 1900 am Beispiel der Malereikritik der Zeitschrift "Kunstwart"* (Hildesheim, Germany: Georg Olms Verlag, 1985).

89. Avenarius's reprinting articles from other journals brought several protests; see, e.g., his response to the editor of *Die Moderne*, who objected to his reprinting a long article by Heinrich Hart (*Der Kunstwart* 4, nos. 15 [May 1891]: 237 and 17 [June 1891]: 269. See also Kratzsch, *Kunstwart und Dürerbund*, 110–11).

90. See *Der Kunstwart* 1, no. 16 (May 1888): 225, in a review by the conservative painter and poet Arthur Fitger from the *Weser Zeitung*; and ibid. 2, no. 5 (Dec. 1888): 67.

91. "Vom Tage," *Der Kunstwart* 1, no. 24 (Sept. 1888): 353–54.

92. Otto von Leixner, *Die Ausstellung von 1878*, vol. 2 of *Die moderne Kunst und die Ausstellungen der Berliner Akademie* (Berlin, 1879); [Avenarius], "Religiöse Kunst," *Der Kunstwart* 1, no. 12 (Mar. 1888): 156. The following articles were: Adolph Hausrath, "Auf die moderne protestantische Malerei," ibid., no. 15 (May 1888): 207; Adolph Ehrhardt, ibid., no. 16 (May 1888): 227; Sprechsaal, ibid., no. 18 (June 1888); [Avenarius], "Die Malerei auf der Münchner Ausstellung, II," ibid. 2, nos. 1 (Oct. 1888): 9 and 2 (Oct. 1888): 22. This quotation is from Avenarius's review of a pamphlet by Albert Ilg, *Moderne Kunstliebhaberei* (Vienna: Graeser, 1887) in *Der Kunstwart* 1, no. 4 (Nov. 1887): 44.

93. Georg Voß, "Gurlitts Kunstsalon in Berlin," *Die Kunst für Alle* 1, no. 4 (Nov. 1885): 56–57. Voss reported on the "frische frohe Farben" of Böcklin's early painting and of his more recent ones "die ihm so begeisterte Anhänger unter den Jungeren, aber auch ebensoviele unversöhnliche Feinde unter den Alteren erworben haben." For information on the Bernstein collection, the Gurlitt exhibition, and press responses, see Nicolaas Teeuwisse, *Vom Salon zur Secession: Berliner Kunstleben zwischen Tradition und Aufbruch zur Moderne, 1871–1900* (Berlin: Deutscher Verlag für Kunstwissenschaft, 1986), 98–107; and Barbara Paul, "Drei Sammlungen französischer impressionistischer Kunst im kaiserlichen Berlin—Bernstein, Liebermann, Arnhold," in *Sammler der frühen Moderne in Berlin*, ed. Thomas W. Gaehtgens, special issue of *Zeitschrift des deutschen Vereins für Kunstwissenschaft* 42, no. 3 (1988): 11–15. Teeuwisse, 107, cites Ludwig Pietzsch's condemnation of the exhibition in the *Vossischen Zeitung* (10 Oct. 1883), 1st supplement: "Der Widerspruch in diesen Malereien gegen Alles, was ein Bild zum Kunstwerk und zum Gegenstand des Wohlgefallens für Augen und Geist macht, ist zu krass!!"

94. Fritz von Uhde to Fritz Gurlitt, 13 Dec. 1887, quoted in full in Brand, *Fritz von Uhde*, 247–48. Georg Voß, in "Eine Ausstellung der Hellmaler," *Die Kunst für Alle* 3, no. 12 (Mar. 1888): 187–88, reviewed paintings by Schlittgen, Skarbina, Kuehl, Kalckreuth, Klaus Meyer, H. Neuhaus, and Stremel.

95. Voß "Berlin," ibid. 4, no. 9 (Feb. 1889): 142, considered the most important part of the second exhibition to be the paintings of Wilhelm Leibl, which had not been seen in Germany for some time. For recent studies on Leibl, see Boris Röhrl, *Wilhelm Leibl: Leben und Werk* (Hildesheim, Germany: Georg Olms Verlag, 1994); and Klaus Jörg Schönmetzler, *Wilhelm Leibl und seine Malerfreunde* (Rosenheim, Germany: Rosenheimer Verlag, 1994).

Adolf Rosenberg reviewed the third Hellmaler exhibit in January 1890 (A.R., "Die Gurlittsche Kunstausstellung in Berlin," *Kunstchronik*, n.s. 1 [Feb. 1890]: col. 259). Writing with his usual acerbity, he singled out Lesser Ury for his "exaggerated caricatures" of naturalistic-impressionistic interiors, and Fritz von Uhde, the "high priest" of the group. For the criticism of Gurlitt, see R.S., "Ausstellung der Hellmaler," *Berliner Tageblatt*, 10 Jan. 1889, cited in Teeuwisse, *Vom Salon zur Secession*, 121.

Later reviews of Lesser Ury's paintings include A.R., "Aus Berliner Kunstausstellung: Lesser Ury," *Kunstchronik*, n.s. 4 (Apr. 1893): cols. 377–78, a very negative appraisal; Max Schmid, "Salon Gurlitt," *Das Atelier* 3, no. 61 (May 1893): 3–4; *Die Kunst für Alle* 8, nos. 14 (Apr. 1893): 219 and 18 (June 1893): 283; Albert Dresdner, "Berliner Kunstbrief," *Der Kunstwart* 6, no. 15 (May 1893); Albert Dresdner, "Berliner Kunstbrief," ibid. 7, no. 13 (Apr. 1894): 201; and O. Bie, "Lesser Ury," ibid. 8, no. 22 (Aug. 1895): 344–45; "Lesser Ury," ibid. 9, no. 2 (Oct. 1895): 29.

Bie points out Ury's total absorption with color and light from his first work and the difficulties he encountered in gaining acceptance for his work. Supported by Gurlitt's gallery, which held several collective exhibitions of his work, Ury achieved solid recognition by the mid-nineties as a modern mood painter. An early monograph on his work maintained that Ury was "the earliest standard-bearer of impressionism" in Germany (Lothar Brieger, *Lesser Ury: Graphiker der Gegenwart* [Berlin: Verlag Neue Kunsthandlung, 1921], 5. See also Karl Schwarz, *Lesser Ury* [Berlin: Verlag für Jüdische Kunst und Kultur, 1920]; Alfred Werner, "The Strange Tale of Lesser Ury," *Leo Baeck Institute Year Book* 19 [1974]: 197–207, which discusses Ury's prickly relationship with Liebermann; and Emily D. Bilski, "Images of Identity and Urban Life: Jewish Artists in Turn-of-the-Century Berlin," in *Berlin Metropolis: Jews and the New Culture, 1890–1918*, exh. cat. [Berkeley: University of California Press, 1999], 106–23).

96. See Georg Voß, "Ein Berliner Realist," *Die Kunst für Alle* 3, no. 11 (Mar. 1888): 168–70, where he discusses Skarbina as heavily influenced by the "new French realism" of Manet and Bastien-Lepage. This positive assessment of Skarbina's work was published in the issue preceding Voss's review of the Hellmaler exhibit. In 1892 the *Zeitschrift* published an earnest defense of Skarbina's painting, claiming that he should be ranked along with Liebermann as pioneering new art that reestablished Germany's place in the international art world. The article, probably written by Henriette Mendelsohn, was given the byline hn: "Franz Skarbina," *Zeitschrift für bildende Kunst* 27, n.s. 3 (1891–92): 49–54. See also Franz Hermann [Meissner], "Atelier-Studien III: Bei Franz Skarbina," *Das Atelier* 1, no. 13 (May 1891): 7–9; and Margrit Bröhan, *Franz Skarbina*, exh. cat. (Berlin: Ars Nicolai, 1995), 28; an earlier catalogue was curated by Irmgard Wirth: *Der Berliner Maler Franz Skarbina: Ein Querschnitt durch sein Werk* (Berlin: Berlin Museum, 1970). An analysis of one of Skarbina's important cityscapes from the mid-1890s is included in John Czaplicka, "Pictures of a City at Work, Berlin, circa 1890–1930: Visual Reflections on Social Structures and Technology in the Modern Urban Construct," in *Berlin: Culture and Metropolis*, ed. Charles W. Haxthausen and Heidrun Suhr (Minneapolis: University of Minnesota Press, 1990), 8–17.

97. Georg Voß, "Eine Ausstellung der Hellmaler," *Die Kunst für Alle* 3, no. 12 (Mar. 1888): 187–88.

98. "Bildende Kunst," *Der Kunstwart* 2, no. 4 (Nov. 1888): 56–58, reprinted from *Kölnische Zeitung* (28 Oct. 1888). A note appended to the article stated that it had already created opposition and that E. Bendemann, speaking for many artists, was publishing a response in the *Kölnische Zeitung*. For identification of Bode as the author and for a reprint of the full text, see Angelika Wesenberg, "'Zur Förderung der deutschen Kunst': Wilhelm Bode als kunstkritischer Anonymus," in *Wilhelm von Bode als Zeitgenosse der Kunst*, 83–94. A contemporary assessment of Bode's significance in creating the modern German museum official and in transforming the Berlin museums into internationally recognized art centers can be found in Woldemar von Seidlitz, "Wilhelm Bode: Rückblick auf eine Museumsthätigkeit von funfundzwanzig Jahren," *Zeitschrift für bildende Kunst* 33, n.s. 9 (1897–98): 1–4. For further information, see Wilhelm von Bode, *Mein Leben* (Berlin, 1930); a new two-volume edition is *Wilhelm von Bode: Mein Leben*, ed. Thomas W. Gaehtgens and Barbara Paul (Berlin: Ars Nicolai, 1997).

99. Wolfgang Kirchback, "Was ist Hellmalerei?" *Der Kunstwart*, 2, no. 12 (Mar. 1889): 177–79. Kirchback provided no further citation for the quotation except to mention that the pamphlet had been reviewed previously in the journal. The pamphlet may have accompanied the second Gurlitt Hellmaler exhibit, or it may have been a pamphlet in the series Gegen der Strom, edited by Arthur Ilg. For other examples of cartoons on the use of technological innovations by modern artists, see "Der Landschaftsmaler auf der Studienreise," *Fliegende Blätter* 91, no. 2301 (1889): 75; and "Wie man ein modernes Bild macht," ibid., no. 2307 (1889): 133.

100. Neumann's article was "Die neue Richtung unserer Malerei," *Der Kunstwart* 2, no. 13 (Apr. 1889): 198–200. A decade later Neumann published a less positive view of the current scene, *Der Kampf um die Neue Kunst*, 2nd ed. (Berlin: Verlag von Hermann Walther, 1897). Neumann began teaching at Heidelberg in 1894 and became a professor there in 1897. He subsequently held professorships at Göttingen, Kiel, and again at Heidelberg.

101. Cornelius Gurlitt, "Was ist Hellmalerei?" *Der Kunstwart* 2, no. 22 (Aug. 1889): 337–39. For a contemporary assessment of Cornelius Gurlitt's importance as one of the first critics to promote the new art forms, see Paul Schultze-Naumburg, "Deutsche Kunstkritiker," *Die Kunst für Alle* 10, no. 11 (Mar. 1895): 162–63. Writing also in *Gegenwart*, *Die Kunst unserer Zeit*, and *Westermann's Monatshefte*, Gurlitt attracted attention to his spirited but measured approach. Avenarius's review appeared as "Erste Münchner Jahresausstellung," *Der Kunstwart* 2, no. 24 (Sept. 1889): 378–79.

102. For the poem, see Cassius, *Spottvogel im Glaspalast: Epigramme in Wort und Bild auf die Münchener Jahres-Ausstellung 1889*, 8–9.

103. C[arl] von Vincenti, "Entwickelung der deutschen 'Freilichtmalerei,'" *Der Kunstwart* 3, no. 11 (Mar. 1890): 169–71. For a brief discussion of the acquisition of Liebermann paintings for the Berlin National Gallery, see Christopher B. With, *The Prussian Landeskunstkommission, 1862–1911: A Study in State Subvention of the Arts* (Berlin: Gebr. Mann Verlag, 1986), 114–15. See particularly the critique in Momme Nissen "Zweite Münchener Jahreausstellung, I," *Der Kunstwart* 3, no. 21 (July 1890): 330. On open-air painting as a comfortable international salon style, see Jensen, *Marketing Modernism*; and Götz Czymmek, ed., *Landschaft im Licht: Impressionistische Malerei in Europa und Nordamerika, 1860–1910*, exh. cat. (Cologne: Wallraf-Richartz-Museum, 1890).

104. F.A. [Avenarius], "Bildung," *Der Kunstwart* 1, no. 3 (Nov. 1887): 25–27; idem, "Unsere Künste: Zum Überblick," ibid., no. 1 (Sept. 1887): 1. See also Kratsch, *Der Kunstwart*, chap. 3–4. Avenarius's views were part of the larger rejection of the materialism and rationalism of modern society by publicists and intellectuals in Germany who have been identified by scholars as cultural pessimists. In these years Avenarius, however, was far from a pessimist; he was sustained by the buoyant optimism of the reformer and by his belief in the strength of the German culture and people. An indispensable study evoking the mentality of influential cultural leaders in the early years of the twentieth century is Gary D. Stark, *Entrepreneurs of Ideology: Neoconservative Publishers in Germany, 1890–1933* (Chapel Hill: University of North Carolina Press, 1981), esp. chap. 3.

105. On Avenarius's call for imagination, see F.A., "Von der Freude am Kunstwerk," *Der Kunstwart* 1, no. 20 (July 1888): 281–83; for the creation of a broad base for art, see "Sprechsaal," ibid. 2, no. 5 (Dec. 1888): 75–76. On art education, see the review of Alfred Lichtwark's work through the Hamburger Kunsthalle to raise public appreciation for art, ibid. 1, no. 5 (Dec. 1887): 54–55. On the revival of graphic arts, see "Bildende Künste," ibid., no. 12 (Mar. 1888): 159–61; and Georg Hirth, "Die graphischen Künste in Deutschland," ibid. 2, no. 18 (June 1889): 278–81. An invaluable and exhaustive study of the revival of graphic art at the end of the century, with particular attention to the role of Alfred Lichtwark, is Henrike Junge, *Wohlfeile Kunst: Die Verbreitung von Künstlergraphik seit 1870 und die Griffelkunst-Vereinigung Hamburg-Langenhorn* (Mainz: Verlag Philipp Zabern, 1989). See Avenarius's brief criticism of Werner's *Kronprinz Friedrich Wilhelm an der Leiche des Generals Abel Douay bei Weißenberg* as a painting that evokes patriotism but is not art in *Der Kunstwart* 4, no. 19 (July 1891): 298.

106. For an early analysis of Böcklin's reception, see Paul Schumann, "Arnold Böcklin," *Die Kunst für Alle* 15, no. 13 (Apr. 1900): 298–300, reviewing Alfred Lichtwark's study of Böcklin, *Die Seele und das Kunstwerk* (Berlin: Bruno & Paul Cassirer, 1899). See also Lutz Tittel, "Die Beurteilung Arnold Böcklins in der *Zeitschrift für bildende Kunst* von 1866 bis 1901," in *Arnold Böcklin, 1827–1901: Gemälde, Zeichnungen, Plastiken. Ausstellung zum 150. Geburtstag*, ed. Dorothea Christ, exh. cat. (Basel: Schwabe & Co., 1977), which supplies the sales figures; Ingrid Koszinowski, "Böcklin und seine Kritiker: Zu Ideologie und Kunstbegriff um 1900," in Mai, Waetzoldt, and Wolandt, *Ideengeschichte und Kunstwissenschaft*, 279–92; and Elizabeth Tumasonis, "Böcklin's Reputation: Its Rise and Fall," *Art Criticism* 6, no. 2 (1990): 48–71.

107. Friedrich Pecht, "Zu Arnold Böcklins 60. Geburtstag," *Die Kunst für Alle* 3, no. 2 (Oct. 1887): 17–20, with all illustrations and plates in this issue by Böcklin. The overenthusiastic commendation came from Max Lehrs, *Arnold Böcklin: Ein Leitfaden zum Verständnis seiner Kunst* (Munich: Photographische Union, 1897), 14. Lehrs's book was reviewed in *Kunstchronik*, n.s. 9 (Oct. 1897): cols. 41–42. See also the report on the whole issue on Böcklin in *Illustrirte Zeitung*, no. 2310 (1887), which contains an article by Aemil Fendler that is reprinted in *Der Kunstwart* 1, no. 3 (Nov. 1887): 30–31. Later tributes included Franz Hermann Meissner, "Arnold Böcklin: Eine Studie," *Die Kunst unserer Zeit* 5, 1st half-vol. (1894): 21–34; Cornelius Gurlitt, "Arnold Böcklin," *Die Kunst für Alle* 9, no. 2 (Oct. 1893): 17–23, heavily illustrated; Carl Neumann, "Zu Arnold Böcklins siebenzigstem Geburtstag," ibid. 13, no. 1 (Oct. 1897): 1–9, with twenty-one illustrations and four full-page plates of paintings not

shown in previous issues; Hugo von Tschudi, "Arnold Böcklin," ibid. 16, no. 11 (Mar. 1901): 251–56; and Heinrich Wölfflin, "Arnold Böcklin: Bei Anlass von Schicks Tagebuch," ibid. 17, no. 1 (Oct. 1901): 1–17, the last two both richly illustrated.

The trajectory of Böcklin's fame can be roughly followed by a cursory look at the purchases for the Berlin National Gallery. In 1877 Böcklin received a commission from the recently opened National Gallery on the recommendation of the director, Max Jordan, for a painting, *Die Gefilde der Seligen* (1877–78), for which he received 15,000 marks. *Pietà* (1873) was purchased for 36,000 marks in 1888, though it was not shown for six years because of legal problems; and *Der Frühlingstag* (1883) and *Meeresbrandung* (1876) were purchased in 1897. One of his best-known works, *Meeresidylle*, also known as *Triton und Nereide* (1875), was rejected by the purchasing committee and the director in 1875, when the price was 12,000 marks, only to be acquired from a private collection in 1910 for 180,000 marks plus an annual pension to the heirs. Both *Pietà* and *Meeresidylle* have been missing since 1945. For information on the National Gallery purchases, see With, *Prussian Landeskunstkommission*, 79–84, 132–34.

108. The quotation "the most German painting, the genuine imaginative painting," which also referred to Max Klinger, is from *Der Kunstwart* 6, no. 2 (Oct. 1892): 18. Tittel, "Die Beurteilung Arnold Böcklins," 125–29, relates the failure of the jury to award the gold medal to Böcklin in 1884.

109. F.A. [Avenarius], "Bildung," *Der Kunstwart* 1, no. 3 (Nov. 1887): 26. For further examples of Avenarius's views on Böcklin, see ibid. 2, no. 2 (Oct. 1888): 22; ibid. 4, no. 4 (Nov. 1890): 58a–61a; ibid., no. 19 (July 1891): 297; and ibid. 5, no. 17 (June 1892): 262–63. The reference to Böcklin as the spiritual leader is from Herman Eichfeld, "Die dritten Münchener Jahresausstellung, I," ibid. 4, no. 20 (July 1891): 315. The charge of "artistic parthenogenesis" was suggested in -n-, "Die 63. akademische Kunstausstellung zu Berlin, I," ibid. 5, no. 17 (June 1892): 263. The reporter, who used only an initial as a byline, complained that this exhibition was a discouraging collection of cheap imitations of earlier works—"Auch-Künstlertum"—including a particularly tedious example of a *Meeres-Idyll* descended from Böcklin's painting of the same name. Avenarius also complained repeatedly about the complete lack of genuine fantasy in the works of those who copied Böcklin's figures; in one review he pointed out that these weak efforts, titled "Mermaid" or "Alpen Fairy," usually only produced a pretty girl wearing a negligee.

110. Avenarius, "Die Malerei auf der Münchner Ausstellung, III," *Der Kunstwart* 2, no. 2 (19 Oct. 1888): 22.

111. See Koszinowski, "Böcklin and seine Kritiker," on this generational issue.

112. Friedrich Haack, "Arnold Böcklin: Zu seinem 70. Geburtstage," *Zeitschrift für bildende Kunst* 33, n.s. 9 (1897–98): 5–13.

113. A[venarius], "Die Internationale Kunst-Ausstellung in Berlin, II," *Der Kunstwart* 4, no. 19 (July 1891); Max Lehrs, "Max Klinger's 'Brahms-Phantasie,'" *Zeitschrift für bildende Kunst* 30, n.s. 6 (1894–95): 113. Lehrs, a professor of art history, began his work in the Dresden Print Collection in 1883, serving as its director in 1896–1904 and again in 1908–24. See also Friedrich Haack, "Böcklin und Klinger: Eine vergleichende Charakteristik," *Die Kunst für Alle* 11, no. 1 (Oct. 1895): 1–4; Julius Vogel, "Altes und Neues von Max Klinger," *Zeitschrift für bildende Kunst* 32, n.s. 8 (1896–97): 153; and Friedrich Gross's lengthy treatment of the rejected genius in "Das Künstler-Genie als Heiland oder Märtyrer," in *Jesus, Luther und der Pabst*, chap. 6.

114. Gerhard Winkler, *Max Klinger* (Leipzig: E. A. Seamann, 1984); Dieter Gleisberg, ed., *Max Klinger, 1857–1920*, exh. cat. (Leipzig: Edition Leipzig, 1992); and idem, "'Er war ihr Stolz, ihre Bewunderung': Max Klinger im Kreise seiner Freunde," in *Max Klinger: Zeichnungen, Zustandsdrucke, Zyklen*, ed. Jo-Anne Birnie Danzker and Tilman Falk, exh. cat. (Munich: Prestel Verlag, 1996), 15–30, provide the most complete information about Klinger's life and work. Klinger's *Surprise Attack at the Wall* had the dubious distinction of being one of the paintings whose purchase by the Berlin Nationalgalerie was vetoed by William II (see Christopher With, *Prussian Landeskunstkommission*, 109–10).

For an explication of the autobiographical nature of Klinger's early graphics, see Dieter Gleisberg, "'Ich muß mir stets ein kleines Monument errichten': Max Klinger in seinen Selbstdarstellungen," in *Max Klinger, 1857–1920*, 13–25. For a careful analysis of shifts in the critical approaches to Klinger's career, see Elizabeth Pendleton Streicher, "'Zwischen Klingers Ruhm und seiner Leistung': Max Klingers Kunst im Spiegel der Kritik, 1877–1920," in Danzker and Falk, *Max Klinger*, 45–55. I am grateful for her willingness to share with me the manuscript of her systematic study. See also Streicher's "Max Klinger's *Malerei und Zeichnung*: The Critical Reception of the Prints and Their Text," in Forster-Hahn, *Imagining Modern German Culture*, 229–50.

115. However, for a very negative response, see Adolf Rosenberg, "Die akademische Kunstausstellung in Berlin," *Zeitschrift für bildende Kunst* 18 (1882–83): 367–78, which charged that Klinger's graphics alternated between the trivial and the fantastic, conveying subject matter that was unpleasant, repetitive, and too drawn-out.

116. For a sensitive analysis, see Robin Reisenfeld, "Max Klinger: *Eine Liebe* (Opus X)," in *The German Print Portfolio, 1890–1930: Serials for a Private Sphere*, exh. cat. (Chicago: David and Alfred Smart Museum of Art, 1992), 35–43. A useful introduction to the graphic cycles is Kirk Varnedoe and Elizabeth Streicher, *Graphic Works of Max Klinger* (New York: Dover Publications, 1977).

117. Georg Voß, "Ausstellungen, Sammlungen," *Die Kunst für Alle* 3, no. 6 (Dec. 1887): 96–97.

118. See Renate Hartleb, "'Eve, sans trêve': Zur Frau im Werk von Max Klinger," in Gleisberg, *Max Klinger, 1857–1920*, 84–90, who points out that Klinger was one of the first German artists to deal with prostitution without condemning the woman. A contemporary view of these issues is Franz Hermann Meissner, *Max Klinger* (Berlin: Schuster & Loeffler, 1899), 69–77, an expanded version of his essay originally published in *Westermann's Illustrierte Deutsche Monatshefte* 71, no. 421 (Oct. 1891): 112–29, and then reproduced in *Die Kunst unserer Zeit* 6, 1st half-vol. (1894): 1–20, with superb plates of his major works. Julius Vogel, a friend of Klinger's and future director of the Leipzig Museum of Art, pointed out in 1897 that Meissner's writing about Klinger was not reliable and was filled with inflated critical nonsense ("Altes und Neues von Max Klinger," *Zeitschrift für bildende Kunst* 32, n.s. 8 [1896–97]: 165–66). See also Cornelius Gurlitt, "Max Klinger, *Die Kunst für Alle* 10, no. 5 (Dec. 1894): 66–73; Käthe Kollwitz, "Ansprache zur Beisetzung von Max Klinger," 8 July 1920, quoted in *Max Klinger: Wege zum Gesamtkunstwerk*, by Roemer-und Pelizaeus Museum, exh. cat. (Mainz: Verlag Philipp von Zabern, 1984), 131–32; and Streicher, "Max Klinger's *Malerei und Zeichnung*," 244.

119. Herman Eichfeld, "Die dritte Münchener Jahresausstellung," *Der Kunstwart* 4, no. 21 (Aug. 1891): 328; Hans W. Singer, "Max Klinger's Gemälde," *Zeitschrift für bildende Kunst* 29, n.s. 5 (1893–94): 49; Pecht, *Die Kunst für Alle* 6, no. 13 (Apr. 1891): 207. See also Pecht's appraisals in ibid. 5, no. 4 (Nov. 1889): 53, where he refers to a graphic series of "unseres Höllenbreughels, Max Klinger, . . . dieses merkwürdig dämonischen Künstlers," and ibid. 11, no. 15 (May 1896): 236. On Avenarius's promotion of Klinger's graphics, see "Griffelkunst," *Der Kunstwart* 5, no. 2 (Oct. 1891): 17–20; and Avenarius, "Max Klinger Zyklus, 'Vom Tode,'" ibid. 8, no. 4 (Nov. 1894): 60, reprinted from Ferdinand Avenarius, *Max Klingers Griffelkunst: Ein Begleiter durch ihre Phantasiewelt* (Berlin: Amsler & Ruthardt, 1895).

120. On the reception in Berlin, see George Voß, "Die Berliner Kunstausstellung," *Die Kunst für Alle* 2, no. 24 (Sept. 1887): 358; referring to Klinger as the "most reck-

less representative" of the modern realists, Voss was mildly critical of the work with its grotesque faces. Nevertheless, he judged the light-filled painting to be extraordinarily beautiful. On Leipzig, see Vogel, "Altes und Neues von Max Klinger"; Vogel included himself among those whose response to the painting was not positive. For Vogel's later account, see Julius Vogel, *Max Klinger und seine Vaterstadt Leipzig: Ein Kapitel aus dem Kunstleben einer deutschen Stadt* (Leipzig: A. Deichertsche Verlagsbuchhandlung, 1923), 8–9. On the Bavarian parliament, see Ludwig, *Kunst, Geld und Politik*, 32. Jager's attack on the nudes in Klinger's painting was part of the same speech on immorality in which he condemned Uhde for his portrayal of Christ as a common criminal.

121. The quotation is from Cornelius Gurlitt, "Max Klinger," *Die Kunst für Alle* 10, no. 5 (Dec. 1894): 66–69. Gurlitt later recounted in more detail the public ridicule of the painting at the Berlin Academy Exhibition and Klinger's aghast response in *Die deutsche Kunst des neunzehnten Jahrhunderts: Ihre Ziele und Thaten*, vol. 2 of *Das Neunzehnte Jahrhundert in Deutschlands Entwicklung*, ed. Paul Schlenther (Berlin: Georg Bondi, 1899), 611–14. See also Aemil Fendler, "Berlin Akademische Kunstausstsellung," *Der Kunstwart* 1, no. 2 (Oct. 1887): 18; and Pecht, "Die Münchener Ausstellung von 1888: Die deutsche Historienmalerei," *Die Kunst für Alle* 3, no. 19 (July 1888): 292.

122. See Gisela Scheffler, "Max Klinger in München," in Danzker and Falk, *Max Klinger*, 9–10, for a careful examination of the archives and the daily press that revises the prevalent myth that the painting was viewed only by invitation for three days. Scheffler found no evidence in police or state records or in the daily press of a scandal or of police action against the exhibition. See also Maria Makela, "The Politics of Parody: Some Thoughts on the 'Modern' in Turn-of-the-Century Munich," in Forster-Hahn, *Imagining Modern German Culture*, 190–93, which treats the painting in the larger context of Catholic efforts to control and censor art in Munich; *Die Kunst unserer Zeit* 2, 1st half-vol. (Mar. 1891), unpaginated notes; Herman Helferich [Emil Heilbut], "Fünf Münchener Ausstellungen," *Die Kunst für Alle* 6, no. 14 (Apr. 1891): 214; and F[riedrich] Pecht, "München," ibid., no. 13 (Apr. 1891): 207. Citations of the coverage through both announcements and reviews from the *Münchener Neuesten Nachrichten* and the *Münchener Allgemeinen Zeitung* and the report on the prince regent's visit are provided in Scheffler, "Max Klinger in München," 10 and 14 nn. 22–23. The article published six months later was Franz Hermann [Meissner], "Max Klinger, Maler-Radierer: Eine Studie," *Westermann's Illustrierte Deutsche Monatshefte* 71, no. 421 (Oct. 1891): 111–29, quoted phrases from 113.

123. Hans Singer, "Max Klinger's Gemälde," *Zeitschrift für bildende Kunst*, n.s. 5 (1893–94): 50. Gurlitt's account, published a year later in "Max Klinger," *Die Kunst für Alle* 10, no. 5 (Dec. 1894): 63, reported that the Munich police had prohibited the painting from being shown; however, after an order came from the culture ministry that the painting could be shown if it were partially covered, it was exhibited. In his 1899 biography Max Schmid referred briefly to *The Crucifixion*'s not receiving good treatment at first and being curtained in Munich (see Max Schmid, *Klinger* [Bielefeld, Germany: Verlag von Velhagen & Klasing, 1899], 84–86).

　　Ludwig Leiss, in his study on censorship of the arts in Germany, *Kunst im Konflikt*, 101–2, states that there were no official records available in the archives to document the actions against the painting, other than the magistrate's order that the painting could be shown if it were partially covered. Citing a 1908 letter from Klinger to Alexander Hummel, Streicher, "Zwischen Klingers Ruhm und seiner Leistung," 49, refers to an outraged response to the painting on the part of the conservative Catholics in Munich that resulted in a police order to drape the figure during the first days of the exhibition. Scheffler, "Max Klinger in München," 10, 14 n. 20, cites the letter written by Klinger to his parents after he had left Munich over the excitement created by the painting and suggests that Klinger's quick compliance with the request from the cultural ministry prevented a scandal. See also Julius Vogel, *Max Klingers Kreuzigung Christi im Museum der bildenden Künste zu Leipzig* (Leipzig: E. A. Seemann, 1918), 13.

124. H[ermann] A[rthur] Lier, "Korrespondenz: Dresden, November 1893," *Kunstchronik*, n.s. 5 (Dec. 1893): col. 122. A brief announcement of the opening of the Lichtenberg exhibition appeared earlier, in "Dresden: Max Klinger," ibid. (Nov. 1893): col. 71. The reporter was Artur Seemann, "Klinger-Ausstellung in Leipzig," ibid. (Jan. 1894): cols. 203–6. Son of the founder and publisher of the *Zeitschrift für bildende Kunst*, Artur Seemann became the publisher of the journal in 1898. Vogel, *Max Klinger und seine Vaterstadt Leipzig*, 11–12, claimed that he had persuaded Klinger to overpaint in order to overcome the Leipzig Kunstverein's fear of offending the religious sensibilities of their members. Vogel characterized the reception of the painting at this 1894 exhibition as better than expected.

125. Karl Woermann, director of the Dresden museums, referring to Klinger as "der phantasiegewaltige Max Klinger," argued that if there was ever an art that was completely of its time, that served to develop strong personalities in art, and was above all in its deepest being German, it was the contemporary imaginative painting ("Was uns die Kunstgeschichte lehrt," *Der Kunstwart* 7, no. 15 [May 1894]: 228). For a further analysis of Klinger's confrontation with the crises of his day, see Manfred Boetzkes, "Wege zum Gesamtkunstwerk," in Roemer- und Pelizaeus Museum, *Max Klinger*, 1–12. Cornelius Gurlitt in 1894 recognized that ideas lay at the heart of Klinger's work: "Also Deutlichkeit des Ausdruckes und Einfachheit des rein malerisch zu erfassenden Gedankens: das ist wohl der Kern von Klingers Zielen. . . . ein einfacher malerischer Gedanke" ("Max Klinger," *Die Kunst für Alle* 10, no. 6 [Dec. 1894]: 82). On Klinger's technical mastery, see *Der Kunstwart* 4, no. 13 (Apr. 1891): 201–2; ibid., no. 21 (Aug. 1891): 328–29; and Herman Helferich [Emil Heilbut], "Etwas über die symbolistische Bewegung," *Die Kunst für Alle* 10, no. 3 (Nov. 1894): 34. See also the special issue of *Jugend* (12 Sept. 1910) devoted to Schopenhauer on the fiftieth anniversary of his death, in which Klinger's print *Der befreite Prometheus* was given a double-page spread on 890–91.

126. For a provocative analysis of the subversive nature of David Friedrich Strauß's distinction between the Jesus of history and the Christ of faith, see Marilyn Chapin Massey, *Christ Unmasked: The Meaning of "The Life of Jesus" in German Politics* (Chapel Hill: University of North Carolina Press, 1983).

127. I am indebted here to a systematic analysis of this painting by Friedrich Gross, "Vom Alltagsgetriebe fern: Der Große Einzelne in Klingers *Kreuzigung Christi* und *Christus im Olymp*," in Gleisberg, *Max Klinger, 1857–1920*, 72–75. The legacy of the golden-haired Christ portrayed in both of these paintings was unfortunate for Klinger's reputation. Winkler, *Max Klinger*, 39–47, relates that in 1937 the Leipzig Art Society mounted a large Klinger retrospective that was intended to mask the confiscation by the National Socialists of modern art from the Leipzig museums and, more profoundly, to appropriate the tall, red-haired Klinger—seventeen years after his death—as an exponent of the ideal blond racial type and an advocate of the Germanic Christ of National Socialism. Winkler also traces the shifting attitudes toward Klinger's work in the successive postwar decades in the German Democratic Republic.

128. Vogel, *Max Klingers Kreuzigung*, 11.

129. After viewing the painting in Klinger's studio, Richard Dehmel wrote an ecstatic poem, titled "Jesus und Psyche: Phantasie bei Klinger" (1902), connecting the painting to Klinger's monumental statue of Beethoven and interpreting both as presaging a new era of sensual joy (Gross, "Vom Alltagsgetriebe fern," 76).

130. Alexander Dückers, *Max Klinger* (Berlin: Rembrandt Verlag, 1976), cogently demonstrates the pervasive influence of Schopenhauer's philosophy both in Klinger's

graphic cycles and in his monumental paintings of Christ, who for Schopenhauer was the symbol of suffering and of the negation of the will to live. On Nietzsche's influence upon Klinger's work, see Hans-Dieter Erbsmehl, "Kulturkritik und Gegenästhetik: Zur Bedeutung Friedrich Nietzsches für die bildende Kunst in Deutschland, 1892–1918" (Ph.D. diss., University of California, Los Angeles, 1993), chap. 3. Gleisberg, who argues convincingly for the essential subjectivity of Klinger's work, applies a variation of Cartesian logic to Klinger: "Ich zeichne mich, also bin ich" (Gleisberg, "Ich muß mir stets . . . ," in Gleisberg, *Max Klinger, 1857–1920*, 24).

131. It is worth noting that of the articles that were devoted entirely to a single contemporary artist in the *Zeitschrift für bildende Kunst* from 1890 to 1918 the largest number by far—16—were about Klinger and his work (1894, 1895, 1897, 1898, 1900, 1902 [whole issue], 1905, 1909 [2], 1911, 1915, 1916, 1917 [2], 1918). About Liebermann there were 6 articles (1893, 1901, 1907, 1913, 1916, 1917); about Menzel, 5 (1886, 1896, 1903, 1905, 1915); about Lenbach, 3 (1904, 1905, 1906); about Hermann Prell, 3 (1885, 1896, 1904); and about Kollwitz, 2 (1905, 1909). Böcklin and Stuck each merited only a single article, as did other contemporary artists.

132. Franz Hermann [Meissner], "Hans Thoma," *Zeitschrift für bildende Kunst* 27, n.s. 3 (1891–92): 225, linked Thoma and Stuck to Klinger as pathbreaking artists. The quotation on artistic revolution was made by Max Georg Zimmermann in "Kritische Gänge," *Die Kunst für Alle* 8, no. 24 (Sept. 1893): 375, an article that was not enthusiastic about the new art; indeed, it was quite critical of various aspects of the modern world, especially socialism (see *, "Dresden," ibid. 9, no. 2 [Oct. 1893]: 29).

133. Friedrich Haack, "Böcklin und Klinger," *Die Kunst für Alle* 11, no. 1 (Oct. 1895): 2.; Dr. Relling [Jaro Springer], "Die Ausstellung der XI," ibid. 9, no. 13 (1 Apr. 1894): 200. Springer, son of an eminent professor of art history, worked from 1882 to 1915 as a directorial assistant and curator of the Berlin Kupferstichkabinett (Print Collection) and married the daughter of August von Heyden, a professor of history painting at the Institute for Fine Art, Berlin. A strong supporter of new art forms whose judgment was reinforced by his art historical work, Springer reported regularly for *Die Kunst für Alle*. On Springer, see Schultze-Naumburg, "Deutsche Kunstkritiker," ibid. 10, no. 12 (Mar. 1895): 178. The further statements on Klinger were from Dr. Relling [Springer], "Die Berliner Künstausstellung," ibid. 8, no. 19 (July 1893): 291; and Helferich [Heilbut], "Fünf Münchener Ausstellungen," ibid. 6, no. 14 (Apr. 1891): 215.

134. Vogel, *Max Klingers Kreuzigung*, 17–20; idem, *Max Klinger und seine Vaterstadt Leipzig*, 35–39; Gleisberg, *Max Klinger, 1857–1920*, 341; Carl Schuchhardt, *Max Klinger's "Kreuzigung" in Hannover: Vortrag im Hannoverschen Kunstlerverein am 24 April 1899* (Hannover: Commissionsverlag von Schmorl & von Seefeld Nachf., 1899), 23. Before he became director of the Kestner Museum (1887–1907), Schuchhardt was an archaeologist at the Pergamum dig and worked on the Pergamum altar after its transfer to Berlin.

135. Vogel, *Max Klingers Kreuzigung*, 16–17, and idem, *Max Klinger und seine Vaterstadt Leipzig*, 19, 33, recount the events in Leipzig. Avenarius discussed Klinger's paintings at length in his review of the exhibition, "Leipziger Bericht: Die Sächsisch-Thüringische Gewerbeausstellung," *Der Kunstwart* 10, no. 20 (July 1897): 315–16. A longer account of Pastor Hölscher's attack upon the "sacrilegious caricature" was published by Cornelius Gurlitt, *Die deutsche Kunst des neunzehnten Jahrhunderts*, 614–16. He reported on Georg Treu's response to Hölscher, which discussed Klinger's painting in the context of the new Protestant religious art in Germany. The full citations for these fifteen-page pamphlets are [H. Sellnick], *Kling! Klang! Klung! Betrachtungen über das Klingersche Bild "Christus im Olymp": Von ein Kunstverständigen* (Leipzig: Brückner & Niemann, 1897); and C. Gattermann, *Der Olympier Kritik des Klingerschen Bildes "Christus im Olymp"* (Leipzig: Brückner & Niemann, 1897). Reviews of the Klinger rooms in the Saxon-Thuringian Industrial Exhibition are in "Aus der Kunsthalle der sächsisch-thuringischen Ausstellung in Leipzig," *Die Kunst für Alle* 12, no. 23 (Sept. 1897): 380–82. Richard Graul, "Aus Leipzig," *Pan* 3, no. 2 (1897–98): 108–10, pointed out that Klinger's paintings formed the monumental centerpiece of the exhibition. For further information about the efforts to place Klinger's three large paintings together into a museum, see Max Lehrs, "Alexander Hummel und Max Klinger," *Zeitschrift für bildende Kunst* 50, n.s. 26 (1914–15): 29–52.

136. Hans Singer, "Max Klinger's Gemälde," ibid. 29, n.s. 5 (1893–94): 50.

137. Schuchhardt, *Max Klinger's "Kreuzigung,"* 16–22.

138. The laudatory stanza appeared in Gurlitt, "Max Klinger," *Die Kunst für Alle* 10, no. 5 (Dec. 1894): 69; the reference to "Crucify him," in Schmid, *Klinger*, 86.

139. Max Lehrs, in "Max Klinger's 'Brahms-Phantasie,'" *Zeitschrift für bildende Kunst* 30, n.s. 6 (1894–95): 113, quoted this statement taken from Lichtwark's pamphlet *Wege und Ziele des Dilettantismus* (Munich: Verlags-

anstalt für Kunst und Wissenschaft, 1894) in a discussion of Klinger's suffering at the hands of the uncomprehending public.

Part I, Chapter 2
Carrying Art to the Public
1. Georg Voß, "Die Eröffnung der Berliner Jubiläums-Ausstellung," *Die Kunst für Alle* 1, no. 18 (June 1886): 247–49. This narrative of the opening ceremony and quotations are all drawn from Voss's account. A map of the exhibition park, a floor plan of the exhibition, and a listing of the works with selective illustrations is available in *Jubiläums-Ausstellung der Kgl. Akademie der Künste im Landes-Ausstellungsgebäude zu Berlin von Mai bis October 1886: Illustrirte Katalog*, exh. cat. (Berlin: 1886). For more detail on the Kaisersaal and decorations of the domed entry hall, see Adolf Rosenberg, "Die Jubiläumskunstausstellung in Berlin, II," *Zeitschrift für bildende Kunst* 21 (1885–86): 247–56; and Anton von Werner, *Erlebnisse und Eindrücke, 1870–1890* (Berlin: Ernst Siegfried Mittler und Sohn, 1913), 464. Extensive coverage of the organization of the exhibition park, the building, and architectural details, including maps and floor plans as well as a verbatim report on the opening speeches, was provided throughout the summer of 1886 in the *Centralblatt der Bauverwaltung* 6 (May–Sept. 1886): 177–79, 186–88, 210–11, 222–23, 296–98, 314–15, 335–36, 377–78, 387–88.

2. The impressive contingent of paintings from England was a result, according to Werner, of negotiations by Crown Princess Victoria, the eldest daughter of England's Queen Victoria. Rosenberg drew a different conclusion from France's absence. Since the French had refused to participate in this Jubilee Exhibition, he wrote in his report, "Die Jubiläumskunstausstellung in Berlin, I," *Zeitschrift für bildende Kunst* 21 (1885–86): 205, Berlin probably would not send a German exhibition to the Paris Universal Exposition of 1889. Germany, in fact, did have an unofficial exhibition in Paris in 1878 that was arranged by Werner with the explicit permission of Bismarck. For details on this episode and a careful examination of political aspects of the Franco-German relationship in the international expositions, see Françoise Forster-Hahn, "'La Confraternité de l'art': Deutsch-französische Ausstellungspolitik von 1871 bis 1914," *Zeitschrift für Kunstgeschichte* 48, no. 1 (1985): 506–37.

3. Rosenberg, "Die Jubiläumskunstausstellung in Berlin, I," 207–14, has a lively contemporary description of these temples, dioramas, and panoramas; and Stephan Oettermann, *Das Panorama: Die Geschichte eines Massenmediums* (Frankfurt am Main: Syndikat, 1980), 202, provides further details. A thorough discussion of the cultural and political aspects of the German archaeological excavations in Pergamum and Olympia is presented by Suzanne

L. Marchand, *Down from Olympus: Archaeology and Philhellenism in Germany, 1750–1970* (Princeton: Princeton University Press, 1996), 75–103.

4. Georg Voß, "Das griechische Fest in Berliner Ausstellungspark," *Die Kunst für Alle* 1, no. 20 (July 1886): 287–90; Werner, *Erlebnisse*, 466. Marchand, *Down from Olympus*, 95, suggests that the artists' festival, although cloaked in classical costumes, would have been perceived as a celebration of the German victory over the French because of Attalus's victory in 184 B.C. over the Galatians, who were actually Celts. Paul Lindenberg, "Die Osteria auf der Berliner Jubiläums-Ausstellung," *Die Kunst für Alle* 2, no. 3 (Nov. 1886): 44–47, described an Italianate building with a garden café created in the park by the Verein Berliner Künstler as a place for artists to relax. It was also opened for public use at stated times. The financial results were reported in #, "Verein Berliner Künstler," ibid. 1, no. 21 (1 Aug. 1886): 309–10.

5. ∗∗, "Berlin: Der Schluss der Jubiläums Ausstellung," *Die Kunst für Alle* 2, no. 4 (Nov. 1886): 63–64, and Werner, *Erlebnisse*, 467, supply details of the closing ceremony. Final reports containing lengthy statistics were published a year later in "Ein Rückblick auf die Jubiläums-Kunstausstellung in Berlin," *Die Kunst für Alle* 2, no. 24 (Sept. 1887): 377.

6. Friedrich Pecht, "Die Berliner Jubiläums-Ausstellung," *Die Kunst für Alle* 1, no. 18 (June 1886): 250. For a repetition of this litany, see Pecht's thoughts before the opening of the Third Munich International in Friedrich Pecht, "Die Münchener Ausstellungen von 1888: Einleitung," ibid. 3, no. 17 (June 1888): 261–63. For a brief summary of Berlin as an art center in the latter half of the century, see Robin Lenman, *Artists and Society in Germany, 1850–1914* (Manchester: Manchester University Press, 1997), 113–16; and for further detail, Nicolaas Teeuwisse, *Vom Salon zur Secession: Berliner Kunstleben zwischen Tradition und Aufbruch zur Moderne, 1871–1900* (Berlin: Deutscher Verlag für Kunstwissenschaft, 1986).

7. Liebermann, who had returned to Berlin from Munich in 1884, showed *Amsterdamer Waisenmädchen im Garten* (1885), *Das Tischgebet* (1886), and *Altmännerhaus* (1880–81) in the 1886 Berlin Jubilee Exhibition. Uhde showed *Komm Herr Jesu* (1885, also titled *Das Tischgebet*). See Pecht's review of the English painters in *Die Kunst für Alle* 1, no. 24 (Sept. 1886): 345–49. In addition to articles already cited, extensive coverage of the exhibition appeared in the following issues of *Die Kunst für Alle*: 1, nos. 18–24 (June–Sept. 1886): 250–58, 263–71, 279–87, 295–304, 311–21, 330–35, 343–51; 2, nos. 1–3 (Oct.–Nov. 1886): 1–8, 17–26, 33–43. Adolf Rosenberg published articles in the *Zeitschrift für bildende*

Kunst: "Die Jubilaumskunstausstellung, III: Die München-er Schule," 21 (1885–86): 278–85 and 22 (1886–87): 10–16; "Die Jubilaumskunstausstellung, IV: Berlin," 22 (1886–87): 40–48; and "Die Jubilaumskunstausstellung, V: Düsseldorf, Dresden, & Königsberg, and VI: Das Aus-land," ibid., 97–110.

8. Oskar Bie, "Berliner Brief: Die Zeitungen," *Der Kunst-wart* 9, no. 2 (Nov. 1895): 57–58.

9. Friedrich Pecht, "Die Berliner Jubiläums Kunstausstel-lung, XII," *Die Kunst für Alle* 2, no. 3 (Nov. 1886): 42; Voß, "Die Eröffnung der Berliner Jubiläums-Ausstellung," 243; Werner, *Erlebnisse*, 467. Pecht had initially expressed displeasure with the Berliners' penchant for favoring for-eign art and culture rather than cultivating their own, a feature he found symbolized in the Egyptian pavilion and the Greek temple in the exhibition gardens. By the end of the summer, however, his view had clearly changed under the impact of the public response to the setting. Rosen-berg reported the following year on how important and pleasant the park, with its concerts and restaurant, had been for the public visiting the exhibitions, though he warned that this combination of art and pleasure, of the ideal and the material, could easily degenerate into a noisy market fair. He pointed out, however, that the park had provided an essential respite from the exhibition in the iron and glass palace, which was unbearably hot in the summer and too cold in the winter (Adolf Rosenberg, "Die akademische Kunstaussstellung in Berlin," *Kunstchronik* 22 [Aug. 1887]: cols. 557–58).

10. With income totaling 932,000 marks and expenditures of 762,000 marks, when the final reports were in, the Berlin Jubilee Exhibition of 1886 had earned a remarkable profit of 170,000 marks. The reports provide breakdowns by nationality for a total of 1,632 artists; 2,323 works of art; 500,000 lottery tickets sold; and the sale of paintings at 884,442 marks. The large attendance figures were also extolled: 1,161,461 day tickets were purchased during 162 days and 10,100 season tickets. On the average more than 7,000 individuals viewed the exhibition each day ("Ein Rückblick auf die Jubiläums-Kunstausstellung in Berlin," *Die Kunst für Alle* 2, no. 24 [Sept. 1887]: 377).

11. Shown in Berlin in 1886, Lindenschmidt's painting was reproduced along with the exhibition review in ibid. 1, no. 15 (June 1886): 254. One of the famous salon paint-ings of the era still to be seen is Hans Makart's *Entrance of Karl V into Antwerp* (1878) at the Hamburger Kunsthalle.

12. "Berlin," *Die Kunst für Alle* 12, no. 1 (Oct. 1896): 15. It is instructive to compare the attendance figures for the Berlin Jubilee with statistics cited for the blockbuster exhi-bitions in the United States a century later. A *New York*

Times article claiming that 1997 had been "a banner year" stated that the most heavily attended exhibition had been "Picasso: The Early Years," at the National Gallery, in Washington, D.C., with 530,911 visitors. Echoing a re-frain from the previous century, the author of the article, commenting on the perennial selling power of Picasso, van Gogh, and Monet, lamented, "All of which raises the specter that the public's taste drives the content of exhibi-tions much more than it once did" (Judith H. Dobrzynski, "Painting Prosperity by the Numbers," *New York Times*, 26 Feb. 1998). The show that drew the largest crowds in 1998 was "Monet in the Twentieth Century," at the Boston Museum of Fine Arts, with nearly 566,000 visitors. In 1991, the Matisse show at the Museum of Modern Art in New York drew a total of 940,000. The overall record for blockbuster exhibitions in the United States in the twenti-eth century, however, is thought to be held by the Metro-politan's "Treasures of Tutankhamun" in 1978, with 1.2 million visitors, roughly equal to the number attending the Berlin Jubilee Exhibition of 1886 (Ralph Blumenthal, "My Renoir Beats Your Vermeer," ibid., 6 June 1999).

13. A fine analysis of travel as an essential part of the life of the cultured bourgeoisie in nineteenth-century Ger-many is Barbara Wolbring, "'Auch ich in Arkadien!' Die bürgerliche Kunst- und Bildungsreise im 19. Jahrhundert," in *Bürgerkultur im 19. Jahrhundert: Bildung, Kunst, und Lebenswelt*, ed. Dieter Hein and Andreas Schulz (Munich: Verlag C. H. Beck, 1996), 82–101. For a series of satirical stories about various types of tourists—the spring-vacation tourist, the hiker in the Tyrol, the Yankee tourist buying art, the world's fair tourist—see *Fliegende Blätter* 77, nos. 1938–41 (1882).

14. The total number of residents in Great Berlin in 1885 was 1,537,000, according to Michael Erbe, "Berlin im Kaiserreich (1871–1918)," in *Geschichte Berlins: Von der Märzrevolution bis zur Gegenwart*, ed. Wolfgang Ribbe (Munich: Verlag C. H. Beck, 1987), 694.

15. The attendance figures were particularly strong, given that the 1887 Berlin Academy Exhibition was small, with only 1,324 works, and open for only seventy-one days. An average of well over 4,000 persons attended daily, for a to-tal of 265,000 visitors; in addition, 7,000 season tickets were sold, presumably to local patrons who came to the exhibition repeatedly. With a total income of 170,000 marks against costs of 106,000 marks, the Academy again had a surplus of 60,000 marks. And 150,000 lottery tickets were sold to the public for a chance to win works of art from the exhibition (*Die Kunst für Alle* 3, no. 18 [June 1888]: 290).

16. For reviews of the exhibition, see Georg Voß, "Die Berliner Kunstausstellung," ibid. 2, no. 23 (Sept. 1887):

356–59; Aemil Fendler, "Berlin akademische Kunstausstellung," *Der Kunstwart* 1, no. 2 (Oct. 1887): 18–19, which applied the phrase "baroque hallucination" to Klinger's *Judgment of Paris*; and Rosenberg, "Die akademische Kunstaussstellung in Berlin," *Kunstchronik* 22 (Aug. 1887): cols. 557–60; see also idem, "Die akademische Kunstausstellung zu Berlin," *Zeitschrift für bildende Kunst* 23 (1887–88): 9–16. On Begas's electric lamp, see Ludwig Pietsch, "Aus der akademischen Kunstausstellung, XV," *Vossische Zeitung*, Oct. 1887; and N.N., "Kunstausstellung, VII," *Berliner Börsen-Courier*, Aug. 1887, both quoted in Teeuwisse, *Vom Salon zur Secession*, 138, 145–46.

17. Sales of paintings at the Munich exhibitions were 677,860 marks in 1883, 1,070,540 marks in 1888, and 479,250 marks in 1889, for a total of 2,227,650 marks (see Horst Ludwig, *Kunst, Geld und Politik um 1900 in München: Formen und Ziele der Kunstfinanzierung und Kunstpolitik während der Prinzregentenära [1886–1912]* [Berlin: Gebr. Mann Verlag, 1986], 120–21; and Paul Drey, *Die wirtschaftlichen Grundlagen der Malkunst: Versuch einer Kunstökonomie* [Stuttgart: J. G. Cotta, 1910], table 10).

18. Among the many books on Munich's art institutions the following are essential: Maria Makela, *The Munich Secession: Art and Artists in Turn-of-the-Century Munich* (Princeton: Princeton University Press, 1990), chap. 1, for a systematic overview of the Munich art scene in the 1880s; York Langenstein, *Der Münchner Kunstverein im 19. Jahrhundert: Ein Beitrag zur Entwicklung des Kunstmarkts und des Ausstellungswesens* (Munich: UNI-Druck, 1983), for an authoritative account of the two main nineteenth-century art associations; Eugen Roth, *Der Glaspalast in München: Glanz und Ende, 1854–1931* (Munich: Süddeutscher Verlag, 1971), on the Glass Palace as both a building and an institution; and Lenman, *Artists and Society in Germany*, 106–13.

19. Information and statistics for the Munich International of 1869 can be found in Marcus Harzenetter, *Zur Münchner Secession: Genese, Ursachen, und Zielsetzungen dieser intentionellen neuartigen Münchner Künstlervereinigung* (Munich: Stadtarchivs München, 1992), 79; and Myrna Smoot, "The First International Art Exhibition in Munich 1869," in *Salons, Galleries, Museums, and Their Influence in the Development of Nineteenth and Twentieth Century Art*, ed. Francis Haskell (Bologna: CLUEB, 1981), 109–14, which gives the number of works shown, based on the official catalogue of the exhibition, as 3,386. Lengthy reports on the 1888 International were published by Friedrich Pecht under the title "Die Münchener Ausstellungen von 1888" in *Die Kunst für Alle* 3, nos. 17–24 (June–Sept. 1888): 259–65, 275–83, 291–99, 307–14,

323–29, 339–46, 355–60, 372–79, and ibid. 4, no. 1 (Oct. 1888): 1–9. For details on the organization and financial details, see Ludwig, *Kunst, Geld und Politik*, 83–92, 120–21; and Makela, *Munich Secession*, 161–62.

20. *Die Kunst für Alle* 2, no. 17 (June 1887): 270; ibid. 3, no. 2 (Oct. 1887): 31–32; and ibid., no. 11, (Mar. 1888): 174–75, cited from the Prussian budget as follows: 324,000 marks for acquisitions for the royal museums and 300,000 for the National Gallery, monuments, and murals.

21. Accurate statistics are difficult to ascertain. The report at the closing of the exhibition gave the profit and sales figures cited in the text. It also made the following breakdown of tickets: 211,977 day cards at 1 mark; 40,533 discounted day cards at 50 pfennigs; and 7,252 multiple entry cards costing from 3 to 20 marks, for a total income from tickets of 302,238 marks ("Die Jubiläums-Ausstellung, 1888," ibid. 4, no. 4 (Nov. 1888): 62). Andrea Grösslein, *Die internationalen Kunstausstellungen der Münchener Künstlergenossenschaft im Glaspalast von 1869 bis 1888* (Munich: UNI-Druck, 1987), 156–57, places the number of visitors who purchased regular tickets at 313,680, with an additional 4,670 long-term tickets. She also calculates that most of the 242,393 registered tourists staying overnight in Munich during these months likely had come to visit the exhibition. In comparison, Munich's total population at this time was 240,000. Harzenetter, *Zur Münchner Secession*, 80, uses the phrase "quasi-encyclopedic" to describe the overview of contemporary European art.

22. Trübner achieved recognition late in life. The first major articles in the journals came years later, in Karl Voll, "Wilhelm Trübner," *Zeitschrift für bildende Kunst* 36, n.s. 12 (1900–1901): 273–82; and a lead article by Hans Rosenhagen, "Wilhelm Trübner," in *Die Kunst für Alle* 17, no. 16 (May 1902): 361–69, accompanied by illustrations throughout the issue. See also Rosenhagen, *Wilhelm Trübner* (Bielefeld, Germany: Verlag von Velhagen & Klasing, 1909).

23. Friedrich Pecht, "Die Münchener Ausstellungen von 1888," *Die Kunst für Alle* 4, no. 1 (Oct. 1888): 6–8. Pecht frequently used the term *zöpfig* to belittle international tendencies in the art world. The term literally refers to the pigtail on eighteenth-century wigs and was commonly used to describe paintings of the Rococo period. Religious paintings were shown by Zimmermann, Piglhein, Thoma, Max, Kirchbach, Uhde, and others.

24. Avenarius, *Der Kunstwart* 1, nos. 23–24 (Sept. 1888): 335–36, 353–54, and 2, nos. 1 (Oct. 1888): 9, 21–23, and 5 (Dec. 1888): 67–69.

25. R. Muther, "Die internationale Kunstausstellung in München," *Zeitschrift für bildende Kunst* 23 (1887–88): 284–91, 308–14, 329–39.

26. Munich in 1888 attracted 252,510 day visitors and 7,252 multiple ticket holders, compared with Berlin's 1886 figures of 1,160,000 day visitors and 7,000 season pass holders. In 1887, with the exhibition only open for seventy-one days, Berlin's daily counts totaled 265,000 visitors, in addition to 7,000 season tickets. In 1888 in Berlin, 298,174 daily and 4,000 season tickets were considered by Berliners to be disappointingly low. These figures are based on the reports for Munich in "Die Jubiläums-Ausstellung, 1888," *Die Kunst für Alle* 4, no. 4 (Nov. 1888): 62; and for Berlin in 1886 in "Eine Rückblick auf die Jubiläums-Kunstausstellung in Berlin," ibid. 2, no. 24 (Sept. 1887): 377. For Berlin in 1887, see ibid. 3, no. 18 (June 1888): 290; and for 1888, ibid. 4, no. 10 (Feb. 1889): 158.

The perception of Munich as the city of art was memorialized and criticized in innumerable books and stories. Among the most famous is Thomas Mann's *Gladius Dei* (1902), which presents Munich's art world through the eyes of an ascetic modern-day Savonarola.

27. Georg Voss reported on the 1888 Berlin Academy Exhibition in "Die Berliner Kunstausstellung," *Die Kunst für Alle* 3, no. 22 (Aug. 1888): 344–46. Liebermann's paintings were *Münchner Biergarten* and *Flachsscheuer in Laren*. Kampf's painting *Aufbahrung der Leiche Kaiser Wilhelms im Berliner Dom* (1888) was part of his turn to history painting, particularly of events from the wars of liberation and the life of Frederick the Great, as in his *Choral von Leuthen* (1887). In 1915–25 Kampf was director of the Hochschule für bildende Künste in Berlin. For a further review, see Adolf Rosenberg, "Die akademische Kunstausstellung zu Berlin," *Zeitschrift für bildende Kunst* 23 (1887–88): 9–16, 43–51.

28. *˙*·˙*, "Berlin: Kosten bei Ausstellungen," *Die Kunst für Alle* 8, no. 13 (Apr. 1893): 204–5. The surplus reported here was 3,000 marks higher than had been reported earlier. Munich offered season passes at from 3 marks to 20 marks. Munich also offered free and discounted daily passes to those on limited incomes; in 1888, 40,533 such passes were issued at 50 pfennigs each. For the relevant figures, see ibid. 4, no. 4 (Nov. 1888): 62.

29. An informative discussion of the close interconnections between the tourist industry and artists in Munich is presented by Robin Lenman, "Art and Tourism in Southern Germany, 1850–1930," in *The Arts, Literature, and Society*, ed. Arthur Marwick (London: Routledge, 1990), 163–80.

30. Ludwig, *Kunst, Geld und Politik*, 14–44, provides detailed information and lengthy excerpts from the parliamentary debates of 1888 and 1890, including the quotations from Lutz (20) and from Crailsheim (39). The budget for art in the Bavarian Ministry for Ecclesiastical Affairs and Education was divided into five major parts, including funds for (1) the Munich Academy of Art, (2) museum maintenance, (3) support and care of art monuments, (4) acquisition of art, and (5) exhibitions. The amount allocated for the direct support of exhibitions remained at 8,600 marks from 1886 to 1907. The amount for the acquisition of art, which was used largely for state purchases of artworks from the Glaspalast, was 20,000 marks annually from 1886 to 1889, with an additional 60,000 marks approved for the 1888 International. The debate in 1888 and again in 1890 in the Landtag was over the ministry's request to increase the budgeted amount for acquisitions to 120,000 marks. After extended debates and negotiations, with the Center Party in the lower house opposing the increase, the annual amount granted was 100,000 marks, and this allocation was continued for the next decade.

31. Ludwig, *Kunst, Geld und Politik*, 44.

32. Friedrich Pecht, "Der künftige Münchener 'Salon,'" *Die Kunst für Alle* 4, no. 3 (Nov. 1888): 42–43. Pecht's predictions were confirmed two years later when the Association of Munich Art Dealers announced that they would no longer support the exhibitions of the Munich Artists' Association, either by providing works from their galleries or by purchasing new works, because their businesses had been financially damaged by the unprofessional handling of sales in the annual exhibitions ("München," *Kunstchronik*, n.s. 1 [Apr. 1890]: col. 358).

33. Both Makela, *Munich Secession*, chap. 2, and Harzenetter, *Zur Münchner Secession*, chap. 3–4, provide a thorough analysis of the debate and of the politics surrounding it and detailed examination of the subsequent annual exhibitions. Makela discusses both the German and foreign paintings that were featured and includes reproductions of many of the major works.

34. For reviews of the First Annual Munich Exhibition, see [Avenarius], "Erste Münchner Jahresausstellung," *Der Kunstwart* 2, no. 24 (Sept. 1889): 378–79; Friedrich Pecht, "Vor Eröffnung der ersten Münchener Jahres Ausstellung 1889," *Die Kunst für Alle* 4, no. 19 (July 1889): 289–91; idem, "Die erste Münchener Jahres-Ausstellung 1889," ibid. 4, nos. 20–24 (July–Sept. 1889): 305–9, 321–24, 337–42, 353–56, 369–71, and 5, nos. 1–4 (Oct.–Nov. 1889): 1–4, 17–21, 33–36, 49–55. Makela, *Munich Secession*, 30–31, describes Stuck's figure well as "an erotic hermaphrodite whose thick, pouty lips and suggestive stance allude to a sensual 'paradise.'" And she argues effectively in "The Politics of Parody:

Some Thoughts on the 'Modern' in Turn-of-the-Century Munich," in *Imagining Modern German Culture: 1889–1910*, ed. Françoise Forster-Hahn (Washington, D.C.: National Gallery of Art, 1996), 185–207, that this erotic art in Munich, citing specifically the work of Stuck, Corinth, and Slevogt, was a singularly modern form of rebellion against Munich's academic fixation upon Renaissance art and against the increasing efforts of Catholic conservatives to regulate and censor art; she contends "that the politics of parody, and thus also of the 'modern' in turn-of-the-century Munich, were those of aesthetic persecution" (187).

35. Makela, *Munich Secession*, 31–32. For a lengthy contemporary review, see Franz Hermann Meissner, "Gabriel Max," *Die Kunst unserer Zeit* 10, 1st half-vol. (1899): 1–32, including twelve plates. An earlier article discussed Max's exploration of Darwin's theories in his series of paintings of apes (Bruno Stern, "Pithecanthropus Alalus: Gemälde von Professor Gabriel Max," ibid. 5, 2nd half-vol. [1894]: 55–56).

36. Published by Franz Hanfstaengel Kunstverlag in Munich, *Die Kunst unserer Zeit* appeared from 1890 to 1912. It was a folio-sized journal printed on heavy creamy matte paper, with heavier stock for the large number of plates. Beautifully designed and produced, its photographic reproductions captured the qualities of oil paintings particularly well. The articles and reviews were long and serious.

37. The following reviews covered the Second Annual exhibition in Munich: Momme Nissen, "Zweite Münchner Jahresausstellung, I–II," *Der Kunstwart*, 3, nos. 21–22 (July–Aug. 1890): 329–30, 345–47; Friedrich Pecht, "Vor Eröffnung der zweiten Münchener Jahres-Ausstellung 1890," *Die Kunst für Alle* 5, no. 19 (July 1890): 290–92; idem, "Die zweite Münchener Jahres-Ausstellung," ibid., nos. 20–24 (July–Sept.): 305–10, 321–26, 338–43, 353–58, 370–76; H. E. v. Berlepsch, "Die Münchener Jahresausstellung 1890," *Die Kunst unserer Zeit* 1 (1890): 93–197; and Alfred Gotthold Meyer, "Die zweite Münchener Jahresausstellung," *Zeitschrift für bildende Kunst* 26, n.s. 2 (1890–91): 71–76, 95–100.

Those covering the Third Annual exhibition were Herman Eichfeld, "Die dritte Münchener Jahresausstellung," *Der Kunstwart* 4, nos. 20–23 (July–Sept. 1891): 315, 328–29, 345–46, 363–64; Friedrich Pecht, "Die Münchener Jahres-Ausstellung von 1891," *Die Kunst für Alle* 6, nos. 20–24 (July–Sept.): 305–8, 321–24, 337–40, 353–59, 369–74; Alfred Gotthold Meyer, "Die Dritte Münchener Jahresausstellung," *Kunstchronik*, n.s. 3 (Oct.–Dec. 1892): cols. 33–39, 49–58, 67–73, 81–90, 103–12; and H. E. von Berlepsch, "Münchener Ausstellungs-Gänge," *Die Kunst unserer Zeit* 2, 2nd half-vol. (1891): 19–22, 73–87, 139–58.

38. Pecht's "Die Münchener Jahres-Ausstellung von 1891," *Die Kunst für Alle* 6, no. 22 (Aug. 1891): 339–40, briefly analyzes Manet's painting style, singling out his *Portrait of Antonin Proust* for comment in his praise of the French for their fine academic training and pointing out that the impressionistic works of German artists were more raw and distorted than those of their French counterparts. On French Impressionists in the Munich Secession exhibitions, see Makela, *Munich Secession*, 49, 58 n. 82, 180 n. 53.

Among the Scottish artists singled out for discussion were John Lavery, David Gauld, Alexander Roche, James Guthrie, James Paterson, and George Henry. The Scandinavian artists included Fritz Thaulow, Peder Severin Krøyer, Erik Werenskiold, Albert Edelfelt, Anders Zorn, and Otto Ludwig Sinding. Pecht characterized them as the "most extreme naturalists." Berlepsch followed his reviews of the Third Annual exhibition with a special article titled "Die Skandinaven," which appeared in *Die Kunst unserer Zeit* 2, 2nd half-vol. (1891): 23–49. A similar judgment had been made earlier by the correspondent for *Der Kunstwart* in Paris. Reviewing the international art exhibition at the 1889 Universal Exposition in Paris, the reporter had argued that the northern Europeans had achieved far more in open-air paintings than had the French (S.S., "Die deutschen Künstler auf der Pariser Weltausstellung," *Der Kunstwart* 3, no. 6 [Dec. 1889]: 88). For illustrations and a discussion of the paintings of both groups in the Munich exhibitions, see Makela, *Munich Secession*, 39–49. A fine study of the Scandinavian painters is Kurt Varnedoe, *Northern Light: Nordic Art at the Turn of the Century* (New Haven, Conn.: Yale University Press, 1988).

39. The references to "modern" art are taken from Friedrich Pecht, "Die zweite Münchener Jahres-Ausstellung," *Die Kunst für Alle* 5, no. 20 (July 1890): 306; and Momme Nissen, "Paris und die Malerei der Nicht-Franzosen," *Die Kunst unserer Zeit* 2, 1st half-vol. (1891): 27–37. See also similar comments about Uhde and Liebermann by Nissen a year earlier in *Der Kunstwart* 3, no. 21 (July 1890): 330.

40. Alfred Gotthold Meyer, "Die Zweite Münchener Jahresausstellung," *Zeitschrift für bildende Kunst* 26, n.s. 2 (1890–91): 71–76, 95–100; idem, "Die Münchener Kunstausstellung," ibid. 28, n.s. 4 (1892–93): 25–36, 49–58, 80–82, quotations from 49, 54–55. *The Fall of Babylon* was shown in the Sixth International Art Exhibition, organized by the Allgemeine Deutsche Kunstgenossenschaft in Munich in 1892. The review of the exhibition in *Das Atelier*, scathing in its dismissal of the Rochegrosse painting as "a colossal county-fair side show decoration . . . shameless self-advertisement," reported that the clerics in Munich wanted the painting removed from the exhibition, an action that would provide great publicity for the artist (Max

Schmid, "Die Münchner Internationale Kunstausstellung 1892," *Das Atelier* 2, no. 40 [June 1892]: 4). See Makela, *Munich Secession*, 157 n. 26, for an explanation of the numbering of international exhibitions in Munich.

41. On the 1889 exhibition, see Georg Voß, "Die Berliner akademische Kunstausstellung," *Die Kunst für Alle* 5, no. 3 (Nov. 1889): 43–46; and X, "Akademische Kunstausstellung zu Berlin," *Der Kunstwart* 3, no. 4 (Nov. 1889): 55. Werner later claimed in his memoirs that the 1889 exhibition was a disaster because the Academy senate insisted on holding it in the small, crowded rooms of the Academy instead of canceling it when they discovered that the state exhibition hall was not available that year (*Erlebnisse*, 561). On the 1890 exhibition, see Perfall, "Ebbestand der Berliner Kunst," *Der Kunstwart* 4, no. 1 (Sept. 1890): 11–13. Perfall's regular columns in the *Kölnische Zeitung* covering all the major art exhibitions in both Germany and France attracted a wide readership. Paul Schultze-Naumburg, "Deutsche Kunstkritiker," *Die Kunst für Alle* 10, no. 12 (Mar. 1895): 177, characterized Perfall as a fighter for modern art who never raised claims for everything new to a reckless principle. The *Kölnische Zeitung*, one of the oldest, most respected newspapers in Germany, had gained not only a national standing but also international attention by 1860. It was the first German newspaper to publish a feuilleton section devoted to "scholarly and belletristic" articles. Perfall was the editor of its feuilleton and its art critic from 1886 to 1911. For a history of the newspaper, see Georg Potschka, "Kölnische Zeitung (1802–1945)," in *Deutsche Zeitungen des 17. bis 20. Jahrhunderts*, ed. Heinz-Dietrich Fischer (Pullach bei Munich, Germany: Verlag Dokumentation, 1972), 145–58.

42. Appearing from 1887 until 1914, *Moderne Kunst in Meister-Holzschnitten nach Gemälden und Sculpturen Berühmter Meister der Gegenwart* was published by the Berlin firm of Richard Bong, who had developed exceptionally fine woodcut techniques for making colored reproductions of paintings. For information about his work, see J. Landau, "Richard Bong: Zum fünfundzwanzigjährigen Geschäftsjubiläum," *Moderne Kunst* 12 (1898): 66–67. Georg Malkowsky, who became the editor of *Deutsche Kunst* in 1896, was a strong supporter of the Hohenzollern dynasty, as indicated in his book *Die Kunst im Dienste der Staatsidee: Hohenzollernsche Kunstpolitik vom Großen Kurfürsten bis auf Wilhelm II* (Berlin, 1912). Among the novellas published in *Moderne Kunst* was "Irrtum," written by young Heinrich Mann, whose later work brilliantly caricatured that "kaiserliche Kultur" (*Moderne Kunst* 9 [1895]: 45–49). On William II, see Alfred Holzbock, "Die Kaiser-Festspiele in Wiesbaden," and "Niemand zu Liebe, Niemand zu Leide," *Moderne Kunst* 11 (1897); on Menzel, see ibid. 10 (1896). Françoise Forster-Hahn, "Adolph

Menzel: Readings between Nationalism and Modernity," in *Adolph Menzel, 1815–1905: Between Romanticism and Impressionism*, ed. Claude Keisch and Marie Ursula Riemann-Reyher, exh. cat. (New Haven, Conn.: Yale University Press, 1996), 103–12, analyzes the differing interpretations of Menzel's work as the political scene has changed in Germany.

43. See Adolf Rosenberg, "Die Internationale Kunstausstellung in Berlin," *Kunstchronik*, n.s. 2 (May 1891): col. 435. Werner was chair of the Verein Berliner Künstler from 1887 to 1894 and again from 1899 to 1907. He recounts some of his trials and achievements with the Verein in *Erlebnisse*, 477–79. For a report on the negotiations to allow the Verein, rather than the Academy, to handle the exhibition, see "International Kunst-Ausstellung 1891," *Das Atelier* 1, no. 3 (Dec. 1890): 7. For reports on the diplomatic contretemps, see *Kunstchronik*, n.s. 2 (Feb.–Mar. 1891): cols. 281, 300, 317; "Internationale Kunstausstellung," *Das Atelier* 1, no. 9 (Mar. 1891): 8; and *Die Kunst unserer Zeit* 2, 1st half-vol. (Feb. 1891), unpaginated notes.

For his own lively account of these events, see Werner, *Erlebnisse*, 575–76, 588–95, blaming the dowager empress for causing the scandal, which she indignantly denied in letters to her mother (see Hannah Pakula, *An Uncommon Woman: The Empress Frederick, Daughter of Queen Victoria, Wife of the Crown Prince of Prussia, Mother of Kaiser Wilhelm* [New York: Simon and Schuster, Touchstone, 1995], 544–47). An imaginative tribute to Victoria, who was an active patron of art as well as an amateur artist, is Karoline Müller, "Leftie Loser Lobbyist: Eine Textcollage der Kronprinzessin Victoria gewidmet," in *Profession ohne Tradition: 125 Jahre Verein der Berliner Künstlerinnen*, by Berlinische Galerie, exh. cat. (Berlin: Kupfergraben, 1992), 311–30. For further information, see Forster-Hahn, "La Confraternité de l'art," 531–32; and Dominik Bartmann, *Anton von Werner: Zur Kunst und Kunstpolitik im Deutschen Kaiserreich* (Berlin: Deutscher Verlag für Kunstwissenschaft, 1985), 179–87.

Reviews of the 1891 Berlin International included: *Kunstchronik*, n.s. 2 (May 1891): cols. 425–27; "Die Internationale Kunst-Ausstellung in Berlin," *Der Kunstwart* 4, no. 16 (May 1891): 249; Dr. M[ax] Schmid, "Italiener und Spanier auf der Internationalen Ausstellung zu Berlin," and Dr. van Eyck, "Die Malerei auf der internationalen Ausstellung des Vereins Berliner Künstler 1891" *Das Atelier* 1, nos. 15, 20, 22 (June and Sept. 1891). For a witty description, dripping with sarcasm, of the opening ceremonies by an observer who despised the artistic pretensions of the royal Hohenzollern court, see Friedrich Freiherr von Khaynach, *Anton von Werner und die Berliner Hofmalerei* (Zürich: Verlags-Magazin, 1893), 30–34. Avenarius voiced his judgments in "Die Internationale Kunst-Ausstellung in Berlin," *Der Kunstwart* 4, nos. 19, 21 (July–Aug. 1891): 297–98, 326. For the terse comments

of the critic from Berlin, Jaro Springer, see "Die Internationale Kunstausstellung zu Berlin," *Die Kunst für Alle* 6, nos. 17, 18, 21 (June–Aug. 1891): 257–62, 273–76, 329–32, quotation from 273. Examples of the light-color painting were not entirely absent. Liebermann showed four paintings, including the *Flachsscheuer in Holland*; Hofmann was represented by a painting titled *Frühlingssonne*; and Stuck's *Lucifer* and Uhde's *Damenportrait* were present (the catalog listed no works by Klinger). These paintings, however, were virtually lost among the five thousand works of the exhibition. See *Internationale Kunst-Ausstellung veranstaltet von Verein Berliner Künstler anlässlich seines fünfzigjahrigen Bestehens 1841–1891: Katalog und Führer* (Berlin: Verlag des Vereins Berliner Künstler, 1891), which is well illustrated with photographs of all of the major rooms of each national section.

44. In 1891 the public spent 146,000 marks on day entrance tickets for the Berlin exhibition. More than 40,000 marks' worth of season tickets were purchased in the first two weeks, and 800,000 marks were spent on artworks (*Kunstchronik*, n.s. 2 [May 1891]: col. 456, and 3 [Nov. 1891]: col. 76). The sales comparisons could be misleading since Munich showed only 3,000 works that year, compared with 5,000 at Berlin. The reviewer charging the 1892 exhibition of showing examples of "artistic parthenogenesis" was -n-, in "Die 63. akademische Kunstausstellung zu Berlin," *Der Kunstwart* 5, nos. 17–18 (June 1892): 262–63, 278–79. *Das Atelier* provided extended coverage of the 1892 exhibition, beginning with a moderately positive review by Max Schmid, "Berliner Kunstausstellung 1892," *Das Atelier* 2, no. 38 (May 1892): 3–4. Dr. van Eyck, "Zwanglose kritische Gänge durch die akademische Ausstellung, Berlin 1892, I–IV," ibid., nos. 39–42 (June–July 1892), was critical of Liebermann's work and of his negative influence upon other artists but praised Leibl, Böcklin, and Thoma. The statistics for 1892 and 1893 were printed in *Kunstchronik*, n.s. 4 (Dec. 1892): col. 128, and 5 (26 Oct. 1893): cols. 41–42; and in *Die Kunst für Alle* 9, no. 3 (Nov. 1893): 42–43.

Springer continued his attack on the conservativeness of the Berlin exhibitions in 1894, as did Dresdner (see Dr. Relling, "Die große Berliner Kunstausstellung 1894," ibid. 9, nos. 18–20 [June–July 1894]: 280–82, 296–99, 312–14; and Albert Dresdner, "Die Berliner Kunstausstellung, I–III," *Der Kunstwart* 7, nos. 17–19 [June–July 1894]: 263–64, 281–82, 298–99). For attendance and profits at the 1895 exhibition, see *Die Kunst für Alle* 10, no. 23 (Sept. 1895): 364, and 11, no. 6 (Dec. 1895): 94, which also reported that 400,000 marks' worth of artworks were sold. This tension between critical judgment and popular attendance continued through the nineties. In 1898 the Great Berlin Art Exhibition, which Springer characterized as "the poorest we have yet had here" in ibid. 14, no. 2 (Oct. 1898): 27, was financially very suc-

cessful, producing profits of more than 50,000 marks (ibid., no. 8 [Jan. 1899]: 126).

45. In this connection, see Andrew Lees, "The Civic Pride of the German Middle Classes, 1890–1918," in *Another Germany: A Reconsideration of the Imperial Era*, ed. Jack R. Dukes and Joachim Remak (Boulder, Colo.: Westview Press, 1988), 41–59, who examines the ways in which cities functioned as cultural centers.

46. For a sample of reviews of Dresden's exhibitions on paper, see "Die Aquarellausstellung in Dresden," *Der Kunstwart* 1, no. 1 (Sept. 1887): 8; Δ, "Die zweite internationale Ausstellung von Aquarellen, Pastellgemälden, Zeichnungen und Radierungenen," ibid. 3, nos. 23–24 (Aug.–Sept. 1890): 361–62, 377–78; ibid. 4, no. 1 (Sept. 1890): 10; Paul Schumann, "Die zweite internationale Ausstellung von Aquarellen u.s.w. in Dresden," *Die Kunst für Alle* 6, no. 1 (Oct. 1890): 9–11, and no. 3 (Nov. 1890): 37–38; r, "Die III. internationale Aquarell-Ausstellung zu Dresden," *Der Kunstwart* 6, no. 1 (Oct. 1892): 9–10; and Paul Schumann, "Die dritte internationale Aquarell Ausstellung in Dresden," *Die Kunst für Alle* 8, no. 1 (Oct. 1892): 4–7. For a later assessment of the importance of watercolors in the development of the new impressionistic styles, particularly among artists in Berlin, see Wolfgang Kirchbach, "Aquarellistische Betrachtungen," ibid. 12, no. 11 (Mar. 1897): 161–66. Dresden's long tradition of art salons and royal patronage is effectively summarized in Lenman, *Art and Society in Germany*, 103–4.

47. On the First International Dresden Exhibition, in 1897, see *Die Kunst für Alle* 11, no. 15 (May 1896): 235–36; Paul Schumann, "Die Dresdner Kunstausstellung," ibid. 12, no. 21 (Aug. 1897): 339–44; H. A. Lier, "Die Internationale Kunstaussstellung in Dresden," *Kunstchronik*, n.s. 8 (May and Aug. 1897): cols. 395, 497–504; ibid. 9 (Oct. 1897): col. 25; idem, "Korrespondenz aus Dresden," ibid. (Dec. 1897): cols. 113–18; and A[venarius], "Dresdener Bericht: Internationale Kunstausstellung, I," *Der Kunstwart* 10, no. 17 (June 1897): 265–67.

48. On the German Art Exhibition in 1899, see Paul Schumann, "Deutsche Kunstausstellung Dresden 1899," *Die Kunst für Alle* 14, nos. 18–19 (June–July 1899): 273–75, 293–96, and 15, no. 9 (Feb. 1900): 212; H.W.S., "Die deutsche Kunstausstellung in Dresden," *Kunstchronik*, n.s. 10 (May 1899): cols. 367–73, 380; and Avenarius, "Deutsche Kunstausstellung zu Dresden," *Der Kunstwart* 12, nos. 18, 22 (June and Aug. 1899): 202, 341–42. Kuehl's efforts to reform the Dresden exhibitions have been carefully examined by Uta Neidhardt, "Gotthardt Kuehl in Dresden, 1895–1915," in *Gotthardt Kuehl, 1850–1915*, ed. Gerhard Gerkens and Horst Zimmermann, exh. cat. (Leipzig: E. A. Seemann, 1993), 58–61.

49. Alfred Freihofer, "Die Internationale Gemäldeausstellung in Stuttgart," *Die Kunst für Alle* 6, nos. 13–14 (Apr. 1891): 198–200, 209–12; idem, "Die Stuttgarter Internationale Kunstausstellung," *Kunstchronik*, n.s. 2 (Apr.–June 1891): cols. 369–74, 447, 489. The income for the exhibition was 383,400 marks, including 118,155 marks for paintings. Of the 52 paintings sold, 40 were purchased by official agencies: the Staatsgalerie purchased 7; the royal collection, 6; and 27 were acquired for the local lottery. The Second International Painting Exhibition, held in 1896, was modeled on the 1891 exhibition and was also quite conservative. Uhde and Liebermann were represented, as were Herkomer, Crane, and the Glasgow Boys, but there was little from France (Alfred Freihofer, "Die Zweite Internationale Gemälde Ausstellung in Stuttgart," *Die Kunst für Alle* 11, no. 14 [Apr. 1896]: 209–11; *Kunstchronik*, n.s. 7 [May 1896]: cols. 393–400).

50. By the time of his death in 1914 Lichtwark had acquired for the Hamburger Kunsthalle a significant collection of nineteenth-century German paintings, among them major works by Caspar David Friedrich, Philipp Otto Runge, Ferdinand Waldmüller, Menzel, Leibl, Trübner, Thoma, Liebermann, Corinth, and Slevogt, as well as by French modernists, including Courbet, Manet, Monet, Sisley, Renoir, Pierre Bonnard, and Édouard Vuillard. He also actively supported both German and French contemporary artists by commissioning art that featured views of the city and portraits of the city fathers. An overview of Lichtwark's work can be found in Helmut R. Leppien, ed., *Kunst ins Leben: Alfred Lichtwarks Wirken für die Kunsthalle und Hamburg von 1886 bis 1914*, exh. cat. (Hamburg: Hamburger Kunsthalle, 1986).

Further valuable information on developments in Hamburg is contained in Carsten Meyer-Tönnesmann, *Der Hamburgische Künstlerclub von 1897* (Hamburg: Christians Verlag, 1985); and Carolyn Kay, *Art and the German Bourgeoisie: Alfred Lichtwark and Modern Painting in Hamburg, 1886–1914* (Toronto: University of Toronto Press, forthcoming). Hamburg's International Exhibition of 1895 was reviewed by Dr. Ernst Zimmermann in "Kunstausstellung in Hamburg," *Die Kunst für Alle* 10, no. 16 (May 1895): 249–51; and Wilhelm Schölermann in "Die Internationale Ausstellung des Hamburger Kunstvereins," *Kunstchronik*, n.s. 6 (May 1895): cols. 401–7. Surplus income of 6,700 marks and sales of more than 60,000 marks were reported in ibid. 7 (Apr. 1896): col. 356.

51. The protest over the poster and against Lichtwark was reported in "Hamburg," *Die Kunst für Alle* 11, no. 13 (Apr. 1896): 207. Meyer-Tönnesmann, *Hamburgische Künstlerclub*, 23–31, 96–141, and Kay, *Art and the German Bourgeoisie*, present detailed accounts of the events in the scandal of 1896. The report on the negative reaction to

Klinger's painting in 1894 appeared in "Späziergänge durch zwei Hanseatische Kunstausstellungen," *Kunstchronik*, n.s. 5 (May 1894): col. 410. Dieter Gleisberg, ed., *Max Klinger, 1857–1920*, exh. cat. (Leipzig: Edition Leipzig, 1992), 354, reports that Klinger's painting was in the Wertheim Collection in Hamburg until it was purchased by the Museum der bildenden Künste Leipzig in 1904 for 60,000 marks.

52. Paul Clemen, "Die Deutsch-Nationale Kunstausstellung zu Düsseldorf," *Die Kunst für Alle* 17, no. 23 (Sept. 1902): 531–44. Clemens claimed that "millions streamed here this summer." Plans reported earlier in the decade to build this exhibition palace had included the proposal that Düsseldorf could then cooperate with Berlin and Munich on a rotation of major international exhibitions, with each city serving as host every third year (ibid. 7, no. 16 [May 1892]: 252). For detailed information about the exhibition halls, see Georg Friedrich Koch, "Die Bauten der Industrie-, Gewerbe- und Kunst-Ausstellung in Düsseldorf 1902 in der Geschichte der Ausstellungsarchitektur," in *Kunstpolitik und Kunstförderung im Kaiserreich: Kunst im Wandel der Sozial- und Wirtschaftsgeschichte*, ed. Ekkehard Mai, Hans Pohl, and Stephan Waetzoldt (Berlin: Gebr. Mann Verlag, 1982), 149–65. Not only did industries provide the funds to build the new exhibition hall but, as a result of the successful exhibition in 1902, Geheimer Kommerzienrat Franz Haniel gave the city 100,000 marks, whose interest was to be used to buy paintings and artworks for the Städtische Gemälde Galerie, according to notes in *Die Kunst für Alle* 18, no. 5 (Dec. 1902): 124.

The Verein Düsseldorfer Künstler zu gegenseitiger Unterstützung und Hilfe, a fifty-six-year-old organization that maintained funds to support needy artists, was coping with a deficit brought on by poor economic conditions the previous year. They were currently providing support for nineteen ill members at a cost of 11,129 marks and pensions for twenty-eight widows at 110 marks each, for a total of 8,965 marks (see tz, Düsseldorf, ibid. 8, no. 20 [July 1893]: 318). On Düsseldorf's importance as an art center in the early years of the nineteenth century, see Eduard Trier and Willy Weyres, eds., *Kunst des 19. Jahrhunderts im Rheinland*, exh. cat., 5 vols. (Düsseldorf: Schwann, 1977); for a brief overview, see Lenman, *Art and Society in Germany*, 104–6.

53. "Gegen die Kunstausstellungen," *Der Kunstwart* 1, no. 3 (Nov. 1887): 31. This review quoted at length from Leixner and then simply outlined his recommendations, offering no opinion upon his ideas. Leixner's attack, initially published in his book *Zwecklose Randglossen*, elicited a response from Rosenberg, who defended the annual Berlin Academy exhibitions as essential for the support of artists.

54. Heinrich Steinhausen, "Kunstgenuss und Vergnügen," *Der Kunstwart* 2, no. 1 (Oct. 1888): 1–4. The German phrases lose their punch in translation: "die kalte Reflexion des Geschmäcklers, das öde Bewundern des künstlerischen Geschicklichkeit oder der Heißhunger des gebildeten Pöbels nach Stoff für Unterhaltung und Salongeschwätz."

55. Max Kretzer, "Randglossen zum Kapital 'Berliner Kunstausstellung,'" ibid., no. 2 (Oct. 1888): 27. The phrase "compact majority" had been popularized by Ibsen's play *The Enemy of the People*, published in German in 1883. Kretzer's reference to the "scandalous walk" reflected awareness that prostitutes were intruding into the public spaces around art exhibitions (see Lynn Abrams, "Prostitutes in Imperial Germany, 1870–1918: Working Girls or Social Outcasts," in *The German Underworld: Deviants and Outcasts in German History*, ed. Richard J. Evans [London: Routledge, 1988]: 189–209).

56. Kretzer, "Randglossen zum Kapital 'Berliner Kunstausstellung,'" 27–28. Kretzer's novels were *Die Betrogenen* (1882), *Die Verkommenen* (1883), *Im Sturmwind des Sozialismus* (1883), and *Meister Timpe* (1887). Katherine Roper, *German Encounters with Modernity: Novels of Imperial Berlin* (Atlantic Highlands, N.J.: Humanities Press International, 1991), 91–92, 111–18, points out that *Die Betrogenen* (The betrayed) may well have been inspired by Henri Murger's *Scènes de la Bohème*, which was published in German in 1881. On private business rescuing art, see "Kunstgenuß und Vergnügen," *Der Kunstwart* 2, no. 3 (6 Nov. 1888): 43–44.

57. [Avenarius], "Sprechsaal," *Der Kunstwart* 2, no. 5 (Dec. 1888): 75–76.

58. For the entry in Grimm's dictionary, see *Deutsches Wörterbuch von Jacob und Wilhelm Grimm* (1889; facsimile reprint, Munich: Deutscher Taschenbuch, 1984), 13: cols. 2201–2. The discussion of the word *Publikum*, covering less than a single page, stands in marked and revealing contrast to the sixty-two-column analysis of the word *Volk* and its derivatives in volume 26 of Grimm's dictionary.

59. For quite different analyses of the intertwining of bourgeois ideals and self-conceptions with the arts, see Thomas Nipperdey, *Wie das Bürgertum die Moderne fand* (Berlin: Siedler, 1988); Wolfgang J. Mommsen, *Bürgerliche Kultur und künstlerische Avantgarde: Kultur und Politik im deutschen Kaiserreich, 1870 bis 1918* (Frankfurt am Main: Propyläen-Studienausgabe, 1994), 7–41; and Wolfgang Kaschuba, "Kunst als symbolisches Kapital: Bürgerliche Kunstvereine und Kunstideale nach 1800, oder, Vom realen Nutzen idealer Bilder," in *Vom realen Nutzen idealer Bilder: Kunstmarkt und Kunstvereine*, ed. Peter Gerlach (Aachen, Germany: Alano-Verlag, 1994): 9–20. In the same collection of essays Andreas Vowinckel, "Ausstellungen in Kunstvereinen: Spezifische Formen und Charakteristika im Spannungsfeld regionaler, überregionaler, und internationaler Konkurrenz," 45–60, stresses the commercial and conservative characteristics of the art societies from the late eighteenth century to the present. See also Walter Grasskamp, "Die Einbürgerung der Kunst: Korporative Kunstförderung im 19. Jahrhundert," in *Sammler, Stifter, und Museen: Kunstförderung in Deutschland im 19. und 20. Jahrhundert*, ed. Ekkehard Mai and Peter Paret (Cologne: Böhlau Verlag, 1993), 104–13.

60. Paul Schumann, "Die Vereinigung der Kunstvereine," *Die Kunst für Alle* 12, no. 10 (Feb. 1897): 147–49, provided a concise history and explanation of the aims of the art societies. Langenstein, *Münchner Kunstverein*, 1–42, in his thorough analysis of the art societies discusses the joint-stock-company aspects. Voluntary associations were a central part of the public life of the bourgeoisie in Germany. The historical literature analyzing the rise and transformation of these associations in the course of the nineteenth century is extensive. A seminal article defining the historical importance of the associations in Germany is Thomas Nipperdey, "Verein als soziale Struktur in Deutschland im späten 18. und frühen 19. Jahrhundert: Eine Fallstudie zur Modernisierung I," in his *Gesellschaft, Kultur, Theorie: Gesammelte Aufsätze zur neueren Geschichte* (Göttingen, Germany: Vandenhoeck & Ruprecht, 1976), 174–205.

David Blackbourn focused on the central importance of the voluntary societies in "Law, Voluntary Association, and the Rise of the Public," in *The Peculiarities of German History: Bourgeois Society and Politics in Nineteenth-Century Germany*, by David Blackbourn and Geoff Eley (Oxford: Oxford University Press, 1984), pt. 2, chap. 2. A more recent study examining the structure, function, and life of these bourgeois societies, which reached their high point in the middle of the century, is Michael Sobania, "Vereinsleben: Regeln und Formen bürgerlicher Assoziationen im 19. Jahrhundert," in Hein and Schulz, *Bürgerkultur im 19. Jahrhundert*, ed. 170–90, which points out that the general associations were superseded by specialized and professional societies in the latter half of the century.

I use the term *bourgeoisie—Bürgertum*—as it has been defined in a number of major publications: as an elitist social category that refers to the upper layers of mercantile, financial, industrial, and propertied middle classes but excludes the nobility and the lower middle class. This bourgeoisie was influential beyond its small numbers, which constituted roughly 5 percent of the German population. My understanding is based on definitions and analyses that examine the German bourgeoisie in the context of the larger European pattern in Jürgen Kocka and

Allan Mitchell, eds., *Bourgeois Society in Nineteenth-Century Europe* (Oxford: Berg, 1993), 1–39; David Blackbourn and Richard Evans, eds., *The German Bourgeoisie: Essays on the Social History of the German Middle Class from the Late Eighteenth to the Early Twentieth Century* (New York: Routledge, 1991), 1–45; and Klaus Vondung, "Zur Lage der Gebildeten in der wilhelminischen Zeit," in *Das wilhelminische Bildungsbürgertum: Zur sozialgeschichte seiner Ideen* (Göttingen, Germany: Vandenhoeck & Ruprecht, 1976), 20–33.

61. On the special lottery for artworks in 1897, see *Die Kunst für Alle* 12, no. 16 (May 1897): 262. The first prize included a Lenbach portrait of Bismarck, H. W. Jansen's *Holländische Winterlandschaft*, and Hermann Hahn's bronze *Adam* (ibid., no. 21 [Aug. 1897]: 346; Langenstein, *Münchner Kunstverein*, 41). Peter Paret discusses Rethel's project for the town hall in Aachen in *Art as History: Episodes in the Culture and Politics of Nineteenth-Century Germany* (Princeton: Princeton University Press, 1988): 86–90.

62. A complete list of art societies can be found in *Die Kunst für Alle* 12, no. 24 (Sept. 1897): 401; and in Theodor Seemann, "Die Aufgaben und Leistungen der deutschen Kunstvereine," *Deutsche Kunst* 1, no. 4 (Oct. 1896): 37–38. In the English literature, the German names for these societies and associations have been translated in different, often confusing ways. In order to maintain as much clarity as possible in the text, I have chosen to consistently translate the word *Verein* as "society" and the word *Genossenschaft* as "association." Here are the various German names with the English translations that I shall use: *Kunstverein*, "art society"; *Künstlerverein*, "artists' society" or "society of artists"; *Kunstgenossenschaft*, "art association"; *Künstlergenossenschaft*, "artists' association" or "association of artists." The national organization representing all of the local artists' associations and artists' societies was the Allgemeine Deutsche Kunstgenossenschaft (General German Art Association). The first thorough study of these artist associations was published by the general secretary of the General German Art Association in the 1880s and 1890s, Heinrich Deiters: *Geschichte der Allgemeinen Deutschen Kunstgenossenschaft: Von ihrer Entstehung im Jahre 1856 bis auf die Gegenwart. Nach den offiziellen Berichten, eigenen Erinnerungen und Erlebnissen* (Düsseldorf: August Bagel, [1903]). For more recent careful analyses of the rise of the *Kunstgenossenschaft* and their relation to the *Kunstverein*, see Langenstein, *Münchner Kunstverein*, 178–83; and Harzenetter, *Zur Münchner Secession*, 62–90.

63. Makela, *Munich Secession*, 6–14, in her discussion of the functions and strength of the Munich Artists' Association makes a strong case for the liberal populism that supported the organization in Munich in the 1880s. The official statement of the founding of the Society of Berlin Artists, read at the fiftieth-anniversary celebration, was published as "Die Gründung des Vereins Berliner Künstler (19. Mai 1841)" in *Die Kunst für Alle* 6, no. 19 (1 July 1891): 297–301. Among frequent reports on the Berlin artists' society, the following discuss the new headquarters: *Kunstchronik*, n.s. 7 (Apr. 1896): col. 356; ibid. 10 (Nov. 1898): cols. 58–59, 87–90; and *Die Kunst für Alle* 11, no. 16 (May 1896): 255.

See Werner's account, in *Erlebnisse*, 477–78, of his role in moving the society first into the Architects' House, on Wilhelmstrasse, and then into its own Artists' House, financed with the help of the city, on Bellevuestrasse. *Kunstchronik* reported the cost of the new building as 850,000 marks. For a historical overview of the Society of Berlin Artists in the nineteenth century, see Helmut Börsch-Supan, "Der Verein Berliner Künstler im neunzehnten Jahrhundert," in *Verein Berliner Künstler: Versuch einer Bestandsaufnahme von 1841 bis zur Gegenwart* (Berlin: Ars Nicolai, 1991): 9–44. Peter Paret, *The Berlin Secession: Modernism and Its Enemies in Imperial Germany* (Cambridge: Harvard University Press, 1980), 9–28, gives an account of these complicated negotiations in Berlin.

64. Theodor Paulsen, "Im Sächsischen Kunstverein," *Die Kunst für Alle* 2, no. 9 (Feb. 1887): 123–24. Friedrich Pecht, "Der Münchener Kunstverein," ibid. 9, no. 11 (Mar. 1894): 169–70.

65. See Karl Voll, "Die Reform der deutschen Kunstvereine, illustrierte am Münchener Verein," ibid. 14, no. 17 (June 1899): 257, reviewing charges made by Lichtwark in a recent lecture in the Münchener Literarischen Gesellschaft. Voll then continued with his own analysis of the art societies, in which he argued for a change in the lottery system. An art historian, Voll was a curator at the Alte Pinakothek from 1900 to 1907. The negative comments came from *Der Kunstwart* 5, no. 13 (Apr. 1892): 199; and Immergrün, "Gemäldeausstellungen," ibid. 9, no. 16 (May 1896): 253.

66. The controversies in Hamburg occurred in 1892–93 over Liebermann's portrait of Mayor Petersen and in 1896 over Ernst Eitner's poster for the Hamburg Kunstverein exhibition (see Caroline Kay, "The Petersen Portrait: The Failure of Modern Art as Monument in Fin-de-Siècle Hamburg," *Canadian Journal of History* 32 [Apr. 1997]: 56–75). Pecht's defense appeared in "Der Münchener Kunstverein," 170.

67. The full title of the journal is *Deutsche Kunst: Central-Organ Deutscher Kunst- und Künstler-Vereine. Wochenblatt für das gesammte deutsche Kunstschaffen*. The official spon-

sors on the masthead in January 1897 were: the Deutsche Kunstverein in Berlin, the Schlesischen Kunstverein in Breslau, the Kunstverein of the Grand Dukedom of Hesse in Darmstadt, the Anhalt Kunstverein in Dessau, the Württemberg Kunstverein in Stuttgart, the Schleswig Holstein Kunstverein in Kiel, and the art societies of Munich, Mannheim, Nürnberg, Gera, Altenburg, Elberfeld, Barmen, Bielefeld, Görlitz, Danzig, Königsberg, Stettin, and other cities.

68. Theodor Seemann, "Die Aufgben und Leistungen der deutschen Kunstvereine," *Deutsche Kunst* 1, no. 4 (Oct. 1896): 37–38, included the following chart:

Art Society Sales, 1879:

Augsburg	10,080
Königsberg	38,600
Munich	70,463
Hamburg	14,500
Düsseldorf	42,350
Bremen	64,702
Berlin	57,010

Art Society Sales, 1880:

Altenburg	6,983
Cologne	106,735
Dresden	41,914
Freiburg	3,400
Heilbronn	10,000
Bremen	64,702
Lübeck	5,590
Magdeburg	25,522
Nordhausen	14,600
Ostdeutsche Art Societies	15,000
Artists' income from these sales	557,951
Adding income received from the other 23 art societies	725,960

69. Theodor Seeman, "Die Aufgaben und Leistungen der deutschen Kunstvereine" ibid., no. 12 (Dec. 1896): 133–34.

70. For the quotation on the purpose of the journal, see "An unsere Leser," ibid., no. 13 (Dec. 1896): 145–46; on Tschudi's purchases, "Neuerwerbungen der Berliner Nationalgalerie," ibid., 150–51. The Berlin National Gallery was the first major museum to purchase a painting by Manet. The first Manet paintings in the Metropolitan Museum of Art in New York and the Musée du Luxembourg were gifts to the museums, not purchases.

71. Pecht, "Der Münchener Kunstverein," *Die Kunst für Alle* 9, no. 11 (Mar. 1894): 169. Pecht gives the date of the soci-

ety's move to its own building as 1869, but Langenstein, *Münchner Kunstverein*, 76, gives the date as 1866. Langenstein provides further information about the society's reliance upon the art dealer. When the Hofgarten arcade was rebuilt after World War II, the Munich Art Society moved back into rooms at the end of the arcade. The 1888 annual meeting reported 5,700 members and an annual income of 120,000 marks; its annual gifts and lottery distributed oil paintings, sculptures, and watercolors worth 82,000 marks to its members (see *Die Kunst für Alle* 3, no. 12 [Mar. 1888]: 193, and 4, no. 11 (Mar. 1889): 75; ibid. 9, no. 11 (Mar. 1894): 174, for statistics in 1894; and *Die Kunst unserer Zeit* 5, 1st half-vol. [1894], supplement, 16 Feb.).

72. Langenstein, *Münchner Kunstverein*, 76–77, 163–64, 207–9.

73. *Die Kunst für Alle* 11, no. 23 (Sept. 1896): 364, includes further facts about the Dresden society from 1895: 2,885 works exhibited, with 2,106 from Dresden; a total income of 47,028 marks; expenditures, 45,845 marks; membership at 2,524, a drop from 2,681 members in 1893. Complete 1896 statistics are in ibid. 12, no. 24 (Sept. 1897): 400. By the first years of the new century Dresden's membership rolls and sales were again dropping, causing various plans for revitalization until in 1904 cooperation with the dealers Ernst Arnold and Emil Richter—which provided free entry for members into the dealers' shows—and special exhibitions of French Impressionist and Post-Impressionist works in 1899 increased their membership again. P. Sch. [Paul Schumann], "Die Entwickelung der modernen Malerei," *Die Kunst für Alle* 12, no. 24 (Sept. 1897): 395–96, 400; and *Deutsche Kunst* 1, no. 13 (Dec. 1896): 151, both reported on Seidlitz's lectures. "Aus den Kunstvereinen," ibid. 1, no. 2 (Oct. 1896): 19, reported on Leipzig.

74. A short history of the Hamburg Art Society can be found in Meyer-Tönnessmann, *Der Hamburgische Künstlerclub*, 31–34. Henrike Junge, "Alfred Lichtwark und die 'Gymnastik der Sammeltätigkeit,'" in Mai and Paret, *Sammler, Stifter, und Museen*, 202–14, provides useful information on Lichtwark's promotion of art in Hamburg.

75. On Düsseldorf, see *Die Kunst für Alle* 11, no. 21 (Aug. 1896): 334, and 18, no. 23 (Sept. 1903): 556. Annual reports with extensive statistics from Hanover were printed regularly in the journal. The Hanover society continued its growth after the turn of the century: by 1901 membership had climbed to 10,541; in 1902 1,000 people a day attended an exhibition of both German and foreign works; in 1903 membership soared to 11,212 despite unfavorable economic conditions in the city, and sales in an exhibition of sixteen hundred foreign and German works totaled 153,275 marks.

76. *Die Kunst für Alle* 5, no. 8 (Jan. 1890): 127. The following chart from the journal provides an overview of the Cologne Art Society's financial condition and its sales of works of contemporary art.

	Income in marks	Art exhibition purchases in marks
1839–48	342,066	256,665
1849–58	234,747	115,501
1859–68	303,103	362,666
1869–78	427,144	883,387
1879–88	542,777	898,277
Total	1,849,837	2,516,496

Income was used to pay for the following purposes:

Artworks for lottery	781,872
Annual gift to members	311,818
Fund for needy artists	27,367
Share for the city of Cologne	182,567
Administrative costs	494,815

Works of art were purchased from the society's art exhibitions for the following purposes:

By the Society for its lottery	781,872
By private individuals, the city of Cologne, and the Museums' Society	552,307
By the lottery for the cathedral building fund	1,182,317

77. These are rough counts. Records for 1894–1900 are missing from the lists, but the difference between the large number of established artists with truly long runs of appearances before 1888 and the predominance of artists whose names appeared infrequently after that date is striking (see Peter Gerlach, ed., *Statistik, Kunstvereins-Menu, Zahlen, Listen und Dokumente zu Personen, Ausstellungen, Künstlern, Jahresgaben*, in *KölnischerKUNSTverein: Einhundertfünfzig Jahre Kunstvermittlung, 1839–1989* (Cologne: Kölnischer Kunstverein, 1989). For the statistics on artists, see the attached MS DOS diskette, "Ausstellende Künstler 1839–1925," file S8.KKV; for statistics on membership, see "Mitglieder des Kölnischen Kunstvereins 1839–1989," file S1.KKV.

78. M.S., "Breslau, Liegnitzer Kunstverein," *Die Kunst für Alle* 14, no. 19 (July 1899): 300–301; *Deutsche Kunst* 1, no. 2 (Oct. 1896): 19.

79. G.W., "Permanent Cyklus- (Wander-) Ausstellungen," *Die Kunst für Alle* 1, no. 1 (Oct. 1885): 13. For further notes, see ibid. 3, no. 12 (Mar. 1888): 192; ibid. 21, no. 2 (1905); and *Deutsche Kunst* 1, no. 8 (Nov. 1896): 92. For information and a typology of traveling exhibitions, see Langenstein, *Münchner Kunstverein*, 1–13, 128–57. See also Walter Grasskamp, "Die Reise der Bilder: Zur Infrastruktur der Moderne," in *Stationen der Moderne: Die bedeutenden Kunstausstellungen des 20. Jahrhunderts in Deutschland*, ed. Jörn Merkert, exh. cat. (Berlin: Berlinische Galerie, 1988), 25–33.

80. The *Allgemeinen Kunstausstellungskalendars* were published annually by Münchener Kunstspeditionsgeschäft Gebr. Wetsch. The maps in *Die Kunst für Alle* were printed from 1886 to 1900, usually in the 1 February issue on p. 144 and inside the cover page. For other examples, see *Kunstchronik*, n.s. 1 (Jan. 1890): col. 219, and 2 (Jan. 1891): cols. 251–52. The description of the 1896 cycles appears in Seemann, "Die Aufgaben und Leistungen der deutschen Kunstvereine, III," 133–34. For notes on a meeting setting up the annual schedule for the 1887 tour of the Federation of Art Societies East of the Elbe, see *Die Kunst für Alle* 2, no. 4 (Nov. 1886): 64. According to this report, the Prussian minister of culture had authorized that works purchased at the Berlin Jubilee Exhibition for the National Gallery be available for their cycle. An announcement of the schedule and regulations for submissions of works of art for the 1888 annual cycle of the Rhenish Art Society Cycle was published in ibid. 3, no. 10 (Feb. 1888): 161–62. A report on the sales of the Westphalian Cycle for 1886 and 1887 (a total of 17,000 marks) and for the 1888 schedule for the three cities appears in ibid., 162; and a brief report of the annual meeting of the Palatine Cycle with income figures appears in ibid. 5, no. 8 (Jan. 1890): 127.

81. *Die Kunst für Alle* 8, no. 20 (July 1893): 318, briefly reports on the unified cycle without mentioning which cities were involved; *Kunstchronik*, n.s. 7 (Apr. 1896): col. 340, reports in considerable detail on works exhibited and sold in Darmstadt, Gießen, Mainz, and Hanau, as well as about their lottery. The note on the Gotha conference is in *Die Kunst für Alle* 9, no. 2 (15 Oct. 1893): 30.

82. Grasskamp, "Die Reise der Bilder," 25–33, argues very effectively that this unhinging of works of art from their localities and transporting them around Europe was a nineteenth-century precondition for the development and success of modern art, with its international markets, as well as twentieth-century exhibition practices. On Marr's tour, see ==, "München," *Die Kunst für Alle* 5, no. 4 (Nov. 1889): 62. Reports on Preuschen's tours appeared in *Deutsche Kunst* 1, nos. 3 (Oct. 1896): 31 and 12 (Dec. 1896): 139; and in *Die Kunst für Alle* 10, no. 4 (Nov. 1894): 61, and 12, no. 3 (Nov. 1896). "Kuriosa aus Ate-

lier und Werkstatt," *Deutsche Kunst* 1, no. 15 (Jan. 1897): 178, published a report from the *Metzer Zeitung* on Hermine von Preuschen's description of her research for the painting of Irene von Spilimberg. Noting that the public in Metz had received the painting with enthusiasm and that many were calling for the city gallery to purchase the work, *Deutsche Kunst* caustically commented that the 1,000 marks she requested for the painting was a bargain since the frame alone cost 450 marks: "Geliebte Tizian's, Gift, Viktor von Scheffel, Burkhardt, Leichenhallen, Todtenphotographie, viel darinstechender Schmerz, Rahmen für 450 mark—und dazu noch ein Gemälde von Hermine von Preuschen—mehr kann man für 1000 Mark allerdings nicht verlangen."

83. C[arl] von Lützow, "Zum Beginn," *Zeitschrift für bildende Kunst* 25, n.s. 1 (1889–90): 1–2. The art dealer Eduard Schulte arranged for the Munch paintings to be shown in Cologne, Düsseldorf, Berlin, Copenhagen, Breslau, Dresden, and Munich (Grasskamp, "Die Reise der Bilder," 27 n. 5). Walter Feilchenfeldt, *Vincent van Gogh and Paul Cassirer, Berlin: The Reception of Van Gogh in Germany from 1901 to 1914* (Zwolle, Netherlands: Waanders, 1988), 18–41, gives detailed information about the van Gogh tours arranged by Cassirer. Paintings by van Gogh, Paul Gauguin, and other Pont-Aven painters were shown at the Munich Art Society in autumn 1904 (A.H. [Alexander Heilmeyer], "München. Kunstverein," *Die Kunst für Alle* 20, no. 2 [Oct. 1904]: 46).

84. A Post-Impressionist traveling exhibition in 1906–7 organized by Dr. R. A. Meyer included paintings by Matisse, Seurat, Signac, Gauguin, van Gogh, Vuillard, Denis, and Rysselberghe, which fascinated artists along the route and, in Karlsruhe, enraged the public (ibid. 22, nos. 3 [Nov. 1906]: 77 and 12 [Mar. 1907]: 295).

The Bridge participated in a series of traveling exhibitions that promoted its work in more than sixty cities in eight years (Peter Betthausen, "Die 'Brücke'—Künstlergemeinschaft und Kunstverein des Expressionismus," in *Expressionisten: Die Avantgarde in Deutschland, 1905–1920*, ed. Roland März, exh. cat. [Berlin: Henschelverlag Kunst und Gesellschaft, 1986], 29). The first brief, negative review in *Die Kunst für Alle* of the Brücke artists was occasioned by their exhibit at the Karlsruhe Art Society in 1908 ("Karlsruhe Kunstverein," *Die Kunst für Alle* 23, no. 11 [Mar. 1908]: 258). For information on the Brücke exhibitions, see Reinhold Heller, *Brücke: German Expressionist Prints from the Granvil and Marcia Specks Collection*, exh. cat. (Evanston, Ill.: Mary and Leigh Block Gallery, Northwestern University, 1988), 9, 13–14.

In 1909, paintings of Kandinsky and others in the New Art Society of Munich that had been in the Thannhauser Gallery toured from Munich to Elberfeld, Barmen, and Hagen; then in 1910 works by the same

artists, plus works by Derain, Vlaminck, Rouault, Braque, and Picasso, were shown in Karlsruhe and Mannheim (Grasskamp, "Die Reise der Bilder," 27).

Herwarth Walden, who organized a Society for Art in 1904 to foster contemporary artists and writers, made heavy use of traveling exhibitions to promote the Sturm artists. In the years 1912–24 he organized more than two hundred exhibitions in Berlin and arranged more than three hundred in more than forty German cities and fourteen foreign countries (see *Sturm-Abende: Ausgewählte Gedichte* [Berlin: Verlag der Sturm, (1918)]; Georg Brühl, *Herwarth Walden und "Der Sturm"* [Cologne: DuMont Buchverlag, 1983], 20–21, 109–11; and Robin Lenman, "Painters, Patronage, and the Art Market in Germany, 1850–1914," *Past and Present*, no. 123 [1989]: 135).

85. Lengthy statements of the purpose of the German Art Society in Berlin and listings of the persons leading and backing the society are given in *Die Kunst für Alle* 8, no. 10 (Feb. 1893): 156; and D.R. [Hans Rosenhagen], "Zur Lage," *Das Atelier* 3, no. 53 (Jan. 1893): 6–7, 12. The report in *Die Kunst für Alle* stressed that the society was particularly devoted to helping smooth the way for younger artists, as well as to fostering all art movements. "Ein neuer Berliner Kunstverein," *Der Kunstwart* 6, no. 2 (Oct. 1892): 29, however, reported that at a meeting in October 1892 the purpose was defined as to provide oil paintings and watercolors from living artists to counteract the mechanical colored reproductions of works of art from the art societies that were flooding the market and undermining sales for young artists.

86. Plans were made to offer different levels of membership—from 30 to 60, 90, 120, or 250 marks per half-year. The lottery and its premiums would be open only to those who remained members throughout the year. The level of membership determined the quality of artwork a member could choose at an exhibition of available premiums from the lottery (see also "Neue Deutsche Kunstvereins in Berlin," ibid., no. 11 [Mar. 1893]: 168–69).

A short note in *Kunstchronik* indicated the rapid growth of the society ("Der Deutsche Kunstverein in Berlin," *Kunstchronik*, n.s. 4 [Apr. 1893]: col. 379). In an 1898 article on Wilhelm Bode, Woldemar von Seidlitz cited Bode's establishing the German Art Society as an example of his commitment to the struggle for modern art ("Wilhelm Bode: Rückblick auf eine Museumsthätigkeit von fünfundzwanzig Jahren," *Zeitschrift für bildende Kunst* 33, n.s. 9 [1897–98]: 1–4). G, "Berlin," *Die Kunst für Alle* 8, nos. 18 (June 1893): 284 and 21 (Aug. 1893): 333; and ibid. 9, no. 12 (Mar. 1894): 188, reported on works for the first lottery that were exhibited at Schulte's gallery, including graphics by Klinger and drawings by Leibl, Menzel, and Liebermann. *Das Atelier* 4, no. 4 (Feb. 1894): 10, no. 6 (Mar. 1894): 8, and no. 12 (June 1894): 7, reported

details about the current activities, including the membership of more than 1,600 members, and announced that the emperor might become protector of the society. *Deutsche Kunst* provided a summary of the society's 1895 report: 1,578 members, income of 28,440 marks with 17,440 marks spent to purchase works of art, and administrative costs of 7,594 marks ("Berlin: Der deutsche Kunstverein," *Deutsche Kunst* 1, no. 1 [Oct. 1896]: 8). The modern works used for the lottery were reported in *Kunstchronik*, n.s. 10 (Dec. 1898): cols. 106, 125–26, and ibid. (July 1899): cols. 490–91. However, two years earlier, when the chamberlain of the empress, B. von dem Knesebeck, had been chairman of the society, the lottery had featured 250 portfolios with portraits of eminent German men, including the scientist Hermann von Helmholtz and General Helmuth von Moltke.

Part II
The Public and the Critic

1. Since no words in English capture the full negative connotations of these contemptuous words, *Schaupöbel* and *Kunstpöbel*, both based on the word *Pöbel*, they are not translated into English but are set in roman and lowercased as if they were English words. In its usage the word *Pöbel*, derived from the Latin *populus* and the French *peuple* and often used to form compound nouns, referred to the common crowds, poor people, lower estates. Traced in a variety of forms from the thirteenth century, it began to carry pejorative overtones in Luther's writing in the sixteenth century. By the nineteenth century, under the influence of the French Revolution, the word carried increasingly derogatory connotations and appeared in the writing of Kant, Goethe, Schlegel, and Heine. For an example relevant to this chapter, consider a phrase from Schiller, "auch ein mensch von feinen sitten kann zuweilen . . . an dem kontrast zwischen den sitten der feinern welt und des pöbels sich belustigen." For this quotation with its lowercase forms and for further usage examples, see *Deutsches Wörterbuch von Jacob und Wilhelm Grimm* (1889; facsimile reprint, Munich: Deutscher Taschenbuch, 1984), 13: cols. 1950–56. *Pöbel* is translated in Adler's *Dictionary of German and English Language* (New York, 1884) as mob, rabble, populace, vulgar, or plebian; the *Flügel-Schmidt-Tanger Wörterbuch* (Braunschweig: G. Westermann, 1902) adds to those words riffraff, unwashed, coarse, and low; while *Muret-Sanders Wörterbuch* stresses the French derivation.

2. E. v. Franquet, *Schaupöbel: Stuck, Klinger, Exter, v. Hofmann etc. "Die künftigen Heroen der Rumpelkammer." Glossen zum Streit der Alten und Jungen* (Leipzig: Verlag von Max Spohr, 1893), 27. Franquet's older brother, Arthur, purchased a painting by Edvard Munch, *Moonlight*, in early 1893, according to Indina Kampf, "'Ein enormes Ärgernis' oder: Die Anarchie in der Malerei: Edvard Munch und die deutsche Kritik, 1892–1902," in *Munch und Deutschland*, ed. Uwe M. Schneede and Dorothee Hansen, exh. cat. (Hamburg: Hamburger Kunsthalle, 1994), 88, 90 n. 70. Thomas E. Crow, *Painters and Public Life in Eighteenth-Century Paris* (New Haven, Conn.: Yale University Press, 1985), describes a similar use of appeals to the reputed demands of the public by critics in arguments over the Paris Salons. He also points out that these debates provoked a flurry of pamphlets and counterpamphlets.

3. H. E. von Berlepsch, "Die Frühjahr-Ausstellung der Münchener Secession," *Die Kunst für Alle* 9, no. 15 (May 1894): 226, wrote about the new German words, which had caught on and had generated the series of brochures currently being discussed in Munich. Although other writers also believed that the terms *Schaupöbel* and *Kunstpöbel* had been coined at this time, at least one critic had used *Schaupöbel* some years earlier. In his scathing parody of self-styled connoisseurs and critics at contemporary exhibitions, Otto von Leixner, *Anleitung in 60 Minuten Kunstkenner zu werden* (Berlin: Verlag von Brachvogel & Boas, 1886), 9, had referred to the "'Publikum'—das Wort läßt sich hier als Schaupöbel übersetzen." See also [Avenarius], "Kunst-Literatur, 12," *Der Kunstwart* 7, no. 11 (Mar. 1894): 167–68.

4. Perfall, "Die Berliner Kunstausstellung," ibid. 6, no. 17 (June 1893): 265–66, reprinted from *Kölnischen Zeitung*; and H. A. Lier, "Korrespondenz: Aus Dresden, February 1894," *Kunstchronik*, n.s. 5 (Feb. 1894): col. 251.

5. Hermann Bahr, "Die 62. Berliner Akademische Kunstausstellung," *Der Kunstwart* 3, nos. 20–21 (July 1890): 314, 330. Bahr, whose reports from Paris appeared regularly in *Der Kunstwart* from 1888 to 1890, became a strong advocate of the Vienna Secession and later wrote on Expressionism (1916). For Bahr's changing views on contemporary art, see Robert Jensen, *Marketing Modernism in Fin-de-Siècle Europe* (Princeton: Princeton University Press, 1994), 183, 205–6; and Donald G. Daviav, "Hermann Bahr and the Secessionist Art Movement in Vienna," in *Turn of the Century: German Literature and Art, 1890–1915*, ed. Gerald Chapple and Hans H. Schulte (Bonn: Bouvier Verlag, 1981): 433–62, although Daviav's narrow focus on Bahr's writing on Vienna leads him to overemphasize the originality of his thinking. See also Adolf Rosenberg, "Die Akademische Kunstausstellung in Berlin," *Zeitschrift für bildende Kunst* 25, n.s. 1 (1889–90): 300.

6. Alfred Gotthold Meyer, "Die Zweite Münchener Jahresausstellung," *Zeitschrift für bildende Kunst* 26, n.s. 2 (1890–91): 71–72. See Jensen, *Marketing Modernism*, 89–91, 202–4, for the complete quotation of Zola's statement on the Salon des Refusés and on Zola's reception in

Germany, where his book *L'Oeuvre* was published in translation in 1886. Discussing Zola, Jensen points out that the laughter of the mob—the "chorus of laughter"— was the mark of artistic immortality in nineteenth-century French art criticism but in practice was not welcomed. See [Wilhelm Trübner], "Das Kunstverständnis von Heute" (1892), in *Personalien und Prinzipien* (Berlin: Bruno Cassirer, 1907), 124–82. Trübner developed these ideas into a more substantial book, *Die Verwirrung der Kunstbegriffe: Betrachtungen* (Frankfurt am Main: Rütten & Loening, 1898), which was critically reviewed by Paul Schumann in *Der Kunstwart* 12, no. 2 (Oct. 1898): 50–53. See also Maria Makela, *The Munich Secession: Art and Artists in Turn-of-the-Century Munich* (Princeton: Princeton University Press, 1990), 60–61.

7. Benno Becker, "Die Ausstellung der Secession in München," *Die Kunst für Alle* 8, no. 22 (Aug. 1893): 343–44.

8. For a judicious summary of intellectuals' response to the disturbing social changes in Germany at this time, see Gary D. Stark, *Entrepreneurs of Ideology: Neoconservative Publishers in Germany, 1890–1933* (Chapel Hill: University of North Carolina Press, 1981), 106–10. Geoff Eley has succinctly summarized this period as one "of unprecedented social change—of astonishing urban growth, massive migration and pervasive cultural dislocation, in which people were forced either to defend their accustomed way of life or to adapt rapidly and resourcefully to a new environment" ("The German Right, 1860–1945: How It Changed," first printed in *Society and Politics in Wilhelmine Germany*, ed. Richard J. Evans [New York: Barnes and Noble, 1978], 53–82).

Wolfgang J. Mommsen, "Society and State in Europe in the Age of Liberalism, 1870–1890," in his *Imperial Germany, 1867–1918: Politics, Culture, and Society in an Authoritarian State*, trans. Richard Deveson (New York: Arnold of Hodder Headline, 1995), 57–74, analyzes this development in Germany within the broader European context. James Retallack, "The Birth of the Modern Age," in *Germany in the Age of Kaiser Wilhelm II* (New York: St. Martin's Press, 1996), chap. 2, provides an introductory historiographic survey of research on these issues, as does Richard J. Evans, *Rethinking German History: Nineteenth-Century Germany and the Origins of the Third Reich* (London: Allen and Unwin, 1987). A pessimistic analysis of the challenge to the bourgeoisie comes from Hans Mommsen, "The Decline of the Bürgertum in Late Nineteenth- and Early Twentieth-Century Germany," in *From Weimar to Auschwitz: Essays in German History*, trans. Philip O'Connor (Princeton: Princeton University Press, 1991), 1–25.

9. Helpful sources in this area are Margaret Lavinia Anderson, "Voter, Junker, *Landrat*, Priest: The Old Authorities and the New Franchise in Imperial Germany," *American Historical Review* 98, no. 5 (1993): 1448–74; Helmut Walser Smith, "Religion and Conflict: Protestants, Catholics, and Anti-Semitism in the State of Baden in the Era of Wilhelm II," *Central European History* 27, no. 3 (1994): 283–314; and David Blackbourn, "The Politics of Demagogy in Imperial Germany," *Past and Present*, no. 113 (1986): 152–84. The following studies provide somewhat different interpretations of these political developments: Richard S. Levy, *The Downfall of the Anti-Semitic Political Parties in Imperial Germany* (New Haven, Conn.: Yale University Press, 1975); Jehuda Reinharz, *Fatherland or Promised Land: The Dilemma of the German Jew, 1893–1914* (Ann Arbor: University of Michigan Press, 1975); Marjorie Lamberti, *Jewish Activism in Imperial Germany: The Struggle for Civil Equality* (New Haven, Conn.: Yale University Press, 1978): 1–54; and David Blackbourn, "Catholics, the Centre Party, and Anti-Semitism," in *Populists and Patricians: Essays in Modern German History* (London: Allen and Unwin, 1987), 168–87.

10. Hermine von Preuschen-Telman, "Über das künstlerische Studium der Frau: Vortrag gehalten auf dem Internationalen Kongreß für Frauenwerke und Frauenbestrebungen in Berlin am 22. September 1896," cited in Iris Schröder, "Der 'Verein der Künstlerinnen und Kunstfreundinnen zu Berlin' und die Frauenbewegung vor dem Ersten Weltkrieg 1867–1914," in *Profession ohne Tradition: 125 Jahre Verein der Berliner Künstlerinnen*, by Berlinische Galerie, exh. cat. (Berlin: Kupfergraben, 1992), 375. Basic information on these different organizations can be found in Ute Frevert, *Women in German History: From Bourgeois Emancipation to Sexual Liberation*, trans. Stuart McKinnon-Evans (Oxford: Berg, 1988); Thomas Nipperdey, *Deutsche Geschichte, 1866–1918*, vol. 1, *Arbeitswelt und Bürgergeist* (Munich: Verlag C. H. Beck, 1990), 82; James D. Steakley, *The Homosexual Emancipation Movement in Germany* (New York: Arno Press, 1975), 21–69; and John C. Fout, "Sexual Politics in Wilhelmine Germany: The Male Gender Crisis, Moral Purity, and Homophobia," *Journal of the History of Sexuality* 2, no. 3 (1992): 388–421.

11. An essential study of the social and cultural organizations of the socialist labor movement in these decades is Vernon Lidtke, *The Alternative Culture: Socialist Labor in Imperial Germany* (New York: Oxford University Press, 1985). Lynn Abrams, *Workers' Culture in Imperial Germany* (London: Routledge, 1992), supplies a further analysis of the advent of a working-class commercial culture in the cities, while a new middle-class urban phenomenon is analyzed in Peter Jelavich, *Berlin Cabaret* (Cambridge: Harvard University Press, 1993). Eleanor L. Turk, "The Great Berlin Beer Boycott of 1894," *Central European History* 15, no. 4 (1982): 377–97, demonstrates

the wide-ranging consequences of a specific instance of resistance on the part of workers in Berlin.

Not only did immigration from the countryside in the years 1880–1900 result in the doubling of Munich's population but half of the population by 1907 were Bavarians who had not been born in Munich (see Robert Eben Sackett, *Popular Entertainment, Class, and Politics in Munich, 1900–1923* [Cambridge: Harvard University Press, 1982], 37–38). For a description of the immigrant workers in Berlin, see Hsi-Huey Liang, "Immigrants in Wilhelmine Berlin," *Central European History* 3, no. 1/2 (1970): 94–111. A concise analysis of problems facing German cities is provided in Peter Merkl, "Urban Challenge under the Empire," in *Another Germany: A Reconsideration of the Imperial Era*, ed. Jack R. Dukes and Joachim Remak (Boulder, Colo.: Westview Press, 1988), 61–72. Nipperdey, *Deutsche Geschichte*, chap. 1, "Bevölkerung," includes statistical tables and an analysis of the growing urban demographics.

12. Pecht believed that despite its standing above serious problems, the magazine was such a true mirror of contemporary German life that later cultural historians would be able to use it to gain an insight into the morals, fashions, and customs of this era. He himself devoted two successive, heavily illustrated lead articles to the magazine: "Von den Münchener *Fliegenden Blättern*," *Die Kunst für Alle* 6, nos. 2 (Oct. 1890): 17–22 and 3 (Nov. 1890): 33–36.

Similarly, Paul Schultze-Naumburg characterized *Fliegende Blätter* as a conservative paper that had remained the same year after year, picking up the small weaknesses of human society from the height of sunny optimism. Its world was cheerful, harmless, without suffering and without social democracy (*Der Kunstwart* 9, no. 19 [July 1896]: 290). See also Fred. Walter, "Eine Jubiläums-Studie," *Die Kunst unserer Zeit* 5, 1st half-vol. (1894): 75–98; and "Lose Blätter," *Der Kunstwart* 15, no. 9 (Feb. 1902): 411–48, which included a collection of drawings and cartoons taken from the magazines *Jugend*, *Simplicissimus*, and *Fliegende Blätter*, including a cartoon strip by Franz Stuck and a delightful spoof, "Der dressierte Drache," written by F. Avenarius and illustrated by Adolf Oberländer.

13. For a significant exhibition of the humorists, see R.M. [Richard Mortimer], *Die Kunst für Alle* 14, no. 17 (June 1899): 268, on the Cassirer Gallery exhibition featuring original drawings created for the humor magazines. For thoughtful and informative analyses of the function of the humor magazines, see Henry Wassermann, "The *Fliegende Blätter* as a Source for the Social History of German Jewry," *Leo Baeck Institute Year Book* 28 (1983): 93–138; and Ann Taylor Allen, *Satire and Society in Wilhelmine Germany: "Kladderadatsch" and "Simplicissimus," 1890–1914* (Lexington: University Press of Kentucky, 1984).

Allen places the circulation of *Kladderadatsch* in 1890 at fifty thousand. A valuable study by Mary Lee Townsend, *Forbidden Laughter: Popular Humor and the Limits of Repression in Nineteenth-Century Prussia* (Ann Arbor: University of Michigan Press, 1992), treats the humor and cartoons of the first half of the nineteenth century.

14. For contemporary tributes to Oberländer, see Adolf Bayersdorfer, "Adolf Oberländer," *Die Kunst für Alle* 4, no. 4 (Nov. 1888): 49–54, lead article; Walther Gensel, "Die XIII. Ausstellung der Berliner Secession," ibid. 22, no. 19 (July 1907): 442; and Georg Jacob Wolf, "Zu Adolf Oberländers 70. Geburtstag," ibid. 31, no. 3/4 (Nov. 1915): 57–72.

15. For a sample of cartoons based on popular paintings, see on Sasha Schneider's "Das Gefühl des Abhängigkeit," *Kladderadatsch* 49, no. 18 (May 1896), cover; on Stuck's "Sphinx," ibid., no. 26 (June 1896), and ibid. 52, no. 17 (Apr. 1904), 1st supplement; and on Stuck's "Verlorene Paradies," ibid. 50, no. 29 (July 1897), 1st supplement; and "Böcklin Galerie," *Lustige Blätter* 20, no. 6 (Feb. 1905). The single most parodied work of art was William II's sketch "Völker Europas, wahret Eure heiligsten Güter" (see fig. 73). For parodies of exhibitions and their catalogues, see the following. In *Fliegende Blätter* see "Eine Privat-Kunstausstellung," 88, no. 2236 (1888): 204–7; "Eine Gallerie modernster Meister," 91, no. 2311 (1889): 170–72; and v. Miris, "Münch'ner Jahres-Ausstellungs-Schnadahüpfeln," 95, no. 2406 (1891): 81–82. In *Kladderadatsch* see 50, nos. 22 (May 1897) and 29 (July 1897); 52, no. 24 (June 1899), 1st supplement; and 53, no. 22 (June 1900). In *Simplicissimus* see 1, no. 46 (Feb. 1897), cover; and in *Jugend* see 1, no. 37 (Sept. 1896): 600–602; and 2, no. 27 (July 1897): 463, 494–95, 544, 736–37.

16. In *Fliegende Blätter* see "Die Kohl-Maler," 91, no. 2315 (1889): 205; "Unbewußte Kritik," 97, no. 2455 (1892): 56; H. Schlittgen, "Verkannt," ibid., 2461 (1892): 112; Edwin Heine, "Die verkannte Malercolonie," ibid., no. 2471 (1892): 205; H. Schliepmann, "Die lebende Staffelei, oder: Abenteuer eines Freilichtmalers," 105, no. 2677 (1896): 197–98; A. Hengeler, "Erster Gedanke," 106, no. 2688 (1897): 49; "Unbewußte Kritik," ibid., no. 2694 (1897): 108; "Ländliche Kritik," 107, no. 2719 (1897): 92; and "Metamorphose," ibid., no. 2724 (1897): 147–48. In *Jugend* see R. M. Eichler, "Das ernste Studium: Allerhand Lumperei falle den Stadtleut ein!" 4, no. 66 (Apr. 1899): 255; and Eichler, "Denn alle Schuld rächt sich auf Erden," ibid., no. 24 (June 1899): 383.

17. In *Fliegende Blätter* see "Triumph der Kunst," 81, no. 2040 (1884): 68; "In der Kunstausstellung," 86, no. 2163

(1887): 10; E.K. [Eugen Kirchner], "Sehr glaublich," 91, no. 2305 (1889): 110; Th. Gratz, "Höchster Triumph der Landschaftsmalerei," 92, no. 2344 (1890): 225; "Auch eine Kritik," 97, no. 2470 (1892): 190; "Selbstgefühl," 98, no. 2484 (1893): 88; Oberländer, "In der Kunstausstellung," 103, no. 2610 (1895): 56; Th. Gratz, "Stoßseufzer," 104, no. 2653 (1896): 206; and v. Meissl, "In der Gemäldegalerie," 117, no. 2978 (1902).

18. The historical overview in Wassermann, *"Fliegende Blätter,"* of comic Jewish stereotypes of the newly emancipated and assimilating Jews in German society in the nineteenth century provides a carefully differentiated analysis of the humor. Wasserman insists upon the necessity of understanding the context in which the cartoon was received as a means of avoiding ideologically predetermined interpretations. Further informative comments on the interpretation of images are in Peter Dittmar, *Die Darstellung der Juden in der populären Kunst zur Zeit der Emanzipation* (Munich: K. G. Saur, 1992); and Townsend, *Forbidden Laughter,* 139–45. Extended discussions of popular Jewish stereotypes have been published both by George L. Mosse, in "From Science to Art: The Birth of Stereotypes," in *Toward the Final Solution: A History of European Racism* (New York: Harper Colophon Books, 1978), chap. 2, and "The Image of the Jew in German Popular Literature: Felix Dahn and Gustav Freytag," in *Germans and Jews: The Right, the Left, and the Search for a "Third Force" in Pre-Nazi Germany* (New York: Howard Fertig, 1970), chap. 3; and by Sander Gilman, in *The Jew's Body* (New York: Routledge, 1991).

19. To acquire the title Kommerzienrat a businessman had to be worth 750,000 marks during the years 1865–93 and 1 million marks after 1893 (see Peter Hayes, "German Businessmen and the Crisis of the Empire," in *Imperial Germany: Essays,* ed. Volker Dürr, Kathy Harms, and Peter Hayes [Madison: University of Wisconsin Press, 1985], 51). For a thorough examination of the meaning and process of disseminating honors, see Alastair Thompson, "Honours Uneven: Decorations, the State, and Bourgeois Society in Imperial Germany," *Past and Present,* no. 144 (1994): 171–204.

Karin Kaudelka-Hanisch, "The Titled Businessman: Prussian Commercial Councillors in the Rhineland and Westphalia during the Nineteenth Century," in *The German Bourgeoisie: Essays on the Social History of the German Middle Class from the Late Eighteenth to the Early Twentieth Century,* ed. David Blackbourn and Richard J. Evans (New York: Routledge, 1991), 87–114, points out that the title was a strictly Prussian title granted primarily to Protestants and Catholics. However, for a fascinating study of the rise of the Jewish banker Gerson Bleichröder through the various ranks of honors until he was granted a patent of hereditary nobility by William I and acquired an aristocratic estate from Field Marshal Albrecht von Roon, see Fritz Stern, *Gold and Iron: Bismarck, Bleichröder, and the Building of the German Empire* (New York: Random House, Vintage Books, 1979), chap. 8. Stern provides a sobering account of the anti-Semitic world that surrounded and resisted Bleichröder's accomplishments.

An informative analysis of the process of assimilation of Jews into the German bourgeoisie in the late nineteenth century is Shulamit Volkov, "The *Verbürgerlichung* of the Jews as a Paradigm," in *Bourgeois Society in Nineteenth-Century Europe,* ed. Jürgen Kocka and Allan Mitchell (Oxford: Berg, 1993), 267–91. In her close study of Germany's wealthiest businessmen at this time, Dolores L. Augustine found that approximately 25 percent were Jewish and that the most active supporters of cultural activities were drawn from this group (see Augustine, "Arriving in the Upper Class: The Wealthy Business Elite of Wilhelmine Germany," in Blackbourn and Evans, *German Bourgeoisie,* 46–86; and idem, *Patricians and Parvenus: Wealth and High Society in Wilhelmine Germany* [Oxford: Berg, 1994], 214–19, 35–50).

A valuable review and analysis of recent scholarship on the social assimilation of Jews across both rural and urban Germany is Marion Kaplan, "Friendship on the Margins: Jewish Social Relations in Imperial Germany," *Central European History* 34, no. 4 (2001): 471–501. A useful context for the assimilation of new wealth in the early years of the empire is provided in Jost Hermand, "Der gründerzeitliche Parvenü," in *Aspekte der Gründerzeit* (Berlin: Akademie der Künste, 1974): 7–15. The topic of assimilation inspired a large number of cartoons. In addition to those reproduced here, see the following from *Fliegende Blätter*: "Hochgefühl," 75, no. 1876 (1881): 15; "Appetitreizend," ibid., no. 1881 (1881): 52; H. Schlittgen, "Noble," 86, no. 2174 (1887): 105l; E. Harburger, "Selbstgefühl," 98, no. 2483 (1893): 75; E. Harburger, "Selbstbewußt," 107, no. 2735 (1897): 260.

20. Fritz Stern analyzed the economic difficulties of the aristocracy in the first decades of the empire and the rise of Jewish wealth in "Money, Morals, and the Pillars of Bismarck's Society," *Central European History* 3, no. 1/2 (1970): 49–72. Volker R. Berghahn, *Imperial Germany, 1871–1914: Economy, Society, Culture, and Politics* (Providence, R.I.: Berghahn Books, 1994), 6, writes that five thousand large estates were declared bankrupt between 1885 and 1900. In an important article on luxury in turn-of-the-century Germany, Warren G. Breckman, "Disciplining Consumption: The Debate about Luxury in Wilhelmine Germany, 1890–1914," *Journal of Social History* 24, no. 3 (1991): 484–505, points out that the educated upper classes scorned those whose wealth allowed them to indulge in conspicuous consumption, while their behavior and speech marked them as having risen above their station.

21. By 1906 Wilhelm Bode explicitly complained that art had become a commodity acquired to enhance the social standing of the parvenu ("Vom Luxus," *Der Kunstwart* 19 [1906]: 493–96). For further examples of cartoons of Jews acquiring ancestor portraits, see the following from *Fliegende Blätter*: "In der Ahnengallerie," 81, no. 2038 (1884): 55; "Ein kleiner Kunstkritiker," 91, no. 2294 (1889): 15; E. Harbürger, "Auch ein Kunstfreund," 94, no. 2372 (1891): 13; E. Reinicke, "Begreiflich," ibid., no. 2376 (1891): 48; 96, no. 2447 (1892): 224; "Nach Bedarf," 97, no. 2471 (1892): 204; Th. Grätz, "Anzüglich," 99, no. 2510 (1893): 91; "Ahn und Enkel," 106, no. 2706 (1897): 224; "Im Ahnensaal," ibid., no. 2699 (1897): 149; "Die Raubritter," 115, no. 2930 (1901): 147; and E. Kirchner, "Der kritische Schloßgeist," 117, no. 2980 (1902): 115.

Wassermann, "*Fliegende Blätter*," 129–38, argues that these cartoons were not anti-Semitic since readers, both Gentiles and Jews, distinguished these to be light humor—"köstliche Judenkarikatur"—and not to represent anti-Semitic hatred, as they would have done in an overtly anti-Semitic journal. Wassermann's argument rests on intent, context, and reception. Eduard Fuchs in 1921 also argued that a clear distinction should be maintained between the humor magazines' playful caricatures and those of the anti-Semitic press (Fuchs, *Die Juden in der Karikatur: Ein Beitrag zur Kulturgeschichte* [Munich: Albert Langen Verlag, 1921], 237).

22. An early explicit linking of the philistine and the Jew in caricature was made by Clemens Brentano in his rebuslike drawing made to illustrate his satire "Der Philister vor, in und nach der Geschichte," presented to the Christlich-Deutsche Tischgesellschaft in March 1811. The drawing, presenting a single figure formed from the intertwined bodies of the Jew and the philistine, is reproduced in Dittmar, *Die Darstellung der Juden*, 254, fig. 213.

23. James F. Harris, introduction to *Christian Religion and Anti-Semitism in Modern German History*, special issue of *Central European History* 27, no. 3 (1994): 265–66; Peter G. J. Pulzer, *The Rise of Political Anti-Semitism in Germany and Austria* (New York: John Wiley and Sons, 1964), 219; Lamberti, *Jewish Activism*, 14–17.

24. Gerhard Kratzsch, "*Kunstwart*" und *Dürerbund: Ein Beitrag zur Geschichte der Gebildeten im Zeitalter des Imperialismus* (Göttingen, Germany: Vandenhoeck & Ruprecht, 1969), 121–22, points out that Avenarius, who did not want anti-Semitic articles in the journal, relieved his principal literary critic, Adolf Bartels, of his position in 1902 over the issue of Bartels's increasingly outspoken anti-Semitism. In his years with *Der Kunstwart* Bartels followed a not uncommon political path from being a liberal democrat to becoming a follower of Friedrich Naumann's socialist nationalism and finally a radical anti-Semite. H. E. v. Berlepsch, "Münchener Brief," *Der Kunstwart* 8, no. 19 (July 1895): 298–300, provided a full quotation from the newspaper. Although considerable attention has been given to Jewish patronage of art in Germany at this time, no study has been made of newspapers to trace the possible sources for the public perception of the role of Jews in the promotion of contemporary art before 1900. For a useful analysis of the issues and problems surrounding such an inquiry, see Peter Paret, "Bemerkungen zu dem Thema: Jüdische Kunstsammler, Stifter, und Kunsthändler," in *Sammler, Stifter, und Museen: Kunstförderung in Deutschland im 19. und 20. Jahrhundert*, ed. Ekkehard Mai and Peter Paret (Cologne: Böhlau Verlag, 1993), 173–85. See also the essays in Emily D. Bilski, ed. *Berlin Metropolis: Jews and the New Culture, 1890–1918*, exh. cat. (Berkeley: University of California Press, 1999).

25. Cornelius Gurlitt, "Die VI. Internationale Kunstausstellung zu München 1892," *Die Kunst unserer Zeit* 3, 1st half-vol. (1892): 97–111, quotation on p. 97.

26. Cornelius Gurlitt, "Die Münchener Ausstellung, II. Die Secession," ibid. 4, 2nd half-vol. (1893): 101–18.

27. For just one example of the thinking of those who clung to the past, see Herbert Hirth, "Die Resultate der Münchener Sezessionsausstellung," *Kunstchronik*, n.s. 5 (Nov. 1893): cols. 98–99.

28. Dr. Relling [Springer], "Die Ausstellung der 'XI,'" *Die Kunst für Alle* 8, no. 14 (Apr. 1893): 217–18. In his review the following year, Springer again criticized the tendency of Berlin's officialdom to politicize art by finding modern art to be subversive (idem, "Die Ausstellung der 'XI,'" ibid. 9, no. 13 [Apr. 1894]: 199–202).

29. Adolf Rosenberg, "Die Ausstellung der 'Vereinigung der Elf' in Berlin," *Kunstchronik*, n.s. 4 (Mar. 1893): col. 287; -nn, "Düsseldorf," ibid. (Aug. 1893): cols. 332–33; Albert Dresdner, "Ludwig von Hofmann," *Der Kunstwart* 6, no. 14 (Apr. 1893): 218. In his pamphlet written after the two controversial shows in Berlin, Franquet pointed out that the laughter over Hofmann had begun the previous spring, at Schulte's first showing of the Eleven. At the same time, Stuck had a show of his recent works in several adjacent rooms at Schulte's. Franquet was incredulous over the offensive treatment Stuck's work received from the "cultivated classes" of people who frequented the art dealer's gallery (see Franquet, *Schaupöbel*, 6–8, 16–18).

30. Paul Schultze-Naumburg, "Ludwig von Hofmann," *Die Kunst für Alle* 14, no. 14 (Apr. 1899): 213. Other reports that summer included Alfred Freihofer, "Die Münchener Kunstausstellungen, II," *Der Kunstwart* 6, no. 24

(Sept. 1893): 378, and Albert Dresdner, "Die Berliner Kunstausstellung, IV," ibid., 378–79.

31. Elizabeth Pendleton Streicher, "'Zwischen Klingers Ruhm und seiner Leistung': Max Klingers Kunst im Spiegel der Kritik, 1877–1920," in *Max Klinger: Zeichnungen, Zustandsdrucke, Zyklen,* ed. Jo-Anne Birnie Danzker and Tilman Falk, exh. cat. (Munich: Prestel Verlag, 1996), 50, points out that 1893–94 marked the high point of Klinger's career, with comprehensive exhibitions in Dresden and in the Leipzig Art Society, as well as gallery exhibitions in Berlin at Gurlitt's and at Amsler & Ruthardt. For an evaluation of the work of Hofmann, Stuck, and Klinger in Berlin, see Albert Dresdner, "Die Berliner Kunstausstellung, III," *Der Kunstwart* 6, no. 22 (Aug. 1893): 346–47.

Dr. Relling [Springer], "Die Berliner Kunstausstellung," *Die Kunst für Alle* 8, nos. 19–20 (July 1893): 290, 306, reported that a ticket attached to the *Pietà* in the Munich Secession exhibition in Berlin announced that the Dresden Painting Gallery had purchased it; a later brief report confirmed this (∗, "Dresden," ibid. 9, no. 2 [15 Oct. 1893]: 29). *Grosse Berliner Kunst-Ausstellung 1893, 14 Mai bis 17 September im Landes-Ausstellungsgebäude am Lehrter Bahnhof: Illustrirter Katalog,* exh. cat. (Berlin: Verlag von Rud. Schuster, 1893), provides a list of all the works exhibited and photographs of many of the paintings.

A review of Stuck's painting in Munich is Alfred Freihofer, "Die Münchner Kunstausstellung," *Der Kunstwart* 7, no. 4 (Nov. 1893): 57. Stuck's painting was purchased by a private patron for 4,000 marks during the Munich Secession exhibition and was then sold to the Bavarian state for the Neue Pinakothek. Maria Makela recounts the convoluted proceedings of the purchase, which she thinks were designed to enable the state to obtain the work without endorsing the separate exhibition of the Secession (*Munich Secession,* 174 n. 53). Writing in 1894 about the effect of the events of 1893 on Franz Stuck's career, Anna Spier characterized it as the "summer of triumph," when fame "settled in full bloom over Stuck's head" (A. Spier, "Franz Stuck," *Westermann's Illustrierte Deutsche Monatshefte* 38, half-vol. 76 [Aug. 1894]: 561). For an evocative account of the excitement of seeing *The Sin* at the Munich Secession exhibition in 1893, see Hans Carossa's memoirs, quoted in Heinrich Voss, *Franz von Stuck, 1863–1928: Werkkatalog der Gemälde mit einer Einführung in seinen Symbolismus* (Munich: Prestel Verlag, 1973), 268–69.

32. For a report on the photographs of French paintings at the Ernst Arnold Salon, see = =, "Dresden," *Die Kunst für Alle* 5, no. 17 (June 1890): 271. On the Lichtenberg exhibitions, see H. A. Lier, "Korrespondenz. Dresden," *Kunstchronik,* n.s. 4 (Nov. 1892): cols. 67–68, and ibid. (11 May 1893): cols. 385–87. See also the report in *Die Kunst*

für Alle 8, no. 8 (Jan. 1893): 122. Illness forced Lichtenberg to turn over the Dresden branch to his partner, Ferdinand Morawe, in June 1893, and the name was altered to "Theodore Lichtenberg, Nachfolger (Ferdinand Morawe)" (see the announcements in *Das Atelier* 3, nos. 51 [Dec. 1892]: 6 and 63 [June 1893]: 16).

33. H[ermann] A[rthur] Lier, "Korrespondenz. Dresden, November 1893," *Kunstchronik,* n.s. 5 (Dec. 1893): cols. 120–27. Lier's praise for the Dresden museum leaders was occasioned by a recent "reactionary declaration" from Jordan, the director of the National Gallery in Berlin. Avenarius reported on the same speech, calling Jordan "an eager warrior against the new art." In his talk Jordan had referred to the new artists as "prophets of ugliness, of the trivial and non-essential" (see "Künstgelehrte über moderne Kunst," *Der Kunstwart* 7, no. 3 [Nov. 1893]: 41). Avenarius also positively reviewed the exhibitions at the Lichtenberg Art Salon (ibid. 7, nos. 5 [Dec. 1893]:74 and 10 [Feb. 1894]: 152–53), and the art salon was also positively reviewed in ∗, "Dresden," *Die Kunst für Alle* 9, no. 12 (Mar. 1894): 187. *Das Atelier* 3, no. 74 (Nov. 1893): 11, noted the Klinger exhibition; and Gerhart Romint, "Max Klinger-Ausstellung in Lichtenberg's Kunstsalon zu Dresden," ibid., no. 76 (Dec. 1893): 5–6, provided a careful formal analysis of the paintings, especially the *Kreuzigung,* with no mention of anything scandalous.

On Gutbier's exhibitions at the Ernst Arnold Art Salon, see Lier, "Korrespondenz. Dresden, November 1893," *Kunstchronik,* n.s. 5 (Dec. 1893): cols. 126–27; "Dresden," *Die Kunst für Alle,* 9, no. 11 (Mar. 1894): 171; *Das Atelier* 3, no. 74 (Nov. 1893), 10; and Gerhart Romint, "Die Ausstellung der Münchner Sezessionisten in Dresden, I–II," ibid., nos. 75–76 (Dec. 1893): 3–4, 4–5. A report on a secession of artists in Dresden appeared in *Kunstchronik,* n.s. 4 (Aug. 1893): cols. 534–35. The official incorporation of the new group took place a year later ("Dresden," *Die Kunst für Alle* 9, no. 17 [June 1894]: 270).

34. Reporting on the events in Dresden was H. A. Lier, "Korrespondenz. Aus Dresden, February 1894," *Kunstchronik,* n.s. 5 (Feb. 1894): col. 249–52. The quotation is from Franquet, *Schaupöbel,* 27.

35. Hans W. Singer, "Max Klinger's Gemälde," *Zeitschrift für bildende Kunst* 29, n.s. 5 (1893–94): 49. Writing several years later, Lichtwark credited Paul Schumann's promotion of modern artists in the *Dresdner Anzeiger* and the enlightened support from officials within the state cultural bureaucracy, Woermann, Lehrs, Treu, and Gurlitt, for the progressive turn in Dresden's art policies (Lichtwark, "Aus Dresden," *Pan* 2, no. 2 [Aug. 1896]: 134–37).

36. The new paper, the *Dresdner Rundschau,* was dedicated to exposing local problems through candid criticism

and merciless satire that, according to Lier in *Kunst-chronik*, often verged on libel. Objects of Ehrenberg's wrath were Schumann, the feuilleton editor of the *Dresdner Anzeiger*, a national liberal paper, and Kirchbach, critic for both the *Anzeiger* and the *Dresdner Neueste Nachrichten*. Schumann was an active critic who wrote for many newspapers, magazines, and journals, including the *Der Kunstwart*, *Die Kunst für Alle*, and the *Zeitschrift für bildende Kunst*; Kirchbach was an old friend of Avenarius's (see Kratsch, *Kunstwart und Dürerbund*, 110, 129). [Carl Ehrenberg], *Die neue Kunst und der Schaupöbel: Von einem Mitgliede des Schaupöbels* (Dresden: Kunst-druckerei Union, 1894). In his full account of these events surrounding the publication of the pamphlet, Lier identi-fied Ehrenberg as the author in "Korrespondenz. Aus Dresden, Februar 1894," cols. 251–52.

37. For further reports on the furor created by the pamphlet, see [Avenarius], "Kunst-Literatur, 12," *Der Kunstwart* 7, no. 11 (Mar. 1894): 168; [Hans Rosenhagen], "Bücherschau," *Das Atelier* 4, no. 3 (Feb. 1894): 12–13; and W[oldemar] von Seidlitz, "Dresdens Junge Kuenstlerschaft," *Pan* 2, no. 2 (Aug. 1896): 140. Lier reported on the events in the par-liament in "Korrespondenz. Aus Dresden, Februar 1894," *Kunstchronik*, n.s. 5 (Feb. 1894): col. 253.

38. H. A. Lier, "Aus Dresden, Juni 1894," *Kunstchronik*, n.s. 5 (June 1894): cols. 463–65, 478–82. Reviewing paint-ings by Erik Werenskiold, Eilif Petersen, Otto Sinding, Chris-tian Skredsvig, Frederick Collet, Edvard Dirik, Jörgen Sörensen, and Gustav Wenttzel, Lier concluded that the en-tire exhibition was highly satisfactory, rivaling in importance the showing of the Norwegians in the Third Munich Annual, of 1891. See reports of the 1899 Impressionist ex-hibition in *Die Kunst für Alle* 14, no. 16 (May 1899): 252; *Kunstchronik*, n.s. 10 (Mar. 1899): col. 313; and *Der Kunstwart* 12, no. 14 (Apr. 1899): 65.

39. Dr. Gustav Fritsch, *Unsere Körperform im Lichte der modernen Kunst* (Berlin: Carl Habel, 1893); [Avenarius], "Kunst-Literatur, 12," *Der Kunstwart* 7, no. 11 (Mar. 1894): 168; H. A. Lier, "Zum Streit über die Moderne Kunst," *Kunstchronik*, n.s. 5 (May 1894): cols. 377–82; *Die Kunst für Alle* 9, no. 11 (Mar. 1894): 175. Among the paintings that particularly incensed Fritsch was Stuck's *Toter Orpheus* (1891), in which blood gushed from a neatly decapitated body lying in a meadow, clutching a lyre.

40. August von Heyden, *Aus eigenem Rechte der Kunst: Ein Wort zur Abwehr* (Berlin: F. Fontane & Co., 1894). Hey-den wrote his response two days after Fritsch's lecture. Hans Rosenhagen stated in "Bücherschau," *Das Atelier* 4, no. 4 (Feb. 1894): 12–14, that the only good aspect of Fritsch's unwarranted attack was that it elicited Heyden's

calm and measured response. The German title of Fritsch's pamphlet was *Ne sutor supra crepidam! Er-widerungen an einige meiner besondern Gönner unter der Kunstkritik, Antwort auf Herrn von Heydens offenen Brief, betitelt: "Aus eigenem Rechte der Kunst," nebst zustimmenden Urtheilen der Tagespresse und Meinungs-äußerungen namhafter Naturkenner über meine Schrift "Unsere Körperformen im Lichte der Modernen Kunst"* (Berlin: Carl Habel, 1894). Disparaging reviews of Fritsch's books were published by Avenarius, "Kunst-Literatur," *Der Kunstwart* 7, nos. 11–12 (Mar. 1894): 168, 185–86; and [Rosenhagen], "Bücherschau," *Das Atelier* 4, no. 6 (Mar. 1894): 12.

Information about the strife was reported by Lier, "Zum Streit über die Moderne Kunst," *Kunstchronik*, n.s. 5 (May 1894): cols. 377–82, who rejected Fritsch's crude and uninformed attack and applauded Heyden's rea-soned defense of the modern artists. Citing the demean-ing words that Fritsch used to describe contemporary art—"schmutziger Phantasie," "exzentrischer Laune," "Fleckfieber," "epidemischer Krankheit," "abscheuliche Vortragsweise," "Drecks," "abstoßenden"—Avenarius told his readers that the intemperate language made rational discussion impossible. Avenarius's later attack on the "educated rabble" was made in "Die Kunst im Reich-stage," *Der Kunstwart* 12, no. 12 (Mar. 1899): 395: "den Hochmut des deutschen Bildungspöbels gegenüber der lebendigen Kunst."

41. Hans Schliepmann, "Kunstkenner und Kennerkunst," *Der Kunstwart* 5, no. 4 (Nov. 1891): 58–60. The German statement is more effective than the English because of its play on the word *kennen*.

42. Dr. Relling [Springer], "Die Ausstellung der 'XI,'" *Die Kunst für Alle* 9, no. 13 (Apr. 1894): 199. The comman-dant's order about his officers' visiting the Berlin Secession exhibition in 1899 is reported by Peter Paret, *The Berlin Se-cession: Modernism and Its Enemies in Imperial Germany* (Cambridge: Harvard University Press, 1980), 82. These negative words applied by the public to modern art were cited in a brief introduction to an article on Karl Woer-mann's book *Was uns die Kunstgeschichte lehrt: Einige Be-merkungen über alte, neue, und neueste Malerei* (Dresden: Verlag von L. Ehlermann, 1894) in *Der Kunst-wart* 7, no. 14 (Apr. 1894): 209. Lier in his report on Fritsch's book in *Kunstchronik*, n.s. 5 (May 1894), had contrasted it negatively to Woermann's book, which he praised as a genuine authoritative approach to modern art written by a recognized expert. He thought that Woer-mann's reasonable and serious approach to modern art was "a highly welcome weapon in the contemporary bat-tle" in that it provided principles for judging the perfor-mance of contemporary artists.

43. Ostensibly, all of the critics at this time were men. Only in the last years of the century did women emerge from behind the camouflage of initials, for example, in A[nna] L. Plehn and H.M. [Henriette Mendelsohn].

44. For this image of the "great divide" I am indebted to two scholars whose books I read early in the process of thinking about this project. Those who are familiar with the late Thomas Nipperdey's concise exploration of the appropriation of the arts by the bourgeoisie in the nineteenth century, *Wie das Bürgertum die Moderne fand* (Berlin: Siedler, 1988), will recognize his influence upon my own conceptualization of this period. As I read through the pages of the German art journals of the 1880s and 1890s, Nipperdey's "precipitous opposition" (p. 46) between artist and philistine blended into the evocative image of the "great divide," Andreas Huyssen's metaphor from *After the Great Divide: Modernism, Mass Culture, Postmodernism* (Bloomington: Indiana University Press, 1986). My interpretation of the great divide differs in emphasis and method from Huyssen's: his lies between high art and popular culture; mine divides the artist from the public and is based on the frequency with which the verbal images of chasm, abyss, cleft, gulf, and rift appeared in the critical writing in journals in the 1890s. That very language is a reminder of how old and how modern the perception of the great divide between the artist and the philistine is.

The underlying reality of that cleft between the majority of the educated art public and the modernists is not difficult to find in scholarly studies, as in a brief statement by Wolfgang Hardtwig, "Drei Berliner Porträts: Wilhelm von Bode, Eduard Arnhold, Harry Graf Kessler. Museumsmann, Mäzen, und Kunstvermittler—drei herausragende Beispiele," in *Mäzenatentum in Berlin: Bürgersinn und kulturelle Kompetenz unter sich verändernden Bedingungen*, ed. Günter Braun and Waltraut Braun (Berlin: Walter de Gruyter, 1993), 51–53. The issue is not the newness of the idea but how one approaches it and what one makes of it. I have chosen to make it the central axis upon which my interpretation of these two decades in the German world of art rests.

45. Herman Helferich [Emil Heilbut], "Künstler und Kunstkritiker," *Die Kunst für Alle* 6, nos. 11–12 (Mar. 1891): 164–69, 180–82, quotations on 166 (his italics), 182.

46. The article was reprinted from the *Post* in Fritsch, *Ne supor supra crepidam!* 25–26.

47. Originally published as "Nachwort zur Münchener Jahresausstellung" in *Kölnische Zeitung* (262), the article was reprinted in two parts by Perfall, under the title "Über die modernste Kunstkritik," in *Der Kunstwart* 4, nos. 5 (Nov. 1890): 73–74 and 7 (Jan. 1891): 107–8.

48. Ibid., long quotation on 74.

49. The earlier article from the *Kölnische Zeitung* was Perfall, "Ebbestand der Berliner Kunst," *Der Kunstwart* 4, no. 1 (Sept. 1890): 11–13. Perfall then repeated much of the same argument in an article reprinted in *Der Kunstwart* in 1893. Other reviewers concurring in the negative view of the Berlin public at this time were Hermann Bahr, "Die Kunst und die Kritik," ibid. 6, no. 10 (Feb. 1893): 153–54; Cornelius Gurlitt, "Berlin als Kunstheimat," ibid 5, no. 20 (July 1892): 311–12 and 6, no. 3 (Nov. 1892): 44, a speech given at the Freie Literarische Gesellschaft in Berlin and reported in the *Tägliche Rundschau* (Berlin) and in *Magazin*; and Albert Dresdner, "Berliner Kunstausstellung 3," *Der Kunstwart* 7, no. 19 (July 1894): 298–99, who excused the Berlin public because they were the victims of negative official art policies and statements.

50. See Pecht's discussion of the "complete revolution" that had taken place in the art world in the decade since 1885 and the difficulty critics faced in trying to find the right guidelines for judging the new and exasperating art: "Zum Beginn des zehnten Jahrgangs," *Die Kunst für Alle* 10, no. 2 (Oct. 1894): 1. Compare this with his much more confident statement only three years earlier, in which he had called on critics to uphold standards against the temptation to approve questionable art and, in so doing, confuse the public, "Über die Beurteilung von Bildern," ibid. 6, no. 10 (Feb. 1891): 152–55. The question what criteria could guide critics coping with the new art continued to be raised (see Paul Johannes Rée, "Was ist Kunst?" ibid. 10, no. 16 [May 1895]: 242–43; Paul Schultze-Naumburg, "Die Ausstellung der Secession in München," *Zeitschrift für bildende Kunst* 32, n.s. 8 [1896–97]: 49–50; and Max Schmid, "Alte und neue Kunstkritik," *Die Kunst für Alle* 13, no. 1 [Oct. 1897]: 10–12).

Peter Wallé, "Kunst und Kritik," *Das Atelier* 1, no. 3 (Dec. 1890): 2–3, had argued earlier that the problem for newspaper art critics was not that they did not appreciate modern art but that they had neither the time nor the training to appreciate art at all. Agreeing with this condemnation of critics was an article by an English writer, John Greenock, who charged that German critics were incompetent, published as "Münchner Landschaftsmalerei und deutsche Kunstkritik," *Der Kunstwart* 7, no. 17 (June 1894): 265–68. For the parable of the critic's dilemma, see Wilhelm Herbert, "Kritikers Traum," *Die Kunst für Alle* 10, no. 1 (Oct. 1894): 13–14. See also H. E. von Berlepsch, "Münchener Ausstellungs-Gänge," *Die Kunst unserer Zeit* 2, 2nd half-vol. (1891): 19–22, in which he begins his review of the Third Annual Munich Exhibition with a lengthy description of a nightmare.

51. Wolfgang von Oettingen, "Altes und Neues aus Düsseldorf," *Die Kunst für Alle* 11, 1 no. 3 (Apr. 1896): 201,

and Albert Dresdner, "Aus Berlin," *Der Kunstwart* 8, no. 9 (Feb. 1895): 138–39, both were critical of provocative young artists. See also E. v. Keyserling, "Das Laienurteil," *Die Kunst für Alle* 12, no. 6 (Dec. 1896): 71–72. A response to this article published four years later agreed in principle with Keyserling; however, it argued that the public had the responsibility to become better informed about what artists were trying to do: E. Henrici, "Das Laienurteil," ibid. 15, no. 22 (Aug. 1900): 520–23.

52. Paul Schultze-Naumburg, "Münchener Bericht 1," *Der Kunstwart* 9, no. 14 (Apr. 1896): 217–18. A similar report had appeared the previous year: T——r, München, "Allerlei von der Kunst," *Die Kunst für Alle* 10, no. 14 (Apr. 1895): 214–17.

53. Schultze-Naumburg, "Die Ausstellung der Secession in München," *Zeitschrift für bildende Kunst* 32, n.s. 8 (1896–97): 49. He reviewed the same exhibition for *Die Kunst für Alle* 11, nos. 19–20 (July 1896): 289–93, 305–9. The considerable difference between the approaches in the two journals is well illustrated in his two articles cited here.

Schultze-Naumburg published articles and reviews in the *Zeitschrift für bildende Kunst*, *Pan*, *Jugend*, *Die Kunst für Alle*, beginning in 1892, and above all in *Der Kunstwart*, where he moved rapidly from writing articles and reviews beginning in 1895 to become the fine arts editor. He ran an art school in Munich with his artist wife, Ernestine, taught at the Ducal Art Academy in Weimar, was the artistic director of a prosperous interior-decorating workshop, and in 1907 became one of the founders of the German Werkbund, an organization that promoted higher standards of quality in industrial design. As both an artist and critic, he was noted in the 1890s as an established young modernist and disciple of Nietzsche. In the decade before World War I he became increasingly conservative, and later, in the 1930s, he became rabidly nationalist and racist.

54. Schultze-Naumburg, "Deutsche Kunstkritiker," *Die Kunst für Alle* 10, nos. 11–12 (Mar. 1895): 161–66, 177–79. An example of material excerpted from a simultaneously published book is his "Ideen über den Studiengang des modernen Malers," *Zeitschrift für bildende Kunst* 31, n.s. 7 (1895–96): 27–40. In his introduction Schultze-Naumburg stated that the book of the same title was intended for those who wanted to learn more about art and move away from the heavy ballast of uninformed stereotypes and clichés taught in school. Referring to the small number of cultivated people who knew anything about modern art, he blamed the educators, from small-town schoolteachers to pseudomasters in art academies, with laying obstacles in the path of any forward-looking movements. See also Wolfgang von Oettingen, "Der Moderne Maler," ibid. 32, n.s. 8 (1896–97): 125–26. Oettingen's

review was published two issues after the preceding article by Schultze-Naumburg. For further comments on the deepening divide between artists and the public, see idem, "Altes und Neues aus Düsseldorf," *Die Kunst für Alle* 11, no. 13 (Apr. 1896): 201, 204.

55. The comment about German newspaper reading is from Thomas Nipperdey, "Die Presse," in *Deutsche Geschichte*, 797. For basic information on the major German newspapers, see Heinz-Dietrich Fischer, ed., *Deutsche Zeitungen des 17. bis 20. Jahrhunderts* (Pullach bei München, Germany: Verlag Dokumentation, 1972). From a historical point of view, these newspaper sources could provide valuable insights into the public reception and understanding of contemporary and modern art—into, in other words, factors that were influential in the formation of the schaupöbel. The task of uncovering and analyzing those possible sources, however, is daunting, and the research has yet to be undertaken in a systematic fashion. Considerable attention, however, has been given by literary and social historians to the national family magazines, such as *Gartenlaube*, and the various illustrated newspapers, though generally not by art historians. In the absence of evidence directly from the daily press, the art journals' response to the views expressed in the popular press will have to suffice in this study, despite their obvious biases.

56. Friedrich Fuchs, "Kunstkritik in der Tagespresse und im Allgemeinen," *Das Atelier* 2, no. 39 (June 1892): 1–2. Oskar Bie "Berliner Brief: Die Zeitungen," *Der Kunstwart* 9, no. 4 (Nov. 1895): 58, used the phrase, "zeichnende Malerei," referring to the drawing style of the Nazarenes, particularly Peter Cornelius, which had been much admired in the mid-century Germany of Pietsch's youth. See also idem, "Tageskritik über bildende Kunst," ibid., no. 15 (May 1896): 227.

57. An art historian, Bie was editor from 1895 to 1922 of the *Neue Deutsche Rundschau*, published by S. Fischer. For information on Bie and the journal, see Karl Ulrich Syndram, "Die kontinuierliche Publikation der Moderne. Die *Neue Rundschau (Freie Bühne)* und der Verlag S. Fischer," in *Kulturpublizistik und nationales Selbstverständnis: Untersuchungen zur Kunst- und Kulturpolitik in den Rundschauzeitschriften des Deutschen Kaiserreiches (1871–1914)* (Berlin: Gebr. Mann Verlag, 1989), 98–126. The journal counted among its contributors many of the best-known writers and critics of the period, including Richard Dehmel, Gerhard Hauptmann, Arthur Schnitzler, Hugo von Hofmannsthal, Thomas Mann, Richard Muther, Julius Meier-Graefe, Heinrich Wölfflin, and Alfred Kerr.

58. Leonh. Lier, "Kritisches über Tageskritik," *Der Kunstwart* 9, no. 8 (Jan. 1896): 114–15; Alfred Freihofer, "Die

Münchner Kunstausstellungen, 3," ibid 7, no. 1 (Oct. 1893): 12. See also Karl Erdmann, "Kennen und Können," ibid. 8, no. 1 (Oct. 1894): 1.

59. Adolph Horwicz, "Was ist Kunst?" ibid. 1, no. 9 (2 Feb. 1888): 105–8; v.S., "Moderne Bilder in unseren Familienblättern," ibid. 4, no. 13 (Apr. 1891): 210; Paul Schultze-Naumburg, "Die Bedeutung der illustrierten Zeitschriften für die Kunst," *Die Kunst für Alle* 8, no. 7 (Jan. 1893): 97–101; H. E. v. Berlepsch, "Münchener Brief," *Der Kunstwart* 8, no. 23 (Sept. 1895): 359; *Kunstchronik*, n.s. 9 (Oct. 1897): cols. 41–42. See also comments on the family magazines by Paul Schumann in his review of Wilhelm Trübner's book, "Die Verwirrung der Kunstbegriffe," *Der Kunstwart* 12, no. 2 (Oct. 1898): 52–53.

60. See an early call for using mass reproduction of prints and paintings to raise the taste of the public in Nautilus, "Neue Radierungen," *Kunstchronik*, n.s. 2 (Nov. 1890): cols. 97–101. The article on art in shop windows is by ch, "Schaufenster-Ausstellungen," *Das Atelier* 4, no. 24 (Dec. 1894): 1–2, reprinted in part in *Der Kunstwart* 8, no. 10 (Feb. 1895): 158.

61. For a succinct, matter-of-fact reference to this rift five years later, see Bernhard Kayser's "Die Frühjahr-Ausstellung der Münchener Secession," *Die Kunst für Alle* 18, no. 14 (Apr. 1903): 324. See also the heightened rhetoric against the public at the turn of the century by an early supporter of the modernists, Fritz von Ostini, in *Uhde* (Bielefeld, Germany: Verlag von Velhagen & Klasing, 1902), 5.

62. The list was published in *Die Kunst für Alle* 13, no. 21 (Aug. 1898): 333–34. This list of comments is reminiscent of the small booklet published by Otto von Leixner, *Anleitung in 60 Minuten Kunstkenner zu werden*, ostensibly designed to give uncertain visitors to exhibitions advice on what to say; in actuality, the book carried a sarcastic, negative message about the new art.

63. G.Gr. [Georg Gronau], "Kunst und Publikum," *Die Kunst für Alle* 14, no. 15 (May 1899): 232–35.

64. Ibid.; the quotations are Gronau's paraphrases of Tschudi's talk from his report in *Die Kunst für Alle*.

65. Reporting on the Berlin gossip was R.M. [Richard Mortimer], "Berlin," ibid., no. 20 (July 1899): 315–16. For further details about the circumstances of Tschudi's talk, see Barbara Paul, *Hugo von Tschudi und die moderne französische Kunst im Deutschen Kaiserreich* (Mainz: Verlag Philipp von Zabern, 1993), 106–9. Peter Paret has carefully analyzed Tschudi's contentious relationship with William II in "The Tschudi Affair," *Journal of Modern History*

53 (Dec. 1981): 589–618. See also Nicolaas Teeuwisse, *Vom Salon zur Secession: Berliner Kunstleben zwischen Tradition und Aufbruch zur Moderne, 1871–1900* (Berlin: Deutscher Verlag für Kunstwissenschaft, 1986), 197–220.

66. Ludwig Leiss, *Kunst im Konflikt: Kunst und Künstler im Widerstreit mit der "Obrigkeit"* (Berlin: Walter de Gruyter, 1971), 555 n. 32, briefly cites the emperor's ban on viewing Klinger's paintings. Paret, *Berlin Secession*, 20–28, and Teeuwisse, *Vom Salon zur Secession*, 155–61, pay considerable attention to William's ideas and actions. For an extended discussion of Werner's and William II's views on art, see Ekkehard Mai, "Die Berliner Kunstakademie im 19. Jahrhundert: Kunstpolitik und Kunstpraxis," in *Kunstverwaltung, Bau- und Denkmal-Politik im Kaiserreich*, ed. Ekkehard Mai and Stephan Waetzoldt (Berlin: Gebr. Mann Verlag, 1981), 458–69.

Reproductions of William II's art were published in the following volumes of *Moderne Kunst*: in 1896, "Kampf der Panzerschiffe. Nach einer Tuschzeichnung Seiner Majestät des Kaisers und Königs Wilhelm II" (double-page spread); in 1897, Alfred Holzbock, "Die Kaiser-Festspiele in Wiesbaden" (article including reproductions of William's theater sets), and "Niemand zu Liebe, Niemand zu Leide" (article on his drawings); in 1898, "Die historischen Denkmäler in der Siegesallee zu Berlin" (article with photographs of different sculptural groups). The accounts of the emperor's conversation in Rome were published in *.*., "Kaiser Wilhelm II über moderne und alte Kunst," *Kunstchronik*, n.s. 4 (May 1893): cols. 394–96; and in D.R. [Hans Rosenhagen], "Zur Lage," *Das Atelier* 3, no. 61 (May 1893): 7.

67. Among the many articles relating to the emperor, the following are noteworthy: Dr. Relling [Springer], *Die Kunst für Alle* 8, no. 19 (July 1893): 289–92, dismissing the paintings of the emperor's favorite artists as "horrors" and "gruel"; ibid. 11, no. 17 (June 1896), with the emperor's address for the two-hundredth anniversary of the Academy of Arts in Berlin buried without any comment in the notes section; ibid., no. 23 (Sept. 1896): 364, for a cool note on his recent drawing. Pecht's review of William II's sketches is in ibid. 12, no. 7 (Jan. 1897): 107, 111, with illustrations of both engravings. Detailed information was available at the time about Knackfuß's long friendship with the emperor in ibid. 13, no. 23 (Sept. 1899), and in "Niemand zu Liebe, Niemand zu Leide," *Moderne Kunst* (1896). See also Christa Stolz, *Hermann Knackfuß* (Wissen, Germany: Verlag G. Nising, 1975).

And finally, among the many caricatures based on William II's drawings are "Der Feind aus dem Osten naht, rüstet euch zum Losschlagen! Völker Europas, verkauft eure theuersten Güter," *Kladderadatsch* 49, no. 27 (July 1896); "Ein Erinnerungsblatt: Der deutsche Michael im Jahre 1890," ibid., no. 45 (Nov. 1896); "Die russische

Eisenbahn durch die Mandchurei," ibid. 50, no. 1 (Jan. 1897); "Der kritische Moment," ibid. 57, no. 35 (Aug. 1904); "Welche Wendung! Die Völker Asiens haben ihre heiligsten Güter gewahrt und—erhalten dafür den Orden 'pour le mérite,'" *Lustige Blätter* 20, no. 4 (1905); Knak-fu-tse, "Völker Asiens ———," ibid. 23, no. 46 (1908); Scholz, "Völker Europas, wahret Eure heiligsten Güter! Der Krieg vertreibt Kunst und Gewerbe," *Simplicissimus* 1, no. 28 (Oct. 1896): 4–5, a double-page drawing showing the devastation of war; and "Völker Europas, wahret Eure heiligsten Güter," a poster calling for volunteers and money to fight the Bolsheviks in Russia in the immediate postwar months.

68. An early article published by Avenarius on the emperor was by C. Mario, "Was erwartet die deutsche Kunst von Kaiser Wilhelm II?" *Der Kunstwart* 2, no. 9 (Feb. 1889): 131–32; this review of an anonymous brochure published in Leipzig by W. Friedrich brought a series of responses from readers in ibid., no. 12 (Mar. 1889). Among articles critical of Wilhelmine monuments, see ibid. 4, no. 1 (Sept. 1890): 13; Paul Roland, "Die Kunst auf den öffentlichen Plätzen Berlins," ibid., no. 10 (Feb. 1891): 156; "Unsere Künste," ibid. 6, no. 2 (Oct. 1892): 18; and "Der Fall Begas," ibid., no. 9 (Feb. 1893): 129–31. For Avenarius's comments on William II's views in Rome about art, see "Die Äusserungen des Kaisers über Berliner Kunstverhält-nisse," ibid., no. 17 (June 1893): 269. The attack upon the barbarian taste of William II was by Friedrich Freiherr von Khaynach, *Anton von Werner und die Berliner Hof-malerei* (Zürich: Verlags-Magazin, 1893), 8, 21–22, 24. Avenarius's review of the book appeared in "Kunst-Literatur, 12," *Der Kunstwart* 7, no. 11 (Mar. 1894): 168. An aristocrat with socialist leanings, Khaynach also directed his pungent derision against the Jewish financiers and stock-market parvenus, whose money, he insisted, controlled the art scene in tandem with the court policies.

69. For Avenarius's criticism of Wilhelm II, see the following, "Staatliche und Hofkunst," ibid. 8, no. 6 (Dec. 1894): 81–83 (lead article); "Eine künstlerische Mahnruf des Kaisers," ibid. 9, no. 5 (Dec. 1895): 72; "Die Standbilder für die Berliner Siegesallee," ibid., no. 12 (Mar. 1896): 188–89; "Pax: Nach einem Entwurfe Seiner Majestät des Deutschen Kaisers von H. Knackfuß," ibid. 10, no. 2 (Oct. 1896): 30; and A[venarius], "Hofkunst und andere Kunst," ibid. 15, no. 3 (Nov. 1901): 85–90. In another article, "Zur Rede des Kaisers," ibid, no. 8 (Jan. 1902): 361–65, Avenarius attacked the emperor's favored project, the creation of an avenue of Hohenzollern ancestors in the Tiergarten, referring to "diese Siegesallee, die zumal im Auslande fast nur als Witzblattvorwurf beachtet wird."

70. For an analysis and translation of the crucial sections of William's Siegesallee speech, see Paret, *Berlin Seces-*

sion, 25–28. In her study of William II's use of the rhetoric of Protestant sermons, Gisela Brude-Firnau concludes that the emperor expressed ideas and thoughts that were commonly accepted by the people ("Preussische Predigt: Die Reden Wilhelms II," in Chapple and Schulte, *Turn of the Century*, 166).

71. Friedrich Nietzsche, *Also sprach Zarathustra: Ein Buch für Alle und Keinen* (1883–85), vol. 13 of Friedrich Nietzsche, *Gesammelte Werke*, ed. Richard Oehler, Max Oehler, and Friedrich Würzbach, 23 vols. (Munich: Musarion Verlag, 1920–29). Appearing privately in 1883–85, the book was first published in 1892. For an accessible English edition, see Friedrich Nietzsche, *Thus Spoke Zarathustra: A Book for All and None*, trans. Walter Kaufmann (New York: Penguin Books, 1978).

In his nuanced and thorough study of Nietzsche's reception in the German art world, Jürgen Krause, *"Mär-tyrer" und "Prophet": Studien zum Nietzsche-Kult in der bildenden Kunst der Jahrhundertwende* (Berlin: Walter de Gruyter, 1984), comments upon the close association of Nietzsche with the loneliness of the sea, the ice of the high mountains, and desert places (55–56). See also Jost Hermand, "Der gründerzeitliche Parvenü," 13–15, who characterizes Nietzsche as the consummate parvenu from the Gründerzeit, the first years after the unification of Germany in 1871. Klaus Jeziorkowski makes a strong argument for the pervasiveness of this upward-striving idealism in Germany at the end of the century in "Empor ins Licht: Gnostizismus und Licht-Symbolik in Deutschland um 1900," in Chapple and Schulte, *Turn of the Century*, 171–96.

See also Hermann Glaser, *Die Kultur der Wilhelmi-nischen Zeit: Topographie einer Epoche* (Frankfurt am Main: S. Fischer, 1984), who uses as a basic metaphor for his interpretation of this period Karl May's tale of Sitara, with its evil lowlands of Ardistan and good highlands of Dschinnistan, inhabited by noble souls.

72. For a comprehensive survey of Nietzsche's reception in Germany, see Steven E. Aschheim, *The Nietzsche Legacy in Germany, 1890–1990* (Berkeley: University of California Press, 1992). The quotation is Aschheim's phrase. A valuable critique of Nietzsche's influence upon the art world at this time is presented in Hans-Dieter Erbs-mehl, "Kulturkritik und Gegenästhetik: Zur Bedeutung Friedrich Nietzsches für die bildende Kunst in Deutschland 1892–1918" (Ph.D. diss., University of California, Los Angeles, 1993).

73. Friedrich Nietzsche, "Vom Gesindel," *Also sprach Zarathustra*, part 2, 123–26. For this long quotation I have used Kaufmann's translation, "On the Rabble," in *Thus Spoke Zarathustra*, 97–98.

74. Friedrich Nietzsche, "Zarathustra's Vorrede," *Also sprach Zarathustra*, 5–15; quotation on 15. For a helpful interpretation of this passage, see Kathleen Marie Higgins, *Nietzsche's Zarathustra* (Philadelphia: Temple University Press, 1987), chap. 4.

75. The word *Pöbel* appeared frequently along with other derogatory characterizations in his diatribes against the rabble or the mob in Nietzsche, *Also sprach Zarathustra*. These references to the *Pöbel* are found on pp. 325, 362, 341, 310, and 364. For further references, see *Sachregister*, vol. 23 of *Gesammelte Werke*, 122, which also indicates the other volumes in which Nietzsche used the word to address the dominance of the rabble in contemporary German society.

76. Friedrich Nietzsche, "Unzeitgemässe Betrachtungen. David Strauss, der Bekenner und der Schriftsteller" (1873), in *Gesammelte Werke*, 6:129–220.

77. See, e.g., Friedrich Nietzsche, *Jenseits von Güte und Böse* (1885), vol. 15 of *Gesammelte Werke*, aphorism nos. 44, 224, 282, 287, or *Der Wille zur Macht: Versuch einer Umwerthung aller Werthe* (written 1884–88, published 1895–1901), vol. 19 of *Gesammelte Werke*, aphorism nos. 792, 864, 943, in which the plaint can be summed up as "Alles ist verpöbelt."

78. Friedrich Nietzsche, "Die Deutschen als Künstler," in *Die fröhliche Wissenschaft*, vol. 12 of *Gesammelte Werke*, bk. 2, aphorism 105.

79. Chth, "Nietzsche und seine Bedeutung," *Der Kunstwart* 12, no. 8 (Mar. 1895): 177–78. The maxim "Nichts ist wahr, Alles ist erlaubt," is found in Nietzsche, "Der Schatten," in *Also sprach Zarathustra*, 345.

80. Max Nordau, *Degeneration* (1895; reprint, New York: Howard Fertig, 1968), 415–72, quotation on 446. In his introduction to this edition, "Max Nordau and His *Degeneration*," xv–xxxiv, George L. Mosse provided a valuable summary of Nordau's liberal ideals and his faith in scientific progress. A further analysis of Nordau's position is P. M. Baldwin, "Liberalism, Nationalism, and Degeneration: The Case of Max Nordau," *Central European History* 13, no. 2 (1980): 99–120. Baldwin described Nordau, whose books were translated widely and published in scores of editions, "As a personality he was as colossal as his reputation. As critic, philosopher, novelist, playwright, sociologist, versifier, orator, journalist, polyglot, Zionist, psychologist, and physician, his versatility is impressive." Son of a rabbi, Nordau would turn—after the Dreyfus affair—from a cosmopolitan secularist into one of the leaders of Zionist nationalism. For a different perspective, see Hans-Peter Söder, "Disease and Health as Context of Modernity: Max

Nordau as a Critic of Fin-de-Siècle Modernism," *German Studies Review* 14 (1991): 473–87.

81. See, e.g., Herman Eichfeld, "Die dritte Münchener Jahresaussstellung," *Der Kunstwart* 4, no. 21 (Aug. 1891): 328, comparing Klinger to Nietzsche; or Avenarius, "Max Klinger Zyklus, 'Vom Tode,'" ibid. 8, no. 4 (Nov. 1894): 61, which deals at length with Klinger's graphic cycle in language evocative of Zarathustra. On Hofmann and Nietzsche, see Krause, "Märtyrer" und "Prophet," 75; on Klinger and Nietzsche, see Erbsmehl, "Kulturkritik und Gegenästhetik," chap. 3.

82. Georg Fuchs, "Friedrich Nietzsche und die bildende Kunst," *Die Kunst für Alle* 11, nos. 3 (Nov. 1895): 33–38; 5 (Dec. 1895): 71–73; 6 (Dec. 1895): 85–88, quotations on 86 and 88. Fuchs was the first editor of *Deutsche Kunst und Dekoration* (Alexander Koch Verlag), helped to organize the Darmstadt exhibition and festival "Ein Dokument deutscher Kunst," and wrote for the *Münchner Neuesten Nachrichten*. Krause, "Märtyrer" und "Prophet," 155–57, discusses Fuchs's position among the followers of Nietzschean ideas. Peter Jelavich, *Munich and Theatrical Modernism: Politics, Playwriting, and Performance, 1890–1914* (Cambridge: Harvard University Press, 1985), 187–208, traces Fuchs's career in Munich and Darmstadt and his increasing nationalism and anti-Semitism. Paul Schultze-Naumburg, who similarly moved to the political far right, also revealed Nietzsche's influence and language in his reviews in the mid-1890s, as in the long emotional conclusion to his article "Deutsche Kunstkritiker," *Die Kunst für Alle* 10, no. 12 (Mar. 1895): 179. A useful short study of Böcklin's celebrated painting is Frans Zelger, *Arnold Böcklin. Die Toteninsel: Selbstheroisierung und Abgesang der abendländischen Kultur* (Frankfurt am Main: Fischer Taschenbuch Verlag, 1991).

83. A note in *Der Kunstwart* 3, no. 9 (Jan. 1890): 138, only brought the book to the readers' attention, promising longer consideration later for [Julius Langbehn], *Rembrandt als Erzieher: Von einem Deutschen* (Leipzig: Verlag von C. L. Hirschfeld, 1890).

84. A critical evaluation of the book and its reception in terms of its undoubted anti-Semitism by Fritz Stern, "Julius Langbehn and Germanic Irrationalism," in *The Politics of Cultural Despair: A Study in the Rise of the Germanic Ideology* (Berkeley: University of California Press, 1961), 97–180, determined scholars' understanding for several decades. See also George L. Mosse, *The Crisis of German Ideology: Intellectual Origins of the Third Reich* (New York: Grosset and Dunlap, 1964), chap. 2, for an analysis of Langbehn's ideas and influence. Raising questions about Stern's interpretation, Kratzsch, "Kunstwart" und Dürerbund, 14–17, analyzes

the difficulty of assessing the influence and extent of ideas among the public.

My interpretation of the reception in the art journals, which differs from Stern's reading, is based on a close analysis of which portions of Langbehn's book were quoted and the extent of the attention the book received in the journals. The excerpts from the book were published in the journals with no indication of the page numbers in the book. I have supplied page numbers from the thirty-seventh edition (1891). Pecht's lengthy excerpt on modern times and on art rooted in the German character was taken from *Rembrandt als Erzieher*, 15–16, 19, and was printed in F. Pt. [Friedrich Pecht], "Rembrandt als Erzieher," *Die Kunst für Alle* 5, no. 13 (Apr. 1890): 193–95.

Relevant to the consideration of Langbehn is the scholarly acceptance of the 1890s as a period of increasing cultural pessimism; this interpretation has been intelligently critiqued by Ann Taylor Allen in "Feminism, Social Science, and the Meanings of Modernity," *American Historical Review* 104, no. 4 (1999): 1084–1113, arguing that this understanding of cultural pessimism was "a specific dilemma of male elites," who responded negatively to the challenges of modernizing society, while women writers and scholars, on the contrary, welcomed the changes with "a new sense of optimism and intellectual empowerment."

85. [Avenarius], "Vom Zeitalter deutscher Kunst," *Der Kunstwart* 3, no. 12 (Mar. 1890): 177–79, quotation on 177, from [Langbehn], *Rembrandt als Erzieher*, 3. Avenarius's brief statement is on 179: "Die Pöbel ist nicht das Volk."

86. For a discussion of Langbehn's relationship with Avenarius, see Kratsch, *Kunstwart und Dürerbund*, 127–28. The lengthy quotation is from [Langbehn], *Rembrandt als Erzieher*, 344–45.

87. The review in *Kunstchronik*, "Rembrandt als Erzieher," ibid., n.s. 1 (Jan. 1890): cols. 209–13, was largely made up of excerpts interlaced with positive comments. Stern, *Politics of Cultural Despair*, 109–10, 140–42, discusses the intensifying anti-Semitism of the later editions; this was already evident in the thirty-seventh edition, in 1891.

88. Both *Die Kunst für Alle* and *Der Kunstwart* did report on Bode's attack upon art academies and on specialized graduate work in art history, occasioned by his review of *Rembrandt als Erzieher* for the *Preussische Jahrbücher*, and on the subsequent argument between Bode and Hermann Grimm, a professor of art history, who defended the current training of graduate students in Berlin University. Like Avenarius and Pecht, Bode singled out the issue that was foremost in his thinking—the necessity of reform in the art academies—from the mass of charges and contra-

dictions that made up Langbehn's book (see *Der Kunstwart* 3, no. 13 [Mar. 1890]: 202–3, extract from Wilhelm Bode, "Rembrandt als Erzieher von einem Deutschen," *Preussische Jahrbücher* 65, no. 3 [Mar. 1890]: 301–14; and *Die Kunst für Alle* 5, no. 18 [June 1890]: 285–86).

Hilmar Frank relates that Bode corresponded with Langbehn from 1889 to 1892, supported the publication of the book, and recommended it to significant officials, in addition to reviewing it. Seidlitz, who introduced Bode to Langbehn's book, was a strong supporter who provided substantial financial support to Langbehn. Both Seidlitz and Gurlitt wrote enthusiastic reviews when the book first appeared. Their reviews did not appear in the journals, but in a newspaper and in a cultural review, *Die Gegenwart*, in Munich. The enthusiasm and support of all three men had faded by 1892, as Langbehn's erratic behavior and irrational ideas became more manifest (Hilmar Frank, "Übereilte Annäherung: Bode und der 'Rembrandt-deutsche,'" in *Wilhelm von Bode als Zeitgenosse der Kunst*, ed. Angelika Wesenberg [Berlin: Nationalgalerie, Staatliche Museen zu Berlin, 1995], 77–82).

89. F. Pt. [Pecht], "'Rembrandt als Erzieher' und seine Gegner," *Die Kunst für Alle* 6, no. 16 (May 1891): 255–56. Reviewing the books responding to Langbehn, Pecht wrote that the most amusing book was a parody titled *Höllenbreughel als Erzieher* (Leipzig: Reißner, 1891), written "also by a German." Another book reviewed by Pecht, *Est, Est, Est: Randbemerkungen zu "Rembrandt als Erzieher" von ein niederdeutscher Bauern* (Dresden: Pierson, 1891), was more of an exposé of the weakness of the book; its author was later identified as Ehrenberg, who attacked Franquet's pamphlet in 1894. A third book, Nautilus, *Billige Weisheit* (Leipzig: E. A. Seemann, 1891), attacked the ideas in the book, particularly charging that Dürer would have been a more appropriate choice for German artists to emulate than Rembrandt. Finally, Pecht praised D. H. Pudor, *Ein ernstes Wort* (Göttingen, Germany: Dietrich, 1891) for his reasonable approach to the book, although he thought Pudor was somewhat too enthusiastic. Nordau's dismissal of Langbehn appeared in his *Degeneration*, 106, 454.

Almost half a century ago Andreas Dorpalen commented trenchantly on the usefulness of sales figures of books: "But books are not always bought to be read; Germans consider a library of the nation's classics part of a properly furnished home, and the number of those who are truly familiar with the contents of such a library has never been very large" (*Heinrich von Treitschke* [New Haven, Conn.: Yale University Press, 1957], 291).

Part III, Chapter 4
Modern Artists: Pauper, Dilettante, and Prince

1. Announcements of Liebermann's invitation from Antonin Proust, commissioner for the art exhibitions at the

Paris Universal Exposition, to serve on the jury and to organize a German section for the international exhibition appeared in *Kunstchronik* 24 (Mar. 1889): col. 379, and in "Beteiligung deutscher Künstler an der Pariser Weltausstellung," ibid. (May 1889): col. 491. Otto Brandes, reporting regularly about the Paris exhibitions in *Die Kunst für Alle*, noted that Liebermann was a member of the jury for the international exhibition and had received an award (see *Die Kunst für Alle* 4, nos. 12 [Mar. 1889]: 186–87, 19 [July 1889]: 304, 21 [Aug. 1889]: 334. The July issue briefly reported on the toasts for the celebration dinner on 21 May. Erich Hancke, *Max Liebermann: Sein Leben und seine Werke*, 2nd ed. (Berlin: Bruno Cassirer, 1923), 266, quoted Liebermann's French statement as well as the *Kreuzzeitung* translation. For the English translation and a brief account of this controversy, see Peter Paret, *The Berlin Secession: Modernism and Its Enemies in Imperial Germany* (Cambridge: Harvard University Press, 1980), 46–47.

2. Hancke, *Max Liebermann*, 262–63; Anton von Werner, *Erlebnisse und Eindrücke, 1870–1890* (Berlin: Ernst Siegfried Mittler und Sohn, 1913), 564–67. For thorough information on Bismarck's refusal to endorse either official or unofficial participation in the Paris Exposition of 1889 and on the negative response to the artists who did participate, see Françoise Forster-Hahn, "'La Confraternité de l'art': Deutsch-französische Ausstellungspolitik von 1871 bis 1914," *Zeitschrift für Kunstgeschichte* 48, no. 1 (1985): 521–31. ****, "Beteiligung deutscher Künstler an der Pariser Weltausstellung," *Kunstchronik* 24 (May 1889): cols. 506–7, reprinted an official statement from the *Berliner Politischen Nachrichten* chastising those artists who had sullied the honor of the nation by their shameful and unpatriotic participation in the Paris Exposition.

For the German daily press attacks on Liebermann, see Forster-Hahn, "La Confraternité de l'art," 524 n. 49. Nicolaas Teeuwisse, *Vom Salon zur Secession: Berliner Kunstleben zwischen Tradition und Aufbruch zur Moderne, 1871–1900* (Berlin: Deutscher Verlag für Kunstwissenschaft, 1986), 152–54, discusses the press response. For information about these events written from the perspective of Kuehl's long sojourn in the Parisian art world, see Rachel Esner, "'C'est un peintre français': Gotthardt Kuehl und die Pariser Kunstkritik," in *Gotthardt Kuehl, 1850–1915*, ed. Gerhard Gerkens and Horst Zimmermann, exh. cat. (Leipzig: E. A. Seemann, 1993), 31–32. On the awards, see Hancke, *Max Liebermann*, 265–67. Uhde, as a Saxon living in Bavaria not subject to Prussian regulations, was able to accept the French Legion of Honor.

3. The journal reports on the Paris Exposition included: Otto Brandes's reports, O.B., "Paris," *Die Kunst für Alle* 4, no. 13 (Apr. 1889): 204–5; Otto Brandes, "Der Pariser Salon 1889," ibid., nos. 19–20 (July 1889): 292–95, 309–12, praising, among others, the work of Lhermitte, Dagnan-Bouveret, Roll, and Moreau; Brandes, "Die Ausstellung der fremden Malerschulen auf dem Marsfelde," ibid. 5, no. 3 (Nov. 1889): 37–43; and Brandes, "Pariser Brief," ibid., no. 11 (Mar. 1890): 171–72.

See also Hermann Bahr, "Pariser Kunstbriefe, I–IV," *Der Kunstwart* 2, nos. 16, 18–20 (May–July 1889): 249–50, 283–84, 299, 314–15; S.S. "Die deutschen Künstler auf der Pariser Weltausstellung," ibid. 3, nos. 5–6 (Dec. 1889): 72–73, 88–89; Richard Graul, "Pariser Kunstausstellung," *Zeitschrift für bildende Kunst* 24 (1888–89): 250–56, 279–81, 311–13; and idem, "Pariser Kunstausstellung," *Kunstchronik* 24 (June 1889): cols. 593–97, in which Graul began by expressing his regret that Germany was represented in a halfhearted fashion through the unfortunate last-minute efforts of Liebermann, Uhde, and others, whose art simply reflected French art.

A useful assessment of the state of international art is contained in Brandes's report in November, as well as in a review two years later positively evaluating the work of Uhde and Liebermann within the context of French artistic developments, "Paris und die Malerei der Nicht-Franzosen," *Die Kunst unserer Zeit* 2, 1st half-vol. (1891): 27–37, a review written, remarkably, by Momme Nissen, who a year later became a disciple of Langbehn's views. Werner's view on the German art in the 1889 fair is quoted in Forster-Hahn, "Confraternité de l'art," 526.

4. See "Stoßseufzer eines deutschen Malers," *Fliegende Blätter* 93, no. 2365 (1890): 184–85; and Friedrich Pecht, "Hermann Vogel-Plauen," *Die Kunst für Alle* 4, no. 18 (June 1889): 274–77, with illustrations throughout the issue. The continued popularity of Richter's and Schwind's images was reinforced by the tributes to them published on anniversaries of their deaths. See, e.g., Fr. Pecht, "Ludwig Richter's Selbstbiographie," ibid. 1, nos. 4 (Nov. 1885): 47–51 and 6 (Dec. 1885): 77–81; Erich Haenel, "Zum 100. Geburtstag Ludwig Richters," ibid. 18, no. 24 (Sept. 1903): 562–72; and Anton Springer, "Zum achtzigsten Geburtstage Ludwig Richters," *Zeitschrift für bildende Kunst* 18 (1882–83): 377–86. On Schwind, see H. E. von Berlepsch, "Zum fünfundzwanzigsten Todestage Moritz von Schwinds, 1804–1871," *Die Kunst für Alle* 11, no. 10 (Feb. 1896): 145–53; Friedrich Haack, "Moritz von Schwind: Zu seinem 100. Geburtstag," ibid. 19, no. 8 (Jan. 1904): 177–88; and Jakob Baechtold, "Briefwecksel zwischen Moritz von Schwind und Eduard Mörike," *Zeitschrift für bildende Kunst* 25, n.s. 1 (1889–90): 101–8, 158–64, 211–21.

5. Friedrich Schiller, "Nänie," trans. George F. Peters, in *The German Mind of the Nineteenth Century*, ed. Hermann Glaser (New York: Continuum, 1981), 56. The

reference in the text is to lines in the middle of the poem: "Aphrodite will not soothe the wound of the beautiful youngster, / So horribly gouged by the boar in his delicate flesh."

For a thorough history and analysis of the *Judensau,* literally "Jewish sow," see Isaiah Shachar, *The Judensau: A Medieval Anti-Jewish Motif and Its History* (London: Warburg Institute, University of London, 1974). See also Peter Dittmar, *Die Darstellung der Juden in der populären Kunst zur Zeit der Emanzipation* (Munich: K. G. Saur, 1992), 28–33; and Eduard Fuchs, *Die Juden in der Karikatur: Ein Beitrag zur Kulturgeschichte* (Munich: Albert Langen Verlag, 1921), 114–23, with illustrations of the Judensau throughout. Shachar argues that the extraordinary obscenity of the image contributed to its longevity and contributed fundamentally to the understanding of the Jews as an abominable category of beings.

On the torture and trial of Jews in Trent in 1475 for the alleged ritual murder of Simon of Trent, see the provocative essay by Kathleen Biddick, "Paper Jews: Inscription/Ethnicity/Ethnography," *Art Bulletin* 78, no. 4 (1996): 597–98. References to the ritual-murder charges in 1891 and 1900 can be found in Marion Kaplan, "Friendship on the Margins: Jewish Social Relations in Imperial Germany," *Central European History* 34, no. 4 (2001): 476.

6. Although the Prussian government refused to allow Liebermann to accept the Legion of Honor in 1889, he was able to receive it when the French government offered it again in 1896, a year before his major retrospective exhibition in Berlin. By an odd coincidence, the announcement of his being named a Knight of the French Legion of Honor was published in the same issue of *Die Kunst für Alle* in which the lead article celebrated the twenty-fifth anniversary of the death of Schwind (WO, "Berlin," *Die Kunst für Alle* 11, no. 10 [Feb. 1896]: 155). See also *Kunstchronik,* n.s. 7 (Jan. 1896): col. 212. On Rathenau's assassination, see David Felix, *Walther Rathenau and the Weimar Republic: The Politics of Reparation* (Baltimore: Johns Hopkins Press, 1971): 168–74; the nasty couplet was "Schlag tot den Walther Rathenau / Die gottverdammte Judensau," cited in Shachar, *Judensau,* 64.

7. Pecht, "Hermann Vogel-Plauen," 276. Pecht printed an extended autobiographical statement from Vogel in his review. A surprising tribute to Vogel as a successful cartoon artist came from George Grosz, who recounted how impressed he had been by the detailed drawings of all the woodland creatures that populated the artist's hermit life deep in the woods outside of Dresden, where Grosz was a student at the Royal Art Academy (*Ein kleines Ja und ein grosses Nein: Sein Leben von ihm selbst erzählt* [Hamburg: Rowohlt Verlag, 1955], 89–90). See Vogel's full-page drawings "The New Pegasus—Vision of an Idealist

after Reading a Modern Book of Poetry" (*Fliegende Blätter* 101, no. 2554 [1894]: 23) and "The 'Moderns' and the 'Ancients'" (ibid. 108, no. 2758 [1898]: 232).

8. [Wilhelm Bode], "Bildende Kunst," *Der Kunstwart* 2, no. 4 (Nov. 1888): 56–58, reprinted from *Kölnische Zeitung,* no. 300 (28 Oct. 1888). Bode repeated similar warnings in an attack upon art academies that he included in his review of Julius Langbehn's *Rembrandt als Erzieher* in the *Preussischen Jahrbücher.* An extract was printed in *Der Kunstwart* 3, no. 13 (Mar. 1890): 202–3. For the continuing debate involving Bode, Hermann Grimm, Jordan, and Lenbach over reform of the art academies, see Herman Helferich [Emil Heilbut], "Rundschau," *Die Kunst für Alle* 9, no. 6 (Dec. 1893): 86–88. *Die Kunst für Alle* provided annual reports on the enrollments in the major academies.

For statistical tables and analysis of the trends, see the pioneering work of Paul Drey, *Die wirtschaftlichen Grundlagen der Malkunst: Versuch einer Kunstökonomie* (Stuttgart: J. G. Cotta, 1910), 71–73 and table 1. Paret, *Berlin Secession,* 168–70, presents statistics on artists and discusses the problem of overpopulation. For valuable detailed information about the economic and social position of artists in imperial Germany, see the archival studies by Robin Lenman: "Politics and Culture: The State and the Avant-Garde in Munich, 1886–1914," in *Society and Politics in Wilhelmine Germany,* ed. Richard J. Evans (New York: Barnes and Noble, 1978); "A Community in Transition: Painters in Munich, 1886–1924," *Central European History* 15, no. 1 (1982): 3–33; "Painters, Patronage, and the Art Market in Germany, 1850–1914," *Past and Present,* no. 123 (1989): 109–40; and "Der deutsche Kunstmarkt 1840–1923: Integration, Veränderung, Wachstum," in *Sammler, Stifter, und Museen: Kunstförderung in Deutschland im 19. und 20. Jahrhundert,* ed. Ekkehard Mai and Peter Paret (Cologne: Böhlau Verlag, 1993), 135–52. Lenman's valuable articles, revised and enlarged, were published in *Die Kunst, die Macht, und das Geld: Zur Kulturgeschichte des kaiserlichen Deutschland, 1871–1918,* trans. Reiner Grundmann (Frankfurt am Main: Campus Verlag, 1994), and then revised and significantly expanded as *Artists and Society in Germany, 1850–1914* (Manchester: Manchester University Press, 1997).

9. An analysis of economic trends is available in Knut Borchardt, *Perspectives on Modern German Economic History and Policy* (Cambridge: Cambridge University Press, 1991), chap. 1. An English scholar, William Harbutt Dawson, *Bismarck and State Socialism* (London: Swan Sonnenschein and Co., 1890), gave a lively contemporary analysis of the political aspects of economic policy. Reports on the U.S. custom tax were prepared by Robert Köhler, "Der amerikanische Kunstzoll," *Die Kunst für Alle*

2, no. 22 (Aug. 1887): 339–41; ibid. 3, no. 12 (Apr. 1888): 189–90; and ibid. 6, no. 3 (Nov. 1890): 48. Drey analyzed German art exports in *Die wirtschaftlichen Grundlagen der Malkunst*, 108–14.

An extended, thoughtful analysis of German art on the international market by Karl Voll had appeared more than a decade earlier: "Internationale Kunstausstellungen," *Die Kunst für Alle* 12, no. 16 (May 1897): 249–53. Voll's analysis coincided with Drey's later conclusion that the cheap quality of German art hurt its market in America.

For the specific figures and further analysis of exports to America, see Lenman, "Community in Transition," 21–22; and idem, *Artists and Society*, 158–59. On the U.S. financial crisis, see "Kunsthandel in Amerika," *Der Kunstwart* 8, no. 15 (May 1895): 236–37. A wickedly satirical story about a wealthy Yankee tourist from Chicago who brought his family to Europe to buy art for his house was published in "Touristen," *Fliegende Blätter* 77, no. 1940 (1882): 105–7.

10. See "Ein neuer französischer Importartikel," *Die Kunst für Alle* 5, no. 16 (May 1890): 250–52. Unsigned, the article bears the marks of Pecht's editorial style. Pecht's remarks may have been prompted by his recent reading of Langbehn's *Rembrandt als Erzieher*—his review had been published a month earlier—or by the current exhibition of photographic reproductions of French nineteenth-century painting arranged by Gutbier at the Ernst Arnold Art Salon in Dresden, which was reviewed in the next issue (=, "Dresden," *Die Kunst für Alle* 5, no. 17 [June 1890]: 271).

11. [Pecht], "Künstler und Käufer," ibid., no. 24 (Sept. 1890): 376–77; idem, "Auktionswesen," ibid., no. 23 (Sept. 1890): 362–64. Maria Makela provides a thorough analysis of sales at the annual Munich exhibitions in *The Munich Secession: Art and Artists in Turn-of-the-Century Munich* (Princeton: Princeton University Press, 1990), chap. 2, esp. nn. 44, 68, and 99.

12. Detailed analyses of these controversies in Munich are presented in Makela, *Munich Secession*; Markus Harzenetter, *Zur Münchner Secession: Genese, Ursachen, und Zielsetzungen dieser intentionell neuartigen Münchner Künstlervereinigung* (Munich: Stadtarchivs München, 1992); Rita Hummel, *Die Anfänge der Münchner Secession* (Munich: tuduv-Verlag, 1989); and Renate Heise, *Die Münchener Secession und ihre Galerie: Eine Ausstellung des Vereins Bildender Künstler Münchens, e.v. Secession* (Munich: Stadtmusuem, 1975).

13. H. E. von Berlepsch's "Münchener Ausstellungs-Gänge," *Die Kunst unserer Zeit* 2, 2nd half-vol. (1891): 19–22; "Über die Münchner Jahresausstellungen," *Der Kunstwart* 5, no. 3 (Nov. 1891): 42–44; and "Ein Wort über die Münchener Jahresausstellung," *Kunstchronik*, n.s. 3 (Jan. 1892): cols. 225–31. Berlepsch picked up his attack upon the exhibitions system in 1895, when he argued that the artists did not receive any of the profits from these exhibitions ("Was ist die Kunst bei uns?" *Die Kunst für Alle* 11, no. 1 [Oct. 1895]: 5).

14. The poem was by von Miris, "Münch'ner Jahres-Ausstellungs-Schnadahüpfeln," *Fliegende Blätter* 95, no. 2406 (1891): 81–82. See also Nautilus, "Die bösen Spanier: Epistola obscure viri Coloniensis," *Kunstchronik*, n.s. 3 (Jan. 1892): cols. 193–97. Using this pseudonym, Nautilus also published a pamphlet, *Billige Weisheit* (Leipzig: E. A. Seemann, 1891), reviewed in *Die Kunst für Alle* 6, no. 16 (May 1891): 255–56, in which the writer attacked *Rembrandt als Erzieher*.

15. My figures for 1888 and 1891 are based on statistics from Makela, *Munich Secession*, 161–62, 168–69; and Horst Ludwig, *Kunst, Geld und Politik um 1900 in München: Formen und Ziele der Kunstfinanzierung und Kunstpolitik während der Prinzregentenära (1886–1912)* (Berlin: Gebr. Mann Verlag, 1986), 120–21. See also Wilhelm Schölermann, "Die Münchener Jahresausstellung im Glaspalast," *Kunstchronik*, n.s. 6 (Nov. 1895): col. 481.

16. See reports on the proposed exhibitions in *Der Kunstwart* 1, no. 1 (Oct. 1887): 9; *Die Kunst für Alle* 3, nos. 1–2 (Oct. 1887): 14, 32; and *Der Kunstwart* 1, no. 17 (June 1888): 242; and "Eine 'anonyme Ausstellung,'" ibid. 5, no. 18 (June 1892): 280. Rosenhagen makes no mention in his regular weekly Berlin column in *Das Atelier* of any such show of rejected work in 1892.

17. In "Die freie Berliner Kunstausstellung," *Die Kunst für Alle* 8, no. 20 (July 1893): 314–15, Springer spoke highly of one of the rejected paintings by Munch, his *Night in Saint-Cloud*. To explain the frequent necessity, if not praiseworthiness, of compromise decisions, Springer used a common but unfortunate maxim: "Haust du meinen Juden, hau ich deinen Juden." See also A.R. [Adolf Rosenberg], "Freie Berliner Kunstausstellung," *Kunstchronik*, n.s. 4 (June 1893): cols. 440, 459; nrs, "Freie Berliner Kunstaussstellung," *Der Kunstwart* 6, no. 19 (July 1893): 299, essentially agreeing with Springer's judgment; D.R. [Hans Rosenhagen], "Zur Lage," *Das Atelier* 3, no. 63 (June 1893): 7–8; and idem, "Freie Kunstausstellung," ibid., no. 64 (June 1893): 1–2.

18. Carl Aldenhoven, "Über Kunst und Armut," *Der Kunstwart* 6, nos. 16–18 (May–June 1893): 251–53, 267–69, 281–82, quotation on 268. Aldenhoven (1842–1907) was director of the Wallraf-Richartz Museum in Cologne at that time. Poverty of artists was, of course, not a new problem. On Menzel's view of artistic poverty,

see Richard Graul, "Adolph Menzel: Zum 80. Geburtstage des Meisters, 8 Dezember 1895," *Die Kunst für Alle* 11, no. 6 (Dec. 1895): 81–84, which starts with a description of Menzel's "melancholische Idealbild einer Künstlerlaufbahn." For an analysis of the concern over poverty among artists in Germany, see Joachim Grossmann, "Kunstlerpauperismus," in *Künstler, Hof und Bürgertum: Leben und Arbeit von Malern in Preußen, 1786–1850* (Berlin: Akademie Verlag, 1994), 161–66.

19. Friedrich Pecht, "Zum 70. Geburtstage Adolf Menzels," *Die Kunst für Alle* 1, no. 5 (Dec. 1885): 62. For reproductions and analysis of the lithographic cycle, see *Adolf Menzel: Zeichnungen, Druckgraphik, und illustrierte Bücher* (Berlin: Nationalgalerie, 1984), illus. 188.1–14. For examples of cartoons about poor artists, see the following from *Fliegende Blätter*: "Auf dem Rentamt," 84, no. 2112 (1886): 23; "Invidia," 86, no. 2163 (1887): 14; "Zweierlei," 93, no. 2361 (1890): 147; A[dolf] Hengeler, "Ein Pfiffikus," 94, no. 2385 (1891): 134–35; "Durchschaut," 96, no. 2428 (1892): 56; "Das theuere Modell," 105, no. 2672 (1896): 147; "Modernes Unglück," 105, no. 2679 (1896): 216; "Der Nagel als Retter in der Noth," 106, no. 2686 (1897): 32; "Das Wertvollste," 107, no. 2724 (1897); "Oekonomisch," 109, no. 2772 (1898): 107; and "Prosaisch," 109, no. 2774 (1898): 128.

20. A[lbert] Ilg, *Unsere Künstler und die Gesellschaft* (Vienna: Graeser, 1885–86); the booklet was reviewed and excerpted in *Der Kunstwart* 1, no. 8 (Jan. 1888): 95–96. See also Max Kretzer, "Randglossen zum Kapital Berliner Kunstausstellung," ibid. 2, no. 2 (Oct. 1888). 27–28.

21. See "Zum Kunstwucher," *Der Kunstwart* 5, no. 19 (July 1892): 297. See also Dr. A., "Zum Schwindel mit alten Bildern," ibid. 4, no. 23 (1 Sept. 1891): 264–65, on the authentication and sale of art forgeries; J. Janitsch, "Kunstpolitik," ibid. 6, no. 3 (Nov. 1892): 40–41; and Otto Brandt, ibid., no. 2 (Oct. 1892): 29. For an example of Springer's reports, see "Die graphische Ausstellung in der Berliner Akademie," *Die Kunst für Alle* 10, no. 7 (Jan. 1895): 99–101. See also Carl Aldenhoven, "Über Kunst und Armut," *Der Kunstwart* 6, nos. 16–18 (May–June 1893).

22. O, "75 jüngere selbständige Künstler Berlins," *Kunstchronik*, n.s. 3 (Apr. 1892): 363. Reports of the politics that lay behind the rejection of the petition appeared in "Die Petition der Künstler an den Magistrat von Berlin," *Das Atelier* 2, nos. 34 (Mar. 1892): 8 and 35 (Apr. 1892): 8; *Die Kunst für Alle* 7, no. 14 (Apr. 1892): 218; and ibid. 9, no. 22 (Aug. 1894): 350. Rosenhagen continued in his weekly editorial column to report on the unhappy situation of young artists in Berlin, whose petition did not result in further support from the state or the city.

The Verein für Originalradierung Karlsruhe, formed in 1894 by Karlsruhe faculty, was designed to promote original etchings, lithographs, and woodcuts. As chair of the society, Kalckreuth made arrangements for students at the academy to receive training in lithographic techniques (see Henrike Junge, *Wohlfeile Kunst: Die Verbreitung von Künstlergraphik seit 1870 und die Griffelkunst-Vereinigung Hamburg-Langenhorn* [Mainz: Verlag Philipp Zabern, 1989], 55–58). The report on the negative response in Munich to the action of the Landtag in refusing financial support for the Munich Art Academy was published in *Der Kunstwart* 3, no. 12 (18 Mar. 1890): 186. See also Ludwig, *Kunst, Geld und Politik*, 30–31.

23. *Kunstchronik*, n.s. 6 (Nov. 1894): col. 89. For the earlier report, see Theodor Paulsen, "Im Sächsischen Kunstverein," *Die Kunst für Alle* 2, no. 9 (Feb. 1887): 123–24.

24. On the Munich cooperative, see ibid. 10, no. 4 (Nov. 1894): 63; and D.R. [Hans Rosenhagen], "Zur Lage," *Das Atelier* 4, nos. 21 (Nov. 1894): 6 and 22 (Nov. 1894): 6. See also "Neue Deutsche Kunstverein in Berlin," *Der Kunstwart* 6, no. 11 (Mar. 1893): 168–69.

25. Michael Georg Conrad, "Aus dem Münchener Kunstleben," *Die Gesellschaft* 9, no. 1 (1893): 230, quoted in Bettina Brand, *Fritz von Uhde: Das religiose Werk zwischen künstlerischer Intention und Öffentlichkeit* (Heidelberg: Bettina Brand, 1983), 271 n. 580.

26. "Aus Berliner Künstlerateliers," *Die Kunst für Alle* 10, no. 4 (Nov. 1894): 61. Although this report was unsigned, Springer must have written it. At the time, he was the only Berlin correspondent, writing under his own name and under his pseudonym, Dr. Relling. The next report came in a review: Jaro Springer, "Die graphische Ausstellung in der Berliner Akademie," ibid., no. 7 (Jan. 1895): 99–101. The third one was signed R.: "Berlin," ibid. 10, no. 9 (Feb. 1895): 139.

See also a report from Karlsruhe at this time that began with a reference to the "current well-known unfavorable situation in the art market" and went on to cite the "amazing" news that two young artists had actually undertaken a project without financial backing to create an expensive colossal oil painting (ibid., no. 13 [Apr. 1895]: 202).

27. Manfred Wittich, "Kunst und Sozialdemokratie," *Der Kunswart* 6, no. 7 (Jan. 1893): 108–9; Franz Mehring, "Klassisch und Modern," ibid., no. 22 (Aug. 1893): 347–49.

28. "In Sachen: Kunst und Sozialdemokratie," ibid. 6, no. 23 (Sept. 1893): 362–65, in which the anonymous author recommended a book by Dr. E. Reich, from the Vienna

Hochschule, *Die bürgerliche Kunst und die besitzlosen Volksklassen*, which discusses the incomprehensibility of bourgeois art for workers.

29. "Hütet Euch!" *Der Kunstwart* 8, no. 11 (Mar. 1895): 22–23, Berlin supplement. The flier spelled out the proposed changes affecting the arts in the Criminal Code, Article 1, §§ 111a, 126, 130, and Article 33, § 184. A good analysis of the events surrounding the bill is Robert W. Lougee, "The Anti-Revolution Bill of 1894 in Wilhelmine Germany," *Central European History* 15, no. 4 (1982): 224–40. Further evidence of the state's efforts to control the working classes in the 1890s is provided by Eleanor Turk, "The Berlin Socialist Trials of 1896: An Examination of Civil Liberty in Wilhelmian Germany," *Central European History* 19, no. 4 (1986): 323–42.

30. "Kunst und Sozialdemokratie," *Der Kunstwart* 9, no. 21 (Aug. 1896): 331–32, reprinted from *Sächsischen Arbeiter-Zeitung*.

31. Erich Schlaikjer, "Kunst und Sozialdemokratie," *Der Kunstwart* 10, no. 3 (Nov. 1896): 45–46, reprinted from *Zeit: Organ für nationalen Sozialismus auf christlicher Grundlage*. On the ambivalent and troubled relationship between socialist workers and naturalist writers, see Vernon L. Lidtke, "Naturalism and Socialism in Germany," *American Historical Review* 79, no. 1 (1974): 14–37. Lidtke provides an account of the debate over naturalism and socialism from the Gotha congress, including lengthy quotations that confirm the use of the phrases cited in *Der Kunstwart*.

32. Fritz Hellway, "Die 'fliegenden' Kunsthändler," *Die Kunst für Alle* 26, no. 18 (June 1911): 418–25. Drey, *Die wirtschaftlichen Grundlagen der Malkunst*, 79–80, 227–28, gives further details on these practices. He points out that both Grützner and Corot were frequent victims of these forged "originals" and quotes Dr. Paul Clemen, who, in a lecture at the Städel Museum Society, reported that in America, where Corot was in great demand, one could find 15,000 Corot paintings, though he had painted only 7,000 in his lifetime.

33. Paul Schultze-Naumburg, "Ideen über den Studiengang des modernen Malers," *Zeitschrift für bildende Kunst* 31, n.s. 7 (1895–96): 27–40, reprinted with Avenarius's strong recommendation in *Der Kunstwart* 9, nos. 11–12 (Mar. 1896): 172–73, 184–87. For a useful collection of reports on the underclass in nineteenth-century Germany, see Klaus Bergmann, ed., *Schwarze Reportagen: Aus dem Leben der untersten Schichten vor 1914: Huren, Vagabunden, Lumpen* (Reinbek bei Hamburg, Germany: Rowohlt Taschenbuch Verlag, 1984).

34. For efforts to reconstruct the incomes and living standards of artists, see Robin Lenman's articles and books listed in the bibliography. See also Th. v. Frimmel, "Schwankungen der Bilderpreise," *Kunstchronik*, n.s. 7 (Apr. 1896): cols. 329–35.

35. Konrad Lange, "Ueber Bilderpreise," *Die Kunst für Alle* 18, no. 1 (Oct. 1902): 13–18; and [Wilhelm Bode] in *Der Kunstwart* 2, no. 4 (Nov. 1888): 58. Lange reiterated and expanded his position in two later articles, Konrad Lange, "Die Notlage unserer Maler," *Die Kunst für Alle* 27, nos. 12 (Mar. 1912): 278–86 and 14 (Apr. 1912): 324–30. Paret, *Berlin Secession*, 168–70, cogently analyzes the negative implications of the economic hardship for artists in the decades before World War I.

36. Drey, *Die wirtschaftlichen Grundlagen der Malkunst*, 84, 117, 133–34, 246–52. Although Drey's analysis focused on the first decade of the new century, his commentary provides valuable detail to augment the earlier reports cited in the text. He refers, for example, to a report from 1907 that more than forty thousand works of art had been offered for sale in one year in Munich alone. This, he wrote, was an art market in which artists' need was so great that many sold their paintings for less than the price of the frame; yet he also contended that prices for good middle-level paintings—anywhere from 200 to 1000 marks—were generally considerably higher than the prices for foreign works that came on the German market.

In addition, practical technical developments, such as factory-prepared paint in tubes or photographic aids, combined with the revolutionary changes in exhibitions that accompanied the new modern art styles, had resulted in much greater creative output by individual artists. Whereas thirty years earlier an artist could spend a year or more preparing a large, meticulously painted "exhibition painting," by the turn of the century artists routinely created works that were smaller, more rapidly painted, and roughly finished, works that older artists considered to be no more than preparatory sketches.

See also Carl Vinnen, *Noch mehr Künstlerelend? Auch ein Prolog zur Grundsteinlegung eines deutschen Künstlerhauses in Rom* (Zurich: Verlags Magazin, J. Schabelitz, 1894), reviewed in *Das Atelier* 4, no. 8 (Apr. 1894): 12–13; and by Pecht in *Die Kunst für Alle* 9, no. 18 (June 1894): 287. *Die Kunst für Alle* published a judiciously critical review when Vinnen's notorious brochure appeared, "Ein Protest Deutscher Künstler," ibid. 26, no. 18 (June 1911): 426–28, which coincidentally appeared right after the article on dishonest dealers and art factories. This was followed by "Die Antwort auf den 'Protest Deutsche Künstler,'" ibid. 27, no. 1 (Oct. 1911): 45–46, 50. For a description and analysis of the "Protest of German Artists" organized by Vinnen and its aftermath, see Paret, *Berlin Secession*, 182–99.

37. Carl Neumann, *Der Kampf um die Neue Kunst*, 2nd ed. (Berlin: Verlag von Hermann Walther, 1897), 36–39. The substantial book, not a pamphlet, appeared in a second edition in 1897. His argument about artists' pandering to the public or scorning them was developed in the first chapter, "Kunst und Publikum"; the quotations on modern art are from the chapter "Die gegenwärtige Lage." *Der Kunstwart* 10, nos. 7–8 (Jan. 1897): 108–9, 125–27, summarized the major arguments of the book.

38. J.S. [Jaro Springer], "Berlin," *Die Kunst für Alle* 7, no. 19 (July 1892): 299–300. For negative views of Preuschen's ability to generate publicity, see "Lose Blätter," *Der Kunstwart* 7, no. 7 (Jan. 1894): 109; and "Rundschau," ibid. 15, no. 10 (Feb. 1902): 505.

39. J.S. [Jaro Springer], "Berlin," *Die Kunst für Alle* 8, no. 12 (Mar. 1893): 186. His comment on Hitz appeared in his review of her works shown at the Eduard Schulte Art Salon, ibid., no. 13 (Apr. 1893): 202; another positive review of the show was by R. [Hans Rosenhagen], "Die Schulte'sche Ausstellung," *Das Atelier* 3, no. 57 (Mar. 1893): 5. Other reviews of women artists are Jaro Springer, "Die freie Berliner Kunstausstellung," *Die Kunst für Alle* 8, no. 20 (July 1893): 314; and J.S. "Berlin," ibid. 9, no. 14 (Apr. 1894): 220.

40. See Dr. Relling [Jaro Springer], *Die Kunst für Alle* 9, nos. 18–20 (June–July 1894): 280–82, 296–99, 312–15, comments on women artists on 314; and J.S. "Berlin," ibid. 11, no. 9 (Feb. 1896): 141. For further discussion of Hitz's work in these years, see =*=, "Berlin: Dora Hitz," ibid. 9, no. 14 (Apr. 1894): 218; Albert Dresdner, "Die Berliner Kunstausstellung 2," *Der Kunstwart* 7, no. 18 (June 1894): 281–82; and idem, "Aus Berlin," ibid. 8, no. 7 (Jan. 1894): 105. Referring to Hitz as the most decisively modern of all the women artists, Dresdner found her art somewhat bizarre and nervous but demonstrating a fine sense of color, reminding him of Hofmann. Her paintings were reproduced in *Die Kunst für Alle*; for example, *Dämmerung*, shown in the 1896 Berlin International, was reproduced in 11, no. 18 (June 1896): 284. See also Margrit Bröhan, "Dora Hitz (1856–1924), Malerin," in *Profession ohne Tradition: 125 Jahre Verein der Berliner Künstlerinnen*, by Berlinische Galerie, exh. cat. (Berlin: Kupfergraben, 1992), 49–57.

41. The review of the Gurlitt show is WO, "Berlin," *Die Kunst für Alle* 7, no. 17 (Jan. 1892): 110. Rosenberg's review of the 1890 Berlin Academy Exhibition is "Die Akademische Kunstausstellung in Berlin," *Zeitschrift für bildende Kunst* 25, n.s. 1 (1889–90): 330. The announcement of the medals awarded by the emperor for the Berlin exhibition was printed in *Die Kunst für Alle* 6, no. 3 (Nov. 1890): 46. The text provides only a brief list of the names

that appeared frequently in the journals. Of these, Parlaghy, Hitz, Clara Lobedan, and Hildegard Lehnert were chosen to represent Germany in the women's exhibition at the Columbian Exposition in Chicago in 1893. For biographical information on the women artists, see Sophie Pataky, ed., *Lexikon deutscher Frauen der Feder: Eine Zusammenstellung der seit dem Jahre 1840 erschienenen Werke weiblicher Autoren, nebst Biographieen der lebenden und einem Verzeichnis der Pseudonyme*, 2 vols. (Berlin: Carl Pataky Verlagsbuchhandlung, 1898; facsimile reprint, Bern: Herbert Lang, 1971); Neue Gesellschaft für Bildende Kunst e.V., Berlin, ed., *Das Verborgene Museum I. Dokumentation der Kunst von Frauen in Berliner öffentlichen Sammlungen*, exh. cat. (Berlin: Edition Hentrich, 1987); Berlinische Galerie, *Profession ohne Tradition*; and Verein der Berliner Künstlerinnen e.v., ed., *Käthe, Paula und der ganze Rest* (Berlin: Kupfergraben, 1992), a valuable listing with biographies of all of the women artists and friends of art who were members of the Verein der Berliner Künstlerinnen.

42. See reports on Parlaghy's painting in *Das Atelier* 1, no. 16 (June 1891): 10; Dr. van Eyck, "Die Berliner Jury und das Parlaghi'sche Moltke-Bildniss," ibid., no. 17 (July 1891): 1–3; and *.**, "Ein Bildnis des Generalfeldmarschalls Grafen von Moltke," *Kunstchronik*, n.s. 2 (July 1891): cols. 550–52.

43. A statement from the jury and the exhibition committee sent to the members of the Berlin artists' society was printed in full in ==, "Berlin," *Die Kunst für Alle* 6, no. 22 (Aug. 1891): 351–52; J.S. [Jaro Springer], "Berlin," *Die Kunst für Alle* 6, no. 20 (July 1891): 317. On Werner's possible role in the rejection, see Friedrich Freiherr von Khaynach, *Anton von Werner und die Berliner Hofmalerei* (Zürich: Verlags-Magazin, 1893), 33–34. Carola Muysers, "Warum gab es berühmte Künstlerinnen? Erfolge bildender Künstlerinnen der zweiten Hälfte des 19. Jahrhunderts," in Berlinische Galerie, *Profession ohne Tradition*, 32, discusses the bureaucratic hassle over payment.

44. "Berlin," *Die Kunst für Alle* 9, no. 21 (Aug. 1894): 330; "Berlin," ibid., no. 23 (Sept. 1894): 363; O.W., "Berlin," ibid. 10, no. 5 (Dec. 1894): 78; "Staatliche und Hofkunst," *Der Kunstwart* 8, no. 6 (Dec. 1894): 81–83; D.R. [Hans Rosenhagen], "Zur Lage," *Das Atelier* 4, nos. 18 (Sept. 1894) and 21–22 (Nov. 1894); C.M., "Berlin," *Die Kunst für Alle* 10, no. 12 (Mar. 1895): 186, reviewing Parlaghy's privately organized exhibition and concluding that she was a very talented, effective portraitist but that her work was changeable and not always reliable, proving that she was a woman. For further biographical information, see "Vilma Parlaghy," in Neue Gesellschaft für Bildende Kunst e.V., Berlin, *Das Verborgene Museum I*, 151–52.

45. "Yellow Brochure" was the popular name of a pamphlet written by Helene Lange, *Die höhere Mädchenschule und ihre Bestimmung* (Berlin, 1887); excerpts from the pamphlet are published in Susan Groag Bell and Karen M. Offen, eds., *Women, the Family, and Freedom: The Debate in Documents* (Stanford, Calif.: Stanford University Press, 1983), 150–55. Further information is provided by James C. Albisetti, *Schooling German Girls and Women: Secondary and Higher Education in the Nineteenth Century* (Princeton: Princeton University Press, 1988), chap. 4.

46. Meisenbach, "Vergangenheit, Gegenwart, und Zukunft," ibid. 86, no. 2180 (1887): 162, delineated the subordination of men to dominating women, a theme that became popular in the cartoons of the nineties. The tale of the art-loving landlady is by E. Henle, "Leiden und Freuden einer Vermietherin," ibid. 84, nos. 2118–21 (1886): 65–67, 74–75, 82–83. For other cartoons on women artists, see Emil Reinicke, "Naive Anschauung," *Fliegende Blätter* 80, no. 2013 (1884): 59; "Johann als Fliegenverscheucher," ibid. 85, no. 2151 (1886): 126; and "Unerklärlich," ibid. 87, no. 2204 (1887): 149.

47. H.M. [Henriette Mendelsohn], "Über Berliner Damenmalerei," *Die Kunst für Alle* 6, no. 4 (Nov. 1890): 49–52. A letter signed "A.E.," published a month later, protested against the article, saying that the difficulty women were facing in entering the art world was too serious to be handled in such a curious fashion. "A.E." wondered if it had been written by a woman or had been meant as a joke (A.E., "Zur Abwehr. Erwiderung auf den Artikel, 'Berliner Damenmalerei,'" ibid., no. 6 [Dec. 1890]: 96).

48. Debates over the value of dilettantism in the arts had a long history in Germany and gained in intensity as women moved into the professions. Lichtwark began early in his tenure at the Kunsthalle in Hamburg to promote dilettantism as a means of increasing appreciation and patronage for the visual arts. His 1887 brochure *Zur Organisation der Hamburger Kunsthalle*, about dilettantism as an essential aspect of producing a visually literate public, was endorsed by Avenarius in *Der Kunstwart* 1, no. 5 (Dec. 1887): 54–55.

Lichtwark's promotion of dilettantism as an appropriate learning method was unquestionably directed at affluent women in Hamburg who had the requisite leisure and means to engage in art-related activities. In 1894 he organized an exhibition of dilettante art created through the various lay art organizations that he had established in association with the Kunsthalle. Several publications accompanied this effort: Alfred Lichtwark, "Das Aufleben des Dilettantismus," *Der Kunstwart* 7, nos. 10–12 (Feb.–Mar. 1894): 153–54, 168–70, 187–88, reprinted from the *Hamburgischen Korrespondenten; Wege und Ziele des Dilettantismus* (Munich: Verl.-Anst. für Kunst und Wissenschaft, 1894), and *Vom Arbeitsfeld des Dilettantismus* (Dresden: Kühlmann, 1897). A response to Lichtwark's efforts was Dr. Hans Schmidkunz's "Der Dilettant," *Die Kunst für Alle* 11, no. 12 (Mar. 1896): 177–83, in which he elaborated at length upon a statement in Goethe's *Über den Dilettantismus* (1799) and concluded that dilettantism would have only deleterious results, producing superficial, imitative forms of inferior art.

For an analysis of the class and gender implications of Lichtwark's dilettantism, see Renate Berger, *Malerinnen auf dem Weg ins 20. Jahrhundert: Kunstgeschichte als Sozialgeschichte* (Cologne: DuMont Buchverlag, 1982), 58–149; and Marina Sauer, "Dilettantinnen und Malweiber: Künstlerinnen im 19. und 20. Jahrhundert," in Neue Gesellschaft für Bildende Kunst e.V., Berlin, *Das Verborgene Museum I*, 21–31. A careful exploration of the role of dilettantism in the formation of women's patronage of art is Susanne Jensen, "'Wo sind die wieblichen Mäzene. . . ?' Private Kunstförderung im 'Verein der Künstlerinnen und Kunstfreundinnen zu Berlin,'" in Berlinische Galerie, *Profession ohne Tradition*, 307–9.

49. Prof. Dr. Max Haushofer, *Die Ehefrage im Deutschen Reich* (Berlin: Richard Taendler Verlag, 1895), 70–72, presented a convincing analysis of the urban amenities offered to single men, who sustained a comfortable lifestyle at less expense and with less bother than would be required to support a household with a family. His analysis included a series of progressive arguments against solutions being proffered by persons who believed that women could marry if they chose, that unmarried women should remain celibate, or that a bachelor tax or law against male celibacy would solve the marriage question.

50. A basic study of the German women's movement is Ute Frevert, *Women in German History: From Bourgeois Emancipation to Sexual Liberation*, trans. Stuart McKinnon-Evans (Oxford: Berg, 1988), chap. 10. See also Elke Frederiksen, ed., *Die Frauenfrage in Deutschland, 1865–1915* (Stuttgart: Philipp Reclam jun., 1981); and Barbara Greven-Aschoff, *Die bürgerliche Frauenbewegung in Deutschland, 1894–1933* (Göttingen, Germany: Vandenhoeck & Ruprecht, 1981). Albisetti provides an extended treatment of the controversies over the education of women in *Schooling German Girls and Women*, chap. 4. An early study of education for women artists is J. Diane Radycki, "The Life of Lady Art Students: Changing Art Education at the Turn of the Century," *Art Journal* 42, no. 1 (1982): 9–13.

An invaluable source of documentation and essays on specific aspects of the history of the Berlin Society of Women Artists and Friends of Art is *Profession ohne Tradition: 125 Jahre Verein der Berliner Künstlerinnen*, organized by the Berlinische Galerie and the Verein der Berliner

Künstlerinnen in 1992, which includes a history of the society's school by Dietmar Fuhrmann and Klaus Jestaedt, "'. . . alles Das zu erlernen, was für eine erfolgreiche Ausübung ihres Berufes von ihnen gefordert wird . . .': Die Zeichen- und Malschule des Vereins der Berliner Künstlerinnen," 353–66, and Ulrike Krenzlin, "'auf dem ernsten Gebiet der Kunst ernst arbeiten': Zur Frauenausbildung im künstlerischen Beruf," 73–87. An announcement of the creation of a scholarship fund in Berlin to promote painting as a female profession was printed in "Berlin," *Die Kunst für Alle* 2, no. 2 (Oct. 1886): 32.

51. "Karlsruhe," ibid., no. 22 (Aug. 1887): 352, reporting on the second year of instruction at the Women's Art School in Karlsruhe, stated that the faculty recognized the need to give its students a strong systematic training in order to steer them away from the "dangerous feminine dilettantism" that was currently spreading through the visual arts. The Karlsruhe school had grown out of private art classes for women organized by Paul Borgmann, who held that women were as capable as men to become artists and argued that "die Malerinnen-Schule soll es als ihr vornehmstes Ziel betrachten, den Dilettantismus zu bekämpfen, die berufsmäßige ernste Arbeit mit aller Kraft zu fördern," quoted in Ulrike Grammbitter, "Die 'Malweiber' oder: Wer küßt den Künstler, wenn die Muse sich selbst küßt?" in *Kunst in Karlsruhe, 1900–1950*, by Staatliche Kunsthalle, exh. cat. (Karlsruhe, Germany: Verlag C. F. Müller, 1981), 27–28. A short report on the women's art schools from Karlsruhe in 1891 raised doubts about these goals. It encouraged art education for women but insisted that since their capacity for originality in art was limited, they should concentrate on the feminine decorative arts (P.S., "Karlsruhe," *Die Kunst für Alle* 6, no. 11 [Mar. 1891]: 174).

An informative article on the Union of Women Painters and Sculptors in Paris is Tamar Garb, "Revising the Revisionists: The Formation of the Union des Femmes Peintres et Sculpteurs," *Art Journal* 48, no. 1 (1989): 63–70. Her later, thorough study of women artists in Paris is *Sisters of the Brush: Women's Artistic Culture in Late Nineteenth-Century Paris* (New Haven, Conn.: Yale University Press, 1994). Reports from Berlin were published in O.W., "Berliner Verein der Künstlerinnen und Kunstfreundinnen," *Die Kunst für Alle* 5, nos. 1 (Oct. 1889): 32, 9 (Feb. 1890): 127, 11 (Mar. 1890): 174–75, and 14 (Apr. 1890): 222; and *Kunstchronik*, n.s. 1 (Feb. 1890): col. 234. An information-packed chronology is "Chronik des Vereins der Berliner Künstlerinnen, 1867–1992," in Berlinische Galerie, *Profession ohne Tradition*, 426–37.

52. Berlinische Galerie, *Profession ohne Tradition*, 432–37, provides extensive information about the Berlin Society of Women Artists and Friends of Art, including Günter Meyer, "Auf der Suche nach den historischen Stätten des 'Vereins der Berliner Künstlerinnen,'" 291–98, on the location of the society and its school. The women's balls in Berlin raised as much as 13,000 marks for scholarships. The society also held a Christmas fair, which provided additional substantial monies for scholarships and pensions. Sales of paintings at its exhibitions were not as profitable until 1898, when 17,000 marks' worth of art was sold. *Die Kunst für Alle* 14, no. 12 (Mar. 1899): 190, reported on the Munich carnival of 1899. A decade earlier, in September 1889, the journal published a double-page plate of a carnival scene by Josef Weiser, in which only women are shown costumed in seventeenth-century styles for male and female roles.

53. Membership figures for the Münchner Künstlergenossenschaft were reported in =, "München," ibid. 7, no. 14 (Apr. 1892): 220; "Verein der Künstlerinnen und Kunstfreundinnen zu Berlin," *Das Atelier* 2, no. 39 (June 1892): 9; =, "Berlin," *Die Kunst für Alle* 9, no. 3 (Nov. 1893): 45, announcing the opening of the new school in Berlin; and H. A. Lier, "Korrespondenz: Aus Dresden, Anfang November 1892," *Kunstchronik*, n.s. 4 (Nov. 1892): cols. 68–70, reviewing the Saxon women artists' exhibition in Dresden, with particular praise for the work of Hitz. On the Victoria Lyceum, see Albisetti, *Schooling German Girls and Women*, 117–21.

54. The census figures are published in Drey, *Die wirtschaftlichen Grundlagen der Malkunst*, table 1 and 2 and pp. 73–74. The figure on women artists exhibiting in Munich is in *Illustrirter Katalog der Münchener Jahresausstellung von Kunstwerken Aller Nationen im Kgl. Glaspalaste, 1894*, exh. cat. (Munich: Franz Hanfstaengl Kunstverlag, 1894).

55. Cornelius Gurlitt, "Marie Bashkirtseff und ihr Tagebuch," *Die Kunst unserer Zeit* 3, 1st half-vol. (1892): 61–74. Gurlitt based his account upon her diary, published in France in 1887; the German edition appeared later, *Tagebuch der Maria Bashkirtseff*, trans. Lothar Schmidt, vol. 1 (Breslau, 1897), vol. 2 (Oppeln, 1901). It was published in the United States as *The Journal of a Young Artist, 1860–1884*, trans. Mary J. Serrano (New York: Cassell and Co., 1889). On the conscious cultivation of scandal, fame, and the cult of the genius by women artists, see Muysers, "Warum gab es berühmte Künstlerinnen?" 31–34. Albert Lamm singled out Bashkirtseff's painting in his review of the 1898 exhibition of the Berlin Society of Women Artists and Friends of Art, *Der Kunstwart* 11, no. 11 (Mar. 1898): 366. For the influence of Bashkirtseff's aspiration and death upon a young German woman who, aspiring to be an artist, fled from her aristocratic family in Schleswig-Holstein to enter the sexually liberated artist circles in Munich, see Johann Albrecht von Rantzau, "Zur Geschichte der sexuellen Revolution: Die Gräfin

Franziska zu Reventlow und die Münchener Kosmiker," *Archiv für Kulturgeschichte* 56, no. 2 (1974): 402.

From a wealthy Russian family, Bashkirtseff studied in Paris at the Académie Julian, which she memorialized in a painting, now in the Hermitage, first exhibited under a pseudonym in 1881, reproduced in *Die Kunst für Alle* (15 Aug. 1899), that presented a scene in the women's studio with a live model modestly draped as a shepherd boy. The Académie Julian was one of the few that allowed women to work from live male models. Bashkirtseff won an honorable mention in the Paris Salon of 1883 for her painting *Jean and Jacques*, which was followed by other paintings of street urchins and unglamorous women caught in ordinary life. For several years before her death from consumption in 1884 she was closely associated with Bastien-LePage, twelve years her senior, who was at the height of his fame for his peasant paintings. His also untimely death came only a month after hers. In 1898 her painting *The Umbrella* was shown posthumously in the Berlin Society of Women Artists exhibition.

56. Georg Malkowsky, "Das moderne Weib," *Moderne Kunst* 9 (1895): 11 ("Die Aerztin"), 22–23 ("Sport und Arbeit"), 125 ("Die Malerin").

57. [Adolf Rosenberg], "Sammlungen und Ausstellungen," *Kunstchronik*, n.s. 3 (Feb. 1892): col. 266 and 5 (Mar. 1894): cols. 319–20.

58. Georg Voß, *Die Frauen in der Kunst* (Berlin: Richard Taendler Verlag, 1895), 215, reviewed and recommended to readers by Friedrich Pecht in *Die Kunst für Alle* 11, no. 14 (Apr. 1895): 223; Dora Hitz's letter appears on pp. 234–37 of Voss's book. *Die Kunst für Alle* 9, no. 14 (Apr. 1894): 218, has a notice of Hitz's opening a new school in Berlin.

This continuing concern over the inequities of the educational process for women art students was shown in other articles on the inadequacies of the whole art educational situation at that time. See Schultze-Naumburg, "Ideen über den Studiengang des modernen Malers," *Zeitschrift für bildende Kunst* 31, n.s. 7 (1895–96): 27–40; Dr. Georg Habich, "Alte und neue Akademien," *Die Kunst für Alle* 14, no. 22 (Aug. 1899): 337–45; and H.M. [Henriette Mendelsohn], "Pariser Studientage: Kollegialischer Ratgeber für Malerinnen und solche, die es werden wollen," ibid. 12, no. 10 (Feb. 1897): 150–53. Mendelsohn carefully critiqued all of the private academies in Paris that admitted women—the Académie Julian (for wealthy dilettantes, especially American), Colarossi (serious, for both women and men), Delecluse (weak), Vitti (the newest and best), Laurens & Aman-Jean (very chic)—but she urged women to get their studio training in Germany, where masters paid attention to talent, not payments. Then they should go to Paris to learn in museums

and dealers' galleries.

The list in Voß, *Die Frauen in der Kunst*, 237–44, includes artists from other European countries. In Germany, he singled out for recognition 97 names in Berlin, 26 in Munich, and 41 in twenty-two other cities. By medium in Berlin he named 42 portrait painters, 22 landscape painters, 28 still-life painters, and 5 sculptors; and in Munich, 13 portrait painters, 10 landscape painters, and 3 others.

59. *Der Kunstwart* 3, no. 10 (Feb. 1890): 155; Albert Dresdner, "Berliner Bericht," ibid. 9, no. 9 (Feb. 1896): 134. The exhibition reviewed by Dresdner was the same exhibit that Springer reviewed favorably in J.S., "Berlin," *Die Kunst für Alle* 11, no. 9 (Feb. 1896): 141. In ibid. 6, no. 21 (Aug. 1891): 335, Pecht reported that the faculty—Ludwig Herterich, Franz Simms, and Tina Blau-Lang—were producing students whose achievements were scarcely behind those of men in the academies. Given his critique of the academies, this may not have been praise. See also Pecht's very positive assessments of the growth, management, and instruction in the school run by the Society of Women Artists in Berlin in ibid. 10, no. 2 (Oct. 1894), and 11, no. 2 (Oct. 1895): 19.

Mrs. Ernest Hart, "Unterliegen die Frauen auf dem Gebiete der Kunst?" ibid. 10, no. 15 (May 1895): 234, praised a contemporary novel by Mrs. Humphrey Ward, *David Grieve*, in which a young artist torn between love and art gave up art to support her husband. This, she wrote, would always be the case; women were bound to follow a higher and more honorable calling to duty that meant they would always be defeated in the realm of art by the men. See also a book review in *Die Kunst für Alle* 9, no. 6 (Dec. 1893), supplement, 1, of Jeanne Mairet's *Eine Künstlerin*, the tale of a young female artist forced to leave her artist husband because of his jealousy over her talent. After long separation, however, they are reunited and live happily ever after, both as artists.

The statistics on family responsibilities of artists are not entirely comprehensible (see Drey, *Die wirtschaftlichen Grundlagen der Malkunst*, tables 4 and 5). Of the 969 women artists in Germany in 1895, 825, or 85 percent, were single, 57 were married, and 87 were divorced or widowed. However, even though the majority of them did not have a husband, they managed to have, on average, 6 to 7 family members each. The same statistics for male artists give a sharply different profile: among a total of 7,921 male artists, 50 percent of whom were single, only every third male lived with a family member other than his wife.

From these figures it is impossible to tell how many of the households were dependent upon the women artists for support or, conversely, how many of the women were supported by their families. What they do suggest is the great difficulty women artists faced in finding space or

time for their own work, whereas the men may have had fewer distractions. Drey's category "Familienangehörige" (family members) is divided into two groups: those under fourteen years and those fourteen years and over. Spouses were not included in this category. There is also no way of knowing, beyond the age, who was included in the category. Since an exceptionally large number of family members—4,955—of women artists were over fourteen, I assume that siblings, parents, and other older relatives were included in that number.

"Sabine Lepsius," in Neue Gesellschaft für Bildende Kunst e.V., Berlin, *Das Verborgene Museum I*, 153–54; Berger, *Malerinnen auf dem Weg ins 20. Jahrhundert*, 238–39; and Berlinische Galerie, *Profession ohne Tradition*, 64–65, all emphasize the burdens women artists faced within their marriages. Annette Dorgerloh, "Geniekult und Professionalisierung: Die Selbstinszenierung der Sabine Lepsius," in *Mythen von Autorschaft und Weiblichkeit im 20. Jahrhundert: Beiträge der 6. Kunsthistorikerinnen-Tagung, Tübingen 1996*, ed. Kathrin Hoffmann-Curtius and Silke Wenk (Marburg, Germany: Jonas Verlag, 1997), 130–45, carefully qualifies this view, arguing that Sabine Graef-Lepseus deliberately took upon herself the role of the professional artist and strong partner who provided the stability and bore the full financial responsibility within the marriage.

60. On the 1896 exhibition of the Berlin Society of Women Artists and Friends of Art, see O., "Berlin," *Die Kunst für Alle* 11, no. 13 (Apr. 1896): 204; on the 1898 exhibition, see Dr. R., "Berlin," ibid. 13, no. 12 (Mar. 1898): 188–89, and "Berliner Kunstbericht," *Deutsche Kunst* 2, no. 10 (Feb. 1898): 184–85; these reviews singled out the works of Graef-Lepsius, Ernestine Schultze-Naumburg, Hitz, Parlaghy, Begas-Parmentier, and Blau-Lang for special attention, but above all, they praised the graphics of Paczka-Wagner for demonstrating a heightened sense of form and a mastery of her material. The Berlin statistics are from Berlinische Galerie, *Profession ohne Tradition*, 434. Information on Munich is from Ludwig, *Kunst, Geld und Politik*, 62–63; and *Die Kunst für Alle* 15, no. 12 (Mar. 1900): 287.

61. See "München: Allgemeine Deutsche Kunstgenossenschaft," ibid. 12, no. 11 (Mar. 1897): 174. On Frau Weber-Petsche, see #, "München," ibid., no. 13 (Apr. 1897): 202; on Linda Kögel see "München," ibid. 13, no. 3 (Nov. 1897): 46.

Helen Zimmern was a successful writer of children's stories, author of studies on Schopenhauer and Lessing, and translator of *Tales from the Edda*, Firdusi's *Epic of Kings*, and Nietzsche's *Beyond Good and Evil* (into English). She began signing her own name to art reviews long before other women. Among her reviews were "Die neapolitanische Malerschule," *Die Kunst für Alle* 5, no. 6

(Dec. 1889): 81–88; and "Hubert Herkomer," ibid. 6, no. 1 (Oct. 1890): 1–11. She also contributed regularly to *Die Kunst unserer Zeit*, including the articles "Die moderne Kunst in Italien," 1 (1890): 74–82; "Sir John Everett Millais," ibid., 216–25; "Schottische Maler," 2, 1st half-vol. (1891): 90–101; "Alma Tadema," ibid., 2nd half-vol. (1891): 130–38; "Hubert Herkomer über Radierkunst," 3, 1st half-vol. (1892): 112–16; "George Frederick Watts," 4, 1st half-vol. (1893): 92–100; and "Lord Leighton †," 7, 1st half-vol. (1896): 97–106. She also wrote under the pseudonym Helene Zimmermann.

As a student of Franz Skarbina, Henriette Mendelsohn became both a painter and an art historian. Her early articles, published under only her initials, were critiques of dilettantism and women's art training in 1890 and 1896; these were followed by "Der junge Künstler von ehedem und heute," *Die Kunst für Alle* 6, no. 17 (June 1891): 265–67; and "Skandinavische Kunst, I–II," *Zeitschrift für bildende Kunst* 33, n.s. 9 (1897–98): 14–21, 35–47. The tribute "Franz Skarbina," ibid. 27, n.s. 3 (1892): 49–54, signed with the initials "hn," is quite likely hers. Articles written under her full name include "Die nördlichste Feste dänischer Kunst," *Die Kunst für Alle* 11, no. 21 (Aug. 1896): 324–26; "Die skandinavische Ausstellung in Stockholm, ein Rückblick," ibid. 13, no. 3 (Nov. 1897): 33–37; "Berliner Atelier Skizzen," ibid., no. 4 (Nov. 1897): 49–55; and "Das Kunstjahr 1897," ibid., no. 7 (Jan. 1898): 103–5. Under the name Henri Mendelsohn, she published *Böcklin: Geisteshelden*, Führende Geister: Eine Sammlung von Biographien, 40 (Berlin, 1901).

Anna L. Plehn published as "A. L. Plehn" until 1904, when she began to publish as "Anna L. Plehn." Although she was not a regular contributor to *Die Kunst für Alle*, her articles were substantive and sophisticated in their understanding of theoretical and technical aspects of painting and graphic arts: "Der moderne Kolorismus und seine Ankläger," *Die Kunst für Alle* 15, no. 11 (Mar. 1900): 243–48, in which she questioned an article on color by Karl Woermann in the *Zeitschrift für bildende Kunst* (Woermann responded to her article in the same issue of *Die Kunst für Alle*, 248); "Der Impressionismus und sein Ausgang," ibid. 17, nos. 6 (Dec. 1901): 121–26 and 7 (Jan. 1902): 154–59; "Käthe Kollwitz," ibid., no. 10 (Feb. 1902): 227–30 (one of the earliest articles devoted to Kollwitz); "Kombinationsdrücke," ibid., no. 15 (May 1902): 346–49; "Vom Wert des Neo-Impressionismus," ibid., 19, no. 22 (Aug. 1904): 514–22; "Der Kampf gegen den Bildinhalt," ibid., 21, no. 10 (Feb. 1906): 229–33; "Das Weiss in der deutschen Malerei des 19. Jahrhunderts," ibid., 22, no. 6 (Dec. 1906): 137–46. See also her "Clara Siewert als Zeichnerin," *Zeitschrift für bildende Kunst* 43, n.s. 19 (1907–8): 316. *Thieme-Becker*, vol. 17 (1933), records two women artists at the time with the same last name: Rose Plehn (born 1865), a portrait painter who studied

with Carl Gussow and Ludwig Herterich; and Alice Plehn, a landscape painter living in Berlin.

Anna Spier wrote as "A. Spier" the following in *Die Kunst unserer Zeit*: "Hermann Kaulbach," 4, 1st half-vol. (1892): 1–10; "Jakob Emil Schindler," ibid., 2nd half-vol. (1893): 1–20; "Anton Burger," 5, 2nd half-vol. (1894): 57–80; "Die Ausstellung der Münchener Secession 1894," ibid., 91–104; and "Franz von Lenbach," 6, 1st half-vol. (1895): 78–100. As Frau Dr. Anna Spier she wrote "Hans Thoma," ibid. 11, 1st half-vol. (1900): 61–112. Among her articles was an essay titled "Franz Stuck," published first in *Westermann's Illustrierte Deutsche Monatshefte* 38, half-vol. 76 (Aug. 1894): 545–63, and then as a separate publication. She is listed simply as living in Frankfurt am Main, with no further information, in Pataky, *Lexikon deutscher Frauen der Feder*, vol. 2.

Helene Vollmar began writing as an art critic in 1885 for the *Norddeutschen Allgemeinen Zeitung*. Until 1896 her articles were signed simply "V." Among her articles published under "H. Vollmar" were "Menzel," *Moderne Kunst* (1896), special issue celebrating his eightieth birthday; "Peter Janssen," *Die Kunst für Alle* 13, no. 14 (Apr. 1898): 209–15; "Friedrich Geselschap," ibid. 14, no. 10 (Feb. 1899): 145–49; "Hermann Prell's Wandgemälde im Palazzo Caffarelli zu Rom," ibid. 15, no. 8 (Jan. 1900): 173–80; and "Das Treppenhaus im Dresdener Albertinum," *Zeitschrift für bildende Kunst* 39, n.s. 15 (1903–4): 110–13. For further information about her work with a variety of women's organizations, see Pataky, *Lexikon deutscher Frauen der Feder*, vol. 2.

62. †, "Berlin," *Die Kunst für Alle* 9, no. 17 (June 1894): 267. Richard Mortimer also devoted considerable, positive attention to women artists from Berlin in his review, "Die Berliner Kunstausstellung im Landesausstellungsgebäude," ibid. 14, no. 19 (July 1899): 297–98. In *Kunstchronik*, n.s. 10 (Apr. 1899): cols. 346–47, among the artists singled out for praise were Olga von Boznnska, Gerresheim, Rose Plehn-Lubochin, Kollwitz, Margarethe von Kurowski, and Siewert.

63. Dr. Georg Habich, "Alte und neue Akademien," *Die Kunst für Alle* 14, no. 22 (Aug. 1899): 344–45.

64. Recently formed artist pension and welfare societies included one that opened in Eisenach in 1893, as well as one formed in Weimar in 1894. A number of welfare societies had been formed in the hard times of 1844 and 1845. For information on the three societies formed in Berlin (1844), in Munich (1845), and in Düsseldorf (1844), see Grossmann, *Künstler, Hof und Bürgertum*, 164–66. All of these organizations had periodic reports in *Die Kunst für Alle*; see. e.g., the notes on efforts in both Düsseldorf and Weimar in 1893 and 1894 to raise funds through artist festivals for needy artists and their widows

suffering from the current poor economic situation in vols. 8, nos. 20 (July 1893) and 22 (Aug. 1893); and 9, nos. 3 (Nov. 1893), 18 (June 1894), 21 (Aug. 1894), and 23 (Sept. 1894). See also Lenman, "Community in Transition," 12.

65. H.M. [Henriette Mendelsohn], "Der junge Künstler von ehedem und heute," *Die Kunst für Alle* 6, no. 17 (June 1891): 265. On Makart, see K[arl] v[on] Vincenti, "Zum zehnten Todestage Hans Makarts," ibid. 10, no. 2 (Oct. 1894): 17–20; and Klaus Gallwitz, *Hans Makart: Triumph einer schöne Epoche* (Baden-Baden, Germany: Staatliche Kunsthalle, 1972).

On Defregger, see Ludwig Pietsch, "Franz von Defregger," *Die Kunst unserer Zeit* 6, 2nd half-vol. (1895): 3–14; "Franz von Defregger," *Der Kunstwart* 8, no. 15 (May 1895): 233–34; and Friedrich Pecht, "Franz von Defregger: Zu seinem 60. Geburtstag, am 30 April 1895," *Die Kunst für Alle* 10, no. 14 (Apr. 1895): 209–13, with photographs of the artist in his studio, house, and summer house. Considering Defregger, who was ennobled in 1883, to be one of the great contemporary painters, with his portrayals of Tirolean peasant uprisings from the Napoleonic era, Pecht reproduced his paintings frequently in the first decade of the journal.

On Grützner, see Friedrich Pecht, "Eduard Grützner," ibid. 5, no. 12 (Mar. 1890): 177–82; and Heinrich Rottenburg, "Eduard Grützner," *Die Kunst unserer Zeit* 9, 1st half-vol. (1898): 33–56. See also Lenman, *Die Kunst, die Macht, und das Geld*, 124–27. Decades later, Grosz, the visual chronicler of life in the Weimar Republic, wrote of his childhood fascination with Grützner's monks and his determination to become a genre painter following in Grützner's footsteps, see George Grosz, "Jugenderinnerungen," *Das Kunstblatt* 13, nos. 6 (June 1929): 170 and 7 (July 1929): 197; and *George Grosz: An Autobiography* (1955), trans. Nora Hodges (New York: Macmillan/Imago, 1983), 10, 52.

66. Georg Habich, "Friedrich August von Kaulbach," *Die Kunst für Alle* 15, nos. 1–2 (Oct. 1899): 1–10, 25–35; Carl von Lützow, "Ein Besuch bei Lenbach," *Kunstchronik*, n.s. 1 (Oct. 1889): cols. 1–3, describing the studio, accompanied by current portraits of Bismarck, Moltke, Gladstone, and Prince Hohenlohe.

67. For contemporary tributes and assessments, see A[nna] Spier, "Franz von Lenbach," *Die Kunst unserer Zeit* 6, 1st half-vol. (1895): 78–100; F[ritz] v[on] Ostini, "Lenbach in der Kunst des 19. Jahrhunderts," *Zeitschrift für bildende Kunst* 39, n.s. 15 (1903–4): 195–97; Theodor Schreiber, "Franz von Lenbach: Eine Gedächtnisrede," ibid. 40, n.s. 16 (1905–6): 127–36; Pecht, "Franz von Lenbach: Zu seinem 50. Geburtstage am 13. Dezember 1886," *Die Kunst für Alle* 2, no. 6 (Dec. 1886): 81–86; H. E. v. Berlepsch, "Zu

Franz von Lenbachs sechzigstem Geburtstage," ibid. 12, no. 5 (Dec. 1896): 65–70; Franz Wolter, "Franz von Lenbach," ibid. 18, no. 1 (Oct. 1902): 1–10; "Franz von Lenbach's Künstlerisches Credo: Ein Selbstbekenntnis des Meisters," ibid., 21–22; Franz Wolter, "Franz von Lenbach, 1836–1904," ibid. 19, no. 17 (June 1904): 391–400, all of which were accompanied by reproductions of Lenbach's portraits and sketches that filled the respective issues.

On Lenbach's heroic Bismarck portraits, see Pecht, "Bismarck und die deutsche Kunst," ibid. 14, no. 12 (Mar. 1899): 181–82. For thorough treatment of Lenbach's career and relationship with royalty, see Sonja von Baranow, *Franz von Lenbach: Leben und Werk* (Cologne: DuMont Buchverlag, 1986); Sonja Mehl, *Franz von Lenbach in der Städtischen Galerie im Lenbachhaus München* (Munich: Prestel Verlag, 1980); and Winfried Ranke, "Franz von Lenbach 1836–1904," in *Franz von Lenbach, 1836–1904*, ed. Rosel Gollek and Winfried Ranke, exh. cat. (Munich: Prestel Verlag, 1987), 24–40.

68. Georg Fuchs, *Sturm und Drang in München um die Jahrhundertwende* (Munich, 1936), 140–46, cited in Johanna Eltz, "Der große Bilderdiebstahl oder das 'originale' Fälschen," in Gollek and Ranke, *Franz von Lenbach*, 139; Eltz provides a careful analysis of the trials. The Panama Canal scandal had broken two years earlier, in 1892, when the French newspaper *La Libre Parole* ran a series of articles exposing the corruption and bankruptcy of the French company. Notes on the Lenbach scandal in the art journals appeared in *Das Atelier* 3, no. 74 (Nov. 1893): 9; *Die Kunst für Alle* 9, no. 6 (Dec. 1893): 95, reporting that one Munich dealer had sold more than 54,000 marks' worth of stolen or counterfeited sketches; and =, "München," ibid. 11, no. 6 (Dec. 1895): 95, reporting on the second trial against the four Munich art dealers who were involved in the handling of the stolen art and two men charged with forging Lenbach's signature. The report ended with a lengthy statement by an assembly of Munich artists calling for a legal definition and defense of the artist's signature. See also Xs, "Zum Lenbachprozess," *Der Kunstwart* 9, no. 4 (Nov. 1895): 61.

69. On Lenbach's use of photography in his portraits, see Jul. Raphaels, "Die Photographie für Maler," *Die Kunst für Alle* 12, no. 22 (Aug. 1897): 361–63; and J. A. Schmoll gen. Eisenwerth, "Lenbach und die Photographie," in Gollek and Ranke, *Franz von Lenbach*, 63–75. For photographs and analysis of Lenbach's use of frames, see Eva Mendgen, *In Perfect Harmony: Picture and Frame, 1850–1920* (Zwolle, Netherlands: Waanders, 1995), 29–42; and for prices and honors, see Mehl, *Franz von Lenbach*, 29–33, 38–40.

70. For information about the Munich artists' social club Allotria, see H. E. von Berlepsch, "Allotria," *Die Kunst für Alle* 9, no. 1 (Oct. 1893); almost the entire issue was dedi-

cated to this long article with caricatures, cartoons, and programs created by the artists. See also Andreas Haus, "Gesellschaft, Gesellikeit, Künstlerfest: Franz von Lenbach und die Münchner 'Allotria,'" in Gollek and Ranke, *Franz von Lenbach*, 99–116.

71. Articles on festivals in the first volume of *Die Kunst für Alle* (1885–86) included K[arl] von Perfall, "Die Achenbach-Feier in Düsseldorf," 17–20; Georg Voß, "Die Berliner Menzel-Feste," 101–3; "Das Winterfest der Münchener Künstler," 166–73, with many drawings of the festivities; Georg Voß, "Das griechische Fest im Berliner Ausstellungspark," 287–91; "Ein Sommerfest im Malkasten," 304; and Paul Schumann, "Sommerfest des Künstlervereins 'Mappe,'" 352. For information on the Düsseldorf artists' festivals, see "Im 'Malkasten' zu Düsseldorf," ibid. 9, no. 10 (Feb. 1894): 145–51; "Die Jubiläumsfeier des Künstlervereins 'Malkasten,'" ibid. 13, no. 21 (Aug. 1898): 326–29; and "Düsseldorfer Malkasten," *Moderne Kunst* 12 (1898).

72. On Munich festivals, see H. E. von Berlepsch, "Allerlei," *Die Kunst unserer Zeit* 2, 1st half-vol. (Feb. 1891): 37–43; F.W., "Märchen und Sage: Ein Fest der Münchener Akademiker," *Die Kunst für Alle* 8, no. 13 (Apr. 1893): 194–98; and M.H., "Die Münchener Künstlerfeste im Sommer 1893," ibid., no. 21 (Aug. 1893): 328–30. =, "München," ibid. 11, no. 11 (Mar. 1896): 175, described the scenes of the "Underworld"; and *Jugend* 1, no. 8 (Feb. 1896), featured the festival of the "Underworld" with a series of satirical stories and caricatures.

73. For a carefully differentiated study of the nineteenth-century German love affair with the Classical world, see Suzanne L. Marchand, *Down from Olympus: Archaeology and Philhellenism in Germany, 1750–1970* (Princeton: Princeton University Press, 1996), esp. chaps. 4 and 5. Fürtwangler's books were *Meisterwerke der griechischen Plastik* (1893) and *Denkmäler griechischer und römischer Skulptur* (1898).

74. "Das Münchner Künstlerfest 1898," *Die Kunst für Alle* 13, no. 13 (Apr. 1898): 193–200, illustrated with postcards, posters, and photographs made of the event. For further details of the preparations and photographs of the costumes and set designs, see Theodor Pixis, "Wie ein Künstlerfest gemacht wird," *Kunst und Handwerk* 47, no. 8 (1897–98): 269–84. For analysis and photographs, see Andreas Haus, "Gesellschaft, Gesellikeit, Künstlerfest" and "Künstlergesellschaften und Künstlerfeste," in Gollek and Ranke, *Franz von Lenbach*, 111–14 and 431–84, respectively.

75. Paul Schultze-Naumburg, "Münchener Bericht: International Kunstausstellung," *Der Kunstwart* 10, no. 19

(July 1897): 297–99. Lenman points out that the entrance prices for the festivals ranged up to fifty marks, which was beyond the financial ability of most artists (*Die Kunst, die Macht, und das Geld*, 139).

76. The tribute to Stuck was by Carl von Lützow, "Franz Stuck," *Zeitschrift für bildende Kunst* 30, n.s. 6 (1894–95): 20–25, reviewing Otto Julius Bierbaum, *Franz Stuck* (Munich: Verlag von Dr. E. Albert & Co., 1893). Another important article, richly illustrated with his major paintings, was by A[nna] Spier, "Franz Stuck," *Westermann's Illustrierte deutsche Monatshefte* 38, half-vol. 76 (Aug. 1894): 545–63. Heinrich Voss, in his systematic study of Stuck, *Franz von Stuck, 1863–1928: Werkkatalog der Gemälde mit einer Einführung in seinen Symbolismus* (Munich: Prestel Verlag, 1973), presents an exhaustive psychological analysis of the erotic symbolism and function of Stuck's mythological images in the social milieu of the 1890s. He also includes a biographical chronology listing all the honors and awards Stuck received, as well as a thorough catalogue of his work.

Examples of cartoons based on Stuck's images are A[dolf] Hengeler, "Die Centauren-Schwiegermutter," *Fliegende Blätter* 101, no. 2564 (1894): 108; M[ax] Feldbauer, "Oedipus v. die Sphinx," *Jugend* 2, no. 6 (Feb. 1897): 97; ibid. 1, no. 19 (May 1896): back cover; and "Die Colonialsphinx (nach Stuck)," *Kladderadatsch* 57, no. 17 (Apr. 1904), supplement.

77. For fables and novels based on Stuck's *The Sin*, see Ernst Rosmer, "Die Sünde: Ein Märchen zu dem Bilde von Franz Stuck," *Die Kunst unserer Zeit* 5, 1st half-vol. (1894): 34–36; and Max Bernstein, "Schlangenspiel," ibid. 4, 1st half-vol. (1893): 79–81. A review of Anton von Perfall's *Die Sünde* (2nd ed., Berlin: R. Eckstein, 1896) appeared in *Die Kunst für Alle* 11, no. 14 (Apr. 1896): 223. Anton von Perfall also had serialized novellas in *Moderne Kunst* 11 (1897) and *Die Kunst für Alle* 14 (1898). For a sample of the advertisements for the novel with a reproduction of the painting, see *Jugend* 1, nos. 40 (Oct. 1896): 651 and 48 (Nov. 1896): 782. Peter-Klaus Schuster argues convincingly that Stuck's *Sin* was also the inspiration for Mann's imaginary painting in *Gladius Dei* (1901) that drove the young monk to his Savonarola-like actions against the decadence of Munich (Schuster, "'München leuchtet,'" in *"München leuchtete": Karl Caspar und die Erneuerung christlicher Kunst in München um 1900*, ed. Schuster, exh. cat. [Munich: Prestel Verlag, 1984], 35).

The rivalry between Lenbach and Stuck inspired a wicked caricature and satire of Lenbach's life in a mock obituary in "Kunstmaler aus Deutschland," *Jugend* 2, no. 9 (Fasching 1897): 143, with drawings by Arpad Schmidhammer, that ended with the artist dying after hearing that his notorious secessionist rival had been called to be a pro-

fessor at the Dingsda Academy. Parodies of Lenbach and the Munich art scene appeared fairly often in *Jugend*, for example, "Der berühmte Wiedehopf," ibid. 1, no. 16 (Apr. 1896): 254–55; and "Doktor Franz Ritter von Lenbach," in a drawing with poems under the title "Münchner Kunstausstellung 1897," ibid. 2, no. 32 (Aug. 1897): 544.

78. Herbert Hirth, "Villa Stuck," *Die Kunst für Alle* 14, no. 19 (July 1899): 289–93. Franz Hermann Meissner, "Franz Stuck: Ein modernes Künstlerbildness," *Die Kunst unserer Zeit* 9, 1st half-vol. (1898): 1–33, was later published as *Franz Stuck* (Berlin: Schuster & Loeffler, 1899). Of the first five artists honored in the series, Stuck was the youngest, followed by Klinger, Uhde, Thoma, and Böcklin; Defregger, G. F. Watts, and Menzel were featured in the next three volumes. The books were issued and reissued in editions of nine thousand copies. The consecutive lead articles were Fritz von Ostini, "Franz Stuck," *Die Kunst für Alle* 19, nos. 1–2 (Oct. 1903): 1–7, 33–40. The painters who had already received two consecutive lead articles were Uhde (1886), Liebermann (1887), Klinger (1894), and the director of the Munich Academy of Art, F. A. Kaulbach (1899).

For later articles, see Georg Jacob Wolf, "Franz von Stuck," ibid. 26, no. 1 (Oct. 1910): 1–13, with plates; and Fritz von Ostini, "Neue Arbeiten von Franz von Stuck," ibid. 31, no. 1 (Oct. 1915): 1–9. It is worth noting that in the last article, written in the second year of World War I, Ostini felt it necessary to defend Stuck against charges that he was not German enough. He argued that Stuck's lifelong search for the soul of Classical Greece was what made him profoundly German.

For excellent photographs of Stuck's meticulously framed paintings against the backdrop of his studio, see Mendgen, *In Perfect Harmony*, 97–112. Further biographical information can be found in Eva Mendgen, *Franz von Stuck, 1863–1928* (Munich: Benedikt Taschen Verlag, 1994); Horst Ludwig, *Franz von Stuck und seine Schüler: Gemälde und Zeichnungen*, exh. cat. (Munich: Villa Stuck, 1989); and Gabriele Kolber, ed., *Die Villa Stuck in München: Inszenierung eines Künstlerlebens* (Munich: Bayerische Vereinsbank, 1992).

79. Berlin, however, did not lack artists with heavily decorated, luxuriant studios, some of whom were closely associated with the court (see Henriette Mendelsohn, "Berliner Atelier Skizzen," *Die Kunst für Alle* 13, no. 4 [Nov. 1897]: 49–55, for photographs of studios belonging to Paul Meyerheim, Eugen Bracht, Franz Skarbina, and Max Koner).

80. Werner's relationship to the court as an aspect of the liberal bourgeois accommodation to the united empire is analyzed in Peter Paret, *Art as History: Episodes in the Culture and Politics of Nineteenth-Century Germany* (Princeton: Princeton University Press, 1988), chap. 5.

81. The article that began the controversy was Wilhelm Bode, "Die Berliner Akademie: Gedanken bei der Feier ihres 200 Jaehrigen Bestehens," *Pan* 2, no. 1 (June 1896): 45–48, followed by Werner's response in *Deutsche Revue* 33 (1897): 64–92; both men then delivered counterattacks in the respective journals. Pecht commented upon the exchanges between Bode and Werner in a brief note in which he reaffirmed his view of the importance of Werner's paintings of contemporary historical events (*Die Kunst für Alle* 12, no. 11 [Mar. 1897]: 174). For details of this controversy and reproductions of Werner's many paintings of the royal family and court affairs, see Dominik Bartmann, *Anton von Werner: Zur Kunst und Kunstpolitik im Deutschen Kaiserreich* (Berlin: Deutscher Verlag für Kunstwissenschaft, 1985), 236–41.

82. Paul Schumann, "Anton von Werner and Wilhelm Bode," *Der Kunstwart* 10, no. 20 (July 1897): 332–34, including the report from the *Tägliche Rundschau*. Werner's election was reported in *Die Kunst für Alle* 14, no. 24 (Sept. 1899): 379. For information and illustrations of the caricatures attacking and celebrating Werner, see Britta Kaiser-Schuster, "Anton von Werner in der Karikatur," in *Anton von Werner: Geschichte in Bildern*, ed. Dominik Bartmann, exh. cat. (Munich: Hirmer Verlag, 1993), 110–17.

83. Liebermann's retrospective was singled out as the best part of the exhibition by Paul Schultze-Naumburg, "Die Große Berliner Kunstausstellung," *Die Kunst für Alle* 12, no. 18 (June 1897): 281–84, as well as by Albert Dresdner, "Berliner Bericht: Die Berliner Kunstausstellung, I," *Der Kunstwart* 10, no. 17 (June 1897): 267. W.O., "Berlin," *Die Kunst für Alle* 11, no. 10 (Feb. 1896): 155, reported that Liebermann had been named a Knight of the French Legion of Honor and that the Luxembourg Museum had purchased his *Biergarten in Brandenburg*. Liebermann's receiving the great gold medal was reported by *Kunstchronik*, n.s. 8 (June 1897): col. 442; and by H. S., "Berlin," *Die Kunst für Alle* 12, no. 20 (Aug. 1897): 328; and his receiving the title of professor and his election to the academy were announced in ibid. 13, no. 12 (Mar. 1898): 188.

84. On Liebermann's position in the Berlin art world, see Marion Deshmukh, "'Politics Is an Art': The Cultural Politics of Max Liebermann in Wilhelmine Germany," in *Imagining Modern German Culture: 1889–1910*, ed. Françoise Forster-Hahn (Washington, D.C.: National Gallery of Art, 1996), 165–83; idem, "Max Liebermann, ein Berliner Jude," in *Max Liebermann—Jahrhundertwende*, ed. Angelika Wesenberg, exh. cat. (Berlin: Ars Nicolai, 1997), 59–64; and essays in Emily D. Bilski, ed., *Berlin Metropolis: Jews and the New Culture, 1890–1918*, exh. cat. (Berkeley: University of California Press, 1999). On the sale of the paintings, see Erich Hancke, *Max Liebermann: Sein Leben und seine Werke*, 2nd ed. (Berlin: Bruno Cassirer, 1923), 175. Margreet Nouwen, "Vom 'Apostel des Hässlichen' zum Porträtmaler des Bürgertums," in Wesenberg, *Max Liebermann*, 239–44, analyzes his turn to portraiture in the 1890s and points out that, not counting those of his own family, he completed more than two hundred portraits, the subjects for more than half of which were drawn from the high bourgeois Jewish community. On the commissioning and controversial reception of the portrait of the mayor of Hamburg, see Caroline Kay, "The Petersen Portrait: The Failure of Modern Art as Monument in Fin-de-Siècle Hamburg," *Canadian Journal of History* 32 (Apr. 1997): 56–75. On Liebermann's paintings of his garden villa, see Anna Teut, *Max Liebermann: Gartenparadies am Wannsee* (Munich: Prestel Verlag, 1997).

85. Georg Buss, "Die Berliner Kunstausstellung 1897," *Moderne Kunst* 11 (1897), supplement. A similar assessment was published by Georg Malkowsky in "Die Separat-Ausstellungen des Berliner Kunstausstellung," *Deutsche Kunst* 1, no. 44 (July 1897): 520–21, in which the emphasis was upon Liebermann's individuality and ability, which lifted him above any movement or tendentious position. Later in the year, *Deutsche Kunst* 2, no. 3 (Nov. 1897), published two substantial articles by Henriette Mendelsohn and Carl Langhammer on Liebermann, accompanied by illustrations of a dozen paintings and studies.

86. Hans Rosenhagen, "Max Liebermann, *Die Kunst für Alle* 19, no. 7 (Jan. 1904): 153–59. Richard Mortimer, "Berliner Kunstbrief," ibid. 14, no. 7 (Jan. 1899): 100, emphasized both Liebermann's influence and his uniqueness in a review of the first exhibition at the Cassirer Gallery in 1899, in which he asserted that "Liebermann ist eine Erscheinung für sich, schwer unfügbar, anziehend mit seinem genialen Qualitäten samt Schwächen," and concluded, "So wie er ist, ist er eine Persönlichkeit, auf die die deutsche Kunst stolz sein könnte." See also Paul Schultze-Naumburg, "Neues von Max Liebermann," ibid. 16, no. 7 (Jan. 1901): 155–58.

87. Herman Helferich [Emil Heilbut], "Studie über den Naturalismus und Max Liebermann," *Die Kunst für Alle* 2, no. 15 (May 1887): 226; idem, "Studie über den Naturalismus und Max Liebermann," ibid. 12, no. 15 (May 1897): 225–28. Heilbut's unequivocal evaluation of Liebermann as the most important artist within the new art brought an angry response from Uhde. In his 1887 article, Heilbut had ranked Uhde, as a more masterful painter, alongside Liebermann as a leader of the new naturalism. In this 1897 article Heilbut acclaimed Liebermann as the great rock upon which the new movement in art still rested, while claiming that Uhde, who had once been important, had collapsed into a rotten pile. Enraged by this

condemnation, Uhde became an increasingly bitter and difficult man.

While the stature of Lenbach, Werner, and Stuck within the art world after 1905 rapidly diminished, Liebermann's stature as an artist and statesman within the art world rose, culminating years later in his unanimous election as president of the Prussian Academy of Arts—one of the hopeful signs in the fragile new German republic in 1920. For an indication of the fundamental shift that had occurred in the twenty years since Heilbut's first lengthy assessment of Liebermann in 1887, see J. Meier-Graefe, "Max Liebermann," ibid. 22, no. 8 (Jan. 1907): 177–90, praising Liebermann extravagantly, discussing his development as a continuous process of simplification that led to the complete unity of his work and comparing him to the best of the French modernists. Then, instead of showing the nervousness about Liebermann's Jewishness that was present in Heilbut's analysis, Meier-Graefe credits his rigorous talent to his Jewish heritage, saying that his descent from businessmen and his wealth had given him material independence, "das elastische Sprungbrett modernen, notwendig isolierten Künstlertums."

For a discerning assessment of Liebermann's position in Germany as a modern German artist, a prominent Jew, and a high functionary in the art world, see Peter Paret, "The Enemy Within"—Max Liebermann as President of the Prussian Academy of Arts," Leo Baeck Memorial Lecture 28 (New York: Leo Baeck Institute, 1984), trans. Tilmann von Stockhausen under the title "Der innere Feind: Max Liebermann als Präsident der Preußischen Akademie der Künste," in Wesenberg, Max Liebermann, 65–74.

Part III, Chapter 5
Modern Art for an Elite Public

1. Friedrich Pecht, "Zum Beginn des zehnten Jahrgangs," *Die Kunst für Alle* 10, no. 1 (Oct. 1894): 1.

2. Jaro Springer, "Die Ausstellung der 'XI,'" ibid. 11, no. 14 (Apr. 1896): 211. Articles analyzing the challenge to the naturalism of Liebermann and Uhde by the neo-idealism of younger artists appeared frequently at this time. For a thoughtful example, see Henriette Mendelsohn, "Das Kunstjahr 1897," ibid. 13, no. 7 (Jan. 1898): 103–5.

In 1898 Jaro Springer, who had reported from Berlin since 1890, wrote his last major review for *Die Kunst für Alle*, covering the 1898 Great Berlin Art Exhibition, which he described as "the poorest we have ever had." See Dr. J. Relling [Jaro Springer], "Die große Berliner Kunstausstellung," *Die Kunst für Alle* 13, nos. 22 (Aug. 1898): 340–41 and 23 (Sept. 1898): 353–54; and idem, "Berliner Brief," ibid. 14, no. 2 (Oct. 1899): 27. With his alter ego Dr. Relling—useful when he had two major reports in the same issue—he continued to write occasional notes

from Berlin. Mortimer took over as the Berlin correspondent in January 1899. Springer's obituary reported that he served as curator of the Kupferstichkabinett for more than thirty years before his death on the eastern front in August 1915. The journal credited him with being one of its first critics to recognize and support Liebermann, Klinger, and the new artists (ibid. 31, no. 1/2 [Oct. 1915]: 40).

Unlike Springer, Heilbut enthusiastically continued to support the new ideas, which he believed were sweeping across Germany, Belgium, France, and England. Although these symbolist ideas might bring changes to naturalism, he was certain that Liebermann would continue to be ranked at the forefront (Herman Helferich [Emil Heilbut], "Etwas über die symbolistische Bewegung," ibid. 10, no. 3 [Nov. 1894]: 33–37).

3. Max Liebermann, "Reden zur Eröffnung von Ausstellungen der Berliner Sezession," in *Die Phantasie in der Malerie: Schriften und Reden*, ed. Günter Busch (Frankfurt am Main: S. Fischer, 1978), 170–71, translation from Peter Paret, *The Berlin Secession: Modernism and Its Enemies in Imperial Germany* (Cambridge: Harvard University Press, 1980), 166. Liebermann's statement came from his address opening the second annual Berlin Secession exhibition in the spring of 1900. Although Nietzsche's phrase "Umwertung aller Werte" was not utilized as a subtitle until his posthumously published *Der Wille zur Macht. Versuch der Umwertung aller Werte* (1901), Liebermann's reference to "die fortwährende Umwertung der Kunstwerke" is surprising evidence of the rapidity in which catchwords from Nietzsche entered into contemporary language.

4. An outspoken champion of the modernists and a collector of French Impressionist art, Julius Elias, in his review "Die VI. Internationale Kunstausstellung in München," *Der Kunstwart* 6, no. 2 (Oct. 1892): 26, claimed that Schlittgen's rich colorist paintings were underestimated.

One of seventeen Toorop paintings in the 1893 exhibition, *The Three Brides* created enough of a stir and public debate that Pecht featured it, along with a lengthy explanatory statement by the artist, as one of the full-page plates accompanying his review of the exhibition, "Jahresausstellung 1893 der Künstlergenossenschaft zu München," *Die Kunst für Alle* 9, no. 3 (Nov. 1893): 34–35. *Die Kunst unserer Zeit* 4, 2nd half-vol. (1893): 97, also published a reproduction of the painting. Alfred Freihofer, "Die Münchner Kunstausstellungen," *Der Kunstwart* 6, no. 24 (Sept. 1893): 378, singled out the paintings of Toorop and Khnopff, along with those of the Scandinavians, as the most modern in the otherwise displeasing Glass Palace exhibition. Soon thereafter, in a review of Symbolist art at Gurlitt's gallery, Jaro Springer speculated that the Buddhist influence upon Toorop's paintings might presage an enrichment of European art (Dr. R., "Berlin,"

Die Kunst für Alle 9, no. 10 [Feb. 1894]: 156). In an article on Toorop in 1897, Paul Schultze-Naumburg characterized the artist as a "pure color symbolist" whose work was heavily influenced by his childhood in Java and his familiarity with Buddhism ("Jan Toorop," ibid. 13, no. 6 [Dec. 1897]: 89–91).

The slipperiness of the terms describing the various styles did not prevent the cartoonists from identifying stereotyped images and surface characteristics with each term. My use of the terms in this text follows the usage of the writers and critics in the journals at that time. For an excellent analysis of the problems posed to art historians by the difficulties of defining Symbolism, see Reinhold Heller, "Concerning Symbolism and the Structure of Surface," *Art Journal* 45, no. 2 (1985): 146–53.

5. George Bötticher, "Nicht mehr Trumpf," *Fliegende Blätter* 108, no. 2747 (1898): 115–16, a story with five pointed illustrations parodying the styles in the current exhibitions.

6. The statement "Der Philister liebt nicht das Neue" was cited in a report on the controversy over Lichtwark's support of modern art in Hamburg in *Die Kunst für Alle* 11, no. 13 (Apr. 1896): 207. The long analysis of the young artists is by Karl von Perfall, "Von neuer Kunst," *Der Kunstwart* 5, no. 6 (Dec. 1891): 80–81, reprinted from *Kölnische Zeitung*. Avenarius appended a conciliatory comment to this article in *Der Kunstwart* in 1891, stating that Perfall underestimated the strength of personality of young artists, who were in the process of creating a new German art. An articulate statement of the problem facing the public was made by Dr. Paul Johannes Rée, "Was ist Kunst?" ibid. 10, no. 16 (May 1895): 242.

7. T——r, "München, Allerlei von der Kunst," *Die Kunst für Alle* 10, no. 14 (Apr. 1895): 214–17.

8. H. E. v. Berlepsch, "Die Frühjahr-Ausstellung der Münchener Secession," ibid. 9, no. 15 (May 1894): 225–28.

9. Richard Mortimer, "Die Ausstellung der Berliner Secession," ibid. 14, no. 20 (July 1899): 314. Peter Paret presents a lucid analysis of the conditions and considerations that produced secessionist groups in Europe at this time in *Berlin Secession*, 29–37.

10. This concise definition came from Benno Becker, an active member of the Munich Artists' Association and the artists' social club Allotria, who became one of the secretaries of the Munich Secession and wrote an account of the formation of the Munich Secession that was first published as "Die Ausstellung der Secession in München," *Die Kunst für Alle* 8, nos. 22 (Aug. 1893): 343–44 and 24

(Sept. 1893): 369–74, and later expanded into a longer article, "Die Secession," *Pan* 2, no. 3 (Nov. 1896): 243–47. In a review of the Munich Secession in 1895, Paul Schultze-Naumburg, "Die Frühjahr-Ausstellung der Münchener Secession," *Die Kunst für Alle* 10, no. 15 (May 1895): 225, provided exactly the same definition of the Secession program.

11. *,*,*, "Innerhalb der Pariser Künstlerschaft," *Zeitschrift für bildende Kunst* 25, n.s. 1 (1889–90): 115; idem, "Die neue Pariser Künstlergesellschaft," *Kunstchronik*, n.s. 1 (Feb. 1890): col. 261. *Der Kunstwart* 3, no. 8 (Jan. 1890): 122–23, published a long report written by Ernest Leblanc for the *Neue Zürchner Zeitung* in which he described the conflict that had led to the split over jury practices, including those having to do with foreign artists, who many artists felt were becoming too dominant in the salons. A review of the Bouguereau Salon and the first Meissonier Salon, which included paintings by Kühl, Liebermann, Uhde, and Hitz, appeared in *Der Kunstwart* 3, no. 17 (May 1890): 264–65.

Otto Brandes's first reports of trouble in Paris appeared in O.B., "Paris," *Die Kunst für Alle* 5, no. 10 (Feb. 1890): 159–60. Two weeks later, in "Pariser Brief," ibid. 5, no. 11 (Mar. 1890): 171–72, Brandes reported that the break was complete in Paris, with two separate societies now vying for public attention. The following summer, stressing that the difference between the two salons was not particularly obvious, Brandes found the salon on the Champs Élysées, headed by Bouguereau, to be more academic, while Meissonier's Salon, at the Champs de Mars, was more individualistic and independent in outlook (Brandes, "Die beiden Pariser Salons," *Die Kunst für Alle* 6, no. 18 [June 1891]: 276–83, with illustrations from both salons).

Die Kunst unserer Zeit also covered the Paris salons: Momme Nissen, "Ein Rückblick auf die Pariser Kunst des Jahres 1890," 1 (1890): 225–36, covered both the Meissonier and Bouguereau salons in the summer of 1890; and he considered the influence of the French on German artists who exhibited in Paris that summer in "Paris und die Malerei der Nicht-Franzosen," ibid. 2, 1st half-vol. (Feb. 1891): 27–37. Both salons in 1891 were reviewed in G. Grahame, "Ein Blick in die beiden Pariser Salons," ibid., 2nd half-vol. (1891): 1–17.

On the trend setting of the French, see Max Georg Zimmermann, "Kritische Gänge," *Die Kunst für Alle* 8, no. 24 (Sept. 1893): 374, and Benno Becker, "Die Ausstellung der Secession in München," ibid., no. 22 (Aug. 1893): 344. See Robert Jensen, *Marketing Modernism in Fin-de-Siècle Europe* (Princeton: Princeton University Press, 1994), 159–66, for a discussion of the common motivations behind the secessions in France and in central Europe; for information on the French events, see Constance Cain Hungerford, "Meissonier and the Founding of the

Société Nationale des Beaux-Arts," *Art Journal* 48, no. 1 (1989): 71–77.

12. A useful introduction to the arts in Düsseldorf is Marion F. Deshmukh, "Between Tradition and Modernity: The Düsseldorf Art Academy in Early Nineteenth Century Prussia," *German Studies Review* 6 (1983): 439–73. See also the Stadtmuseum Düsseldorf exhibition catalogue *Armer Maler—Malerfurst: Künstler und Gesellschaft, Düsseldorf 1819–1918* (Düsseldorf, 1980). Reviews of the first opposition exhibition were in tz, "Düsseldorf," *Die Kunst für Alle* 7, no. 11 (Mar. 1892): 172; and "Die beiden Jahresausstellungen der Düsseldorfer Künstler im März 1892," ibid., no. 14 (Apr. 1892): 209–13.

13. Reviews of all of these exhibitions in Düsseldorf were given regular, substantial space in the journals. The Free Society's second exhibition, at Schulte's salon in March 1893, again held at the same time as the established society's exhibit at the Kunsthalle, was controversial. In contrast, a portfolio of paintings and graphics, accompanied by prose and poetry from contemporary writers, *Unsere Kunst: Mit Beiträgen deutscher Dichter*, ed. Freien Vereinigung Düsseldorfer Künstler (Düsseldorf: Verlag von Hermann Michels, 1893), reviewed in Adolf Rosenberg, "Neue Prachtwerke," *Zeitschrift für bildende Kunst* 29, n.s. 5 (1893–94): 69–71, was well received. In a review that strongly endorsed their work, Cologne-based Perfall argued that the Free Society artists had moved beyond the stereotypes associated with the naturalist open-air painting into a much more solid form of impressionistic work, characterized by warmer colors and stronger compositions (Perfall, "Über die Düsseldorfer März-Ausstellungen," *Der Kunstwart* 6, no. 14 [Apr. 1893]: 219).

Further reviews were published in nn, "Die Märzausstellung der Düsseldorfer Künstler," *Kunstchronik*, n.s. 4 (Mar. 1893): cols. 321–30, which included a strong statement by an eminent landscape artist endorsing the necessity of the shift from the "asphalt" darkness of painting in the 1860s to the bright, light colors of the "pleinairists"; "Die Jahresausstellung der Düsseldorfer Künstler," *Die Kunst für Alle* 8, no. 5 (15 Apr. 1893): 214–17; and G. Stein, "Ausstellung der 'Freien Vereinigung Düsseldorfer Künstler' und ihrer Freunde," *Das Atelier* 3, no. 59 (Apr. 1893): 4–5. Among the well-known artists in the established Düsseldorf Society of Artists were Oswald Achenbach and C. L. Bokelmann; the leading figures in the Free Society were Kampf, Theodore Rocholl, and Alexander Frenz. The Free Society continued to include mostly younger artists and some women. A note in June 1893 reported that both of the annual exhibitions had enjoyed lively sales (tz., "Düsseldorf," *Die Kunst für Alle* 8, no. 18 [June 1893]: 283–84).

For reports from succeeding years, see Wolfgang von Oettingen, "Die Düsseldorfer März Ausstellungen," ibid.

9, nos. 14 (Apr. 1894): 212–15 and 15 (May 1894): 229–33; "Das Düsseldorfer Frühjahr," ibid. 10, no. 13 (Apr. 1895): 198–200; idem, "Altes und Neues aus Düsseldorf," ibid. 11, no. 13 (Apr. 1896): 201–4; idem, "Die Düsseldorfer Frühjahr-Ausstellungen," ibid. 12, no. 14 (Apr. 1897): 216–18; "Die Frühjahr-Ausstellungen in Düsseldorf," ibid. 13, no. 15 (May 1898): 230–32; and "Das Düsseldorfer Frühjahr 1900," ibid. 15, no. 16 (1 May 1900): 377–79. See also nn, "Die Märzausstellungen der Düsseldorfer Künstler," *Kunstchronik*, n.s. 5 (Apr. 1894): cols. 351–54, 364–69; Wilhelm Schölermann, "Die Märzausstellung der Düsseldorfer Künstler," ibid. 6 (Apr. 1895): cols. 321–24, 342–45; Franz Hancke, "Die Düsseldorfer Märzausstellungen," ibid. 7 (Mar. 1896): cols. 301–3; Rudolf Klein, "Die Jahresausstellungen der Düsseldorfer Künstlerschaft," ibid. 8 (Apr. 1897): cols. 327–330; P., "Die Düsseldorfer Frühjahrs-Ausstellung," ibid. 9 (Apr. 1898): cols. 341–43; idem, "Düsseldorf," ibid. 10 (Apr. 1899): cols. 346, finding the exhibition to be "cold and unpleasant"; and -r-, "Düsseldorf," ibid. 12 (Mar. 1901): col. 296, an announcement that the tenth annual exhibition of the Free Society would be handled by an art dealer, Bismeyer & Kraus. *Deutsche Kunst* also provided reports on both of these societies in its regular section on notes from art societies.

14. For the historical background of the St. Luke's Club, see Ekkehard Mai, "Kunstpolitik am Rhein: Zum Verhältnis von Kunst und Staat am Beispiel der Düsseldorfer Kunstakademie," in *Malerei*, vol. 3 of *Kunst des 19. Jahrhunderts im Rheinland*, ed. Eduard Trier and Willy Weyres, exh. cat. (Düsseldorf: Schwann, 1979), 17, which characterizes the Brotherhood of St. Luke, made up of Viennese artists who gathered together in Rome, as "one of the first anti-academic secessions." These were the men who, returning to the German states, were responsible for the midcentury renewal of art in the German art centers.

Reviews of St. Luke's Club exhibitions appeared in *Die Kunst für Alle*: tz, "Düsseldorf," 8, no. 12 (Mar. 1893): 187–88; O.R., "Düsseldorf," 9, no. 11 (Mar. 1894): 172; Dr. R., "Berlin," 9, no. 16 (May 1894): 252; O.R., "Düsseldorf," 10, no. 8 (Jan. 1895): 124–25; W. von Oettingen, "Die Düsseldorfer St. Lucas Ausstellung," 11, no. 9 (Feb. 1896): 133–34; idem, "Die Düsseldorfer St. Lucas Ausstellung," ibid. 12, no. 9 (Feb. 1897): 134–36; A.A., "Düsseldorf," 13, no. 8 (Jan. 1898): 122–23; idem, "Düsseldorf," 14, no. 9 (Feb. 1899): 142; idem, "Düsseldorf," 15, no. 9 (Feb. 1900): 209–10.

For reviews in *Das Atelier*, see: "Die St. Lukas-Gilde in Düsseldorf," 3, no. 53 (Jan. 1893): 10; Friedrich Fuchs, "Bei Schulte," 4, no. 8 (Apr. 1894): 5–6, stating that the membership was 11 in 1893, 12 in 1894. Reviews in *Kunstchronik* were: nn, "Düsseldorf," n.s. 5 (Jan. 1894): cols. 194–95; W. Schölermann, "Die 'Lucas-Klub'-Ausstellung in Düsseldorf," 6 (24 Jan. 1895): cols.

200–201; Scuratow, "Ausstellung des Düsseldorfer Künst-lerklubs 'St. Lukas,'" 7 (Jan. 1896): cols. 201–4; Rudolf Klein, "Ausstellung des Düsseldorfer Künstlerklubs 'St Lu-cas,'" 8 (14 Jan. 1897): cols. 164–65, with its interna-tional artists; P., "Die Lukasausstellung in Düsseldorf," 9 (Jan. 1898): col. 186, reporting that guests included, among others, Constantin Meunier and Segantini; idem, "Düsseldorf," 10 (Jan. 1899): cols. 170–71.

The eleven original members of the St. Luke's Club were Kampf, Frenz, Rocholl, Gerhard Janssen, Olof Jern-berg, Eugen Kampf, Th. Leisegang, Gustav Wendling, Heinrich Hermanns, E. Zimmermann, and A. Henke. Also reporting on the 1896 exhibition was J. H. Schorer, "Die Aussstellung des Künstlerklubs, 'St. Lucas' in Düsseldorf," *Deutsche Kunst* 1, no. 15 (Jan. 1897): 175–76. Artists shown from outside Düsseldorf were Menzel, Liebermann, Uhde, Stuck, Oberländer, Klinger, and Kühl from Ger-many; Böcklin from Florence; Israëls and Maris from the Hague; George Clausen, Alma Tadema, and Crane from England; Emil Claus, Albert Baertsen, and George Claussen from Belgium; and P. B. Besnard from Paris.

15. For views of the Düsseldorf art scene in the late nineties, see =, "Düsseldorf," *Die Kunst für Alle* 13, no. 1 (Oct. 1896): 14, noting that sales in 1895 had dropped consider-ably, both in the exhibitions and in the art dealers' galleries; A.A. "Düsseldorf," ibid. 14, no. 15 (May 1899): 237–28, bluntly stating that the annual March exhibitions were weaker than ever; *Kunstchronik*, n.s. 8 (Aug. 1897): col. 509; P., "Die Düsseldorfer Frühjahrsausstellungen," ibid. 9 (Apr. 1898): cols. 341–43; and "Die Ausstellung des Lucas-clubs in Dusseldorf," *Deutsche Kunst* 2, no. 8 (Jan. 1898): 149–50, tempering its pessimistic view of the Düsseldorf scene with praise for the "independent, creative spirit" of the artists of the St. Luke's Club. On the Düsseldorf Artists' Society 1899, see P., "Düsseldorf," *Kunstchronik*, n.s. 10 (Mar. 1899): cols. 269–70; Friedrich Schaarschmidt, "Die Düsseldorfer Künstler-Vereinigung 1899," *Die Kunst für Alle* 14, no. 16 (May 1899): 246–47, with a photograph of a 1900 exhibition held in the studio of Hermann E. Pohle; and A.A., "Düsseldorf," ibid. 15, no. 14 (Apr. 1900): 327–28.

16. In his extended study *Marketing Modernism* Robert Jensen argues that the European-wide secessions of the 1890s constituted a coherent group of internationally suc-cessful artists who formed an elite intermediary in the market between the canonical French modernists and the art proletariat. While I agree with his emphasis on the elite and market-oriented motivations of these splinter groups, I am less convinced of the self-conscious coherence of the European secessionists in his schematic reading. For an earlier interpretation that applied the term *secessionist* to all the art of the 1890s, see Siegfried Wichmann, *Seces-sion: Europäische Kunst um die Jahrhundertwende*, exh. cat. (Munich: Haus der Kunst, 1964).

17. See *Kunstchronik*, n.s. 3 (Mar. 1892): col. 330, an-nouncing the formation of the new group that would hold its first exhibition in April; and "Berlin: Verein der Elf," *Der Kunstwart* 5, no. 14 (Apr. 1892): 213.

18. Adolf Rosenberg, "Die Vereinigung der 'Elf,'" *Kunst-chronik*, n.s. 3 (Apr. 1892): cols. 359–61. See Friedrich Fuchs, "Kunstkritik in der Tagespresse und im Allge-meinen," *Das Atelier* 2, no. 39 (June 1892): 1–2, for a study of the reactions in the daily newspapers to the first exhibition of the Eleven. Commenting that the critics ap-peared not to have thought seriously about what they wrote, he was astounded by the pronouncements about the artists, which he found to be "scarcely decent." He characterized the criticism as ranging from pure ignorance of the most elementary ideas to complete lack of sensitiv-ity about the works and total inflexibility of outlook.

19. J.S. [Jaro Springer], "Berlin," *Die Kunst für Alle* 7, no. 18 (June 1892): 282; idem, "Berlin," ibid., no. 19 (July 1892): 298. Max Schmid, "Die Ausstellung der Elf!" *Das Atelier* 2, no. 36 (Apr. 1892): 3–4, was equally enthusiastic over the Eleven, whom he saw as shaking up the dreary Berlin art scene. The artists of the Eleven were Liebermann, Leistikow, Hofmann, Skarbina, Herrmann, Jacob Alberts, Hugo Vogel, Stahl, George Mosson, H. Schnars-Ahlquist, and Konrad Müller-Kurzwelly, an "old style" landscape painter whom Springer called "der Kompromißschultze der 'XI.'" Müller-Kurzwelly soon left the group, and Klinger became a mem-ber, first showing in the group's third exhibition, in 1894. An analysis of the activities of the Eleven in Berlin and an aes-thetic assessment of the work of the artists can be found in Paret, *Berlin Secession*, 37–56. Nicolaas Teeuwisse, *Vom Salon zur Secession: Berliner Kunstleben zwischen Tradition und Aufbruch zur Moderne, 1871–1900* (Berlin: Deutscher Verlag für Kunstwissenschaft, 1986), 165–83, discusses each of the annual exhibitions of the Eleven at Schulte's and the press reception from 1892 to 1899.

20. Adolf Rosenberg, "Die Ausstellung der 'Vereinigung der Elf' in Berlin," *Kunstchronik*, n.s. 4 (Mar. 1893): cols. 285–88.

21. Reviews of the Eleven in 1893 and 1894 included Dr. Relling [Jaro Springer], "Die Ausstellung der 'XI,'" *Die Kunst für Alle* 8, no. 14 (Apr. 1893): 217–18; Albert Dresdner, "Ludwig von Hofmann," *Der Kunstwart* 6, no. 13 (Apr. 1893): 218–19; Dr. Relling, "Die Ausstellung der 'XI,'" *Die Kunst für Alle* 9, no. 13 (Apr. 1894): 199–202; Albert Dresdner, "Berliner Kunstbriefe," *Der Kunstwart* 7, no. 12 (Mar. 1894): 184–85; and A.R. [Adolf Rosenberg], "Die dritte Ausstellung der Vereinigung der 'Elf' in Berlin," *Kunstchronik*, n.s. 5 (Mar. 1894): cols. 289–90, which, despite his mildly positive view of most of the Eleven, still castigated Liebermann and Hoffmann.

For the continued coverage of the later annual exhibitions, see the following articles in *Die Kunst für Alle*: J.S., "Berlin," 10, no. 13 (Apr. 1895): 204–5; Jaro Springer, "Die Ausstellung der 'XI,'" 11, no. 14 (Apr. 1896): 211–13, questioning the appearance of neo-idealism in the work of the Eleven and giving high praise only to Liebermann; "Berlin," 12, no. 24 (Sept. 1897): 397, reporting that Herrmann and Hofmann had left the group and Hitz and Martin Brandenburg were new members, with Böcklin and Klinger as outside members; R.M. [Richard Mortimer], "Berlin," 14, no. 12 (Mar. 1899): 187, saying that that year's exhibition, held at Keller & Reiner, still maintained its "vornehmen, echt künstlerischen Charakter, der dieser Vereinigung zu dem guten Klang verhalf, den sie besitzt."

Der Kunstwart also reviewed each of the later exhibitions: Albert Dresdner, "Aus Berlin," 8, no. 12 (Mar. 1895): 186–87; idem, "Berliner Bericht," 9, no. 13 (Apr. 1896): 205–6; idem, "Berliner Bericht," 10, no. 13 (Apr. 1897): 201–2; Albert Lamm, "Die Berliner Ausstellung der 'XI,'" 11, no. 12 (Mar. 1898): 399; "Rundschau—Bildende Kunst," 12, no. 11 (Mar. 1899): 390.

Reviews in *Kunstchronik* remained skeptical about the Eleven: n.s. 6 (Feb. 95): cols. 268–29; 7 (Feb. 1896): cols. 273–74, pronouncing Leistikow's paintings as not art but pathology; A.R., "Aus den Berliner Kunstausstellungen," 8 (Feb. 1897): cols. 250–51; Adolf Rosenberg, "Die VII. Ausstellung der Vereinigung der XI in Berlin," 9 (Mar. 1898): cols. 305–8, lead article lamenting the loss of excitement resulting from the formation of the small groups and, surprisingly, declaring that the last hope was the exhibition of the Eleven. That hope, Rosenberg regretted, now lay in ruins, as did the group, which was disintegrating as members left and new, weaker members took their place. Although by 1899 he no longer found the Eleven shocking, his dislike of Hofmann's work remained (ibid., n.s. 10 [Feb. 1899]: cols. 235–36).

22. Dr. Relling [Jaro Springer], "Die Ausstellung der 'XI,'" *Die Kunst für Alle* 9, no. 13 (Apr. 1894): 199; *Kunstchronik*, n.s. 5 (Apr. 1894): col. 354. The Berlin critic cited here was Richard Graul, "Die XI," *Pan* 2, no. 1 (July 1896): 49–53. Hofmann's paintings remained controversial until the end of the decade, when critics commented that he had become a favorite whose work was eagerly anticipated in exhibitions.

This combination of controversy and success was demonstrated in a report from Breslau in 1900. There the Breslau Art Society showed several collections of new artists, including paintings by Hofmann and by some of the Worpswede artists. The reporter commented: "Vor der dekorativen Monumentalkunst Hofmanns stand der zurückgebliebene Teil unseres 'Kunstpublikums'—vielleicht war es der Zahl nach sogar die Majorität—freilich mit gerungenen Händen." However, he went on to relate,

the willing friends of beauty were not afraid to buy these unfamiliar works. Two of Hofmann's paintings were sold to private collections, and the Breslau Museum bought his large painting *Allegory*, as reported in *Die Kunst für Alle* 16, no. 1 (Oct. 1900): 27–28.

Hofmann's reputation peaked in the early years of the twentieth century. A book on Hofmann was included in 1903 in Velhagen & Klasing's Künstler-Monographien series (Oskar Fischel, *Ludwig von Hofmann* [Bielefeld, Germany: Verlag von Velhagen & Klasing, 1903]), and articles continued to appear in the art journals through the war years (see, e.g., "Neue Arbeiten von Ludwig von Hofmann," *Die Kunst für Alle*, 30, nos. 5–6 [Dec. 1914]: 103–6; Edwin Redslob, "Ludwig von Hofmanns Lithographien und Holzschnitte," ibid. 32, nos. 17–18 [June 1917]: 353–58; and Botho Graef, "Die Künstlerische Welt in den Bildern Ludwig von Hofmanns," *Zeitschrift für bildende Kunst* 52, n.s. 28 [1917]: 133–44).

For reports on the importance of the Eleven in creating a new market for art, see G.V. [Georg Voß], "Der Klub der XI," *National-Zeitung* (21 Feb. 1897), morning edition, and Alfred Lichtwark, *Brief an die Kommission für die Verwaltung der Kunsthalle* (Hamburg, 1899), 5:11–12, both quoted in Teeuwisse, *Vom Salon zur Secession*, 180–81. Patricia Mainardi, *The End of the Salon: Art and the State in the Early Third Republic* (Cambridge: Cambridge University Press, 1993), 136–42, describes a similar situation a decade earlier in France, where private gallery shows and smaller exhibitions appealed to the affluent classes, who were not eager to associate with the general public in the great salons, a phenomenon she astutely calls "social protectionism."

23. Jost Hermand provides a critical analysis of those members of the socially privileged classes in Germany interested in culture who pursued "a carousel of -isms" in the late 1890s in "The Commercialization of Avant-Garde Movements at the Turn of the Century," *New German Critique*, no. 29 (spring/summer 1983): 71–83.

24. After the first successful Eleven exhibition in the spring of 1892, Springer expressed great disappointment in the fall exhibition at Schulte's, where not a single new artist was shown. Because Schulte's spring exhibitions had been so successful, said Springer, everyone assumed that his gallery had become the home for the new movements. Instead, he was back to showing conservative Düsseldorf painters (J.S., "Berlin," *Die Kunst für Alle* 8, no. 4 [Nov. 1892]: 60). Springer's criticism notwithstanding, the Schulte Art Salon remained the home for the Eleven until their last exhibit in 1899. The comment on the rich offerings of Berlin dealers was R.M. [Richard Mortimer], "Berlin," ibid. 14, no. 8 (Jan. 1899): 124. Three other dealers in Berlin also handled contemporary work but were much less prominent: the Salon Ribera, the Ernst

Zäslein Kunsthandlung, and the Künstlerhaus, which was the gallery of the Society of Berlin Artists.

Although from its first issues *Die Kunst für Alle* carried brief reviews of dealers' shows, beginning in the crucial years 1892–93 the amount of space allocated to systematic coverage of these dealers' exhibitions rapidly expanded. Similarly, *Der Kunstwart* began to carry reviews of shows at Berlin and Dresden galleries in those same years, with the length of the reviews increasing steadily through the 1890s until the journal was reorganized and streamlined in 1897 (see, e.g., A.L. [Albert Lamm], "Die Berliner Ausstellung der 'XI,'" ibid. 11, no. 12 [Mar. 1898]: 399).

25. On the Artist West Club, see Dr. R. [Jaro Springer], "Berlin," *Die Kunst für Alle* 9, no. 14 (Apr. 1894): 218–19; idem, "Berlin," ibid. 10, no. 13 (Apr. 1895): 203; Albert Dresdner, "Berliner Kunstbriefe," *Der Kunstwart* 7, no. 12 (Mar. 1894): 184–84; idem, "Berliner Bericht," ibid. 9, no. 11 (Mar. 1896): 170; and idem, "Berliner Bericht," ibid. 10, no. 13 (Apr. 1897): 201. The group functioned as a social group that held an annual winter festival long before it held its first exhibition. Both reviewers criticized the Artist West Club for failing to develop a group program or personality. "Industrious" seemed the best way to describe its members: "Zu viel bemühen, möchte man fast sagen." Adolf Rosenberg belittled the group (see "Aus den Berliner Kunstausstellungen," *Kunstchronik*, n.s. 7 [Feb. 1896]: col. 256; A.R., "Aus den Berliner Kunstausstellungen," ibid. 8 [Feb. 1897]: col. 250; A.R., "Aus den Berliner Kunstausstellungen," ibid. 9 [Feb. 1898]: cols. 235–36). Hans Rosenhagen, on the other hand, was far more positive, seeing the group as bringing fresh air and promise to the Berlin art scene ("Die Ausstellung des Künstler-West-Club in Berlin," *Das Atelier* 4, no. 4 [Feb. 1894]: 2–3).

Exhibiting with the Artist West Club in this first exhibition were Ludwig Dettmann, who was to become a major war artist in 1914–18, Oskar Frenzel, Wilhelm Feldmann, Hans Fechner, Carl Langhammer, Max Schlichting, Adelsteen Normann, Max Uth, Heinrich Wilke, Hermann Hendrich, Hans Volker, Paul Höniger, and Georg Meyn. Jarno Jessen, "Der Künstler-Westklub bei Schulte," *Deutsche Kunst* 2, no. 9 (Feb. 1898): 167–68, positively reviewed forty new works by eighteen men. Teeuwisse, *Vom Salon zur Secession*, 191, positions the Artist West Club midway between the modernity of the Eleven and the academic styles of the Society of Berlin Artists.

On the Society of German Watercolorists, see J.S. [Jaro Springer], "Berlin," *Die Kunst für Alle* 8, no. 14 (Apr. 1893): 220; idem, "Berlin," ibid. 9, no. 14 (Apr. 1894): 219; idem, "Berlin," ibid. 10, no. 14 (Apr. 1895): 222; idem, "Berlin," ibid. 11, no. 15 (May 1896): 235; Wolfgang Kirchbach, "Aquarellistische Betrachtungen," ibid. 12, no. 11 (Mar. 1897): 161–66; and R.M. [Richard Mortimer], "Berlin," ibid. 14, no. 11 (Mar. 1899): 171. The first four annual shows were held at Amsler & Ruthardt;

the later ones were held at other sites, including the Gurlitt Art Salon in 1896 and the Künstlerhaus in 1899. Members of the society regularly mentioned in reviews included Skarbina, Herrmann, Stahl, Dettmann, Bantzer, Bartels, Kampf, Hitz, Leistikow, and Liebermann.

On the November Society, see Joh. Rodberg, "Die Ausstellung im Salon Schulte," *Das Atelier* 4, no. 22 (Nov. 1894): 3–4, which provides a careful analysis of each artist's work, including a brief reference to Maria von Brocken, who showed with the group in November 1894. For a negative reaction to the paintings of Hitz and the Society of Four at Schulte's, see "Aus den Berliner Kunstausstellung," *Kunstchronik*, n.s. 6 (Nov. 1894): col. 89. For reviews of later shows, see "Aus Berliner Kunstausstellungen," ibid. 8 (Nov. 1896): cols. 93–94, which described Trübner as "diesen Hohenpriester der Trivialität"; A.R. [Adolf Rosenberg], "Aus Schultes Kunstausstellung in Berlin," ibid. 9 (Nov. 1897): cols. 91–92; and Gr. [Georg Gronau], "Berlin," *Die Kunst für Alle* 13, no. 7 (Jan. 1898): 110, discussing work of current members, who were, in addition to the founders, Uth, Josef Block, and Reinhold and Sabine Graef-Lepsius.

26. On the Society of Free Art, see Albert Dresdner, "Berliner Bericht," *Der Kunstwart* 9, no. 11 (Mar. 1896): 171; A. [Adolf Rosenberg], "Aus den Berliner Kunstausstellungen," *Kunstchronik*, n.s. 7 (Feb. 1896): col. 256; idem, "Aus den Berliner Kunstausstellungen," ibid. 9 (Jan. 1898): cols. 184–85; R.M. [Richard Mortimer], "Berlin," *Die Kunst für Alle* 14, no. 11 (Mar. 1899): 171, noting the group's show at the Künstlerhaus; and "Freie Kunst," *Deutsche Kunst* 2, no. 9 (Feb. 1898): 162–63, providing analyses of each member's work. The six members exhibiting in 1898 were Otto Heinrich Engel, Langhammer, Herrmann R. C. Hirzel, Gustav Meng, Schlichting, and Martin Schauß (sculptor). Guest artists at that exhibit included Trübner and Karl Hagemeister.

On the Society 1897, see A.R. [Adolf Rosenberg], "Aus Schultes Kunstausstellung in Berlin," *Kunstchronik*, n.s. 9 (Dec. 1897): cols. 106–7; and J.S. [Jaro Springer], "Berlin," *Die Kunst für Alle* 13, no. 7 (Jan. 1898): 110, not only judging the group, organized by the sculptor Fritz Klimsch, to be ephemeral but saying that the work shown was undistinguished.

27. The Munich Secession has been examined by a number of scholars. The only thorough study in English is Maria Makela, *The Munich Secession: Art and Artists in Turn-of-the-Century Munich* (Princeton: Princeton University Press, 1990). Using archival sources, Makela provides a careful analysis of the background, the events leading to the formation of the Secession, the negotiations for a site for its exhibitions, and details about the first exhibitions in 1893. The last third of the book examines the work of the major Secessionist artists.

Since Makela's book includes an extensive bibliography of earlier sources, here I shall cite more recent studies, including Markus Harzenetter, *Zur Münchner Secession: Genese, Ursachen, und Zielsetzungen dieser intentionell neuartigen Münchner Künstlervereinigung* (Munich: Stadtarchivs München, 1992), which, covering much the same material, focuses on a strong polemical argument against interpreting the Secession as motivated by progressive aesthetic concerns. Both studies provide extensive documentation of the inner organizational matters leading to the Secession.

An eyewitness account by one of the central figures in the formation of the Secession is also worth noting. The business manager of the Munich Artists' Association, Adolf Paulus, sided with the Secessionists and became their business manager. Twenty years later he published his own, somewhat self-serving account of the first years in "Zwanzig Jahre Münchner Secession, 1893–1913," *Die Kunst für Alle* 28, no. 14 (Apr. 1913): 326–36.

Hirth's role in encouraging public support through the newspaper both for the annual exhibitions in Munich and for the new Secession has been well documented. For information on the early meetings in February–April 1892 in preparation for the secession, and for the role of Hirth's newspaper, see Rita Hummel, *Die Anfänge der Münchner Secession* (Munich: tuduv-Verlag, 1989), 14–19; the book includes a useful chronology of the actions, letters, petitions, and memoranda issued in the course of the secession and the formation of the new society. See also Renate Heise, *Die Münchener Secession und ihre Galerie: Eine Ausstellung des Vereins Bildender Künstler Münchens, e.v. Secession* (Munich: Stadtmusuem, 1975), 12–19, 27–30, which provides detailed information about the role of Hirth's press and his attack upon the Munich Artists' Association. Basic information on the newspaper is available in Kurt A. Holz, "*Münchner Neueste Nachrichten* (1848–1945)," in *Deutsche Zeitungen des 17. bis 20. Jahrhunderts*, ed. Heinz-Dietrich Fischer (Pullach bei München, Germany: Verlag Dokumentation, 1972), 191–207.

28. For journal reports on the formation of the new Secession, see ٭٭, "In der Münchener Künstlergenossenschaft," *Kunstchronik*, n.s. 3 (Apr. 1892): cols. 362–63; and ٭٭, "Die Spaltung in der Münchener Künstlergenossenschaft," ibid., col. 380, reported that, following the example of the Paris Société Nationale des Beaux-Arts, the new group had established statutes and would be financially secure. In its first report of the new society, *Das Atelier* 2, no. 37 (May 1892): 7, stressed the importance of the patronage of Hirth and Paulus in ensuring the success of the group. *Der Kunstwart* 5, no. 14 (Apr. 1892): 213, reported the names of the members of the new executive committee and referred to the new group as the Secessionists. *Die Kunst unserer Zeit* 3, 1st half-vol. (Apr. 1892), supplement, also gave the full roster of the executive committee and gave the name of the group as Gesellschaft bildender Künstler Münchens.

Die Kunst für Alle 7, no. 16 (May 1892): 250, published the text of the letter of resignation with a complete list of the members of the executive committee, as well as of the regular members who were withdrawing to form the new society. According to Hummel, *Die Anfänge der Münchner Secession*, 18 n. 10, the letter also was sent to the Bavarian cultural ministry. Sch, "Die Münchner 'Sezessionisten,'" *Der Kunstwart* 5, no. 19 (July 1892): 293–94, published the whole text of the June memorandum, with only a few deletions and a short commentary. ٭٭, "Die Spaltung der Münchener Künstlerschaft," *Kunstchronik*, n.s. 3 (June 1892): cols. 531–32, summarized the text and reported on the negative response of the cultural minister to the request for exhibition space. For the text of the memorandum, along with a translation, see Makela, *Munich Secession*, app. 2, 145–53, as well as an earlier letter circulated to members of the Munich Artists' Association (app. 1) and a full roster of the membership in June 1892 (app. 3).

On the Secession and Munich's Sixth International, in 1892, see *Die Kunst für Alle* 7, no. 17 (June 1892): 267. A later note pointed out that the Secessionists were not represented on the jury of the Sixth International because the Artists' Association said they had disqualified themselves by leaving the organization (ibid., no. 22 [Aug. 1892]: 348). For a continuing series of substantive reviews of this exhibition, see Julius Elias, "Die VI Internationale Kunstausstellung zu München," *Der Kunstwart* 5, nos. 20–24 (July–Sept. 1892): 308–10, 323–25, 357–58, 374–75, and ibid. 6, nos. 1–2 (Oct. 1892): 8–9, 26, and 7 (Jan. 1893): 104–7. Describing this exhibition as "between the battles," Elias used the review to present a strong defense of the "young" modern artists. In the process, he provided a thorough analysis of the art scene in Munich leading up to the Secession, including two articles that examined the art from other countries shown in the 1892 exhibition. A more measured review, nonetheless one favorable to the Secession artists, was Alfred Gotthold Meyer, "Die Münchener Kunstausstellung," *Zeitschrift für bildende Kunst* 28, n.s. 4 (1892–93): 25–36, 49–58, 80–82, 99–107.

See also Friedrich Pecht's reviews, "Die Münchener internationale Ausstellung von 1892," *Die Kunst für Alle* 7, nos. 17–24 (June–Sept. 1892): 257–60, 273–75, 289–93, 305–8, 321–24, 337–41, 354–58, 369–72. Discussing problems of national and international art, Pecht systematically covered art from Germany, France, Austria, England, France, Japan, Russia, Poland, Hungary, and the Scandinavian countries. D.R. [Hans Rosenhagen], "Zur Lage," *Das Atelier* 2, no. 43 (Aug. 1892): 7, discussed the press "duel." The German title of the Artists' Association's newsletter was *Anzeiger der Münchener Künstlergenossenschaft: Organ für die Interessen der bildenden Künstler*.

29. *Der Kunstwart* 5, no. 15 (May 1892): 231, published the anonymous letter.

30. That the statement of purpose was well understood at the time is demonstrated by a note about the upcoming first Secession exhibition in Munich by B.B. [Benno Becker], "München," *Kunstchronik*, n.s. 4 (June 1893): 474, reporting that it would be smaller, more intimate. The English translation of the memorandum is from Makela, *Munich Secession*, 7. Harzenetter argues for the centrality of this principle of elitism in the formation and actions of the Munich Secessionists in *Zur Münchner Secession*, chap. 5. *Der Kunstwart* 5, no. 19 (July 1892): 293–94, asserted the high quality of the Secessionists' work.

The roll call of corresponding members from Belgium, France, Holland, Denmark, England, Scotland, Italy, Norway, and Germany are those whom Jensen has characterized as the *juste-milieu* of European secessionism. Noteworthy among the German members were artists from *Fliegende Blätter*, not only Schlichter but also Hengeler, Kirchner, and Reinike. Professors from the Munich Academy of Arts included Keller, Kuehl, Piglhein, Uhde, Ernst Zimmermann, and Heinrich Zügel. Among the avowed modernists were Liebermann, Corinth, Stuck, Skarbina, and Trübner; Hofmann, Klinger, Ury, Leistikow, and Stahl had joined by the first exhibition in 1893, as had Vinnen, whose protest against French and modern artists made him notorious in 1911. By 1893 regular members numbered 130, corresponding members, 284.

The roster for the 1893 Secession exhibition in Munich remained exclusively male; even Sabine Graef-Lepsius, whose husband Reinhold was a member, was not included. Women artists were included in the Artists' Association exhibition at the Glass Palace.

31. Although the great exhibitions in Munich were officially organized by the private Munich Artists' Association, both the Bavarian and the municipal government contributed heavily to the support of the association. The Bavarian government provided space for year-round shows of local artists in its Art and Industry Building on Königsplatz and also gave priority to the association in the use, free of charge, of the Glass Palace for the great exhibitions. The state also provided significant funds to underwrite the exhibitions and then purchased a large percentage of the works that were sold (see Makela, *Munich Secession*, 6–10, for details on these arrangements). Makela, chap. 3, provides a detailed discussion of the controversy in 1891–92 over the organization of the association's exhibitions and the decision of the membership to reverse the new organizational rules that had been followed in the three controversial annual exhibitions in 1889, 1890, and 1891.

32. Reports of these efforts to gain official support, giving the full text of petitions and letters, but with minimal com-

mentary, were published in *Die Kunst für Alle* 7, nos. 20 (July 1892): 315, 21 (Aug. 1892): 332, and 23 (Sept. 1892): 363; and ibid. 8, nos. 3–4 (Nov. 1892): 44 and 60, 8 (Jan. 1893): 123–24, 12 (Mar. 1893): 188, and 13 (Apr. 1893): 204. Short notices of petitions to Munich authorities and negotiations with Dresden and Berlin were reported in *Kunstchronik*, n.s. 3 (Aug. 1892): col. 581; 4 (Dec. 1892): cols. 129, 148; (Jan. 1893): col. 195; and (Mar. 1893): col. 296. Reports on the negotiations, often offering suggestions favoring the Secession, appeared also in *Der Kunstwart*: 5, no. 22 (Aug. 1892): 341–42; 6, no. 1 (Oct. 1892): 12; "Vom Münchener Künstlerstreit," 6, nos. 3–4 (Nov. 1892): 43–44, 60; 6, no. 5 (Dec. 1892): 77; Hermann Eichfeld, "Die Reform der Kunstausstellungen und die Entstehung der Münchener Sezession," 6, no. 8 (Jan. 1893): 123–24; and "Münchner 'Sezessionisten,'" 6, no. 11 (Mar. 1893): 173.

Also reporting on events in Munich, editorial commentaries fully supporting the Secession and censuring the Artists' Association appeared in every issue of *Das Atelier* from July through December 1892 (vol. 2, no. 41, through vol. 3, no. 52) in the regular column by D.R. [Hans Rosenhagen], "Zur Lage." This Berlin-based journal then enthusiastically reported on the negotiations that led to the Secession exhibition in Berlin in "Zur Lage," 3, nos. 55–58 (Feb.–Mar. 1893).

33. "München," *Die Kunst für Alle* 8, no. 13 (Apr. 1893): 204, published details on the invitation to participate in the Great Berlin Art Exhibition, and "München," ibid., no. 19 (July 1893): 299, announced with pleasure the forthcoming Secession exhibition in Munich. In Berlin, 300 works of regular members and 150 works of corresponding members were hung; in Munich, the Secession showed 900 works, including 650 paintings. For an engaging account of all of these events, see Makela, *Munich Secession*, chap. 3, which discusses the art and its installation in the new Munich Secession building. Makela's book is also valuable for its substantial number of illustrations of the art shown in both the Munich annual exhibitions of 1889–91 and the Munich Secession exhibitions.

34. Karl von Perfall, "Die Berliner Kunstausstellung," *Der Kunstwart* 6, no. 17 (June 1893): 265. Further reviews of the Munich Secession show at the Great Berlin Art Exhibition are Dr. Relling [Jaro Springer], "Die Berliner Kunstausstellung," *Die Kunst für Alle* 8, nos. 19–20 (July 1893): 289–92, 305–9, with the final evaluation "München alles, Berlin nichts"; Albert Dresdner, "Die Berliner Kunstausstellung," *Der Kunstwart* 6, nos. 18 (June 1893): 279–80, 19 (July 1893): 298–99, and 22 (Aug. 1893): 346–47; ***, "Zur Berliner Kunstausstellung," *Kunstchronik*, n.s. 4 (Apr. 1893): 379, announcing that 450 works from Munich Secessionists were sent to Berlin, including Uhde's *In der heiligen Nacht*; Adolf Rosenberg,

"Die Grosse Berliner Kunstausstellung," ibid. (June–July 1893): cols. 449–54, 465–70, 497–501, a series of articles conveying Rosenberg's fundamental distrust and dislike of the modern artists, whom he accused here of carrying on a "battle in the revolution against authority" with unfinished, disturbing caricatures of art; Max Schmid, "Berliner Kunstausstellung 1893," *Das Atelier* 3, no. 62 (May 1893): 4–5; D.R. [Hans Rosenhagen], "Zur Lage," ibid., 7; and R., "Die Sezessionisten auf der Grossen Berliner Kunstausstellung 1893," ibid. 3, nos. 63, 65–66, 68, and 70 (June–Sept. 1893).

A short article published during the Secession exhibition in Berlin, PP, "Der Kunstgenuß in unsern Ausstellung," *Die Kunst für Alle* 8, no. 22 (Aug. 1893): 347, attacked current great exhibitions for being huge shops crowded with pictures that not only provided "no nourishment for the artistic taste of the people, but offered poison instead." Max Georg Zimmermann, "Kritische Gänge," ibid., no. 24 (Sept. 1893): 374–78, applied the term "un-culture" to the public. Statistics on the Secessionists' Berlin 1893 exhibition are published in WO, "Berlin," ibid. 9, no. 3 (Nov. 1893): 42–43; *Kunstchronik*, n.s. 5 (Oct. 1893): cols. 41–42; and ibid. (Nov. 1893): col. 72. Berlin day visitors and season-ticket holders amounted to more than 800,000 visitors in 127 days; 271 works were sold for a total of 300,000 marks. How much of the sales went to the Munich Secession artists is not recorded in the journals. Financial reports of the Munich exhibition appeared in ibid. (Feb. 1894): col. 259; and in *Die Kunst für Alle* 9, no. 11 (Mar. 1894): 174. Reports on attendance in Munich appeared in ibid., no. 2 (Oct. 1893): 30; and in *Kunstchronik*, n.s. 4 (Sept. 1893): col. 556. Makela states that 60,000 tickets were sold for the Munich exhibition (*Munich Secession*, 177 n. 80).

35. Among the foreign art were works by Gervex, Carolus-Duran, Dagnan-Bouveret, members of the Hague School, Herkomer, the Glasgow Boys, Munthe, Larsson, and Krøyer. For further information about the Secession building, its construction, and the opening exhibition in 1893, see Hummel, *Die Anfänge der Münchner Secession*, 68–78, quoting Richard Braungart's comment about the beginning of a new era; and Makela, *Munich Secession*, 66–69. For a sample of the many reviews on this Munich Secession exhibition, see Benno Becker, "Die Ausstellung der Secession in München," *Die Kunst für Alle* 8, nos. 22 (Aug. 1893): 343–44 and 24 (Sept. 1893): 369–74, a lengthy rationale for the necessity of the Secession by one of the first members; Max Georg Zimmermann, "Kritische Gänge durch die I. Ausstellung der Secession in München," ibid. 9, no. 4 (Nov. 1893): 49–55; Cornelius Gurlitt, "Die Münchener Ausstellungen, II: Die Secession," *Die Kunst unserer Zeit* 4, 2nd half-vol. (Sept. 1893): 101–18; Sch., "Die Münchner Ausstellung, I: 'Künstlergenossenschaft,' und 'Sezession,'" *Das Atelier* 3, no. 67

(Aug. 1893): 3–4; Sch., "Die Münchner Ausstellungen, II: Die Sezession (Deutschland)," ibid., no. 69 (Sept. 1893): 2–4; Alfred Gotthold Meyer, "Die Münchener Kunstausstellungen," *Zeitschrift für bildende Kunst* 29, n.s. 5 (1893–94): 62–68, 111–21, arguing that this was an age of transition, an "Übergangsepochen"; "München," *Kunstchronik*, n.s. 4 (June 1893): 459–60; and B.B. [Benno Becker], "Die erste Ausstellung der Sezession in München," ibid. 5 (Oct. 1893): cols. 21–26, and Herbert Hirth, "Die Resultate der Münchener Sezessionsausstellung," ibid. (Nov. 1893): cols. 97–101, both of which were highly laudatory.

For Hirth the elite Secessionist exhibition represented a turning point in art, while the Glass Palace exhibition had a retrospective character. He claimed that both the public and the press were generally favorable. After its considerable success in financing its building and exhibition through private capitalist sources, the Secession turned back to the Bavarian government to get it to change its purchasing policies to include the Secession exhibitions (see *Kunstchronik*, n.s. 5 [Nov. 1893]: col. 106; *Die Kunst für Alle* 9, no. 7 [Jan. 1894]: 112; ibid., no. 16 [May 1894]: 254; and ibid., no. 19 [July 1894]: 300). A debate in the Bavarian Chamber of Deputies over the budget for governmental support of art, particularly relating to the Secession, was reported in ibid., no. 14 (Apr. 1894): 221–22. In less than five years the Secession was being significantly underwritten by the state and municipality and had agreed to hold periodic joint exhibitions in the Glass Palace with the Munich Artists' Association (see *Kunstchronik*, n.s. 7 [May 1896]: col. 436; and *Die Kunst für Alle* 11, nos. 18 [June 1896]: 285 and 19 [July 1896]: 303).

36. The quotations are from Albert Dresdner's description after viewing the exhibitions of the Munich Secession of 1893 in Berlin and of the Eleven in the spring of 1894, "Berliner Kunstbriefe," *Der Kunstwart* 7, no. 12 (Mar. 1894): 184; from Alfred Freihofer, "Die Münchner Kunstausstellungen," ibid., nos. 1–2 (Oct. 1893): 10–13, 25–26, quotation on 11, and 4 (Nov. 1893): 57–59; and from Carl von Lützow, "Neue Bahnen in der Kunst," *Zeitschrift für bildende Kunst* 29, n.s. 5 (1893–94), 2, reprinted in *Der Kunstwart* 7, no. 3 (Nov. 1893): 42. Many contemporary tributes appeared at Lützow's death; among them "Carl von Lützow," *Zeitschrift für bildende Kunst* 32, n.s. 8 (1896–97): 233–38; and "Karl von Lützow," *Deutsche Kunst* 1, no. 31 (May 1897): 365.

37. C. von L. [Carl von Lützow], "Münchener Eindrücke," *Kunstchronik*, n.s. 4 (Oct. 1892): col. 1. The Third Annual Munich Exhibition, in 1891, organized by Uhde, had been criticized for not hanging foreign and German paintings separately (see Friedrich Pecht, "Die Münchener Jahres-Ausstellung von 1891," *Die Kunst für Alle* 6, no. 20 [July

1891]: 305). Freihofer's review is "Die Münchner Kunstausstellungen," *Der Kunstwart* 7, no. 2 (Oct. 1893): 26. In his successive reviews on the Secession exhibition, Freihofer made clear his choices for the "core troop" who would "guarantee" the future: Hugo König, Arthur Langhammer, P. W. Keller-Reutlinger, Adolf Hölzel, and Vinnen, landscape artists associated with the Dachau artist colony.

38. Avenarius expressed these views both in his own writing and in his choice of articles by others that he published in the journal. The quotation here is taken from his article written in the midst of the secession negotiations, which he fully supported, "Unsere Künste," *Der Kunstwart* 6, no. 1 (Oct. 1892): 17–20.

39. The article from the *Tägliche Rundschau*, "Über Deutschgesinnung und Modernität," reprinted in *Der Kunstwart* 7, no. 8 (Jan. 1894): 123–24, used the following phrases: "ein wahrhaftes 'Modern sein' mit nationaler Wurzelhaftigkeit, mit kerniger Volkshaftigkeit. . . . Was heißt den modern? Doch wohl nichts Anderes, als—zeitreif." Another article reprinted from the *Tägliche Rundschau* raising these issues, was "Sein Credo," ibid., no. 4 (Nov. 1893): 38–40, written by Ein deutscher Maler, who concluded: "Die Kunst der Innerlichkeit ist unser Beruf, und Niemandes Wettbewerb haben wir hier zu fürchten, da Niemand ein Gemüt hat, so reich, so tief, so warm, wie das unsere." On the need to represent the authentic embodiment of "the people" in France in the mid-nineteenth century, see Linda Nochlin, *Realism* (New York: Penguin Books, 1971), 111–22.

For Avenarius's review of Woermann's book, see "Was uns die Kunstgeschichte lehrt," *Der Kunstwart* 7, nos. 14 (Apr. 1894): 209–13 and 15 (May 1894): 225–30. The phrase Woermann used to express the basic criteria of the artist was "eigner Volksart, eigenem Zeitgeist, eigner Persönlichkeit." Another positive review of Woermann's book as a judicious approach to modern art came from H. A. Lier, "Zum Streit über die moderne Kunst," *Kunstchronik*, n.s. 5 (May 1894): col. 382.

40. See "Unsere Künste," *Der Kunstwart* 6, no. 1 (Oct. 1892): 20, and introductory comment to Elias, "Die VI. Internationale Kunstausstellung zu München," ibid., no. 7 (Jan. 1893): 104.

41. On reforms in the Munich Artists' Association, see "Münchner Künstlergenossenschaft," ibid. 7, no. 7 (Jan. 1894): 105–6; *Die Kunst für Alle* 9, nos. 7–8 (Jan. 1894): 111–12, 126, and 10 (Feb. 1894): 155; and *Das Atelier* 4, no. 1 (Jan. 1894): 7. The literary critic was Otto Julius Bierbaum, whose review was published as a book: *Aus beiden Lagern: Betrachtungen, Karakteristiken, und Stimmungen aus dem ersten Doppel-Ausstellungsjahre in München 1893* (Munich: Karl Schüler, 1893). The Nietz-

schean reference in Bierbaum's motto "Jenseits von Genossenschaft und Secession" was not accidental. Bierbaum (1865–1910) wrote for or edited various literary journals before becoming the co-editor of *Pan*, an elegant new journal of the arts, in 1895. He managed to review these exhibitions in 1893 without naming a single artist; he did, however, include a series of tributes with photographs of seven artists, four of whom were members of the Munich Secession. Pecht's comments were made in his review of the 1894 Glass Palace exhibition, "Die Jahres Ausstellung 1894 der Künstlergenossenschaft zu München," *Die Kunst für Alle* 9, no. 21 (Aug. 1894): 322. Alfred Freihofer emphasized the favorable influence of the Secession upon the Glass Palace exhibition in "Die Münchner Kunstausstellungen von 1894," *Der Kunstwart* 7, no. 21 (Aug. 1894): 329–30.

42. Announcements appeared in *Die Kunst für Alle* 9, no. 5 (Dec. 1893): 76; "Dresden," ibid., no. 11 (Mar. 1894): 171, reporting on Gutbier's efforts to bring regular exhibitions of the Munich Secession to the new gallery of Ernst Arnold in Dresden; "Stuttgart," ibid., nos. 15 (May 1894): 238 and 17 (June 1894): 268; and *Kunstchronik*, n.s. 5 (Feb. 1894): col. 259 and (Mar. 1894): cols. 273–74. Favorable reviews of the first spring exhibition, in March–April 1894, appeared in Herbert Hirth, "Die Frühjahrsausstellung der Münchener Sezessionisten," ibid. (Apr. 1894): cols. 361–64; F. Fabricius, "Die Frühjahrs-Ausstellung der Münchener 'Secession,'" *Die Kunst unserer Zeit* 5, 2nd half-vol. (1894): 2–20; H. E. v. Berlepsch, "Die Frühjahr Ausstellung der Münchener Secession," *Die Kunst für Alle* 9, no. 15 (May 1894): 225–28; and H.E., "Münchner Kunstbriefe," *Der Kunstwart* 7, no. 15 (May 1894): 234–35.

A financial report from the exhibitions in 1894 was printed in *Kunstchronik*, n.s. 6 (Dec. 1894): col. 122; and ibid. (Jan. 1895): col. 185, reported that in Dresden five thousand visitors had seen the Secession exhibition at the Ernst Arnold Art Salon. The photogravure portfolio was reviewed positively in "Kunstblätter und Bilderwerke, 9," *Der Kunstwart* 7, no. 10 (Feb. 1894): 154–55. Titled *Sezession: Eine Sammlung von Photogravüren nach Bildern und Studien von Mitgliedern des "Vereins bildender Künstler München"* (Berlin: Kunstverlag der Photographischen Gesellschaft, 1893), the first issue was given a glowing review by Carl von Lützow in "Neue Prachtwerke," *Zeitschrift für bildende Kunst* 29, n.s. 5 (1893–94): 71–72. Reports on the Vienna exhibition appeared in R.B., "Die Münchener 'Secession' im Wiener Künstlerhaus," *Kunstchronik*, n.s. 6 (Jan. 1895): cols. 212–16; and Gustav Schoenaich, "Die Münchener Secession in Wien," *Die Kunst für Alle* 10, no. 8 (Jan. 1895): 119–20.

43. *Kunstchronik* was as scathing in its review of the Twenty-four as it had been about the Eleven (see Adolf

Rosenberg, "Die Ausstellung der Münchener '24' in Berlin," *Kunstchronik*, n.s. 4 [Jan. 1893]: cols. 185–88). Dr. Relling [Jaro Springer], "Die Ausstellung der '24' in Berlin," *Die Kunst für Alle* 8, no. 10 (Feb. 1893): 153–54, attributed to the group better work overall and a more unified program than the Eleven (see also idem, "Die Ausstellung der '24' in Berlin," ibid. 9, no. 11 [Mar. 1894]: 167–68; and J.S., "Berlin," ibid. 10, no. 10 [Feb. 1895]: 156). Disappointed in the last two shows, Springer said that the group had failed to establish a clear identity because the members who exhibited kept changing. In contrast, the Eleven had become "an entirely firm concept and as such a factor in Berlin's exhibition life."

The anonymous critic who stressed the excitement and interest of the public wrote as G.C., "Die Münchner '24' in Berlin," *Das Atelier* 3, no. 54 (Jan. 1893): 4–5. Albert Dresdner, "Berliner Kunstbrief," *Der Kunstwart* 7, no. 9 (Feb. 1894): 139, expressed similar views to Springer's on the second Twenty-four show and went on in 1895 to argue that the artists had lost all connections to the public, leaving contemporary art with no purpose and fully separated from life (see "Aus Berlin," ibid. 8, no. 9 [Feb. 1895]: 138–39). A brief review of the "experimental optics" of the Twenty-four at an exhibition in the Schulte Art Salon in Düsseldorf appeared in "Düsseldorf: Die Ausstellung der Münchener '24,'" *Kunstchronik*, n.s. 5 (Mar. 1894): col. 275. At the 1899 exhibition the best work, according to the reporter, was Uhde's *Ruhe auf der Flucht*; otherwise, he found the show disappointing (ibid. 10 [Jan. 1899]: col. 186).

44. A valuable evaluation of the spread of secessionism across Germany was published by Fr. Carstanjen in his "Münchner Kunstbriefe," *Der Kunstwart* 7, no. 15 (May 1894): 235–36. Carstanjen argued that the secessions' efforts to institute both strong juries and elite exhibitions could only create worse conditions and lead to further dissent and secessions. A similar position had been taken by Dr. van Eyck, in "Sezessionismus," *Das Atelier* 3, no. 49 (Nov. 1892): 1–3, who, portraying the Munich Secessionists as breaking out of their "servile community" to follow freer, modern, and purely artistic principles, raised the question whether this was a good thing: was it not a case of the Devil's being driven out by Beelzebub?

For reports on the Munich Free Society, see *Kunstchronik*, n.s. 5 (Feb. 1894): col. 259; =, "München," *Die Kunst für Alle* 9, nos. 11–12 (Mar. 1894): 174, 186, and 14 (Apr. 1894): 221; Dr. R. [Jaro Springer], "Berlin," ibid. 9, no. 18 (June 1894): 284, on the first show at the Gurlitt Art Salon; and R. [Hans Rosenhagen], "Die 'Münchner Freie Vereinigung' bei Gurlitt," *Das Atelier* 4, no. 9 (May 1894): 2–3. Harzenetter, *Zur Münchner Secession*, 48–54, provides a detailed account of the initial break and the negotiations with the Munich Artists' Association. For Corinth's involvement with the Free Society, see Horst Uhr, *Lovis*

Corinth (Berkeley: University of California Press, 1990), 67–68, 120. See also Peter-Klaus Schuster, Christoph Vitali, and Barbara Butts, eds., *Lovis Corinth*, exh. cat. (Munich: Prestel Verlag, 1996); and Walter Stephan Laux, *Der Fall Corinth und die Zeitzeugen Wellner* (Munich: Prestel Verlag, 1998). In his monumental monograph, Hans-Jürgen Imiela, *Max Slevogt: Eine Monographie* (Karlsruhe, Germany: G. Braun, 1968), 29–31, 352, draws on the memoirs and letters of artists in his discussion of the aesthetic aspects of the art of the Munich Free Society.

45. The society's annual exhibitions at the Gurlitt Art Salon were reviewed by Albert Dresdner, "Berliner Kunstbrief," *Der Kunstwart* 7, no. 16 (May 1894): 252–53, and ibid. 8, nos. 12 (Mar. 1895): 187 and 13 (Apr. 1895): 202; Dr. R. "Berlin," *Die Kunst für Alle* 9, no. 18 (June 1895): 284; and J.S., "Berlin," ibid. 10, no. 13 (Apr. 1895): 201–2. The Munch-Gallén show was reviewed in idem, "Berlin," ibid., no. 14 (Apr. 1895): 222. Springer commented on the poster and stated that the exhibition was in a private house; he was impressed by Munch's paintings, particularly his half-figure of a Madonna, and by his new graphic efforts.

46. Reviews of Munich Secession exhibitions continued to command major attention in the journals through the nineties. The second summer exhibition, in 1894, was received with even more enthusiasm than the first one (see Georg Voß, "Die Ausstellung der Münchener Secession im Sommer 1894," *Die Kunst für Alle* 9, nos. 19–20 [July 1894]: 289–94, 306–9; Alfred Freihofer, "Die Münchner Kunstausstellungen von 1894," *Der Kunstwart* 7, nos. 21–22 [Aug. 1894]: 329–30, 344–45, and 23 [Sept. 1894]: 361–62, and 8, nos. 1–2 [Oct. 1894]: 11–12, 26–27, and 4 [Nov. 1894]: 57–58; and A[nna] Spier, "Die Ausstellung der Münchener Secession 1894," *Die Kunst unserer Zeit* 5, 2nd half-vol. [1894]: 91–104).

Reviews of the 1895 Secession exhibition included Paul Schultze-Naumburg, "Die Frühjahrsausstellung der Secession München 1895," *Kunstchronik*, n.s. 6 (Apr. 1895): cols. 337–41, arguing that even the educated public had no real aesthetic understanding of art; idem, "Die Frühjahr-Ausstellung der Münchener Secession," *Die Kunst für Alle* 10, no. 15 (May 1895): 225–28; idem, "Die dritte internationale Kunstausstellung der Secession München," *Kunstchronik*, n.s. 6 (June 1895): cols. 465–69 and (Aug. 1895): cols. 518–19, and ibid. 7 (Nov. 1895): cols. 49–54, 84–85; Alfred Freihofer, "Die Malerei auf den Münchener Ausstellungen von 1895," *Die Kunst unserer Zeit* 6, 2nd half-vol. (1895): 59–89; H. E. v. Berlepsch, "Münchener Brief," *Der Kunstwart* 8, no. 23 (Sept. 1895): 357–59; and Jaro Springer, "Die 1895er Jahres-Ausstellung der Münchener Secession," *Die Kunst für Alle* 10, nos. 19 (July 1895): 289–92, 21 (Aug. 1895): 321–24, and 24 (Sept. 1895): 369–72.

Reviews of the Munich Secession in 1896, as in 1895, were dominated by Schultze-Naumburg, who continued to deliberate over the direction art was taking: Paul Schultze-Naumburg, "Die Frühjahrsausstellung der Secession in München," *Kunstchronik*, n.s. 7 (Apr. 1896): col. 344 and (July 1896): cols. 502–3; idem, "Münchener Bericht," *Der Kunstwart* 9, nos. 15 (May 1896): 231–32, 20 (July 1896): 315–16, 22 (Aug. 1896): 345–47, and 24 (Sept. 1896): 378–79, raising issues of decadence and confusion in contemporary art; idem, "Die Internationale Ausstellung 1896 der Secession in München," *Die Kunst für Alle* 11, nos. 19–20 (July 1896): 289–93, 305–9; and idem, "Die Ausstellung der Secession in München," *Zeitschrift für bildende Kunst* 32, n.s. 8 (1896–97): 49–55.

Reports, followed by denials and clarifications in the journals, conveyed the anger and confusion that attended the secession and formation of the Luitpold Group: see "Die Vorstandswahl in der Münchener Künstlergenossenschaft," *Deutsche Kunst* 1, no. 14 (Jan. 1897): 160–62; "Aus den Künstlervereinen," ibid., nos. 15–16 (Jan. 1897): 173–74, 183–84; Paul Schultze-Naumburg, "Die Vorgänge in der Münchener Künstlergenossenschaft," *Kunstchronik*, n.s. 8 (Feb. 1897): cols. 209–12; *Die Kunst für Alle* 12, nos. 7–8 (Jan. 1897): 108, 123, no. 9 (Feb. 1897): 141–42, and no. 12 (Mar. 1897): 187. Winfried Leypoldt, "'Münchens Niedergang als Kunststadt': Kunsthistorische, kunstpolitische, und kunstsoziologische Aspekte der Debatte um 1900" (Ph.D. diss., Ludwig-Maximilians-Universität zu München, 1987), 126–27, has a brief description of the causes of the Luitpold secession, which Leypoldt presents to support his polemical view of the reactionary character of the Munich art establishment in 1900.

47. Regular reports about the 1897 Munich International in *Die Kunst für Alle* carried special notice of the Luitpold Group (see 12, no. 13 [Apr. 1897]: 203–4; and Friedrich Pecht, "Die VII. Internationale Kunstausstellung in München, II: Die Münchener Künstlergenossenschaft, die Luitpoldgruppe, etc.," ibid., no. 21 [Aug. 1897]: 333–38). Karl Voll, "Die retrospective Abteilung der VII. Internationalen Kunstausstellung zu München," ibid., no. 22 (Aug. 1897): 353–56, called Monet's *Hügelpartie* the masterwork of the exhibition. In a strongly negative review of Lenbach's organization of the Seventh International, Paul Schultze-Naumburg, "Münchener Bericht. Internationale Kunstausstellung," *Der Kunstwart* 10, no. 19 (July 1897): 297–99, argued that despite the modernity of the Secession and the Luitpold Group, the whole exhibition would set back the public that had begun to appreciate modern art. E. Wieland, "Die Jahres-Ausstellung im kgl. Glaspalast zu München," *Die Kunst für Alle* 14, no. 20 (July 1899): 305–13, spoke of the "horror and helplessness"; similarly, Leopold Weber, reviewing the exhibit in

Der Kunstwart 12, nos. 23–24 (Sept. 1899): 377–81, 416–18, found only a few good works, including those of the Luitpold Group. Also in the Glass Palace exhibition were one of Corinth's controversial harsh *Crucifixions* and Kollwitz's new graphic cycle, *The Weavers*, which had been denied the gold medal in Berlin the previous year.

48. See Alexander Heilmeyer, "Münchener Jahres-Ausstellungen 1900," *Die Kunst unserer Zeit* 9, 2nd half-vol. (1900): 115–27; and Dr. Georg Habich, "Münchener Frühjahr-Ausstellungen, II: Luitpoldgruppe," *Die Kunst für Alle* 17, no. 15 (May 1902): 339–45.

49. *Der Kunstwart* 11, no. 10 (Feb. 1898): 334, lists the following members of the Ring: painters Hermann Eichfeld, Angelo Jank, Richard Kaiser, F. A. Otto Krüger, Adelbert Niemeyer, Bernhard Pankok, Leo Putz, Richard Riemerschmidt, Paul Schröter, Otto Ubbelohde, Ludwig von Zumbusch, Paul Schultze-Naumburg and sculptors Ed. Beyrer, Theo von Gosen, and Hugo Kaufmann. D., "Leipzig," *Die Kunst für Alle* 13, no. 15 (May 1898): 336, reported that the Ring had opened a show at the Leipzig Kunstverein. Some of these men were active in the formation of the Vereinigte Werkstätten für Kunst im Handwerk in Munich, which was formed at almost the same time as the Ring exhibition in Dresden. For information about the latter and biographical data on the artists, see Kathryn Bloom Hiesinger, *Art Nouveau in Munich: Masters of Jugendstil from the Stadtmuseum, Munich, and Other Public and Private Collections*, exh. cat. (Philadelphia: Philadelphia Museum of Art, 1988).

The German name of the group Plowed Earth, *Scholle*, is difficult to capture in English. *Scholle* refers primarily to clods of soil, tilled or plowed soil; it can also refer to fish, flounder or sole. Avenarius, in a review of a new book entitled *Simplicissimus und seine Zeichner*, commented that *Jugend* had served the important function of popularizing modern art in Germany ("Rundschau—Bildende und angewandte Kunst," *Der Kunstwart* 14, no. 3 [Nov. 1900]: 126).

50. Die Redaction, "An unsere Leser," *Das Atelier* 2, no. 48 (Oct. 1892): 1. Its initial press run of 4,000, announced on its masthead, was soon dropped. The cost was a modest 35 pfennig per issue or 2 marks quarterly. Rosenhagen used the abbreviation D.R. (Die Redaktion) for all of his editorials.

51. See, for example, the positive view of the Munich secessionists in Dr. van Eyck [probably the pseudonym of Karl Voll, who wrote his habilitation thesis on Jan van Eyck], "Die Alten und die Jungen," ibid. 2, no. 38 (May 1892): 1–2. In succeeding issues Rosenhagen dedicated a regular column, "Zur Lage," in which he began with events in Munich and then compared these with the Berlin

scene. The columns cited are D.R. [Hans Rosenhagen], "Zur Lage," ibid., nos. 41, 43, 48, for July, August, and October 1892.

52. The plan for a new committee for organizing the exhibition, the Landeskunstausstellungsgemeinshaft, was intended to settle the contention between the Berlin Academy and the Society of Berlin Artists over responsibility for the exhibition (see Rosenhagen's regular reports in D.R. [Hans Rosenhagen], "Zur Lage," ibid. 2, nos. 40 and 43–48, for June, and August through October 1892). Paret, *Berlin Secession*, 14, 19–20, discusses Werner's role in these negotiations. On the Munch affair, see D.R. [Hans Rosenhagen], "Zur Lage," *Das Atelier* 3, no. 50 (Nov. 1892).

53. See `*·*`, "Aus dem Verein Berliner Künstler," *Kunstchronik*, n.s. 4 (Dec. 1892): col. 148; and D.R. [Hans Rosenhagen], "Zur Lage," *Das Atelier* 3, nos. 51–52 (Dec. 1892), both of which were extremely critical of the actions of Werner and his colleagues and positive about the future of the new Free Society in Berlin. For a full narrative of these events and the aftermath, see Paret, *Berlin Secession*, 50–54; Reinhold Heller, *Munch: His Life and Work* (Chicago: University of Chicago Press, 1984), 99–102; idem, "Anton von Werner, der Fall Munch, und die Moderne im Berlin der 1890er Jahre," in *Anton von Werner: Geschichte in Bildern*, ed. Dominik Bartmann, exh. cat. (Munich: Hirmer Verlag, 1993), 101–9; and Uwe M. Schneede, "'Aus Erinnerung und mit der Phantasie': Skandinavien in Berlin—Munchs 'zweite Heimat,'" in *Munch und Deutschland*, ed. Uwe M. Schneede and Dorothee Hansen, exh. cat. (Hamburg: Hamburger Kunsthalle, 1994), 14–16.

54. Werner's comment "Höflichkeit geht uns nichts an; es hat sich zu zeigen, wer eigentlich Herr im Hause ist," was quoted in D.R. [Hans Rosenhagen], "Zur Lage," *Das Atelier* 3, no. 51 (Dec. 1892): 1. The critical statement was published in the *Vossische Zeitung*, 21 Nov. 1892, with signatures of forty-eight of the members who had walked out of the meeting. The signatories included Liebermann, Skarbina, Hugo Vogel, and August von Heyden; the last three were the professors who left their teaching positions at the art institute. It was printed in full in =, "Berlin: Der Fall Munch," *Die Kunst für Alle* 8, no. 7 (Jan. 1893): 108. Reports of the petition from the three artists to be released from their positions appeared in R., "Berlin," ibid., no. 11 (Mar. 1893): 171, and in `*·*`, "Die Entfernung der Bilder des Norwegers Munch," *Kunstchronik*, n.s. 4 (Jan. 1893): col. 195. Rosenhagen unhappily reported in great detail these actions carried out by Werner and his myrmidons, *Das Atelier* 3, no. 54 (Jan. 1893): 1–3. Friedrich Freiherr von Khaynach, *Anton von Werner und die Berliner Hofmalerei* (Zürich: Verlags-Magazin, 1893), 7–9, provided

a provocative description of the Munch affair and its aftermath.

For a report on the statutes approved by the cultural ministry for the organization of the exhibition, see *Das Atelier* 3, no. 56 (Feb. 1893): 7. Reports on the negotiations over these regulations appeared in the other art journals, for example, in h., "Berlin," *Die Kunst für Alle* 7, nos. 18 (June 1892): 281–82 and 20 (July 1892): 315–16, analyzing the controversy and then providing the complete draft of an initial agreement, and `*·*`, "Berlin," ibid. 8, no. 10 (Feb. 1893): 156, where details of the final statutes were presented without editorial commentary.

55. A brief announcement of the Free Society festival appeared in *Das Atelier* 3, no. 55 (Feb. 1893): 8. For Rosenhagen's views on the Free Society, see D.R. [Hans Rosenhagen], "Zur Lage," ibid. 3, nos. 57 (Mar. 1893), 60 (Apr. 1893), and 64 (June 1893), where he commented that the Free Society had become a mere joke. In ibid. 4, no. 4 (Feb. 1894): 8, he reported, for example, that the monthly meeting of the Free Society had featured an African travelogue, a small display of sketches by members, and plans to produce an album of stone lithographs. According to Teeuwisse, *Vom Salon zur Secession*, 185–91, which argues that Werner's reputation suffered from the Munch affair, the Free Society existed until 1899. Plans for the German Art Society were reported in "Berliner Kunstverein," *Das Atelier* 2, no. 36 (Apr. 1892): 6; Dr. van Eyck, "Die Alten und die Jungen," ibid., no. 38 (May 1892): 2; *Die Kunst unserer Zeit* 3, 1st half-vol. (Apr. 1892), supplement; and D.R. [Hans Rosenhagen] "Zur Lage," *Das Atelier* 3, no. 52 (Dec. 1892): 7.

56. Reports on the events in Berlin appeared in *Der Kunstwart* 6, nos. 4 (Nov. 1892): 60 and 8 (Jan. 1893): 125. The positive reviews in the same journal were by Schönhoff, "Edvard Munch," ibid., 57–58, and Catenarius, "Edvard Munch Ausstellung," ibid., no. 5 (Dec. 1892): 74–75.

57. Also reporting on the Munch Affair were Dr. Relling [Jaro Springer], "Der Fall Munch," *Die Kunst für Alle* 8, no. 7 (Jan. 1893): 102–3; A.R. [Hans Rosenberg], "Eine Ausstellung von Ölgemälden," *Kunstchronik*, n.s. 4 (Nov. 1892): cols. 74–75; "Der Streit in der Berliner Künstlerschaft," ibid., col. 92; and `*·*`, "Aus dem Verein Berliner Künstler," ibid. (Dec. 1892): col. 148. Two years later *Der Kunstwart* 7, no. 10 (July 1894): 312–13, published a thoughtful, positive review by Fr. Carstanjen of *Das Werk des Edvard Munch* (Berlin: S. Fischer, 1894), with essays by Stanislaw Przybyszewski, Franz Servaes, Willy Pastor, and Julius Meier-Graefe.

A lucid analysis of the backward provincialism of Berlin art at this time under Werner is made by Heller, "Anton von Werner," 101–3. For an analysis of critical

responses to Munch, see Indina Kampf, "'Ein enormes Ärgernis' oder: Die Anarchie in der Malerei: Edvard Munch und die deutsche Kritik, 1892–1902," in Schneede and Hansen, *Munch und Deutschland*, 82–90. This catalogue includes a valuable section on Munch's relationship with German artists in the 1890s, "Bilder der Empfindung: Munch und die deutsche Malerei im späten 19. Jahrhundert," ibid., 142–53, and reconstructions of works shown at several of his German exhibitions after the disastrous one in 1892.

58. R. [Hans Rosenhagen], "Die Bilder von Edv. Munch," *Das Atelier* 3, no. 53 (Jan. 1893): 5; D.R. [Hans Rosenhagen], "Zur Lage," ibid., nos. 59–60 (Apr. 1893): 7.

59. "Der norwegische Maler Edvard Munch," *Kunstchronik*, n.s. 4 (Apr. 1893): col. 364, reported on Munch's application. Springer's view was that Munch should have been accepted as a member and would have been had he not been a modern painter (Dr. R., "Berlin," *Die Kunst für Alle* 8, no. 16 [May 1893]: 252). Munch's immediate exploitation of his notoriety was noted in the art journals, which followed his subsequent tour of works around Germany. See tz., "Düsseldorf," ibid., no. 8 (Jan. 1893): 122, for a report on the hanging of his works, which had been shown at the Society of Berlin Artists, at Eduard Schulte's galleries in Düsseldorf and Cologne; and ibid., no. 23 (Sept. 1893): 362–63, illustrating two of his paintings that were shown in Munich and in Berlin, *Portrait of Hans Jaeger* (1889) and *Mystique of a Summer Night* (1892). A reviewer of the Munch work at the Lichtenberg Art Salon in Breslau in April 1893 sternly rejected his work in *Kunstchronik*, n.s. 4 (May 1893): col. 427. Lichtenberg then circulated the show to Dresden in May and Munich in June.

Showing again in Berlin in December 1893 in a rented hall, Munch continued to exhibit in Germany through the 1890s. Dr. R. [Jaro Springer], *Die Kunst für Alle* 9, no. 8 (Jan. 1894): 123, reported that the bizarre sketches and drawings in the Berlin exhibition revealed a Munch caught in sick confusion and nightmares, though a year later J.S. [Jaro Springer], "Berlin," ibid. 10, no. 14 (Apr. 1895): 222, was much more positive, acknowledging that Munch, who would always be controversial, was very talented.

Rosenberg, however, continuing to be incensed by Munch's work, was astonished that Munch had returned again to try his luck in Berlin at Keller & Reiner's gallery (A.R., "Aus Berliner Kunstausstellungen," *Kunstchronik*, n.s. 9 [Apr. 1898]: col. 372). Later that year, his exhibition in Dresden at the Arno Wolffram Gallery elicited the comment from the journal's reporter that "the thinking public" must have been repelled by his work (ibid. 10 [Dec. 1898]: col. 119). For further information about Munch's exhibitions in Germany during these years, see Heller, "Anton

von Werner," 106–7; Kampf, "Ein enormes Ärgernis"; and Jutta Nestagaard, "Munch-Ausstellungen in Deutschland von 1891 bis 1927," in Schneede and Hansen, *Munch und Deutschland*, 255–60.

For the article on German art and Thoma, see Dr. van Eyck, "Deutsche Kunst," *Das Atelier* 3, no. 53 (Jan. 1893): 1–2. The Gurlitt Art Salon held an exhibition of Thoma's work later in the spring (see the review by Albert Dresden, "Berliner Kunstbrief: Hans Thoma, Lesser Ury, Fenner H. Behmer," *Der Kunstwart* 6, no. 15 [May 1893]: 231–32; and a review by J.S. [Jaro Springer], "Berlin," *Die Kunst für Alle* 8, no. 18 [June 1893]: 283).

60. Max Schmid, *Das Atelier* 3, no. 58 (Mar. 1893): 2; his trenchant comment appeared in his lengthy review "Berliner Kunstausstellung 1893," ibid., no. 62 (May 1893): 4–5. Rosenhagen's views were apparent in his articles on the Munich Secession, R., "Die Sezessionisten auf der Grossen Berliner Kunstausstellung 1893," ibid., nos. 63 (June 1893), 65–66 (July 1893), 68 (Aug. 1893).

61. On the battle of artistic ideas, see R. [Hans Rosenhagen], "Freie Kunstausstellung," ibid., no. 64 (June 1893): 1–2.

62. For his response to the Munich Secession negotiations, see D.R. [Hans Rosenhagen], "Zur Lage," ibid., nos. 55–58 (Feb.–Mar. 1893); and for the quotation from an observer, Friedrich Fuchs, see "Das Prachtwerk 'Sezession,'" ibid., no. 73 (Nov. 1893): 4.

63. Rosenhagen's accusation against Werner and his myrmidons about the suicide is in D.R., "Zur Lage," ibid., no. 64 (June 1893): 6–7.

64. The Barbizon exhibition in 1893 was reviewed by Dr. Max Schmid in "Salon Gurlitt," ibid., no. 57 (Mar. 1893): 3–4. Reviews of the December–January exhibition of Barbizon and Impressionist works were by Dr. R. [Jaro Springer], "Berlin," *Die Kunst für Alle* 9, nos. 9–10 (Feb. 1894): 141, 156; and R. [Hans Rosenhagen], "Französische Maler im Salon Gurlitt," *Das Atelier* 3, no. 75 (Dec. 1893): 4–5. Fritz Gurlitt died at the age of thirty-nine. One wonders what role he and his brother Cornelius might have played in this decade of change. As it was, the Gurlitt Art Salon maintained an impressive record in the 1890s, with exhibitions of women artists, French modernists, symbolists, Scandinavian artists, and secessionists. For an appreciative obituary by Rosenhagen, see H.R., "Fritz Gurlitt †," ibid., no. 56 (Feb. 1893): 5–6.

On the state of art in Berlin, see Albert Lamm, "Von guter und schlechter Malerei in Berlin," *Der Kunstwart* 11, no. 11 (May 1898):348–51; and Albert Dresdner, "Berliner Bericht: Die Berliner Kunstausstellung, II," ibid. 10, no. 20 (July 1897): 316–17. See also Paul Schultze-Naumburg,

"Die Berliner Kunstausstellung," ibid. 11, no. 18 (June 1898): 194, written as news emerged that a Berlin Secession was beginning to take shape.

65. For reports on the Dresden Secession, see *Das Atelier* 3, no. 59 (Apr. 1893): 9; *Kunstchronik*, n.s. 4 (Aug. 1893): col. 538; *, "Dresden," *Die Kunst für Alle* 8, no. 21 (Aug. 1893): 333, stating that the group within the Dresden Art Association called itself the Strehlener Ortsgruppe; ibid. 8, no. 23 (Sept. 1893): 363; *Das Atelier* 3, no. 75 (Dec. 1893): 8; ibid. 4, no. 10 (May 1894): 7; H. A. Lier, "Korrespondenz: Aus Dresden," *Kunstchronik*, n.s. 5 (June 1894): cols. 462–63; and *Die Kunst für Alle* 9, no. 17 (June 1894): 270.

For reviews of the first exhibition, see *Das Atelier* 4, no. 19 (Oct. 1894): 10; *Die Kunst für Alle* 10, nos. 3 (Nov. 1894): 46 and 7 (Jan. 1895): 108; P. Schumann, "Dresdner Kunstbrief," *Der Kunstwart* 8, no. 4 (Nov. 1894): 58. Reviews of later exhibitions appeared in *Die Kunst für Alle* 13, no. 12 (Mar. 1898): 187; ibid. 14, no. 13 (Apr. 1899): 199–200; and *Kunstchronik*, n.s. 9 (Mar. 1898): col. 283. The dissolution of the Free Society was reported in ibid. 12 (Jan. 1901): col. 188, and *Die Kunst für Alle* 17, no. 18 (June 1902): 432.

See also W. von Seidlitz, "Dresdens Junge Künstlerschaft," *Pan* 2, no. 2 (Aug. 1896): 139–40, in a special issue devoted to contemporary art in Dresden. "Von der Dresdner Sezession," *Deutsche Kunst* 2, no. 11 (Mar. 1898): 210–11; and *Der Kunstwart* 11, no. 10 (Feb. 1898): 334, both report on the conflict within the joint planning commission for the 1899 German National Exhibition in Dresden, as does Uta Neidhardt, "Gotthardt Kuehl in Dresden, 1895–1915," in *Gotthardt Kuehl, 1850–1915*, ed. Gerhard Gerkens and Horst Zimmermann, exh. cat. (Leipzig: E. A. Seemann, 1993): 56, 74 n. 2. For reviews of the portfolio *Vierteljahrshefte des Vereins bildender Künstler Dresdens*, with four to six original lithographs in each issue, see "Dresden," *Die Kunst für Alle* 10, no. 12 (Mar. 1895): 189; *Der Kunstwart* 8, no. 21 (Aug. 1895): 334; and ibid. 9, no. 12 (Mar. 1896): 184.

Information on Emilie Mediz-Pelikan can be found in W. v. Seidlitz, "Neues aus Dresden, II: Karl Mediz und Emilie Mediz-Pelikan," *Die Kunst für Alle* 10, no. 11 (Mar. 1895): 169–71; and Elke Messer, "Emilie Mediz-Pelikan," in *Das Verborgene Museum I: Dokumentation der Kunst von Frauen in Berliner öffentlichen Sammlungen*, ed. Neue Gesellschaft für Bildende Kunst e.V., Berlin (Berlin: Edition Hentrich, 1987), 161–62.

66. On Karlsruhe's secession, see W. v. Seidlitz, "Der Karlsruher Kuenstlerbund," *Pan* 3, no. 4 (1897–98): 235–38; "Karlsruhe hat nun auch seine Sezession," *Der Kunstwart* 9, no. 18 (June 1896): 285; "München: Ludwig Dill," *Die Kunst für Alle* 14, no. 14 (Apr. 1899): 221; and "Stuttgart," ibid. 15, no. 6 (Jan. 1900): 163. Further information and documentation on events in Karlsruhe can be found in Susanne Himmelheber and Mirko Heipek, "Der Karlsruher Künstlerbund," in Staatliche Kunsthalle, *Kunst in Karlsruhe, 1900–1950*, exh. cat. (Karlsruhe, Germany: Verlag C. F. Müller, 1981), 20–26, 32–41.

On Darmstadt's secession, see "Das Kunstleben in Darmstadt," *Der Kunstwart* 9, no. 22 (Aug. 1896): 347, reporting on the sad condition of art in Darmstadt shortly before the formation of the new society. For later reports on the exhibitions of the Free Society, see "Die Ausstellung in Darmstadt," *Kunstchronik*, n.s. 10 (Oct. 1898): cols. 17–19, discussing the goals of the society, its members, and the first exhibition; ibid. (May 1899): col. 382, on plans for the artists' colony; *Die Kunst für Alle* 14, no. 15 (May 1899): 259, announcing plans for the new artists' colony; B.D., "Aus der hessischen Residenz," ibid., no. 21 (Aug. 1899): 331–34, reporting on the society's second exhibition; "Darmstadt: Freie Vereinigung Darmstädter Künstler," ibid., no. 24 (Sept. 1899): 381; b.d., "Moderne Kunst in Darmstadt," ibid. 15, no. 1 (Oct. 1899): 11–12; H.W., "Die zweite Ausstellung der 'Freien Vereinigung Darmstädter Künstler,'" ibid., no. 4 (Nov. 1899): 80–84; and "Darmstadt," ibid. 16, no. 5 (Dec. 1900): 127. Essays on the Darmstadt artists and the Mathildehöhe colony are available in a five-volume work, Hessisches Landesmuseum, *Darmstadt: Ein Dokument deutscher Kunst, 1901–1976* (Darmstadt: Eduard Roether Verlag, 1977).

67. On the urgency of establishing a secessionist federation, see D.R. [Hans Rosenhagen], "Zur Lage," *Das Atelier* 3, nos. 49–51 (Nov.–Dec. 1892) and 57 (Mar. 1893). A federation was finally achieved in 1903 with the formation of the Allgemeine Deutsche Künstlerbund. Rosenhagen's judgment of German painting is from R., "Die Sezessionisten auf der Grossen Berliner Kunstausstellung 1893, V," ibid., no. 70 (Sept. 1893): 4.

68. The definition of secessions quoted in the text was published by Gerhart Romint, "Die Ausstellung der Münchner Sezessionisten in Dresden, I," ibid., no. 75 (Dec. 1893): 3: "künstlerisches Können, individuelles Empfinden und Ausdrucksvermögen." See the similar list of qualities from Woldemar von Seidlitz's description in *Pan* of the new qualities in art valued by the secessions: "Ehrlichkeit der Empfindung, Einheitlichkeit des Tons, Selbständigkeit der Auffassung." The qualities constituted a revolutionary shift, he wrote, from prizing outer skill to searching for inner meaning (Woldemar von Seidlitz, "Der Karlsruher Kuenstlerbund," *Pan* 3, no. 4 [1897–98]: 235). Echoing these qualities, Albert Dresdner discussed the qualities of modern German painting, which he characterized as "starkes und echtes Empfinden, Ehrlichkeit und vor allem jene Innerlichkeit und Tiefe gezeigt, die nicht an der Außenseite der Dinge haften bleiben," in "Die Berliner Kunstausstellung. 6, Die Deutschen," *Der Kunstwart* 9, no. 2 (Oct. 1895): 26.

Rosenhagen's apparently losing battle for reform and against Werner in Berlin through the pages of *Das Atelier* ended in December 1897, when the journal was purchased and reduced to an abbreviated addendum of announcements for *Deutsche Kunst: Illustrirte Zeitschrift für das gesammte deutsche Kunstschaffen*, the central organ for all German art and artists' societies. Rosenhagen became one of the Berlin critics for *Die Kunst für Alle* (1898–1914). He also founded and edited *Der Tag* (1901–16), a journal of contemporary German literature, in which he published a controversial article on the decline of Munich's art world in 1901.

Part III, Chapter 6
Modernism: Acceptance and Resistance

1. A[nna] Spier, "Franz Stuck," *Westermann's Illustrierte Deutsche Monatshefte* 38, half-vol. 76 (Aug. 1894): 545–50. The metaphors of battles won and revolutionary transformations appeared frequently in the critical writing. Though writers gave different readings, all agreed that radical shifts in taste and perception had occurred since the mid-1880s. For a position not unlike Spier's, see Alfred Freihofer, "Die Münchner Kunstausstellungen von 1894," *Der Kunstwart* 8, no. 2 (Oct. 1894): 26. After this long introduction, Spier went on to state that no living artists had tasted the law of individuality as early and as fully as Franz Stuck. The following consideration of Stuck's artistic work, she wrote, would demonstrate the insufficiency of all programs and of all the demands of the times before the power of individuality.

2. An illuminating study of "the accelerated internationalization of western life at the end of the century" is provided by Roger Chickering in his *Imperial Germany and a World without War: The Peace Movement and German Society, 1892–1914* (Princeton: Princeton University Press, 1976). Pointing to the economic and communications frameworks that enabled both international agencies and innumerable international organizations to be formed in the years 1870–1914, Chickering concentrates on the inexorable link between the rise of peace movements promoting international idealism and the armament races exacerbating nationalist fervor.

3. While *Pan* is regularly acclaimed as the outstanding and most influential art journal of the nineties in Germany, serious studies in English have yet to be published. A seminal article was published by Karl H. Salzmann, "*Pan*: Geschichte einer Zeitschrift," *Imprimatur* 10 (1950–51): 163–85. The most thorough and extensive discussion of the formation of the Genossenschaft Pan and of its board of directors and editorial boards is to be found in Gisela Henze's heavily documented "Der *Pan*: Geschichte und Profil einer Zeitschrift der Jahrhundertwende" (Ph.D. diss., Albert-Ludwigs-Universität zu Freiburg i. Br., 1974).

Henze's sympathy lay overtly with the "avant-garde" writers Meier-Graefe and Bierbaum in their conflict with the "conservative" board of directors, as evidenced by her frequent quotations from both writers' polemical *romans à clef* to characterize the actions of the directors, particularly Bode and Lichtwark. Jutta Thamer, *Zwischen Historismus und Jugendstil: Zur Ausstattung der Zeitschrift "Pan" (1895–1900)* (Frankfurt am Main: Peter D. Lang, 1980), provides a careful analysis of the aesthetic design of the journal. A succinct summary can be found in Karl Ulrich Syndram, "*Pan* und *Insel*: Die Verbindungen der Rundschaupublizistik zu ästhetischen Periodika," in *Kulturpublizistik und nationales Selbstverständnis: Untersuchungen zur Kunst- und Kulturpolitik in den Rundschauzeitschriften des Deutschen Kaiserreiches (1871–1914)* (Berlin: Gebr. Mann Verlag, 1989), 127–41. See also Maria Rennhofer, *Kunstzeitschriften der Jahrhundertwende in Deutschland und Österreich, 1895–1914* (Vienna: Bechtermünz Verlag, 1997), 36–68, which contains a large number of full-color reproductions from *Pan*.

4. An invaluable description of the influence of the Scandinavians in Berlin in the 1890s is Uwe M. Schneede, "'Aus der Erinnerung und mit der Phantasie': Skandinavien in Berlin—Munchs 'zweite Heimat,'" in *Munch und Deutschland*, ed. Uwe M. Schneede and Dorothee Hansen, exh. cat. (Hamburg: Hamburger Kunsthalle, 1994), 12–19. See also Reinhold Heller, *Munch: His Life and Work* (Chicago: University of Chicago Press, 1984), 104–9.

On Bierbaum's activities in Munich from 1891–94, see Peter Jelavich, *Munich and Theatrical Modernism: Politics, Playwriting, and Performance, 1890–1914* (Cambridge: Harvard University Press, 1985). Henze, "Der *Pan*," 124–31, supplies a useful analysis of the background and capacity of both Bierbaum and Meier-Graefe for editorial work. For an adulatory account of Meier-Graefe's role in *Pan*, see Kenworth Moffett, *Meier-Graefe as Art Critic* (Munich: Prestel Verlag, 1973), 9–19. For a more critical view, see L. D. Ettlinger, "Julius Meier-Graefe: An Embattled German Critic," *Burlington Magazine* 117 (Oct. 1975): 672–74. See also a tribute to Meier-Graefe in Thomas W. Gaehtgens, "Die großen Anreger und Vermittler: Ihr prägender Einfluß auf Kunstsinn, Kunstkritik und Kunstförderung," in *Mäzenatentum in Berlin: Bürgersinn und kulturelle Kompetenz unter sich verändernden Bedingungen*, ed. Günter Braun und Waldtraut Braun (Berlin: Walter de Gruyter, 1993): 99–112; and an analysis of Meier-Graefe's critical method in Patricia G. Berman, "The Invention of History: Julius Meier-Graefe, German Modernism, and the Genealogy of Genius," in *Imagining Modern German Culture: 1889–1910*, ed. Françoise Forster-Hahn (Washington, D.C.: National Gallery of Art, 1996): 91–101.

An informative analysis of Dehmel's longstanding involvement with art is Peter-Klaus Schuster, "Leben wie ein

Dichter—Richard Dehmel und die bildenden Künste," in *Ideengeschichte und Kunstwissenschaft: Philosophie und bildende Kunst im Kaiserreich*, ed. Ekkehard Mai, Stephan Waetzoldt, and Gerd Wolandt (Berlin: Gebr. Mann Verlag, 1983), 181–221. Salzmann, *"Pan,"* 163–64, reported that Bierbaum's brief tenure in early 1894 as editor of the *Freie Bühne* (Berlin) ended because of disagreements with the publisher, Samuel Fischer, who wanted concessions made to public taste. Salzmann cites a letter of 13 March 1894 to Bodenhausen in which Bierbaum announced that he, Dehmel, and Przybyszewski had a new idea "die Kunst vor den Handelsleuten zu retten."

For Kessler's association with Bodenhausen and his financial and editorial efforts on behalf of the journal, see Theodore Fiedler, "Weimar contra Berlin: Harry Graf Kessler and the Politics of Modernism," in Forster-Hahn, *Imagining Modern German Culture*, 107–11; Peter Grupp, *Harry Graf Kessler, 1868–1937: Eine Biographie* (Munich: Verlag C. H. Beck, 1995), 58–74; and Burkhard Stenzel, *Harry Graf Kessler: Ein Leben zwischen Kultur und Politik* (Weimar, Germany: Böhlau Verlag, 1995), 48–63. An analysis of Kessler's collection of French modernist painting and his efforts to promote Neo-Impressionist art in Germany has been published by Beatrice von Bismarck, "Harry Graf Kessler und die französische Kunst um die Jahrhundertwende," in *Sammler der frühen Moderne in Berlin*, ed. Thomas W. Gaehtgens, special issue of *Zeitschrift des deutschen Vereins für Kunstwissenschaft* 42, no. 3 (1988), 47–62.

Bodenhausen, who served as chair of the board of directors throughout the life of *Pan* and provided the major financial backing, and Dehmel had both studied law. Dehmel received his doctorate in law in 1887, while Bodenhausen, after completing his legal in-service training, took his doctorate in art history. Later, serving as director of the Troponwerke, a food-processing firm, he commissioned designs from Henry van de Velde, including a well-known poster. By 1902 he was one of the directors of the heavy-industry firm Krupp. Throughout his life he remained a steady patron of the arts.

5. These rough figures are based on the membership and subscriber lists published both in the journal and in the prospectus for the journal. On the reason for the publication of the names, Henze, "Der *Pan*," 17, cites a letter from the publisher to Kessler in 1897: "Wir sind der Ansicht, daß mancher die hohen Abonnements-Gebühren lieber bezahlt, wenn er seinen Namen gedruckt in der Liste findet." In the first list 108 of the 344 were identified only by name and city; by 1897, of 577 names, 138 were accompanied by no further identification. The February 1898 business report on the third year of the company stated that there were 723 subscribers, although the published membership roster lists only 514 regular subscribers and 60 members receiving two luxury editions. The list of

royalty in volume 4 included a Czar Peter Nikolajewitsch. Primarily interested in the literary aspects of the journal, Henze, "Der *Pan*," 229–46, uses different categories in her analysis of the membership lists.

6. The statement of purpose appeared in *Pan* 1, no. 1 (Apr.–May 1895), inside front cover. The general edition of fifteen hundred copies was published on thick, matte copper-print paper; the luxury edition of only seventy-five numbered copies was printed on handmade royal Japanese paper; and the artist edition of thirty-seven numbered copies available only to members, also on royal Japanese, was accompanied by signed, original graphics in a portfolio format.

7. For those members of Pan who had purchased from one to four shares (at 100 marks per share), the subscription to the general edition of *Pan* was reduced to 40 marks. Members with ten shares (1,000 marks) received the general edition free; the luxury edition was free to those with twenty shares (2,000 marks); and the artist edition, available only to members, was free to those with thirty shares (3,000 marks). By the second issue of *Pan*, both special editions, fully reserved, were no longer available for new members. Nonmembers could also purchase individual issues of the general edition for 20 to 30 marks, depending on the issue. In the membership lists, the names of members who held rights to the special editions were followed by the number assigned to their copy.

The price for *Der Kunstwart* was raised to 12 marks when plates were introduced in 1898; and the price of *Die Kunst für Alle* was increased from 12 marks to 14 marks, 60 pfennigs, in 1895. It should be noted that although *Pan* was only a quarterly, it approximated the size of *Die Kunst für Alle*, with an annual total of 300–350 pages and 48 plates. Visually, there is simply no comparison between these journals. *Pan* stands alone. For statistical tables and a detailed description of the journal, see Henze, "Der *Pan*," 255–99; and the tables printed in Thamer, *Zwischen Historismus und Jugendstil*, 156–57, citing figures from Georg Ramsegger, *Literarische Zeitschriften um die Jahrhundertwende* (Berlin, 1941), 113.

8. For negative responses to the cost of the journal, see H. E. v. Berlepsch, "Was ist die Kunst bei uns?" *Die Kunst für Alle* 11, no. 1 (Oct. 1895): 5; Freiherr von Bodenhausen, "Die Volkskunst und der *Pan*," *Der Kunstwart* 8, no. 19 (July 1895): 302–3; and Richard Dehmel, "Berlin," *Pan* 1, no. 2 (June–Aug. 1895): 110–11. For the full quotation from Dehmel's letter, see Salzmann, *"Pan,"* 169, though he provides no documentation beyond the date.

9. Henze, "Der *Pan*," 76–110, analyzes the creation and makeup of the board of directors in careful detail. She blames Meier-Graefe for being so eager to bring prominent, influential men onto the board of directors in order

to attract members to support the journal that he ignored the possible negative consequences of creating a powerful board. A brief, thorough outline of the Nietzschean fragments and images that appear in the journal is provided in Fiedler, "Weimar contra Berlin," 110–11. Hans-Dieter Erbsmehl, "Kulturkritik und Gegenästhetik: Zur Bedeutung Friedrich Nietzsches für die bildende Kunst in Deutschland 1892–1918" (Ph.D. diss., University of California, Los Angeles, 1993), 87–132, discusses in detail the Nietzschean fragments and illustrations in *Pan* and argues that divergent interpretations of Nietzsche's philosophical ideas were at the basis of the conflict between the bohemian co-editors and the influential members of the board of directors, specifically Bodenhausen, Kessler, and Lichtwark.

The editorial board for the first two issues comprised, in addition to Meier-Graefe and Bierbaum, Bodenhausen, Dehmel, Theodor Fontane, H. Grisebach, Hans W. Singer, and Seidlitz. Nineteen of the thirty-eight members of the board of directors were artists: Reinhold Begas, Böcklin, Burne-Jones (English), Hans Grisebach, Hofmann, Kalckreuth, Albert Keller, Khnopff (Belgian), Klinger, Köpping, Kuehl, Liebermann, Rudolf Maison, Max, Rops (Belgian), Skarbina, Stuck, Uhde, and Wilhelm Unger. The eight museum directors and officials on the board of directors were Adolf Bayersdorfer, curator, Alte Pinakothek, Munich; Bode, director of the royal museums, Berlin; Richard Graul, directorial assistant, Kunstgewerbemuseum, Berlin; Martin Hildebrandt, Verein Berliner Künstler; Lichtwark, director, Kunsthalle, Hamburg; Muther, curator, Kupferstick-Kabinett, Munich; Seidlitz, general director, Dresden museums; and Woerman, director, Gemäldegalerie, Dresden.

The works cited are, from *Pan* 1, no. 1 (Apr.–May 1895): Stéphane Mallarmé, "Sonnet," with etching by Fernand Khnopff, *La Poesie de Mallarmé*, full plate; Paul Verlaine, "Prologue pour Varia," with Eckmann borders, 13–14; Böcklin, *Der Drachentöter*, full plate; Félicien Rops, *Oude Kate*, original engraving; Novalis, "Hymne an die Nacht," with Ludwig von Hofmann designs and hand lettering, 4. From *Pan* 1, no. 2 (June–Aug. 1895), are Matthaeus Grünewald, *Die Kreuzigung*, full plate, accompanied by J. K. Huysmann's essay, "Die Kreuzigung von Matthaeus Gruenewald," 95–96. The second number of *Pan* also included three poems by Maurice Maeterlinck. Younger artists who contributed most to the illustrations were Otto Greiner, Otto Eckmann, Leistikow, Josef Sattler, Peter Halm, Fidus (Hugo Höppner), and Th. Th. Heine. Among the acknowledged modernists whose illustrations were also heavily published were Hofmann, Klinger, and Thoma.

10. For informative analyses of the cult of decadence, bohemians, and the literary Symbolists in late-nineteenth-century France, see Jean Pierrot, *The Decadent Imagination, 1880–1900*, trans. Derek Coltman (Chicago: University of Chicago Press, 1981); Jerrold Seigel, *Bohemian Paris: Culture, Politics, and the Boundaries of Bourgeois Life, 1830–1930* (New York: Viking Penguin, 1986), 242–68; and Eugen Weber, *France: Fin de Siècle* (Cambridge: Harvard University Press, 1986), 8–26, 142–58.

11. Max Nordau, *Degeneration* (1895; reprint, intro. George L. Mosse, New York: Howard Fertig, 1968); writers in *Pan* on whom he commented included Verlaine (119–28), Mallarmé (128–31), Maeterlinck (227–40), Baudelaire (285–96), and Huysmans (298–310). Nordau concentrated upon French literature in this book, with only glancing references to disturbing aspects of the visual arts. In 1897 he gave a lecture in Turin titled "Art and Society," in which he traced the purpose of art from the time of the caveman and argued that in the future art would serve the masses by providing relief from industrial work (see th., "Rom," *Die Kunst für Alle* 12, no. 21 [Aug. 1897]: 348–49). *Jugend* published a satirical piece on Nordau's attack on modern art as degenerate in "Vom Terrorismus," *Jugend* 4, no. 48 (Nov. 1899): 758. A decade after his first book, Nordau turned his attention to the social mission of art in French painting in *On Art and Artists*, trans. W. F. Harvey (Philadelphia: G. W. Jacobs, 1907).

In addition to his other activities, Nordau was the correspondent for the *Vossische Zeitung* in Paris, where, as the resident medical doctor in a hotel, he treated Werner during the latter's visit to the Paris World Fair in 1889 (see Anton von Werner, *Erlebnisse und Eindrücke, 1870–1890* [Berlin: Ernst Siegfried Mittler und Sohn, 1913], 564–67). Closely associated with women, degeneration became a serious preoccupation of European writers in many fields in the latter half of the nineteenth century. Informative essays on different aspects of this concept are collected in J. Edward Chamberlin and Sander L. Gilman, *Degeneration: The Dark Side of Progress* (New York: Columbia University Press, 1985). Pierrot, *Decadent Imagination*, 45–49, contains a valuable analysis of the belief in degeneration as a source of the pessimism of this era. Also helpful is Robert A. Nye, *Crime, Madness, and Politics in Modern France: The Medical Concept of National Decline* (Princeton: Princeton University Press, 1984).

12. A[venarius], "Von allermodernster Kunst," *Der Kunstwart* 8, no. 16 (May 1895): 241–45. In making his judgment about *Pan*'s failure to carry out its claims he was reacting to statements such as one made in the 1894 prospectus that laid out a program to provide an "ungetrübtes und vollständiges Bild der kunstschaffenden Kräfte unserer Zeit, sowie einen Überblick über verwandte Bestrebungen früherer Epochen" (quoted in Thamer, *Zwischen Historismus und Jugendstil*, 27). Avenarius discussed in detail the art and poetry in the journal. He was puzzled

by Stuck's "stark semitisch aussehenden Herrn" on the cover and offended by Sattler's archaizing illustrations for "Rabbi Jeschua" by Detlev von Liliencron. He ridiculed Dehmel's "Trinklied," not for its hedonistic message, but for its use of glossolalia. See also his review of the second issue in *Der Kunstwart* 8, no. 20 (July 1895): 316–17. Not surprisingly, Avenarius was pleased with the change of editors (see A[venarius], "*Pan*: Viertes Heft," ibid. 9, no. 12 [Mar. 1896]: 184). In =, "Pan," *Die Kunst für Alle* 10, no. 16 (May 1895): 254, the writer was explicit in supporting Bode's position on the design expressed in the first issue, asserting that Bierbaum's ideas would result in a peculiar affectation that was already apparent in the first issue.

13. Richard Dehmel, "Das Trinklied," *Pan* 1, no. 1 (Apr.–May 1895): full plate, both sides, drawings by G. Lührig. Also controversial were Paul Scheerbart, "Das Königslied," with graphics by Axel Gallén, and, in the second number, Anna Croissant-Rust, "Truppenrevue," illustrated by Th. Th. Heine. For more on these objections, see Salzmann, "Pan," 170–71; and Thamer, *Zwischen Historismus und Jugendstil*, 32–34. Disagreements about the design were raised in the first issue by W. Bode, in "Anforderungen an die Ausstattung einer illustrierten Kunstzeitschrift," *Pan* 1, no. 1 (Apr.–May 1895): 30–33, and rejected by the editors, in "Zur Ausstattungsfrage," ibid., 40–41. Alfred Lichtwark, "Rundschau: Zur Einführung," ibid. 1, no. 2 (June–Aug.): 97–100, raised a different agenda for the journal, while Richard Dehmel, "Berlin," ibid., 110–17, objected to the elitist audience. The announcement of editorial changes was published on the inside of the cover of the third issue, whose contents had been planned by Meier-Graefe and Bierbaum before their dismissal. Members named to the new editorial commission were Bode, Bodenhausen, Otto Erich Hartleben, Kessler, Köpping, Lichtwark, Seidlitz, Caesar Flaischlen (the new literary editor), and Graul (the new arts editor). On the function of the first editorial board and the second editorial commission, see Henze, "Der *Pan*," 110–23, 131–43; Salzmann, "Pan," 172–76; and Thamer, *Zwischen Historismus und Jugendstil*, 25–38, all of which, drawing on memoirs and letters, have informative discussions of the controversies that beset the first editors, including the financial mismanagement by Meier-Graefe and Bierbaum. See Syndram, *Kulturpublizistik*, 133, for his comments on the collective editorial concept.

14. The lithograph was accompanied by a tribute to Toulouse-Lautrec written by Arsène Alexandre. Although the acquisition and inclusion of the Toulouse-Lautrec lithograph were considered by many to be the crucial actions leading to the removal of the editors and their editorial board, an article on posters written by a member of that fated board, Hans W. Singer, was published in the fifth issue. In it, Singer praised Toulouse-Lautrec as "einem der geistvolleren Künstler, einem der raffiniertesten Meister die es je gegeben hat," and warned readers not to make quick judgments about Lautrec ("Plakatkunst," *Pan* 1, no. 5 [Feb.–Mar. 1896]: 331–32). The Kupferstichkabinett of the Royal Prussian Museums acquired an original of this lithograph in 1899. Lichtwark's article, "Die Entwickelung des Pan," *Pan* 1, no. 3 (Sept.–Nov.): 173–76, was immediately followed by articles on Besnard, Segantini, and Toulouse-Lautrec, accompanied by his offending lithograph.

15. Lichtwark had signaled his dissatisfaction with the editors in the previous issue in "Rundschau: Zur Einführung," *Pan* 1, 2 (June–Aug. 1895): 97–100. In that article, in which he called for educating the consumers of art, he had argued that Germany was being threatened by the invasion of English products, especially arts and crafts. His language was belligerent: "Die englische Invasion droht unsre unabhängige Entwicklung zu hemmen. . . . Wir haben den Feind im Lande" (98–99). Opposition to Lichtwark's support and promotion of the "neue Richtung in der Kunst" was reported in "Hamburg," *Die Kunst für Alle* 11, no. 13 (Apr. 1896): 207, and in ibid. 14, no. 8 (Jan. 1899): 127, reporting on a brochure, *Protest Hamburger Künstler gegen Professor Alfred Lichtwark*, recently published by a disgruntled Hamburg artist. A tribute to Lichtwark's active role in promoting modern art was published in "Hamburg," ibid. 16, no. 6 (Dec. 1900): 142.

16. The new statement of goals appeared in the prospectus announcing plans for the second volume, "Pan 1896–1897, Zweiter Jahrgang," and in *Pan* 2, no. 1 (June 1896). Four years later, in an article published for the *Amtliche Katalog der Ausstellung des Deutschen Reiches auf der Pariser Weltausstellung*, Lichtwark presented his understanding of the history of German art, that is, with strong roots in the old princely cities with historic academies. The article was reprinted as Alfred Lichtwark, "Deutsche Kunst," in *Die Kunst für Alle* 15, no. 20 (July 1900): 441–49, and also in *Der Kunstwart* 13, no. 22 (Aug. 1900): 355–62. Thamer, *Zwischen Historismus und Jugendstil*, 35–37, contains a valuable analysis of Lichtwark's regionalization program for *Pan*. Artists included in the regional issues were: in 2, no. 1 (June 1896), on Berlin, Liebermann, Hofmann, Menzel, Skarbina, Leistikow, Paczka-Wagner, and Zorn; in ibid., no. 2 (Aug. 1896), on Dresden and Leipzig, Klinger, Otto Fischer, Paul Baum, Greiner, Max Pietschmann, Hans Unger, Mediz, Georg Lührig, Werenskiold, and Munch; in ibid., no. 3 (Nov. 1896), on Munich, Böcklin, Wilhelm Volz, Halm, Kirchner, Bernard Pankok, Eckmann, Thoma, Trübner, Köpping, Werenskiold, and Heine; on Hamburg, Artur Illies, J. Alberts, Thomas Herbst, P. O. Runge, and Valentin Ruths, and there was a special section on English and American artists.

17. Henze, "Der *Pan*," 115–21, discusses the circumstances of Liebermann's and Hofmann's appointment to the editorial board and points out that Bode saw Liebermann's international connections with artists, dealers, and patrons as invaluable for *Pan*, while Hofmann's symbolist painting was seen as balancing Liebermann's more conservative work. Kessler's interest in contemporary French art and literature was demonstrated in the first volume of *Pan* with his article on the French Symbolist poet Henri de Régnier, which was illustrated by Greiner's drawings (*Pan* 1, no. 4 [Dec. 1895–Jan. 1896]: 243–49).

For artists given special attention in *Pan*, see *Pan* 3, no. 2 (Sept. 1897), which was a tribute to Böcklin on his seventieth birthday, with a special congratulatory sheet drawn by Klinger and an article by Heinrich Alfred Schmid (73–80); and ibid. 4, no. 1 (July 1898), which devoted a special section to Böcklin. Klinger dominated ibid. 5, no. 1 (Aug. 1899), with an article by Georg Treu, "Max Klinger als Bildhauer," (27–35), plates of his sculpture, and recent graphic work. Liebermann's drawings and sketches were featured in ibid. 4, no. 3 (Dec. 1898), and 5, no. 4 (May 1900). Adolf Hildebrandt's sculpture was celebrated in ibid. 5, no. 2 (Nov. 1899), and Kalckreuth in ibid., no. 3 (Feb. 1900). Hofmann, who appeared with great regularity throughout the five volumes, illustrated almost the entire issue of ibid. 4, no. 4 (May 1899), and the last issue, 5, no. 4 (May 1900), featured his drawings and Liebermann's. Younger German artists appearing in the last issues included Hans Baluschek, Corinth, and Kollwitz.

18. For French art in *Pan*, see, e.g., W. v. Seidlitz, "Degas," and Roger Marx, "Gustave Moreau: Seine Vorlaeufer, Seine Schule, Seine Schueler," *Pan* 3, no. 1 (July 1897): 57–60, 61–64, with a plate by Degas and illustrations by Puvis de Chavannes and Moreau. Neo-Impressionist artists included in ibid. 4, no. 1 (July 1898), were Signac, Hippolyte Petitjean, Luce, Rysselberghe, Seurat, and Cross. The article by Paul Signac was "Neo-impressionismus," ibid., 55–62. *Pan* 4, no. 3 (Dec. 1898): 193–96, published Liebermann, "Degas," with several photographs of his paintings and drawings. For a negative review of Liebermann's study of Degas, see Albert Lamm, "Ueber Liebermann, Degas und einiges Andere," *Der Kunstwart* 13, no. 2 (Oct. 1899): 54–58. On Symbolism, see Magnus von Wedderkop, "Paul Verlaine und die Lyrik der Décadence in Frankreich," *Pan* 2, no. 1 (June 1896): 69–77, with a portrait of Verlaine by Zorn, a handwritten French poem, and several translated by Flaischlen; Oscar A. H. Schmitz, "Die Abendroete der Kunst," ibid. 3, no. 3 (Dec. 1897): 185–90, on Symbolist writers and Gauguin, Redon, Munch, and Heran; A. Brunneman, "Maurice Maeterlinck," ibid., no. 4 (Feb. 1898): 254–58; and Verlaine and Rimbaud's poetry in translation in ibid. 5, no. 1 (Aug. 1899).

19. Wilhelm Bode, "Die bildenden Künste beim Eintritt in das neue Jahrhundert," *Pan* 5, no. 4 (May 1900): 245–49. "Rundschau-Bildende Kunst," *Der Kunstwart* 14, no. 1 (Oct. 1900): 40–43, lamented the demise of *Pan*, praising its serious contributions from artists and significant essays by Lichtwark, Bode, and Seidlitz. *Die Kunst für Alle* 15, no. 6 (Dec. 1899): 144, noted briefly that the Pan Company had folded, ending the journal. In trouble financially, *Pan*, which had lost members and subscribers in the last two years, ended its publication after the last number of volume 5, and its assets, including unsold copies, were liquidated (see Henze, "Der *Pan*," 215–21).

20. This is by no means a complete list of the appearances of the modernist French artists in the many German exhibitions in these years. For a sampling of reviews from just one journal, see, e.g., Friedrich Pecht, "Die Münchener Jahres-Ausstellung von 1891," *Die Kunst für Alle* 6, no. 22 (Aug. 1891): 339–40, on Manet's paintings in the Third Annual Munich Exhibition. Becker, in his review of the first Munich Secession exhibition, discussed paintings by both Degas and Monet ("Die Ausstellung der Secession in München," ibid. 8, no. 24 [Sept. 1893]: 372). H. E. v. Berlepsch, "Die Frühjahr Ausstellung der Münchener Secesion 1896," ibid. 11, no. 15 (May 1896): 228, discussed the modern French graphic artists, including Toulouse-Lautrec, and also the English Beardsley. Dr. Karl Voll, "Die retrospective Abteilung der VII. Internationalen Kunstausstellung zu München," ibid. 12, no. 23 (Sept. 1897): 353–56, praised the work of both Monet and Manet in 1897. On Hamburg, see Dr. Ernst Zimmermann, "Kunstausstellung in Hamburg," ibid. 10, no. 16 (May 1895): 250–51.

21. Tschudi's purchases and reorganization of the National Gallery are reviewed in Adolf Rosenberg, "Ausstellung in der Berliner Nationalgalerie," *Kunstchronik*, n.s. 8 (Jan. 1897): cols. 161–64; Hans Mackowsky, "Die neuen Erwerbungen und die Neugestaltung der Nationalgalerie in Berlin," ibid. 9 (27 Jan. 1898): cols. 193–200; Gr. [Georg Gronau], "Berlin," *Die Kunst für Alle* 13, no. 4 (Nov. 1897): 62; Georg Gronau, "Die Neugestaltung der National-Galerie in Berlin," ibid. 13, no. 9 (Feb. 1898): 129–36, providing the positive assessment of these modernist works, along with fourteen illustrations of the most important new acquisitions and a full-page plate of Manet's *Im Treibhaus*; and Paul Schultze-Naumburg, "Die Neugestaltung der Nationalgalerie," *Der Kunstwart* 11, no. 9 (Feb. 1898): 291–93, praising Tschudi for his skillful cultivation of private patrons, who provided the funds that enabled him to acquire the outstanding new paintings.

For a full account of these purchases and a complete listing of the works, see Barbara Paul, *Hugo von Tschudi und die moderne französische Kunst im Deutschen Kaiserreich* (Mainz: Verlag Philipp von Zabern, 1993), 61–106;

and Eberhard Roters, "Die Nationalgalerie und ihre Stifter: Mäzenatentum und staatliche Förderung in Dialog und Widerspruch," in Braun and Braun, *Mäzenatentum in Berlin*, 83–92. Tschudi's role in promoting modernism in Berlin is carefully analyzed in Peter Paret, "The Tschudi Affair," *Journal of Modern History* 53 (Dec. 1981): 589–618, revised as "Die Tschudi-Affäre," in *Manet bis van Gogh: Hugo von Tschudi und der Kampf um die Moderne*, ed. Johann Georg Prinz von Hohenzollern and Peter-Klaus Schuster, exh. cat. (Munich: Prestel Verlag, 1996), 396–401, which also includes plates of the works Tschudi acquired for both Berlin and Munich museums.

22. The reorganization of the National Gallery was completed by December 1897; debates over Tschudi's acquisitions and reorganization occurred in the annual budget sessions of the Prussian Landtag in March 1898 and 1899. Concise descriptions of these reactions to Tschudi's work are given in Paul, *Hugo von Tschudi*, 96–102; and Nicolaas Teeuwisse, *Vom Salon zur Secession: Berliner Kunstleben zwischen Tradition und Aufbruch zur Moderne, 1871–1900* (Berlin: Deutscher Verlag für Kunstwissenschaft, 1986), 204–14. Jörn Grabowski, "'Euer Excellenz zur gfl. Kenntnisnahme . . .': Hugo von Tschudi als Direktor der Nationalgalerie," in Hohenzollern and Schuster, *Manet bis van Gogh*, 391–95, provides a careful examination of the relevant documents.

A basic history of Berlin's National Gallery is Paul Ortwin Rave, *Die Geschichte der Nationalgalerie Berlin* (Berlin: Nationalgalerie, Staatliche Museen Preußischer Kulturbesitz, [1968]). On Durand-Ruel in Berlin, see J.S. [Jaro Springer], "Berlin," *Die Kunst für Alle* 13, no. 9 (Feb. 1898): 142; and Teeuwisse, *Vom Salon zur Secession*, 241, 308–9 n. 593. Springer mentioned particularly the good Corots, a Don Quixote by Daumier, a snow scene by Monet, as well as works by Pissarro and Sisley and two particularly amazing Degas. The comment on French art filling Berlin came from E. K[estner], "Berlin," *Die Kunst für Alle* 15, no. 4 (Nov. 1899): 94.

23. Reports on the opening of the two new galleries appeared in *Kunstchronik*, n.s. 10 (Oct. 1898): cols. 11–12; ibid. (Nov. 1898): col. 57; ibid. (Dec. 1898): col. 105; *Der Kunstwart* 12, no. 9 (Feb. 1899): 321–23; "Ein neuer Berliner Kunstsalon," *Deutsche Kunst* 2, no. 4 (Nov. 1897): 77–78, for photographs and a detailed description of the interior decoration of Keller & Reiner. The renovation of Keller & Reiner in 1898 was designed by Messel, van de Velde, Richard Riemerschmidt, and Dressler, of the Vereinigten Werkstätten für Kunst in Munich. An excellent description of a poetry reading in the gallery was written by Paula Modersohn-Becker in her diary in 1901. Van de Velde's work on the Keller & Reiner gallery and shortly after on the Cassirer Gallery was preceded by the publicity surrounding his interior designs in the Samuel Bing "Art

Nouveau" collection at the International Dresden Exhibition in 1897.

24. For further descriptions of the new dealers' galleries, see Teeuwisse, *Vom Salon zur Secession*, 235–42, quoting at length from Lichtwark's account of Keller & Reiner; and Peter Paret, *The Berlin Secession: Modernism and Its Enemies in Imperial Germany* (Cambridge: Harvard University Press, 1980), 70–71, citing Rainer Maria Rilke's impressions of the Cassirer's "exclusive" gallery and reading room. After giving a long report on the series of readings held at Keller & Reiner during January and February, *Pan* published a statement made by Dehmel before his reading of his poems (Richard Dehmel, "Kunst und Persoenlichkeit," *Pan* 5, no. 1 [Aug. 1899]: 25–26, with photograph of Klinger's *Ledarelief*). Arthur Moeller-Bruck provided introductory lectures on the first five evenings. The information about the offprint of Signac's article in *Pan* comes from Fiedler, "Weimar contra Berlin," 110. The reference to "bizarre" art appeared in a long report by Richard Mortimer, "Berliner Kunstbrief," *Die Kunst für Alle* 14, no. 7 (Jan. 1899): 98. Hofmann's continuing rise to fame was underlined by an article that appeared in connection with the highly successful exhibition at Keller & Reiner in the spring of 1899, written by Paul Schultz-Naumburg, "Ludwig von Hofmann," *Die Kunst für Alle* 14, no. 14 (Apr. 1899): 212–15, in which he pointed out that most of Hofmann's works were immediately sold to private collectors.

I should note that four other new art galleries were opened in Berlin in the years 1897–1900. In November 1897 Mathilde Rabl, a former treasurer for the Society of Berlin Artists, opened a two-room gallery on Potsdamerstrasse, the Mathilde Rabl Kunstsalon. The opening was well attended, and the gallery owner intended to exhibit all the various tendencies in contemporary Berlin painting from Werner to Liebermann (*Kunstchronik*, n.s. 9 [Nov. 1897]: col. 56). In the following decade *Die Kunst für Alle* reviewed her shows for Gebhardt, Trübner, Liebermann, Lenbach, Manet, Menzel, and Thoma. In 1899 the Kunstsalon Ribera was showing works by the Worpswede artists and the young Baluschek (see R.M. [Richard Mortimer], "Berlin," ibid. 14, no. 8 [Jan. 1899]: 125; ibid., no. 11 [Mar. 1899]: 171; *Kunstchronik*, n.s. 10 [Feb. 1899]: col. 222; and ibid. [Apr. 1899]: col. 363, where the reporter commented that the Kunstsalon Ribera wanted to present the newest, most modern artists, but not in the sense of modern as in the "van-de-Velde-cult"). The Ernst Zäslein Kunsthandlung opened a new, large gallery in Berlin, and the Künstlerhaus, built by the Verein Berliner Künstler, opened its exhibition gallery in late 1898 with a mixed exhibition of Berlin and Munich artists, including Hitz and Hofmann.

25. See Richard Mortimer, "Berliner Kunstbrief," *Die Kunst für Alle* 14, no. 7 (Jan. 1899): 100; Paul Schultze-

Naumburg, *Der Kunstwart* 12, no. 3 (Nov. 1898): 105–6, reporting on the Cassirer Gallery.

26. R.M. [Richard Mortimer], "Berlin," *Die Kunst für Alle* 14, no. 8 (Jan. 1899): 124, reviewing a show of Rops, Raffaelli, and James Patterson; Richard Mortimer, "Berliner Brief," ibid., no. 14 (Apr. 1899): 217; and *Kunstchronik*, n.s. 10 (2 Feb. 1899): cols. 217–22. On the Neo-Impressionists, see "Königsberg," *Die Kunst für Alle* 14, no. 15 (1 May 1899): 238. On Dresden, see "Kunstsalon Ernst Arnold," ibid., no. 16 (May 1899): 252; and "Rundschau: Bildende Kunst," *Der Kunstwart* 12, no. 14 (Apr. 1899): 64–66. The review of the Cassirer drawings was R.M. [Richard Mortimer], "Berlin," *Die Kunst für Alle* 14, no. 17 (June 1899): 228. Georg Gronau reviewed Liebermann's book on Degas, printed by Paul Cassirer, in ibid., no. 18 (June 1899). See also Dr. Karl Voll, "Die VII. internationale Kunstausstellung der Münchener Secession," ibid., no. 21 (Aug. 1899): 324.

On the French salon art at the Berlin Academy, see E. K[estner], ibid. 15, no. 3 (Nov. 1899): 66 (ironically, this entire issue was illustrated with paintings by Manet); and E. Kestner, "Französische Bilder in Berlin," ibid., no. 8 (Jan. 1900): 181–82, with a photograph of the installation of French paintings at the Eduard Schulte Art Salon. The catalogue for the fall Cassirer show, which also included work by Puvis de Chavannes, began with an essay on Manet written by Zola in 1866 (see *Ausstellung von Werken von Édouard Manet, H-G. E. Degas, P. Puvis de Chavannes, Max Slevogt* [Berlin: Bruno und Paul Cassirer, 1899]). *Die Kunst für Alle* published J. Meier-Graefe, "Die Stellung Eduard Manet's," in 15, no. 3 (Nov. 1899): 58–64, and E. K[estner], "Berlin," ibid., no. 4 (Nov. 1899): 94, covering shows at Cassirer's and Schulte's galleries. The October–November show at the Cassirer Gallery was also reviewed in *Kunstchronik*, n.s. 11 (Dec. 1899): cols. 122–23. On high prices for French modernists, see also W. v. Seidlitz, "Degas," *Pan* 3, no. 1 (July 1897): 57. On Slevogt, who was being wooed by Leistikow and Cassirer to move to Berlin, see Ernst-Gerhard Güse, Hans-Jürgen Imiela, and Berthold Roland, eds., *Max Slevogt: Gemälde, Aquarelle, Zeichnungen,* exh. cat. (Stuttgart: Verlag Gerd Hatje, 1992); and Hans-Jürgen Imiela, *Max Slevogt: Eine Monographie* (Karlsruhe, Germany: G. Braun, 1968), 41–54.

27. Paul Schultze-Naumburg, "Münchener Bericht, 1," *Der Kunstwart* 9, no. 14 (Apr. 1896): 218.

28. The significant change of coverage in the journals from great exhibitions to art dealers is documented in the text in a comparison between volumes 3 (1887–88) and 13 (1897–98) of *Die Kunst für Alle*, containing 360 and 380 pages, respectively. The journal also devoted ten lengthy, successive lead articles to the Berlin Jubilee Exhibition in

1886 and the same to the 1888 Munich International. By contrast, in 1896 the International Jubilee Exhibition in Berlin was given only one lead article and two secondary articles, while the Seventh Munich International Exhibition, in 1897, with participants from all of the Munich art groups, received four lead articles, and the Glass Palace exhibition of 1898 was covered in two articles. The number of pages in the journal was also increased in 1899, from 380 pages to 580 pages in each annual volume, further reducing the proportion of space allocated to the great exhibitions, despite their continued large attendance figures.

29. After dismissing the philistine public, Otto Ernst, "Die Kunst und die Massen," *Pan* 2, no. 4 (Feb. 1897): 309, went on to discuss very positively Lichtwark's program in Hamburg to encourage dilettantism as a means of arousing interest and lifting taste in art among the better classes. Lichtwark, whose views were instrumental in ending the first editors' tenure, would have rejected the perceptions about the inaccessibility of modern art. Reflecting his deep nationalist convictions, Lichtwark's work in Hamburg was guided by the possibility of creating popular, steadily widening circles of local communities through careful involvement of people in the life of the museum and, at the same time, building an active group of collectors and commissioning works of art from the leading contemporary artists. His firm belief in the centrality of local identity as the building block of national identity has been interestingly corroborated in an innovative study on local historical associations by Celia Applegate, *A Nation of Provincials: The German Idea of Heimat* (Berkeley: University of California Press, 1990). See also Woldemar von Seidlitz, "Das moderne Kunstgewerbe und die Ausstellungen," *Pan* 5, no. 1 (Aug. 1899): 45–50, arguing the need for a small circle of patrons to slowly raise the taste of the public in order to produce a market for fine modern, industrially produced arts and crafts.

30. The statement "Die Pöbel ist nicht das Volk" appeared in Avenarius's review of Langbehn in "Vom Zeitalter deutscher Kunst," *Der Kunstwart* 3, no. 12 (Mar. 1890): 177–78. See also R. Batka, "Ungekürzte Aufführungen," ibid. 12, no. 11 (Mar. 1899): 357–60; and idem, "Vom Kunstpietismus," ibid., no. 20 (July 1899): 242, for the definition of the *Volk*. The critical assessment by George L. Mosse, *The Crisis of German Ideology: Intellectual Origins of the Third Reich* (New York: Grosset and Dunlap, 1964), is an essential introduction to the concept of the *Volk* and *volkisch* ideas.

31. Avenarius's ideas were expressed in "Volks- und Gipfelkunst," *Der Kunstwart* 12, no. 1 (Oct. 1898): 2–4; "Volkskunst," ibid., no. 8 (Jan. 1899): 266–69; and "Was wir wollen," ibid. 13, no. 1 (Oct. 1899): 2, including the quotation on art as bread.

For Avenarius's definition of "volkstümliche Kunst" as art that was rooted in contemporary life, was German in the core of its being, and grew out of the individual personality of the artists, see "Unsere Sache," ibid. 9, no. 1 (Oct. 1895): 2. For a brief, illuminating discussion of Avenarius's ability to articulate middle-class preconceptions, see Gerhard Kratzsch, *"Kunstwart" und Dürerbund: Ein Beitrag zur Geschichte der Gebildeten im Zeitalter des Imperialismus* (Göttingen, Germany: Vandenhoeck & Ruprecht, 1969), 130–34.

32. See also A[venarius], "Den alten Lesern zum Dank, den neuen zum Willkomen," ibid. 12, no. 1 (Oct. 1898): 1–2; and *"Der Kunstwart wird weiter ausgebildet,"* ibid., no. 24 (Sept. 1899): 385–86. Schultze-Naumburg's series "Über Kunstpflege im Mittelstande" began in January 1898 and appeared in the first issue of each month through July 1899. This series of articles fostering art among the middle bourgeoisie was only the first of several long series that Schultze-Naumburg presented in the journal before publishing them separately. It was not until well into the next decade that *Der Kunstwart* reached the height of its popularity, with 23,000 subscribers. An exception to the German lineup of artists, a painting by Segantini was included as a memorial upon his death in 1899.

33. For the quotation about Thoma, see *Der Kunstwart* 3, no. 18 (June 1890): 281–82, quoting Fritz Baer's review in the *Münchener Neueste Nachrichten*. For reviews stressing Thoma's Germanness, see Dr. van Eyck, "Deutsche Kunst," *Das Atelier* 3, no. 53 (Jan. 1893): 1–2; Albert Dresdner, "Berliner Kunstbrief: Hans Thoma, Lesser Ury, Fenner H. Behmer," *Der Kunstwart* 6, no. 15 (May 1893): 231; "Münchner Kunstbrief," ibid. 7, no. 7 (Jan. 1894): 104–5, quoting O. J. Bierbaum's statement, "Thoma hat die Seele des deutschen Volkslieds in die Farbe gerettet"; and A[venarius], "Hans Thoma," ibid. 13, no. 1 (Oct. 1899): 18–20. Articles appeared throughout the nineties. One of the first was by Cornelius Gurlitt, "Hans Thoma," *Die Kunst unserer Zeit* 2, 1st half-vol. (1891): 55–66; this was followed by Franz Hermann [Meissner], "Hans Thoma," *Zeitschrift für bildende Kunst* 27, n.s. 3 (1891–92): 225–30, stating that "Thoma ist eben als Deutscher ein Charakteristiker, eine modernisirte Auflage von Dürer, mit dem er viele verwandte Züge hat." See also Ernst Zimmermann, "Hans Thoma," *Die Kunst für Alle* 12, no. 18 (June 1897): 297–303, including many sketches, lithographs, and paintings; Frau Dr. Anna Spier, "Hans Thoma," *Die Kunst unserer Zeit* 11, 1st half-vol. (1900): 61–112; and "Hans Thoma's Volkskunst," *Deutsche Kunst* 3, no. 1 (1898). Thoma was also featured in the popular artists' series Künstler-Monographien: Fritz von Ostini, *Thoma* (Bielefeld, Germany: Verlag von Velhagen & Klasing, 1900).

34. R.M. [Richard Mortimer], "Berlin," *Die Kunst für Alle* 14, no. 11 (Mar. 1899): 171, reviewed the Cassirer show. Tributes upon Thoma's sixtieth birthday included poems by Richard Dehmel and Wilhelm Holzamer, *Pan* 5, no. 2 (Nov. 1899). Liliencron's celebratory poem for this occasion is cited from J. B. Beringer, *Thoma: Der Malerpoet*, Kleine Delphin-Kunstbücher, no. 9 (Munich: Delphin Verlag, n.d.). Dresdner's quotation is from his "Berliner Bericht," *Der Kunstwart* 9, no. 6 (Dec. 1895): 88; Thoma's comments about his work and recognition were published in F. v. Ostini, "Hans Thoma zum Thema 'Kunst und Staat,'" *Die Kunst für Alle* 16, no. 23 (Sept. 1901): 549–50, as well as in "Thoma über Kunstvereine und Volkskunst," *Der Kunstwart* 14, no. 22 (Aug. 1901): 410–16. For an ideological defense of Thoma and Böcklin, following in the wake of an explosive controversy over Böcklin, see Henry Thode, "Die künstlerische Wiedergeburt des Menschen aus den Landschaft," *Die Kunst für Alle* 21, no. 4 (Nov. 1905): 86–88.

35. The statement about Böcklin's influence on *Pan* is from a complimentary article by Ferdinand Laban, "Der Musaget Boecklins," *Pan* 4, no. 4 (May 1899): 236–40, in which he wrote about the six paintings by Böcklin then in the National Gallery in Berlin. Drawings, sketches, and plates reproducing his paintings were featured in eleven out of the twenty-one issues of *Pan*. A special birthday issue included an engraving in his honor done by Klinger and a lengthy article by Heinrich Alfred Schmid, "Arnold Böcklin," *Pan* 3, no. 2 (Sept. 1897): 73–80. A second issue with a special section on him was ibid. 4, no. 1 (July 1898), where an edition of a diary written about him by one of his students, Rudolf Schick, and edited by Tschudi began in serialized form, continuing until the last issue of the journal. A feminist reading of the masculine image in self-portraits at this time, including works by Böcklin, Thoma, Corinth, and Liebermann, informed largely by postmodernist theory is Irit Rogoff, "The Anxious Artist—Ideological Mobilisations of the Self in German Modernism," in *The Divided Heritage: Themes and Problems in German Modernism*, ed. Irit Rogoff (Cambridge: Cambridge University Press, 1990): 116–40.

For details on celebrations and honors granted Böcklin in Munich, Weimar, Basel, and Zurich, see *Die Kunst für Alle* 13, no. 4 (Nov. 1897): 59; and for a rundown of tributes from the press, from family papers to *Pan*, see "Böckliniana," *Der Kunstwart* 11, no. 3 (Nov. 1897): 93–94. In Munich, poems and tributes were given by Dehmel, Paul Heyse, Ernst von Wolzogen, and Hirth. *Die Kunst für Alle* also published tributes by Carl Neumann, "Zu Arnold Böcklins siebenzigstem Geburtstag," in 13, no. 1 (Oct. 1897): 1–6, comparing Böcklin to Richter and Schwind, with all of the plates and illustrations in the issue by Böcklin; H. E. von Berlepsch, "Die Holbein und Böcklin Ausstellung in Basel," ibid., no. 3 (Nov. 1897): 41–43;

and "Basel," ibid., no. 5 (Dec. 1897): 74, 77, with a report of Wölfflin's speech.

Further tributes were Heinrich Wölfflin, "Die Böcklin-ausstellung zu Basel," *Kunstchronik*, n.s. 9 (Oct. 1897): cols. 33–37; "Arnold Böcklin," *Der Kunstwart* 11, no. 1 (Oct. 1897): 9–10, filled with extravagant, reverent praise; Max Jordan, "Arnold Böcklin zum 70. Geburtstag," *Deutsche Kunst* 2, no. 1 (Oct. 1897): 1–8, with a photograph of his sculpted herm of the "Frog-King," once removed from an exhibition "on higher orders" because of its unfortunate resemblance to an unnamed personage; and Friedrich Haack, "Arnold Böcklin: Zu seinem 70. Geburtstage," *Zeitschrift für bildende Kunst* 33, n.s. 9 (1897–98): 5–13. For details about the Basel celebratory banquet, with its *tableau vivant* of Böcklin's most popular paintings, see Othmar Birkner, "Böcklin-Jubiläum und Böcklin-Fest Basel 1897," in *Arnold Böcklin, 1827–1901: Gemälde, Zeichnungen, Plastiken. Ausstellung zum 150. Geburtstag*, ed. Dorothea Christ, exh. cat. (Basel: Schwabe & Co, 1977), 147–50.

On the Berlin Academy retrospective, see "Böcklin Ausstellung," *Der Kunstwart* 11, no. 1 (Oct. 1897): 19, also discussing the Schulte showing of Böcklin's *Der Krieg* (1897); "Vom Berliner Kunstleben," ibid., no. 6 (Dec. 1897): 206–7; Georg Malkowsky, "Die Berliner Böcklin Ausstellung," *Deutsche Kunst* 2, no. 7 (Jan. 1898): 126–29; and "Berlin," *Die Kunst für Alle* 13, no. 12 (Mar. 1898): 188, noting that 13,500 illustrated catalogues were sold. After his death in Fiesole in January 1901, *Die Kunst für Alle* published an assessment of his work by Hugo von Tschudi, "Arnold Böcklin," in 16, no. 11 (Mar. 1901): 251–56; and idem, "Die Werke Arnold Böcklins in der Kgl. Nationalgalerie zu Berlin," ibid. 17, nos. 9 (Feb. 1902): 199–206 and 11 (Mar. 1902): 253–56.

36. J.S. [Jaro Springer], "Berlin," *Die Kunst für Alle* 13, no. 8 (Jan. 1898): 123–25. In his adulatory talk, Wölfflin, "Basel," ibid. 13, no. 5 (Dec. 1897): 74, had reminded his audience of Böcklin's three rules: "1. Geht auf keine Akademie, 2. Trinkt kein Bier, sondern Wein, 3. Geht, sobald Ihr könnt, nach Italien." See also Alfred Lichtwark, "Die Böcklin-Ausstellungen in Berlin und Hamburg," *Pan* 4, no. 1 (July 1898): 49–52.

37. Böcklin's changing reception led Lichtwark to reflect upon the late-nineteenth-century misunderstanding and mistreatment of artists in an article that was originally published in *Zukunft* and excerpted at length in *Der Kunstwart* 11, no. 10 (Feb. 1898): 332–36. It was subsequently turned into a book on Böcklin, *Die Seele und das Kunstwerk* (Berlin: Bruno and Paul Cassirer, 1899), reviewed in Paul Schumann, "Arnold Böcklin," *Die Kunst für Alle* 15, no. 13 (Apr. 1900): 298–300. For a cogent argument about the reasons for Böcklin's great popularity in these years, see Ingrid Koszinowski, "Böcklin und seine Kritiker: Zu Ideolo-

gie und Kunstbegriff um 1900," in Mai, Waetzoldt, and Wolandt, *Ideengeschichte und Kunstwissenschaft*, 279–92; and Elizabeth Tumasonis, "Böcklin's Reputation: Its Rise and Fall," *Art Criticism* 6, no. 2 (1990): 48–71. See the laudatory article by Avenarius in the Böcklin issue commemorating his death, "Zu Böcklins Heimgang," *Der Kunstwart* 14, no. 9 (Feb. 1901): 393–96, which concludes that "was Böcklin anrührte, das war Geist. Kunst in diesem Sinn, nordische, germanische, deutsche Kunst ist alles, was er geschaffen hat."

38. Julius Meier-Graefe, *Der Fall Böcklin und die Lehre von den Einheiten* (Stuttgart: Verlag Julius Hoffmann, 1905). *Die Kunst für Alle* devoted considerable coverage to the controversy, beginning with a lengthy critical analysis of Meier-Graefe's attack on Böcklin by H. A. Schmid, "Meier-Graefe Contra Böcklin," in 20, no. 18 (June 1905): 432–36; this was followed by a report on the polemical newspaper exchanges between Henry Thode, a professor at Heidelberg, and Liebermann over anti-Semitic charges by Thode in "Der Meinungsstreit über den Impressionismus," ibid., nos. 22 (Aug. 1905): 530–33 and 23 (Sept. 1905): 558–59. Thode's counterattack against Meier-Graefe and international modernism was spelled out in a series of lectures at Heidelberg in 1905, published as *Böcklin und Thoma: Acht Vorträge über neudeutsche Malerei gehalten für ein Gesamtpublikum an der Universität zu Heidelberg im Sommer 1905* (Heidelberg: Carl Winter's Universitätsbuchhandlung, 1905). This controversy, which began with the arrogant polemic of Meier-Graefe and resulted in ugly, anti-Semitic charges, is analyzed in detail in Paret, *Berlin Secession*, 170–82. The formalist approach of Moffett, *Meier-Graefe as Art Critic*, 52–60, places his account, though usefully filled with contemporary quotations, firmly on the side of Meier-Graefe's elitism. A broader, much more nuanced understanding of the controversy is presented in Robert Jensen, *Marketing Modernism in Fin-de-Siècle Europe* (Princeton: Princeton University Press, 1994), 235–63.

39. Herman Helferich [Emil Heilbut], "Etwas über die Neu-Idealisten," *Die Kunst für Alle* 7, nos. 5–6 (Dec. 1891): 70–72, 85–86, wrote positively about the painting of Paul Flandrin and Puvis de Chavannes but found Moreau's work unduly pretentious. Questioning whether the visual arts could follow the Symbolism of Verlaine, Barrès, and Maeterlinck, he pointed out that the Salon of the Rose + Croix had to have musicians playing Wagner and Bach in order to achieve the requisite mystical and moody atmosphere. *Der Kunstwart* 6, no. 14 (Apr. 1893): 220, printed the short notice; see also Perfall, "Pariser Kunstausstellungen," ibid. 7, no. 10 (July 1894): 313–15.

40. For reviews of Gurlitt's 1894 Symbolist exhibition, see H. [Hans Rosenhagen], "Eine Symbolisten-Ausstellung in

Gurlitt's Kunstsalon," *Das Atelier* 4, no. 1 (Jan. 1894): 2–3; Albert Dresdner, "Berliner Kunstbrief," *Der Kunstwart* 7, no. 9 (Feb. 1894): 140; and Dr. R. [Jaro Springer], "Berlin," *Die Kunst für Alle* 9, no. 10 (Feb. 1894): 156. All three critics pointed out that in Gurlitt's combination of the followers of the English pre-Raphaelites with some German artists only Toorop and Khnopff could be considered authentic Symbolists. Hofmann fit uneasily, despite his accomplished work, while most of the German artists were criticized as weak in painting skills, particularly Fidus (Hugo Höppener).

On the fear that young German artists would imitate the decadence of the French Symbolists, see Herman Helferich [Emil Heilbut], "Etwas über die symbolistische Bewegung," ibid. 10, no. 3 (Nov. 1894): 33–37; and Alfred Freihofer, "Die Münchener Kunstausstellungen," *Der Kunstwart* 8, no. 1 (Oct. 1894): 11–12. News of Oskar Panizza's conviction in Munich and his sentence to a year in prison for blasphemy and obscenity in his play *The Council of Love* reached the public at this time; nonetheless, *Der Kunstwart* published an article that he had written, Oskar Panizza, "Die deutschen Symbolisten," in 8, no. 16 (May 1895): 246–49, with a note by the editor explaining Panizza's situation and commenting that the sentence was extremely stiff for a talented young writer.

41. See, e.g., Alfred Gotthold Meyer, "Die Münchener Kunstausstellung," *Zeitschrift für bildende Kunst* 28, n.s. 4 (1892–93): 33–34, in which Meyer discusses, not uncritically, the "coloristic symbolism" of Stuck, Klinger, Keller, Hofmann, and Exter. On the revival of interest in Keller's paintings, see Alfred Freihofer, "Die Münchener Kunstausstellung von 1894," *Der Kunstwart* 8, no. 4 (Nov. 1894): 57; and H. E. von Berlepsch, "Albert Keller," *Die Kunst für Alle* 12, no. 13 (Apr. 1897): 193–201 (in an unusual editorial move, no other article was included in this issue). In the decades before World War I the journal published three more heavily illustrated articles on Keller: F. v. Ostini, "Albert von Keller: Zu seinem 60. Geburtstage," ibid. 20, no. 15 (May 1905): 345–52; Dr. Jos. Popp, "Albert von Keller," ibid. 23, no. 10 (Feb. 1908): 217–25, on the occasion of a retrospective exhibition at the Munich Secession exhibition; and F. von Ostini, "Albert von Keller: Zum siebzigten Geburtstag des Künstlers," ibid. 29, no. 16 (May 1914): 361–66.

42. For reviews of Sascha (Alexander) Schneider's work, see [Gustav] Pauli, "Neues aus Dresden," ibid. 10, no. 8 (Jan. 1895): 116–19, with illustrations; J.S. [Jaro Springer], "Berlin," ibid., no. 9 (Feb. 1895): 141; and T——r, "München, Allerlei von der Kunst," ibid., no. 14 (Apr. 1895): 216, referring to the northern German press's making Schneider a sensation. Further illustrations appeared in ibid., nos. 15–16 (May 1895): 252; P. Schumann, "Dresdner Kunstbrief," *Der Kunstwart* 8, no. 4 (Nov. 1894): 58; Al-

bert Dresdner, "Aus Berlin," ibid., no. 10 (Feb. 1895): 152–53; "Aus dem Muenchener Kunstleben," *Pan* 1, no. 1 (Apr.–May 1895): 42, reporting that everyone in Munich was talking about Schneider's show there; Pauli, "Neues und Altes von Sascha Schneider," *Die Kunst für Alle* 12, no. 18 (June 1897): 290–93; and *Der Kunstwart* 11, no. 8 (Jan. 1898): 271. See also the Schneider woodcut *Ein Vision*, reproduced in *Kunst und Handwerk* 47, no. 1 (1897–98): 39.

Schneider's drawings lent themselves easily to caricatures of politicians (see "Berlepsch contra Stumm," *Kladderadatsch* 49, no. 18 [May 1896], 1st supplement). Schneider was commissioned to paint frescoes from the book Revelations (see "Dresden," *Die Kunst für Alle* 13, no. 11 [1 Mar. 1898]: 172; W. v. Seidlitz, "Sascha Schneider's Fresko in Cölln bei Meissen," ibid. 15, no. 4 [Nov. 1899]: 75–79; and Karl Voll, "Die Internationale Kunstausstellung 1900 der Münchener Secession," ibid., no. 22 (Aug. 1900): 507–9, critical of Schneider's art). In 1904 he was called to teach at the Weimar Kunstschule. At that same time he gained further attention with a series of covers for a collected edition of Karl May's stories (see Hansotto Hatzig, *Karl May and Saschan Schneider: Dokument einer Freundschaft* [Bamberg, Germany: Karl-May-Verlag, 1976]; and Gerhard Klußmeier and Hainer Plaul, eds., *Karl May: Biographie in Dokumenten und Bildern* [Hildesheim, Germany: Olms Presse, 1978], 226–32). I thank Beeke Tower for the information linking Schneider to May.

43. Paul Schultze-Naumburg, "Internationale Kunstausstellung der Secession in München," *Kunstchronik*, n.s. 7 (Nov. 1895): cols. 50–51, discussed at considerable length the social and economic changes leading to the new forms of art, located the roots of the new idealism in the general search for religious meaning in contemporary society, and pointed out that the return to archaic religious and mystical subject in the nineties was a curious phenomenon in that age of "factory chimneys and Social Democrats." On the image of woman as the "Grundtypus" of Symbolism, see Alfred Gotthold Meyer, "Die Münchener Kunstaustellungen," *Zeitschrift fur bildende Kunst* 29, n.s. 5 (1893–94): 67.

44. Gary D. Stark, "Pornography, Society, and the Law in Imperial Germany," *Central European History* 14, no. 3 (1981): 200–229, provides a careful discussion of the legal definition of the audience or the context in which a work was shown as constituting the distinction between the acceptable art and obscene pornography in the Wilhelmine empire. He provides lengthy citations from the Reichsgericht decisions from 1891–97 as well as from contemporary legal authorities. One of the results of this legal thinking was decisions that declared postcard reproductions of certain works by Old Masters and contemporary paintings to be unacceptable since they could be

viewed by minors or in a vulgar setting inciting eroticism; similar decisions led to the removal of reproductions from show windows (see ibid., 222–29; and Ludwig Leiss, *Kunst im Konflikt: Kunst und Künstler im Widerstreit mit der "Obrigkeit"* [Berlin: Walter de Gruyter, 1971], 245–67).

45. For the review of the work of Rops, see H. E. von Berlepsch, "Brief aus München," *Der Kunstwart* 8, no. 14 [Apr. 1895]: 218; and Félicien Rops, "Oude Kate," *Pan* 1, no. 1 [Apr.–May 1895], original engraving, full plate). P.S., "München," *Die Kunst für Alle* 11, no. 11 (Mar. 1896): 173, reported that the Neumann gallery in Munich was showing works by Rops and Zorn, an exhibition that was "ein künstlerischer Leckerbissen" and a highly interesting artistic occasion. An obituary was published in ibid. 14, no. 1 (Oct. 1898): 13. A mention of Rops's work at the Munich Secession appeared in *Kunstchronik*, n.s. 10 (8 Dec. 1898): col. 106. See also reviews of Rops's art at the Cassirer Gallery in ibid. (Feb. 1899): col. 222; and by R.M. [Richard Mortimer], "Berlin: Cassirer," *Die Kunst für Alle* 14, no. 8 (Jan. 1899): 124–25, who went on to argue that it was wrong to characterize Rops's depictions of the social problem of prostitution as intentionally prurient and also claimed that Rops's best works were his paintings of nature, not his graphics. *Der Kunstwart* 12, no. 13 (Apr. 1899): 32, was less than enthusiastic about Rops's depictions of the "Männermörderin Weib." See also Rudolph Lothar, "Félicien Rops," *Zeitschrift für bildende Kunst* 37, n.s. 13 (1901–2): 146–49, with illustrations of his paintings and engravings.

46. A visualization of this Darwinian process of devolution overtaking a man about town was created by A. Rummel, "Der Zauberspiegel," *Jugend* 2, no. 38 (Sept. 1897): 633: on a stage filled with smoke from a cauldron overseen by human and ape skeletons a nattily dressed man steadily disintegrates into an ape. The articles on Rops were by Wilhelm Schölermann, "Rops," *Pan* 4, no. 3 (Dec. 1898): 198–99; and Franz Blei, "Aubrey Beardsley," ibid. 5, no. 4 (May 1900): 259. An art historian who later became a professor at Weimar, Schölermann (1865–1923) consistently utilized the words *das Weib* in this essay, as did the others writing about Rops.

47. Paul Schultze-Naumburg, "Fernand Khnopff," *Die Kunst für Alle* 15, no. 19 (July 1900): 435. H. E. von Berlepsch, "Münchener Brief: Die Münchener Kunstausstellungen," *Der Kunstwart* 9, no. 2 (Oct. 1895): 28, wrote that for Khnopff, "ist das Weib die gleiche rätselhafte, unberechenbare, hirnverwirrende, fast im nämlichen Moment engels- und teufelsähnliche Macht, die stets über das männliche Wesen, wo es mit dieser Macht in Berührung kommt, den Sieg davon trägt. . . . So ist das Weib!" An illuminating, well-illustrated catalogue is *Fer-nand Khnopff and the Belgian Avant-Garde*, essays by Jeffrey Howe, Reinhold Heller, and Cheryl Kempler (Chicago: David and Alfred Smart Gallery, University of Chicago, 1984).

48. A polemical study, first published in 1890, on the battle of the sexes and the negative impact of feminism as revealed in contemporary naturalist literature is Leo Berg, *Das Sexuelle Problem in Kunst und Leben*, 5th ed. (Berlin: Verlag von Hermann Walther, 1901). In the third edition (1891) Berg commented upon the current "avalanche" of "erotic problem-literature." A concise, erudite analysis of artists' response to the women's movement can be found in Reinhold Heller, "Some Observations concerning Grim Ladies, Dominating Women, and Frightened Men around 1900," in *The Earthly Chimera and the Femme Fatale: Fear of Woman in Nineteenth-Century Art*, exh. cat. (Chicago: David and Alfred Smart Gallery, University of Chicago, 1981). A more recent, heavily illustrated study is Barbara Eschenburg, *Der Kampf der Geschlechter: Der neue Mythos in der Kunst, 1850–1930*, exh. cat. (Cologne: DuMont Buchverlag, 1995), which analyzes the philosophical and mythical sources of the various visual representations of this battle of the sexes. The bibliography of studies of the femme fatale, especially in literature, is voluminous.

Here let me simply acknowledge several works that I found particularly helpful early in my effort to comprehend this widespread phenomenon: Virginia M. Allen, *The Femme Fatale: Erotic Icon* (Troy, N.Y.: Whitston, 1983); Patrick Bade, *Femme Fatale: Images of Evil and Fascinating Women* (New York: Mayflower Books, 1979); and Bram Dijkstra, *Idols of Perversity: Fantasies of Feminine Evil in Fin-de-Siècle Culture* (New York: Oxford University Press, 1986). A recent thoughtful article providing a useful analysis of misogyny at the turn of the century is Claude Cernuschi, "Pseudo-Science and Mythic Misogyny: Oskar Kokoschka's *Murderer, Hope of Women*," *Art Bulletin* 81, no. 1 (1999): 126–48.

Images of Judith had a strong literary source in Friedrich Hebbel's *Judith*; for a few examples of the dominating, masterful Judith, see Hermann Hahn's sculpture of *Judith* holding the head of Holofernes on her knees in both *Pan* 4, no. 4 (May 1899): 224, and *Jugend* 3, no. 35 (Aug. 1898): 585, full plate; Fritz Christ's sculpture of an Egyptian princess holding a severed head in one hand and a sword in another in ibid. 6, no. 43 (1901): 704; and Albert von Keller's version of Judith standing with her sword beside the decapitated body, which was titled *Die Liebe*, underlining its modernity, in *Die Kunst für Alle* 23, no. 10 (Feb. 1908). Böcklin (1888) and Slevogt (1898) each painted a Judith, which the latter turned into a self-portrait (1907). Medusa was frequently integrated into decorative borders in *Pan* and *Jugend*. Böcklin painted a Medusa head (c. 1878), as did Stuck (1892). A painting by Eduard

Kampffer of Perseus slaying the three Gorgons and brandishing the snake-haired Medusa was shown in the Munich Glass Palace in 1894 and was illustrated in *Die Kunst für Alle* 9, no. 22 (Aug. 1894): 341, as well as in *Moderne Kunst* (1898). Liebermann's painting *Sampson and Delilah* was first shown in Berlin in 1902; it is now in the Städelsches Kunstinstitut, Frankfurt am Main.

49. The contemporary study of Salome is Hugo Daffner, *Salome: Ihre Gestalt in Geschichte und Kunst, Dichtung—bildende Kunst—Musik* (Munich: Hugo Schmidt Verlag, 1912). A decade earlier, *Die Kunst für Alle* published a similar study of Salome: Dr. E. W. Bredt, "Die Bilder der Salome," in 18, no. 11 (Mar. 1903): 249–54, with illustrations by Puvis de Chavannes, Lenbach, Böcklin, Beardsley, Marcus Behmer, Klinger, Moreau, and Klimsch and references the same journal's earlier publications of Salomes by Corinth, Habermann, and Klinger. A version of Oscar Wilde's play or inspired by his play may have appeared in Berlin in 1898, when photographs of the actors playing Salome and Johannes in a play titled *Johannes* were published in *Moderne Kunst* 12 (1898). For an invigorating exploration of the gendered preoccupations at the turn of the century, with an emphasis upon English literature, read Elaine Showalter, *Sexual Anarchy: Gender and Culture at the Fin de Siècle* (New York: Penguin Books, 1990); chap. 8, "The Veiled Woman," focuses on the image of Salome. For the opera version of *Salome*, see Sander L. Gilman, "Strauss, the *Pervert*, and Avant Garde Opera of the Fin de Siècle," *New German Critique*, no. 43 (winter 1988): 39–68.

50. On Klinger's *Salome*, see A[venarius], "Max Klingers Salome," *Der Kunstwart* 7, no. 5 (Dec. 1893): 74; Albert Dresdner, "Berliner Kunstbriefe," ibid. 7, no. 12 (Mar. 1894): 184, which singled out the *Salome* in the review of the Amsler & Ruthardt retrospective; H. A. Lier, "Korrespondenz: Dresden, November 1893," *Kunstchronik*, n.s. 5 (Dec. 1893): col. 125, reporting on the first showing at Lichtenberg's of the sculpture "das sicher in der Geschichte der modernen Plastik einen hervorragenden Platz behaupten . . . wird"; Artur Seemann, "Klinger Ausstellung in Leipzig," ibid. (Jan. 1894): cols. 206, 208, the latter on the Amsler & Ruthardt exhibition in Berlin; Dr. R. [Jaro Springer], "Berlin," *Die Kunst für Alle* 9, no. 12 (Mar. 1894): 173; Cornelius Gurlitt, "Max Klinger," ibid. 10, no. 6 (Dec. 1894): 85, with a full plate in the previous issue; Julius Vogel, "Altes und Neues von Max Klinger," *Zeitschrift für bildende Kunst* 32, n.s. 8 (1896–97): 153–54; and Georg Treu, "Max Klinger als Bildhauer," *Pan* 5, no. 1 (Aug. 1899): 27–35, with plates between 45 and 50.

51. For other representations of Salome, see Slevogt, *Salomes Tanz* (1895), reproduced in *Die Kunst für Alle* 10,

no. 21 (Aug. 1895): 327, and Stuck, *Der Kuß der Sphinx* (1895), both reviewed in Jaro Springer, "Die 1895er Jahres-Ausstellung der Münchner Secession," *Die Kunst für Alle* 10, no. 19 (July 1895): 289–92. Stuck's *Sphinx* was reproduced in *Die Kunst unserer Zeit* 6, 1st half-vol. (1895): opposite 90, and in *Der Kunstwart* 12, no. 10 (Feb. 1899): 356. A full plate of Hugo von Habermann's *Herodias* appeared in *Die Kunst für Alle* 12, no. 20 (July 1897): opposite 316. See also Hans Rosenhagen, "Die zweite Ausstellung der Berliner Secession," ibid. 15, no. 20 (July 1900): 462.

Other Salomes of note were painted by Victor Müller (c. 1870), illustrated in ibid. 12, no. 6 (Dec. 1896): opp. 84; Lenbach (1880; 1894, with Mary Stuck as his model), illustrated in ibid. 18, no. 11 (Mar. 1903); Böcklin (1891), illustrated in ibid., 257; Stuck (1906); Trübner (1897); Max (with an ape as Salome); and Erler, *Der Tanz* (1898), illustrated in *Jugend* 5, no. 47 (Nov. 1900): 779. Among the best-known graphic representations in Germany were by Behmer, for the German edition of Wilde's *Salome* (Berlin: Insel Verlag, 1901); Eckmann; Münzer (1899), illustrated in *Jugend* 4, no. 45 (Nov. 1899): 729; Volz, in *Pan* 2, no. 3 (1896–97): 185; F. von Reznicek; and Klinger, in *Versuchung*, plate 11 of *Vom Tode. Zweiter Teil, Opus XIII* (1890–93). In 1900 *Die Kunst für Alle* featured a small illustration by Louis Chalon, "Salome," as the heading on the contents page.

52. Dr. E. W. Bredt, "Die Bilder der Salome," *Die Kunst für Alle* 18, no. 11 (Mar. 1903): 249–54, quotation on 252.

53. The report on Keller's disciplined working habits was by H. E. von Berlepsch, "Albert Keller," ibid. 12, no. 13 (Apr. 1897): 198. The paintings of Salome and Heriodias illustrated in full-page plates were by Habermann, Lenbach, Müller, and Severo Rodriguez-Etchart. Böcklin's knight, *Der Abenteuerer*, was reproduced as a plate in ibid., no. 15 (May 1897). The lotus flower paintings were by Erler, *Lotos*, plate in ibid. 11, no. 23 (Sept. 1896); and Heine, *Die Blumen des Bosen*, ibid., no. 22 (Aug. 1896): 342, associating the flowers of evil with a nude white woman and a black man. Keller's *Witch's Sleep* (1888) was reproduced as a full plate in ibid. 12, no. 13 (Apr. 1897). On Keller's crucified women and Stuck's "rätselhafte Weib," see Albert Dresdner, "Die Berliner Kunstausstellung," *Der Kunstwart* 9, no. 1 (Oct. 1895): 10. For full-plate reproductions of Keller's crucified saints, see *Die Kunst unserer Zeit* 3, 2nd half-vol. (1892): opposite 48, and ibid. 5, 2nd half-vol. (1894): opposite 88.

54. For the Munich membership list, see Rita Hummel, *Die Anfänge der Münchner Secession* (Munich: tuduv-Verlag, 1989), 95–100. The identity of one of the first women in the Berlin Secession is uncertain. Carola Hartlieb, "Bildende Künstlerinnen zu Beginn der Moderne—die

Künstlerinnen der 'Berliner Secession,'" in *Profession ohne Tradition: 125 Jahre Verein der Berliner Künstlerinnen*, by Berlinische Galerie, exh. cat. (Berlin: Kupfergraben, 1992), 59–72, identifies on p. 60 the four as stated in the text above but on p. 66 identifies the fourth woman as Julie Wolfthorn; Margrit Bröhan, "Dora Hitz (1856–1924), Malerin," in ibid., 53, names the artist as Julie Wolf, citing a handwritten list by Walter Leistikow from 18 November 1898, reproduced in Bröhan, *Walter Leistikow, 1865–1908: Maler der Berliner Landschaft*, exh. cat. (Berlin: Nicolaische Verlagsbuchhandlung, 1988), 122. In any case, Julie Wolfthorn was a member in 1900, and Käthe Kollwitz in 1901, Maria Slavona was a corresponding member in 1902, and Clara Siewert was a member in 1903.

55. One example of the dual message conveyed in *Die Kunst für Alle* can be found in the very positive review of the portraits of Susanne Goldschmidt that were given special prominence in the 1896 Glass Palace exhibition in Munich. The review of this student of Hitz referred to her strong talent and rapid artistic development and quoted her ideas about art at some length ("Berlin," *Die Kunst für Alle* 12, no. 16 [May 1897]: 249, 263). This review, in an issue carrying one of her portraits on the title page, appeared a month and a half after the article on Keller by Berlepsch cited above and before an issue containing Habermann's *Heriodias*.

For an example of Rosenhagen's sarcasm, see R., "In Ed. Schulte's Kunstsalon," *Das Atelier* 4, no. 7 (Apr. 1894): 4, where he castigates women, who, lacking patience, strength, originality, and depth, were capable only of imitative work. Seven years later, in his review of an exhibition of the Vereinigung von Künstlerinnen in Berlin at the Gurlitt Art Salon, his views of women remained unchanged (see Hans Rosenhagen, "Berliner Ausstellungen," *Die Kunst für Alle* 16, no. 12 [Mar. 1901]: 291–93). Kollwitz was the only woman whom Rosenhagen acknowledged to be worthy to be considered as an artist, although he did admit that Hitz's paintings were competent. Carola Hartlieb's essay cited above provides further examples of the ambivalence of critics in their rejection of originality in women artists as a whole and their praise for individual artists, whom they often characterized as painting like men.

56. Of the five women artists whose works were included in *Pan*, Mabel Dearmer, Hitz, and Paczka-Wagner each had one illustration; Kollwitz had two; and Theodora Onasch had several in two volumes. Hitz was the only German woman artist on the membership/subscriber list in the 1897 *Pan* prospectus. The single article on a woman artist was by Max Lehrs, "Cornelia Paczka," *Pan* 2, no. 1 (June 1896): 55–56. Wilhelm Volz, *Salome*, first appearing in ibid., no. 3 (Nov. 1896): 185, original lithograph in green on cream pa-

per; Salome has red hair and shoes, and John the Baptist's hair is purple. A small reproduction of Moreau's *Salome* was printed in ibid. 3, no. 1 (July 1897): 57.

57. Diogenes, the Greek Cynic philosopher (412–323 B.C.), lived a life of total self-denial and taught the virtue of self-control. Aspasia was a renowned courtesan in fifth-century Athens; mistress of Pericles, she was reputed to have taught rhetoric to Socrates and Pericles, though an eminent German classicist, Wilamowitz-Möllendorff, writing in 1900, rejected the possibility of her intellectual achievements. For the comedy fragment and the modern version, see Otto Erich Hartleben, "Diogenes: Ein Komoedien-Fragment," ibid. 2, no. 3 (Nov. 1896): 223–32; and Anselm Heine, "Geöffnete Türen," ibid. 3, no. 2 (Sept. 1897): 87–88, illustrated by a Klinger drawing of a modern woman being wooed. For a more extended analysis of the image of women in *Pan*, see Thamer, *Zwischen Historismus und Jugendstil*, 124–32.

58. There were, of course, women, particularly aristocratic women, among the subscribers to *Pan*; however, despite the cultural cachet offered by these socially prominent women, they constituted only a small portion of the subscribers. Of the 574 names on the 1897 list of members and subscribers, less than one-sixth were women, including 12 aristocrats and 6 foreigners.

An early example of declarations of modernity being couched in gender-driven language conveying contempt for the feminine and valorizing the masculine appeared on the first page of Michael Georg Conrad's new review, *Die Gesellschaft*, on 1 January 1885. His intent was to herald the emancipation of his journal from the uncritical mushiness of the popular family magazines, particularly *Die Gartenlaube*; nevertheless, his language associated the old criticism with schoolgirls, old maids, castration (e.g., in the sense of expurgated texts), and endangered manliness, and the new criticism with masculinity, humanity, and freedom. See also an article a decade later charging contemporary artists with effeminate complaining and calling upon them to demonstrate their masculine discipline and manly souls in their creative struggle (L. Weber, "Künstlerschmerzen," *Der Kunstwart* 9, no. 18 [June 1896]: 272–73).

See the review of the international exhibition of women's art, both historical and contemporary, held by the Vereinigung bildender Künstlerinnen Oesterreichs in the Viennese Secession building, Karl M. Kuzmany, "Die Kunst der Frau: Zur Ausstellung in der Wiener Secession," *Die Kunst für Alle* 26, no. 9 (Feb. 1911): 193–202, with illustrations and plates throughout the issue. The most notorious book defining the impossibility of aesthetic creativity in women was written by the first editor of *Kunst und Künstler*, Karl Scheffler, *Die Frau und die Kunst: Eine Studie* (Berlin: Verlag Julius Bard, 1908).

59. For detailed information on the moral purity movement and its connection to the women's movement, see John C. Fout, "The Moral Purity Movement in Wilhelmine Germany and the Attempt to Regulate Male Behavior," *Journal of Men's Studies* 1, no. 1 (1992): 5–31; a case study of Hanover illuminating the efforts of women in Germany that brought them increasingly into the male public sphere at this time is Nancy R. Reagin, *A German Women's Movement: Class and Gender in Hanover, 1880–1933* (Chapel Hill: University of North Carolina Press, 1995).

60. Two important articles on prostitution and pornography are Stark, "Pornography, Society, and the Law"; and Richard J. Evans, "Prostitution, State, and Society in Imperial Germany," *Past and Present*, no. 70 (1976): 106–29, citing a leaflet, *Die Kampf gegen die Unsittlichkeit*, published in 65,000 copies by the morality associations in 1891, which warned against the ruin of civilizations by immorality (121). Since these articles appeared, a considerable number of studies in German and English have appeared on prostitution. See, e.g., Lynn Abrams, "Prostitutes in Imperial Germany, 1870–1918: Working Girls or Social Outcasts," in *The German Underworld: Deviants and Outcasts in German History*, ed. Richard J. Evans (London: Routledge, 1988): 189–209; and Ann Taylor Allen, "Feminism, Venereal Diseases, and the State in Germany, 1890–1918," *Journal of the History of Sexuality* 4, no. 1 (1993): 27–50. Women's organizations were deeply involved in the struggle against prostitution, with strategies across the spectrum from deregulation of prostitution to greater regulation. Driving the women's associations, however, was a greater sense of the prostitute as the victim of male society rather than the evil corrupter of society.

61. See George L. Mosse, "Masculinity in Crisis: The Decadence," in *The Image of Man: The Creation of Modern Masculinity* (New York: Oxford University Press, 1996), 77–106, quotation on 78; and John C. Fout, "Sexual Politics in Wilhelmine Germany: The Male Gender Crisis, Moral Purity, and Homophobia," *Journal of the History of Sexuality* 2, no. 3 (1992): 388–421, reprinted in idem, ed., *Forbidden History: The State, Society, and the Regulation of Sexuality in Modern Europe* (New York: Columbia University Press, 1992). Both Mosse and Fout argue that the double challenge of women and homosexuals to socially accepted understanding of masculinity and femininity created this male gender crisis. For an analysis of late-nineteenth-century medical efforts to define the nature of lesbians, see Gudrun Schwarz, "'Mannerweiber' in Männertheorien," in *Frauen suchen ihre Geschichte: Historische Studien zum 19. und 20. Jahrhundert*, ed. Karin Hausen (Munich: Verlag C. H. Beck, 1983), 62–80.

62. For a thorough account and analysis of these efforts to institute increased censorship, see R. J. V. Lenman, "Art, Society, and the Law in Wilhelmine Germany: The Lex Heinze," *Oxford German Studies* 8 (1973): 86–113; see also Maria Makela, "The Politics of Parody: Some Thoughts on the 'Modern' in Turn-of-the-Century Munich," in Forster-Hahn, *Imagining Modern German Culture*, 193–95, analyzing anticlerical parodies created by Munich artists in response to efforts of Catholics in Bavaria to censor art.

63. The debate in the Bavarian parliament was reported in "München," *Die Kunst für Alle* 11, no. 18 (June 1896): 286.

64. The statement by Max Liebermann von Sonnenberg, one of the leaders of the Deutsch-Soziale Reformpartei, is quoted in Lenman, "Art, Society, and the Law," 91, while Stark, "Pornography, Society, and the Law," 210, cites the supposed conspiracy of Jews reported in *Deutsches Blatt* (Hamburg), 31 Aug. and 18 Oct. 1894. On Édouard Drumont, see Mosse, *Image of Man*, 70.

65. See [Avenarius], "Kunst und Polizei," *Der Kunstwart* 5, no. 7 (Jan. 1892): 93–96; and "Nacktheit und Züchtigkeit bei Kunstwerken," ibid. 7, no. 8 (Jan. 1894): 125, reprinted from the *Juristischen Wochenschrift*. The advertisements stated that a pamphlet, *Fort mit der Censur in der bildenden Kunst!* (Düsseldorf: Eduard Lintz Verlag, n.d.), was available for 50 pfennigs from the publisher. The book of photographs was Max Koch, ed., *Der Akt. 100 Modellstudien in Lichtdruck nach Naturaufnahmen* (Berlin: Internationaler Kunstverlag M. Bauer & Co., n.d.). For Avenarius's second strong argument, see A., "Vom Nackten in der bildenden Kunst," *Der Kunstwart* 12, no. 17 (June 1899): 131–36. Hofmann's poster showed his typical woman with flowing hair and draperies, nude torso, and an armful of roses. The removal of Slevogt's *Danaë* was reported by Dr. Karl Voll in "Die VII. internationale Kunstausstellung der Münchener Secession," *Die Kunst für Alle* 14, no. 21 (Aug. 1899): 322, and in "Rundschau. Bildende Kunst," *Der Kunstwart* 12, no. 18 (June 1899): 202–3. In his review of the Munich Secession exhibition at the Glass Palace, Leopold Weber reported at length on Slevogt's *Danaë*, which he said was painted with Slevogt's well-known virtuosity ("Rundschau. Bildende Kunst," ibid. 12, no. 20 [July 1899]: 268).

66. Statements by the Center speaker Spahn and the National Liberal speaker Dr. Pieschel were reported in "Berlin," *Die Kunst für Alle* 13, no. 11 (Mar. 1898): 174. The *Kölnische Zeitung* article was reprinted in *Der Kunstwart* 11, no. 14 (Apr. 1898): 66, and in *Die Kunst für Alle* 13, no. 15 (May 1898): 237. The excerpt, "Der moderne Schönheitsbegriff vom weiblichen Körper," ibid. 14, no. 23

(Sept. 1899): 361–63, was from the book with the same title by Dr. C. H. Strantz.

67. A sarcastic report on official actions against "indecent" art appeared in "Rundschau. Bildende Kunst," *Der Kunstwart* 13, no. 10 (Feb. 1900): 398; and Paul Schultze-Naumburg, "Die bildende Kunst und die Lex Heinze," ibid., no. 12 (Mar. 1900): 459–61, similarly rejected the Lex Heinze as ridiculous. For the text of Avenarius's speech, see "Die Kunstparagraphen der Lex Heinze," ibid., no. 14 (Apr. 1900): 41–48; his later reflections on the Goethebund were expressed in A[venarius], "Was kann der Goethebund thun?" ibid., no. 16 (May 1900): 121–24; and idem, "Und der Goethebund?" ibid. 14, no. 3 (Nov. 1900): 89–92. See also Max Georg Zimmermann, "Die Darstellung des Nackten und das Sittlichkeitsgefühl in der Kunst," *Kunstchronik*, n.s. 11 (Mar.–Apr. 1900): cols. 289–94, 315–17, 332. and Dr. Karl Voll, "Die Kunst und die Lex Heinze," *Die Kunst für Alle* 15, no. 14 (Apr. 1900): 313–16.

Reports on the debates over the Reichstag decorations were A[venarius], "Die Kunst im Reichstage," *Der Kunstwart* 12, no. 12 (Mar. 1899): 393–97; "Rundschau. Bildende Kunst," ibid., 421; A.R. [Adolf Rosenberg], "Die Kunst im Reichstage," *Kunstchronik*, n.s. 10 (Mar. 1899): cols. 273–77, on the debate, in which Center Deputy Dr. Lieber referred to Stuck's work as "Schmiererein" and "Spottgeburten von Dreck und Feuer," and the resulting petition by artists, which was then reprinted in part in "Vermischtes," ibid., cols. 299–301, 317–19, with news of Wallot's resignation; ibid. (July 1899): col. 489, announcing that Stuck's rejected frieze was on exhibit in the Künstlerhaus in Berlin; "Berlin," *Die Kunst für Alle* 14, no. 13 (Apr. 1899): 205, also on Lieber's speech against Stuck's frieze; "München," ibid., no. 14 (Apr. 1899): 221, on petitions from artists and architects in Berlin, Munich, and Vienna supporting Hildebrand, Stuck, who refused to alter his drawings for the frieze, and Wallot, who also refused to do any further decorations on the building; and "Berlin," ibid., no. 17 (June 1899): 266, noting that the decoration commission had decided not to allow Stuck's plans for the frieze to be executed. Lieber's attack on Stuck is reproduced in Leiss, *Kunst im Konflikt*, 152–54.

68. *Kladderadatsch* also carried frequent cartoons that mocked the activities of the politicians who were promoting the Lex Heinze in the Reichstag (see, e.g., "Die Anschuld vom Lande," ibid. 52, no. 4 [Jan. 1899]: back cover; "Während eines Schlummerstündchens," ibid. 53, no. 12 [Mar. 1900]: 2nd supplement; "Illustrirte Rückblicke," ibid., no. 13 [Apr. 1900]: 1st supplement; and "Das Ende der Lex Heinze," ibid., no. 22 [June 1900]: back cover). On the debate over the Reichstag decorations, see ibid. 52, no. 11 (Mar. 1899): back cover; and "Ein Kränzchen," ibid., no. 12 (Mar. 1899): 1st supple-

ment, using Gabriel's *Monkeys as Critics* to parody the conservative deputies. Ann Taylor Allen, *Satire and Society in Wilhelmine Germany: "Kladderadatsch" and "Simplicissimus," 1890–1914* (Lexington: University Press of Kentucky, 1984), presents an extended comparison of the two journals.

69. *Jugend* 1, no. 1/2 (Jan. 1896): 2; the statement of purpose was signed by Hirth and Ostini.

70. In a lengthy announcement published in the first number in 1896, Hirth stipulated that caricatures should show a general sense of "freien Weltanschauung und deutschnationalen Gesinnung" but should not take any special partisan position. Reviews of *Jugend* appeared in *Kunstchronik*, n.s. 8 (Oct. 1896): col. 10; and A. [Avenarius], "Jugend," *Der Kunstwart* 9, no. 19 (July 1896): 289–92. Obituaries of Dr. Georg Hirth were published in *Die Kunst für Alle* 31, no. 15/16 (1 May 1916), and in *Jugend*, no. 14 (1916); the whole of ibid., no. 28 (1916), was a memorial to him. *Jugend* has received surprisingly little attention from historians or art historians, who tend to dismiss it as a middle-brow journal not meriting study. A short discussion of *Jugend* accompanied by color reproductions of the covers can be found in Rennhofer, *Kunstzeitschriften der Jahrhundertwende*, 68–75.

71. Hirth's efforts to make the journal as accessible as possible and to increase the number of subscriptions was demonstrated in notices in the advertisement section in the summer of 1897 requesting that travelers and vacationers make a point of asking for a copy of the journal at hotels and restaurants and that they send the journal the names of those establishments that did not carry it. Advertisements appeared in other weekly magazines and in cultural journals (see, e.g., *Der Kunstwart* 9, no. 20 [July 1896]: 319). Estimates of the readership appeared in "Dissidenten-Abonnements auf die *Jugend*," *Jugend* 3, no. 48 (Nov. 1898): 812. A more sober analysis appeared in 1900, when the editors reported that the actual edition remained at forty thousand and that the journal had been running at a loss despite being read by a hundred thousand people in reading circles and local cafés. As a result, prices were raised to 3.50 marks a quarter (ibid. 5, no. 21 [May 1900]: 355).

72. For the tribute to the artists in the one hundredth number, see ibid. 2, no. 48 (Nov. 1897). Robin Lenman, "A Community in Transition: Painters in Munich, 1886–1924," *Central European History* 15, no. 1 (1982): 24, reports that *Jugend* paid between 200 and 300 marks for a title page.

73. Among the parodies of *Pan* are "Luciane. Bruchstück eines roth-grünen Romans von Deuterich Mystifizinsky, mit

zwei Zeichnung von Dabert Symbolewitsch," *Jugend* 2, no. 8 (Feb. 1897): 120–21; Arpad Schmidhammer, "Im Ausstellungssaale der naiv-primitiv-rudimentär-violette-sensitiv-symbolistischen Künstlergruppe 'Isis,'" ibid., no. 27 (July 1897): 463; and Julius Diez, "Genre," ibid. 4, no. 20 (May 1899): 315, showing an artist standing by a painting that is a caricature of symbolist themes.

In 1898 a traveling exhibition of Eckmann's work was organized by the Berlin Kunstgewerbe Museum; it was shown in numerous museums in Germany and eventually went to London. His work extended from book illustrations to decorative objects, including lamps, vases, furniture, and jewelry (see Ernst Zimmermann, "Otto Eckmann-Ausstellung," *Kunstchronik*, n.s. 9 [Mar. 1898]: cols. 276–79).

74. Exceptions to these generalizations about the images in *Jugend*, of course, can certainly be cited; worth noting here are drawings by Steinlen of the tragedy of impoverished women and children in the city, in *Jugend* 1, no. 5 (Feb. 1896): 72–73, and the pessimistic series of drawings "Ein neuer Todten-Tanz," by Seitz, in ibid., no. 16 (Apr. 1896): 252–53, which continued through the first four volumes, in 2, no. 26 (June 1897): 432–33; 3, no. 10 (Mar. 1898): 160–61; and 4, no. 14 (Apr. 1899): 218–19.

75. Georg Hirth, "Das Gehirn unsrer Lieben Schwestern," *Jugend* 1, no. 3 (18 Jan. 1896): 49–50. Hirth's sarcasm over the deep bass voices demanding that women "go back" is revealed in this passage, in which he characterizes the "scientific convictions" used to turn back women's rights as "ja zumeist nichts als geschlechtsegotistische Ueberhebung, mit der wir seit Adams Zeiten unser ach! so lieben und ach! so unentbehrlichen Schwestern der Schlangenrolle zu verdächtigen und zur Strafe dafür auch noch zu terrorisiren, mit Eifersucht zu quälen, zu haremisiren und zu kemenatisiren gewohnt sind, immer unter dem heuchlerischen Vorwande der ritterlichen Fürsorge."

76. For images on the woman's question, citing only those in the first volume, see Rudolf Wilke, ibid., no. 14 (Apr. 1896): 224–25, a negative view of women in the university; E. Kneiss, "All Heil!" ibid., nos. 26 (June 1896): 414–18 and 50 (Dec. 1896): 816–17, both linking bicycling to women's liberation; "Der Mensch," ibid., no. 26 (June 1896): 420, linking Darwinian ideas to the woman's question; Julius Diez, "Die gelehrte Frau," ibid., no. 27 (July 1896): 432, substituting a woman's head in Holbein's portrait of Erasmus, surrounded by vignettes of the woman scholar at the university; and Carl Bauer, ibid., no. 29 (July 1896): cover, showing a woman with a bicycle in short skirt and leggings.

The following depict woman as disseminating evil: Valère Bernard, "Der Krieg," ibid., no. 25 (June 1896): 399, showing woman as a deadly tiger; Angelo Jank, "Ein schönes Weib—Hat den Teufel im Leib," ibid., no. 32 (Aug. 1896): 513; Bruno Paul, "Adam and Eva," ibid., no. 30 (July 1896): 483, and "Der Sündenfall," ibid., no. 34 (Aug. 1896): 553; Maximilian Dasio, "Circe," ibid., no. 38 (Sept. 1896): 612–13; Christian Wild, "Versuchung," ibid., no. 45 (Nov. 1896): 725; Carl Schmidt-Helmbrechts, "Sphinx," ibid., no. 46 (Nov. 1896): 739, accompanying a poem by Otto Erich Hartleben, "Falsch wie das Weib, wie des Meeres Wogen, Tötlichen Zaubers Sphinx"; Bruno Paul, "Vision," ibid., 748, showing the Devil leading a procession of women parading with flowers past men; and Hugo L. Braune, "Circe," ibid., no. 51 (Dec. 1896): 834.

77. For statements dismissing women's rights, see F. V. Kapff-Essenther, "Gleichheit: Eine social Betrachtung," *Jugend* 2, no. 28 (July 1897): 476; and Otto Ernst, "Von den Frauen: Eine verwegene Plauderei," ibid., no. 48 (Nov. 1897): 809–12, arguing that women's-rights advocates were on the wrong track, that women were too shallow in their thinking to ever be creative, and that the true talent of woman was to be a receptive apostle or follower of man and to support the genius and the creative man. For the image of the woman with the human boa, see A. Schmidhammer, "Nachtrag zu 'Symbolik der Mode,'" ibid. 4, no. 51 (Dec. 1899): 843; for the drawing by Hofmann, ibid. 2, no. 18 (May 1897): 285; on the Bavarians, Rudolf Wilke, "Er soll dein Herr sein," ibid. 4, no. 19 (May 1899): 299, and idem, "Weiblicher Wettbewerb," ibid. 3, no. 21 (May 1898): 353; on nudes fighting snake and ape, Fidus, "Glück," ibid. 2, no. 29 (July 1897): 489, or 4, no. 51 (Dec. 1899): 860; on schoolgirls, Julie Wolfthorn, "Höhere Töchter," ibid., no. 36 (Sept. 1899): 583.

78. Georg Hirth, "Deutsche Frauenfrage," ibid. 5, no. 4 (Jan. 1900): 62.

79. Möbius's 1901 book became so popular that it continued to be published well after the war, as in this eleventh edition: Dr. P. J. Möbius, *Über den physiologischen Schwachsinn des Weibe* (Halle: Carl Marhold Verlagsbuchhandlung, 1919). Hirth's articles against Möbius's theory were "Faustrecht oder—Gretchenrecht?" *Jugend* 6, no. 32 (1901): 527–28; and "Wir Feministen!" ibid. 7, no. 22 (1902): 363–64. On Helen Stöcker, see her "Öffener Brief an die Sittlichkeitsleute in Magdeburg," ibid. 10, no. 41 (1905): 800a, and advertisements in the 1905 volume for Stöcker's newspaper, *Mutterschutz, Zeitschrift zur Reform der sexuellen Ethik*.

80. See the satirical piece parodying letters from ostensibly highly moral people, such as a letter from an English striptease dancer that begins, "O shocking, shocking, shocking, was für schamlose Frauen und girls es gibt today!" in "Für die öffentlich Sittlichkeit," *Jugend* 2, no. 21 (May 1897): 341. For satirical cartoons on the morality

crusaders, see "Das vergroßerte Feigenblatt," ibid., 344; "In Dingsda ist des Franz Stuck 'Sphinx' in polizeilichen Gewahrsam genommen worden, weil sie der Schamhaftigkeit und Sittsamkeit gefährlich," ibid. 1, no. 19 (May 1896): last page; "Kunst und Polizei: Die Leda mit dem Schwan muß 'rrraus aus dem Schaufenster," ibid. 5, no. 23 (June 1900): 388; and "Der Obersthofnuditätenjägermeister," ibid., no. 10 (Mar. 1900): 180.

81. The responses to the Lex Heinze were published in ibid., nos. 12–13 (Mar. 1900): 216a–c, 232. Among the more pithy responses were Bode, "Lex mihi ars," recalling a legendary moment in German history; Klinger, "Die lex Heinze ist die Rache der Zwangs-Cölibatäre an dem gesunden Menschen"; and Liebermann, "Nicht umsonst heißen Poesie, Malerei, Musik, usw. die *freien* Künste und sie in die Schnürbrust von Polizei-vorschriften zwingen zu wollen, ist ebenso thöricht, als gegen Ideen mit Bajonetten anzukämpfen."

82. The issue that featured only women artists and writers was *Jugend* 3, no. 22 (May 1898), with the cover by Otolia Gräfin Kraszewska; decorative borders by Margarethe von Brauchitsch, Else Mehrle, Gertrud Kleinhempel, Wanda von Kunowski, Marie Stüler-Walde, and Johanna Hipp; a landscape by Marianne Fiedler; portraits and figure studies by Kögel, Elisabeth Hähnel, Wolfthorn, and Tini Rupprecht; and an allegorical drawing by Mathilde Ade.

83. For other cartoons ridiculing women artists, see also R. Wilke, "Der Frosch in der Damen-Malschule," ibid. 2, no. 23 (June 1897): 379; and Julius Diez, "Die Malerinnen auf dem Lande sollen so fleißig sein, daß sie oft spät Abends noch an einer Morgenstimmung malen," ibid., no. 48 (Nov. 1897): 817. Jank and Feldbauer taught at the Ladies' Academy, organized by the Munich Society of Women Artists. An excellent discussion of the positive and negative images of the new woman in popular literature and journals is David Ehrenpreis, "Cyclists and Amazons: Representing the New Woman in Wilhelmine Germany," *Woman's Art Journal* 20, no. 1 (1999): 25–31.

84. Georg Hirth, ed., *Dreitausend Kunstblätter der Münchner Jugend: Ausgewählt aus den Jahrgängen 1896–1909,* 2nd enl. ed. (Munich: Verlag der Jugend, 1909). The first edition of the catalog, in 1908, was published in an edition of 10,000 copies; the second edition printed an additional 5,000 copies. By 1912 a catalogue of color reproductions had appeared; counting its edition in 1918, 75,000 copies of the color catalogue had been printed.

85. See R.M. [Richard Mortimer], "Berlin," *Die Kunst für Alle* 14, no. 17 (June 1899): 269. The Cassirer exhibition combined drawings from artists of *Jugend, Simplicissimus,* and *Fliegende Blätter,* with master drawings by Leibl, Men-

zel, Liebermann, and Thoma; other rooms in the gallery featured Chéret's poster designs and drawings by Degas, Steinlen, and Segantini. Reviewing their separate exhibit at the Glass Palace were E. Wieland, "Die Jahres-Ausstellung im kgl. Glaspalast zu München," *Die Kunst für Alle* 14, no. 20 (July 1899): 311; Dr. G.H——ch [Georg Habich], "Die 'Jugendgruppe' auf der Jahresausstellung in Münchener Glaspalast," ibid. 15, no. 3 (Nov. 1899): 51–58; and Leopold Weber, "Münchener Glaspalast," *Der Kunstwart* 12, no. 23 (Sept. 1899): 378. *Jugend* was capable of self-satire, as in its parody of the Group G exhibition ostensibly written by "Dr. Quietsch" (mocking the archconservative Ludwig Pietsch), "Die 'Jugend-Leute' im Münchener Glaspalast," *Jugend* 4, no. 38 (Sept. 1899): 622.

On the Gurlitt exhibition, see "Die Scholle," *Kunstchronik,* n.s. 11 (Jan. 1900): col. 186. Art of the Scholle artists was included among the graphics and watercolors shown at the winter exhibition of the Berlin Secession (see H.R. [Hans Rosenhagen], "Die IV. Ausstellung der Berliner Secession," *Die Kunst für Alle* 17, no. 8 [Jan. 1902]: 188; and Ludwig Kaemmerer, "Zeichnende Künste: Vierte Ausstellung der Berliner Secession," *Zeitschrift für bildende Kunst* 37, n.s. 13 [1901–2]: 82–83).

86. In the years before World War I the Scholle as a group exhibited regularly in the Glass Palace in Munich and in the Berlin Secession. Critics commending their focus on the homeland included Alexander Heilmeyer, "Münchener Jahres-Ausstellungen 1900," *Die Kunst unserer Zeit* 11, 2nd half-vol. (1900): 128–30; F.v.O. [Fritz von Ostini], "München," *Die Kunst für Alle* 17, no. 3 (Nov. 1901): 69–70; and Hans Rosenhagen, "Die Münchener Künstlervereinigung 'Scholle,'" ibid. 20, nos. 17–18 (June 1905): 395–406, 419–32. The reference to "golden recklessness" came from Fritz von Ostini, "Die 'Scholle' im Münchener Glaspalast 1906," ibid. 21, no. 22 (Aug. 1906): 505–16.

In 1903, two years before Rosenhagen's article, the Scholle artists dedicated an issue of *Jugend* to denying that they were either primarily decorative artists or Heimatkünstler. They concluded a long statement claiming that their initial and continuing work was as painters, not illustrators, with the following assertion: "Die 'Scholle' hat kein anderes gemeinsames besußtes Ziel, keine andere Marschroute und Parole, *als die Forderung an ihre Mitglieder, daß jeder seine eigene Scholle bebaue, die freilich auf keiner Landkarte zu finden ist*" (ibid. 8, no. 42 [1903]: 754, 758). Poking fun at references to the flounder (*Scholle*) that appeared in some of the reviews, Fritz Erler created a painting for the cover in which a huge fish swam in deep water that had fully submerged the sunken towers of Munich's Frauenkirche, around which an octopus had wrapped his tentacles.

For information on Erler's career, see Fritz von Ostini,

"Fritz Erler," *Die Kunst für Alle* 24, no. 1 (Oct. 1908): 1–22, profusely illustrated with his murals; idem, "Fritz Erler," *Velhagen & Klasings Monatshefte* 28, no. 5 (Jan. 1914): 1–17; Richard Braungart, "Kriegsbilder von Fritz Erler und Ferdinand Spiegel," *Die Kunst für Alle* 31, no. 1/2 (Oct. 1915): 31–34; Josef Ponten, "Fritz Erler und Ferdinand Spiegel als Kriegsmaler," *Velhagen & Klasings Monatshefte* 30, no. 12 (Aug. 1916): 434–45; and Christina Schroeter, *Fritz Erler: Leben und Werk* (Hamburg: Christians Verlag, 1992).

87. *Kunstchronik*, n.s. 9 (May 1898): col. 410. The report also stated that the effort to form a secession was being led by Adelsten Normann and Max Uth and that thirty-five artists had joined, including Leistikow and Liebermann. See also [Paul] Schultze-Naumburg, "Die Berliner Kunstausstellung," *Der Kunstwart* 11, no. 18 (June 1898): 194–95.

88. Reports on the negotiation efforts and the subsequent founding of the Berlin Secession appeared in "Vereine und Gesellschaften," *Kunstchronik*, n.s. 10 (Jan. 1899): cols. 172–73, 187–88; "Berlin," *Die Kunst für Alle* 14, no. 9 (Feb. 1899): 138, containing the first mention of the Berlin Secession or of the rejection of the Leistikow painting in this Munich journal; ibid., no. 11 (Mar. 1899): 174, announcing the official formation of the Berlin Secession and naming the members of the executive committee; R.M. [Richard Mortimer], "Berlin," ibid., no. 12 (Mar. 1899): 190; "Berlin," ibid., no. 15 (May 1899): 239, on the new building on the terrace of the Theater des Westens on Kantstrasse and the contract with the Cassirers; ibid., nos. 16 (May 1899): 253, and 17 (June 1899): 267, on the Berlin Secession as a legally incorporated company. Paret, *Berlin Secession*, chap. 3, provides a thorough account and analysis of these events.

89. Liebermann's speech has been reprinted in "Reden zur Eröffnung von Ausstellungen der Berliner Sezession. Frühling 1899," in his *Die Phantasie in der Malerei: Schriften und Reden*, ed. Günter Busch (Frankfurt am Main: S. Fischer, 1978): 169–70. See also Richard Mortimer, "Die Ausstellung der Berliner Secession," *Die Kunst für Alle* 14, nos. 20 (July): 314–15 and 21 (Aug. 1899): 326–27, the first article including a photograph of Grisebach's building for the Secession. The Berlin humor magazine *Kladderadatsch* 53, no. 22 (June 1900), 1st supplement, featured a two-page parody of the Secession's claim not to represent a particular style. Presenting two pages of caricatures of works shown in the Berlin Secession of June 1900, the "catalogue" asserted that the Secession's basic principle was "Kunst ist für uns—nach dem Worte des heiligen Augustinus—was die großen Künstler gemacht haben." See also *Kladderadatsch*'s double-page parody of paintings from the first Berlin Secession exhibition in ibid. 52, no. 24 (June 1899), 1st supplement.

90. Notes on the financial success of the first exhibition, with its profit of thirty-three thousand marks, appeared in *Kunstchronik*, n.s. 11 (Nov. 1899): col. 92; and "Berlin," *Die Kunst für Alle* 15, no. 7 (Jan. 1900): 166.

91. See Adolf Rosenberg's review in "Die Ausstellung der Berliner Secession," *Kunstchronik*, n.s. 10 (June 1899): cols. 417–22; and see the reviews in "Rundschau. Bildende Kunst," *Der Kunstwart* 12, no. 19 (July 1899): 238–39; and in *Deutsche Kunst* 3, no. 15 (June 1899), with photographs of Liebermann in his studio and of several of the exhibitions rooms in the Secession building. The Munich journal *Die Kunst unserer Zeit* did not publish any reviews of the Berlin Society of Eleven or the Berlin Secession, though it did cover the Great Berlin exhibitions and, of course, the Munich Secession.

92. On the 1899 Great Berlin Art Exhibition, see Richard Mortimer, "Die Berliner Kunstausstellung im Landesausstellungsgebäude," *Die Kunst für Alle* 14, no. 18 (June 1899): 280–81; and "Grosse Berliner Kunstausstellung," *Kunstchronik*, n.s. 10 (May 1899): cols. 391–92. Ibid. (Aug. 1899): col. 507 also reported that Liebermann and two other members of the Secession, Oskar Frenzel and Richard Friese, had been disqualified from deciding upon medals for the Great Berlin exhibition even though they were all entitled to do so by virtue of being previous medal winners.

93. Paret, *Berlin Secession*, 79–82, identified among those who visited the show the president of the Royal Academy, the artist who headed the committee organizing the current Great Berlin, the mayor of Charlottenburg, and the chancellor of the empire. See also the description written in 1911 by a Berlin critic of the social differences between those who attended the Berlin Secession exhibition and those who attended the great exhibitions in ibid., 81.

94. See "Die Kunst in Schurzfell und Kittel," *Der Kunstwart* 11, nos. 16 (May 1898): 131–32, 17 (June 1898): 159, and 21 (Aug. 1898): 290, including the original report from the *Frankfurter Zeitung*, a rebuttal pointing out errors in the newspaper account, and a rejoinder by the artist himself.

95. For the curious role of Leistikow's painting in Berlin's art politics, see Paret, *Berlin Secession*, 42, 56; Paul, *Hugo von Tschudi*, 105–6; and Peter-Klaus Schuster, "Hugo von Tschudi und der Kampf um die Moderne," in Hohenzollern and Schuster, *Manet bis van Gogh*, 31–32, which is also a valuable source of information on these museum directors. Appointments after 1900 included: Kessler and van de Velde, hired to create a museum of modern art in Weimar in 1902; Karl Ernst Osthaus, who opened the Folkwang Museum in Hagen with his collection of French

Impressionist and Post-Impressionist works in 1902; Georg Swarzenski, director of the Städel Institute in Frankfurt in 1906, who purchased French art from works by the Barbizon School to Impressionist art; Fritz Wichert, director of the new Kunsthalle in Mannheim in 1909, where he built a strong collection of French and German modern art.

96. The collector who transformed Pan's head into the head of a Polish Jew was Martin Schubart, who had ranted against Meier-Graefe's plans for *Pan* at a gathering in Munich in the summer of 1894 (see Salzmann, "*Pan*," 167).

97. On Liebermann as a collector, see Peter Kreiger, "Max Liebermanns Impressionisten-Sammlung und ihre Bedeutung für sein Werk," in *Max Liebermann in seiner Zeit*, ed. Sigrid Achenbach and Matthias Eberle, exh. cat. (Berlin: Nationalgalerie, Staatliche Museen Preußischer Kulturbesitz, 1979), 60–71; and Claude Keisch, "Liebermann, Künstler und Kunstfreund: Die Sammlung," in *Max Liebermann—Jahrhundertwende*, ed. Angelika Wesenberg, exh. cat. (Berlin: Ars Nicolai, 1997), 221–32.

As director of the painting and sculpture collections of the Prussian museums in the 1890s, Bode had effectively cultivated a handful of wealthy Berliners to both collect art and donate work to the museums, particularly Renaissance and seventeenth-century Dutch work (see Thomas W. Gaehtgens, "Wilhelm von Bode und seine Sammler," in *Sammler, Stifter, und Museen: Kunstförderung in Deutschland im 19. und 20. Jahrhundert*, ed. Ekkehard Mai and Peter Paret [Cologne: Böhlau Verlag, 1993], 153–72). Focusing on the modern period, Tschudi followed his former mentor Bode in turning to private collectors for help in financing his acquisitions for the National Gallery.

Information about Berlin patrons of art and analyses of the role of Jews in that patronage can be found in Nicolaas Teeuwisse, "Bilder einer verschollenen Welt: Aufstieg und Niedergang der Berliner Privatsammlung in Berlin," in *Der unverbrauchte Blick: Kunst unserer Zeit in Berliner Sicht. Eine Ausstellung aus Privatsammlungen 1871–1933 in Berlin*, ed. Christos M. Joachimides, exh. cat. (Berlin: Martin-Gropius-Bau, 1987), 13–39; Teeuwisse, *Vom Salon zur Secession*, 220–30; Barbara Paul, "Drei Sammlungen französischer impressionistischer Kunst im kaiserlichen Berlin—Bernstein, Liebermann, Arnhold," and Verena Tafel, "Paul Cassirer als Vermittler deutscher impressionistischer Kunst in Berlin: Zum Stand der Forschung," in Gaehtgens, *Sammler der frühen Moderne in Berlin*, 11–30 and 31–46; Werner Knopp, "Kulturpolitik, Kunstförderung und Mäzenatentum in Kaiserreich: Im Spannungsfeld zwischen Staatskonservativismus und bürgerlicher Liberalität," Wolfgang Hardtwig, "Drei Berliner Porträts: Wilhelm von Bode, Eduard Arnhold, Harry Graf Kessler. Museumsmann, Mäzen, und Kunstvermittler—drei herausragende Beispiele," and Thomas W. Gaehtgens, "Die großen

Anreger und Vermittler: Ihr prägender Einfluß auf Kunstsinn, Kunstkritik und Kunstförderung," in Braun and Braun, *Mäzenatentum in Berlin*, 15–71, 112–26; Stefan Pucks, "Von Manet zu Matisse—Die Sammler der französischen Moderne in Berlin um 1900," in Hohenzollern and Schuster, *Manet bis van Gogh*, 386–90; and Pucks, "'Ein kleiner Kreis der Feinschmecker unter den Kunstfreunden': Liebermann, Cassirer, und die Berliner Sammler," in Wesenberg, *Max Liebermann*, 233–38, which provides a long list of the collectors of Max Liebermann's art.

For details on one of these large collections, see the auction catalogue *Kunstsammlung Rudolf Mosse, Berlin* (Berlin: Rudolph Lepke's Kunst-Auctions-Haus, 1934), with an introductory essay by Hans Rosenhagen, "Die Sammlung Rudolf Mosse." The Mosse collection contained paintings by most of the artists featured in this book, with the exception of the women. Mosse was only one of the eighty-nine Jewish patrons identified by Cella-Margaretha Girardet as contributing more than 80 percent of the donations to the official museums in Berlin from 1880 to 1933 in her *Jüdische Mäzene für die Preußischen Museen zu Berlin: Eine Studie zum Mäzenatentum im Deutschen Kaiserreich und in der Weimarer Republik* (Egelsbach, Germany: Hänsel-Hohenhausen, 1997).

Peter Paret has published perceptive and cautionary analyses of the methodological problems of defining the role of Jews in relationship to modern art (see his "Bemerkungen zu dem Thema: Jüdische Kunstsammler, Stifter, und Kunsthändler," in Mai and Paret, *Sammler, Stifter, und Museen*, 173–85; and his "Modernism and the 'Alien Element' in German Art," in *German Encounters with Modernism, 1840–1945* [Cambridge: Cambridge University Press, 2001], 60–91), also included in a valuable collection of essays, Emily D. Bilski, ed., *Berlin Metropolis: Jews and the New Culture, 1890–1918*, exh. cat. (Berkeley: University of California Press, 1999). See also an earlier article by Peter Gay, "Encounters with Modernism: German Jews in German Culture, 1881–1914," *Midstream* 21, no. 2 (1975): 23–65.

98. The reference to "national sanctuary of art" came from a National Liberal deputy during budget debates in March 1898, which are cited at some length in Dominik Bartmann, *Anton von Werner: Zur Kunst und Kunstpolitik im Deutschen Kaiserreich* (Berlin: Deutscher Verlag für Kunstwissenschaft, 1985), 214–18. Bartmann reproduces Werner's report of the emperor's April visit to the National Gallery and cites a later report that Werner was the source of the rumors that William was unhappy with Tschudi and had ordered him to get rid of the "Französele." On these events, see Paul, *Hugo von Tschudi*, 100–102, 109–10. R.M. [Mortimer], "Berlin," *Die Kunst für Alle* 14, no. 20 (July 1899): 315–16, did not specify who had started these rumors but said that it was not difficult to see through them. In this same report, Mortimer discussed the

unfortunate furor that took place around works by Menzel that were to be included in the Berlin Secession until unfounded charges were made that the Secession was using his work without permission; for further details on the sad episode in which opponents of modern art pressured the elderly artist, see also Paret, *Berlin Secession*, 84 n. 63. Mortimer had earlier criticized deputies in the Reichstag for an unfair attack on Tschudi's handling of the National Gallery (Richard Mortimer, "Berliner Brief," *Die Kunst für Alle* 14, no. 14 [Apr. 1899]: 220). A brief note in *Der Kunstwart* similarly reported on the emperor's generous behavior and nonintervention in National Gallery affairs, a surprising report in view of Avenarius's consistent criticism of William II's interference in art matters (ibid. 12, no. 19 [July 1899]: 239).

99. This imperial order has been interpreted more stringently by historians. I find convincing the interpretations presented in recent essays and documentation of Tschudi's response by Schuster, "Hugo von Tschudi," 26–29, and Grabowski, "'Euer Excellenz zur gfl. Kenntnisnahme. . . ,'" 393–95. Providing a careful review of Tschudi's reorganization to comply in part with the order, Barbara Paul views the order as having a more negative impact on Tschudi's freedom (*Hugo von Tschudi*, 109–16).

100. See, e.g., the racist accusations of a Jewish conspiracy to control German art published by Philipp Stauff, "Das Fremdtum in Deutschlands bildender Kunst, oder Paul Cassirer, Max Liebermann usw.," in *Semi-Kürschner oder Literarisches Lexikon*, ed. Philipp Stauff (Berlin: Ph. Stauff, 1913). I thank Peter Paret for sending me a copy of this article.

101. Hans Rosenhagen, "Berlin," *Die Kunst für Alle* 20, no. 7 (Jan. 1905): 164–66. The three categories were characterized as the "Deutschtümler"; those with "deutsche Gesinnung"; and the "deutsche Franzosen" or "deutsche Französeler." After discussing these categories and identifying the upcoming young artists who fit into each, he reviewed the large van Gogh exhibition at the Cassirer Gallery, describing the artist as an extraordinary genius. Since this was a review of current shows, Rosenhagen here made no mention that Cassirer also showed the artists he praised as authentic German artists—Thoma, Leibl, and Trübner. A thorough analysis of the way in which these factors were manifested in the two decades up to World War I is contained in Paret, *Berlin Secession*, esp. 88–89, 108–12; and for his accounts of the controversies of 1905 and 1911, see ibid., 170–99.

Epilogue
Jew, Emperor, and Paranoia
1. "München," *Die Kunst für Alle* 18, no. 9 (Feb. 1903): 224, reported on the break between the Berlin and the Munich Secessions and mentioned the large number of polemical articles that had appeared in the newspapers of both cities. The article that started this chain of events was Hans Rosenhagen, "Münchens Niedergang als Kunststadt," *Der Tag*, 13–14 Apr. 1901. Recognizing the importance of Rosenhagen's critique, *Die Kunst für Alle* 17, no. 11 (Mar. 1902): 264, reported on the publication of *Münchens "Niedergang als Kunststadt": Eine Rundfrage von Eduard Engels*, statements by thirty-three well-known persons responding to Rosenhagen's essays. A succinct summary of these events in the controversy between the Secessions is given by Maria Makela in *The Munich Secession: Art and Artists in Turn-of-the-Century Munich* (Princeton: Princeton University Press, 1990), 133–41, where she also discusses the unquestioned decline of Munich's art reputation after 1900 and the departure of important young artists associated with the decorative arts movement.

Both Corinth and Slevogt left Munich in 1901 after difficulties with the Munich Secession. Corinth's *Salome* was rejected in 1900, and Slevogt's *Danaë* was abruptly removed in 1899; both were then shown by invitation at the Berlin Secession. On Corinth's move to Berlin, see Peter-Klaus Schuster, Christoph Vitali, and Barbara Butts, eds., *Lovis Corinth*, exh. cat. (Munich: Prestel Verlag, 1996), 34–35; on Slevogt's, see Hans-Jürgen Imiela, *Max Slevogt: Eine Monographie* (Karlsruhe, Germany: G. Braun, 1968), 41–55. An exhaustive analysis of Rosenhagen's article and its impact is provided by Winfried Leypoldt, "'Münchens Niedergang als Kunststadt': Kunsthistorische, kunstpolitische, und kunstsoziologische Aspekte der Debatte um 1900" (Ph.D. diss., Ludwig-Maximilians-Universität zu München, 1987).

2. The diatribe against Rosenhagen was published in *Jugend* 8, no. 3 (Jan. 1903): 41; the cover and caricature appeared three weeks later, in ibid. 8, no. 6 (Jan. 1903), cover and 97, respectively. There had been anti-Semitic accusations earlier in the relationship between Liebermann and Uhde, who had become president of the Munich Secession in 1900. Paul Schultze-Naumburg, "Münchener Bericht," *Der Kunstwart* 10, no. 24 (Sept. 1897): 378–79, noted that Uhde was engaging in aggressive polemics against friends and foes who claimed that his work was no longer the focal point of contemporary art. Reacting angrily to Heilbut's article on Liebermann in 1897, Uhde wrote to *Die Kunst für Alle* to protest its publishing an article with clear "Semitic sympathies" and later wrote that the article might have been appropriate for a Jewish paper in Berlin but was not appropriate in a Munich newspaper (see Bettina Brand, *Fritz von Uhde: Das religiose Werk zwischen künstlerischer Intention und Öffentlichkeit* [Heidelberg: Bettina Brand, 1983], 313–17, for the texts of letters from Uhde to *Die Kunst für Alle*; and see Makela, *Munich Secession*, 138, for further instances

of Uhde's resentment against Liebermann's continuing success).

Expressions of anti-Semitism in private or in letters certainly were not uncommon at this time in Germany. Uhde's anti-Semitism was intensified by his own professional disappointment. Elsewhere it cropped out in casual nastiness, as in a letter written by Bodenhausen to Kessler about Bode's efforts in April 1897 to bring Liebermann on to the editorial board of *Pan*; see Gisela Henze, "Der *Pan*: Geschichte und Profil einer Zeitschrift der Jahrhundertwende" (Ph.D. diss., Albert-Ludwigs-Universität zu Freiburg i. Br., 1974), 121.

The linkage of modernism to Jews by those who were opposed to the work of modern artists took a strange turn in Hanover in the aftermath of the controversy over Klinger's *Crucifixion*. In 1902 Klinger was denounced as "a baptized Jew" in an official deposition to the Prussian minister of justice for his paintings of Christ, which, it was charged, had offended the emperor, who should not be defamed by anyone, certainly not by "an offspring of Jews." This incident is reported in Gerhard Winkler, *Max Klinger* (Leipzig: E. A. Seeman, 1984), 42–43 n. 141, citing documents from the interior ministry.

A large selection of caricatures of Liebermann after 1900 from *Lustige Blätter*, *Simplicissimus*, and *Kladderadatsch* are reproduced by Immo Wagner-Douglas, "Realist, Secessionist, Jude und Patriarch—Liebermann in der Karikatur," in *Max Liebermann—Jahrhundertwende*, ed. Angelika Wesenberg, exh. cat. (Berlin: Ars Nicolai, 1997). An early study is Michael Klant, "Hommage comique à Liebermann: Eine Studie zum Rezeptionswandel Max Liebermanns im Spiegel der Karikatur," *Kritische Berichte* 13, no. 2 (1985): 5–20.

3. "Die historischen Denkmäler in der Siegesallee zu Berlin," *Moderne Kunst* 12 (1898): 133, included photographs of the first sculptural groups. Avenarius's review

appeared in *Der Kunstwart* 11, no. 13 (Apr. 1898): 35. *Deutsche Kunst* 3, no. 6 (1898) also published an article on the unveiling of the first statues, and *Pan* 1, no. 1/2 (Apr.–May 1895), reported on the plans in its notes section. Avenarius voiced his objections in "Die Standbilder für die Berliner Siegesallee," *Der Kunstwart* 9, no. 12 (Mar. 1896): 188–89, which he followed after the Siegesallee was completed with articles calling for a clear distinction to be made between imperial art promoted by the emperor and genuine art (A., "Hofkunst und andere Kunst," ibid. 15, no. 3 [Nov. 1901]; and A. "Zur Rede des Kaisers," ibid., no. 8 [Jan. 1902]: 361–65).

The parody placing a Siegesallee in working-class Berlin is "Schmücke deine Vaterstadt," *Fliegende Blätter* 17, no. 4 (1902): 6. The famous Odol advertisements ran in all of these humor magazines. On Odol advertisements, see Henriette Vüth-Hinz, *Odol: Reklame-Kunst um 1900* (Giessen, Germany: Anabas-Verlag, 1985). Other satires of the avenue of statues appeared in *Jugend* 6, no. 47 (1901): 785; 7, nos. 1–2 (1902); and 10, no. 38 (1905): 726.

4. Konrad Lange's defense of modern art was published in "Die Freiheit der Kunst," *Die Kunst für Alle* 17, no. 9 (Feb. 1902): 193–98, and "Die Grenzboten und die Moderne Kunst," ibid., no. 14 (Apr. 1902): 327–30.

5. Hermann Tarbutt, "Die keinerausstellung des Künstlervereins 'Paranoia,'" ibid. 11, no. 17 (June 1896): 263–65. A small footnote to the article informed the reader that this "amusing parody" had first been published in the current carnival edition of the *Münchener Neuesten Nachrichten*. Although Klinger's *Beethoven* was not completed or shown until 1901, it was well known by 1896 that he was working on what was expected to be his greatest sculptural masterpiece.

Selected Bibliography

Contemporary Sources

Contemporary Art Journals

Articles, reviews, reports, and cartoons from the journals listed below are fully cited in the notes to each chapter. Asterisks indicate journals for which the volume year begins in October and extends to the following September; hence the year given for each volume is the year in which the volume ends. I am indebted to Joan Weinstein for providing me with a copy of her notes on *Kunstchronik*, 1890–1902, and on *Der Kunstwart*, 1899–1902. Translations are mine, with help from Richard Figge, Susan Figge, Peter Paret, and Mary Lee Townsend, for which I am grateful.

Das Atelier. Semimonthly. Vols. 1–4. Berlin: Verlag Wilhelm & Brasch, 1890–94.

**Deutsche Kunst: Central-Organ Deutscher Kunst- und Künstler-Vereine. Wochenblatt für das gesammte deutsche Kunstschaffen*. Vols. 1–3. Berlin, 1896–99.

Jugend: Münchner Illustrierte Wochenschrift für Kunst und Leben. 1896–1919. Vols. 1–9, Munich: G. Hirth's Kunstverlag, 1896–1904; Verlag der Münchner Jugend, 1905–19. Beginning in 1905 the journal was identified by the year, not by a volume number.

Kunstchronik: Wochenschrift für Kunst und Kunstgewerbe. New series. Vols. 1–13. Leipzig: E. A. Seemann, 1890–1902. Prior to 1890, *Kunstchronik* was published as a supplement to the *Zeitschrift für bildende Kunst*.

**Die Kunst für Alle*. Semimonthly. Vols. 1–39. Vols. 1–11, Munich: Verlagsanstalt für Kunst und Wissenschaft, Friedrich Bruckmann, 1886–96; vols. 12–39, Munich: Verlagsanstalt F. Bruckmann, 1897–1919. With vol. 15 (1899–1900), *Die Kunst für Alle* became part 1 of the journal *Die Kunst: Monatsheft für freie und angewandte Kunst*, though it simultaneously retained its old title and numbering, which are consistently used in the notes.

Die Kunst unserer Zeit. Vols. 1–12. Munich: Franz Hanfstaengl Kunstverlag, 1890–1901.

**Der Kunstwart: Rundschau über alle Gebiete des Schönen*. Semimonthly. Vols. 1–16. Vols. 1–7, no. 12, Dresden: Kunstwart Verlag, 1888–94; vol. 7, no. 13–vol. 16, Munich: Georg D. W. Callwey Verlag, 1894–1903.

Moderne Kunst in Meister-Holzschnitten nach Gemälden und Sculpturen Berühmter Meister der Gegenwart. Vols. 9–12. Berlin: Verlag Rich. Bong, 1895–98.

Pan. Vols. 1–5. Vol. 1, Berlin: Verlag Pan, 1895–96; vols. 2–5, Berlin: F. Fontane & Co., 1896–1900.

**Zeitschrift für bildende Kunst*. Vols. 20–53. Leipzig: E. A. Seemann, 1885–1918. A new series began with vol. 25, with volumes simultaneously continuing the old numbering.

Contemporary Humor Magazines

Fliegende Blätter. Vols. 75–127. Munich: Braun & Schneider, 1875–1907.

Kladderadatsch. Vols. 49–52. Berlin: Verlag A. Hofmann & Comp., 1896–99.

Simplicissimus. Vols. 1–3. Munich: Albert Langen Verlag, 1896–99.

Contemporary Criticism, Accounts, and Exhibitions

Avenarius, Ferdinand. *Max Klingers Griffelkunst: Ein Begleiter durch ihre Phantasiewelt*. Berlin: Amsler & Ruthardt, 1895.

Bashkirtseff, Marie. *The Journal of a Young Artist, 1860–1884*. Trans. Mary J. Serrano. New York: Cassell and Co., 1889.

Berg, Leo. *Das Sexuelle Problem in Kunst und Leben*. 5th ed. Berlin: Verlag von Hermann Walther, 1901.

Bierbaum, Otto Julius. *Aus beiden Lagern: Betrachtungen, Karakteristiken, und Stimmungen aus dem ersten Doppel-Ausstellungsjahre in München 1893*. Munich: Karl Schüler, 1893.

———. *Fritz von Uhde*. Munich: Georg Müller Verlag, 1908.

Die Bösen Buben in der Berliner Kunstausstellung. Berlin: Verlag von S. Fischer, 1889.

Brieger, Lothar. *Lesser Ury: Graphiker der Gegenwart*. Berlin: Verlag Neue Kunsthandlung, 1921.

Busch, Wilhelm. "Maler Klecksel" (1884). In *Wilhelm Busch: Sämtliche Werke*, ed. Otto Nöldeke, 2:427–93. Munich: Braun & Schneider, 1943.

Cassius, K. *Spottvogel im Glaspalast: Epigramme in Wort und Bild auf die III. Internationale Kunstausstellung in München 1888*. Munich: Commissionsverlag von Wilhelm Behrens, 1888.

———. *Spottvogel im Glaspalast: Epigramme in Wort und Bild auf die Münchener Jahres-Ausstellung 1889*. Munich: Verlag von Ulrich Putze, Kunsthandlung, 1889.

Daffner, Hugo. *Salome: Ihre Gestalt in Geschichte und Kunst, Dichtung—bildende Kunst—Musik*. Munich: Hugo Schmidt Verlag, 1912.

Dawson, William Harbutt. *Bismarck and State Socialism*.

London: Swan Sonnenschein and Co., 1890.

Deiters, Heinrich. *Geschichte der Allgemeinen Deutschen Kunstgenossenschaft: Von ihrer Entstehung im Jahre 1856 bis auf die Gegenwart. Nach den offiziellen Berichten, eigenen Erinnerungen und Erlebnissen.* Düsseldorf: August Bagel, [1903].

Drey, Paul. *Die wirtschaftlichen Grundlagen der Malkunst: Versuch einer Kunstökonomie.* Stuttgart: J. G. Cotta, 1910.

[Ehrenberg, Carl]. *Die neue Kunst und der Schaupöbel: Von einem Mitgliede des Schaupöbels.* Dresden: Kunstdruckerei Union, 1894.

Fischel, Oskar. *Ludwig von Hofmann.* Künstler-Monographien, ed. H. Knackfuß, 63. Bielefeld, Germany: Verlag von Velhagen & Klasing, 1903.

Franquet, E. v. *Schaupöbel: Klinger, Exter, v. Hofmann etc. "Die künftigen Heroen der Rumpelkammer." Glossen zum Streit der Alten und Jungen.* Leipzig: Verlag von Max Spohr, 1893.

Fritsch, Gustav. *Ne sutor supra crepidam! Erwiderungen an einige meiner besonderen Gönner unter der Kunstkritik. Antwort auf Herrn von Heyden's offenen Brief, betitelt: "Aus eigenem Rechte der Kunst," nebst zustimmenden Urtheilen der Tagespresse und Meinungsäußerungen namhafter Naturkenner über meine Schrift "Unsere Körperform im Lichte der modernen Kunst."* Berlin: Carl Habel, 1894.

———. *Unsere Körperform im Lichte der modernen Kunst.* Berlin: Carl Habel, 1893.

Grosse Berliner Kunst-Ausstellung 1893, 14 Mai bis 17 September im Landes-Ausstellungsgebäude am Lehrter Bahnhof: Illustrirter Katalog. Exh. cat. Berlin: Verlag von Rud. Schuster, 1893.

Gurlitt, Cornelius. *Die deutsche Kunst des neunzehnten Jahrhunderts: Ihre Ziele und Thaten.* Vol. 2 of *Das Neunzehnte Jahrhundert in Deutschlands Entwicklung,* ed. Paul Schlenther. Berlin: Georg Bondi, 1899.

Hancke, Erich. *Max Liebermann: Sein Leben und seine Werke.* 1914. 2nd ed. Berlin: Bruno Cassirer, 1923.

Haushofer, Max. *Die Ehefrage im Deutschen Reich.* Der Existenzkampf der Frau in modernen Leben, ed. Gustav Dahms, 3. Berlin: Richard Taendler Verlag, 1895.

Heyden, August von. *Aus eigenem Rechte der Kunst: Ein Wort zur Abwehr.* Berlin: F. Fontane & Co., 1894.

———. *Jury und Kunstausstellungen.* Berlin: F. Fontane & Co., 1894.

Hirth, Georg, ed. *Dreitausend Kunstblätter der Münchner Jugend: Ausgewählt aus den Jahrgängen 1896–1909.* 2nd enl. ed. Munich: Verlag der Jugend, 1909.

Ilg, Albert. *Moderne Kunstliebhaberei.* Gegen den Strom: Flugschriften einer literarische-künstlerische Gesellschaft, 13. Vienna: Graeser, 1887.

———. *Unsere Künstler und die Gesellschaft.* Gegen den Strom: Flugschriften einer literarische-künstlerische Gesellschaft, 8. Vienna: Graeser, 1885–86.

Illustrirter Katalog der Münchener Jahresausstellung von Kunstwerken Aller Nationen im Kgl. Glaspalaste, 1894. Exh. cat. Munich: Franz Hanfstaengl Kunstverlag, 1894.

Internationale Kunst-Ausstellung Berlin 1896 zur Feier des 200. Jahrigen Bestehens der Königlichen Akademie der Künste. Exh. cat. Berlin: Verlag von Rud. Schuster, 1896.

Internationale Kunst-Ausstellung veranstaltet von Verein Berliner Künstler anlässlich seines fünfzigjährigen Bestehens 1841–1891: Katalog und Führer. Exh. cat. Berlin: Verlag des Vereins Berliner Künstler, 1891.

Jordan, Max. *Das Werk Adolf Menzels, 1815–1905.* Munich: Verlagsanstalt F. Bruckmann, 1905.

Jubiläums-Ausstellung der Kgl. Akademie der Künste im Landes-Ausstellungsgebäude zu Berlin von Mai bis October 1886: Illustrirte Katalog. Exh. cat. Berlin, 1886.

Katalog der deutschen Kunstausstellung der "Berliner Secession." Exh. cat. Berlin: Bruno und Paul Cassirer, 1899.

Khaynach, Friedrich Freiherr von. *Anton von Werner und die Berliner Hofmalerei.* Zürich: Verlags-Magazin, 1893.

Klinger, Max. *"Malerei und Zeichnung," Tagebuchaufzeichnungen und Briefe.* Ed. Anneliese Hübscher. Leipzig: Philipp Reclam jun., 1985.

Kunstsammlung Rudolf Mosse, Berlin. With an introductory essay by Hans Rosenhagen. Berlin: Rudolph Lepke's Kunst-Auctions-Haus, 1934.

[Langbehn, Julius]. *Rembrandt als Erzieher: Von einem Deutschen.* 37th ed. Leipzig: Verlag von C. L. Hirschfeld, 1891.

Lehrs, Max. *Arnold Böcklin: Ein Leitfaden zum Verständnis seiner Kunst.* Munich: Photographische Union, 1897.

Leixner, Otto von. *Anleitung in 60 Minuten Kunstkenner zu werden.* Berlin: Verlag von Brachvogel & Boas, 1886.

Liebermann, Max. *Die Phantasie in der Malerei: Schriften und Reden.* Ed. Günter Busch. Frankfurt am Main: S. Fischer, 1978.

Mann, Thomas. "Gladius Dei" (1902). In *Stories of Three Decades,* 181–93. New York: Alfred A. Knopf, 1936.

Meier-Graefe, Julius. *Der Fall Böcklin und die Lehre von den Einheiten.* Stuttgart: Verlag Julius Hoffmann, 1905.

Meissner, Franz Hermann. *Arnold Böcklin.* Das Künstlerbuch, 1. Berlin: Schuster & Loeffler, 1903.

———. *Franz Stuck.* Das Künstlerbuch, 3. Berlin: Schuster & Loeffler, 1899.

———. *Fritz von Uhde.* Das Künstlerbuch, 5. Berlin: Schuster & Loeffler, 1900.

———. *Max Klinger.* Das Künstlerbuch, 2. Berlin: Schuster & Loeffler, 1899.

Muther, Richard. *Geschichte der Malerei im XIX. Jahrhundert.* Vol. 3. Munich: G. Hirth's Kunstverlag, 1894.

————. *The History of Modern Painting*. Rev. ed. 4 vols. London: J. M. Dent and Co., 1907.

Neumann, Carl. *Der Kampf um die Neue Kunst*. 1896. 2nd ed. Berlin: Verlag von Hermann Walther, 1897.

Nietzsche, Friedrich. *Also sprach Zarathustra: Ein Buch für Alle und Keinen* (1883–85; first published 1892). Vol. 13 of *Gesammelte Werke*. Ed. Richard Oehler, Max Oehler, and Friedrich Würzbach. Munich: Musarion Verlag, 1925. Trans. Walter Kaufmann under the title *Thus Spoke Zarathustra: A Book for All and None* (New York: Penguin Books, 1978).

————. *Gesammelte Werke*. Ed. Richard Oehler, Max Oehler, and Friedrich Würzbach. 23 vols. Munich: Musarion Verlag, 1920–29.

Nordau, Max. *Degeneration*. London: William Heinemann, 1895. Reprint, intro. George L. Mosse, New York: Howard Fertig, 1968. Originally published as *Entartung*, 2nd ed. (Berlin: C. Duncker, 1892).

Ostini, Fritz von. *Böcklin*. Künstler-Monographien, ed. H. Knackfuß, 70. Bielefeld, Germany: Verlag von Velhagen & Klasing, 1904.

————. *Thoma*. Künstler-Monographien, ed. H. Knackfuß, 46. Bielefeld, Germany: Verlag von Velhagen & Klasing, 1900.

————. *Uhde*. Künstler-Monographien, ed. H. Knackfuß, 61. Bielefeld, Germany: Verlag von Velhagen & Klasing, 1902.

Pataky, Sophie, ed. *Lexikon deutscher Frauen der Feder: Eine Zusammenstellung der seit dem Jahre 1840 erschienenen Werke weiblicher Autoren, nebst Biographieen der lebenden und einem Verzeichnis der Pseudonyme*. 2 vols. Berlin: Carl Pataky Verlagsbuchhandlung, 1898. Facsimile reprint, Bern: Herbert Lang, 1971.

Redslob, Edwin. *Ludwig von Hofmann: Erstmaliger Überblick über das Schaffen des Künstlers, 1891–1916*. Exh. cat. Dresden: Galerie Ernst Arnold, 1917.

Rosenberg, Adolf. *Anton von Werner*. Künstler-Monographien, ed. H. Knackfuß, 9. Bielefeld, Germany: Verlag von Velhagen & Klasing, 1895.

Rosenhagen, Hans. *Max Liebermann*. Künstler-Monographien, ed. H. Knackfuß, 45. Bielefeld, Germany: Verlag von Velhagen & Klasing, 1900.

————. *Uhde: Des Meisters Gemälde in 285 Abbildungen*. Klassiker der Kunst, vol. 12. Stuttgart: Deutsche Verlags-Anstalt, 1908.

————. *Wilhelm Trübner*. Künstler-Monographien, ed. H. Knackfuß, 98. Bielefeld, Germany: Verlag von Velhagen & Klasing, 1909.

Scheffler, Karl. *Die Frau und die Kunst: Eine Studie*. Berlin: Verlag Julius Bard, 1908.

Schmid, Max. *Klinger*. Künstler-Monographien, ed. H. Knackfuß, 41. Bielefeld, Germany: Verlag von Velhagen & Klasing, 1899.

Schuchhardt, Carl. *Max Klinger's "Kreuzigung" in Hannover: Vortrag im Hannoverschen Kunstlerverein am 24 April 1899*. Hannover: Commissionsverlag von Schmorl & von Seefeld Nachf., 1899.

Schwarz, Karl. *Lesser Ury*. Judische Bücherei, ed. Karl Schwarz, 17. Berlin: Verlag für Jüdische Kunst und Kultur, 1920.

Seidel, Paul. *Der Kaiser und die Kunst*. Berlin: Reichsdruckerei, 1907.

Singer, Hans W. *Zeichnungen von Max Klinger: Zweiundfünfzig Tafeln mit Lichtdruck nach des Meisters Originalen*. Meister der Zeichnung, ed. Hans W. Singer, 1. Leipzig: A. Schumann's Verlag, 1912.

Stauff, Philipp. "Das Fremdtum in Deutschlands bildender Kunst, oder Paul Cassirer, Max Liebermann usw." In *Semi-Kürschner oder Literarisches Lexikon*, ed. Philipp Stauff. Berlin: Ph. Stauff, 1913.

Thode, Henry. *Böcklin und Thoma: Acht Vorträge über neudeutsche Malerei gehalten für ein Gesamtpublikum an der Universität zu Heidelberg im Sommer 1905*. Heidelberg: Carl Winter's Universitätsbuchhandlung, 1905.

Trübner, Wilhelm. "Das Kunstverständnis von Heute" (1892). In *Personalien und Prinzipien*, 124–82. Berlin: Bruno Cassirer, 1907.

————. *Die Verwirrung der Kunstbegriffe: Betrachtung*. Frankfurt am Main: Rütten & Loning, 1898.

Vogel, Julius. *Max Klingers Kreuzigung Christi im Museum der bildenden Künste zu Leipzig*. Leipzig: E. A. Seemann, 1918.

————. *Max Klinger und seine Vaterstadt Leipzig: Ein Kapitel aus dem Kunstleben einer deutschen Stadt*. Leipzig: A. Deichertsche Verlagsbuchhandlung, 1923.

Voß, Georg. *Die Frauen in der Kunst*. Der Existenzkampf der Frau im modernen Leben, ed. Gustav Dahms, 8. Berlin: Richard Taendler Verlag, 1895.

Weigmann, Otto, ed. *Schwind: Des Meisters Werke in 1265 Abbildungen*. Klassiker der Kunst, 9. Stuttgart: Deutsche Verlags-Anstalt, 1906.

Werner, Anton von. *Erlebnisse und Eindrücke, 1870–1890*. Berlin: Ernst Siegfried Mittler und Sohn, 1913.

Secondary Sources

Abrams, Lynn. "From Control to Commercialization: The Triumph of Mass Entertainment in Germany, 1900–1925." *German History* 8, no. 3 (1990): 278–93.

————. *Workers' Culture in Imperial Germany*. London: Routledge, 1992.

————. "Prostitutes in Imperial Germany, 1870–1918: Working Girls or Social Outcasts." In *The German Underworld: Deviants and Outcasts in German History*, ed. Richard J. Evans, 189–209. London: Routledge, 1988.

SELECTED BIBLIOGRAPHY

Achenbach, Sigrid, and Matthias Eberle, eds. *Max Liebermann in seiner Zeit*. Exh. cat. Berlin: Nationalgalerie, Staatliche Museen Preußischer Kulturbesitz, 1979.

Albisetti, James C. *Schooling German Girls and Women: Secondary and Higher Education in the Nineteenth Century*. Princeton: Princeton University Press, 1988.

Allen, Ann Taylor. "Feminism, Social Science, and the Meanings of Modernity." *American Historical Review* 104, no. 4 (1999): 1084–1113.

———. "Feminism, Venereal Diseases, and the State in Germany, 1890–1918." *Journal of the History of Sexuality* 4, no. 1 (1993): 27–50.

———. *Satire and Society in Wilhelmine Germany: "Kladderadatsch" and "Simplicissimus," 1890–1914*. Lexington: University Press of Kentucky, 1984.

Allen, Virginia M. *The Femme Fatale: Erotic Icon*. Troy, N.Y.: Whitston, 1983.

Anderson, Margaret Lavinia. "The Limits of Secularization: On the Problem of the Catholic Revival in Nineteenth-Century Germany." *Historical Journal* 38 (1995): 647–70.

———. "Voter, Junker, *Landrat*, Priest: The Old Authorities and the New Franchise in Imperial Germany." *American Historical Review* 98, no. 5 (1993): 1448–74.

———. *Windhorst: A Political Biography*. Oxford: Oxford University Press, 1981.

Andree, Rolf. *Arnold Böcklin: Die Gemälde*. 2nd rev. and enl. ed. Basel: Friedrich Reinhardt Verlag, 1998.

Anselm, Sigrun, and Barbara Beck, eds. *Triumph und Scheitern in der Metropole: Zur Rolle der Weiblichkeit in der Geschichte Berlins*. Berlin: Dietrich Reimer Verlag, 1987.

Applegate, Celia. *A Nation of Provincials: The German Idea of Heimat*. Berkeley: University of California Press, 1990.

Aschheim, Steven E. *The Nietzsche Legacy in Germany, 1890–1990*. Weimar and Now: German Cultural Criticism, ed. Anton Kaes, 2. Berkeley: University of California Press, 1992.

Augustine, Dolores L. "Arriving in the Upper Class: The Wealthy Business Elite of Wilhelmine Germany." In *The German Bourgeoisie: Essays on the Social History of the German Middle Class from the Late Eighteenth to the Early Twentieth Century*, ed. David Blackbourn and Richard J. Evans, 46–86. New York: Routledge, 1991.

———. *Patricians and Parvenus: Wealth and High Society in Wilhelmine Germany*. Oxford: Berg, 1994.

Bade, Patrick. *Femme Fatale: Images of Evil and Fascinating Women*. New York: Mayflower Books, 1979.

Baeumer, Max L. "Imperial Germany as Reflected in Its Mass Festivals." In *Imperial Germany: Essays*, ed. Volker Dürr, Kathy Harms, and Peter Hayes, 62–74. Madison: University of Wisconsin Press, 1985.

Bahns, Jörn. *Wilhelm Trübner, 1851–1917*. Exh. cat. Heidelberg: Kurpfälisches Museum, 1994.

Baldwin, P. M. "Liberalism, Nationalism, and Degeneration: The Case of Max Nordau." *Central European History* 13, no. 2 (1980): 99–120.

Baranow, Sonja von. *Franz von Lenbach: Leben und Werk*. Cologne: DuMont Buchverlag, 1986.

Barkin, Kenneth D. "The Crisis of Modernity, 1887–1902." In *Imagining Modern German Culture: 1889–1910*, ed. Françoise Forster-Hahn, 19–35. Studies in the History of Art, 53. Washington, D.C.: National Gallery of Art, 1996.

Bartmann, Dominik. *Anton von Werner: Zur Kunst und Kunstpolitik im Deutschen Kaiserreich*. Berlin: Deutscher Verlag für Kunstwissenschaft, 1985.

———, ed. *Anton von Werner: Geschichte in Bildern*. Exh. cat. Munich: Hirmer Verlag, 1993.

Belgum, Kirsten. "Displaying the Nation: A View of Nineteenth-Century Monuments through a Popular Magazine." *Central European History* 26, no. 4 (1994): 457–74.

Bell, Susan Groag, and Karen M. Offen, eds. *Women, the Family, and Freedom: The Debate in Documents*. Stanford, Calif.: Stanford University Press, 1983.

Belting, Hans. *The Germans and Their Art: A Troublesome Relationship*. New Haven, Conn.: Yale University Press, 1998.

Bergdoll, Barry. *Karl Friedrich Schinkel: An Architecture for Prussia*. New York: Rizzoli International Publications, 1994.

Berger, Renate. *Malerinnen auf dem Weg ins 20. Jahrhundert: Kunstgeschichte als Sozialgeschichte*. Cologne: DuMont Buchverlag, 1982.

Berghahn, Volker R. *Imperial Germany, 1871–1914: Economy, Society, Culture, and Politics*. Providence, R.I.: Berghahn Books, 1994.

Bergmann, Klaus, ed. *Schwarze Reportagen: Aus dem Leben der untersten Schichten vor 1914: Huren, Vagabunden, Lumpen*. Kulturen und Ideen, ed. Johannes Beck et al. Reinbek bei Hamburg, Germany: Rowohlt Taschenbuch Verlag, 1984.

Berlinische Galerie. *Profession ohne Tradition: 125 Jahre Verein der Berliner Künstlerinnen*. Exh. cat. Berlin: Kupfergraben, 1992.

Berman, Patricia G. "The Invention of History: Julius Meier-Graefe, German Modernism, and the Genealogy of Genius." In *Imagining Modern German Culture: 1889–1910*, ed. Françoise Forster-Hahn, 91–101. Studies in the History of Art, 53. Washington, D.C.: National Gallery of Art, 1996.

Bertuleit, Sigrid. *Max Liebermann: Gemälde 1873–1918*. Hannover: Niedersächsisches Landesmuseum, 1994.

Betthausen, Peter. "Die 'Brücke'—Künstlergemeinschaft und Kunstverein des Expressionismus." In *Expressionisten: Die Avantgarde in Deutschland, 1905–1920*, ed. Roland März, 25–30. Exh. cat.

Berlin: Henschelverlag Kunst und Gesellschaft, 1986.

Betthausen, Peter, et al., eds. *Adolph Menzel, 1815–1905: Master Drawings from East Berlin*. Exh. cat. Alexandria, Va.: Art Services International, 1990.

Bilski, Emily D., ed. *Berlin Metropolis: Jews and the New Culture, 1890–1918*. Exh. cat. Berkeley: University of California Press, 1999.

Birkner, Othmar. "Böcklin-Jubiläum und Böcklin-Fest Basel 1897." In *Arnold Böcklin, 1827–1901: Gemälde, Zeichnungen, Plastiken. Ausstellung zum 150. Geburtstag*, ed. Dorothea Christ, 147–50. Exh. cat. Basel: Schwabe & Co., 1977.

Bismarck, Beatrice von. "Harry Graf Kessler und die französische Kunst um die Jahrhundertwende." In *Sammler der frühen Moderne in Berlin*, ed. Thomas W. Gaehtgens, special issue of *Zeitschrift des deutschen Vereins für Kunstwissenschaft* 42, no. 3 (1988): 47–62.

Blackbourn, David. "Catholics, the Centre Party, and Anti-Semitism." In *Populists and Patricians: Essays in Modern Germany History*. London: Allen and Unwin, 1987.

———. "Law, Voluntary Association, and the Rise of the Public." In *The Peculiarities of German History: Bourgeois Society and Politics in Nineteenth-Century Germany*, by David Blackbourn and Geoff Eley, pt. 2, chap. 2. Oxford: Oxford University Press, 1984.

———. *The Long Nineteenth Century: A History of Germany, 1780–1918*. New York: Oxford University Press, 1998.

———. *Marpingen: Apparitions of the Virgin Mary in Bismarckian Germany*. New York: Random House, Vintage Books, 1995.

———. "The Politics of Demagogy in Imperial Germany." *Past and Present*, no. 113 (1986): 152–84.

———. *Populists and Patricians: Essays in Modern Germany History*. London: Allen and Unwin, 1987.

Blackbourn, David, and Geoff Eley. *The Peculiarities of German History: Bourgeois Society and Politics in Nineteenth-Century Germany*. Oxford: Oxford University Press, 1984.

Blackbourn, David, and Richard Evans, eds. *The German Bourgeoisie: Essays on the Social History of the German Middle Class from the Late Eighteenth to the Early Twentieth Century*. New York: Routledge, 1991.

Boas, George. "Il faut être de son temps." *Journal of Aesthetics and Art Criticism* 1 (1941): 52–65.

Boberg, Jochen, Tilman Fichter, and Eckhart Gillen, eds. *Die Metropole: Industriekultur in Berlin im 20. Jahrhundert*. Industriekultur deutscher Städte und Regionen, Berlin, ed. Hermann Glaser, 2. Munich: Verlag C. H. Beck, 1986.

Boime, Albert. *Art and the French Commune: Imagining Paris after War and Revolution*. Princeton: Princeton University Press, 1995.

———. "Entrepreneurial Patronage in Nineteenth-Century France." In *Enterprise and Entrepreneurs in Nineteenth- and Twentieth-Century France*, ed. Edward Carter et al., 331–50. Baltimore: Johns Hopkins University Press, 1976.

Borchardt, Knut. *Perspectives on Modern German Economic History and Policy*. Cambridge: Cambridge University Press, 1991.

Borowitz, Helen. "Visions of Salome." *Criticism* 14, no. 1 (1972): 12–21.

Borrmann, Norbert. *Paul Schultze-Naumburg, 1869–1949: Maler, Publizist, Architekt. Vom Kulturreformer der Jahrhundertwende zum Kulturpolitiker im Dritten Reich*. Essen: Verlag Richard Bacht, 1989.

Börsch-Supan, Helmut. "Der Verein Berliner Künstler im neunzehnten Jahrhundert." In *Verein Berliner Künstler: Versuch einer Bestandsaufnahme von 1841 bis zur Gegenwart*, 9–44. Berlin: Ars Nicolai, 1991.

Boskamp, Katrin. *Studien zum Frühwerk von Max Liebermann mit einem Katalog der Gemälde und Ölstudien von 1866–1889*. Hildesheim, Germany: Georg Olms Verlag, 1994.

Bovenschen, Silvia. *Die imaginierte Weiblichkeit*. Frankfurt am Main: Suhrkamp, 1979.

Bramsted, Ernest K. *Aristocracy and the Middle-Classes in Germany: Social Types in German Literature, 1830–1900*. Chicago: University of Chicago Press, 1964.

Brand, Bettina. *Fritz von Uhde: Das religiöse Werk zwischen künstlerischer Intention und Öffentlichkeit*. Heidelberg: Bettina Brand, 1983.

Braun, Günter, and Waldtraut Braun, eds. *Mäzenatentum in Berlin: Bürgersinn und kulturelle Kompetenz unter sich verändernden Bedingungen*. Berlin: Walter de Gruyter, 1993.

Breckman, Warren G. "Disciplining Consumption: The Debate about Luxury in Wilhelmine Germany, 1890–1914." *Journal of Social History* 24, no. 3 (1991): 484–505.

Bringmann, Michael. *Friedrich Pecht (1814–1903): Maßstäbe der deutschen Kunstkritik zwischen 1850 und 1900*. Berlin: Gebr. Mann Verlag, 1982.

———. "Die Kunstkritik als Faktor der Ideen und Geistesgeschichte: Ein Beitrag zum Thema 'Kunst und Öffentlichkeit' im 19. Jahrhundert." In *Ideengeschichte und Kunstwissenschaft: Philosophie und bildende Kunst im Kaiserreich*, ed. Ekkehard Mai, Stephan Waetzoldt, and Gerd Wolandt, 253–78. Kunst, Kultur, und Politik im Deutschen Kaiserreich, ed. Stephan Waetzoldt, 3. Berlin: Gebr. Mann Verlag, 1983.

Bröhan, Margrit. "Dora Hitz (1856–1920), Malerin." In *Profession ohne Tradition: 125 Jahre Verein der Berliner Künstlerinnen*, by Berlinische Galerie, 49–57. Exh. cat. Berlin: Kupfergraben, 1992.

Bröhan, Margit. *Franz Skarbina*. Exh. cat. Berlin: Ars Nicolai, 1995.

———. *Walter Leistikow, 1865–1908: Maler der Berliner Landschaft*. Exh. cat. Berlin: Nicolaische Verlagsbuchhandlung, 1988.

Bruch, Rüdiger vom. "Kunst- und Kulturkritik in führenden bildungsbürgerlichen Zeitschriften des Kaiserreichs." In *Ideengeschichte und Kunstwissenschaft: Philosophie und bildende Kunst im Kaiserreich*, ed. Ekkehard Mai, Stephan Waetzoldt, and Gerd Wolandt, 313–47. Kunst, Kultur, und Politik im Deutschen Kaiserreich, ed. Stephan Waetzoldt, 3. Berlin: Gebr. Mann Verlag, 1983.

Brude-Firnau, Gisela. "Preussische Predigt: Die Reden Wilhelms II." In *The Turn of the Century: German Literature and Art, 1890–1915*, ed. Gerald Chapple and Hans H. Schulte, 149–70. Bonn: Bouvier Verlag, 1981.

Brühl, Georg. *Herwarth Walden und "Der Sturm."* Cologne: DuMont Buchverlag, 1983.

Buerger, Janet E. "Art Photography in Dresden, 1899–1900: German Avant-Garde at the Turn of the Century." *Image* 27, no. 2 (1984): 1–24.

Busch, Günter. *Max Liebermann: Maler, Zeichner, Graphiker*. Frankfurt am Main: S. Fischer, 1986.

Cernuschi, Claude. "Pseudo-Science and Mythic Misogyny: Oskar Kokoschka's *Murderer, Hope of Women.*" *Art Bulletin* 81, no. 1 (1999): 126–48.

Chamberlin, J. Edward, and Sander L. Gilman. *Degeneration: The Dark Side of Progress*. New York: Columbia University Press, 1985.

Chapple, Gerald, and Hans H. Schulte, eds. *The Turn of the Century: German Literature and Art, 1890–1915*. Bonn: Bouvier Verlag, 1981.

Chickering, Roger. *Imperial Germany and a World without War: The Peace Movement and German Society, 1892–1914*. Princeton: Princeton University Press, 1976.

Christ, Dorothea, ed. *Arnold Böcklin, 1827–1901: Gemälde, Zeichnungen, Plastiken. Ausstellung zum 150. Geburtstag*. Exh. cat. Basel: Schwabe & Co., 1977.

Cocks, Geoffrey, and Konrad H. Jarausch, eds. *German Professions, 1800–1950*. New York: Oxford University Press, 1990.

Craig, Gordon. *Germany, 1866–1945*. New York: Oxford University Press, 1978.

Crow, Thomas E. *Painters and Public Life in Eighteenth-Century Paris*. New Haven, Conn.: Yale University Press, 1985.

Czaplicka, John. "Pictures of a City at Work. Berlin, circa 1890–1930: Visual Reflections on Social Structures and Technology in the Modern Urban Construct." In *Berlin: Culture and Metropolis*, ed. Charles W. Haxthausen and Heidrun Suhr, 3–36. Minneapolis: University of Minnesota Press, 1990.

Czymmek, Götz, ed. *Landschaft im Licht: Impressionistische Malerei in Europa und Nordamerika, 1860–1910*. Exh. cat. Cologne: Wallraf-Richartz-Museum, 1990.

Danzker, Jo-Anne Birnie, and Tilman Falk, eds. *Max Klinger: Zeichnungen, Zustandsdrucke, Zyklen*. Exh. cat. Munich: Prestel Verlag, 1996.

Daviav, Donald G. "Hermann Bahr and the Secessionist Art Movement in Vienna." In *Turn of the Century: German Literature and Art, 1890–1915*, ed. Gerald Chapple and Hans H. Schulte, 433–62. Bonn: Bouvier Verlag, 1981.

Deshmukh, Marion F. "Art and Politics in Turn-of-the-Century Berlin: The Berlin Secession and Kaiser Wilhelm II." In *The Turn of the Century: German Literature and Art, 1890–1915*, ed. Gerald Chapple and Hans H. Schulte, 463–76. Bonn: Bouvier Verlag, 1981.

———. "Between Tradition and Modernity: The Düsseldorf Art Academy in Early Nineteenth Century Prussia." *German Studies Review* 6 (1983): 439–73.

———. "Max Liebermann, ein Berliner Jude." In *Max Liebermann—Jahrhundertwende*, ed. Angelika Wesenberg, 59–64. Exh. cat. Berlin: Ars Nicolai, 1997.

———. "'Politics Is an Art': The Cultural Politics of Max Liebermann in Wilhelmine Germany." In *Imagining Modern German Culture: 1889–1910*, ed. Françoise Forster-Hahn, 165–83. Studies in the History of Art, 53. Washington, D.C.: National Gallery of Art, 1996.

Dijkstra, Bram. *Idols of Perversity: Fantasies of Feminine Evil in Fin-de-Siècle Culture*. New York: Oxford University Press, 1986.

Dittmar, Peter. *Die Darstellung der Juden in der populären Kunst zur Zeit der Emanzipation*. Quellen zur Antisemitismusforschung, ed. Zentrum für Antisemitismusforschung der Technischen Universität Berlin. Munich: K. G. Saur, 1992.

———. "Der zwölfjährige Christus im Tempel von Adolph Menzel: Ein Beispiel für den Antijudaismus im 19. Jahrhundert." In *Idea. Werke. Theorien. Dokumente: Jahrbuch der Hamburger Kunsthalle, VI*, ed. Werner Hofmann and Martin Warnke, 81–96. Munich: Prestel Verlag, 1987.

Doede, Werner. *Die Berliner Secession: Berlin als Zentrum der deutschen Kunst von der Jahrhundertwende bis zum Ersten Weltkrieg*. Frankfurt am Main: Propyläen, Verlag Ullstein, 1977.

Dorgerloh, Annette. "Geniekult und Professionalisierung: Die Selbstinszenierung der Sabine Lepsius." In *Mythen von Autorschaft und Weiblichkeit im 20. Jahrhundert: Beiträge der 6. Kunsthistorikerinnen-Tagung, Tübingen 1996*, ed. Kathrin Hoffmann-Curtius and Silke Wenk, 130–45. Marburg, Germany: Jonas Verlag, 1997.

———. "'Ich werfe meinen künstlerischen Ruf getrost in

die Waagschale!' Eine Künstlerin in Berlin am Ende des 19. Jahrhunderts." In *Kunstverhältnisse: Ein Paradigma kunstwissenschaftlicher Forschung*, 79–84. Berlin: Akademie der Künste der DDR, 1989.

Dorpalen, Andreas. *Heinrich von Treitschke*. New Haven, Conn.: Yale University Press, 1957.

Düchting, Hajo, and Karin Sagner-Düchting. *Die Malerei des deutschen Impressionismus*. Cologne: DuMont Buchverlag, 1993.

Dückers, Alexander. *Max Klinger*. Berlin: Rembrandt Verlag, 1976.

Dukes, Jack R., and Joachim Remak, eds. *Another Germany: A Reconsideration of the Imperial Era*. Boulder, Colo.: Westview Press, 1988.

Dürr, Volker, Kathy Harms, and Peter Hayes, eds. *Imperial Germany: Essays*. Madison: University of Wisconsin Press, 1985.

Düwell, Kurt. "Geistesleben und Kulturpolitik des Deutschen Kaiserreichs." In *Ideengeschichte und Kunstwissenschaft: Philosophie und bildende Kunst im Kaiserreich*, ed. Ekkehard Mai, Stephan Waetzoldt, and Gerd Wolandt, 15–30. Kunst, Kultur, und Politik im Deutschen Kaiserreich, ed. Stephan Waetzoldt, 3. Berlin: Gebr. Mann Verlag, 1983.

Eberle, Matthias. *Max Liebermann, 1847–1935: Werkverzeichnis der Gemälde und Ölstudien*. 2 vols. Munich: Hirmer Verlag, 1995.

Ehrenpreis, David. "Cyclists and Amazons: Representing the New Woman in Wilhelmine Germany." *Woman's Art Journal* 20, no. 1 (1999): 25–31.

Ehrhardt, Ingrid, and Simon Reynolds, eds. *Kingdom of the Soul: Symbolist Art in Germany, 1870–1920*. Exh. cat. Munich: Prestel Verlag, 2000.

Eisenman, Stephen F. "The Intransigent Artist or How the Impressionists Got Their Name." In *The New Painting: Impressionism, 1874–1886*, ed. Charles S. Moffett, 51–59. Exh. cat. San Francisco: Fine Arts Museums, 1986.

Eley, Geoff. "Class, Culture, and Politics in the Kaiserreich." *Central European History* 27, no. 3 (1994): 355–75.

———. *From Unification to Nazism: Reinterpreting the German Past*. Cambridge: Unwin Hyman, 1986.

———. "The German Right, 1860–1945: How It Changed." In *Society and Politics in Wilhelmine Germany*, ed. Richard J. Evans, 53–82. New York: Barnes and Noble, 1978.

———, ed. *Society, Culture, and the State in Germany, 1870–1930*. Social History, Popular Culture, and Politics in Germany, ed. Geoff Ely. Ann Arbor: University of Michigan Press, 1996.

Elias, Norbert. *The Civilizing Process: The Development of Manners*. Trans. Edmund Jephcott. New York: Urizen Books, 1978. Originally published as *Über den Prozess der Zivilisation* (Basel: Haus zum Falken, 1939).

Ellenius, Allan. "Public Art and Ideologies in the Western Countries." In *Romantic Nationalism in Europe*, ed. J. C. Eade, 47–67. Canberra: Humanities Research Centre, Australian National University, 1983.

Eltz, Johanna. "Der große Bilderdiebstahl oder das 'originale' Fälschen." In *Franz von Lenbach, 1836–1904*, ed. Rosel Gollek and Winfried Ranke, 139–48. Exh. cat. Munich: Prestel Verlag, 1987.

Erbe, Michael. "Berlin im Kaiserreich (1871–1918)." *Geschichte Berlins: Von der Märzrevolution bis zur Gegenwart*, ed. Wolfgang Ribbe, 690–792. Munich: Verlag C. H. Beck, 1987.

Erbsmehl, Hans-Dieter. "Kulturkritik und Gegenästhetik: Zur Bedeutung Friedrich Nietzsches für die bildende Kunst in Deutschland 1892–1918." Ph.D. diss., University of California, Los Angeles, 1993.

Eschenburg, Barbara. *Der Kampf der Geschlechter: Der neue Mythos in der Kunst, 1850–1930*. Exh. cat. Cologne: DuMont Buchverlag, 1995.

Esner, Rachel. "'C'est une peintre français': Gotthardt Kuehl und die Pariser Kunstkritik." In *Gotthardt Kuehl, 1850–1915*, ed. Gerhard Gerkens and Horst Zimmermann, 26–37. Exh. cat. Leipzig: E. A. Seemann, 1993.

Ettlinger, L. D. "Julius Meier-Graefe: An Embattled German Critic." *Burlington Magazine* 117 (Oct. 1975): 672–74.

Evans, Ellen Lovell. *The German Center Party, 1870–1933: A Study in Political Catholicism*. Carbondale: Southern Illinois University Press, 1981.

Evans, Richard J. "Feminism and Female Emancipation in Germany, 1870–1945: Sources, Methods, and Problems of Research." *Central European History* 9, no. 4 (1976): 323–51.

———. "Liberalism and Society: The Feminist Movement and Social Change." In *Society and Politics in Wilhelmine Germany*, 186–213. New York: Barnes and Noble, 1978.

———. "Prostitution, State, and Society in Imperial Germany." *Past and Present*, no. 70 (1976): 106–29.

———. *Rethinking German History: Nineteenth-Century Germany and the Origins of the Third Reich*. London: Allen and Unwin, 1987.

Feilchenfeldt, Walter. *Vincent van Gogh und Paul Cassirer, Berlin: The Reception of Van Gogh in Germany from 1901 to 1914*. Zwolle, Netherlands: Waanders, 1988.

Feldenkirchen, Wilfried. "Staatliche Kunstfinanzierung im 19. Jahrhundert." In *Kunstpolitik und Kunstförderung im Kaiserreich: Kunst im Wandel der Sozial- und Wirtschaftsgeschichte*, ed. Ekkehard Mai, Hans Pohl, and Stephan Waetzoldt, 1–55. Kunst, Kultur, und Politik im Deutschen Kaiserreich, ed. Stephan Waetzoldt, 2. Berlin: Gebr. Mann Verlag, 1982.

Felix, David. *Walther Rathenau and the Weimar Republic:*

SELECTED BIBLIOGRAPHY

The Politics of Reparation. Baltimore: Johns Hopkins Press, 1971.

Fiedler, Theodore. "Weimar contra Berlin: Harry Graf Kessler and the Politics of Modernism." In *Imagining Modern German Culture: 1889–1910*, ed. Françoise Forster-Hahn, 107–25. Studies in the History of Art, 53. Washington, D.C.: National Gallery of Art, 1996.

Fischer, Heinz-Dietrich, ed. *Deutsche Zeitschriften des 17. bis 20. Jahrhunderts*. Pullach bei München, Germany: Verlag Dokumentation, 1973.

———. *Deutsche Zeitungen des 17. bis 20. Jahrhunderts*. Pullach bei München, Germany: Verlag Dokumentation, 1972.

Forster, Kurt. "Schinkel's Panoramic Planning of Central Berlin." *Modulus* 16 (1983): 62–77.

Forster-Hahn, Françoise. "Adolph Menzel: Readings between Nationalism and Modernity." In *Adolph Menzel, 1815–1905: Between Romanticism and Impressionism*, ed. Claude Keisch and Marie Ursula Riemann-Reyher, 103–12. Exh. cat. New Haven, Conn.: Yale University Press, 1996.

———. "Adolph Menzel's 'Daguerreotypical' Image of Frederick the Great: A Liberal Bourgeois Interpretation of German History." *Art Bulletin* 59, no. 2 (1977): 242–61.

———. "Adolph Menzel's *Eisenwalzwerk*: Kunst im Konflikt zwischen Tradition und sozialer Wirklichkeit." In *Die nützlichen Künste*, ed. Tilmann Buddensieg and H. Rogge. Berlin: Quadriga, 1981.

———. "'La Confraternité de l'art': Deutsch-französische Ausstellungspolitik von 1871 bis 1914." *Zeitschrift für Kunstgeschichte* 48, no. 1 (1985): 506–37.

———, ed. *Imagining Modern German Culture: 1889–1910*. Studies in the History of Art, 53. Washington D.C.: National Gallery of Art, 1996.

Forster-Hahn, Françoise, and Kurt W. Forster. "Art and the Course of Empire in Nineteenth-Century Berlin." In *Art in Berlin, 1815–1989*, 13–40. Exh. cat. Atlanta: High Museum of Art, 1989.

Fout, John C. "The Moral Purity Movement in Wilhelmine Germany and the Attempt to Regulate Male Behavior." *Journal of Men's Studies* 1, no. 1 (1992): 5–31.

———. "Sexual Politics in Wilhelmine Germany: The Male Gender Crisis, Moral Purity, and Homophobia." *Journal of the History of Sexuality* 2, no. 3 (1992): 388–421.

———, ed. *Forbidden History: The State, Society, and the Regulation of Sexuality in Modern Europe*. New York: Columbia University Press, 1992.

———. *German Women in the Nineteenth Century: A Social History*. New York: Holmes and Meier, 1984.

Frank, Hilmar. "Übereilte Annäherung: Bode und der 'Rembrandtdeutsche.'" In *Wilhelm von Bode als Zeitgenosse der Kunst*, ed. Angelika Wesenberg, 77–82. Berlin: Nationalgalerie, Staatliche Museen zu Berlin, 1995.

Franke, Ernst A. "Publikum und Malerei in Deutschland von Biedermeier zum Impressionismus." Ph.D. diss., Ruprecht-Karls-Universität zu Heidelberg, 1934.

Frecot, Janos, Johann Friedrich Geist, and Drehart Kerbs. *Fidus, 1868–1948: Zur asthetischen Praxis bürgerlichen Fluchtbewegungen*. Munich: Rogner & Bernhard, 1972.

Frederiksen, Elke, ed. *Die Frauenfrage in Deutschland, 1865–1915*. Stuttgart: Philipp Reclam jun., 1981.

Frevert, Ute. *Women in German History: From Bourgeois Emancipation to Sexual Liberation*. Trans. Stuart McKinnon-Evans. Oxford: Berg, 1988.

Fruitema, Evelyn J., and Paul A. Zoetmulder, eds. *The Panorama Phenomenon*. The Hague: Foundation for the Preservation of the Centenarian Mesdag Panorama, 1981.

Fuchs, Eduard. *Die Juden in der Karikatur: Ein Beitrag zur Kulturgeschichte*. Munich: Albert Langen Verlag, 1921.

Fuhrmann, Dietmar, and Klaus Jestaedt. "'. . . alles Das zu erlernen, was für eine erfolgreiche Ausübung ihres Berufes von ihnen gefordert wird . . .': Die Zeichen- und Malschule des Vereins der Berliner Künstlerinnen." In *Profession ohne Tradition: 125 Jahre Verein der Berliner Künstlerinnen*, by Berlinische Galerie, 353–66. Exh. cat. Berlin: Kupfergraben, 1992.

Gaehtgens, Barbara. "Holland als Vorbild." In *Max Liebermann—Jahrhundertwende*, ed. Angelika Wesenberg, 83–92. Exh. cat. Berlin: Ars Nicolai, 1997.

Gaehtgens, Thomas W. "Anton von Werner und die französische Malerei." In *Anton von Werner: Geschichte in Bildern*, ed. Dominik Bartmann, 49–61. Exh. cat. Munich: Hirmer Verlag, 1993.

———. "Die großen Anreger und Vermittler: Ihr prägender Einfluß auf Kunstsinn, Kunstkritik und Kunstförderung." In *Mäzenatentum in Berlin: Bürgersinn und kulturelle Kompetenz unter sich verändernden Bedingungen*, ed. Günter Braun und Waldtraut Braun, 99–126. Berlin: Walter de Gruyter, 1993.

———. "Wilhelm von Bode und seine Sammler." In *Sammler, Stifter, und Museen: Kunstförderung in Deutschland im 19. und 20. Jahrhundert*, ed. Ekkehard Mai and Peter Paret, 153–72. Cologne: Böhlau Verlag, 1993.

———, ed. *Sammler der frühen Moderne in Berlin*. Special issue of *Zeitschrift des deutschen Vereins für Kunstwissenschaft* 42, no. 3 (1988).

Gaehtgens, Thomas W., and Barbara Paul, eds. *Wilhelm von Bode: Mein Leben*. 2 vols. Quellen zur deutschen Kunstgeschichte vom Klassizismus bis zur Gegenwart, 4. Berlin: Ars Nicolai, 1997.

Gallwitz, Klaus. *Hans Makart: Triumph einer schönen Epoche*. Baden-Baden, Germany: Staatliche Kunsthalle, 1972.

Garb, Tamar. "Revising the Revisionists: The Formation of the Union des Femmes Peintres et Sculpteurs." *Art Journal* 48, no. 1 (1989): 63–70.

———. *Sisters of the Brush: Women's Artistic Culture in Late Nineteenth-Century Paris*. New Haven, Conn.: Yale University Press, 1994.

Gay, Peter. "Encounters with Modernism: German Jews in German Culture, 1881–1914." *Midstream* 21, no. 2 (1975): 23–65.

Gerkens, Gerhard, and Horst Zimmermann, eds. *Gotthardt Kuehl, 1850–1915*. Exh. cat. Leipzig: E. A. Seemann, 1993.

Gerlach, Peter, ed. *KölnischerKUNSTverein: Einhundertfünfzig Jahre Kunstvermittlung, 1839–1989*. Cologne: Kölnischer Kunstverein, 1989.

———. *Vom realen Nutzen idealer Bilder: Kunstmarkt und Kunstvereine*. Aachen, Germany: Alano-Verlag, 1994.

Geyer, Michael. "Historical Fictions of Autonomy and the Europeanization of National History." *Central European History* 22, no. 3/4 (1989): 316–42.

Gilman, Sander L. *The Jew's Body*. New York: Routledge, 1991.

———. "Strauss, the Pervert, and Avant Garde Opera of the Fin de Siècle." *New German Critique*, no. 43 (winter 1988): 35–68.

Girardet, Cella-Margaretha. *Jüdische Mäzene für die Preußischen Museen zu Berlin: Eine Studie zum Mäzenatentum im Deutschen Kaiserreich und in der Weimarer Republik*. Egelsbach, Germany: Hänsel-Hohenhausen, 1997.

Glaser, Hermann. *Die Kultur der Wilhelminischen Zeit: Topographie einer Epoche*. Frankfurt am Main: S. Fischer, 1984.

———, ed. *The German Mind of the Nineteenth Century*. New York: Continuum, 1981.

Gleisberg, Dieter. "'Er war ihr Stolz, ihre Bewunderung': Max Klinger im Kreise seiner Freunde." In *Max Klinger: Zeichnungen, Zustandsdrucke, Zyklen*, ed. Jo-Anne Birnie Danzker and Tilman Falk, 15–30. Exh. cat. Munich: Prestel Verlag, 1996.

———. "'Ich muß mir stets ein kleines Monument errichten': Max Klinger in seinen Selbstdarstellungen." In *Max Klinger, 1857–1920*, ed. Dieter Gleisberg, 13–25. Exh. cat. Leipzig: Edition Leipzig, 1992

———. "Max Klinger—Sein Werk und seine Wirkung." In *Max Klinger: Wege zum Gesamtkunstwerk*, by Roemer- und Pelizaeus Museum, 14–23. Exh. cat. Mainz: Verlag Philipp von Zabern, 1984.

———, ed. *Max Klinger, 1857–1920*. Exh. cat. Leipzig: Edition Leipzig, 1992.

Gollek, Rosel, and Winfried Ranke, eds. *Franz von Lenbach, 1836–1904*. Exh. cat. Munich: Prestel Verlag, 1987.

Grabowski, Jörn. "'Euer Excellenz zur gfl. Kenntnisnahme . . .': Hugo von Tschudi als Direktor der Nationalgalerie." In *Manet bis Van Gogh: Hugo von Tschudi und der Kampf um die Moderne*, ed. Johann Georg Prinz von Hohenzollern and Peter-Klaus Schuster, 391–95. Exh. cat. Munich: Prestel Verlag, 1996.

Grammbitter, Ulrike. "Die 'Malweiber' oder: Wer küßt den Künstler, wenn die Muse sich selbst küßt?" In *Kunst in Karlsruhe 1900–1950*, by Staatliche Kunsthalle, 27–28. Exh. cat. Karlsruhe, Germany: Verlag C. F. Müller, 1981.

Grasskamp, Walter. "Die Einbürgerung der Kunst: Korporative Kunstförderung im 19. Jahrhundert." In *Sammler, Stifter, und Museen: Kunstförderung in Deutschland im 19. und 20. Jahrhundert*, ed. Ekkehard Mai and Peter Paret, 104–13. Cologne: Böhlau Verlag, 1993.

———. "Die Reise der Bilder: Zur Infrastruktur der Moderne." In *Stationen der Moderne: Die bedeutenden Kunstausstellungen des 20. Jahrhunderts in Deutschland*, ed. Jörn Merkert, 25–33. Exh. cat. Berlin: Berlinische Galerie, 1988.

———. *Die unbewältigte Moderne: Kunst und Öffentlichkeit*. Munich: Verlag C. H. Beck, 1989.

Greven-Aschoff, Barbara. *Die bürgerliche Frauenbewegung in Deutschland, 1894–1933*. Göttingen, Germany: Vandenhoeck & Ruprecht, 1981.

Gross, Friedrich. *Jesus, Luther und der Pabst im Bilderkampf 1871 bis 1918: Zur Malereigeschichte der Kaiserzeit*. Marburg, Germany: Jonas Verlag, 1989.

———. "Vom Alltagsgetriebe fern: Der Große Einzelne in Klingers *Kreuzigung Christi* und *Christus im Olymp*." In *Max Klinger, 1857–1920*, ed. Dieter Gleisberg, 72–83. Exh. cat. Leipzig: Edition Leipzig, 1992.

Gross, Michael B. "Kulturkampf and Unification: German Liberalism and the War against the Jesuits." *Central European History* 30, no. 4 (1997): 545–66.

Grösslein, Andrea. *Die internationalen Kunstausstellungen der Münchner Künstlergenossenschaft im Glaspalast in München von 1869 bis 1888*. Miscellanea Bavarica Monacensia, 137. Munich: UNI-Druck, 1987.

Grossmann, Joachim. *Künstler, Hof und Bürgertum: Leben und Arbeit von Malern in Preußen, 1786–1850*. Artefact, ed. Tilmann Buddensieg, Fritz Neumeyer, and Martin Warnke, 9. Berlin: Akademie Verlag, 1994.

Grosz, George. *Ein kleines Ja und ein grosses Nein: Sein Leben von ihm selbst erzählt*. Hamburg: Rowohlt Verlag, 1955.

Grupp, Peter. *Harry Graf Kessler, 1868–1937: Eine Biographie*. Munich: Verlag C. H. Beck, 1995.

Güse, Ernst-Gerhard, Hans-Jürgen Imiela, and Berthold Roland, eds. *Max Slevogt: Gemälde, Aquarelle, Zeichnungen*. Exh. cat. Stuttgart: Verlag Gerd Hatje, 1992.

Gutbrod, Evelyn. *Die Rezeption des Impressionismus in Deutschland, 1880–1910*. Stuttgart: W. Kohlhammer, 1980.

Hall, Alex. "By Other Means: The Legal Struggle against the SPD in Wilhelmine Germany, 1890–1900." *Historical Journal* 17 (1974): 365–86.

Hamilton, George Heard. *Manet and His Critics*. New York: W. W. Norton, 1969.

Hammer, Klaus. *Ludwig von Hofmann: Maler und Werk*. Dresden: VEB Verlag der Kunst, 1988.

Hansen, Dorothee, ed. *"Nichts trügt weniger als der Schein": Max Liebermann, der deutsche Impressionist*. Exh. cat. Bremen, Germany: Kunsthalle, 1996.

Hardtwig, Wolfgang. "Drei Berliner Porträts: Wilhelm von Bode, Eduard Arnhold, Harry Graf Kessler. Museumsmann, Mäzen, und Kunstvermittler—drei herausragende Beispiele." In *Mäzenatentum in Berlin: Bürgersinn und kulturelle Kompetenz unter sich verändernden Bedingungen*, ed. Günter Braun and Waltraut Braun, 39–71. Berlin: Walter de Gruyter, 1993.

———. "Geschichtsinteresse, Geschichtsbilder, und politische Symbole in der Reichsgründungsära und im Kaiserreich." In *Kunstverwaltung, Bau- und Denkmal-Politik im Kaiserreich*, ed. Ekkehard Mai and Stephan Waetzoldt, 47–74. Kunst, Kultur, und Politik im Deutschen Kaiserreich, ed. Stephan Waetzoldt, 1. Berlin: Gebr. Mann Verlag, 1981.

———. "Politische Topographie und Nationalismus: Städtegeist, Landespatriotismus, und Reichsbewußtsein in München, 1871–1914." In *Nationalismus und Bürgerkultur in Deutschland, 1500–1914: Ausgewählte Aufsätze*, 219–45. Göttingen, Germany: Vandenhoeck & Ruprecht, 1994.

Harris, James F. Introduction to *Christian Religion and Anti-Semitism in Modern German History*. Special issue of *Central European History* 27, no. 3 (1994): 265–66.

Hartleb, Renate. "'Eve, sans trêve': Zur Frau im Werk von Max Klinger." In *Max Klinger, 1857–1920*, ed. Dieter Gleisberg, 84–90. Exh. cat. Leipzig: Edition Leipzig, 1992.

Hartlieb, Carola. "Bildende Künstlerinnen zu Beginn der Moderne—die Künstlerinnen der 'Berlin Secession.'" In *Profession ohne Tradition: 125 Jahre Verein der Berliner Künstlerinnen*, by Berlinische Galerie, 59–72. Exh. cat. Berlin: Kupfergraben, 1992.

Harzenetter, Markus. *Zur Münchner Secession: Genese, Ursachen, und Zielsetzungen dieser intentionell neuartigen Münchner Künstlervereinigung*, Neue Schriftenreihe des Stadtarchivs München, 158. Munich: Stadtarchivs München, 1992.

Hatzig, Hansotto. *Karl May and Sascha Schneider: Dokument einer Freundschaft*. Bamberg, Germany: Karl-May-Verlag, 1967.

Haus, Andreas. "Gesellschaft, Geselligkeit, Künstlerfest: Franz von Lenbach und die Münchner 'Allotria.'" In *Franz von Lenbach, 1836–1904*, ed. Rosel Gollek and Winfried Ranke, 99–116. Exh. cat. Munich: Prestel Verlag, 1987.

Haxthausen, Charles W., and Heidrun Suhr, eds. *Berlin: Culture and Metropolis*. Minneapolis: University of Minnesota Press, 1990.

Hayes, Peter. "German Businessmen and the Crisis of the Empire." In *Imperial Germany: Essays*, ed. Volker Dürr, Kathy Harms, and Peter Hayes, 46–61. Madison: University of Wisconsin Press, 1985.

Heesen-Cremer, Gabriele von. "Zum Problem des Kulturpessimismus: Schopenhauer-Rezeption bei Künstlern und Intellektuellen von 1871 bis 1918." In *Ideengeschichte und Kunstwissenschaft: Philosophie und bildende Kunst im Kaiserreich*, ed. Ekkehard Mai, Stephan Waetzoldt, and Gerd Wolandt, 45–70. Kunst, Kultur, und Politik im Deutschen Kaiserreich, ed. Stephan Waetzoldt, 3. Berlin: Gebr. Mann Verlag, 1983.

Hein, Dieter, and Andreas Schulz, eds. *Bürgerkultur im 19. Jahrhundert: Bildung, Kunst, und Lebenswelt*. Munich: Verlag C. H. Beck, 1996.

Heise, Renate. *Die Münchener Secession und ihre Galerie: Eine Ausstellung des Vereins Bildender Künstler Münchens, e.v. Secession*. Munich: Stadtmusuem, 1975.

Heller, Reinhold. "Anton von Werner, der Fall Munch, und die Moderne im Berlin der 1890er Jahre." In *Anton von Werner: Geschichte in Bildern*, ed. Dominik Bartmann, 101–9. Exh. cat. Munich: Hirmer Verlag, 1993.

———. *Brücke: German Expressionist Prints from the Granvil and Marcia Specks Collection*. Exh. cat. Evanston, Ill.: Mary and Leigh Block Gallery, Northwestern University, 1988.

———. "Concerning Symbolism and the Structure of Surface." *Art Journal* 45, no. 2 (1985): 146–53.

———. *The Earthly Chimera and the Femme Fatale: Fear of Woman in Nineteenth-Century Art*. Exh. cat. Chicago: David and Alfred Smart Gallery, University of Chicago, 1981.

———. *Munch: His Life and Work*. Chicago: University of Chicago Press, 1984.

Henderson, W. O. *The Rise of German Industrial Power, 1834–1914*. Berkeley: University of California Press, 1975.

Henze, Gisela. "*Der Pan*: Geschichte und Profil einer Zeitschrift der Jahrhundertwende." Ph.D. diss., Albert-Ludwigs-Universität zu Freiburg i. Br., 1974.

Hepp, Corona. *Avantgarde: Moderne Kunst, Kulturkritik und Reformbewegungen nach der Jahrhundertwende*. Munich: Deutscher Taschenbuch Verlag, 1987.

Hermand, Jost. "The Commercialization of Avant-Garde Movements at the Turn of the Century." *New German Critique*, no. 29 (spring/summer 1983): 71–83.

———. "Der gründerzeitliche Parvenü." In *Aspekte der Gründerzeit*, 7–15. Berlin: Akademie der Künste, 1974.

Herminghouse, Patricia, and Magda Mueller, eds. "Looking for Germania." In *Gender and Germanness: Cultural Productions of Nation*. Modern German Studies, no. 4. Providence, R.I.: Berghahn Books, 1997.

Hessisches Landesmuseum. *Darmstadt: Ein Dokument deutscher Kunst, 1901–1976*. 5 vols. Darmstadt: Eduard Roether Verlag, 1977.

Hiesinger, Kathryn Bloom. *Art Nouveau in Munich: Masters of Jugendstil from the Stadtmuseum, Munich, and Other Public and Private Collections*. Exh. cat. Philadelphia: Philadelphia Museum of Art, 1988.

Higgins, Kathleen Marie. *Nietzsche's Zarathustra*. Philadelphia: Temple University Press, 1987.

High Museum of Art. *Art in Berlin, 1815–1989*. Exh. cat. Atlanta, 1989.

Hofmann, Werner. *Luther und die Folgen für die Kunst*. Exh. cat. Hamburg: Hamburger Kunsthalle, 1983.

Hofmann, Werner, and Klaus Herding, eds. *Courbet und Deutschland*. Exh. cat. Hamburg: Hamburger Kunsthalle, 1978.

Hohenzollern, Johann Georg Prinz von, and Peter-Klaus Schuster, eds. *Manet bis Van Gogh: Hugo von Tschudi und der Kampf um die Moderne*. Exh. cat. Munich: Prestel Verlag, 1996.

Holt, Elizabeth Gilmore. *The Expanding World of Art, 1874–1902*. New Haven, Conn.: Yale University Press, 1988.

Howe, Jeffrey W. "The Face in the Mirror: The Art of Fernand Khnopff." In *Fernand Khnopff and the Belgian Avant-Garde*, 6–15. Exh. cat. Chicago: David and Alfred Smart Gallery, University of Chicago, 1984.

Howoldt, Jenns E., and Birte Frenssen, eds. *Max Liebermann: Der Realist und die Phantasie*. Exh. cat. Hamburg: Dölling und Galitz Verlag, 1997.

Hull, Isabel V. "Feminist and Gender History through the Literary Looking Glass: German Historiography in Postmodern Times." *Central European History* 22, no. 3/4 (1989]): 279–300.

Hummel, Rita. *Die Anfänge der Münchner Secession*. Schriften aus dem Institut für Kunstgeschichte der Universität München, ed. Hermann Bauer, 46. Munich: tuduv-Verlag, 1989.

Hungerford, Constance Cain. "Meissonier and the Founding of the Société Nationale des Beaux-Arts." *Art Journal* 48, no. 1 (1989): 71–77.

Huyssen, Andreas. *After the Great Divide: Modernism, Mass Culture, Postmodernism*. Theories of Representation and Difference, ed. Teresa de Lauretis. Bloomington: Indiana University Press, 1986.

Imiela, Hans-Jürgen. *Max Slevogt: Eine Monographie*. Karlsruhe, Germany: G. Braun, 1968.

———. "Zur Rezeption des deutschen Impressionismus." In *Beiträge zur Rezeption der Kunst des 19. und 20. Jahrhunderts*, ed. Wulf Schadendorf, 73–84. Munich: Prestel Verlag, 1975.

Jelavich, Peter. *Berlin Cabaret*. Cambridge: Harvard University Press, 1993.

———. "Berlin's Path to Modernity." In *Art in Berlin, 1815–1989*, by High Museum of Art, 13–40. Exh. cat. Atlanta, 1989.

———. *Munich and Theatrical Modernism: Politics, Playwriting, and Performance, 1890–1914*. Cambridge: Harvard University Press, 1985.

———. "Munich as Cultural Center: Politics and the Arts." In *Kandinsky in Munich, 1896–1914*, by Solomon R. Guggenheim Museum, 17–26. Exh. cat. New York, 1982.

Jensen, Robert. *Marketing Modernism in Fin-de-Siècle Europe*. Princeton: Princeton University Press, 1994.

Jensen, Susanne. "'Wo sind die weiblichen Mäzene. . . ?' Private Kunstförderung im 'Verein der Künstlerinnen und Kunstfreundinnen zu Berlin.'" In *Profession ohne Tradition: 125 Jahre Verein der Berliner Künstlerinnen*, by Berlinische Galerie, 299–309. Exh. cat. Berlin: Kupfergraben, 1992.

Jeziorkowski, Klaus. "Empor ins Licht: Gnostizismus und Licht Symbolik in Deutschland um 1900." In *The Turn of the Century: German Literature and Art, 1890–1915*, ed. Gerald Chapple and Hans H. Schulte, 171–96. Bonn: Bouvier Verlag, 1981.

Junge, Henrike. "Alfred Lichtwark und die 'Gymnastik der Sammeltätigkeit.'" In *Sammler, Stifter, und Museen: Kunstförderung in Deutschland im 19. und 20. Jahrhundert*, ed. Ekkehard Mai and Peter Paret, 202–14. Cologne: Böhlau Verlag, 1993.

———. *Wohlfeile Kunst: Die Verbreitung von Künstlergraphik seit 1870 und die Griffelkunst-Vereinigung Hamburg-Langenhorn*. Mainz: Verlag Philipp Zabern, 1989.

Kampf, Indina. "'Ein enormes Ärgernis' oder: Die anarchie in der Malerei: Edvard Munch und die deutsche Kritik, 1892–1902." In *Munch und Deutschland*, ed. Uwe M. Schneede and Dorothee Hansen, 82–90. Exh. cat. Hamburg: Hamburger Kunsthalle, 1994.

Kaplan, Marion. "Friendship on the Margins: Jewish Social Relations in Imperial Germany." *Central European History* 34, no. 4 (2001): 471–501.

Kaschuba, Wolfgang. "Kunst als symbolisches Kapital: Bürgerliche Kunstvereine und Kunstideale nach 1800, oder, Vom realen Nutzen idealer Bilder." In *Vom realen Nutzen idealer Bilder: Kunstmarkt und Kunstvereine*, ed. Peter Gerlach, 9–20. Aachen, Germany: Alano-Verlag, 1994.

Kaudelka-Hanisch, Karin. "The Titled Businessman: Prussian

Commercial Councillors in the Rhineland and West-phalia during the Nineteenth Century." In *The German Bourgeoisie: Essays on the Social History of the German Middle Class from the Late Eighteenth to the Early Twentieth Century*, ed. David Blackbourn and Richard Evans, 87–114. New York: Routledge, 1991.

Kay, Caroline. *Art and the German Bourgeoisie: Alfred Lichtwark and Modern Painting in Hamburg, 1886–1914.* Toronto: University of Toronto Press, forthcoming.

———. "The Petersen Portrait: The Failure of Modern Art as Monument in Fin-de-Siècle Hamburg." *Canadian Journal of History* 32 (Apr. 1997): 56–75.

Keisch, Claude. "Liebermann, Künstler und Kunstfreund: Die Sammlung." In *Max Liebermann—Jahrhundertwende*, ed. Angelika Wesenberg, 221–32. Exh. cat. Berlin: Ars Nicolai, 1997.

Keisch, Claude, and Marie Ursula Riemann-Reyher, eds. *Adolph Menzel, 1815–1905: Between Romanticism and Impressionism.* Exh. cat. New Haven, Conn.: Yale University Press, 1996.

Kemnitz, Thomas Milton. "The Cartoon as a Historical Source." *Journal of Interdisciplinary History* 4, no. 1 (1973): 81–93.

Kern, Josef. *Impressionismus im Wilhelminischen Deutschland.* Würzburg: Königshausen u. Neumann, 1989.

Klant, Michael. "Hommage comique à Liebermann: Eine Studie zum Rezeptionswandel Max Liebermanns im Spiegel der Karikatur." *Kritische Berichte* 13, no. 2 (1985): 5–20.

Knoch, Eberhard. *Ludwig von Hofmann, 1861–1945: Gedächtnis-Ausstellung.* Exh. cat. Berlin-Charlottenburg: Kunstamt Berlin-Charlottenburg, 1962.

Koch, Georg Friedrich. "Die Bauten der Industrie-, Gewerbe- und Kunst-Ausstellung in Düsseldorf 1902 in der Geschichte der Ausstellungsarchitektur." In *Kunstpolitik und Kunstförderung im Kaiserreich: Kunst im Wandel der Sozial- und Wirtschaftsgeschichte*, ed. Ekkehard Mai, Hans Pohl, and Stephan Waetzoldt, 149–65. Kunst, Kultur, und Politik im Deutschen Kaiserreich, ed. Stephan Waetzoldt, 2. Berlin: Gebr. Mann Verlag, 1982.

Kocka, Jürgen, and Allan Mitchell, eds. *Bourgeois Society in Nineteenth-Century Europe.* Oxford: Berg, 1993.

Kolber, Gabriele, ed. *Die Villa Stuck in München: Inszenierung eines Künstlerlebens.* Munich: Bayerische Vereinsbank, 1992.

Korff, Gottfried, and Reinhard Rürup. *Berlin, Berlin: Die Ausstellung zur Geschichte der Stadt.* Exh. cat. Berlin: Nicolai, 1987.

Koshar, Rudy J. "Playing the Cerebral Savage: Notes on Writing German History before the Linguistic Turn." *Central European History* 22, no. 3/4 (1989): 343–59.

Koszinowski, Ingrid. "Böcklin und seine Kritiker: Zu Ideolo-gie und Kunstbegriff um 1900." In *Ideengeschichte und Kunstwissenschaft: Philosophie und bildende Kunst im Kaiserreich*, ed. Ekkehard Mai, Stephan Waetzoldt, and Gerd Wolandt, 279–92. Kunst, Kultur, und Politik im Deutschen Kaiserreich, ed. Stephan Waetzoldt, 3. Berlin: Gebr. Mann Verlag, 1983.

———. *Von der Poesie des Kunstwerks: Zur Kunstrezeption um 1900 am Beispiel der Malereikritik der Zeitschrift "Kunstwart."* Hildesheim, Germany: Georg Olms Verlag, 1985.

Kratzsch, Gerhard. "*Der Kunstwart* und die bürgerlich-soziale Bewegung." In *Ideengeschichte und Kunstwissenschaft: Philosophie und bildende Kunst im Kaiserreich*, ed. Ekkehard Mai, Stephan Waetzoldt, and Gerd Wolandt, 371–96. Kunst, Kultur, und Politik im Deutschen Kaiserreich, ed. Stephan Waetzoldt, 3. Berlin: Gebr. Mann Verlag, 1983.

———. *Kunstwart und Dürerbund: Ein Beitrag zur Geschichte der Gebildeten im Zeitalter des Imperialismus.* Göttingen, Germany: Vandenhoeck & Ruprecht, 1969.

Krause, Jürgen. *"Märtyrer" und "Prophet": Studien zum Nietzsche-Kult in der bildenden Kunst der Jahrhundertwende.* Monographien und Texte zur Nietzsche-Forschung, ed. Ernst Behler et al., 14. Berlin: Walter de Gruyter, 1984.

Kreiger, Peter. "Max Liebermanns Impressionisten-Sammlung und ihre Bedeutung für sein Werk." In *Max Liebermann in seiner Zeit*, ed. Sigrid Achenbach and Matthias Eberle, 60–71. Exh. cat. Berlin: Nationalgalerie, Staatliche Museen Preußischer Kulturbesitz, 1979.

Krenzlin, Ulrike. "'auf dem ernsten Gebiet der Kunst ernst arbeiten': Zur Frauenausbildung im künstlerischen Beruf." In *Profession ohne Tradition: 125 Jahre Verein der Berliner Künstlerinnen*, by Berlinische Galerie, 73–87. Exh. cat. Berlin: Kupfergraben, 1992.

Kulhoff, Birgit. *Bürgerliche Selbstbehauptung im Spiegel der Kunst: Untersuchungen zur Kulturpublizistik der Rundschauzeitschriften im Kaiserreich (1871–1914).* Bochum, Germany: Universitätsverlag Dr. N. Brockmeyer, 1990.

Kunath, Robert Charles. "War and Art: Nationalist Ideology, Academic Artists, and the Interpretation of the Visual Arts in Imperial Germany, 1914–1918." Ph.D. diss., Stanford University, 1993.

Lamberti, Marjorie. *Jewish Activism in Imperial Germany: The Struggle for Civil Equality.* New Haven, Conn.: Yale University Press, 1978.

Lang, Karen. "Monumental Unease: Monuments and the Making of National Identity in Germany." In *Imagining Modern German Culture: 1889–1910*, ed. Françoise Forster-Hahn, 275–99. Studies in the History of Art, 53. Washington, D.C.: National Gallery of Art, 1996.

Langenstein, York. *Der Münchner Kunstverein im 19. Jahrhundert: Ein Beitrag zur Entwicklung des Kunstmarkts und des Ausstellungswesens.* Miscellanea Bavarica Monacensia, ed. Karl Bosl and Richard Bauer, 22. Munich: UNI-Druck, 1983.

Laux, Walter Stephan. *Der Fall Corinth und die Zeitzeugen Wellner.* Munich: Prestel Verlag, 1998.

Lees, Andrew. "The Civic Pride of the German Middle Classes, 1890–1918." In *Another Germany: A Reconsideration of the Imperial Era,* ed. Jack R. Dukes and Joachim Remak, 41–59. Boulder, Colo.: Westview Press, 1988.

Leiss, Ludwig. *Kunst im Konflikt: Kunst und Künstler im Widerstreit mit der "Obrigkeit."* Berlin: Walter de Gruyter, 1971.

Lenman, Robin. "Art and Tourism in Southern Germany, 1850–1930." In *The Arts, Literature, and Society,* ed. Arthur Marwick, 163–80. London: Routledge, 1990.

———. *Artists and Society in Germany, 1850–1914.* Manchester: Manchester University Press, 1997.

———. "Art, Society, and the Law in Wilhelmine Germany: The Lex Heinze." *Oxford German Studies* 8 (1973): 86–113.

———. "A Community in Transition: Painters in Munich, 1886–1924." *Central European History* 15, no. 1 (1982): 3–33.

———. "Der deutsche Kunstmarkt 1840–1923: Integration, Veränderung, Wachstum." In *Sammler, Stifter, und Museen: Kunstförderung in Deutschland im 19. und 20. Jahrhundert,* ed. Ekkehard Mai and Peter Paret, 135–52. Cologne: Böhlau Verlag, 1993.

———. "From 'Brown Sauce' to 'Plein Air': Taste and the Art Market in Germany, 1889–1910." In *Imagining Modern German Culture: 1889–1910,* ed. Françoise Forster-Hahn, 53–69. Studies in the History of Art, 53. Washington, D.C.: National Gallery of Art, 1996.

———. *Die Kunst, die Macht, und das Geld: Zur Kulturgeschichte des kaiserlichen Deutschland, 1871–1918.* Trans. Reiner Grundmann. Frankfurt am Main: Campus Verlag, 1994.

———. "Painters, Patronage, and the Art Market in Germany, 1850–1914." *Past and Present,* no. 123 (1989): 109–40.

———. "Politics and Culture: The State and the Avant-Garde in Munich, 1886–1914." In *Society and Politics in Wilhelmine Germany,* ed. Richard J. Evans, 90–111. New York: Barnes and Noble, 1978.

Leppien, Helmut R. *Der zwölfjährige Jesus im Tempel von Max Liebermann.* Hamburg: Kulturstiftung der Länder in Verbindung mit der Hamburger Kunsthalle, [1989].

———, ed. *Kunst ins Leben: Alfred Lichtwarks Wirken für die Kunsthalle und Hamburg von 1886 bis 1914.* Exh. cat. Hamburg: Hamburger Kunsthalle, 1986.

Leppien, Helmut R., and Dörte Zbikowski, eds. *Der Hamburgische Künstlerclub von 1897.* Exh. cat. Hamburg: Hamburger Kunsthalle, 1997.

Levy, Richard S. *The Downfall of the Anti-Semitic Political Parties in Imperial Germany.* New Haven, Conn.: Yale University Press, 1975.

Lewis, Beth Irwin. "*Kunst für Alle*: Das Volk als Förderer der Kunst." In *Sammler, Stifter, und Museen: Kunstförderung in Deutschland im 19. und 20. Jahrhundert,* ed. Ekkehard Mai and Peter Paret, 186–201. Cologne: Böhlau Verlag, 1993.

Leypoldt, Winfried. "'Münchens Niedergang als Kunststadt': Kunsthistorische, kunstpolitische, und kunstsoziologische Aspekte der Debatte um 1900." Ph.D. diss., Ludwig-Maximilians-Universität zu München, 1987.

Liang, Hsi-Huey. "Immigrants in Wilhelmine Berlin." *Central European History* 3, no. 1/2 (1970): 94–111.

Lidtke, Vernon. *The Alternative Culture: Socialist Labor in Imperial Germany.* New York: Oxford University Press, 1985.

———. "Naturalism and Socialism in Germany." *American Historical Review* 79, no. 1 (1974): 14–37.

———. *The Outlawed Party: Social Democracy in Germany, 1878–1890.* Princeton: Princeton University Press, 1966.

Lougee, Robert W. "The Anti-Revolution Bill of 1894 in Wilhelmine Germany." *Central European History* 15, no. 3 (1982): 224–40.

Ludwig, Horst. *Franz von Stuck und seine Schüler: Gemälde und Zeichnungen.* Exh. cat. Munich: Villa Stuck, 1989.

———. *Kunst, Geld und Politik um 1900 in München: Formen und Ziele der Kunstfinanzierung und Kunstpolitik während der Prinzregentenära (1886–1912).* Kunst, Kultur, und Politik im deutschen Kaiserreich, ed. Stephan Waetzoldt, 8. Berlin: Gebr. Mann Verlag, 1986.

———. "Die Münchner Secession und ihre Maler." *Weltkunst* 53, no. 1 (1983): 24–26.

———, ed. *Bruckmanns Lexikon der Münchener Kunst: Münchner Maler im 19. Jahrhundert.* 4 vols. Munich: Bruckmann Verlag, 1981–83.

Mai, Ekkehard. "Akademie, Sezession, und Avantgarde—München um 1900." In *Tradition und Wider-spruch: 175 Jahre Kunstakademie München,* ed. Thomas Zacharias, 145–77. Munich: Prestel Verlag, 1985.

———. "Die Berliner Kunstakademie im 19. Jahrhundert: Kunstpolitik und Kunstpraxis." In *Kunstverwaltung, Bau- und Denkmal-Politik im Kaiserreich,* ed. Ekkehard Mai and Stephan Waetzoldt, 431–79. Kunst, Kultur, und Politik im Deutschen Kaiserreich, ed. Stephan Waetzoldt, 1. Berlin: Gebr. Mann Verlag, 1981.

———. *Expositionen: Geschichte und Kritik des Ausstellungswesens.* Munich: Deutscher Kunstverlag, 1986.

SELECTED BIBLIOGRAPHY

Mai, Ekkehard. "Kunstpolitik am Rhein: Zum Verhältnis von Kunst und Staat am Beispiel der Düsseldorfer Kunstakademie." In *Malerei*, vol. 3 of *Kunst des 19. Jahrhunderts im Rheinland*, ed. Eduard Trier and Willy Weyres, 11–42. Exh. cat. Düsseldorf: Schwann, 1979.

———. "Programmkunst oder Kunstprogramm? Protestantismus und bildende Kunst am Beispiel religiöser Malerei im späten 19. Jahrhundert." In *Ideengeschichte und Kunstwissenschaft: Philosophie und bildende Kunst im Kaiserreich*, ed. Ekkehard Mai, Stephan Waetzoldt, and Gerd Wolandt, 431–59. Kunst, Kultur, und Politik im Deutschen Kaiserreich, ed. Stephan Waetzoldt, 3. Berlin: Gebr. Mann Verlag, 1983.

Mai, Ekkehard, Hans Pohl, and Stephan Waetzoldt, eds. *Kunstpolitik und Kunstförderung im Kaiserreich: Kunst im Wandel der Sozial- und Wirtschaftsgeschichte*. Kunst, Kultur, und Politik im Deutschen Kaiserreich, ed. Stephan Waetzoldt, 2. Berlin: Gebr. Mann Verlag, 1982.

Mai, Ekkehard, and Peter Paret, eds. *Sammler, Stifter, und Museen: Kunstförderung in Deutschland im 19. und 20. Jahrhundert*. Cologne: Böhlau Verlag, 1993.

Mai, Ekkehard, and Stephan Waetzoldt, eds. *Kunstverwaltung, Bau- und Denkmal-Politik im Kaiserreich*. Kunst, Kultur, und Politik im Deutschen Kaiserreich, ed. Stephan Waetzoldt, 1. Berlin: Gebr. Mann Verlag, 1981.

Mai, Ekkehard, Stephan Waetzoldt, and Gerd Wolandt, eds. *Ideengeschichte und Kunstwissenschaft: Philosophie und bildende Kunst im Kaiserreich*. Kunst, Kultur, und Politik im Deutschen Kaiserreich, ed. Stephan Waetzoldt, 3. Berlin: Gebr. Mann Verlag, 1983.

Mai, Paul. "Kirchliche Kulturpolitik im Spannungsfeld zwischen Staatskirche und Ultramontanismus—Bistum Regensburg." In *Ideengeschichte und Kunstwissenschaft: Philosophie und bildende Kunst im Kaiserreich*, ed. Ekkehard Mai, Stephan Waetzoldt, and Gerd Wolandt, 397–408. Kunst, Kultur, und Politik im Deutschen Kaiserreich, ed. Stephan Waetzoldt, 3. Berlin: Gebr. Mann Verlag, 1983.

Mainardi, Patricia. *The End of the Salon: Art and the State in the Early Third Republic*. Cambridge: Cambridge University Press, 1993.

Makela, Maria. *The Munich Secession: Art and Artists in Turn-of-the-Century Munich*. Princeton: Princeton University Press, 1990.

———. "The Politics of Parody: Some Thoughts on the 'Modern' in Turn-of-the-Century Munich." In *Imagining Modern German Culture: 1889–1910*, ed. Françoise Forster-Hahn, 185–207. Studies in the History of Art, 53. Washington, D.C.: National Gallery of Art, 1996.

Marchand, Suzanne L. *Down from Olympus: Archaeology and Philhellenism in Germany, 1750–1970*. Princeton: Princeton University Press, 1996.

Martin, K. *Wilhelm Trübner und sein Kreis*. Exh. cat. Karlsruhe, Germany: Staatliche Kunsthalle, 1951.

Massey, Marilyn Chapin. *Christ Unmasked: The Meaning of "The Life of Jesus" in German Politics*. Chapel Hill: University of North Carolina Press, 1983.

Mehl, Sonja. *Franz von Lenbach in der Städtischen Galerie im Lenbachhaus München*. Munich: Prestel Verlag, 1980.

Meißner, Günter. *Max Liebermann*. 4th rev. ed. Leipzig: E. A. Seemann, 1998.

Mendgen, Eva. *Franz von Stuck, 1863–1928*. Munich: Benedikt Taschen Verlag, 1994.

———. *In Perfect Harmony: Picture and Frame, 1850–1920*. Zwolle, Netherlands: Waanders, 1995.

Merkl, Peter. "Urban Challenge under the Empire." In *Another Germany: A Reconsideration of the Imperial Era*, ed. Jack R. Dukes and Joachim Remak, 61–72. Boulder, Colo.: Westview Press, 1988.

Meyer, Günter. "Auf der Suche nach den historischen Stätten des 'Vereins der Berliner Künstlerinnen.'" In *Profession ohne Tradition: 125 Jahre Verein der Berliner Künstlerinnen*, by Berlinische Galerie, 291–98. Exh. cat. Berlin: Kupfergraben, 1992.

Meyer-Tönnesmann, Carsten. *Der Hamburgische Künstlerclub von 1897*. Hamburg: Christians Verlag, 1985.

Moeller, Magdalena M. "Moderne Künstlervereinigungen in Düsseldorf." In *Der Sonderbund: Seine Voraussetzungen und Anfange in Düsseldorf*, 25–36. Cologne: Rheinland-Verlag, 1984.

Moffett, Charles S., ed. *The New Painting: Impressionism, 1874–1886*. Exh. cat. San Francisco: The Fine Arts Museums, 1986.

Moffett, Kenworth. *Meier-Graefe as Art Critic*. Studien zur Kunst des 19. Jahrhunderts, 19. Munich: Prestel Verlag, 1973.

Mommsen, Hans. "The Decline of the Bürgertum in Late Nineteenth- and Early Twentieth-Century Germany." In *From Weimar to Auschwitz: Essays in German History*. Trans. Philip O'Connor. Princeton: Princeton University Press, 1991.

Mommsen, Wolfgang J. *Bürgerliche Kultur und künstlerische Avantgarde: Kultur und Politik im deutschen Kaiserreich, 1870 bis 1918*. Frankfurt am Main: Propyläen-Studienausgabe, 1994.

———. *Imperial Germany, 1867–1918: Politics, Culture, and Society in an Authoritarian State*. Trans. Richard Deveson. New York: Arnold of Hodder Headline, 1995.

———. "Kaiser Wilhelm II and German Politics." *Journal of Contemporary History* 25, no. 2/3 (1990): 289–316.

Mosse, George L. *The Crisis of German Ideology: Intellectual Origins of the Third Reich*. New York: Grosset and Dunlap, 1964.

———. *Germans and Jews: The Right, the Left, and the Search for a "Third Force" in Pre-Nazi Germany.*

New York: Howard Fertig, 1970.

———. "Jewish Emancipation: Between *Bildung* and Respectability." In *Confronting the Nation: Jewish and Western Nationalism*, 131–38. Hanover, N.H.: Brandeis University Press, 1993.

———. "Masculinity in Crisis: The Decadence." In *The Image of Man: The Creation of Modern Masculinity*. New York: Oxford University Press, 1996.

———. *Nationalism and Sexuality: Respectability and Abnormal Sexuality in Modern Europe*. New York: Howard Fertig, 1985.

———. *The Nationalization of the Masses: Political Symbolism and Mass Movements in Germany from the Napoleonic Wars through the Third Reich*. New York: Howard Fertig, 1975.

———. *Toward the Final Solution: A History of European Racism*. New York: Harper Colophon Books, 1978.

Müller, Karoline. "Leftie Loser Lobbyist: Eine Textcollage der Kronprinzessin Victoria gewidmet." In *Profession ohne Tradition: 125 Jahre Verein der Berliner Künstlerinnen*, by Berlinische Galerie, 311–30. Exh. cat. Berlin: Kupfergraben, 1992.

Müller, Oskar A. *Albert von Keller: 1844 Gais/Schweiz—1920 München*. Munich: Verlag Karl Thiemig, 1981.

Müller, Sebastian. "Official Support and Bourgeois Opposition in Wilhelminian Culture." In *The Divided Heritage: Themes and Problems in German Modernism*, ed. Irit Rogoff, 163–90. Cambridge: Cambridge University Press, 1990.

Muysers, Carola. "Warum gab es berühmte Künstlerinnen? Erfolge bildender Künstlerinnen der zweiten Hälfte des 19. Jahrhunderts." In *Profession ohne Tradition: 125 Jahre Verein der Berliner Künstlerinnen*, by Berlinische Galerie, 21–34. Exh. cat. Berlin: Kupfergraben, 1992.

Neidhardt, Uta. "Gotthardt Kuehl in Dresden, 1895–1915." In *Gotthart Kuehl, 1850–1915*, ed. Gerhard Gerkens and Horst Zimmermann, 56–77. Exh. cat. Leipzig: E. A. Seemann, 1993.

Nerdinger, Winfried. "Die Kunststadt München." In *Die Zwanziger Jahre in München*, ed. Christoph Stölzl, 93–110. Exh. cat. Munich: Stadtmuseum, 1979.

Neue Gesellschaft für Bildende Kunst e.V., Berlin, ed. *Das Verborgene Museum I: Dokumentation der Kunst von Frauen in Berliner öffentlichen Sammlungen*. Exh. cat. Berlin: Edition Hentrich, 1987.

Nipperdey, Thomas. "Antisemitismus—Entstehung, Funktion, und Geschichte eines Begriffs." In *Gesellschaft, Kultur, Theorie: Gesammelte Aufsätze zur neueren Geschichte*, 113–32. Göttingen, Germany: Vandenhoeck & Ruprecht, 1976.

———. *Deutsche Geschichte, 1866–1918*. Vol. 1, *Arbeitswelt und Bürgergeist*. Munich: Verlag C. H. Beck, 1990.

———. *Germany from Napoleon to Bismarck, 1800–1866*. Tran. Daniel Nolan. Princeton: Princeton University Press, 1992.

———. "In Search of Identity: Romantic Nationalism, Its Intellectual, Political, and Social Background." In *Romantic Nationalism in Europe*, ed. J. C. Eade, 1–15. Canberra: Humanities Research Centre, Australian National University, 1983.

———. *Nachdenken über die deutsche Geschichte: Essays*. Munich: Verlag C. H. Beck, 1986.

———. "Nationalidee und Nationaldenkmal in Deutschland im 19. Jahrhundert." *Historische Zeitschrift* 206 (1968): 529–85.

———. "Verein als soziale Struktur in Deutschland im späten 18. und frühen 19. Jahrhundert: Eine Fallstudie zur Modernisierung I." In *Gesellschaft, Kultur, Theorie: Gesammelte Aufsätze zur neueren Geschichte*, 174–205. Göttingen, Germany: Vandenhoeck & Ruprecht, 1976.

———. *Wie das Bürgertum die Moderne fand*. Berlin: Siedler, 1988.

Nochlin, Linda. *Realism*. Style and Civilization, ed. John Fleming and Hugh Honour. New York: Penguin Books, 1971.

Nouwen, Margreet. "Malheimat Holland." In *Max Liebermann: Der Realist und die Phantasie*, ed. Jenns E. Howoldt and Birte Frenssen, 11–20. Exh. cat. Hamburg: Dölling und Galitz Verlag, 1997.

———. "Vom 'Apostel des Häßlichen' zum Porträtmaler des Bürgertums." In *Max Liebermann—Jahrhundertwende*, ed. Angelika Wesenberg, 239–44. Exh. cat. Berlin: Ars Nicolai, 1997.

Nye, Robert A. *Crime, Madness, and Politics in Modern France: The Medical Concept of National Decline*. Princeton: Princeton University Press, 1984.

Oettermann, Stephan. *Das Panorama: Die Geschichte eines Massenmediums*. Frankfurt am Main: Syndikat, 1980. Trans. Deborah Lucas Schneider under the title *The Panorama: History of a Mass Medium* (New York: Zone Books, 1997).

———. "Die Reise mit den Augen—'Oramas' in Deutschland." In *Sehsucht: Das Panorama als Massenunterhaltung des 19. Jahrhunderts*, 41–51. Exh. cat. Bonn: Stroemfeld/Roter Stern, 1993.

Pakula, Hannah. *An Uncommon Woman: The Empress Frederick, Daughter of Queen Victoria, Wife of the Crown Prince of Prussia, Mother of Kaiser Wilhelm*. New York: Simon and Schuster, Touchstone, 1995.

Paret, Peter. *Art as History: Episodes in the Culture and Politics of Nineteenth-Century Germany*. Princeton: Princeton University Press, 1988.

———. "The Artist as Staatsbürger." *German Studies Review* 6 (1983): 421–37.

———. "Bemerkungen zu dem Thema: Jüdische Kunstsammler, Stifter, und Kunsthändler." In *Sammler, Stifter, und Museen: Kunstförderung in Deutschland*

im 19. und 20. Jahrhundert, ed. Ekkehard Mai and Peter Paret. Cologne: Böhlau Verlag, 1993.

Paret, Peter. *The Berlin Secession: Modernism and Its Enemies in Imperial Germany*. Cambridge: Harvard University Press, 1980.

———. *"The Enemy Within"—Max Liebermann as President of the Prussian Academy of Arts*. Leo Baeck Memorial Lecture 28. New York: Leo Baeck Institute, 1984. Trans. Tilmann von Stockhausen under the title "Der innere Feind: Max Liebermann als Präsident der Preußischen Akademie der Künste," in *Max Liebermann—Jahrhundertwende*, ed. Angelika Wesenberg, exh. cat. (Berlin: Ars Nicolai, 1997), 65–74.

———. *German Encounters with Modernism, 1840–1945*. Cambridge: Cambridge University Press, 2001.

———. "Modernism and the 'Alien Element' in German Art." In *Berlin Metropolis: Jews and the New Culture, 1890–1918*, ed. Emily D. Bilski, 32–57. Exh. cat. Berkeley: University of California Press, 1999.

———. "The Tschudi Affair." *Journal of Modern History* 53 (Dec. 1981): 589–618. Rev. as "Die Tschudi-Affäre," in *Manet bis Van Gogh: Hugo von Tschudi und der Kampf um die Moderne*, ed. Johann Georg Prinz von Hohenzollern and Peter-Klaus Schuster, exh. cat. (Munich: Prestel Verlag, 1996), 396–401.

Paul, Barbara. "Drei Sammlungen französischer impressionistischer Kunst im kaiserlichen Berlin—Bernstein, Liebermann, Arnhold." In *Sammler der frühen Moderne in Berlin*, ed. Thomas W. Gaehtgens, special issue of *Zeitschrift des deutschen Vereins für Kunstwissenschaft* 42, no. 3 (1988): 11–30.

———. *Hugo von Tschudi und die moderne französische Kunst im Deutschen Kaiserreich*. Mainz: Verlag Philipp von Zabern, 1993.

Pfefferkorn, Rudolf. *Die Berliner Secession: Eine Epoch deutscher Kunstgeschichte*. Berlin: Haude & Spenersche Verlagsbuchhandlung, 1972.

Pierrot, Jean. *The Decadent Imagination, 1880–1900*. Trans. Derek Coltman. Chicago: University of Chicago Press, 1981.

Pucks, Stefan. "'Ein kleiner Kreis der Feinschmecker unter den Kunstfreunden': Liebermann, Cassirer, und die Berliner Sammler." In *Max Liebermann—Jahrhundertwende*, ed. Angelika Wesenberg, 233–38. Exh. cat. Berlin: Ars Nicolai, 1997.

———. "'Talentiert, aber schmutzig': Max Liebermanns Frühwerk im Spiegel der deutschen Kunstkritik." In *Max Liebermann: Der Realist und die Phantasie*, ed. Jenns E. Howoldt and Birte Frenssen, 58–63. Exh. cat. Hamburg: Dölling und Galitz Verlag, 1997.

———. "Von Manet zu Matisse—Die Sammler der französischen Moderne in Berlin um 1900." In *Manet bis Van Gogh: Hugo von Tschudi und der Kampf um die Moderne*, ed. Johann Georg Prinz von Hohenzollern

and Peter-Klaus Schuster, 386–90. Exh. cat. Munich: Prestel Verlag, 1996.

Pulzer, Peter G. J. *The Rise of Political Anti-Semitism in Germany and Austria*. New Dimensions in History, ed. Norman F. Cantor. New York: John Wiley and Sons, 1964.

Radycki, J. Diane. "The Life of Lady Art Students: Changing Art Education at the Turn of the Century." *Art Journal* 42, no. 1 (1982): 9–13.

Rantzau, Johann Albrecht von. "Zur Geschichte der sexuellen Revolution: Die Gräfin Franziska zu Reventlow und die Münchener Kosmiker." *Archiv für Kulturgeschichte* 56, no. 2 (1974): 394–446.

Rave, Paul Ortwin. *Die Geschichte der Nationalgalerie Berlin*. Berlin: Nationalgalerie, Staatliche Museen Preußischer Kulturbesitz, [1968].

Reagin, Nancy R. *A German Women's Movement: Class and Gender in Hanover, 1880–1933*. Chapel Hill: University of North Carolina Press, 1995.

Reinharz, Jehuda. *Fatherland or Promised Land: The Dilemma of the German Jew, 1893–1914*. Ann Arbor: University of Michigan Press, 1975.

Reisenfeld, Robin, ed. *The German Print Portfolio, 1890–1930: Serials for a Private Sphere*. Exh. cat. Chicago: David and Alfred Smart Museum of Art, University of Chicago, 1992.

Rennhofer, Maria. *Kunstzeitschriften der Jahrhundertwende in Deutschland und Österreich, 1895–1914*. Vienna: Bechtermünz Verlag, 1997.

Retallack, James. "Anti-Semitism, Conservative Propaganda, and Regional Politics in Late Nineteenth-Century Germany." *German Studies Review* 11 (1988): 377–403.

———. *Germany in the Age of Kaiser Wilhelm II*. Studies in European History, ed. Richard Overy. New York: St. Martin's Press, 1996.

Reulecke, Jürgen. "Kunst in den Arbeiterbildungskonzepten bürgerlicher Sozialreformer im 19. Jahrhundert." In *Kunstpolitik und Kunstförderung im Kaiserreich: Kunst im Wandel der Sozial- und Wirtschaftsgeschichte*, ed. Ekkehard Mai, Hans Pohl, and Stephan Waetzoldt, 83–93. Kunst, Kultur, und Politik im Deutschen Kaiserreich, ed. Stephan Waetzoldt, 2. Berlin: Gebr. Mann Verlag, 1982.

Ribbe, Wolfgang, ed. *Geschichte Berlins: Von der Märzrevolution bis zur Gegenwart*. Vol. 2. Munich: Verlag C. H. Beck, 1987.

Richardson, Holly. "Landschaftsmalerei ist die schwerste Kunst. . . ." In *Max Liebermann: Der Realist und die Phantasie*, ed. Jenns E. Howoldt and Birte Frenssen, 21–31. Exh. cat. Hamburg: Dölling und Galitz Verlag, 1997.

Roemer- und Pelizaeus Museum. *Max Klinger: Wege zum Gesamtkunstwerk*. Exh. cat. Mainz: Verlag Philipp von Zabern, 1984.

Rogoff, Irit. "The Anxious Artist—Ideological Mobilisations of the Self in German Modernism." In *The Divided Heritage: Themes and Problems in German Modernism*, ed. Irit Rogoff, 116–40. Cambridge: Cambridge University Press, 1990.

Röhl, John C. G. *The Kaiser and His Court: Wilhelm II and the Government of Germany*. Trans. Terence F. Cole. Cambridge: Cambridge University Press, 1994.

Röhrl, Boris. *Wilhelm Leibl: Leben und Werk*. Studien zur Kunstgeschichte, 85. Hildesheim, Germany: Georg Olms Verlag, 1994.

Roper, Katherine. *German Encounters with Modernity: Novels of Imperial Berlin*. Studies in German Histories. Atlantic Highlands, N.J.: Humanities Press International, 1991.

Ross, Ronald J. *Beleaguered Tower: The Dilemma of Political Catholicism in Wilhelmine Germany*. South Bend, Ind.: University of Notre Dame Press, 1976.

———. "Catholic Plight in the *Kaiserreich*: A Reappraisal." In *Another Germany: A Reconsideration of the Imperial Era*, ed. Jack R. Dukes and Joachim Remak, 73–94. Boulder, Colo.: Westview Press, 1988.

———. "Enforcing the Kulturkampf in the Bismarckian State and the Limits of Coercion in Imperial Germany." *Journal of Modern History* 56 (Sept. 1984): 456–82.

Roters, Eberhard. "Die Nationalgalerie und ihre Stifter: Mäzenatentum und staatliche Förderung in Dialog und Widerspruch." In *Mäzenatentum in Berlin: Bürgersinn und kulturelle Kompetenz unter sich verändernden Bedingungen*, ed. Günter Braun und Waldtraut Braun, 73–98. Berlin: Walter de Gruyter, 1993.

Roth, Eugen. *Der Glaspalast in München: Glanz und Ende, 1854–1931*. Munich: Süddeutscher Verlag, 1971.

Ruhmer, Eberhard. "Adolph Friedrich von Schach und seine Sammlung." In *Arnold Böcklin, 1827–1901: Gemälde, Zeichnungen, Plastiken. Ausstellung zum 150. Geburtstag*, ed. Dorothea Christ, 43–46. Exh. cat. Basel: Schabe & Co., 1977.

———. *Die Münchner Schule, 1850–1914*. Munich: Haus der Kunst, 1979.

Sackett, Robert E. *Popular Entertainment, Class, and Politics in Munich, 1900–1923*. Cambridge: Harvard University Press, 1982.

Salzmann, Karl H. "*Pan*: Geschichte einer Zeitschrift." *Imprimatur* 10 (1950–51): 163–85. Reprinted in *Archiv für Geschichte des Buchwesens* 1 (1958): 212–15 and, shortened, in *Jugendstil*, ed. Jost Hermand, 178–208 (Darmstadt: Wissenschaftliche Buchgesellschaft, 1971).

Sauer, Marina. "Dilettantinnen und Malweiber: Künstlerinnen im 19. und 20. Jahrhundert." In *Das Verborgene Museum I: Dokumentation der Kunst von Frauen in Berliner öffentlichen Sammlungen*, ed. Neue

Gesellschaft für Bildende Kunst e.V., Berlin, 21–31. Exh. cat. Berlin: Edition Hentrich, 1987.

Scheffler, Gisela. "Max Klinger in München." In *Max Klinger: Zeichnungen, Zustandsdrucke, Zyklen*, ed. Jo-Anne Birnie Danzker and Tilman Falk, 9–14. Exh. cat. Munich: Prestel Verlag, 1996.

Scheuner, Ulrich. "Die Kunst als Staatsaufgabe im 19. Jahrhundert." In *Kunstverwaltung, Bau- und Denkmal-Politik im Kaiserreich*, ed. Ekkehard Mai and Stephan Waetzoldt, 13–46. Kunst, Kultur, und Politik im Deutschen Kaiserreich, ed. Stephan Waetzoldt, 1. Berlin: Gebr. Mann Verlag, 1981.

Schlawe, Fritz. *Literarische Zeitschriften, 1885–1910*. Stuttgart: J. B. Metzlersche Verlagsbuchhandlung, 1961.

Schneede, Uwe M. "'Aus der Erinnerung und mit der Phantasie': Skandinavien in Berlin—Munchs 'zweite Heimat.'" In *Munch und Deutschland*, ed. Uwe M. Schneede and Dorothee Hansen, 12–19. Exh. cat. Hamburg: Hamburger Kunsthalle, 1994.

Schneede, Uwe M., and Dorothee Hansen, eds. *Munch und Deutschland*. Exh. cat. Hamburg: Hamburger Kunsthalle, 1994.

Schönmetzler, Klaus Jörg. *Wilhelm Leibl und seine Malerfreunde*. Rosenheim, Germany: Rosenheimer Verlag, 1994.

Schröder, Iris. "Der 'Verein der Künstlerinnen und Kunstfreundinnen zu Berlin' und die Frauenbewegung vor dem Ersten Weltkrieg 1867–1914." In *Profession ohne Tradition: 125 Jahre Verein der Berliner Künstlerinnen*, by Berlinische Galerie, 375–81. Exh. cat. Berlin: Kupfergraben, 1992.

Schroeter, Christina. *Fritz Erler: Leben und Werk*. Hamburg: Christians Verlag, 1992.

Schuster, Peter-Klaus. "Hugo von Tschudi und der Kampf um die Moderne." In *Manet bis Van Gogh: Hugo von Tschudi und der Kampf um die Moderne*, ed. Johann Georg Prinz von Hohenzollern and Peter-Klaus Schuster, 21–40. Exh. cat. Munich: Prestel Verlag, 1996.

———. "Leben wie ein Dichter—Richard Dehmel und die bildenden Künste." In *Ideengeschichte und Kunstwissenschaft: Philosophie und bildende Kunst im Kaiserreich*, ed. Ekkehard Mai, Stephan Waetzoldt, and Gerd Wolandt, 181–221. Kunst, Kultur, und Politik im Deutschen Kaiserreich, ed. Stephan Waetzoldt, 3. Berlin: Gebr. Mann Verlag, 1983.

———. "Max Liebermann—Jahrhundertwende." In *Max Liebermann—Jahrhundertwende*, ed. Angelike Wesenberg, 43–58. Exh. cat. Berlin: Ars Nicolai, 1997.

———. "Menzel's Modernity." In *Adolph Menzel, 1815–1905: Between Romanticism and Impressionism*, ed. Claude Keisch and Marie Ursula Riemann-Reyher, 138–59. Exh. cat. New Haven, Conn.: Yale University Press, 1996.

Schuster, Peter-Klaus, ed. *"München leuchtete": Karl Caspar und die Erneuerung christlicher Kunst in München um 1900*. Exh. cat. Munich: Prestel Verlag, 1984.

Schuster, Peter-Klaus, Christoph Vitali, and Barbara Butts, eds. *Lovis Corinth*. Exh. cat. Munich: Prestel Verlag, 1996.

Schwarz, Gudrun. "'Mannweiber' in Männertheorien." In *Frauen suchen ihre Geschichte: Historische Studien zum 19. und 20. Jahrhundert*, ed. Karin Hausen, 62–80. Munich: Verlag C. H. Beck, 1983.

Sehsucht: Das Panorama als Massenunterhaltung des 19. Jahrhunderts. Exh. cat. Bonn: Stroemfeld/Roter Stern, 1993.

Seigel, Jerrold. *Bohemian Paris: Culture, Politics, and the Boundaries of Bourgeois Life, 1830–1930*. New York: Viking Penguin, 1986.

Shachar, Isaiah. *The Judensau: A Medieval Anti-Jewish Motif and Its History*. London: Warburg Institute, University of London, 1974.

Sheehan, James J. "From Princely Collections to Public Museums: Toward a History of the German Art Museum." In *Rediscovering History: Culture, Politics, and the Psyche*, ed. Michael S. Roth, 169–82. Stanford, Calif.: Stanford University Press, 1994.

———. *German Liberalism in the Nineteenth Century*. Chicago: University of Chicago Press, 1978.

———. *Museums in the German Art World: From the End of the Old Regime to the Rise of Modernism*. New York: Oxford University Press, 2000.

———. "What Is German History? Reflections on the Role of Nation in German History and Historiography." *Journal of Modern History* 53 (Mar. 1981): 1–23.

Showalter, Elaine. *Sexual Anarchy: Gender and Culture at the Fin de Siècle*. New York: Penguin Books, 1990.

Siebenmorgen, Harald. "'Kulturkampfkunst': Das Verhältnis von Peter Lenz und der Beuroner Kunstschule zum Wilhelminischen Staat." In *Ideengeschichte und Kunstwissenschaft: Philosophie und bildende Kunst im Kaiserreich*, ed. Ekkehard Mai, Stephan Waetzoldt, and Gerd Wolandt, 409–30. Kunst, Kultur, und Politik im Deutschen Kaiserreich, ed. Stephan Waetzoldt, 3. Berlin: Gebr. Mann Verlag, 1983.

Sitt, Martina, and Ute Ricke-Immel. *Angesichts des Alltäglichen: Genremotive in der Malerei zwischen 1830 und 1900*. Exh. cat. Cologne: Böhlau Verlag, 1996.

Smith, Helmut Walser. *German Nationalism and Religious Conflict: Culture, Ideology, Politics, 1870–1914*. Princeton: Princeton University Press, 1995.

———. "The Learned and the Popular Discourse of Anti-Semitism in the Catholic Milieu of the Kaiserreich." *Central European History* 27, no. 3 (1994): 315–28.

———. "Religion and Conflict: Protestants, Catholics, and Anti-Semitism in the State of Baden in the Era of Wilhelm II." *Central European History* 27, no. 3 (1994): 283–314.

Smoot, Myrna. "The First International Art Exhibition in Munich 1869." In *Salons, Galleries, Museums, and Their Influence in the Development of Nineteenth and Twentieth Century Art*, ed. Francis Haskell, 109–14. Proceedings of the Twenty-fourth International Congress of the History of Art, vol. 7. Bologna: CLUEB, 1981.

Sobania, Michael. "Vereinsleben: Regeln und Formen bürgerlicher Assoziationen im 19. Jahrhundert." In *Bürgerkultur im 19. Jahrhundert: Bildung, Kunst, und Lebenswelt*, ed. Dieter Hein and Andreas Schulz, 170–90. Munich: Verlag C. H. Beck, 1996.

Söder, Hans-Peter. "Disease and Health as Context of Modernity: Max Nordau as a Critic of Fin-de-Siècle Modernism." *German Studies Review* 14 (1991): 473–87.

Specht, Agnete von. *Streik: Realität und Mythos*. Exh. cat. Berlin: Deutsches Historisches Museum, 1992.

Sperber, Jonathan. *Popular Catholicism in Nineteenth-Century Germany*. Princeton: Princeton University Press, 1984.

Staatliche Kunsthalle. *Kunst in Karlsruhe, 1900–1950*. Exh. cat. Karlsruhe, Germany: Verlag C. F. Müller, 1981.

Städtische Galerie. *Ludwig von Hofmann (1861–1945): Zeichnungen, Pastelle, Druckgraphik*. Exh. cat. Albstadt, Germany, 1995.

Stadtmuseum Düsseldorf. *Armer Maler—Malerfürst: Künstler und Gesellschaft, Düsseldorf 1819–1918*. Exh. cat. Düsseldorf, 1980.

Stark, Gary D. *Entrepreneurs of Ideology: Neoconservative Publishers in Germany, 1890–1933*. Chapel Hill: University of North Carolina Press, 1981.

———. "Pornography, Society, and the Law in Imperial Germany." *Central European History* 14, no. 3 (1981): 200–229.

Steakley, James D. *The Homosexual Emancipation Movement in Germany*. New York: Arno Press, 1975.

Stenzel, Burkhard. *Harry Graf Kessler: Ein Leben zwischen Kultur und Politik*. Weimar, Germany: Böhlau Verlag, 1995.

Stern, Fritz. *Gold and Iron: Bismarck, Bleichröder, and the Building of the German Empire*. New York: Random House, Vintage Books, 1979.

———. "Julius Langbehn and Germanic Irrationalism." In *The Politics of Cultural Despair: A Study in the Rise of the Germanic Ideology*. Berkeley: University of California Press, 1961.

———. "Money, Morals, and the Pillars of Bismarck's Society." *Central European History* 3, no. 1/2 (1970): 49–72.

Stolz, Christa. *Hermann Knackfuß*. Wissen, Germany: Verlag G. Nising, 1975.

Streicher, Elizabeth Pendleton. "Max Klinger's *Malerei und Zeichnung*: The Critical Reception of the Prints and

Their Text." In *Imagining Modern German Culture: 1889–1910*, ed. Françoise Forster-Hahn, 229–49. Studies in the History of Art, 53. Washington, D.C.: National Gallery of Art, 1996.

———. "'Zwischen Klingers Ruhm und seiner Leistung': Max Klingers Kunst im Spiegel der Kritik, 1877–1920." In *Max Klinger: Zeichnungen, Zustandsdrucke, Zyklen*, ed. Jo-Anne Birnie Danzker and Tilman Falk, 44–55. Exh. cat. Munich: Prestel Verlag, 1996.

Syndram, Karl Ulrich. *Kulturpublizistik und nationales Selbstverständnis: Untersuchungen zur Kunst- und Kulturpolitik in den Rundschauzeitschriften des Deutschen Kaiserreiches (1871–1914)*. Kunst, Kultur, und Politik im Deutschen Kaiserreich, ed. Stephan Waetzoldt, 9. Berlin: Gebr. Mann Verlag, 1989.

———. "Rundschau-Zeitschriften: Anmerkungen zur ideengeschichtlichen Rolle eines Zeitschriftentyps." In *Ideengeschichte und Kunstwissenschaft: Philosophie und bildende Kunst im Kaiserreich*, ed. Ekkehard Mai, Stephan Waetzoldt, and Gerd Wolandt, 349–70. Kunst, Kultur, und Politik im Deutschen Kaiserreich, ed. Stephan Waetzoldt, 3. Berlin: Gebr. Mann Verlag, 1983.

Tafel, Verena. "Paul Cassirer als Vermittler deutscher impressionistischer Kunst in Berlin: Zum Stand der Forschung." In *Sammler der frühen Moderne in Berlin*, ed. Thomas W. Gaehtgens, special issue of *Zeitschrift des deutschen Vereins für Kunstwissenschaft* 42, no. 3 (1988): 31–46.

Teeuwisse, Klaas. "Berliner Kunstleben zur Zeit Max Liebermanns." In *Max Liebermann in seiner Zeit*, ed. Sigrid Achenbach and Matthias Eberle, 72–87. Exh. cat. Berlin: Nationalgalerie, Staatliche Museen Preußischer Kulturbesitz, 1979.

Teeuwisse, Nicolaas. "Bilder einer verschollenen Welt: Aufstieg und Niedergang der Berliner Privatsammlung in Berlin." In *Der unverbrauchte Blick: Kunst unserer Zeit in Berliner Sicht. Eine Ausstellung aus Privatsammlungen 1871–1933 in Berlin*, ed. Christos M. Joachimides, 13–39. Exh. cat. Berlin: Martin-Gropius-Bau, 1987.

———. *Vom Salon zur Secession: Berliner Kunstleben zwischen Tradition und Aufbruch zur Moderne, 1871–1900*. Berlin: Deutscher Verlag für Kunstwissenschaft, 1986.

Teut, Anna. *Max Liebermann: Gartenparadies am Wannsee*. Munich: Prestel Verlag, 1997.

Thamer, Jutta. *Zwischen Historismus und Jugendstil: Zur Ausstattung der Zeitschrift "Pan" (1895–1900)*. Europäische Hochschulschriften, Kunstgeschichte, 8. Frankfurt am Main: Peter D. Lang, 1980.

Thompson, Alastair. "Honours Uneven: Decorations, the State, and Bourgeois Society in Imperial Germany." *Past and Present*, no. 144 (1994): 171–204.

Tittel, Lutz. "Die Beurteilung Arnold Böcklins in der

Zeitschrift für bildende Kunst von 1866 bis 1901." In *Arnold Böcklin, 1827–1901: Gemälde, Zeichnungen, Plastiken. Ausstellung zum 150. Geburtstag*, ed. Dorothea Christ, 123–30. Exh. cat. Basel: Schwabe & Co., 1977.

———. "Monumentaldenkmäler von 1871 bis 1918 in Deutschland: Ein Beitrag zum Thema Denkmal und Landschaft." In *Kunstverwaltung, Bau- und Denkmal-Politik im Kaiserreich*, ed. Ekkehard Mai and Stephan Waetzoldt, 215–75. Kunst, Kultur, und Politik im Deutschen Kaiserreich, ed. Stephan Waetzoldt, vol. 1. Berlin: Gebr. Mann Verlag, 1981.

Townsend, Mary Lee. *Forbidden Laughter: Popular Humor and the Limits of Repression in Nineteenth-Century Prussia*. Social History, Popular Culture, and Politics in Germany, ed. Geoff Eley. Ann Arbor: University of Michigan Press, 1992.

Trier, Eduard, and Willy Weyres, eds. *Kunst des 19. Jahrhunderts im Rheinland*. 5 vols. Exh. cat. Düsseldorf: Schwann, 1979.

Tumasonis, Elizabeth. "Böcklin's Reputation: Its Rise and Fall." *Art Criticism* 6, no. 2 (1990): 48–71.

Turk, Eleanor L. "The Berlin Socialist Trials of 1896: An Examination of Civil Liberty in Wilhelmian Germany." *Central European History* 19, no. 4 (1986): 323–42.

———. "The Great Berlin Beer Boycott of 1894." *Central European History* 15, no. 4 (1982): 377–97.

Uhr, Horst. *Lovis Corinth*. Berkeley: University of California Press, 1990.

Varnedoe, Kurt. *Northern Light: Nordic Art at the Turn of the Century*. New Haven, Conn.: Yale University Press, 1988.

Varnedoe, Kurt, and Elizabeth Streicher. *Graphic Works of Max Klinger*. New York: Dover Publications, 1977.

Verein der Berliner Künstlerinnen e.V., ed. *Käthe, Paula und der ganze Rest*. Künstlerinnenlexikon. Berlin: Kupfergraben, 1992.

Volkov, Shulamit. "Antisemitism as a Cultural Code in Imperial Germany: Reflections on the History and Historiography of Antisemitism in Imperial Germany." *Leo Baeck Institute Year Book* 23 (1978): 25–46.

———. *The Rise of Popular Anti-Modernism in Germany: The Urban Master Artisans, 1873–1896*. Princeton: Princeton University Press, 1978.

———. "The *Verbürgerlichung* of the Jews as a Paradigm." In *Bourgeois Society in Nineteenth-Century Europe*, ed. Jürgen Kocka and Allan Mitchell, 267–91. Oxford: Berg, 1993.

Vondung, Klaus. "Zur Lage der Gebildeten in der wilhelminischen Zeit." In *Das wilhelminische Bildungsbürgertum: Zur sozialgeschichte seiner Ideen*, 20–33. Göttingen, Germany: Vandenhoeck & Ruprecht, 1976.

Voss, Heinrich. *Franz von Stuck, 1863–1928: Werkkatalog*

SELECTED BIBLIOGRAPHY

der Gemälde mit einer Einführung in seinen Symbolis-mus. Materialien zur Kunst des 19. Jahrhunderts, 1. Munich: Prestel Verlag, 1973.

Vowinckel, Andreas. "Ausstellungen in Kunstvereinen: Spezifische Formen und Charakteristika im Span-nungsfeld regionaler, überregionaler, und interna-tionaler Konkurrenz." In *Vom realen Nutzen idealer Bilder: Kunstmarkt und Kunstvereine*, ed. Peter Ger-lach, 45–60. Aachen, Germany: Alano-Verlag, 1994.

Vüth-Hinz, Henriette. *ODOL: Reklame-Kunst um 1900*. Werkbund-Archiv, 14. Giessen, Germany: Anabas-Verlag, 1985.

Wagner-Douglas, Immo. "Realist, Secessionist, Jude, und Patriarch—Liebermann in der Karikatur." In *Max Liebermann—Jahrhundertwende*, ed. Angelika We-senberg, 267–76. Exh. cat. Berlin: Ars Nicolai, 1997.

Wassermann, Henry. "The *Fliegende Blätter* as a Source for the Social History of German Jewry." *Leo Baeck Institute Year Book* 28 (1983): 93–138.

Weber, Eugen. *France: Fin de Siècle*. Cambridge: Harvard University Press, 1986.

Weisberg, Gabriel. *The Realist Tradition: French Painting and Drawing, 1830–1900*. Exh. cat. Cleveland: Cleveland Museum of Art, 1981.

Werner, Alfred. "The Strange Tale of Lesser Ury." *Leo Baeck Institute Year Book* 19 (1974): 197–207.

Wesenberg, Angelika, ed. *Max Liebermann—Jahrhundert-wende*. Exh. cat. Berlin: Ars Nicolai, 1997.

———. *Wilhelm von Bode als Zeitgenosse der Kunst*. Berlin: Nationalgalerie, Staatliche Museen zu Berlin, 1995.

Wichmann, Siegfried. *Secession: Europäische Kunst um die Jahrhundertwende*. Exh. cat. Munich: Haus der Kunst, 1964.

Wilhelm, Karl. *Wirtschafts- und Sozialgeschichte des Kunst-auktionswesens in Deutschland vom 18. Jahrhundert bis 1945*. Munich: tuduv-Verlag, 1989.

Willey, Thomas E. "Thomas Mann's Munich." In *The Turn of the Century: German Literature and Art, 1890–1915*, ed. Gerald Chapple and Hans H. Schulte, 477–91. Bonn: Bouvier Verlag, 1981.

Winkler, Gerhard. *Max Klinger*. Leipzig: E. A. Seemann, 1984.

Wirth, Irmgard. *Der Berliner Maler Franz Skarbina: Ein Querschnitt durch sein Werk*. Berlin: Berlin Museum, 1970.

With, Christopher B. "The Emperor, the National Gallery, and Max Slevogt." *Zeitschrift des deutsche Vereins für Kunstwissenschaft* 30 (1976): 86–94.

———. *The Prussian Landeskunstkommission, 1862–1911: A Study in State Subvention of the Arts*. Kunst, Kultur, und Politik im Deutschen Kaiserreich, ed. Stephan Waetzoldt, vol. 6. Berlin: Gebr. Mann Ver-lag, 1986.

Wolbring, Barbara. "'Auch ich in Arkadien!' Die bürger-liche Kunst- und Bildungsreise im 19. Jahrhundert." In *Bürgerkultur im 19. Jahrhundert: Bildung, Kunst, und Lebenswelt*, ed. Dieter Hein and Andreas Schulz, 82–101. Munich: Verlag C. H. Beck, 1996.

Zacharias, Thomas, ed. *Tradition und Widerspruch: 175 Jahre Kunstakademie München*. Munich: Prestel Ver-lag, 1985.

Zelger, Franz. *Arnold Böcklin. Die Toteninsel: Selbst-heroisierung und Abgesang der abendländischen Kultur*. Frankfurt am Main: Fischer Taschenbuch Ver-lag, 1991.

Acknowledgments

As historians know, research projects are often voyages into unexplored territories, voyages accompanied by obstacles, detours, excitement, and—one hopes—new understanding of a bygone world. Such journeys would be impossible without help and guidance from many others. That is certainly true for this book. Like many forays into the past, this one was conceived in long, intense discussions with a close colleague, in this case Joan Weinstein, whose clarity of mind and enthusiasm helped to forge the initial steps of the voyage, charting the way through the newly opened Arntz collection of German art periodicals in the J. Paul Getty Research Library. Although circumstances led to Joan's relinquishing her active participation in the project, she continued to share her insights along the long road, even when my attention became focused on what we had planned to be only the first stage.

Many others contributed to my slow journey through books and journals over the last decades, but the most significant support came from Peter Paret, who, inviting me to become his research associate in the School of Historical Studies at the Institute for Advanced Study in Princeton (1989–90, 1991–92, 1994, 1996), granted me the rare gifts of sheltered time, financial support, countless hours of probing conversations, and incisive criticism of my work. My conceptions of historical exploration were also challenged and enriched by the wisdom and knowledge of the many scholars at the Institute for Advanced Study, especially Mary Lee Townsend, Henning Köhler, Hagen Schulze, Lloyd Kramer, Joan Wallach Scott, Albert Hirschman, Sabine MacCormack, the late Thomas Nipperdey, members of the Force in History seminar, and the faculty of the School of Historical Studies.

Financial support, necessary for travel to research centers and museums, came from the Getty Center for the History of Art and the Humanities (1988); a Scholar in Residence grant from the Robert Gore Rifkind Center for German Expressionist Studies (1989); an Interpretive Research Grant from the National Endowment for the Humanities (1990–94); a General Research Grant from the American Philosophical Society (1998); a Research Support Grant from the Getty Research Institute (1998); and both travel and publication grants from the faculty development fund (1993, 1995) and the Henry Luce III Fund for Distinguished Scholarship (2001) at the College of Wooster.

As a stranger traveling to research centers and museums, I was guided by many individuals who generously extended helping minds and hands to me: Anna-Mieke Halbrook and Judy Edwards at the Getty Research Center Library (Santa Monica) and the Getty Research Library (Brentwood); Susan Wyngaard at the Fine Arts Library of Ohio State University; Carolyn Rahnema, interlibrary loan librarian at the College of Wooster; librarians at the Staatsbibliothek zu Berlin, the Kunstbibliothek der Staatlichen Museen zu Berlin, the Marquand Fine Arts Library at Princeton University, the Fine Arts Library at the University of California, Los Angeles, and the Cleveland Museum of Art Library. Museum directors and curators who facilitated my visits to their collections, often to storage rooms in search of late-nineteenth-century paintings, included Dr. Peter-Klaus Schuster, Nationalgalerie, Berlin; Dr. Claude Keisch and Herr Brauner, Alte Nationalgalerie; Dr. Sigrid Achenbach, Kupferstichkabinett, Staatliche Museen zu Berlin; Dr. Helmut R. Leppien and Dr. Uwe M. Schneede, Hamburger Kunsthalle; Dr. Dietluf Sander, Museum

der bildenden Künste Leipzig; Dr. Gerhard Leistner, Museum Ostdeutsche Galerie, Regensburg; Dr. Christian Lenz, Bayerisches Staatsgemäldesamm-lungen; Dr. Barbara Eschenburg, Städtische Galerie im Lenbachhaus, Munich; Dr. Elisabeth Boser, Dachauer Gemäldegalerie, Dachau; Dr. Siegmar Holsten, Staatliche Kunsthalle Karlsruhe; Frau Wies-mann, Hessisches Landesmuseum Darmstadt; Dr. Hans-Joachim Ziemke, Städelsches Kunstinstitut, Frankfurt am Main; Dr. Ekkehard Mai, Wallraf-Richartz-Museum, Cologne; Dr. Andreas Kreul, Kunsthalle Bremen; and Dr. Sigrid Bertuleit, Nieder-sächsisches Landesmuseum Hannover.

Friends are an absolute necessity during a lengthy voyage of discovery and writing. Twenty years ago, encouragement from O. K. Werckmeister and members of the Department of Art History at the University of California, Los Angeles, started me on the interdisciplinary path that has led to this book. David Kunzle, in particular, inspired me with his crea-tive work on the significance of comic strips. Over the years, I have been sustained and encouraged in this project by Sara L. Patton, Henry Copeland, Stanton Hales, John and Rena Hondros, Susan and Richard Figge, Mary Lee Townsend, Isabel Paret, Antje Harnisch, Eric Rosenberg, and Vernon Lidtke.

Special thanks go to Ekkehard Mai and Reinhold Heller, each for his thorough reading and discerning commentary on the final manuscript.

Turning a manuscript of this complexity into a book required vision and enthusiasm from Nancy Grubb, executive editor at Princeton University Press, from her gracious managing editor Kate Zanzucchi and editorial assistant Cynthia Grow, and from her production staff led by Devra K. Nelson, fine arts production editor, whose gentle guidance brought order to a difficult process, and by Ken Wong, production manager, with Sarah Henry, production coordinator. Essential tasks were excep-tionally handled by copyeditor Joanne S. Allen, proofreader June Cuffner, and book designer Jean Wilcox. I am deeply indebted to each of these dedi-cated individuals who supplied the special skills that turned an unwieldy manuscript into a well-crafted book.

Those who knew the late George L. Mosse will recognize the extent to which his conception of cultural history has fundamentally influenced my approach to the study of German art.

And finally, this book is my loving tribute to Arnold Lewis, who was steadfastly certain that I could and would complete the voyage.

ACKNOWLEDGMENTS

Index

Page references in italics refer to illustrations and captions

Achenbach, Heinrich von, 138
Against the Current, 198
Agrarian League, 145
Aldenhoven, Carl, 365n.18
alienation of the public, from modern art, 317n.9. *See also* public and critic
Allen, Ann Taylor, 361n.84
Amsler & Ruthardt, 249
anti-Semitic political parties, 145, 153, 292–93
anti-Semitism, 48–50, *49, 52,* 77, *122,* 145, 325n.52; in art journals, 154, 354n.24; and the Berlin Secession, 309, 310, 312, *313; Judensau* images, 189, *190–91;* of Langbehn, 182, 362n.87; pervasiveness of, 153; and ritual murder, *191*
Applegate, Celia, 318n.3
aristocratic rank, 150, 353n.19
Arnhold, Eduard, 57, 309, 410n.97
art academies/schools: enrollment at, 191–92, 364n.8; proliferation of, 200–201, *201*
art criticism. *See* public and critic; *specific critics*
art dealers, 130, 159, 198–99, 205, 224, 226, 347n.72, 381n.24. *See also* art societies; *specific dealers*
artists' associations, 126
artists' festivals, 226–29, *228,* 374n.75
Artist West Club, 249, 382n.25
art journals, 98, 170. *See also specific journals*
art societies, 124–30, 345n.60, 346n.62, 347n.68; traveling art cycles of, 133–39, *134, 136–37,* 348n.80, 348–49nn.82–84. *See also specific societies*
Art Societies West of the Elbe, 135
Art Society for Rhineland and Westphalia (Düsseldorf), 132
Das Atelier, 260–61, 388n.50, 391n.68
Augustine, Dolores L., 353n.19
Avenarius, Ferdinand, 68–71, 73–75, 330n.89, 332n.104; on art dealers, 226; on art for the people, 122, 124, 142–43, 172, 279; on the Berlin International Art Exhibition, 116–17; on Böcklin, 77, 79, 333n.109; on the First International Dresden Exhibition, 118; on foreign art, 194; on Fritsch, 163, 356n.40; on *Jugend*, 295; on Klinger, 82, 85, 286; on Munch, 262; on national identity, 255; on *Pan*, 272–73, 394n.12; on Preuschen, *209;* on *Rembrandt as Educator*, 180, 181–82; on socialism, 204; on the Third International Art Exhibition, 104–6; on William II, 175–77, 360n.69

Bahr: "Two Studios," 222, *222*
Bahr, Hermann, 143–44, 167–68, *209,* 350n.5
Baluschek, Hans, 82
Balzer, L.: "The Dilettante's Prayer," *213*
Bantzer, Carl, 265
Barbizon School, 102, 104, 105, 106, 264, 390n.64
Bartels, Adolf, 354n.24
Bashkirtseff, Marie, 216, 370n.55
Bastien-Lepage, Jules, 106, 112, 118, 370n.55
Baudelaire, Charles, 317n.6
Bavarian art budget, 103, 107, 108, 128, 307–8, 339n.20, 340n.30, 384n.31
Becker, Benno, 144, 244, 378n.10
Beckh, Hermann, 67, 68
Begas, Reinhold: *The Electric Spark*, 100, *101*
Begas-Parmentier, Luise, 215; *View of Venice, 209, 210*
Béraud, Jean: *A Popular Assembly*, 43, 45, *45*
Berlepsch, Hans Eduard von, 154, 167–68, 172, 194, 243–44, 365n.13
Berlin: art world of, 97–98, 116–17, 232, 249, 375n.79; art world of, tensions in, 260–66, 389nn.52–55, 390n.59 (*see also* Berlin Secession); population of, 232, 338n.14
Berlin Academy Exhibitions (1887–1890, 1892), 100, 106, 114–16, *117,* 126–27, 144, 338n.15, 340n.27, 342n.41, 344n.53
Berlin Eleven, 157, 162, 356n.38; formation/critical reception of, 246–49, 380nn.18–19, 380n.21, 381n.24; second exhibition of, 263
Berliner Tageblatt, 171, 175
Berlin Illustrirte Zeitung, 171
Berlin International Art Exhibition (1891), 106, 116, 342–43nn.43–44
Berlin Jubilee Exhibition (1886), 14, 93–94, *95–96,* 96–100, 106, 107, 120, *121,* 340n.26
Berlin Secession, 289, 304–7, *305, 308,* 309–10, 312, 403n.54, 409nn.87–89, 409n.93, 410n.98, 411n.1
Berlin Society of Women Artists and Friends of Art, 207–8, 209, 214–15, 219, 370n.52
Bernhardi, Anna, 221
Bernstein collection, 70
Bie, Oscar, 72, 331n.95, 358n.57; on art criticism, 171–72; on the Berlin press, 98; on Pietsch, 171
Bierbaum, Otto Julius, 229, 268–69, 271, 273, 386n.41, 392n.4
Bierck, Thomas, 58
Bing, Siegfried, 118

INDEX

Bismarck, Otto, 224, 225
Blau-Lang, Tina, 221; *Tuilleries, Sunny Day,* 209, *210*
Bleichröder, Gerson, 353n.19
Bley, Fritz, 61, 328nn.73–74
Block, Joseph, 113, 114
blockbuster exhibitions (U.S.), 338n.12
Böcklin, Arnold, 46, 113, 332n.107, 333n.109; critical reception of, 280–82, 336n.131, 399n.35, 400n.37; *In the Play of the Waves,* 20, 78, 79–80, *81,* 85, 104, 105–6, *168,* 301; *Isle of the Dead, 168,* 180, *181; Prometheus,* 79, *80;* success/critical reception of, 78–82, *81,* 332n.107, 333n.109; Symbolism of, 284; *Villa on the Sea,* 230
Bode, Wilhelm, 73, *74,* 138, 349n.86, 354n.21, 362n.88, 410n.97; on art academies, 232–33, 364n.8; on overproduction, 191; at *Pan,* 275, 396n.19; and Werner, 232–33, 376n.81
Bodenhausen, Eberhard, 268–69, 271, 392n.4
Bong, Richard, 342n.42
Boskamp, Katrin, 325n.51
Bouguereau, William, 114, 116, 119; on salon, 378n.11
bourgeoisie, 124–25, 345n.60. *See also* art societies
Boznnska, Olga von, 373n.62
Brand, Bettina, 327n.62
Brandes, Georg, 83–84, 363n.3
Brandes, Otto, 61–62, 316n.3, 328n.75; on Liebermann and Uhde, 362n.1, 363n.3; on the salons, 378n.11
Brandt, Otto, 199
Braun, Louis, 34
Brentano, Clemens, 354n.22
Breslau Art Society, 133, 381n.22
Bridge (Brücke), 137, 349n.84
Brinckmann, Justus, 128
Bruckman, Friedrich, 39
Bühlmann, Joseph, 228, *228*
Burkhardt, Jacob, 128

Callwey, Georg D. W., 330n.88
cartoons, 146–50, 198, 238–39, 353n.18. *See also* Cassius, K.; *Fliegende Blätter;* Oberländer, Adolf; Schlittgen, Hermann; Stuck, Franz
Cassirer Gallery, 277–78, 311, 397n.24, 411n.101
Cassius, K., 56, *56,* 57, *57, 63;* "Arnold Böcklin," 79, *81;* "Begas, Reinh., 'A Great Equilibrium Production,'" *101;* "The Gentleman in White," 111, *111;* "Open-Air Painters' Victory Song," 75
Catholic art, 327n.68
Catholics: anti-Semitism of, 145; cultural battle against (Kulturkampf), 41–42, 48, 50–51; on Protestants, 42, 48, 58, 323n.34; on socialism, 58
censorship, 293, 405n.65
Center Party, 145
Central Association of German Citizens of the Jewish Faith, 145
Chicago world's fair (1893), 100

Christian faith, 87–91
Classical antiquity/tradition, 87–90, 94, 96–98, 154, 177, 189, 227; archaeological expeditions, 58–59, 94, 227, 327n.66
Cluseret, Paul, 328n.75
collectors, 309, 410n.97
Cologne Art Society, 132–33, 138–39, 348nn.76–77
Commeter, J. M., 130
Conrad, Michael Georg, 202–3
contemporary art for the modern nation, 28–92; Böcklin's paintings, 78–82, *80–81,* 332n.107, 333n.109; critical responses to, 60–68, *63, 66–67,* 89–92, 328nn.72–75, 329nn.77–79, 329n.83, 330n.87, 336n.132; demand for, 39–40, 322n.27; and German Empire's formation, 28–31, *29,* 41, 318nn.2–3; Klinger's works, 78–79, 82–89, *83–85, 86, 88* (see also Klinger, Max); in *Die Kunst für Alle,* 36, 37, 40, *41–42,* 41–46, *45,* 321n.21, 323n.35; in *Der Kunstwart,* 32, 37, 68–70, 320n.13; Liebermann's paintings, *18,* 46–54, *48–53, 55,* 325n.51 (see also Liebermann, Max); light-color painting, 62, 70–78, *71–74, 76, 78,* 329n.77, 331nn.95–96, 331–32nn.98–101, 332n.104; monuments/panoramas, 31–38, *32–33, 36–37,* 319nn.10–11, 320n.17, 320nn.13–14, 321nn.19–20; Pecht on, 38–46, *41,* 322n.24, 322n.27, 323n.35; Uhde's paintings, 46, 54–60, *55–57, 59* (see also Uhde, Fritz von). *See also* modernism; transient artistic styles
cooperative exhibitions, 201
Corinth, Lovis: *Salome II,* 287, *287; Walter Leistikow,* 257, *258*
Cornelius, Peter, 358n.56
Corot, Camille, 102, 104, 367n.32
Corpus Christi Day, 42, 323n.34
Courbet, Gustave, 46, 47, 55, 102, 119
Crailsheim, Krafft Freiherr von, 68, 108–9
Cranach, Lucas, 118
criticism. *See* public and critic; *specific critics*
Cubists, 137
cultural nationalism, 29, 318n.3

Dagnan-Bouveret, P. A. J., 112, 118, 119
Daller, Balthasar, 47–48
Darmstadt Secession, 265–66, 391n.66
Darwinism, 39–40, 285, 402n.46
Defregger, Franz von, 119, 223, 373n.65
Degas, Edgar, 118, 275, 278
Dehmel, Richard, 268–69, 271, 273, 335n.129
Deutsche Kunst, 128, 129, 134–35, 209, 346n.67
Diez, Julius: "Sweet Love Loves in May," 296–97, *298*
dilettantism, 208, 212–14, 221, 369n.48, 370n.51, 398n.29
Dorpalen, Andreas, 362n.89
Dreifus, Clara von: *In the Studio, 217*

Dresden, Hofmann/Klinger/Stuck controversies in, 157–63, 354n.29, 355n.36, 356nn.39–40
Dresden Art Association, 265
Dresden exhibitions, 117–18
Dresdner, Albert: on Hofmann, 157; on the public and critics, 167–68, 357n.49; on Thoma, 280; on women artists, 219, 368n.40
Dresdner Rundschau, 355n.36
Drey, Paul, 193, 206–7, 364n.9, 367n.36, 371n.59
Dückers, Alexander, 335n.130
Dürer League, 172
Düsseldorf Artists' Society 1899, 246
Düsseldorf exhibitions, 120, 344n.52
Düsseldorf Society of Artists, 245, 379n.13

East German Art Federation, 135
Eckmann, Otto, 295, 406n.73
economic status of artists. *See* finances of artists
Ehrenberg, Carl, 161–62, 355n.36
Eichler, Reinhold-Max: "The Martyrdom of the Woman Painter," *300–301*, 302; "The Serious Study," 303, *303*
Eitner, Ernst, 346n.66
Eley, Geoff, 351n.8
Elias, Julius, 256, 377n.4, 383n.28
Elias, Norbert, 318n.3, 328n.72
elite public. *See* public, elite
Erler, Fritz, *294*, 294–95; "I demand a hearing for the tale of the hallowed races," 303, *303*
Ernst Arnold Art Salon, 159, 160, 162, 347n.73
Ernst Zäslein Kunsthandlung (Berlin), 397n.24
Esser, Theodor: *The Strike of the Blacksmiths*, 43, *44*, 323n.36
exhibitions. *See* public, carrying art to; traveling exhibitions; *specific exhibitions*

Fauves, 137
Federation of Art Societies East of the Elbe, 135, 348n.80
Federation of South German Art Societies, 133–34, *134*, 135
Feldbauer, Max, *313*
feminism, 286, 402n.48. *See also* women
Fidus: *Prayer to Light*, *178*
Fiedler, Conrad, 322n.24
finances of artists: and artist-public hostility, 207; art prices, 205–6, 367n.36; and foreign art, 193, 194–95, 365n.10; juries, 195–96, *196*; the market, 192–94, *194*, 195, 198, 200–201, 364n.9; overproduction, 189, 191, 193–96, *194*, 198, 199, 200–201, 206, *206*, 365n.13; painter-princes of Berlin, 231–37, *233–36*, 375n.79; painter-princes of Munich, 221–31, *222–23*, *225*, *228*, *230–31*, 373n.65; pension and welfare societies, 221, 373n.64; poverty, 196–203, *197–202*, 205–6, 221–22, *222*, 365n.18, 366n.22, 366n.26; and socialism, 203–5, *206*,

366n.28; women artists, and overproduction, 207–14, *209–10*, *212–13*, 221, 368n.40, 368n.44, 369n.47; women artists, presence of/pressures on, 214–21, *217–20*, 370nn.51–52, 370n.55, 371–73nn.58–62
First Annual Munich Exhibition (1889). *See* Munich Annual Exhibitions
First International Art Exhibition (Munich, 1879), 102
First International Dresden Exhibition (1897), 118
Fischer-Cörlin, Ernst: "Toni Müller, the Woman Painter," *213*
"flatlands of the contemptible mob," 177
Fliegende Blätter: anti-Semitism of, 52, 150, 153, 325n.52, 354n.21; Berlepsch on, 172; on Böcklin, 79–80, *81*; circulation of, 146; on foreign art, 194–95; influence of, 146, 352n.12; Jewish stereotypes in, 149–50, *150–53*, 153–54, 353n.18; on Liebermann, *76*; on the lower classes, *148–49*, 149; on the "moderns" vs. the "ancients," 307, *308*; on new art, 67, 68; on painter-princes, 223, *223*; on *Pan*, 272; on the Paris Universal Exposition, 187; on poverty of artists, 197, *198–200*, 202, *202*; on the public's enjoyment of art, *147*, 147–48; Schultze-Naumburg on, 169, *170*; on the secessionists, 258, *259*; on transient styles, 241, *243*; on women artists, 211–12, *213*, *218*. *See also* Oberländer, Adolf
forgeries, 205, 224, 226, 367n.32, 374n.68
Franco-Prussian War, 28–31, 33–35
Franke, Ernst A., 317n.9
Frankfurt Art Society, 201
Franquet, Eugen von: *Schaupöbel*, *142*, 142–43, 157, *158*, 159, 160–62, 177, 248, 354n.29
Frederick William, crown prince and emperor, 93, 94, 116
Free Association of Dresden Artists, 160
Free Berlin Exhibition (1893), 195–96
Free Society of Berlin Artists, 261–62, 389n.55
Free Society of Darmstadt Artists, 265–66
Free Society of Düsseldorf Artists and Its Friends, 245–46, 379n.13
free trade, 192–93
Freihofer, Alfred, 172, 254–55, 377n.4, 385n.37
Frémiet, Emmanuel: *Gorilla Kidnapping a Woman*, 8, 9, 10–11, 13, *81*, 104–5, 316n.3
French art, 61, 328n.72; modern, 275–82, *276*, *281*, 349nn.83–84, 396–97nn.21–22, 397n.24. *See also* Impressionism; plein air painting
French National Society of the Fine Arts, 186
French Post-Impressionist exhibitions, 137–38, 349n.84
Fritsch, Gustav, 162–63, 166, 356nn.39–40
Fuchs, Eduard, 180, *181*, 224, 354n.21, 361n.82, 380n.18
Furniss, Harry: "Art Criticism," 164–65, *164–65*
Fürstenberg, Carl, 309
Furtwängler, Adolf, 227, 228

Gallén, Axel, 257
Gartenlaube, 171, 172, 358n.55

Gebhardt, Eduard von, 59

Gedon, Lorenz, 47

General Art Exhibition Calendar, 134, 135

General Conference of German Morality Associations, 291

General German Art Association, 126, 219–20

German Art Exhibition (Dresden, 1899), 118

German Art Society (Berlin), 138, 201, 262, 349nn.85–86

German Exhibition Federation, 134–35

German-National Commercial Employees' Union, 145

Gerresheim, Anna, 219, 373n.62

Glasgow Boys, 131, 144

Glass Palace (Munich), 102, *103,* 110

Goethe, Johann Wolfgang von, 197, *197*

Goltz, Alexander: *Portrait, 217*

Gossler, Gustav von, 93, 97, 99–100

Graef-Lepsius, Sabine, 371n.59; *Self-Portrait,* 219, *219*

Gratz, Th.: "Up-to-Date Improvements," *136*

Graul, Richard, 336n.135, 363n.3

Great Berlin Art Exhibitions (1893–1899), 117, 127, 142, 195, 196, 208, 306–7, 343n.44

Greenebäum, Jos.: "A Secret," *52*

Greenock, John, 357n.50

Greiner, Otto: *The Devil Displays the Female to the People,* 291, *291*

Griess, R.: "From an Art Exhibition," *170;* "High Modern," *156;* "In the Studio of a Modern Stylist," *283*

Grimm, Herman, 327n.62, 362n.88

Gronau, Georg, 174–75

Grösslein, Andrea, 339n.21

Grosz, George, 364n.7, 373n.65

Group G, 303–4, 408n.85

Grützner, Edward, 223, 367n.32

Gurlitt, Cornelius, *20,* 75, 128, 332n.101; on Bashkirtseff, 216, 370n.55; on Klinger, 84, 85, 91, 334n.121, 335n.123, 335n.125; on the public at art exhibitions, 155–57, *158,* 167–68; on *Rembrandt as Educator,* 362n.88

Gurlitt, Fritz, *20,* 70–71, 78–79, 390n.64

Gurlitt Art Salon, 70, 113, 208–9, 245, 249, 264–65, 283, 390n.64

Gussow, Carl, 70

Gutbier, Adolf, 159

Habermann, Hugo von, 70

Habich, Georg, 221

Hague School, 54, 102, 105

Hamburg Art Society, 131–32

Hamburg International Exhibitions (1894, 1895), 119

Hanover Art Society, 15, 132, 347n.75

Harbürger, Edmund: "The Art Parvenu," *150;* "Egotism," *151;* "Hardening," *49;* "A Modern Art Lover," *193, 194;* "The Public Prosecutor at the Art Exhibition," *173*

Harrison, Alexander, 161

Hartleben, Otto Erich, 290

Harzen, George Ernst, 130

Hass, F.: "People of East Asia, Protect Your Most Holy Possessions," *176*

Haushofer, Max, 214, 369n.49

Heilbut, Emil (*pseud.* Herman Helferich), 63–64, 320n.13, 329n.79; on art criticism, 165–66; on Liebermann, 236, 376n.87, 377n.2; on Symbolism, 283; on Uhde, 376n.87

Heine, Thomas Theodor: *The Fisherman,* 257, *258*

Helferich, Herman. *See* Heilbut, Emil

Hengeler, Adolf: "A Cheap Substitute," *109;* "The True Businessman," 150, 153, *153*

Herkomer, Hubert, 98, 104

Herrmann, Hans, 106

Herrmann, Johann Michael von, 130

Hermann monument (Teutoberger Forest), 31

Heyden, August von, 163, 356n.40

Heyden, Hubert von: *Morning Walk,* 159

Hirschfeld, Magnus, 145

Hirth, Georg, 110, 250, 294–95, 382n.27, 385n.35, 406n.70. *See also Jugend*

Hitz, Dora, 118, 209, 217, 220, 221, 368n.40, 368n.41; *Young Woman in a Poppy Field, 23,* 208

Hofmann, Ludwig von: critical/public reception of, 157, 159, 180, 249, 342n.43, 354n.29, 381n.22; *Evening Peace,* 156, *158; Lost Paradise (The Fall of Adam and Eve), 158,* 159, 248; at *Pan,* 275, 396n.17; *Spring, 24,* 248; *Springtime,* 248; *Symphony in Blue and Red,* 157. *See also* Berlin Eleven

Hofmann, Werner, 322n.27

homosexuality, 145, 292

Humann, Karl, 94

humor magazines, 146–48. *See also Fliegende Blätter*

Huysmans, Joris Karl, 323n.37

Huyssen, Andreas, 357n.44

The Image of Christ in German Art (1896), 58, 327n.65

immigrant workers, 146, 351n.11

imperial sculptures (Triumphal Avenue), 312–14, *314,* 412n.3

Impressionism: critical reception of, 61–63, *63,* 65, 328nn.73–75; as intransigent, 64; in *Pan,* 275, 396n.18

International Exhibition of Watercolors, Pastels, Drawings, and Engravings (Dresden, 1887, 1890, 1893), 117–18

International Women's Congress on Tasks and Goals of Women, 145

Israel, Richard, 309

Israëls, Jozef, 54, 119

Jäger, Eugen, 60, 68

Jensen, Robert, 317n.8, 380n.16

Jesus, 49–51, 58, 88–89, 90

Jews: as art collectors, and wealth, 309, 310, 354n.21,

410n.97; assimilation of, 150, *151*, 353nn.18–19; as Germany's "misfortune," 153, *154*; *Judensau* images of, 189, *190–91*; and modern art, 309, 310, 312, *313*, 411n.2; as philistine art collectors, 150, *151–53*, 153–54, 354n.22; pornography charges against, 292–93. *See also* anti-Semitism

Jeziorkowski, Klaus, 360n.71

Jordan, Max, 94, 128, 355n.33

journals, circulation of, 39, 322n.25

Judensau images, 189; *The Great Judensau, 190–91*

Judith images, 286, 402n.48

Jugend, 312, *313*; anti-Semitism of, 154, 304, 312, *313*; cartoons in, 174; on the imperial sculptures, 314, *314*; modernism of, 294, *294–99, 296–301*, 301–4, 303, 307, 406nn.70–71, 407nn.76–77, 408n.85; on overproduction, *206*; publication/success of, 303, 408n.84; "The Self-Portraits of Painter Modeslaw Manierewicz," 241, *242*; women artists in, 302, 408n.82

juries, 195–96, *196*

Kaemmerer, Ludwig, 65–66

Kaiser Panorama, 320n.14

Kalckreuth, Leopold von, 70, 200, 366n.22; *The Rainbow, 266*

Kampf, Arthur, 106–7, 116, 340n.27

Kandinsky, Wassily, 137, 349n.84

Kant, Immanuel, 328n.72

Karlsruhe Academy, 265

Karlsruhe Artists' League, 265

Kaulbach, Friedrich August von, 200, 224; "Lenbach as Painter of Bismarck," *225*

Keller, Albert: *Witch's Sleep, 104, 105*, 289, 403n.53

Keller, Ferdinand: *Emperor William, 8, 10, 11, 13*, 28, 29, 99, 104–5, 316n.2, 317n.1

Keller & Reiner (Berlin), 249, 277–78, 397n.24

Kessler, Count Harry, 268–69, *270*, 392n.4

Keyserling, Eduard von, 169

Khaynach, Friedrich Freiherr von, 360n.68

Khnopff, Ferdinand, 159

Kirchbach, Wolfgang, 74

Kirchner, Eugen: "Children and Fools," *173*; "Difficult Task," *152*; "Genteel," *151*; "The Sick Cow," *218*

Kladderadatsch, 148, 294, 406n.68, 409n.89

Klinger, Max, 46, 118; *Beethoven*, 412n.5; *The Blue Hour, 119*, 159, 344n.51; *Christ in Olympus, 86, 87, 88, 89*, 90–91, 118, 310, 335n.127, 335n.129; critical reception of, 82–87, 89–92, 334n.118, 334nn.120–21, 335n.125, 336n.131, 336n.135; *The Crucifixion of Christ, 21*, 85–91, *86, 88*, 159–60, *162, 164*, 248, 334–35nn.122–24, 335n.127, 411n.2; *Deliberation on a Competition on the Theme of Christ, 82, 83*; *Drama (Opus IX)*, 82–83, 333n.115; *Eve and the Future*, 82; *Fantasy over Finding a Glove*, 82; *Fettered, 83, 84*, 84–85; *The Judgment of Paris*, 85,

86, 87, 100, 104, 334nn.120–21; *A Life, Opus VIII, 83, 84*, 84–85; *A Love*, 83; "A Mother," 82–83, 333n.115; *The New Salome*, 25, 286–87, *288*; as painter-prince, 232; *Pietà, 87, 90*, 159, *160–62, 161*, 355n.31; *Prometheus Unshackled, 181*; public reception of, 157, 159, 180; *Return from the Sermon on the Mount, 82, 83*; *Shame, 83, 84*, 84–85; success of, 355n.31; *Surprise Attack at the Wall, 82*, 333n.114; Symbolism of, 284; William II on, 175. *See also* Berlin Eleven

Kögel, Linda, 118, 209, 220, 221

Kolbe, Georg: "Go not to the people nor remain in the wasteland!" *178*

Kollwitz, Käthe, 82, 84–85, 221, 336n.131, 373n.62

Kölnische Zeitung, 73–74, 171, 331n.98, 342n.41

Koopmann, W., 320n.13

Köpping, Karl, 118, 186

Kratzsch, Gerhard, 330n.88

Kretzer, Max, 121–22, 198, 345nn.55–56

Kreuzzeitung, 186

Krohg, Christian, 83–84, 161

Kuehl, Gotthardt, 70, 118, 186; *Pont-Royal in Paris, 72*

Kunstchronik, 35; on art prices, 205–6; on art schools, 200–201; on foreign art, 195; on Hofmann, 157; on Liebermann, 64–65; on Munich Annual Exhibitions, 112; on the Paris Universal Exposition, 186; on *Rembrandt as Educator*, 182; on Uhde, 329n.83; on William II, 175; on women artists, 216, 221

Die Kunst für Alle, 321n.22; on art societies, 125, 132, 348n.76, 349n.85; on the Berlin Academy Exhibitions, 107; on the Berlin Jubilee Exhibition, 97; circulation of, 39; on contemporary art for the modern nation, 36, 40, *41–42*, 41–46, *45*, 323n.35; critics, new vs. old, 238, 377n.2; on cycles of art, 133–35, *134*, 348n.80; on forgeries, 205; goals/focus of, 260, 278, 398n.28; on Impressionism, 61–62; on Liebermann, 51, 63–64, 66, 186, 329n.79, 362n.1; on markets, 193; on monuments/panoramas, 36, 37, 321n.21; on Munich Annual Exhibitions, 112; on Nietzsche, 180; "Non-Exhibition of the Art Society Paranoia," 315, 412n.5; on painter-princes, 224; on the Paris Universal Exposition, 186–87; on Parlaghy, 211, 368n.44; on Prussian vs. Bavarian art budgets, 103, 107, 339n.20; on the public at art exhibitions, 154, 172–74; publication of, 98; on *Rembrandt as Educator*, 182–83; on Stuck, 230; on the Third International Art Exhibition, 102, 104; on Uhde, 51, 53, 62–63; on William II, 175; on women artists, 212, 216, *217*, 219, 220, 221, 289–90, 404n.55. *See also* Pecht, Friedrich

Kunstpöbel (art rabble), 142, *143*, 244, 350n.1, 350n.3. *See also* public and critic

Kunstsalon Ribera (Berlin), 397n.24

Kunst und Künstler, 64

Die Kunst unserer Zeit, 112, 155, 220, 341n.36

INDEX

Der Kunstwart, 330n.89; anti-Semitism in, 154, 354n.24; on art profiteers, 198–99; on art societies, 127–28; on the Berlin Academy Exhibitions, 116; on the Berlin International Art Exhibition, 116; on Böcklin, 79; circulation/success of, 68–69, 279, 330n.88, 399n.32; on exhibition of jury rejects, 195; on the First Annual Munich Exhibition, 111; on Klinger, 85; on light-color painting, 74–75, 77; on monuments/panoramas, 32, 37, 320n.13; on Munich Annual Exhibitions, 112; nationalism of, 279–80; on open-air art, 68–70; on the Paris Universal Exposition, 186–87; on Preuschen, 209; on the public at art exhibitions, 154; publication of, 98; on socialism, 203, 204; on women artists, 219. See also Avenarius, Ferdinand

Kurowski, Margarethe von, 373n.62

Kyffhäuser monument, 31

labor unrest, 43–44, 146, 324n.38

Ladies' Academy (Munich), 214

Langbehn, Julius: Rembrandt as Educator, 180–83, 195, 361nn.83–84, 362nn.87–89, 365n.14

Lange, Konrad, 206, 314

Langenstein, York, 345n.60, 347n.71

Langhammer, Arthur: "At the Art Exhibition," 158

League of German Women's Associations, 145, 215

Lehnert, Hildegard, 368n.41

Lehrs, Max, 82, 332n.107, 333n.113

Leibl, Wilhelm, 47, 105, 113, 118, 331n.95; Three Women in the Church, 70, 71

Leighton, Frederic, 98

Leipzig Museum of Art, 131

Leiss, Ludwig, 335n.123

Leistikow, Walter, 118, 248; Grunewald Lake, 304, 305, 305, 308, 309–10

Leixner, Otto von, 69, 120, 350n.3, 359n.62

Lenbach, Franz von, 47, 49, 119, 130; Arcadian festival of, 227–29, 228; critical reception of, 195, 229, 336n.131; forging of signature of, 224, 226, 374n.68; Portrait of Otto Prince Bismarck in Civilian Dress, 224, 225; The Serpent Game, 230; and Stuck, 230, 375n.77; success of, 226

Lenman, Robin, 319n.10

Leonardo da Vinci, 307

Lex Heinze, 292, 293–94, 301

Lhermitte, Léon, 112, 118

Lichtenberg Art Salon, 159, 160, 355n.32

Lichtwark, Alfred, 92, 119, 127, 128, 132, 344n.50, 355n.35; on Böcklin, 282; on dilettantism, 398n.29; dilettantism promoted by, 369n.48; modern art promoted by, 172, 174; on Pan, 274

Liebermann, Max, 106–7, 118, 346n.66; Arbeiter im Rübenfeld, 325n.46; Baby Piglets, 190–91; in the Berlin Jubilee Exhibition, 97–98 (see also specific works); and the Berlin Secession, 305, 306, 312, 313, 409n.92; The Bleaching Field, 70; as a collector, 309; critical reception of, 48–49, 60–66, 63, 66, 325n.46, 325n.50, 329n.79, 336n.131; Farrowing Pen–Pigpen, 73, 73; Flax-Scourers in Laren, 77, 78, 104, 106–7, 340n.27, 342n.43; Free Time in the Amsterdam Orphanage, 63–64, 234; Home for Old Women in Leyden, 70; In the Studio, 234, 235; Jesus in the Temple, 49, 50; Legion of Honor received by, 189, 233, 364n.6, 376n.83; Mayor Carl Friedrich Petersen, 247, 247, 248, 346n.66; modernism of, 112–13; Munich Beer Garden, 104, 106–7, 340n.27; The Net-Menders, 54, 55, 70, 113, 187; Old Men's Home in Amsterdam, 104; Old Woman with Goats, 55, 65, 66, 113, 191, 247; open-air painting by, 76; as painter-prince, 232, 233–36, 237, 376n.83, 376nn.85–87; at Pan, 275, 396n.17; and the Paris Universal Exposition, 186, 187, 362n.1; Pig Market in Haarlem, 66, 67, 68, 191; portraits by, 376n.84; Potato Harvest, 159; retrospective of, 233, 235, 376n.83; Rope-Walk, 70; Shoemakers Workshop, 234; Striding Farmer, 76; success of, 61; on transient styles, 239, 377n.3; The Twelve-Year-Old Jesus in the Temple among the Elders, 18, 47, 48–51, 50, 56, 66, 102, 289, 325n.51; and Uhde, 53–54; Wilhelm Bode, 74; Women Making Preserves, 46–47; Women Plucking Geese, 301. See also Berlin Eleven

Liegnitzer Art Society, 133

Lier, H. A., 159–60, 163, 355n.36, 356n.38, 356n.40, 356n.42

light-color painting, 62, 70–78, 71–74, 76, 78, 329n.77, 331nn.95–96, 331–32nn.98–101, 332n.104. See also open-air painting

Liljefors, Bruno, 161

Lobedan, Clara, 368n.41

lotteries and public patronage, 125–26, 132–33, 138, 348n.76, 349n.86

Lübke, Wilhelm, 327n.62

Lücke, Hermann, 65

Ludwig, Prince, 109

Ludwig II, king of Bavaria, 94

Luitpold, Prince, 47

Luitpold Group (Munich), 258–60, 387–88nn.46–47

Lustige Blätter, 148, 236, 237

Luther, Martin, 191

Lutz, Johann Freiherr von, 48, 108

Lützow, Carl von, 254

Makart, Hans, 222, 223; Entrance of Karl V into Antwerp, 338n.11

Makela, Maria, 340n.34, 346n.63, 355n.31

Malkowsky, Georg, 116, 128, 216, 342n.42

Manet, Édouard, 112, 278, 341n.38, 347n.70; critical reception of, 61, 119, 328nn.73–74; In the Conservatory, 129, 276, 276, 309; in the Munich International Exhibition, 102

Mann, Heinrich, 342n.42

Mann, Thomas: *Gladius Dei*, 230, 340n.26, 375n.77
Marchand, Suzanne L., 337n.4
Marées, Hans von, 131
markets for art, 192–94, *194*, 195, 198, 200–201, 364n.9. *See also* overproduction
Marr, Carl: *The Flagellants*, 135–36, *137*, 323n.35
Marr, Wilhelm, 48
materialism, 77, 332n.104
Mathildenhöhe (Darmstadt), 265–66
Mathilde Rabl Kunstsalon (Berlin), 397n.24
Max, Gabriel, 104; *Monkeys as Critics*, 111–12, *113*
May, Karl, 360n.71
Mediz-Pelikan, Emilie: *Karl Mediz*, 265, *265*
Mehring, Franz, 203
Meier-Graefe, Julius, 268–69, 271, 273, 282, 393n.9, 400n.38
Meissner, Franz Hermann, 230, 334n.118, 375n.78
Meissonier Salon, 245, 378n.11
Mendelsohn, Henriette, 212–13, 220, 222–23, 371n.58, 372n.61
Menzel, Adolph, 97, 106, 113; *Christ as a Youth in the Temple*, 50, *51*; *Coronation of King William I*, 93, 318n.6; critical reception of, 116, 336n.131; *Frederick and His Men at Hochkirch*, 93; *The Iron Rolling Mill*, 40, 187; and the Paris Universal Exposition, 186; *Procession in Gastein*, 41–43, *42*, 323n.35; *Reality and Posthumous Fame*, 40, 197, *197*; *Supper at the Ball*, 40
Meunier, Constantin, 118
Meyer, Alfred Gotthold, 66, 114, 144
Michel, Louise, 43
Millais, John Everett, 98
Millet, Jean-Françoise, 54, 102, 104
Möbius, Paul J., 296–97, 407n.79
Moderne Kunst (Modern Art in Master-Woodcuts after Paintings and Sculpture of Famous Contemporary Masters), 116, 175, 216, 235, 342n.42
modernism: definition/use of, 12–13, 60, 157, 316–17nn.6–7; French, 275–82, *276*, *281*, 396–97nn.21–22, 397n.24; and individualism/diversity, 267–68, 392n.1; and Jews, 309, 310, 312, *313*, 411n.2; of *Jugend*, 294, 294–99, *296–301*, 301–4, *303*, 307, 406nn.70–71, 407nn.76–77, 408n.85; and moral purity, 290–94, *291*, 299, 301, 405n.60, 405n.65, 406n.67; of museum directors, 308–9, 409n.95; vs. nationalism, 268, 276–80, 285, *291*, 307–9, 398n.29; of *Pan*, 268–75, *270*, *272*, 278–79, 285–86, 392–93nn.3–7, 393n.9, 394–96nn.12–19; Salome images, *25*, 286–89, *287–88*, 290, 403n.49, 403n.53, 404n.56; Symbolism, 282–90, *283–84*, *287–88*, 400–401nn.39–40, 401nn.42–43. *See also* contemporary art for the modern nation
Mommsen, Wolfgang J., 318n.3
Monet, Claude, 112, 118, 119, 278
monuments, 31–32, *32–33*, 319nn.10–11, 320n.13

moral purity, 290–94, *291*, 299, 301, 405n.60, 405n.65, 406n.67
Morawe, Ferdinand, 159, 355n.32
Mortimer, Richard, 244, 376n.86
Mosse, George, 292, 319n.10, 405n.61
Mosse, Rudolf, 138, 309, 410n.97
Müller, Ludwig August von, 68
Munch, Edvard, 136, 196, 257, 349n.83, 350n.2; controversy over exhibition of, 261–63, 390n.59
Münchener Neueste Nachrichten, 110, 251
Munich Academy of Art, 192, 200, 366n.22
Munich Annual Exhibitions: First (1889), 56, *56*, 75, 110–12, 194, 340n.34; Second (1890), 144, 194; Third (1891), 112, 117, 194, 195, 198, 343n.44
Munich Artists' Association, 102, 110, 112, 126, 195, 215, 340n.32, 346n.63. *See also* Munich Secession
Munich Art Society, 102, 127, 128, 130, 135, 136, 347n.71
Munich art world, 108–9, 114, 312, 340n.26, 411n.1
Munich Free Society, 257, *258*, 387nn.44–45
Munich International (1888). *See* Third International Art Exhibition (Munich, 1888)
Munich International Art Exhibitions: (1869), 102; First (1879), 102; Third (1888), 8, 9, 11, *14*, 69; —, income from sales at, 195; —, and the public, 100, 102–6, *103*, 339n.19, 339n.21, 340n.26; Sixth (1892), 341n.40; Seventh (1897), 125–26
Munich Secession, 142, 157, *158*, 159, 160; vs. Berlin Secession, 312, 411n.1; exhibitions of, 252–53, 256, 384–85nn.32–34, 386n.42, 387n.46; formation of, 246–47, 250–51, 382–83nn.27–28; modernism/internationalism of, 252–54, *253*, 255, *258–59*, 384n.30, 385n.35; and national identity, 254–55, 385n.37; Rosenhagen on, 260–61, 264; success of, 253, 254, 256, 257
Munich Society of Women Artists, 209, 215
Münzer, Adolf: "The Artist Marriage," *300–301*, 302
Muther, Richard, 35–36, 66, 68, 321n.19; on Liebermann, 65; on the Third International Art Exhibition, 104, 106; on Uhde, 65

National Gallery (Berlin), 276–77, 309–10, 396–97nn.21–22, 410–11nn.98–99
national identity, bourgeois ideal of, 145, 266
nationalism vs. modernism, 268, 276–80, 285, *291*, 307–9, 398n.29
National Socialists, 314–15, 335n.127
Nazarenes, 358n.56
neo-idealism. *See* Symbolism
Neo-Impressionism, 277
Neue Deutsche Rundschau, 171, 358n.57
Neumann, Carl, 74–75, 207, 332n.100
New Art Society of Munich, 349n.84
newspapers, 170–71, *172*, 358n.55
Niederwald monument, 31, *32*

Nietzsche, Friedrich, 50–51, 360n.71; influence of, 177–80, *181*, 183, *270*, 271, 361n.75, 361n.82, 377n.3, 393n.9; *Thus Spoke Zarathustra*, 177–79, *181*, 271, 361n.75

Nipperdey, Thomas, 318n.3, 357n.44

Nissen, Momme, 112–13, 363n.3

Nochlin, Linda, 322n.27

Nordau, Max, 179–80, 183, 271–72, 361n.80, 394n.11

North German Federation, 135

November Society (Berlin; *formerly* Society of Four), 23, 250, 382n.25

nudity in the arts, 292, 293–94, 405n.65, 406n.67

Oberländer, Adolf: "The Ancestral Portrait," *152*; "At the Painting Exhibition," 168, *168*; "At the Show Window of a Book Dealer," *153*; "Carnival Picture," *52*; "The Commercial Councillor before and after Receiving His Honorary Title," *151*; "From the Heyday of Open-Air Painting," *63*; "The Housewife at the Art Exhibition," *155*; "The Modern Enjoyment of Art," 147, *147*; "Naturalism in Sculpture," *33*; "The Newest Panorama Painting," *36*; "The Painter in the Countryside," *148*; "The Pastel Painter," 67, *68*; "Practical Proposal," 195, *196*; "The Strike of the Master," 223, *223*, 226; "Understood," *14*

obscenity/pornography, 285–86, 291, 292–93, 301, 401n.44

Oettingen, Wolfgang von, 170–71

Olde, Hans, 70

open-air painting, 61–63, 68–70, 329n.77. *See also* light-color painting

Osteria (Berlin Jubilee Exhibition), *121*, 337n.4

Ostini, Fritz von, 56, 326n.60

overproduction, 189, 191, 193–96, *194*, 198, 199, 200–201, 206, *206*, 365n.13

Paczka-Wagner, Cornelia, 118, 372n.60; *Death and Superman*, 219, *220*, 290

painter-princes: of Berlin, 231–37, *233–36*, 375n.79; of Munich, 221–31, *222–23*, *225*, *228*, *230–31*, 373n.65

Pan: Böcklin in, 280–81, *282*, 399n.35; vs. *Jugend*, 294–95, 406n.73; modernism of, 268–75, *270*, *272*, 278–79, 285–86, 392–93nn.3–7, 393n.9, 394–96nn.12–19; on women, 290, 404n.56

Panama Canal Company, 224, 374n.68

panoramas, 32–38, *36–37*, 320n.14, 320n.17, 321nn.19–20

Paret, Peter, 318n.8

Paris Commune (1871), 46

Paris Salon, 11, 245, 316n.3, 378n.11

Paris Universal Exposition, 94, 100, 337n.2; critical/press reception of, 186–87, 363nn.2–3; German participation in, 186–87, 363n.2; and Liebermann, 186, 187, 362n.1; plein air painting at, 187

Parlaghy, Vilma, 209–11, 368n.41, 368n.44; *Portrait of Emperor William II*, 211, *212*

parody, politics of, 340n.34

patronage. *See* lotteries and public patronage

Paul, Bruno, 298; "The Painters' Meadow," *300–301*, 302

Paulsen, Theodor, 127, 201

peasants, political involvement of, 145

Pecht, Friedrich, 10–11, 316n.2, 339n.23; on art criticism, 357n.50; on art for the people, 142–43; on the Berlin Jubilee Exhibition, 97, 98, 338n.9; on Böcklin, 79; conservatism of, 238; on *Fliegende Blätter*, 352n.12; on foreign art, 193; on French art, 61, 62–63, 328n.72; on Impressionism, 62, 328n.75; on Klinger, 85–86; on Liebermann, 47, *48*, 60–61, 62–63, 325n.46; on Manet, 341n.38; on monuments/panoramas, *32*, 36, 39; on Munich, 109–10; on Munich Annual Exhibitions, 110; on the Munich Art Society, 127, 128, 130, 347n.71; on national vs. academic/international art, 38–46, *41*, 278, 322n.24, 322n.27, 323n.35; on overproduction, 193, 365n.10; on Preuschen, 209; on *Rembrandt as Educator*, 180–81, 362n.89; on Scandinavian artists, 341n.38; on the Third International Art Exhibition, 104; on Toorop, 377n.4; on Uhde, 51, 53, 60–61, 62–63, 326n.56; on William II, 175

people, art for, 34, 38–40, 278–80. *See also* public

People's Association for a Catholic Germany, 145

Perfall, Anton von, 230, 375n.77

Perfall, Karl von, 116, 143, 166–68, 243, 283, 342n.41, 357n.49, 378n.6

Pergamum panorama and altar (Berlin Jubilee Exhibition), 94, *96*

Pfaffinger, Michaela: *Self-Portrait as Painter*, *217*

Philippoteux, Félix, 33

Pietsch, Ludwig, 35, 100, 171, 321n.18

Piglhein, Bruno, 58–59, 88, *173*, 321n.19; 327nn.66–67

Pissarro, Camille, 118, 119

Plehn, Anna L., 220, 372n.61

Plehn-Lubochin, Rose, 372n.62

plein air painting, 62–63, 187, 329n.77, 330n.87

Plowed Earth (Munich), 260, 304, 388n.49

pointillism, 62

pornography. *See* obscenity/pornography

Post, 171

poverty of artists, 196–203, *197–202*, 205–6, 221–22, *222*, 366n.18, 366n.22, 366n.26

Preuschen, Hermine von, 211, 215, 221, 316n.4; *Irene von Spilimberg on the Burial Gondola*, 136, 208, *209*, 316n.5, 348n.82; *Mors Imperator*, *11*, 11–12, 13, 100, 136; on women's emancipation, 145

proletarian art, 46–47, 54–57, 204–5

prostitution, 291, 292, 405n.60

protectionism, 192–93

Protestant art, 58–59

Protestant League for the Defense of German Protestant Interests, 58

Protestants: anti-Semitism of, 48; on Catholics, 42, 48, 58, 323n.34; on socialism, 58

Prussian lieutenants, 164, *164*

public, carrying art to, 93–139; art societies, 124–30, 345n.60, 346n.62, 347n.68 *(see also specific societies);* art societies, traveling art cycles of, 133–39, *134, 136–37,* 348n.80, 348–49nn.82–84; Berlin Academy Exhibitions (1887–1890, 1892), 100, 106, 114–16, 117, 126–27, 338n.15, 340n.27, 342n.41, 344n.53; Berlin International Art Exhibition (1891), 116, 342–43nn.43–44; Berlin Jubilee Exhibition (1886), 93–94, *95–96,* 96–100, 106, 107, 120, *121,* 337n.2, 337n.4, 338nn.9–10, 338n.12; exhibition halls/paintings, 99; exhibitions, and benefits of public attraction, 106–10, *109,* 340n.28, 340n.30, 340n.32; exhibitions, expansion of/critical disdain for, 117–24, *121–23,* 344nn.49–52, 345n.55; Great Berlin Art Exhibitions (1893–1899), 117, 127, 343n.44; lotteries and public patronage, 125–26, *132–33,* 138, 348n.76, 349n.86; Munich Annual Exhibitions, 102, 107, 110–14, 117, 339n.17, 340n.28, 343n.44 *(see also* First Annual Munich Exhibition); Third International Art Exhibition, 100, *102–6, 103,* 339n.19, 339n.21, 340n.26

public, definition of, 123, 345n.58

public, elite, 238–66, 278–80, 315; Berlin art world, tensions in, 260–66, 389nn.52–55, 390n.59; secessionists, 243–46, 257–59, 264–66, 378n.11, 379–80nn.13–16, 387n.44; and transient artistic styles, 238–43, *239–40, 242,* 377n.4, 378n.6. *See also* Berlin Eleven; Berlin Secession; Munich Secession; *Pan*

public and critic, 142–83, 350n.2; critics and public discontent, 169–74, *170, 173,* 357n.51, 358nn.54–55, 359n.62; Hofmann/Klinger/Stuck controversies, 157–63, 354n.29, 355n.36, 356nn.39–40; and Langbehn's *Rembrandt as Educator,* 180–83, 361–62nn.83–84, 362nn.87–89; Nietzsche's influence on, 177–80, *181,* 183, 361n.75, 361n.82; the philistine public, *143,* 143–57, *147–56,* 243, 354n.22; public and artist, growing rift between, 163–68, *164–65, 168,* 282, 356n.42, 357n.44, 357nn.49–50; and William II, 259n.67, 360n.69; William II and the "flatlands of the contemptible mob," 174–77, *176*

public patronage. *See* lotteries and public patronage

railroads, 99, 136

Rappard, Clara, 221

Rathenau, Walther, 189, 309, 364n.6

rationalism, 77, 332n.104

Reber, Franz von, 36, 53, 54, 63, 326n.56

Reinheimer, A.: "Dream of a Critic," 168, *168;* "Poster (after a Famous Example)," *231*

Reinicke, Emil: "The Gloomy Tale of Macho Typter and Moses Rypter," *152;* "Mischievous Put-down," *213*

Reinicke, René: "Strong Imagination," *199*

Relling, Dr. *See* Springer, Jaro

Renan, Ernst, 56

Renoir, Pierre-Auguste, 119

respectability/manners, 45–46

Rethel, Alfred, 126

Rhenish Art Society Cycle, 135, 348n.80

Richter, Emil, 347n.73

Richter, Ludwig, 46, 187, 363n.4

Ring (Munich), 260, 388n.49

Rochegrosse, Georges, 114, 341n.40

Rodin, Auguste, 118

Roeseler, A.: "On the Road: Past and Present," 198, *200,* 221–22

Röhl, John C. G., 318n.2

Roll, Alfred, 119

romantic genius, 177

Roosevelt, Theodore, 210

Roper, Katherine, 345n.56

Rops, Félicien, 129, 275, 285–86, 402n.45

Rosenberg, Adolf: on the Berlin Academy Exhibitions, 100, 144, 344n.53; on the Berlin Eleven, 247, 248, 380n.21; on the Berlin Jubilee Exhibition, 337n.2; on Fritsch, 166; on Hofmann, 157; on Klinger, 333n.115; on Liebermann, 63, 65, 235–36; on Munch, 262–63, 390n.59; on the National Gallery, 276; on panoramas, 35, 321n.18; on poverty of artists, 366n.22; on the public's ignorance, 263–64; on Uhde, 56, 63, 65, 329n.83; on Ury, 331n.95; on women artists, 209–10, 216

Rosenhagen, Hans, 54, 232, 391n.68; on German artists, 311, 411n.101; on Impressionism, 311; on Munch, 263; on Plowed Earth, 304; on the secessionists, 260–62, 264, 266, 312, 389n.55; on Symbolism, 283; on women artists, 404n.55

Rossmann, Hans, 296, 297

Royal Academic Institute for the Fine Arts (Berlin), 191–92

Royal Academy (Munich), 126

Royal Academy of Art (Dresden), 117

Royal Painting Gallery (Dresden), 160–61, 162

Sachse, Louis, 130

Sale Hall for Women Artists (Munich), 220

Salome images, 25, 286–89, *287–88,* 290, 403n.49, 403n.53, 404n.56

Salon of the Rose + Croix, 283, 400n.39

Saxon Art Society (Dresden), 127, 131, 347n.73

Scandinavian art, 187, 257, 341n.38

Schadow, Johann Gottfried, 97

Schauff, Richard: "The Thrifty Artist's Wife," *199*

INDEX

Schaupöbel (exhibition rabble), 142, 143, 244, 350n.1, 350n.3. *See also* public and critic
Scheffler, Gisela, 334n.122
Schewpp: "Power of Habit," *151*
Schiller, Friedrich, 189, 363n.5
Schinkel, Carl Friedrich, 33, 93, 97
Schliepmann, Hans, 163–64
Schlittgen, Hermann, 70, 73, 100, 113, 114; "Art and Love," *109;* "At the Art Exhibition" (1890), 147, *147;* "At the Art Exhibition" (1896), 164, *164;* "The Best Direction," *218;* "Dream of a Painter after Visiting the Art Exhibition," 239, *239,* 241; "In the Studio of a Modern Artist," 202, *202;* "Metamorphosis," *240,* 241; "The Modern Painter in the Country," *76;* "Portraits of Life from the World of Women," *213*
Schlüter, Andreas, 93
Schmid, Max, 91, 263–64
Schmidhammer, Arpad: "Anton the Painter of Boots," *233*
Schmidkunz, Hans, 369n.48
Schneider, Sascha: *Meeting Again, 284,* 284–85, 401n.42
Schneider, Theodore, 90–91
Schopenhauer, Arthur, 87, 89, 335n.130
Schrader, C., 130
Schubart, Martin, 309, 410n.96
Schuchhardt, Carl, 90, 91, 336n.134
Schulte Art Salon (Berlin), 142, 157, 164, 248–49, 349n.83, 381n.24. *See also* Berlin Eleven
Schultze-Naumburg, Paul, 342n.41; career of, 358n.53; on *Fliegende Blätter,* 352n.12; on Hofmann, 157, 159; on Lenbach, 229; on the National Gallery, 276; Nietzsche's influence on, 361n.82; on poverty of artists, 205; on the public, 169–70, *170,* 172, 358n.54
Schumann, Paul, 233, 355n.36
Schuster-Woldan, Raffael: *The Woman Painter, 259,* 259–60
Schwabe, Emil: *Unsolved Questions, 40, 41*
Schwartz, Friedrich, 39
Schwind, Moritz von, 187, 363n.4; *The Boy with the Magic Horn,* 189, *190–91; The Captive Princess, 190–91*
Scientific Humanitarian Committee, 145
secessionists, 243–46, 257–59, 264–66, 378n.11, 379–80nn.13–16, 387n.44, 391–92nn.67–68. *See also specific groups*
Second Annual Munich Exhibition (1890), 144, 194
Seemann, Artur, 335n.124
Seemann, Theodor, 128–29, 139, 347n.68
Segantini, Giovanni, 133
Seidlitz, Woldemar von, 15, 131, 330n.88, 362n.88
Seitz, Otto: "To the Pure Everything Is Pure," 299, 301
Servaes, Franz, 128
Seventh International Art Exhibition (Munich, 1897), 125–26
Shachar, Isaiah, 363n.5
shame pictures (*Judensau* images), 189, *190–91*

Sievers, Clara, 221
Siewert, Clara, 373n.62; *Self-Portrait with Palette,* 209, *210*
Signac, Paul, 275, 349n.84
Simon, James, 309
Simon of Trent, *191*
Simplicissimus, 148, 174, *201,* 294, 307
Singer, Hans, 86, 87, 91
Sisley, Alfred, 112, 119
Sixth International Art Exhibition (Munich, 1892), 341n.40
Skarbina, Franz, 71, 106, 113, 114, 248, 331n.96. *See also* Berlin Eleven
Slevogt, Max, 118; *Lady Adventurer,* 287–88, *288*
Social Democratic Party, 146, 203–4
socialism, 41, 43–44, 46, 58, 324n.38; and the finances of artists, 203–5, *206,* 366n.28
Society 1897 (Berlin), 250, 382n.26
Society for Friends of Art (Leipzig), 131
Society for the Promotion of Art (Stuttgart), 132
Society of Berlin Artists, 94, 96, 116, 126–27, 261, 342n.43, 346n.63, 389n.52. *See also* Berlin Secession
Society of Dresden Artists (Secession), 265
Society of Eleven. *See* Berlin Eleven
Society of Free Art (Berlin), 250, 382n.26
Society of German Watercolorists (Berlin), 249–50, 382n.25
Society of Visual Artists of Munich. *See* Munich Secession
Society of Women Artists (Munich), 214, 219, 371n.59
Society of Women Artists and Friends of Art (Leipzig), 215
Spier, Anna, 220, 267–68, 372n.61, 392n.1
Springer, Jaro (*pseud.* Dr. Relling), 336n.133, 343n.44, 377n.2; on the Berlin Eleven, 248, 381n.24, 386n.43; on Böcklin, 281–82; on the Great Berlin Art Exhibition, 208; on Hofmann, 248; on juries, 196; on Klinger, 90; on modern art as subversive, 157, 354n.28; on Munch, 262–63; on the Munich Free Society, 387n.45; on neo-idealist art, 238; on overproduction, 195–96, 199, 203; on Parlaghy and Preuschen, 211; on the Schulte Art Salon exhibition, 164; on Toorop, 377n.4; on the Twenty-four, 256–57, 386n.43; on William II, 359n.67; on women artists, 207–9, 215–16, 290
St. Luke's Club (Düsseldorf), 246, 379–80nn.14–15
Staehle, A.: "Too Anxious," 149, *149*
Stahl, Friedrich: *Pursued,* 113, *115*
Steinhausen, Heinrich, 120, 143
Steinhausen, Wilhelm, 59
Stern, Fritz, 361n.84
Stern, Julius, 309
Stockmann, H.: "Good Taste for Art," *143;* "Up-to-Date," *136*
Stoecker, Adolf, 48–49
Strathmann, Carl: "The Maiden Sniffs the Lily," 295, *296*

Strauss, David Friedrich, 50–51
strikes, labor, 43–44, 146, 324n.38
Struwelpeter, 172
Stuck, Franz, 340n.34, 375n.78; *Battling Fauns*, 192; "The Cattle-Farmer Sepp in the Art Exhibition," *14*; *Centaur and Nymph*, 229; critical/public reception of, 157, 159, 336nn.131–32, 354n.29, 356n.39; *Crucifixion*, 113–14, 159; "Cupid's Mission in the Twelve Months of the Year," 189, *192*; "The Exhibition Is Closed," 79, *81*; *Fighting Fauns*, 229–30, *231*; *Franz and Mary Stuck*, 229, *230*; *The Guardian of Paradise*, 22, 111, *111*, 122, 136, 168, 192, 229, 239; *Innocentia*, 113–14, *192*; *The Kiss of the Sphinx*, 230, 287, *287*, 301; and Lenbach, 230, 375n.77; *Lucifer*, 113–14, *115*, 342n.43; "The Painting Machine," 122, *122*–23; "Pan," 270, 294; *The Sin*, 159, *160*, 168, 230, 355n.31, 375n.77; Spier on, 267, 392n.1; success of, 229–31, 355n.31, 375n.76; Symbolism of, 284; villa of, 230, *232*
Stuttgart International Painting Exhibition (1891), 119, 344n.49
Symbolism, 238, 264–65, 271–72, 275, 282–90, *283*, *283*–*84*, *287*–*88*, 377n.2, 400–401nn.39–40, 401nn.42–43

Theodor Lichtenberg Art Gallery, 133
Third Annual Munich Exhibition (1891). *See* Munich Annual Exhibitions
Third International Art Exhibition (Munich, 1888). *See* Munich International Art Exhibitions
Thoma, Hans, 70, 113, 118, 263, 336n.132; reputation/ reception of, 280; *The Ride to the Gralsburg*, 287–88, *288*; *Taunus Landscape*, 280, *281*; "The Youth and the Incredible Birds," *178*
Toorop, Jan, 159; *The Three Brides*, 241, 377n.4
Toulouse-Lautrec, Henri de, 274, 395nn.14–15
trade barriers, 192–93
transient artistic styles, 238–43, *239*–*40*, *242*, 377n.4, 378n.6
traveling exhibitions, 99, 133–39, *134*, *136*–*37*, 348n.80, 348–49nn.82–84
Treitschke, Heinrich von, 48
Trübner, Wilhelm, 113, 339n.22; *Art Comprehension Today*, 144, 350n.6; *Smoking Moor*, 104, *105*; *Studio Scene*, 130, *131*
Tschudi, Hugo von, 129, 174–75, 276, 309–10, 396–97nn.21–22, 411n.98
Twenty-four (Munich), 256–57, 386n.43

ugliness, aesthetic of, 46–47, 51, 60
Uhde, Fritz von, 46, 118, 119, 342n.43; anti-Semitism of, 411n.2; *The Barrel-Organ Man*, 63; in the Berlin Jubilee Exhibition, 97–98 (*see also* specific works); *Children's Nursery*, 70, 72; *Come Lord Jesus*, 63; critical reception of, 51, 53, 54, 57–58, 59–61, 62–63,

63, 65, 69–70, 73, 326n.56, 329n.83, 376n.87; *Drum Practice*, 53, *53*, 54; *Holy Night*, 63, 104, 159, 329n.78; in *Die Kunst für Alle*, 51; *The Last Supper*, 14–15, 56–57, *57*, 63, 65, 70, 187, 327n.62; and Liebermann, 53–54; modernism of, 112–13; *The Older Sister*, 63; *On the Road to Bethlehem*, 59, 59–60, 113; in the Paris Universal Exposition, 186, 187, 363n.2; *The Sermon on the Mount*, 56, 57, 63, 65, 104; success of, 61; *Suffer Little Children to Come unto Me*, *19*, 54, 56, 63
Union of Women Painters and Sculptors (Paris), 215
United States art market, 193, 364n.9
Ury, Lesser, 118, 156, 331n.95; *At the Friedrichstrasse Station*, 70, 72

van Gogh, Vincent, 137, 349nn.83–84
Velde, Henry van de, 118, 277
Verein für Originalradierung Karlsruhe, 366n.22
Victoria, Dowager Empress, 116, 215, 342n.43
Victoria Lyceum (Berlin), 215
Vincenti, Carl von, 77
Vinnen, Carl, 207
Vogel, Hermann, 364n.7; in *Fliegende Blätter*, 187, *188*, 189, 309; "Heartfelt Lament of a German Painter," 187, *188*, 189, *191*; "Modern Poetry," *154*; "The 'Moderns' and the 'Ancients,'" 307, *308*
Vogel, Julius, 87, 90–91, 334n.118, 334n.120, 335n.124
Volbehr, Theodor, 128
Voll, Karl, 127, 263, 346n.65
Vollmar, Helene, 116, 220, 372n.61
Voss, Georg, 71, 73, 128, 331n.96, 334n.120; on the Berlin Academy Exhibitions, 106–7, 340n.27; on the Berlin Jubilee Exhibition, 93–94, 98; on the Paris Universal Exposition, 186; on Stuck, 375n.76; on women artists, 216–17, 219, 371n.58
Vossische Zeitung, 171, 175, 186

Walden, Herwarth, 137, 349n.84
Wallé, Peter, 357n.50
Wallot, Paul, 211, 293–94, 406n.67
Ward, Mrs. Humphrey, 371n.59
Wasserman, Henry, 353n.18, 354n.21
Weber-Petsche, Frau, 220
welfare societies, 221, 373n.64
Werner, Anton von: on the Berlin Academy Exhibitions, 342n.41; on the Berlin International Art Exhibition, 342n.43; on the Berlin Jubilee Exhibition, 98, 337n.2; and Bode, 232–33, 376n.81; *Congress in Berlin*, 93; influence/status of, 30–31, 261–62, 305, 389n.54; *Moltke with His Staff before Paris*, 93; *The Opening of the Reichstag*, 116, 232, *234*; as painter-prince, 232, 233, *233*, 237; on the Paris Universal Exposition, 187; *The Proclamation of the German Empire*, 29, *29*–30; Sedan panorama by, 34–35, 36, *36*, 320n.17, 321n.20; and William II, 176

Wichmann, Robert, *173*
Wilde, Oscar: *Salome*, 286, 403n.49
Wilke, Rudolf: "The Regulars at the Women Artists' Table in the 'Blue Stocking,'" *300*, 302
William I, Emperor, 93, 105; statues of, 31, 175, 319n.11
William II, Emperor, 116; criticism of, 175–77, 359–60n.67–69; modern art opposed by, 174, 175–76, 249, 314; and the National Gallery, 309–10, 410–11nn.98–99; and Parlaghy, 210–11, *212; People of Europe, Protect Your Most Holy Possessions*, 175, *176*, 352n.15; pseudo-classical sculpture promoted by, 312–14, *314*, 412n.3; and Tschudi, 309–10, 410n.98
Willumsen, Jens F., 257
Woermann, Karl, 128, 255, 356n.42
Wolf, Georg Jacob, *147*
Wölfflin, Heinrich, 131
women: and "battle of the sexes theme," 286, 402n.48; condescension toward, 290, 404n.56, 404n.58; as critics, 220, 357n.43, 372n.61; dominating, subordination of men to, *298, 300–301,* 369n.46; organizations for, 145, 214–15, 405n.60; rights/emancipation of, 145, 212, 296–99, 407n.77; suffrage for, 145; unmarried, 214, 369n.49, 371n.59

women artists, 192, 368n.41, 384n.30; in the Berlin Secession, 289, 403n.54; in *Jugend*, 212, 216, *217*, 219, 220, 302, 408n.82; *Die Kunst für Alle* on, 221, 289–90, 404n.55; and overproduction, 207–14, *209–10, 212–13*, 221, 368n.40, 368n.44, 369n.47; presence of/pressures on, 214–21, *217–20*, 370–73nn.51–62
Women's Art School (Karlsruhe), 214–15, 370n.51
working classes, state control of, 203–4
Württemberg Art Society (Stuttgart), 132, *134*
Württemberg Society of Women Artists (Stuttgart), 215

Zeitschrift für bildende Kunst, 322n.25; on Böcklin, 81–82; on Impressionism, 61, 328nn.73–74; on Klinger, 89; on Liebermann, 64–65; on Munich Annual Exhibitions, 112, 114; on the Paris Universal Exposition, 186; publication of, 98; on traveling art, 136; on Uhde, 65, 329n.83. *See also* Muther, Richard
Zimmern, Helen, 220, 372n.61
Zola, Émile, 61, 144, 328nn.73–74, 350n.6
Zumbusch, Ludwig von, *297*

Photography Credits

Permission to reproduce illustrations is provided by the owners or sources as listed in the captions. Additional photography credits are as follows:

Albert J. Asch, West Bend, Wisconsin (fig. 52)

© 2003 Artists Rights Society (ARS), New York/VG Bild-Kunst, Bonn (plates 1, 7; figs. 13, 15B, 19, 24, 28, 29, 31, 65B, 74A, 74B, 77C, 105, 110, 112B, 124B, 129B, 131B)

© Bildarchiv Preußischer Kulturbesitz Berlin, 2002 (figs. 2, 8C, 9, 30A, 73A, 74A, and 53 [Dietmar Katz 2002]; 89C [Jörg P. Anders 2002]; 104 [K. Petersen 1993])

© Copyright The British Museum, London (fig. 77E)

Dietmar Katz Photograph, Berlin (figs. 16, 38C)

© Fotostudio Hans-Joachim Bartsch, Berlin (figs. 5, 27A)

Fotostudio Otto, Vienna (figs. 36, 89A)

The Getty Research Institute (Visual Media Services), Los Angeles (figs. 8A, 12, 29, 38A–B, 39, 42B, 73B, 74B–C, 76, 87, 103, 109, 114, 117, 120, 126–32, 135, 136

© Hamburger Kunsthalle (Elke Walford), Hamburg (plate 1; figs. 19, 26, 27B, 110)

John Blazejewski, Princeton, New Jersey (fig. 15A)

Jörg P. Anders Photoatelier, Berlin (figs. 15B, 34, 35, 75B, 77C, 81, 89B)

© Metz, Musées de la Cour d'Or (Cliché Jean Munin Tous Droits réservés) (fig. 88)

Münchner Stadtmuseum, Munich (figs. 41B, 111B)

© Museum der bildende Künste Leipzig (Gerstenberger) (plates 2 [1998], 4 [1996, after 1995 restoration], 6 [1999], 8 [1994]; figs. 13 [1994], 27C [2001], 37, 75A [1995], 98B [2000], 123B [1994])

Nationalgalerie, Staatliche Museen zu Berlin—Preußischer Kulturbesitz (Photographische Abteilung), Berlin (figs. 28, 31, 90, and 133 [Bernd Kuhnert 1996]; 94 [Reinhard Saczewski 1996]; 119 [Jörg P. Anders 2002])

The Ohio State University Cartoon Research Library, Columbus (figs. 25B, 63, 102)

The Ohio State University Cartoon Research Library (Theron Ellinger), Columbus (figs. 1, 3, 4A, 6, 7, 14, 17A–B, 23, 25A, 25C, 30B, 33A, 41A, 43, 47, 50, 51A, 54–56, 57A–B, 58–62, 64, 65A, 66B, 68–72, 78–80, 82–84, 86, 91–93, 96, 97, 98C, 101A, 107, 108, 111A, 113, 115, 118, 121, 122, 134)

Sächsische Landesbibliothek—Staats- und Universitätsbibliothek (Deutsche Fotothek), Dresden (plate 7 [Abt. K.-D, Schumacher]; fig. 67)

Schweizerisches Institut für Kunstwissenschaft, Zürich (fig. 105)

Staatliche Kunstsammlung Dresden (Deutsche Fotothek) (figs. 18, 124A [Kramer])

Staatsbibliothek zu Berlin—Preußischer Kulturbesitz (1998), Berlin (figs. 4, 8B, 17C, 20, 33B–C, 40B, 44, 48, 51B, 57C, 99)

Stadtmuseum, Berlin (figs. 46A [Christel Lehmann], 112A)

© Städtische Galerie im Lenbachhaus, Munich (figs. 98A, 100, 112B)

Städtische Kunsthalle Mannheim (Margita Wickenhäuser) (fig. 24A)

© Ursula Edelmann, Frankfurt am Main (fig. 124B)

Wolfram Schmidt Fotografie, Regensburg (fig. 125)